cream

10 curators

10 writers

100 artists

contemporary art in culture

Acknowledgements

Special thanks are due to the 100 artists in *cream*.

Many thanks to all the authors and publishers for permission to reprint their texts: César Aira, Buenos Aires; Arjun Appadurai, Chicago; Nicolas Bourriaud, Paris; Estate of Gilles Deleuze, Paris; Duke University Press, Durham, North Carolina; Les Editions de Minuit, Paris; Chris Kraus, New York; Julia Kristeva and Philippe Sollers, Paris; Toni Morrison, Princeton, New Jersey; Le Nouvel Observateur, Paris; David Robbins, Chicago; Edward Saïd, New York; Eve Kosofsky Sedgwick, Durham, North Carolina; Vintage at Random House, London; Sage Publications Ltd, London; Semiotext(e) Native Agents, New York, Nancy Spector, New York.

We would like to thank the following for their assistance in providing images:
Andréhn-Schiptjenko, Stockholm; Angles Gallery, Santa Monica, California; Galerie Arndt & Partner, Berlin; Artur Barrio, Rio de Janerio; Basilico Fine Arts, New York; Beaconsfield Gallery, London; Jean Bernier Gallery, Athens; Marianne Boesky Gallery, New York; Bonakdar Jancou Gallery, New York; Galleri Andreas Brändström, Stockholm; Bravin Post Lee Gallery, New York; Gavin Brown's enterprise, New York; Cabinet Gallery, London; Galeria Camargo Vilaça, São Paulo; Chisenhale Gallery, London; CRG Gallery, New York; Galerie Chantal Crousel, Paris; Christie's Images, London; D'Amelio Terras Gallery, New York; Anthony d'Offay Gallery, London; Deitch Projects, New York; Feature Inc., New York; Stephen Friedman Gallery, London; Frith Street Gallery, London; Laure Genillard Gallery, London; Sandra Gering Gallery, New York; Maya Gilissen, Brussels; Barbara Gladstone Gallery, New York; Marian Goodman Gallery, New York; Christopher Grimes Gallery, Santa Monica, California; Studio Guenzani, Milan; Hans Haacke, New York; Jenny Holzer, Hoosick, New York; Estate of Douglas Huebler, Valencia, California; Douglas Hyde Gallery, Dublin; Jablonka Galerie, Cologne; Jay Joping/White Cube, London; Casey Kaplan, New York; Mary Kelly, Los Angeles; Gallery Koyanagi, Tokyo; Kunsthalle, Bern; Jean-Jacques Lebel, Paris; Lehmann Maupin Gallery, New York; Nelson Leirner, São Paulo; Carlos Leppe, Santiago; Lisson Gallery, London; Luhring Augustine Gallery, New York; Antonio Manuel, Rio de Janeiro; Galleria Massimo De Carlo, Milan; Estate of Gordon Matta-Clark, Weston, Connecticut; Estate of Ana Mendieta and Galerie Lelong, New York; Victoria Miro Gallery, London; ARC, Musée d'Art Moderne de la Ville de Paris; neugerriemschneider Gallery, Berlin; Annina Nosei Gallery, New York; PaceWildensteinMacGill, New York; Galerie Roger Pailhas, Paris; Margarita Paksa, Buenos Aries; Maureen Paley/Interim Art, London; Galerie Perrotin, Paris; Friedrich Petzel Gallery, New York; Robert Prime Gallery, London; Produzentengalerie, Hamburg; Public Art Development Trust, London; Schipper und Krome, Cologne; Carolee Schneemann, New Paltz, New York; Jo Spence Memorial Archive, London; Monika Sprüth Galerie, Cologne; Tate Gallery, London; Throckmorton Fine Art Inc., New York; Jack Tilton Gallery, New York; Van Abbemuseum, Eindhoven, The Netherlands; Visual Art Projects Ltd., Glasgow; Walker Arts Center, Minneapolis; Shoshana Wayne Gallery, Santa Monica, California; John Weber Gallery, New York; Galerie Barbara Weiss, Berlin; Stephen Willats, London; Wooster Gardens, New York; David Zwirner Gallery, New York

Photographers:
Dan Barsotti; John Berens; Andreas Brändström; Lars Bygdegård; Jenny Carter; Vicente de Mello; Arno Delair; F. Delpech; Ertan/Germen; Fabbri; Rodgerio Faisal; Romulo Fialdini; Brian Forrest; Vladimir Fridkes; Olivier Martin Gambier; Mads Gamdrup; Maria Gotthard; Erik Hanson; Dominique Haneuse; Anna Kelberg; F. Kleinefenn; José Roberto Labato; Larry Lamé; L. Lecat; Mikel Levin; Guy L'Heureux; Scott Lindgren; Roberto Marossi; Werner Maschmann; Murillo Meirelles; Roman Mensing; Elio Montanari; Fredrik Nilsen; Michael James O'Brian; Gene Ogami; Greta Olafsdottir; Douglas M. Parker; Dirk Pauwels; Paolo Pellion; Karl Peterson; Andrew Phelps; Antonio Pinto; Adam Reich; John Riddy; Manuel Paul Rivera; Bent Ryberg; Carol Shadford; Shoba; Oren Slor; Simon Startling; Sue Tallon; Tom Van Eynde; Antti Viitaza; Peter White; Stephen White; Edward Woodman; Wener Zellien; Jens Ziehe

Translators:
Texts by Carlos Basualdo, Rosa Martínez and César Aira translated from Spanish by Christopher Martin.
Texts by Åsa Nacking translated from Swedish by Mike Garner, except 'Superflex' and 'Elin Wikström' translated by Philip Landon and 'Tracey Moffatt' and 'Christine and Irene Hohenbüchler' translated by Kjersti Board.
Texts by Hans Ulrich Obrist translated from German by Shaun Whiteside.
'Relational Aesthetics', Nicolas Bourriaud, translated from French by Simon Pleasance and Fronza Woods.
'Immanence; A life ... ', Gilles Deleuze, translated from French by Nick Millett.
'When Freedom Saves Couples', Julia Kristeva with Philippe Sollers, translated from French by Elizabeth Manchester.
'Cuentos Patrioticos (Patriotic tales)', Pablo Vargas Lugo, (Francis Alÿs), translated from Spanish by Terence Gower.
With thanks to Dominic Currin for his assistance.

Design:
Julia Hasting

All works are in private collections or the artist's collection unless otherwise stated.

Phaidon Press Limited
Regent's Wharf
All Saints Street
London N1 9PA
First published 1998
© Phaidon Press Limited 1998
Works of art © the artists

ISBN 0 7148 3801 2

A CIP catalogue record of this book is available from the British Library.

Printed in Hong Kong

cream preface 5

cream – contemporary art in culture contents

cream: contemporary art in culture is a portable exhibition in a book. A panel of ten curators, selected by Phaidon for their knowledge, their discrimination and their vision, were asked to choose the ten emerging artists they feel are currently producing the most significant, most innovative contemporary art world-wide. The result: a hand-picked list of 100 of the world's most important new artists working in all media — from painting and sculpture, to photography, performance as well as video installation and digital media.

Contemporary art can scream its presence in fluorescent colours or in wall-sized videos, or it might barely whisper, at times verging on the invisible. *cream* presents this amazing variety of ideas and forms in hundreds of images, alongside a brief text by the selecting curator that discusses the key issues for each artist, and their exhibition history and bibliography. This virtual exhibition of new art is accompanied by an Internet conversation among the ten curators: the ensuing debate highlights the motivations behind their choices while commenting on the complicated apparatus surrounding contemporary art — which cannot but include *cream* itself. To frame the broader context in which art is immersed, each curator was also asked to select a favourite recent text — from philosophy to fiction to art criticism — and thus bring together ten contemporary writers: 'guest speakers' who have all contributed on the highest level to the current cultural climate.

cream is a unique introduction, an insider's view, to the art world for the years to come. It would be literally impossible to display all these works under one roof — some are sited on the streets of Hong Kong, others have been left to decay and no longer exist. In contrast to an actual exhibition space, a book offers a kind of flexibility and 'democracy' — every artist is given an equal number of identical 'rooms', four pages each, and has been simply arranged in alphabetical order — and can gather together in a single space many voices, ten curators, ten writers and 100 artists, otherwise scattered all over the globe.

Naturally, we all know that art is meant to be seen 'in the flesh', live and on stage, where the scale, the texture, the immediacy, sometimes even the sound and smell of a work confront or tease you. *cream* does not attempt the impossible task of replacing the experience of art, but provides a invaluable resource in signalling 100 exceptional new artists, offering a comprehensive overview of contemporary art today — with its many voices, pressing debates and ever-shifting boundaries.

Gilda Williams

preface

carlos basualdo

francesco bonami

dan cameron

okwui enwezor

matthew higgs

hou hanru

susan kandel

rosa martínez

åsa nacking

hans ulrich obrist

The following is an edited transcript of an Internet debate among the ten *cream* curators and the Commissioning Editor held from 29 January – 25 February, 1998.

The strain of this attempt to 'converse' coherently on the net – with the time lags, technical impediments and general malaise of 'chatting' with strangers on the other side of the globe – has been somewhat disguised by the re-ordering of speakers and the reconstruction of a linear flow. Thus, the entries do not follow their original chronological order; the actual time and date for each entry has been left intact, admitting to the tangled nature of the original conversation.

10 curators – a conversation on the internet

Who is the audience for contemporary art, and is curiosity becoming so widespread that its core audience could be broadened?

from: dan cameron, 22 february 1998, 00:52hrs

Most art demands a certain level of visual literacy and a degree of concentration, so that viewers who are mostly accustomed to the time-frames presented by movies, television and magazines are not going to enjoy looking steadily at works of art. They might not hate it outright, but they probably won't go back a second time unless they can develop a real level of comfort with the medi-um. I'm certainly not against trying to grow an audience through whatever means are available, but the kind of ongoing scandal that one associates with the entertainment industry (or with 'Sensation' at the Royal Academy in London) is just another form of clever marketing. I'd rather see people really debating the issues that art is raising rather than getting up in the stampede. In the US, the fact that art is no longer as stigmatized a profession as it was only five years ago has made things a lot easier for artists themselves. As a result, art museums of all stripes find themselves with record crowds on their hands. If we could spend more energy getting the message across that even difficult art doesn't need to be alienating, rather than trying to market it as non-threatening and fun, I think we'd be much better off.

from: hou hanru, 11 february 1998, 01:39hrs

My question is: shouldn't we ask how to 'create' an audience for contemporary art rather than trying to figure out who the audi-ence is?

from: gilda williams and clare manchester for phaidon press, 29 january 1998, 13:04hrs

A question about cream as an 'exhibition in a book', and the new post-book media: is a book like cream a means of achieving what contemporary art never has – a mass-produced, mass-distributed product (analogous to the products of the film or music indus-tries)? Or are new media (CD-roms, the web) an even more effective and global arena for changing how and where contemporary art is accessed by both a specialized and non-initiated public? And is there any connection between this and the aims of Conceptual Art (and other 1960–70s movements) to push art 'out out' of the gallery?

from: susan kandel, 5 february 1998, 22:07hrs

This question is interesting for me as the editor of an art magazine, because of course I conceive of every issue of the magazine as an 'exhibition in a book' – with all the difficulties that might imply. Yet we try, nonetheless, as curators do. I would think, to react to a moment – in a manner that is measured, but provocative – and to create discourse around that moment. When you con-sider the fact that many people do not travel to most shows that are covered, it becomes evident that the art magazine is the ultimate destination of the art object. It is not so much a matter of that object being 'dematerialized' in this context, but rather a matter of abandoning all notions of art's 'singularity' – as object, event or otherwise.

from: carlos basualdo, 6 february 1998, 17:21hrs

I think that it would be very useful to focus on the conditions that we are actually dealing with in this project. We were asked to present a certain number (ten) of 'emergent' artists. The artists would be represented through images of their works and not through actual pieces made specifi-cally for the book format. It is not, then, a question of the presentation of works but of their re-presentation. That makes the book clearly not an exhibition but, to put it in simple terms, a book on 100 artists.

On the other hand we were approached not to curate this project, but as practising curators from whose expertise the audience of the book could ideally profit. We are not actually curating (which would involve dealing with the medium of the exhibition, the exhibition environment, even if that means the pages of a book, as in this case) but in fact we are enacting the position of the curator. I understand that a pioneer example of an exhibition made specifically for the printed format was, for example, Seth Siegelaub's January 5-31, 1969.[2] In this case, as he stated in the catalogue. The exhibition consists of (the ideas communicated in) the catalogue: the physical presence (of the work) is supplementary to the catalogue.' One of the artists that I am presenting in the context of this project, Ben Kinmont, has been working very much in that direction (which made his partici-pation in the project paradoxically harder, because Ben had to find a way of, again, representing accurately his pieces for this occasion). It would be interesting to analyze the distance (historical, but also ideological) between cream and January 5-31, 1969.

left to right, Robert Barry, Joseph Kosuth, Douglas Huebler, Lawrence Weiner, 1969, participating artists in Seth Siegelaub's January 5-31, 1969'

from: hou hanru, 16 february 1998, 23:17hrs

A question to the editor: are you considering cream as a rock CD kind of product and to promote it like the British Young Art stuff?

from: gilda williams for phaidon press, 18 february 1998, 16:17hrs

I think the 'British Young Art stuff' was masterfully promoted by Damien Hirst in the show 'Freeze', which celebrates its tenth anniversary this year, and the exhibitions that followed on from that. In many of the YBA's later exhibitions here and abroad or, worse yet, in its presentation in Sunday magazines or in 'dumbing-down' TV documentaries, the new British artists (many of whom are to be admired) come across as so much hype, the good mixed indistinctly with the bad. There's a lot of boredom and suspicion

– alongside the curiosity – regarding new British art, even though there's still plenty of good work being made here. I ask myself how Hirst had avoided all that – after all, he didn't invent anything, he used the tried and tested formula of an exhibition, a catalogue, a lot of press, and yet it felt very new, very genuine. He catalyzed a whole artistic moment with an enterprising, even publicity-seeking spirit, yet without compromise.

I'd like to respond to the first part of your question, about *cream* as a rock CD, in the riskiest way possible, which is to answer 'yes'. I am very interested in pop and world music as well as pop culture as a whole, so I try not to judge one cultural form as more worthy than another. Pop and world music, even at their most cutting-edge ends, do not at all disdain being part of mass culture, and I am intrigued by this contrast with contemporary art. Pop music openly boasts its million-dollar record sales, tries to appeal to as broad a public as possible, makes ever-changing, hierarchical 'top-of-the-charts' lists – all forms of behaviour that are despised and would be considered vulgar, trivializing and disgraceful in the contemporary art world. There is a kind of anti-mass culture purity in contemporary art – is it because whenever it moves outside of its specialized arena it is reduced to a parody of itself, stripped of its ambiguity, exhibitionistic, dull, like the mainstream press' treatment of the young Brits?

Does contemporary art, as your question implies to me, deliberately set itself outside of mass culture simply because it has no mass product to sell (i.e., the rock CD in your question), or because it is a specialized intellectual field – or is it more subtle than that? Is there a real resistance, a protective impetus from within the art world to preserve its dignity and meaning by addressing only its already initiated audience? Is contemporary art only interesting when it functions as a site of resistance? My point is not that contemporary art should necessarily go down the MTV path; I would like to open the debate as to why that path is so insistently resisted.

from: dan cameron, 21 february 1998, 00:22hrs

I'm a little sceptical when people compare art's lack of an effective audience to pop culture's immersion in its audience's self-image. Art is not lacking a mass audience because of some deep inner flaw that makes it opaque and impenetrable to most people. Rather, art's physical and conceptual conditions make it very difficult to market in the way that music, film and even literature are marketed. It's hard to put an advertisement on a painting or sculpture, just as it's difficult to package new art as a kind of who's-who of cultural fusion.

In this sense, I've never really believed *cream* was an exhibition at all, but more like a yearbook of trends and issues. Ironically, I think that its eventual presence as a book is what might make it hugely effective at getting new art across to a larger public. What I'd really like to see is a handbook or supplement instructing ordinary people all over the world on how to discover interesting artists in their own back yard.

from: susan kandel, 24 february 1998, 19:36hrs

I'm quite surprised by Gilda Williams' queries about why contemporary art so resists 'the MTV path'. Of course, it doesn't – that is the point here. The top-ten phenomenon is well enshrined in the art world (consider all of the end-of-the-year wrap-ups, countdowns, best and worst lists in the major art mags, and bi-, tri-, etc. ennials whose business is sweeping qualitative judgements – Grammys? Emmys? Oscars?). In terms of content itself, there is a relentless sniffing at the hindquarters of the entertainment industries (I'll just refer you back to Gilda's own comments on the ubiquitous Damien Hirst, and add cover girl Elizabeth Peyton and everybody Joshua Decter ever put in a group show). What this sniffing means for contemporary art practice is certainly a more tangled question, especially if you are willing to accept the premise that art must compete with popular culture if it is to survive (I don't).

from: rosa martínez, 25 february 1998

Contemporary art will never achieve the audiences of football, pop music or television, so I think we should stop comparing its possible area of influence to that of the big mass-media events. The construction of museums like the Guggenheim Museum Bilbao and some international shows play inside the logic of the spectacle and they attract large numbers of people as 'artistic Disneylands'. Today sensationalism has replaced the critic's knowledge of reality and the laws of the market are stronger than the efforts to fight against singular thought. We live in the empire of marketing, spectacle and seduction, so one of the roles of artists and curators is to deconstruct those strategies, to resist their logic, to use them, and/or to find new means of activism against them.

As far as art is related to any analysis of reality, to revealing the poetics of the unknown or to reviving aesthetics, it cannot be con-

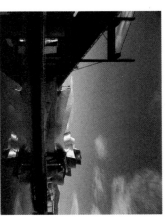
Frank Gehry, Guggenheim Museum Bilbao, 1997

sumed as a mass product. It still has the connotations of an 'elite' because it requires certain knowledge and intellectual level to be understood. The book we are working on is a good example of that. Participating in *cream* I really feel like constructing the best Biennial of 1998 and I think this publication will be an element of reference to draw the situation of a specific moment in time because it gathers the visions of different curators and their challenge to 'bet' on young artists. We are here because we still believe in micro-actions, in aesthetic and ideological militancy as an effort to discover new realities. But art is also part of a powerful cultural industry through which politicians and enterprises need to promote themselves or their values. As far as art deals

with beauty, memory, transcendence, prestige and knowledge' and some other immaterial stuff. it still has an aura that can be used to make the masses aware that they have to climb a lot to get to the heights of Real Culture. The problem is how much they care.

from: gilda williams for phaidon press, 29 january 1998, 12:36hrs

A question about the shifting geography of art and the art world: does geographic and ethnic background help or hinder in discussing an artist's practice, particularly among cross-cultural artists (Huang Yong Ping, Rirkrit Tiravanija, Fiona Tan, Yinka Shonibare, Kendell Geers, etc.)? And in this expanding art world, does this paradoxically turn the curator above all into a sort of local expert?

from: hou hanru, 4 february 1998, 23:52hrs

Well, the curator is also a traveller. A local expert, yes, but he should not be limited to the local. He's like the artist, who is a typical global man. On his body, there's the global influences and the desire to be global while 'local' heritage makes him explore his own world in depth and somehow resist the global. It's when the global and the local meet that interesting things happen.

from: matthew higgs, 6 february 1998, 15:10hrs

Hou Hanru makes some fairly speculative assumptions in the construction of his composite curator. I am not comfortable with the idea – or gender – of Hanru's 'typical global man'. I don't recognize myself in his generic traveller. I have no desire – in Hanru's words – 'to be global', whatever that might mean. His notion that things start to get interesting at the point where the global and the local meet to me only mirrors the empty rhetoric of MTV-style sloganeering ('Think Global, Act Local').

My 'expertise' – if it could be defined as such – is born out of an everyday, lived engagement with a highly specific, local situation. I do not make my living from curating, I cannot afford to travel extensively, I have no private income. I am not supported by an institution or organization. Consequently my experience and understanding of the 'shifting geographies' described in the question is at best speculative – based almost entirely on what I have been able to read.

It is perhaps worth pointing out that of the ten artists I have proposed for this project, eight are British, of whom six are currently based in London. All I would consider to be friends. The remaining two artists, Piotr Uklanski and Udomsak Krisanamis, are both represented by the same gallerist in New York, Gavin Brown, an old friend from college.

from: hou hanru, 16 february 1998, 23:26hrs

By 'global man' I don't mean a superficial tourist. Rather, he is someone who, often by obligation, travels to different places in the world and listens and talks to different voices.

Every curator is different. You can stay all your life. But it's impossible not to talk to the others and listen to other voices, especially voices from other parts of the world. If art has a role to play in today's real life, this is an essential aspect of it.

from: okwui enwezor, 11 february 1998, 00:45hrs

It is funny that Matthew Higgs' point of view is based on the fact that he doesn't travel, and sees himself as rooted in this intense locality called Britain. May I suggest to Higgs that globalization does not exist in the nebulous world of the outside, but may be considered from the vantage point of his locality in how certain daily practices that good old Britain disavows continuously in its cultural, social and political processes. How does Paul Gilroy's Black Atlantic,[3] for instance, figure in the way that Higgs' staunch allegiance to national sentiment squares with the 'shifting geographies' evoked by Hou Hanru? How does the news dispatched from Hong Kong, which now is suddenly Hanru's locality because it is a part of China, define Britain for Higgs?

It is important to pay attention to the fierce way in which we easily invoke the local as a way to pay lip service to our ignorance of the world as it exists in other places. I am most unimpressed by this idea that the artists selected by Higgs are either friends or friends of friends. I mean, how local can one get before it begins to seem like an incestuous exercise in denial of a bigger, more challenging picture? Yes, there is a deep structural problem in the way globalization is discussed today. But the answer is not in disavowing its portents; rather, a new analysis of its meanings needs urgent engagement.

from: matthew higgs, 13 february 1998, 13:19hrs

To respond – briefly – to Okwui Enwezor's comments: there is a significant and important difference between not travelling, and not being able to afford to travel. Not to acknowledge this somewhat undermines your subsequent comments. I do not regard Britain – and more specifically London – as an 'intense locality', nor am I 'rooted' there – it just happens to be where I and twelve million other people live and work.

In responding to Hou Hanru's spurious notion of the curator as some 'typical global man', I was simply – in my own way – trying to point out that our experiences as curators are very different: for instance, I pay to get into museums.

It is probably fair to assume that, with the exception of Hans Ulrich Obrist, the other curators involved with cream are unaware of my activities. To date most of my projects have been by their very nature 'local' – local artists working together within a local context. This does not in my mind translate as a 'staunch allegiance to national sentiment'. It is simply a realistic response to everyday practicalities (some of which are inevitably economic). I am not worried that Okwui is 'most unimpressed' with the nature and make-up of the list of artists I am working with on this project. The list is an honest response to Phaidon's proposal in light of my experience. These are people I know and whose work I find interesting. It is that straightforward. If this is an incestuous

exercise in denial of a bigger, more challenging picture then so be it.

Finally, I haven't read Paul Gilroy's *Black Atlantic*, but then there are many things I haven't read.

from: rosa martínez, 25 february 1998, 18:12hrs

Travelling both physically and intellectually is a tiring but healthy exercise. It puts more — and different — air into your lungs. It allows you to see things from different perspectives, to understand the tensions between local and global, between the dominating centres and the emerging peripheries.

Cross-cultural artists and cross-cultural curators are developing an extraordinary capacity for translation, for using different languages, for moving from one logic to another. This flexibility allows us to become 'floating signifiers', as Lévi-Strauss has put it, and to deconstruct the orthodoxies of fixed identities.

Globalization is producing cultural homogeneity, but its opposite — the extreme defence of local identity — is creating new ideologies, new codes of legitimization that direct us towards other totalitarianisms. Globalization has some positive aspects — the convergence of cultures and ethnicities producing hybridizations that allow escape from puritanism. But it also hides the interests of transnational Capitalism to use the planet as the context for a 'unique thought' and as a unique market to consume the same 'star-products', whether Coca-Cola, Guggenheim museums or Jeff Koons.

So the balance is between the local and the global. To leave home from time to time or to open the door to other guests is a good way to see how complex the village we live in really is.

from: hou hanru, 16 february 1998, 23:33hrs

I like Okwui's idea presented at the ARCO panel of curators held in Madrid a few days ago[4] that art criticism functions to reveal the unknown. Yes, the unknown today comes from confrontation with the pressure of globalization. Globalization brings us more and more information on the 'other'. Do we really know the 'other' only through this increasing information? Or, should one develop real strategies to penetrate and interpret the 'unknown other' in a more profound way? I believe it's in the process of meeting with the 'other' (and travel is an important part of it) that we can start to understand what is really unknown to us; through this, art finds its new positions. Emerging is the unknown.

from: susan kandel, 5 february 1998, 21:59hrs

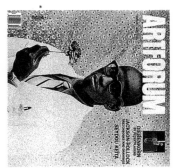

To return to the original question, clearly a shift is taking place, in terms of expanded parameters, when Seydou Keïta makes it on to the cover of *Artforum*.[5] Yet the question I would pose is a somewhat more parochial one: why it is that the 'new' globalism coincides almost exactly with the (virtual) death of the 'old' multi-culturalism in the US? What are the implications of this? Does it ultimately boil down to a question of marketability? And how is the 'new' global art being marketed differently? Is it being supported by the commercial apparatus, as opposed to the non-profit/institutional/museum sector? To my mind, these questions are vital.

If international art is being supported primarily by government initiatives, i.e., the explosion of bi-, tri-, quadr- ennials, then its

Seydou Keïta cover, Artforum, New York, February 1998

long-term viability is, obviously, questionable.

from: okwui enwezor, 6 february 1998, 00:17hrs

I am fascinated by Susan's implicit suspicion of Seydou Keïta's appearance on the cover of *Artforum*. There are several things in operation in this response including the idea that multi-culturalism in the US has died and has been replaced by another *nouvelle vogue* called 'globalization'. Part of the idea that is being ever so delicately placed on the table here is to think of a body of work that spans several decades as somehow denaturalized in its authentic place. Would Susan's suspicions have been raised on the non-issue of the correspondence of patronage with publicity and institutional legitimation; or would she have detected an act of bad faith within the same transaction if we switched Keïta's images for, say, August Sander or Rineke Dijkstra?

It feels quite frustrating to cloud issues unnecessarily when we make comparisons that seem to suggest there is some kind of charity at work when artists we least expect to sit on the cover of our beloved magazines break through the barricades. The paradox is that while Keïta's belated recognition in the West has happened only in the last few years, back in Bamako — where he is a legend — his work has been coveted for almost forty years. Just ask the more than twenty thousand sitters who have posed for him. So the issue here goes back to the limited view of what we consider the art world.

Certainly, in Bamako, where serious issues of subjectivity, representation and consensual modernity asserted themselves in the choice of the photographer who will represent the modern fantasies of its denizens, such limited purview is just that. On another level, I might sometimes tend to share in Susan's pessimism about the global. That word is also so quickly applied to everything, to the point of occluding the basic particularities that make globalization a truly heady subject.

from: susan kandel, 14 february 1998, 01:38hrs

The issue is not Seydou Keïta's place within the art world as defined by those in Bamako as much as Seydou Keïta's place within the art world as defined by New Yorkers (and I speak as a Los Angeleno conscious of the fact that my art world is itself still alternately fetishized and under-represented in many quarters). Keïta's appearance on the cover of *Artforum* — the magazine that still, for good or for ill, defines the art world along the New York/London/Cologne axis — is absolutely cause for discussion. Of course I

wouldn't make the same claim for the presence of August Sander or Rineke Dijkstra on the magazine's cover: European artists regularly appear there. Nor am I suggesting — ever so delicately' or otherwise — that charity is involved here. Actually, I am insisting upon the opposite, which is perhaps somewhat more cynical: that Keïta would never be in this position were his work not now deemed eminently commercial by the institutions that ignored it for decades. What I am suspicious of is that, clearly, only so many artists of colour — no matter where they are from — are invited to the big (money) table at any given moment.

from: dan cameron, 22 february 1998, 00:37hrs

I want to return to Susan Kandel's statement that the birth of the 'new' globalism coincides too neatly with what she calls the death of 'old' multi-culturalism in the US. As far as I'm concerned, the two are one and the same thing, feeding off each other as a kind of logical sequence. Obviously, not all brow-beaten multi-culturalists in the US are pre-disposed to recognizing their ideals in the newer construct, but that's hardly of paramount importance.

A larger process is taking place within the globalist discussion, namely the development of localities as places where consciousness of the other can be realized along historically revisionist lines. On the one hand it seems to be an activist position, but it is also quite practical, in so far as it recognizes the coming age of transcultural fluidity as the only way of avoiding the intransigence of despair. Which is why Matthew Higgs' position unsettles me. In describing 'his' London, he seems to be writing of a place where racism doesn't exist, where different classes talk to each other openly, where post-colonial fallout has been minimal to non-existent. It reminds me a bit of certain third- and fourth-generation New Yorkers who just can't comprehend New York's (or, by implication, the world's) increasingly polyglot culture, who prefer to see it as a nuisance or invisible. It makes me want to ask how much Matthew cares about the other. London, which is not necessarily the one he grew up with or knows best but which certainly exists alongside the one he does care about.

This is why I think nomadism is so important today in curatorial practice: not only does it provide a constant reminder of what being an outsider feels like, but it helps you return home and see the place you live with re-opened eyes. I travel for my research not because I can afford to or because I make my living as a curator or any of those reasons. I travel because I need to, because I think it's that important. In fact, my personal values are probably just as small-town working-class as they were when I first arrived in New York on a Greyhound bus several years ago, which is probably at the root of why I increasingly believe that art's universality is what makes it more essential to civilization than ever before.

from: gilda williams for phaidon press, 29 january 1998, 12:31hrs

What about the changes in and the current state of curatorial practice? Do these curators — or any others — appeal to you as models' for your work or partially define your practice?

• Harald Szeemann ('When Attitudes Become Form', Bern, 1969): the curator as creator of a site where the process of the artwork will happen, where artists can meet, and the exhibition is the work-in-progress result;

• Kynaston McShine ('Information', New York, 1970): the curator as the knowledgeable gatherer of information who presents the new art', suggesting an almost journalistic, objective picture of 'what's going on';

• Germano Celant ('Arte Povera Im Spazio', Genoa, 1967): the curator as the charismatic and articulate champion/spokesperson of a particular group/movement;

• Damien Hirst ('Freeze', London, 1988): the artist as curator, as the enterprising force from within a group who draws together a cohesive scene;

• Catherine David (Documenta X, Kassel, 1997): the curator as the trusted and responsible expert, who presents artists and works on the basis of her/his own intuitive selection.

Is the curator always and inevitably a go-between and facilitator among artists/institution/audience?

from: hou hanru, 4 february 1998, 23:42hrs

I tend to agree with Szeemann's idea: how to open a new space in which art can negotiate with the administrative framework. The bureaucracy of the institutional machine is a crucial challenge for art today. Emphasizing process is an effective strategy in response to this.

But changing venues does not necessarily change the presentation. What is important is to open up art's presence in the space: to go beyond the white-cube kind of presentation space and allow art to live like real life is again our task, even in a book project like cream. There are of course lots of contradictions here. Hopefully we can point them out and find solutions. Artists should have to participate directly although that is not the case now ... What's the solution?

from: francesco bonami, 6 february 1998, 23:08hrs

One solution could be transforming the curator into a virus with no apparent symptoms — you get inside the system and you oblige it to fight you as a virus. Often the problem is that curators become like flies — it's very easy to feed off the institution and follow its conventions.

from: okwui enwezor, 5 february 1998, 23:53hrs

Last summer I was amongst a group of curators, museum directors, critics, artists and a theorist on urbanism and globalization who gathered at the Rockefeller Villa in Bellagio, Italy. The gathering was significant in the sense that it brought together curators

and thinkers from different areas of the world, from Johannesburg, Havana, San Antonio, Dakar, Bangkok, Brisbane, New York, Berlin, Istanbul, Pittsburgh, São Paulo, Costa Rica, Paris and Genoa. All the curators represented different ideas or models of curatorial practice. Some of them, like Germano Celant, can be seen as paradigmatic figures; others, like gallerist/curator René Block, represented the figure of the curator as both enabler, administrator, gallerist and promoter; Paulo Herkenhoff, from the Fundação Bienal de São Paulo, brought a kind of intellectualism that was as disarming as it was serious.

In the ensuing debate that accompanied the three-day symposium, we discussed many different issues related to curatorial practice today, and what it means to be a curator. Needless to say there was no consensus on the matter. However, there was something that was striking about the symposium, which was: despite the fact that many of us came from so-called non-Western areas, it quickly became clear that, try as we might, we were all still speaking the very language of the Western institution, which paradoxically, was critiqued to death.

I am not an exception to this legacy in so far as my own range of intellectual and cultural experience exceeds both the boundaries of the West and of Nigeria where I originally come from. On a different level, Germano Celant raised a crucial question as to what the identity of the curator as a practising intellectual is, relative to the range of activities which comprise his/her practice. He also raised another question as to what the exact language of curatorship is, i.e., whether it possesses a language. For me, these questions are the most efficacious in understanding what it is that curators should strive for. The implication being that with any intellectual activity, it becomes quite necessary to position oneself in such a way that the limits of one's practice are productively used to create moments of examination of those limits and how those explorations open up to other possible worlds. These are questions with which I am still contending.

I believe in all honesty that the models provided within the question deal more with the figure of the curator as icon, as a transgressor, almost as a kind of crude bad boy/girl of the avant garde. It presents a problem for the simple reason that curatorship has not been properly and adequately theorized so as to push it to that space where it can begin to approach the sophistication of the novel, for example. I am thus highly enamoured by this idea of limits — not limits as a means of just exceeding circumscribed boundaries — but limits in terms of what's possible as more and more interesting information constantly emerges from many zones to challenge the comfy nooks we constantly build to ratify our own moribund practices. Increasingly, curators are behaving like ethnographers doing field work — two hours at an airport lounge in Accra, fifteen seconds in a studio in the barrios of Alicante, a scroll through the net, all with the requisite retinue of informers and, the show just might look interesting. I want more than this.

from: rosa martínez, 24 february 1998, 17:18hrs

The practice of being a curator today gives you the chance to work in dialogue with the artist, to co-produce a new reality, to collaborate, to develop new processes, to relate together to new contexts. The critic has a much more analytical distance, but the curator can work very closely, even intimately, with the artist. Together they can construct an exhibition that can become a critical tool, a statement about new intellectual and affective cartographies.

Curatorship is a trendy phenomenon because we seem to have glamour and power. The glamour of the openings and the power of making decisions (which artists are included, which are not) suggest that the curator is like a small god creating a (temporary) world. She is also a heroine traversing obstacles, conquering new territories of knowledge, convincing institutions and sponsors, etc. The curator is still a heroic interpreter who makes big efforts to articulate new discourses and new cultural practices.

from: hans ulrich obrist, 25 february 1998, 17:27hrs

I would like to mention a few examples of curatorial positions from earlier in the century, which I find relevant now. All the cited examples share close dialogues with artists, as well as the mutation of existing structures such as museums, and the invention of new structures. In the words of Willem Sandberg,[6] 'with the courage of the unacademic and the radical, according to the necessities of contemporary art'. In their inbetweenness and blurring of boundaries lies their actuality.

Felix Feneon[7] (1861–1944) has bridged different fields and has continuously sought new forms of arrangement and mediation. He made projects with daily newspapers as it seemed the most appropriate space. He organized small exhibitions and also founded his own structures. All of Feneon's projects were closely related to his dialogues with artists; he defined the curator as a *passerelle* (pedestrian bridge) between the artist and the world. From his desk at the Ministry of War he co-ordinated the activities of the Anarchist Movement.

Harry Graf Kessler[8] (1868–1937) also pursued mobile strategies of arrangement and mediation. He was a junction-maker between artists, architects and writers and created meeting points. From time to time he organized exhibitions to put the art of his salons into a larger social and political context. Kessler also pursued publishing activities parallel to his exhibition organizing.

Herwarth Walder[9] (1879–1941) was a similarly open mediator between the disciplines. He founded the art school and magazine *Der Sturm*, a publishing house, and ran an exhibition space as an open hybrid laboratory for small exhibitions. In 1913 Walder organized the first German Autumn Salon, with more than 360 works by eighty of the most important artists of his time.

Alexander Dorner[10] (1893–1957) defined the museum as a *Kraftwerk* (power station). He invited artists such as El Lissitzky to think up a contemporary dynamic display in the museum. Dorner emphasized in his writings *Ueberwindung der Kunst* ('going beyond art'); he intended to dynamize the static institution from the inside almost like an infiltration. He emphasized the importance of the

flexible museum: he changed the role of the museum from the nineteenth-century model which was simply about displaying work, to a space where debate could be opened out and engaged with, and where the audience has a role to play in the life of the muse-um. Dorner's importance lies in the fact that he anticipated very early on the urgency of issues such as:

- the museum as a space of permanent transformation with parameters which are dynamic and changing;
- a dynamic concept of art history; as John Dewey wrote, it is through Dorner that we are 'amidst a dynamic centre of profound transformations';
- the museum as an oscillation between object and process: 'the processual idea has penetrated our system of certainties' (Dorner):
- the multi-faceted identity of museums;
- the museum on the move;
- the museum as a risk-taking pioneer which acts and does not wait;
- the museum as a location for the intersection of art and life;
- the museum as a laboratory;
- the museum as a relative and not an absolute truth, or in the words of Marcel Broodthaers, 'every museum is one truth which is surrounded by many other truths';
- the flexible museum, which means both flexible display and flexible buildings;
- the museum as a bridge between artists and other disciplines.

In Dorner's own words, 'We cannot understand the forces which are effective in the visual production of today if we do not have a look at other fields of modern life.'

from: carlos basualdo, 5 february 1998, 06:16hrs

Rather than analyzing curatorial practice(s) in abstract terms I would like to pose a few questions regarding the specific project that we are undertaking now. I am particularly puzzled about the notion of 'emergent' and also about the number of artists that we are presenting in the book.

A couple of weeks ago Francesco Bonami, Hans Ulrich Obrist and myself met in a Chelsea gallery in New York and talked a bit about some of the possible implications of this. We mentioned at that time the risk of homogenization in contemporary artistic practice, which I think is simply enormous today. We were wondering how much we may be running the risk of contributing to this, becoming unwitting agents of this homogenizing process.

Hans came up with the idea that we should propose an eleventh artist each for cream. I added that the eleventh artist should not be an 'emergent' one – s/he could be a very well known artist or a completely unknown one. In that way, as Hans noted, we would all be constructing an anonymous eleventh curator made up of the ten of us. A secret curator, or a curator of secrets. I would like to reflect on the need of this sort of curatorial 'collage' as a way of counterposing both homogenization and the figure of the cura-tor as author, as that seems to be strongly suggested as a model in the question.

from: åsa nacking, 24 february 1998, 15:40hrs

I like the idea of adding an eleventh artist for a group chosen by a 'secret' curator. However, even if I do not think that the selec-tion process should be completely transparent, we should perhaps point out that there were overlappings in the choices of the curators. This might give the final list of artists a less definitive perspective.

from: dan cameron, 21 february 1998, 23:23hrs

I'd like to return to the propositions posted by Phaidon in regard to the work of a curator. Frankly, I found all five descriptive positions quite anaemic, in so far as they left out the active role that a curator can play within the (still) ongoing culture wars. I think that the curator should try as much as possible to be an *agent provocateur* or activist, in order to stir up public discussion around art. Whenever I organize an exhibition, I'm fully engaged by the idea that I'm doing it in opposition to something else: either against established notions of art history, against trendiness, or merely against the existing status quo.

Carolee Schneemann, Interior Scroll, 1975

My first exhibition as curator here at the New Museum was to mount a survey of Carolee Schneemann's work – not just because I think it's important and deserving of attention (which it is), but because she seemed to be the kind of artist who is never given proper credit for very significant breakthroughs. To call myself a curator and stand idly by while this historic injustice continues would, for me, be tantamount to bringing discredit to the entire profession. In this light, to credit curators as being experts who can spot artistic talent before it breaks the surface seems disingenuous at best, because it doesn't take into account the very real possibility that the artist may wish to bite the hand that feeds him/her, and that the curator is an empowering force within this process. For that reason, I think Carlos' point about being unwitting agents in the homogenization of art is a very significant one – not because the danger is so very real, but because curators are not usually happy being put in such a passive relationship to their medium.

I'm happy to be invited to participate in *cream* because I like the idea of artists getting attention, but there is an inad-vertent streamlining which is bound to take place, and which already has me cringing a bit ...

from: matthew higgs, 6 february 1998, 18:25hrs

I found Carlos Basualdo's comments intriguing. As prominent international curators and writers who operate from positions of some considerable influence, I would suggest that – in spite of their concerns – Francesco Bonami, Hans Ulrich Obrist and perhaps Carlos himself are inevitably already embroiled in the ongoing process of the homogenization of contemporary practice. It should be stressed that I don't necessarily perceive this as a problem – it simply goes with the territory. What puzzles me is how they could – in Carlos Basualdo's words – become 'unwilling agents' of this process?

from: carlos basualdo, 6 february 1998, 23:55hrs

With all due respect, I have to say that Matthew Higgs' remarks on my comments seem to me too generic and heavyhanded. Matthew seems to imply that we, as curators, are already agents of homogenization, and I wonder if he is referring to our specific practices – for example, to the way in which we have dealt with this issue in this or that show. Without specificity, his observations are vague and imprecise, like saying that all lawyers are liars or that all medical doctors are cold-blooded technicians.

Lygia Clark and Hélio Oiticica, Dialogue of Hands, 1966

I don't think that curators happily homogenize as part of their daily work, quite the contrary, I think that curatorial practice attempts to complicate things at many levels: history, perception, etc. I am sorry to insist on this once again, but I still find it useful to analyze things at the level of their occurrence. To put together a list of 100 'emergent' artists could be potentially dangerous I think, unless we address critically the implicit assumptions which were posed by the editors – for example, the notion of 'emergent', and the kind of work that could be presented here. Here we are, and because we are here, we can try to question the process, the very definition of 'emergent' – which is a fallacy and a misunderstanding, in my opinion – and maybe talk about other practices that we could not include in our list. (What determines that an artist is an 'emergent' artist? His age? His international presence? Are Lygia Clark or Hélio Oiticica still emergent artists? And what about those artists who are still completely unknown internationally but very well known locally?)

In that way, even if we agreed to a certain degree with this whole process, we can make an effort to problematize it from within. In my opinion we seem to be doing that anyway.

from: gilda williams for phaidon press, 9 february 1998, 19:56hrs

In response to Carlos Basualdo's question as to 'what defines an emergent artist', this was a crucial issue which Phaidon attempted to address right from the outset, i.e., what are we asking the curators for? *cream* would like to present as well as reflect upon current art practice in images and writing. With this in mind, the written brief which we sent to all the curators in our very first correspondence was meant to provide some parameters: you were invited to select 'currently practising artists who have recently (since about 1995) emerged on an international platform, or who in your opinion are about to

Ana Mendieta, Facial Hair Transplant, 1972

emerge, who interest you most'. (In subsequent discussions with the curators, we agreed to push the 1995 cut-off date back somewhat in certain circumstances. We have tried to keep the date fairly flexible without betraying the intention of the project.)

So, the obviously sticky question of 'defining an emergent artist' was in fact addressed – rightly or wrongly, that is up for debate – when the project was conceived. 'Age?' No; no age restrictions were given. 'His (or her!) inter-

Mary Kelly, Interim, Part I, 1984–85

national presence?' Yes; there was a cut-off date in the past, but curators' choices could extend infinitely into the future. 'Are Lygia Clark or Hélio Oiticica still emergent artists?' No; Oiticica was showing internationally back in 1969; Clark already in 1952! I am very glad, however, that such figures – artists who have gained or regained relevance or prominence among a more recent generation of artists, a list which could also include, say, Ana Mendieta, Mary Kelly, Douglas Huebler,

Hans Haacke, Gordon Matta-Clark, etc., etc. – have come up in this discussion. Undoubtedly they inform art practice today. But

Douglas Huebler, Variable Works (detail), 1970

where do you stop? Duchamp? Caravaggio? How far back do you go before the project turns into something else?

Hans Haacke, Condensation Cube, 1963

And what about those 'artists that are still completely unknown internationally but very well known locally'? Absolutely yes. In fact, this is what led me to ask elsewhere whether the curator has, paradoxically, become a kind of local art expert. S/he knows the local scene well and is asked, either for a book or an exhibition, to select artists to be set in the international context, i.e., the curator as a go-between between the local and international levels. There are plenty of other potential parameters; the one we decided on best defined what *cream* was meant to do. Other components of the book, like this conversation, were included within its covers in order to address the very pitfalls that you have identified.

from: carlos basualdo, 9 february 1998, 22:08hrs

It is interesting to note that a bestseller art history manual (and this despite its dubious academic merits) like *Constructivism: Origins and Evolution* by George Rickey[11] does not make a single reference to Hélio Oiticica – there is a picture though, of one of Lygia Clark's *Bichos*. It is meant to illustrate in a general way 'Constructivist tendencies (that) appeared in Japan, Argentina,

Brazil, Venezuela, and throughout Western Europe ...'. And I think that nobody would think that an exhibition at the Institut Endoplastique in Paris in 1952 called 'Lygia Clark, artiste brésilienne', would be enough to give her international recognition. These might not be emergent artists in this particular context as it was defined by the editors, but they are still very much so for the canon of the history of modern and contemporary art. At least they are so if we think of the definition of the word 'emergent' that we can find in The Random House College Dictionary (and I will quote it in its entirety, as its nuances are quite relevant here): '1. emerging; rising from a liquid or other surrounding medium. 2. coming into view or notice; issuing. 3. coming into existence, esp. through gaining political independence: the emergent nations from Africa. 4. arising casually or unexpectedly. 5. calling for immediate action; urgent.'

Antonio Manuel, Fantasma (Phantom), 1994

Arturo Barrio, Livro de Carne (Book of meat), 1978–79

Nelson Leirner, Adoração; Altar de Roberto Carlos (Adoration; Altar for Roberto Carlos), c. 1966, collection, Museu de Arte de São Paulo Assis Chateaubriand, São Paulo

It is certainly quite urgent that we acknowledge the fact that the art-historical canon is still quite closed to many practices developed in countries of the so-called peripheries, as is the case with Clark and Oiticica. We need only to consider the fact that they have gained international relevance only very recently, I would say in the last six years. Even in Brazil their work was very little or only partially known before the first years of this decade. But Oiticica and Clark are just the tip of a big iceberg — to continue the metaphor of the emergence from water. Let me add only a few more names to a possible new list of 'emergent' artists: Arturo Barrio (Brazil), Antonio Manuel (Brazil), Nelson Leirner (Brazil), Carlos Leppe (Chile), Margarita Paksa (Argentina). What is at stake here is a certain notion of history and actuality, and that was the point of my previous intervention.

Margarita Paksa, Untitled, 1998

Carlos Leppe, El Ruiseñor y la Rosa (The nightingale and the rose), 1985

I think that a critical redefinition of these notions is very much part of curatorial practice. I also think that I do understand Phaidon's position about the notion of 'emergence'. My intention was to open and further problematize the question. In my view, it is less a question of defining where to stop than of establishing where are we departing from.

from: matthew higgs, 13 february 1998, 15:35hrs

In response to Carlos' question: are Hélio Oiticica and Lygia Clark still 'emergent' artists? It would seem more accurate to describe them as 'neglected' artists — indeed Phaidon might consider an equally contentious volume devoted to the 100 artists considered by the present curators to be the 'most-overlooked'. (Potential candidates might include Stephen Willats and Jo Spence.) I agree with Carlos when he states that '... the art-historical canon is closed to many practices developed in the countries of so-called peripheries ...' but this does not adequately explain the — no doubt complex — reasons as to why both Clark and Oiticica's practices were 'little or partially known' within their native Brazil until fairly recently. Surely it is not possible to blame the 'art-historical canon' for local neglect?

Jo Spence, in collaboration with Dr Tim Sheard, from Narratives of Dis-ease, 1990

Stephen Willats, Freezone, 1997

from: susan kandel, 14 february 1998, 02:18hrs

It seems to me that in accepting the invitation to contribute to *cream*, each of us colludes with the imperative to celebrate the new or celebrate the already celebrated. Period. While I refuse to be placed in the position of defending the ethics or politics of art publishing, I must say that I feel it's disingenuous to lodge complaints about it on the margins of the project (which is where this Internet 'conversation' surely lies).

from: carlos basualdo, 15 february 1998, 18:42hrs

Margins are usually the places where things are framed. Thus, they define the identity of things. In my view it is very important and relevant to argue in (and for) the margins.

from: hou hanru, 16 february 1998, 22:50hrs

I cannot agree with the idea that our participation implies a celebration of the editor's position. Rather, I do think it's a process of negotiation between the curators' individual positions and the project's planner, as well as a process of negotiation between different curators who represent different ideas of contemporary art.

from: hou hanru, 16 february 1998, 23:13hrs

One of the main challenges that we are confronting today is how to develop new critiques in the current cultural and artistic debates. Negotiation with the established art institutions and media is an urgent issue that artists and curators are confronting. It's true that the *cream* project can offer a space in which the curators can present the artists who in their opinion are 'interest-

ing' and 'emerging'. However, the Internet discussion is fortunately different from a simple 'celebratory' space of presentation. It is, on the contrary, a space where critiques and negotiations between different ideas become not only possible, but also imperative. How to use such a space to carry out critiques and to develop strategies to open new spaces for different voices and expressions, especially bearing in mind Carlos' emphasis on the marginal, should be considered as the most valuable aspect of the project, and activities in the art world in general. Accepting the invitation is to use the project to practise such a strategy!

from: rosa martínez, 24 february 1998, 17:18hrs

I have been working for more than ten years now in projects concerned with 'young'/'emerging' artists. The Biennial of Barcelona (which ran from 1985 to 1991) was devoted to artists under the age of 30, so it had a strictly 'biological' criterion, mainly because it was organized and financed by the Youth Department of the City Council. At the Sala Montcada, the space devoted to experimental artists at 'la Caixa' Foundation, the artistic policy requires that the artists presented are starting to have international recognition and developing new languages. The 'emerging' artists at Manifesta 1 (Amsterdam, 1996) were the ones outstanding in their own countries and starting to be known in the European context. The 5th Istanbul Biennale gathered eighty-six international artists from all over the world and had no constraints concerning age or nationality. It was celebrated in 1997, a year in which there was a proliferation of many big international shows, so I decided to concentrate my research in order to present international emerging artists and not to repeat many established names. A big part of the local Turkish art scene felt that the selected artists were not 'famous enough', while many in the international public considered it the only Biennale in 1997, together with Johannesburg, to explore new names, giving space to new voices and trying to make new statements concerning the developments of contemporary thought and aesthetics in a post-colonial context.

Now when I am asked again to collaborate in a project like *cream* where ten 'emerging' curators are invited to present ten 'emerging' artists, I think it is a new opportunity to take risks and it is again about discovery, surprise, promotion, new becomings. From my experience I could draw a portrait of the emerging artist as one who renovates the languages and moves beyond recurrent clichés, taking risks, exploring new ways to transform aesthetics and reality, being biologically young or, better still, being mentally young, not established in the Western world as a 'star'. Sometimes it is tiring to be always on a tightrope, achieving temporary prestige and recognition, offered the possibility of expression but finding it difficult to survive. Feeling that one is used by the market and being constantly drained of energy.

from: francesco bonami, 8 february 1998, 01:50hrs

Orson Welles, The Lady from Shanghai, 1948

It looks as though the curator is watching him or herself in a sort of room of mirrors (like Orson Welles' *The Lady from Shanghai*): sometimes we look thinner, sometimes deformed, often quite fat. The problem is not how we really look, but how to get out of the room. I understand that my approach is not theoretical but I personally find it quite tedious to listen to and breed discussions that only graze the issue of building exhibitions that ideally should be directed at the public and not at our colleagues.

To be a curator today is not a matter of nudging the distance between a new name or another, but to chop down and uproot obsolete strategies and preconceptions which are still well in place and are only politically aimed at a so-called 'wider audience'. Honestly, to focus on personal practices and personal opportunities is, to me, quite useless in order to figure out how the profession can envision the use of public spaces in a way that eventually will create a dialogue wider than the binding of art magazines and hardcover books. I'm not saying that this is an easy task, but at least it could keep us more focused on the real question in making art exhibitions, which is, 'Who the hell cares about what we do?', which is not to imply that, if the answer is 'nobody', then we should give up. Who cares, after all, about ski races or Formula 1?

I feel that in most human activities there is a 'nobody' looming on, but it is always up to the professional to create a sort of vanishing point which will overtake the nobody who is perpetually trying to make everything flat and uninteresting. To paraphrase Sam Fuller when he described what a movie was: this+this+this, in short, emotion!

What I think is missing in curatorial practice is the use of some kind of emotion, a task and risk but a possible path to follow. The worst accusation you allegedly can get curating a show is that the result is 'theatrical'; to me this is quite an achievement, because I despise the spectacle but I very much respect the theatrical element in the visual experience. Of course this cannot be transformed into a formula or into a habit, but the idea of working within the realm of emotion is to me a possibility with little political content.

from: gilda williams for phaidon press, 9 february 1998, 20:29hrs

Maybe Francesco, to get out of the room of mirrors, again without recourse to theory, is to try actually to put into words what it is we really 'get' out of contemporary art. For me: it's the humour, even the in-jokes; the intellectual subtlety (which means I don't mind that most people 'don't get' contemporary art); the access to a social context which allows me to meet and talk to people whose conversation and ideas I enjoy; the visual high (that is, I think, the thrill that viewers once got from the 'beauty' in art and which contemporary art lovers get from all sorts of successful images, some beautiful, some not). For me, it's the form of

contemporary culture which offers the most un-clichéd, intellectually pleasurable, immediate, un-literal response or contribution to … existence, the human condition, the world, whatever. All this and more, of course, only when the art is good. To quote art critic Dave Hickey, 'Works of art are always compensatory objects made by fallible human beings for dubious reasons in an inadequate world.'[12]

from: francesco bonami, 10 february 1998, 03:31hrs

What do we really get out of contemporary art? Well, that's hard to answer. Yes, humour is something few people think about in the extreme effort to create a structure of power, which is usually humourless. I think that in Frank Gehry's Guggenheim Museum Bilbao there is quite a bit of humour, even if he doesn't know it. I think that contemporary art is quite a fantastic laboratory, and no matter how much cynicism we try to put into it, it still remains an interesting place to hang around. Nobody has ever explained to me why people like David Bowie or Kirk Douglas and even the Queen of Holland want desperately to be contemporary artists when they could avoid it altogether and enjoy the little success they probably already have. I'm sure that soon we will have Princess Diana's watercolours coming out in a small retrospective. All the world wants to be an artist, in the old-fashioned sense of the word, and we keep discussing what an emerging artist is. ·

I think that an emerging artist is the only one capable of being kind of out of sync with the cultural, social and at times political mood of the times. Being out of sync, which is what most artists complain about, being a little too early or just a little too late. Julian Schnabel could be in sync in the 1980s with a kind of heroic lousiness, and we have to give credit to him for that; now he is trying to be in sync with art today and that's the problem. To me an emerging artist is one who functions at a different level of perception, who can listen and respond rather than talking and talking and talking. The big difference today is that we are witnessing a shyer attitude among artists rather than the bombastic manner they adopted ten years ago. The change is that the artists now accept being *part* of a dialogue and not *the* dialogue.

Finally, the best emerging artists are those who never go to the opening or the installation of their own shows, artists working within their own context, who rarely travel. These artists picture the tough cultural bones of a society entering the future in a strange way. They represent to me an ancient and perfect way of being artist, as detached as a Gothic mason and yet projected towards a very open vision of the world. Such artists just live, and their art is like fresh-squeezed life.

Editor's notes:

1. 'Sensation', the exhibition of Charles Saatchi's collection of young British art, was held 18 September – 28 December 1997 at the Royal Academy of Arts, London.

2. The catalogue *January 5–31, 1969* and the related exhibition (held at 44 East 52nd Street, Mclendon Building, New York), organized by Seth Siegelaub, presented work by Conceptual Artists Robert Barry, Douglas Huebler, Joseph Kosuth and Lawrence Weiner.

3. Paul Gilroy, *Black Atlantic* (Verso, London, 1993).

4. From 12–17 February, 1998, during the very days of this Internet conversation, the ARCO art fair in Madrid staged the 10th International Contemporary Art Forum, attended by *cream* curators Carlos Basualdo, Francesco Bonami, Dan Cameron, Okwui Enwezor, Hou Hanru, Rosa Martínez and Hans Ulrich Obrist. Other contemporary art curators and critics who attended were Mónica Amor, Sandra Antelo-Suárez, Neal Benezra, Iwona Blazwick, Manuel J. Borja-Villel, Kate Bush, Isabel Carlos, Carolyn Christov-Bakargiev, Bruno Corá, María Corral, Paolo Colombo, Lisa Dennison, Jesús Fuenmayor, Jean Fisher, Boris Groys, Natalia Gutiérrez, Yuko Hasegawa, Paulo Herkenhoff, Liseete Lagnado, Olu Oguibe, Bartomeu Marí, Viktor Misiano, Carolina Ponce de León, Kyong Park, Lisa Phillips, Carrie Przybilla, Guillermo Santamarina, Vicente Todolí, Benjamin Weil and Octavio Zaya.

5. *Artforum*, New York, February 1998.

6. Willem Sandberg (1897–1984), was a Dutch museum official, writer, painter, typographer and Director of the Stedelijk Museum (1945–52).

7. Felix Feneon was a French art critic, dealer and collector; he moved to Paris in 1881. As an art critic he championed the work of the Neo-Impressionists, whose anarchic political views he shared.

8. Harry Graf Kessler was a literary man famous for his memoirs and diaries. He moved between Berlin, Paris and London.

9. Herwarth Walder was a German writer, editor, critic and notable pianist also active in Russia. In 1910 he founded *Der Sturm* (Berlin), a weekly journal on culture and the arts, which became an important mouthpiece for Modernism.

10. Alexander Dorner was Director of the Hannover Museum in the 1920s, where he installed a famous gallery of Lissitzky's abstract art which was destroyed under the Nazi regime.

11. George Rickey, *Constructivism: Origins and Evolution*, George Braziller, New York, 1967, revised and reprinted 1995.

12. Dave Hickey, 'Simple Hearts', *Art issues*, Los Angeles, March/April 1998.

césar aira

arjun appadurai

nicolas bourriaud

gilles deleuze

chris kraus

julia kristeva (with philippe sollers)

toni morrison

david robbins

edward saïd

eve kosofsky sedgwick

10 writers - a cultural context

césar aira, *copi*, 1991, selection by carlos basualdo

Copi is precious for more than one reason. Do you remember the famous story of the Chinaman reading in the queue to the gallows? Any good writer, any writer of truth is really useful to our lives, even though we could be dead in a moment — and, usually, a moment really is all it takes. Our life is a system which certain writers, the ones we read, can complete. Of course we are not able to read all of them, but the system has its own way of completing itself.

Literature is a system. If it were not, it would be of no interest to us. We require not a single book, no famous *œuvre* we would take with us to a desert island. Each and every author is a system, though what possible relation can there be between the system of literature and the respective systems of Proust, Svevo or whoever? Inclusion? Reproduction? Repetition? The existence of a third system, the system of the reader and his existence, would seem to suggest that the relation is one of continuity.

There was something of the dilettante, the *non-fatal* writer in Copi. He could have chosen not to write. He could have unleashed the genius that was at his disposal through other outlets, and indeed this is what he did. And this is what made him all the greater as a writer. His books come across as emanations from a broader system. This is the same fate which befalls all great writers, though in most cases this mechanism is virtual: in Copi's case it was real.

Let us suppose that Copi had opted to follow exclusively the path of plastic arts, drawing or acting. Let us also suppose — and this is much harder — that by doing so, he had remained Copi, the same Copi that we know. Supposing this, we could imagine that his stories would have remained the same, in a state that we might call 'imaginary'. They would have been a sort of 'script' for other gestures, and would, at some point, have been vented in a lightning flash of thought or life.

Here we are touching upon an underlying condition of literature, a sort of ontological vacillation. It is of no importance whether the work exists or not. There is no more persistent or destructive fallacy in the debate on the arts than the issue of importance. Art is not important, and neither is it necessary: on the contrary, it wavers on the very verge of not being and, more often than not, the greater it is, the more likely it is to disappear.

Let us imagine the Copi system in a Copi who never wrote a single line, or produced a drawing, or acted. The entire system, and all the features we are attempting to distinguish within it (miniaturization, speed and so on) would exist all the same in the form of someone living on a family fortune, or a diplomat or a drugs dealer. It would not inhabit his mind like some unfulfilled promise (and this is not a sign of failure or laziness or lack of realization), but would emerge in certain gestures, certain circumstances of his life, on the surface of the body and in his use of time, in what we wrongly call destiny ... His paralytic aunt would never have been transformed into *la Mujer Sentada* (*The seated woman*) because there would have been no seated woman (although there is always Picasso's), but what would have emerged would be the function which is the seated woman, and it would have been equally operative in that form.

This might seem like a pointless exercise of fantasy, and indeed it is. But we might like to think of it the other way round: take a look at someone, anyone, no matter how vulgar or anodyne, and imagine the system in which that person is the sole, untransferable support. As a fantasy exercise this is just as pointless, but much more difficult, and it gives us an idea, an insight into what Lautréamont may have meant when he said, 'Poetry needs to be made for everyone, not for one person.' Can we honestly imagine a world of such infinite literary wealth? This simple statement serves to reduce the 'importance' of literature. Yet such an excessive world, such a baroque plethora, is the only object capable of containing literature.

As we continue in this direction, we are moving away from the 'material' consideration of the text or the work of art in general. I find this type of critique to be erroneous and sad. Literature is a phantasmatic undertaking, it is deprived of any material form. Just what kind of material is it that could never have existed?

Copi is so valuable to us because his style is to withdraw the text into itself, towards the man-made world. He is a great writer because, with him, literature is dissolved: it reaches its culmination — which is not to say its realization.

His work, valuable as it is in itself, is worth less than the man himself, or less than that form of his person that takes shape in his work. His description of different genres, his minimalism, his use of lesser genres, all coincide to make him an artist in action: it is not so much about the resulting work as about the artist himself.

This is the aesthetic of Copi and of his literature. Copi made his mark as a 'Renaissance man', a man of all talents. It was so-called Renaissance 'humanism', that microcosm of knowledge and power, which led to the Baroque System of Arts. Literature is one system among others with which it, in turn, forms a system. And the latter system is imaginary, a mirror of reciprocal 'notes'.

Here there would appear to be a misused democracy at play, but this is where that element so strange in art — quality — comes in. Quality is neither a chance thing nor something that is superimposed on the artist, but an internal requirement of the system. In one direction (from the system to the man), the passage is unlimited, infinite: in the other (from the man to the system), it is quality which serves as the valve regulating the emission of the myth.

Moreover, quality brings with it the temporal dimension. You write well in order to be able to continue writing (there is no better excuse); without quality, art would be instantaneous, its system would not fit the life experienced. This presupposes a vector, a line. But in Renaissance man, unworried by the results of what he does, the duration of the line is transformed into the persis-

tence of a glow. This is the other issue which has always been badly stated, and Copi, as he is in so many other respects, is a good figure to rectify this: it is necessary to distinguish between eternity and duration: the work of art is always eternal, from the very outset, whether it lasts a long time, a short time, or not at all.

After Baroque, the weak point of art in the West would prove to be its constitution into closed systems: systems which were not only closed among themselves, which they are, despite any miserable claims of 'musical poetry' or 'narrative painting' or whatever, but closed in terms of social practice. The continuum remained in the hands of geniuses: the only art we recognize as being great is the art made by great artists, which is sad if you think about it. During our century and prior to it, there have been many attempts at cracking these systems open: Surrealism, compromised art, the application of psychoanalysis: the history of modern movements and schools of thought is nothing but a variation on the same type of attempt. This also goes for the use (which was hinted at by Baroque) of other cultures in which art is not a separate, reified entity. Our fascination with oriental art stems from this, as does our fascination with American art (there is a very good book on the subject, *Hai*, by Le Clézio). I think it would be a good idea to study the purpose of Copi.

César Aira, *Copi*, Beatriz Viterbo Echtora, Buenos Aires, 1991

arjun appadurai, 'disjuncture and difference in the global cultural economy', *modernity at large*, 1996, selection by hou hanru

It takes only the merest acquaintance with the facts of the modern world to note that it is now an interactive system in a sense that is strikingly new [...]

For in the past century, there has been a technological explosion, largely in the domain of transportation and information, that makes the interactions of a print-dominated world seem as hard-won and as easily erased as the print revolution made earlier forms of cultural traffic appear. For with the advent of the steamship, the automobile, the airplane, the camera, the computer and the telephone, we have entered into an altogether new condition of neighbourliness, even with those most distant from ourselves. Marshall McLuhan, among others, sought to theorize about this world as a 'global village', but theories such as McLuhan's appear to have overestimated the communitarian implications of the new media order.[1] We are now aware that with media, each time we are tempted to speak of the global village, we must be reminded that media create communities with 'no sense of place'.[2] The world we live in now seems rhizomic,[3] even schizophrenic, calling for theories of rootlessness, alienation and psychological distance between individuals and groups on the one hand, and fantasies (or nightmares) of electronic propinquity on the other. Here, we are close to the central problematic of cultural processes in today's world.

Thus, the curiosity that recently drove Pico Iyer to Asia[4] is in some ways the product of a confusion between some ineffable McDonaldization of the world and the much subtler play of indigenous trajectories of desire and fear with global flows of people and things. Indeed, if *a* global cultural system is emerging, it is filled with ironies and resistances, sometimes camouflaged as passivity and a bottomless appetite in the Asian world for things Western.

[...] In a further globalizing twist on what Fredric Jameson has recently called 'nostalgia for the present',[5] this is one of the central ironies of the politics of global cultural flows, especially in the arena of entertainment and leisure ... Here, we have nostalgia without memory [...]

As far as the United States is concerned, one might suggest that the issue is no longer one of nostalgia but of a social *imaginaire* built largely around reruns. Jameson was bold to link the politics of nostalgia to the postmodern commodity sensibility, and surely he was right[6] [...]

The past is now not a land to return to in a simple politics of memory. It has become a synchronic warehouse of cultural scenarios, a kind of temporal central casting, to which recourse can be taken as appropriate, depending on the movie to be made, the scene to be enacted, the hostages to be rescued ... But I would like to suggest that the apparent increasing substitutability of whole periods and postures for one another, in the cultural styles of advanced capitalism, is tied to larger global forces, which have done much to show Americans that the past is usually another country [...]

The crucial point, however, is that the United States is no longer the puppeteer of a world system of images but is only one node of a complex transnational construction of imaginary landscapes. The world we live in today is characterized by a new role for the imagination in social life. To grasp this new role, we need to bring together the old idea of images, especially mechanically produced images (in the Frankfurt School sense); the idea of the imagined community (in Anderson's sense); and the French idea of the imaginary (*imaginaire*) as a constructed landscape of collective aspirations, which is no more and no less than the collective representations of Émile Durkheim, now mediated through the complex prism of modern media.

The image, the imagined, the imaginary – these are all terms that direct us to something critical and new in global cultural processes: *the imagination as a social practice*. No longer mere fantasy (opium for the masses whose real work is elsewhere), no

longer simple escape (from a world defined principally by more concrete purposes and structures), no longer elite pastime (thus not relevant to the lives of ordinary people), and no longer mere contemplation (irrelevant for new forms of desire and subjectivity), the imagination has become an organized field of social practices, a form of work (in the sense of both labour and culturally organized practice), and a form of negotiation between sites of agency (individuals) and globally defined fields of possibility. This unleashing of the imagination links the play of pastiche (in some settings) to the terror and coercion of states and their competitors. The imagination is now central to all forms of agency, is itself a social fact, and is the key component of the new global order [...]

Homogenization and Heterogenization

The central problem of today's global interactions is the tension between cultural homogenization and cultural heterogenization. A vast array of empirical facts could be brought to bear on the side of the homogenization argument, and much of it has come from the left end of the spectrum of media studies,[7] and some from other perspectives.[8] Most often, the homogenization argument subspeciates into either an argument about Americanization or an argument about commodification, and very often the two arguments are closely linked. What these arguments fail to consider is that at least as rapidly as forces from various metropolises are brought into new societies they tend to become indigenized in one or another way: this is true of music and housing styles as much as it is true of science and terrorism, spectacles and constitutions [...] For polities of smaller scale, there is always a fear of cultural absorption by polities of larger scale, especially those that are nearby. One man's imagined community is another man's political prison.

[...] The new global cultural economy has to be seen as a complex, overlapping, disjunctive order that cannot any longer be understood in terms of existing centre-periphery models (even those that might account for multiple centres and peripheries). Nor is it susceptible to simple models of push and pull (in terms of migration theory), or of surpluses and deficits (as in traditional models of balance of trade), or of consumers and producers (as in most neo-Marxist theories of development). Even the most complex and flexible theories of global development that have come out of the Marxist tradition[9] are inadequately quirky and have failed to come to terms with what Scott Lash and John Urry have called disorganized capitalism.[10] The complexity of the current global economy has to do with certain fundamental disjunctures between economy, culture and politics that we have only begun to theorize.

I propose that an elementary framework for exploring such disjunctures is to look at the relationship among five dimensions of global cultural flows that can be termed (a) *ethnoscapes*, (b) *mediascapes*, (c) *technoscapes*, (d) *financescapes* and (e) *ideoscapes*. The suffix-*scape* allows us to point to the fluid, irregular shapes of these landscapes, shapes that characterize international capital as deeply as they do international clothing styles. These terms with the common suffix-*scape* also indicate that these are not objectively given relations that look the same from every angle of vision but, rather, that they are deeply perspectival constructs, inflected by the historical, linguistic and political situatedness of different sorts of actors: nation-states, multinationals, diasporic communities, as well as subnational groupings and movements (whether religious, political or economic), and even intimate face-to-face groups, such as villages, neighbourhoods and families. Indeed, the individual actor is the last locus of this perspectival set of landscapes, for these landscapes are eventually navigated by agents who both experience and constitute larger formations, in part from their own sense of what these landscapes offer.

These landscapes thus are the building blocks of what (extending Benedict Anderson) I would like to call *imagined worlds*, that is, the multiple worlds that are constituted by the historically situated imaginations of persons and groups spread around the globe. An important fact of the world we live in today is that many persons on the globe live in such imagined worlds (and not just in imagined communities) and thus are able to contextualize and sometimes even subvert the imagined worlds of the official mind and of the entrepreneurial mentality that surrounds them.

By *ethnoscape*, I mean the landscape of persons who constitute the shifting world in which we live: tourists, immigrants, refugees, exiles, guest workers and other moving groups and individuals constitute an essential feature of the world and appear to affect the politics of (and between) nations to a hitherto unprecedented degree. This is not to say that there are no relatively stable communities and networks of kinship, friendship, work and leisure, as well as of birth, residence and other filial forms. But it is to say that the *warp* of these stabilities is everywhere shot through with the *woof* of human motion, as more persons and groups deal with the realities of having to move or the fantasies of wanting to move ... As international capital shifts its needs, as production and technology generate different needs, as nation-states shift their policies on refugee populations, these moving groups can never afford to let their imaginations rest too long, even if they wish to.

By *technoscape*, I mean the global configuration, also ever fluid, of technology and the fact that technology, both high and low, both mechanical and informational, now moves at high speeds across various kinds of previously impervious boundaries. Many countries are now the roots of multinational enterprise ... The odd distributions of technologies, and thus the peculiarities of these technoscapes, are increasingly driven not by any obvious economies of scale, of political control, or of market rationality but by increasingly complex relationships among money flows, political possibilities and the availability of both unskilled and highly skilled labour [...]

Thus it is useful to speak as well of *financescapes*, as the disposition of global capital is now a more mysterious, rapid and diffi-

cult landscape to follow than ever before, as currency markets, national stock exchanges and commodity speculations move mega-monies through national turnstiles at blinding speed, with vast, absolute implications for small differences in percentage points and time units. But the critical point is that the global relationship among ethnoscapes, technoscapes and financescapes is deeply disjunctive and profoundly unpredictable because each of these landscapes is subject to its own constraints and incentives (some political, some informational and some techno-environmental), at the same time as each acts as a constraint and a parameter for movements in the others. Thus, even an elementary model of global political economy must take into account the deeply disjunctive relationships between human movement, technological flow and financial transfers.

Further refracting these disjunctures (which hardly form a simple, mechanical global infrastructure in any case) are what I call *mediascapes* and *ideoscapes*, which are closely related landscapes of images. *Mediascapes* refer both to the distribution of electronic capabilities to produce and disseminate information (newspapers, magazines, television stations and film-production studios), which are now available to a growing number of private and public interests throughout the world, and to the images of the world created by these media. These images involve many complicated inflections, depending on their mode (documentary or entertainment), their hardware (electronic or pre-electronic), their audiences (local, national or transnational) and the interests of those who own and control them. What is most important about these mediascapes is that they provide (especially in their television, film and cassette forms) large and complex repertoires of images, narratives and ethnoscapes to viewers throughout the world, in which the world of commodities and the world of news and politics are profoundly mixed. What this means is that many audiences around the world experience the media themselves as a complicated and interconnected repertoire of print, celluloid, electronic screens and billboards. The lines between the realistic and the fictional landscapes they see are blurred, so that the farther away these audiences are from the direct experiences of metropolitan life, the more likely they are to construct imagined worlds that are chimerical, aesthetic, even fantastic objects, particularly if assessed by the critera of some other perspective, some other imagined world.

Mediascapes, whether produced by private or state interests, tend to be image-centred, narrative-based accounts of strips of reality, and what they offer to those who experience and transform them is a series of elements (such as characters, plots and textual forms) out of which scripts can be formed of imagined lives, their own as well as those of others living in other places. These scripts can and do get disaggregated into complex sets of metaphors by which people live[11] as they help to constitute narratives of the Other and proto-narratives of possible lives, fantasies that could become prolegomena to the desire for acquisition and movement.

Ideoscapes are also concatenations of images, but they are often directly political and frequently have to do with the ideologies of states and the counter-ideologies of movements explicitly oriented to capturing state power or a piece of it. These ideoscapes are composed of elements of the Enlightenment worldview, which consists of a chain of ideas, terms and images, including *freedom*, *welfare*, *rights*, *sovereignty*, *representation* and the master term *democracy*. The master narrative of the Enlightenment (and its many variants in Britain, France and the United States) was constructed with a certain internal logic and presupposed a certain relationship between reading, representation and the public sphere.[12] But the diaspora of these terms and images across the world, especially since the nineteenth century, has loosened the internal coherence that held them together in a Euro-American master narrative and provided instead a loosely structured synopticon of politics, in which different nation-states, as part of their evolution, have organized their political cultures around different keywords.[13]

As a result of the differential diaspora of these keywords, the political narratives that govern communication between elites and followers in different parts of the world involve problems of both a semantic and pragmatic nature: semantic to the extent that words (and their lexical equivalents) require careful translation from context to context in their global movements, and pragmatic to the extent that the use of these words by political actors and their audiences may be subject to very different sets of contextual conventions that mediate their translation into public politics [...]

These conventions also involve the far more subtle question of what sets of communicative genres are valued in what way (newspapers versus cinema, for example) and what sorts of pragmatic genre conventions govern the collective readings of different kinds of text ... The very relationship of reading to hearing and seeing may vary in important ways that determine the morphology of these different ideoscapes as they shape themselves in different national and transnational contexts. This globally variable synaesthesia has hardly even been noted, but it demands urgent analysis. Thus *democracy* has clearly become a master term, with powerful echoes from Haiti and Poland to the former Soviet Union and China, but it sits at the centre of a variety of ideoscapes, composed of distinctive pragmatic configurations of rough translations of other central terms from the vocabulary of the Enlightenment. This creates ever new terminological kaleidoscopes, as states (and the groups that seek to capture them) seek to pacify populations whose own ethnoscapes are in motion and whose mediascapes may create severe problems for the ideoscapes with which they are presented. The fluidity of ideoscapes is complicated in particular by the growing diasporas (both voluntary and involuntary) of intellectuals who continuously inject new meaning-streams into the discourse of democracy in different parts of the world.

This extended terminological discussion of the five terms I have coined sets the basis for the tentative formulation about the con-

Notes

1. M. McLuhan and B. R. Powers, The Global Village: Transformations in World, Life and Media in the 21st Century, Oxford University Press, New York, 1989. 2. J. Meyrowitz, No Sense of Place: The Impact of Electronic Media on Social Behaviour, Oxford University Press, New York, 1985. 3. G. Deleuze and F. Guattari, A Thousand Plateaux: Capitalism and Schizophrenia, B. Massumi (trans.), University of Minnesota Press, Minneapolis, 1987. 4. P. Iyer, Video Night in Kathmandu, Knopf, New York, 1988. 5. F. Jameson, 'Nostalgia for the Present', The South Atlantic Quarterly, No 2, Durham, North Carolina, Spring, 1989. 6. F. Jameson, 'Postmodernism and Consumer Society', Hal Foster (ed.), The Anti-Aesthetic: Essays on Postmodern Culture, Washington Bay Press, Port Townsend, 1983. 7. C. Hamelink, Cultural Autonomy in Global Communications, Longman, New York, 1983. A. Mattelart, Transnationals and the Third World: The Struggle for Culture, South Hadley, Massachusetts, 1983. H. Schiller, Communication and Cultural Domination, International Arts and Sciences, White Plains, New York, 1976. 8. E. Gans, The End of Culture: Toward a Generative Anthropology, University of California Press, Berkeley, 1985. 9. S. Amin, Class and Nation: Historically and in the Current Crisis, Monthly Review Press, New York and London, 1980. E. Mandel, Late Capitalism, Verso, London, 1978. I. Wallerstein, The Modern World System, 2 Vols, Academic Press, New York and London, 1974. E. Wolf, Europe and the People without History, University of California Press, Berkeley, 1982. 10. S. Lash and J. Urry, The End of Organized Capitalism, University of Wisconsin Press, Madison, 1987. 11. G. Lakoff and M. Johnson, Metaphors We Live By, University of Chicago Press, Chicago and London, 1980. 12. For the dynamics of this process in the early history of the United States, see M. Warner, The Letters of the Republic: Publication and the Public Sphere in Eighteenth Century America, Harvard University Press, Cambridge, Massachusetts, 1990. 13. R. Williams, Keywords, Oxford University Press, New York, 1976.

Minneapolis, 1996

Arjun Appadurai, 'Disjuncture and Difference in the Global Cultural Economy', Modernity at Large, University of Minnesota Press.

[...] volume of each of these flows are now so great that the disjunctures have become central to the politics of global culture [...]
at all periods in human history, there have been some disjunctures in the flows of these things, but the sheer speed, scale and some explanation. First, people, machinery, money, images and ideas now follow increasingly non-isomorphic paths; of course technoscapes, financescapes, mediascapes and ideoscapes. This formulation, the core of my model of global cultural flow, needs ditions under which current global flows occur: they occur in and through the growing disjunctures among ethnoscapes,

nicolas bourriaud, 'an introduction to relational aesthetics', traffic, 1995, selection by åsa nacking

Each one of the twenty-eight artists taking part in the 'Traffic' exhibition' has a whole world of forms, a set of problems and a trajectory which are all peculiar to him/her. They are not linked together by any style and even less so by any theme or iconography. What these artists do have in common, though, is more crucial, because they are working within the same practical and theoretical horizon – the realm of relationships between people. Their works highlight social methods of exchange, interactivity with the onlooker within the aesthetic experience proposed to him/her, and communication processes, in their tangible dimension as tools for linking human beings and groups to one another. So they are all working within what we might call the relational realm. They all pitch their artistic praxis in a proximity which, without belittling the visuality factor, relativizes its place in the exhibition's protocol.

Richard Prince, Untitled (Joke), 1987

The work of art of the 1990s turns the onlooker into a neighbour and interlocutor. It is precisely the attitude of this generation towards communications which helps to define it in relation to pre-vious generations. Most artists who emerged in the 1980s, from Richard Prince to Jeff Koons via Jenny Holzer, pinpointed the visual aspect of communication systems. Their successors, on the other hand, show a preference for contact and tactility. Possible sociological explanations for this phenomenon exist, given that the 1990s, marked as the decade has been by recession, hardly bode well for sensational and

Jeff Koons, Rabbit, 1986

conspicuous undertakings. There are purely aesthetic reasons, too: the 'hark back' pendulum stopped in the 1980s at the 1960s movements – Pop Art, mainly – whose visual effectiveness underpins most of the forms put forward by simulationism. For better

Jenny Holzer, Truisms, 1977-79

or for worse, our period can be identified – right down to its recession 'ambience' – with Arte Povera and the experimental art of the 1970s. This albeit superficial, voguish effect helped to effect a reconsideration of the works of artists like Gordon Matta-Clark and Robert Smithson, while the success of Mike Kelley recently encouraged a re-interpretation of Californian junk art, and of Paul Thek and Tetsumi Kudo. Fashion creates aesthetic micro-climates, whose effects are felt even in our reading of recent his-tory. Otherwise put, the sieve organizes its mesh in different ways, and lets other types of works 'sift through.' – works which, in return, have an influence on the present. This said, we are deal-ing here with a group of artists for the first time since the emergence of Conceptual Art in the mid 1960s, in no way seeks support from the reinterpretation of a past aesthetic movement. Relational art is not the revival of any movement, or the comeback of any style. It issues from an observation of the present and from thinking about the lot of artistic activity. Its basic assumption – the realm of human relations

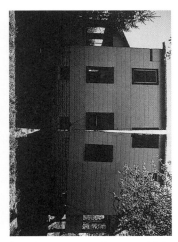

as a setting for the work — has no example to follow in art history, even if, *a posteriori*, it may appear to be the obvious backdrop of all aesthetic praxis, as well as a modernist theme *par excellence*. All one has to do is simply re-read the lecture given by Marcel Duchamp in 1957 — 'The Creative Act'[2] — to be persuaded that interactivity is scarcely a novel idea ...

Novelty is somewhere else. It resides in the fact this generation of artists considers intersubjectivity and interaction neither as theoretical and faddish gadgets, nor as the auxiliaries (alibis) of a traditional practice of art. This generation takes these things as both a springboard and a culmination — in a word, as the principal informers of its activity. The space in which their works are arrayed is altogether one of interaction, one of openness ushered in by any dialogue (Georges Bataille would have written '*déchirure* = split'). What they produce are relational space-times — interhuman experiences which attempt to free themselves from the restrictions of the ideology of mass communications. In some

Gordon Matta-Clark, Splitting Four Corners, 1974

ways, these are places where alternative forms of sociableness are formulated, along with critical models and moments of constructed conviviality.

It is nevertheless clear that the day of the New Man, the age of Futurist manifestos and the moment for summoning a better world all ready to move into, are all well and truly over. Nowadays, we live our utopia on a subjective, day-to-day basis, in the real time of tangible and intentionally fragmentary experiments. The artwork is presented as a social interstice within which these experiments, and these new 'possibilities of life' turn out to be feasible. It would seem more pressing, here and now, to invent possible relationships with our neighbours than to

hold out for brighter tomorrows. That's all there is to it, but it's an awful lot. And, in any event, it represents an awaited alternative to the depressing, authoritarian and reactionary thinking which, in France at least, masquerades as an art theory variant: 'common sense' regained. But

Mike Kelley, Bed, 1990

modernity is not dead, if we recognize as modern a taste for aesthetic experience and for venturesome thinking, running counter to the over-cautious orthodoxies championed by our piecework philosophers, by neo-tradition-

Paul Thek, Ark and Pyramid (detail), 1972

alists ('Beauty' according to the ineffable Dave Hickey[3]), and by Jean Clair-like[4] activists hooked on the past.

With all due respect to these fundamentalists when it comes to yesterday's good taste, today's art is fairly and squarely taking on and taking up the legacy of the twentieth-century avant gardes, while at the same time challenging their dogmatism and their teleology. And lest you should have doubts, this last sentence was much mulled over; it is quite simply time to write it down. For modernism was basking in an 'imagination of opposition', to borrow the term coined by Gilbert Durand,[5] which proceeded by way of separations and contrasts, readily disqualifying the past in favour of the future. It was based on conflict, whereas the imagination of the 1990s is concerned

with negotiations, bonds and forms of co-existence. These days, people no longer try to progress

Robert Smithson, Mirror Displacement, 1969

by way of conflictual clashes, but rather by the invention of new combinations, possible relationships between distinct entities, and constructed alliances between different partners. Like social contracts, aesthetic contracts are seen for what they are. No longer does anyone intend to establish the Golden Age on Earth, and people will be quite happy to create various *modi vivendi* encouraging more equitable social relations, fuller life-styles and fruitful combinations of existence of many kinds. Art, likewise,

Tetsumi Kudo, Philosophy of Impotence, 1962

is not trying to represent utopias, but to build concrete spaces.

Space-Time in the 1990s

Where do the misunderstandings attaching to art in the 1990s stem from? From a short-fall when it comes to theoretical discourse. An overwhelming majority of critics and philosophers actually seem reluctant to come to grips with the elements which specifically inform and define contemporary praxis. So, for the most part, the more complicated and developed this praxis becomes, the more it remains closed to interpretation. It proves impossible to perceive the originality and relevance of these new aesthetic opinions, unless one grasps the intellectual horizons and the formal concerns of artists based on their activity, and not based on problems that have either been sorted out or left in abeyance by earlier generations. We must accept the oh-so-grievous fact that certain issues are no longer being raised. By extension, it is important to pinpoint those issues that are being raised by today's artists. What are the real challenges facing contemporary art *vis-à-vis* society, history and culture? The critic's first job consists in reconstructing the complex set of problems which emerge in any given period, and taking a close look at the various solutions proffered.

Too often, people merely draw up an inventory of yesterday's concerns, the more effectively to be aggrieved at not getting any answers. As far as these new approaches are concerned, the first question obviously has to do with the material form of the works.

How are we to decipher and envisage these apparently elusive productions, be they procedural or behavioural – 'dispersed' or 'splintered', in any event, in terms of traditional standards – if we stop taking refuge behind the history of art in the 1960s? Let us take a few examples of these con-temporary activities. Rirkrit Tiravanija organized a supper at a collector's home, and left him the wherewithal to make a Thai soup. Philippe Parreno invited people to pursue their favourite hob-bies on May Day on an industrial assembly line. Vanessa Beecroft used identical clothes and the same red wig to dress twenty or so women, whom visitors could only glimpse from the doorway (Schipper & Krome Gallery, Cologne, 1994). Maurizio Cattelan fed rats with 'Bel paese' cheese and sold them as multiples, or exhibited recently burgled safes. In a Copenhagen square, Jes Brinch and Henrik Plenge Jacobsen installed an upturned bus which stirred up rivalries and sparked off a riot in the city (Burn Out, 1994). Christine Hill landed a cashier's job in a supermarket, and organized a weekly gym class in a gallery (Eigen+art Gallery, Berlin, 1994). Carsten Höller re-created the chemical formula of the molecules secreted by the human brain in love (Love, 1993), built an inflatable plastic yacht and bred finches so that he could teach them a new song. Noritoshi Hirakawa put a small ad in a newspaper to find a girl who might agree to take part in his show (Pierre Huber Gallery, Paris, 1994). Pierre Huyghe summoned people to a casting session, made a TV transmitter available to the public, and showed a photo of men at work just a few yards from their work site ... And we could mention many other names and many other works.

Jasper Johns, Flag, 1955, collection, The Museum of Modern Art, New York

In these 1990s circles, the liveliest game being played out on the chequerboard of art is complying with rules that are interactive, convivial and relational. The above list, however, gives no more than hints about method, and sidesteps all content. These rela-tional procedures (invitations, casting sessions, convivial venues, meetings and the like) are no more than a repertory of ordinary forms, and vehicles whereby singular thoughts develop, along with connections with the personal world. Nor, for its part, is the further form that each artist will give to this relational production something fixed and immutable. These artists perceive their work from a three-way point of view, which is at once aesthetic (how is it to be materially 'translated'?), historical (how is one to join in the interplay of artistic references?) and social (how is one to find a coherent position in rela-tion to the current state of social production?). If, to all appearances, these practices find their formal and theoretical mark in Conceptual Art, in Fluxus or in Minimal Art, all they do is use them as a vocabulary, as a lexical plinth. In the old days, Johns, Rauschenberg and the New Realists based their work on the readymade, to develop a rhetoric of objects as well as a sociological discourse. Relational art makes ref-

Dan Graham, New Housing Project, Staten Island, 1978, collection, Whitney Museum of American Art, New York

erence to conceptual or Fluxus-inspired situations and methods, or to Gordon Matta-Clark, Robert Smithson and Dan Graham, but in order to convey trains of thought that have nothing to do with theirs. The real rub is this: what are the right ways of substanti-ating (an exhibition) in relation to the cultural context and in relation to art history as it is being updated today? Video, for example, is proving to be an important formal method. But if Peter Land, Gillian Wearing and Henry Bond, to name just three artists, have a soft spot for video recording, they are still not 'video artists'. Simply put, this medium is turning out to be the one best suited to formalizing certain programmes and certain projects. Other artists are coming up with a systematic documen-tation of their work, and, in so doing, drawing lessons from Conceptual Art, but based on radically different aesthetic foundations. Relational art, which is well removed from the administrative rationality underpinning this (the format of the notarized contract,[6] which was so ubiquitous in the art of the 1960s), tends to draw inspiration more from the flexible processes which govern ordinary life. We can talk in terms of communication, but here, too, artists of the 1990s are situated poles apart from the way in which Jeff Koons and Richard Prince made use of the media in the 1980s. Where these artists broached the visual form of mass communica-tion and the icons of popular culture, Liam Gillick, Millos Manetas and Jorge Pardo work on small-scale models of communica-tional situations. This can be interpreted as a change in the collective sensibility. From here on out, the group is played off against the mass, neighbourhood against propaganda, low tech against high tech and the tactile against the visual. And today, above all else, the day-to-day is a far more fertile stomping-ground than lowbrow (popular) culture – a form which only exists in relation to highbrow culture, through it and for it.

To cut short any controversy over the so-called return to a 'conceptual' art, we should bear in mind that these works in no way extol the immaterial. None of these artists has the time of day for performances or concepts – words which no longer mean a whole lot here. In a nutshell, there is no longer anything paramount about the process of working on methods of rendering this work material (unlike the art process of Conceptual Art, which, for their part, fetishized the work process). In the worlds constructed by these artists, objects are part and parcel of language, and both – objects and language – represent the con-nection with the other. In a way, the object is every bit as immaterial as a phone call. And a work that consists of a supper around a bowl of soup is as material as a statue. Objects, institutions, times and works are all part and parcel of human relations, because they render social work material. It is this arbitrary division between the gesture and the forms produced by gestures which is called into question here, in so far as it is the very image of contemporary alienation, the cannily maintained illusion, even in art institutions, that objects excuse methods, and that the end of art justifies the pettiness of the intellectual and ethical means

involved. Objects and institutions, timetables and works, all are at once the outcome of human relations – because they render social work tangible – and factors producing relations – because, conversely, they organize types of sociability and regulate meetings between human beings. Present-day art thus gets us to have a different view of relations between space and time. Essentially, what is more, it derives its main originality, which resides in the very nature of its production, from the way this issue is dealt with. What is actually tangibly produced by artists such as Liam Gillick, Dominique Gonzalez-Foerster and Vanessa Beecroft? What, in the final analysis, constitutes the object of their work? Answer: the wide variety of forms and processes used by most of these artists clearly shows that they do not dictate this object. What is produced in concrete terms is a connection with the world that is broadcast by an object, which itself determines the relationship we have with it. In other words, the relationship with a relationship. A collector of Tiravanija or Douglas Gordon acquires a duration or term, a space-time. Here, though, time turns out to be more important than the space which it informs when it shows itself. Accordingly, for Philippe Parreno's *Snow Dancing* show at Le Consortium in Dijon, he asked for two hours in which to produce the actual exhibition, adopting the social form called a party. Visitors to it were offered all sorts of 'things to do'. The day after the party, it was possible to see what had really been produced. It was not history (like Fluxus happenings, which were part of a historicist vision of art), not relics or fetishes (like the morning after Beuys performances), but the image frozen, focused, for a period of time lived through. For the passing visitor, *Snow Dancing* offered the frustrating spectacle of a time not used, returning us to our daily alienation. A similar sensation strikes the onlooker when he sees Tiravanija's works. He must first realize that the leftovers from meals and vehicles at a standstill, kitted out with survival systems, in no way represent relics (i.e., objects which have some value as memories in space), but instruments producing periods of time, engagers of split-seconds whose artistic value relies on a temporal quality. This status likewise applies to works which are, to all appearances, more formalized, like a Gordon photograph – *Pocket Telepathy* – showing a hand slipping a slide (depicting a Russian medium) into a coat pocket in the Van Abbemuseum cloakroom. The image offered to the onlooker is not the simple documentation of an action. It is just an element in a programme consisting of a gesture, a photo, a form and an idea. We have left behind the world of traces, in favour of a universe of programming. Just like the exhibitions of Parreno, Tiravanija and Pierre Huyghe, Douglas' photographs stem from a space-time which devalues the notions of before and after. In an age of simultaneous communications (satellites, cable TV, faxes, the worldwide web, and so on), forms are taken in an 'on-line' time (an interactive, simultaneous time); they can be reactivated at will, and they are prone to developments. For this generation of artists, time is simply space given form, and space is just time rendered tangible. What they produce smacks of this. The rudimentary 'stage' built out of rough plywood by Gillick for his show at the Basilico Gallery in New York, on which a few pages from the 'Ibuka!' libretto are placed, under glass, is a work which can be taken in many ways. It can be situated in relation to a programme (and not a series) of exhibitions based on his book, an opus in a state of on-going change. At the same time it is a user-friendly object intended to be read, a structure whose form conjures up Minimal Art, and whose function calls to mind Conceptual Art. It is also an open, indeterminate stage – a platform of propositions.

Works and Exchanges

Because art is made of the very same stuff of which social exchanges are made, it has a singular place in collective production, due to the simple fact that a work of art has a particular quality which sets it apart from other products of human activities. This quality is its (relative) social transparentness. If a work of art works, it invariably aims beyond its mere presence in space. It is open to dialogue, discussion and that form of inter-human negotiation that Marcel Duchamp called 'the co-efficient of art', which is a temporal process, being played out here and now. The basis on which this negotiation is established thus turns out to be the 'transparentness' which singles it out as a product of human endeavour. The work of art in fact shows (or suggests) at one and the same time its manufacturing and production process, its position in the interplay of exchanges,

Marcel Duchamp, Etant Donnés, 1946–66, collection, Museum of Art, Philadelphia

the place – or the function – it earmarks for the onlooker and, last but not least, the creative behaviour of the artist (otherwise put, the sequence of postures and gestures which form the artist's work, and which each individual work passes on, in the manner of a sample or marker). So every Jackson Pollock canvas connects the trails of paint so closely to a pattern of artistic behaviour that

Jackson Pollock, Number 23, 1948, collection, Tate Gallery, London

the trails appear as the image – as their 'necessary product', to borrow Hubert Damisch's phrase. The beginning of art is the behaviour adopted by the artist – that set of arrangements and acts whereby the artist acquires his relevance in the present. The 'transparentness' of the work of art comes partly from the fact that the gestures forming and informing it, which are freely chosen and invented, are part of its subject. For example, over and above that popular icon, Marilyn Monroe, the sense of Andy Warhol's *Marilyn* comes from the industrial production process adopted by the artist, which is governed by an altogether mechanical indifference towards the subjects chosen by him. This 'transparentness' of artistic work runs counter, needless to add, to those ideologies which, doubtless out of some obscure nostalgia for the victims of their infancy, try to revamp religion in art. So this transparentness is bothersome, because it is the very form of artistic exchange. We know

that once any kind of production is introduced into the exchange circuit, it takes on a social form which no longer has anything to do with its original usefulness. It acquires an exchange value which duly and partly covers up and masks its primary 'nature'. The fact is that a work of art has no *a priori* useful function. Not that it is socially useless, but because it is available, flexible and has 'infinite propensities'. Put another way, it commits itself, straight away, to the world of exchange and communication – the world of 'commerce' in both senses of the word. Common to all goods is the fact that they have a value, that is a common substance which encourages their exchange. This substance, according to Marx, is the 'quantity of abstract work' used to produce this item. It is represented by a sum of money, which is the 'abstract general equivalent' of all goods taken together. It has been said of art – by Marx first and foremost – that it represented the 'absolute merchandise', because it was the very image of value. Nowadays, this idea is becoming common currency here, there and everywhere. But what exactly is being referred to? The art object, not the practice of art. The work as it appears to be shouldered by the overall economy, and not its own economy. Art, let us remember, represents a barter activity which cannot be regulated by any currency, or any 'common substance'. It is the division of meaning in the wild state – an exchange whose form is determined by the form of the object itself, before being so by determinations outside it. So it is the artist's praxis which constructs the link that will be maintained with the work. In other words, what is produced in the first instance is relations between people and the world, by way of aesthetic objects. Of course, some artists don't give a damn, and reproduce, as such, the relations of alienation, thus fuelling their petty trade in signs. But present-day art is also striving to produce situations of exchange and relational space-times. It is the counter-merchandise. Unlike merchandise, it conceals neither the work process, nor the use value, nor the social relations which allowed its production. It does not reproduce the world that it has been taught. It tries to invent a new world, taking human relations as its material.

Nicolas Bourriaud, 'An Introduction to Relational Aesthetics', *Traffic*, CAPC, Musée d'Art Contemporain, Bordeaux, 1995. (Notes added.)

Notes

1. 'Traffic' was a group exhibition of international young artists curated by Nicolas Bourriaud at CAPC, Musée d'Art Contemporain, Bordeaux, 1995. Artists included in the exhibition were: Vanessa Beecroft, Henry Bond, Jes Brinch and Henrik Plenge Jakobsen, Angela Bulloch, Maurizio Cattelan, Clavadestscher and Schumacher, Honoré d'O, Liam Gillick, Dominique Gonzalez-Foerster, Douglas Gordon, Jens Haaning, Lothar Hempel, Christine Hill, Carsten Höller, Pierre Huyghe, Peter Land, Miltos Manetas, Gabriel Orozco, Jorge Pardo, Philippe Parreno, Jason Rhoades, Grennan and Sperandio, Rirkrit Tiravanija, Xavier Veilhan, Gillian Wearing. 2. Marcel Duchamp, 'The Creative Act', lecture given in Houston, April 1957, published in *ARTnews* 56, No 4, New York, Summer 1957, pp. 28–9. 3. See Dave Hickey, *The Invisible Dragon: Four Essays on Beauty*, Art issues Press, Los Angeles, 1993. 4. Jean Clair was the Curator of the XLVI Venice Biennale, 1995, which was characterized by a return to figurative painting. Clair also discontinued the Aperto section of the Biennale which showed young artists. 5. Gilbert Durand is a French literary and linguistic theorist whose writings cover the fields of literature, poetry, sociology and history/anthropology. He was the founder of the Centre de recherche de l'imaginaire. 6. Seth Siegelaub, whose exhibition and publishing activities were crucial in establishing an international profile for Conceptual Art, produced 'The Artist's Reserved Rights Transfer and Sale Agreement' with the attorney Bob Projansky in 1971.

gilles deleuze, 'immanence: a life ...', *philosophie*, 1995, selection by hans ulrich obrist

What is a transcendental field? It is distinct from experience in that it neither refers to an object nor belongs to a subject (empirical representation). It therefore appears as a pure a-subjective current of consciousness, an impersonal pre-reflexive consciousness, a qualitative duration of consciousness without self. It would seem strange for the transcendental to be defined by such immediate data were it not a question of transcendental empiricism, in opposition to everything that constitutes the world of the subject and object. There is something wild and powerful in such a transcendental empiricism. This is clearly not the element of sensation (simple empiricism) since sensation is only a break in the current of absolute consciousness; it is rather, however close together two sensations might be, the passage from one to the other as becoming, as increase or reduction of power (*puissance*) (virtual quantity). That being the case, should the transcendental field be defined by this pure immediate consciousness with neither object nor self, as movement which neither begins nor ends? (Even the Spinozan conception of the passage or quantity of power invokes consciousness.)

However, the relation of the transcendental field to consciousness is only *de jure*. Consciousness becomes a fact only if a subject is produced at the same time as its object, all three of them being outside the field (*hors-champ*) and appearing as 'transcendents'. On the other hand, as long as consciousness crosses the transcendental field at an infinite speed which is everywhere diffuse, there is nothing that can reveal it. It expresses itself as fact only by reflecting itself on to a subject which refers it to objects. This is why the transcendental field cannot be defined by the consciousness which is nonetheless coextensive with it but which is subtracted from all revelation.

The transcendent is not the transcendental. Without consciousness the transcendental field would be defined as a pure plane of immanence since it escapes every transcendence of the subject as well as of the object. Absolute immanence is in itself; it is not

in something, not to something, it does not depend on an object and does not belong to a subject. In Spinoza immanence is not to substance, the substance and modes are in immanence. When the subject and the object, being outside the plane of immanence, are taken as universal subject or object in general to which immanence is itself attributed, then the transcendental is completely denatured by merely reduplicating the empirical (as in Kant) and immanence is deformed by being contained in the transcendent. Immanence does not relate to a Something that is a unity superior to everything, nor to a Subject that is an act operating the synthesis of things: it is when immanence is no longer immanence to anything other than itself that we can talk of a plane of immanence. The plane of immanence is no more defined by a Subject or an Object capable of containing it than the transcendental field is defined by consciousness.

Pure immanence is A LIFE, and nothing else. It is not immanence to life, but the immanence which is in nothing is itself a life. A life is the immanence of immanence, absolute immanence: it is sheer power, utter beatitude. In so far as he overcomes the aporias of the subject and the object, Fichte, in his later philosophy, presents the transcendental field as a life which does not depend on a Being and is not subjected to an Act: an absolute immediate consciousness whose very activity no longer refers back to a being but ceaselessly posits itself in a life.[1] The transcendental field thus becomes a genuine plane of immanence that reintroduces Spinozism into the heart of the philosophical operation. Was not Maine de Biran taken on a similar adventure in his 'later philosophy' (the one he was too tired to see through to the end) when he discovered an absolute and immanent life beneath the transcendence of effort? The transcendental field is defined by a plane of immanence, and the plane of immanence by a life.

What is immanence? a life ... No one has related what a life is better than Dickens, by taking account of the indefinite article understood as the index of the transcendental. A good-for-nothing, universally scorned rogue is brought in dying, only for those caring for him to show a sort of ardent devotion and respect, an affection for the slightest sign of life in the dying man. Everyone is so anxious to save him that in the depths of his coma even the wretch feels something benign passing into him. But as he comes back to life his carers grow cold and all his coarseness and malevolence return. Between his life and death there is a moment which is now only that of a life playing with death.[2] The life of the individual has given way to a life that is impersonal but singular nevertheless, and which releases a pure event freed from the accidents of inner and outer life; freed, in other words, from the subjectivity and objectivity of what happens. 'Homo tantum' with which everyone sympathizes and which attains a sort of beatitude. This is a haecceity which now singularizes rather than individuates: life of pure immanence, neutral and beyond good and evil, since only the subject which incarnated it in the midst of things rendered it good or bad. The life of such an individuality effaces itself to the benefit of the singular life that is immanent to a man who no longer has a name and yet cannot be confused with anyone else. Singular essence, a life ...

A life should not be contained in the simple moment when individual life confronts universal death. A life is everywhere, in all the moments a certain living subject passes through and that certain lived objects regulate: immanent life carrying along the events or singularities which do nothing more than actualize themselves in subjects and objects. This indefinite life does not itself have moments, however close together they might be, but only meantimes (*des entre-temps*), between-moments. It neither takes place nor follows, but presents the immensity of the empty time where the event can be seen that is still to come and yet has already passed, in the absolute of an immediate consciousness. The novels of Lernet Holenia put the event in a meantime (*un entre-temps*) that is capable of swallowing up whole regiments. The singularities or events constitutive of a life co-exist with the accidents of the corresponding life, but neither come together nor divide in the same way. They do not communicate with each other in the same way as do individuals. It even seems that a singular life can do without any individuality whatsoever, or without any other concomitant that individualizes it. Very young children, for example, all resemble each other and have barely any individuality; but they have singularities, a smile, a gesture, a grimace — events which are not subjective characteristics. They are traversed by an immanent life that is pure power and even beatitude through the sufferings and weaknesses. The indefinites of a life lose all indetermination in so far as they fill a plane of immanence or, which strictly-speaking comes to the same thing, constitute the elements of a transcendental field (individual life on the other hand remains inseparable from empirical determinations). The indefinite as such does not mark an empirical indetermination, but a determination of immanence or a transcendental determinability. The indefinite article cannot be the indetermination of the person without at the same time being the determination of the singular. The One (*L'Un*) is not the transcendent which can contain everything, even immanence, but is the immanent contained in a transcendental field. 'A' (*Un*) is always the index of a multiplicity: an event, a singularity, a life ... Although a transcendent which falls outside the plane of immanence can always be invoked or even attributed to it; it remains the case that all transcendence is constituted uniquely in the immanent current of consciousness particular to this plane. Transcendence is always a product of immanence. A life contains only virtuals. It is made of virtualities, events, singularities. What we call virtual is not something that lacks reality, but something that enters into a process of actualization by following the plane that gives it its own reality. The immanent event actualizes itself in a state of things and in a lived state which bring the event about. The plane of immanence itself is actualized in an Object and Subject to which it attributes itself. But, however hard it might be to separate them from their actualization, the plane of immanence is itself virtual, just as the events which people it are virtualities. The events or singularities give the plane all their virtuality, just as the plane of immanence gives the virtual events a full reality. The event, considered as non-actualized

(indefinite), lacks nothing. To see this one only has to put it in relation with its concomitants: a transcendental field, a plane of immanence: a life, some singularities. A wound incarnates or actualizes itself in a state of things and in a lived state; but it is itself a pure virtual on the plane of immanence which draws us into a life. 'My wound existed before me ...'.[3] Not a transcendence of the wound as a superior actuality, but its immanence as a virtuality always at the heart of a milieu (field or plane). There is a great difference between the virtuals which define the immanence of the transcendental field and the possible forms which actualize them and which transform them into something transcendent.

Gilles Deleuze. 'Immanence: a life ...'. *Theory, Culture and Society*, Vol 14, No 2, Sage Publications, London, May 1997. First published in French in *Philosophie*, No 47, Les Éditions de Minuit, Paris, September 1995, pp. 3-7.

Notes

1. J.G. Fichte. *Science of Knowledge*, Appleton-Century-Crofts, New York, 1970. 2. Charles Dickens, *Our Mutual Friend*, Chapter 3. 3. Joe Bousquet, *Les Capitales*, Le Cercle du Livre.

1955

chris kraus
'scenes from a marriage', i love dick, 1997, selection by susan kandel

Part 1. Scenes from a Marriage. December 3, 1994

Chris Kraus, a thirty-nine year-old experimental filmmaker, and Sylvere Lotringer, a fifty-six year-old college professor from New York, have dinner with Dick – a friendly acquaintance of Sylvere's, at a sushi bar in Pasadena. Dick is an English cultural critic who's recently relocated from Melbourne to Los Angeles. Chris and Sylvere have spent Sylvere's sabbatical at a cabin in Crestline, a small town in the San Bernadino mountains some ninety minutes from Los Angeles. Since Sylvere begins teaching again in January, they will soon be returning to New York. Over dinner the two men discuss recent trends in postmodern critical theory, and Chris, who is no intellectual, notices Dick making continual eye contact with her. Dick's attention makes her feel powerful, and when the check comes she takes out her Diners Club card. 'Please', she says. 'Let me pay'. The radio predicts snow on the San Bernadino highway. Dick generously invites them both to spend the night at his home in the Antelope Valley desert, some thirty miles away.

Chris wants to separate herself from her coupleness, so sells Sylvere on the thrill of riding in Dick's magnificent vintage Thunderbird convertible. Sylvere, who doesn't know a T-bird from a hummingbird and doesn't care, agrees, bemused. Done. Dick gives her copious, concerned directions. 'Don't worry', she interrupts, flashing hair and smiles. 'I'll tail you'. And she does. Slightly buzzed and keeping the accelerator of her pickup truck steady, she's reminded of a performance she did called *Car Chase* at the St Mark's Poetry Project in New York when she was twenty-three. She and her friend Liza Martin had tailed the steelily good-looking driver of a Porsche all the way through Connecticut on Highway 95. Finally he'd pulled over to a rest stop, but when Liza and Chris got out he drove off. The performance ended with Liza accidentally but really stabbing Chris' hand onstage with a kitchen knife. Blood flowed, and everyone found Liza dazzlingly sexy and dangerous and beautiful. Liza, belly popping out of a fuzzy midriff top, fishnet legs tearing up against her green vinyl miniskirt as she rocked back to show her crotch, looked like the cheapest kind of whore. A star is born. No one at the show that night had found Chris' pale anaemic looks and piercing gaze remotely endearing. Could anyone? It was a question that'd temporarily been shelved. But now it was a whole new world. The request line on 92.3 The Beat was thumping. Post-Riot Los Angeles, a city strung on fibreoptic nerves. Dick's Thunderbird was always somewhere in her line of sight, the two vehicles strung invisibly together across the concrete riverbed of highway, like John Donne's eyeballs. And this time Chris was alone.

Back at Dick's, the night unfolds like the boozy Christmas Eve in Eric Rohmer's film *My Night at Maud's*. Chris notices that Dick is flirting with her, his vast intelligence straining beyond the po-mo rhetoric and words to evince some essential loneliness that only she and he can share. Chris giddily responds. At 2 am Dick plays them a video of himself dressed as Johnny Cash commissioned by English public television. He's talking about earthquakes and upheaval and his restless longing for a place called home. Chris' response to Dick's video, though she does not articulate it at the time, is complex. As an artist she finds Dick's work hopelessly naive, yet she is a lover of certain kinds of bad art, art which offers a transparency into the hopes and desires of the person who made it. Bad art makes the viewer much more active. (Years later Chris would realize that her fondness for bad art is exactly like Jane Eyre's attraction to Rochester, a mean horse-faced junky: bad character invites invention.) But Chris keeps these thoughts to herself. Because she does not express herself in theoretical language, no one expects too much from her and she is used to tripping out on layers of complexity in total silence. Chris' unarticulated double-flip on Dick's video draws her even closer to him. She dreams about him all night long. But when Chris and Sylvere wake up on the sofabed the next morning, Dick is gone.

December 4, 1994: 10 am

Sylvere and Chris leave Dick's house, reluctantly, alone that morning. Chris rises to the challenge of extemporizing the Thank You

Note, which must be left behind. She and Sylvere have breakfast at the Antelope IHOP. Because they are no longer having sex, the two maintain their intimacy via deconstruction: i.e., they tell each other everything. Chris tells Sylvere how she believes that she and Dick have just experienced a Conceptual Fuck. His disappearance in the morning clinches it, and invests it with a subcultural subtext she and Dick both share: she's reminded of all the fuzzy one-time fucks she's had with men who're out the door before her eyes are open. She recites a poem by Barbara Barg on this subject to Sylvere.

What do you do with a Kerouac

But go back and back to the sack

with Jack

How do you know when Jack

has come?

You look on your pillow and

Jack is gone ...

And then there was the message on Dick's answerphone. When they came into the house, Dick took his coat off, poured them drinks and hit the Play button. The voice of a very young, very Californian woman came on: 'Hi Dick, this's Kyla. Dick, I — I'm sorry to keep calling you at home, and now I've got your answering machine and, and I just wanted to say I'm sorry how things didn't work out the other night, and — I know it's not your fault, but I guess all I really wanted was just to thank you for being such a nice person ...' 'Now I'm totally embarrassed', Dick mumbled charmingly, opening the vodka. Dick is forty-six years old. Does this message mean he's lost? And, if Dick *is* lost, could he be saved by entering a conceptual romance with Chris? Was the conceptual fuck merely the first step? For the next few hours, Sylvere and Chris discuss this.

December 4: 8 pm

Back in Crestline, Chris can't stop thinking about last night with Dick. So she starts to write a story about it, called *Abstract Romanticism*. It's the first story she's written in five years.

'It started in the restaurant', she begins. 'It was the beginning of the evening and we were all laughing a bit too much.'

[...] Writing, Chris held his face in her mind, and then the telephone rang and it was Dick.

Chris was so embarrassed. She wondered if the call was really for Sylvere, but Dick didn't ask for him, so she stayed on the scratchy line. Dick was phoning to explain his disappearance the night before. He'd gotten up early and drove out to Pear Blossom to pick up some eggs and bacon. 'I'm a bit of an insomniac, you know.' When he'd gotten home to Antelope Valley he was genuinely surprised to find them gone.

At this moment, Chris could've told Dick her own far-fetched interpretation: had she, this story would've taken another turn. But there was so much static on the line, and already she was afraid of him. She feverishly considered proposing another meeting, but she didn't and then Dick got off the phone. Chris stood in her makeshift office, sweating. Then she ran upstairs to find Sylvere.

December 5, 1994

Alone in Crestaline, Sylvere and Chris spent most of last night (Sunday) and this morning (Monday) talking about Dick's three-minute call. Why does Sylvere entertain this? It could be that for the first time since last summer Chris seems animated and alive, and since he loves her, Sylvere can't bear to see her sad. It could be he's reached an impasse with the book he's writing on Modernism and the Holocaust, and dreads returning next month to his teaching job. It could be that he's perverse.

December 6-8, 1994

Tuesday, Wednesday, Thursday of this week pass unrecorded, blurred. If memory serves, Tuesday that term was the day that Chris Kraus and Sylvere Lotringer spent in Pasadena, teaching at Art Center College of Design. Shall we attempt a reconstruction? They get up at 8, drive down the hill from Crestline, grab coffee in San Bernadino, hop on the 215 to the 10 and drive for ninety minutes, hitting LA just after traffic. It's likely they talked about Dick for most of the ride. However, since they planned to move out of Crestline in just ten days, on December 14 (Sylvere to Paris for the holidays, Chris to New York), they must've also briefly talked logistics. A Restless Longing ... driving through Fontana and Pomona, through a landscape that meant nothing, with an inconclusive future looming. While Sylvere lectured on Poststructuralism, Chris drove out to Hollywood to pick up some publicity photos for her film and shopping for cheese at Trader Joe's. Then they drove back out to Crestline, winding up the mountain through darkness and thick fog.

Wednesday and Thursday disappear. It's obvious that Chris' new film isn't going to go very far. What will she do next? Her first experience in art had been as a participant in some druggy psychodramas of the 1970s. The idea that Dick may've proposed a kind of game between them is incredibly exciting. She explains it over and over to Sylvere. She begs Sylvere to phone him, fish around for some sign that Dick's aware of her. And if there is, she'll call.

December 9, 1994: Friday

Sylvere, a European intellectual who teaches Proust, is skilled in the analysis of love's minutiae. But how long can anyone continue analyzing a single evening and a three-minute call? Already, Sylvere's left two unanswered messages on Dick's answerphone. And Chris has turned into a jumpy bundle of emotions, sexually aroused for the first time in seven years. So on Friday morning,

Sylvere finally suggests that Chris write Dick a letter. Since she's embarrassed she asks if he wants to write one too. Sylvere agrees.

Do married couples usually collaborate on *billets doux*? If Sylvere and Chris were not so militantly opposed to psychoanalysis, they might've seen this as a turning point.

Exhibit A: Chris and Sylvere's first letters

Crestline, California

December 9, 1994

Dear Dick

It must be the desert wind that night to our heads or maybe the desire to fictionalize life a little bit. I don't know. We've met a few times and I've felt a lot of sympathy towards you and a desire to be closer. Though we come from different places, we've both tried breaking up with our pasts. You're a cowboy, for ten years I was a nomad in New York.

So let's go back to the evening at your house: the glorious ride in your Thunderbird from Pasadena to the End of the World, I mean the Antelope Valley. It's a meeting we postponed almost a year. And truer than I imagined. But how did I get into that?

I want to talk about that evening at your house. I had a feeling that somehow I knew you and we could just be what we are togeth-er. But now I'm sounding like the bimbo whose voice we heard, unwittingly, that night on your answerphone ...

Sylvere

Crestline, California

December 9, 1994

Dear Dick

Since Sylvere wrote the first letter, I'm thrown into this weird position. Reactive - like Charlotte Stant to Sylvere's Maggie Verver. if we were living in the Henry James novel *The Golden Bowl* - the Dumb Cunt, a factory of emotions evoked by all the men. So the only thing that I can do is tell The Dumb Cunt's Tale. But how?

Sylvere thinks it's nothing more than a perverse longing for rejection, the love I feel for you. But I disagree, at bottom I'm a very romantic girl. What touched me were all the windows of vulnerability in your house ... so Spartan and self-conscious. The propped up *Some Girls* album cover, the dusky walls - how out of date and *declasse*. But I'm a sucker for despair, for flattering - that moment when the act breaks down, ambition fails. I love it and feel guilty for perceiving it and then the warmest indescribable affection floods in to drown the guilt. For years I adored Shake Murphy in New Zealand for these reasons, a hopeless case. But you're not exactly hopeless: you have a reputation, self-awareness and a job, and so it occurred to me that there might be some-thing to be learned by both of us from playing out this romance in a mutually self-conscious way. Abstract romanticism?

It's weird. I never really wondered whether I'm 'your type'. ('Cause in the past, Empirical Romance, since I'm not pretty or mater-nal, I never *am* the type for Cowboy Guys.) But maybe action's all that really matters now. What people do together overshadows Who They Are. If I can't make you fall in love with me for who I am maybe I can interest you with what I understand. So instead of wondering 'Would he like me?', I wonder 'Is he the game?'.

When you called on Sunday night, I was writing a description of your face. I couldn't talk, and hung up on the bottom end of the romantic equation with beating heart and sweaty palms. It's incredible to feel this way. For ten years my life's been organized around avoiding this painful elemental state. I wish that I could dabble like you do around romantic myths. But I can't, because I always lose and already in the course of this three-day totally fictitious romance, I've started getting sick. And I wonder if there'll ever be a possibility of reconciling youth and age, or the anorexic open wound I used to be with the money-hustling hag that I've become. We suicide ourselves for our own survival. Is there any hope of dipping back into the past and circling round it like you do in art?

Sylvere, who's typing this, says this letter lacks a point. What *reaction* am I looking for? He thinks this letter is too literary, too Baudrillardian. He says I'm squashing out all the trembly little things he found so touching. It's not the Dumb Cunt Exegesis he expected. But Dick, I know that as you read this, you'll know these things are true. You understand the game is *real*, or even bet-ter than *reality*, and *better than better* is what it's all about. What sex is better than drugs. What art is better than sex? *Better than* means stepping out into complete intensity. Being in love with you, being ready to take this ride, made me feel sixteen, hunched up in a leather jacket in a corner with my friends. A timeless fucking image. It's about not giving a fuck, or seeing all the conse-quences looming and doing something anyway. And I think you - I - keep looking for that and it's thrilling when you find it in other people.

Sylvere thinks he's that kind of anarchist. But he's not. I love you Dick.

Chris

Chris Kraus, 'Scenes from a Marriage.' *I Love Dick*. Semiotext(e). New York, 1997

julia kristeva (with philippe sollers) in conversation with *le nouvel observateur*, 'when freedom saves couples', 1996, selection by rosa martínez

<u>Le Nouvel Observateur</u> First of all, how would you define love?

<u>Philippe Sollers</u> The confused misuse of this word which is added to the sauce of every modern sentimental dish is such that one can only react with either modesty or rejection … Julia and I are married, granted, but we each have our own separate personality, our name, our activities, our freedom. Love is the full recognition of the other, as other. When this 'other' is very close to you, as in our case, it seems to me that what is at stake is harmony in difference. The difference between a man and a woman is irreducible — no fusion is possible. And so it's about loving a contradiction, and this is what is beautiful. I think of these words of Hölderlin, 'As the quarrels of lovers, are the discords of the world. Reconciliation is in the midst of conflict, and everything that is separated will be reunited. In the heart, arteries separate and rejoin, and everything is life, one eternal, burning entity.'

<u>Julia Kristeva</u> In love there are two inseparable components: the need for complicity and constancy and the dramatic requirements of desire, which may lead to infidelity. A love relationship is this subtle mixture of fidelity and infidelity. In literature, images of the love relationship vary a great deal from the courtly and romantic vision, to the crude and intense explorations of the modern period. Everything which defines our civilization in its sexual and sentimental meditations has the couple fidelity/infidelity at root.

<u>Le Nouvel Observateur</u> But how can you associate fidelity and infidelity?

<u>Kristeva</u> Let's first try to define fidelity. We can say stability, protection, reassurance of continuation. Is fidelity an outdated term, inherited from the past or from our parents, a stale idea which modern times and the force of our desires should sweep into the future? I don't think so. I am speaking here as a psychoanalyst: the child needs two figures, two 'imagos', without which he cannot face the world. The mother, of course, but also the father, whom we don't often talk about, the one from the first infantile identifications. Not the Oedipal father who forbids, but the loving father. In our experiences of love we are also looking for the variations of these two images. This is where we find the psychic need for fidelity. When we have these reference points, these elements of stability, we can open our sensory or sexual relationships to greater liberty, and give free rein to desire.

<u>Sollers</u> I find the systematic reduction of infidelity to the sexual question tiresome. In one century we have moved from sexuality seen to be the Devil, to a belief in sex as fundamental, through technical discussion and promotion. Sex is expected to tell the truth, the whole story of a human being, ignoring the rest, the permanence of feeling in time, the success of thought. Society made something sulphurous out of sex, and now it is making it obligatory and boring […]

<u>Kristeva</u> I think that sexuality has been understood essentially as a revolt against the norm, and this was definitely necessary in a society where prohibitions of religious or puritan origin greatly restricted the individual. On the other hand, today we're always talking about a turning in on oneself, or a return to the norm. It is definitely a regression and a form of conservatism. But it's also a crisis of conscience at what we will have to call the sexual revolt. It had one meaning — liberty. But it also had another meaning — the destruction, often, of the self and the other. In the relationships between men and women, there can be something 'outside' sexual and sensual relations which respects the body and the sensitivity of your principal partner. This is what fidelity is. Not never being separate, or not knowing any other man or woman […]

<u>Sollers</u> True infidelity is in the hardening of the couple's relationship; in its weightiness, the spirit of seriousness becomes resentment. It is above all an intellectual betrayal. And here I want to say that I am against total openness. For example, I am opposed to the kind of contract made between Sartre and de Beauvoir. I am for secrecy.

<u>Kristeva</u> The concept of fidelity goes back to childhood, and the need for security. Personally, I think of myself as someone who received the proofs (pledges) of fidelity in my childhood. This has given me a great deal of self-confidence. I suffered from the evidence of sexual infidelity when I was younger, but I cannot say that it made me feel betrayed. In truth, I do not believe that I can be betrayed. Or, if you prefer, betrayal does not really touch me. Even if, unlike you Philippe, I do not think that the secret can be kept. Everything is found out, or ends up being found out.

<u>Sollers</u> I was talking about the ideology of openness in certain couples.

<u>Kristeva</u> It's important to be clear: the feminine being does not have the same interests, sexual and emotional, as the masculine being. The pleasure (*jouissance*) of men and that of women is different, as is their relation to power, society and children. The two of us are a couple formed of two strangers.

Our different nationalities emphasize even better something which we often hide from ourselves: man and woman are strangers to one another. So the couple which takes on the liberty of two strangers can become a real battlefield. Whence the need to harmonize. Fidelity is a sort of harmonization of strangeness. If you allow the other to be as strange as you are, harmony returns. The false notes are transformed into the elements of a symphony […]

At the end of the 1960s, the years of our youth, there was so much liberty in love relationships that what we call infidelity was not interpreted in this way. Now we are living in a different period, when unemployement, the collapse of opposition to the establishment and fear of AIDS have brought about a new concentration on the couple and fidelity […]

This is a time when the need for security is of prime importance and where economic autonomy is very restricted. One cannot allow

oneself a libertarian point of view on infidelity without a certain amount of psychic security. And of course financial independence.

Women now, despite many attempts, are still a long way from having this.

Sollers Julia and I are totally equal when it comes to economics. It is only from this starting point that we can really discuss the

sophistication of love or the problems of fidelity.

Kristeva We are talking about the behaviour of economically autonomous individuals. Otherwise the discussion would be impossible.

Le Nouvel Observateur You brought up that famous agreement between Sartre and de Beauvoir according to which they each told

the other about their extramarital affairs?

Sollers I think that this story of openness was in reality a form of mutual inhibition, as if they had signed a contract of parallel

frigidity. Why? When you are really getting pleasure, you shut up. And then we don't really know how Sartre lived, compartmental-

ized, watertight. I think that Sartre allowed a lot to be said about him, out of generosity and indifference. He had his hidden life.

We can only regret that he didn't write it down. I can see him managing it on the quiet. In any case I couldn't find a really inter-

esting female character in his work. And not in Camus or Malraux either. Nor in Aragon. Strange century. I learn more about women

in Proust. [laughs] In reality, all this is not very convincing.

Kristeva Sartre and de Beauvoir were libertarian terrorists. Their books had an intellectual and moral audacity which is still far

from being either understood or overtaken. In order to accomplish their agenda of libertarian terrorism, Sartre and de Beauvoir

created a commando of shock. This commando came from their common past, that of wounded individuals. On the one hand,

Sartre's Oedipal wound, with the absent father and the pain of being very clever and ugly. And, on the other, de Beauvoir, with her

masculine ambition, her cold intelligence and probably also her depressive sexual inhibitions. With all this they made something

wonderful: they demonstrated to a dazzled and envying world that a man and a woman can live together, speak together, write

together. Try and see if it's that easy! Meanwhile their terrorist action consisted in tearing a strip off anyone who came near their

partnership and transforming them into victims. Their famous 'openness' was a way of forming an alliance of power against all

those who aspired. But this relationship, which could never be repeated, should be questioned rather than condemned [...]

Le Nouvel Observateur Another couple who will leave their mark is Danielle and François Mitterrand.

Kristeva The mythical representation of the couple corresponds to a social need. The unity of the group, particularly the national

group, nourishes itself from the fantasy of the primordial union, the union of the parents. It is this originating myth of cohesion –

with the fissures which shiver through it – which the political apparatus throws to the common masses like powder in the eyes. We

see it in the vaudeville style of thinking in the United States, with the suspicions of infidelity which have sullied Clinton's career,

and in Great Britain with the saga of Charles and Diana. It is only in France that you will see a husband and his mistress side by

side in front of the coffin of a president of the Republic [...]

Le Nouvel Observateur What do you think of the devouring passion praised by Denis de Rougemont in l'Amour et l'Occident?

Sollers Passion has no reason. Fidelity can be understood by reason, but passion is unjustifiable. Passion does what it wants, good

or bad. The argument of de Rougemont, if I remember correctly, is very romantic – Wagnerian. The passion of love

automatically leads to sacrifice, and to death. It's a very structured ideology, still very powerful today. As if passion should nec-

essarily be punished, as if love inevitably brings about catastrophe. My position on this point is very polemical, violent even. This

is not my conception of love. I am more 'Mozart for ever', as Godard says, than Wagner. Absolutely no sadness. Fidelity, infidelity,

these are concrete social questions. Why not? But passion is recovering from another time.

Kristeva Passion aspires to the absolute and at the same time it calls it into question. We can do nothing against the violence of

its excess. This is as much in pleasure as in destruction. Passion is enthusiasm and proximity to death. It is joy and it is death. It

is destructive and fascinating. It is Shakespearean. It is an explosion, a fragmentation, outside time. Fidelity is in time. I think that

de Rougemont takes us back to a pre-Freudian, pre-modern love experience. Before Picasso, before Artaud, or, if you prefer, before

sex-shops and drag-queens. Today it is impossible to ignore the fact that sexuality is fundamentally perverse and poly-

morphous [...]

We are so full of ourselves, each of us individually and together, that it is difficult for us to imagine ... a passion that would threat-

en our understanding. Difficulties can only appear when a parallel bond which is more important than any other occurs, but there

is still a fundamental philosophical complicity which means that the other relationship dissolves or otherwise persists, albeit in a

reduced form. I often hear patients say, 'He has betrayed me'. (Men, out of pride, complain less.) I understand them as an analyst,

but not as a person. To feel betrayed assumes a lack of self-confidence, a narcissism which has been so destroyed that the small-

est sign of affirmation of the other's individuality is felt as a devastation. The smallest mosquito bite feels like an atomic bomb.

Sollers The idea that one passion refutes another seems to me appallingly badly thought out. I always see in this a return to the

religiosity that poisons these areas of life. We must put the word 'passion' in plural. Affirm the plural [...]

Le Nouvel Observateur So the big problem for couples is still whether to admit your infidelity or to hide it?

Kristeva [...] Admit it or not, if you prefer? You can say things in a hurtful way, or you can say them in a way that respects the

other. We have all known extremely liberated couples who told each other about their affairs with such a sadomasochistic compla-

cency that their relationship ended up being destroyed. In 'telling everything' there can be the desire to annihilate both the marginal partner and the other partner in the couple. It would be better first to question oneself about the need to tell. Why tell? For what purpose? Sometimes it is impossible to hide things, but sincerity in this area is also an illusion. A certain analytical relationship with your passion is therefore necessary.

Sollers I am for secrets. I believe that a human being should never have to justify their sexuality. They are entirely responsible for it. They do not need to talk about it unless it makes them sick, and then they can get on to your couch. We may have debts to pay in our social, material, intellectual and emotional life, but never in our sexual life. The idea of sexual control is inadmissible. I also believe that social surveillance always has a tendency to want to limit individual freedom in this area. There has been a totalitarian nightmare here, but the glorious democracy that we've been promised always provides temptation for repression. We have come to a moment in history when we may feel an urge to get things under control by different methods, by religious fanaticism, for example. Secrecy is therefore necessary. It's the stuff of liberty [...]

Kristeva To come back to secrecy, it preserves, without doubt, but it can also make a victim out of the one who has been pushed aside. So let's talk about lucidity. I have the impression that people who have been analyzed, and even those whose relationship to analysis is only through books, know better how to harmonize the dangers of desire and the violence of passion. We must not idealize liberty. Liberty can also be deadly.

Sollers It's even because of this that it is so frightening, and that sometimes we kill in its name [...]

Julia Kristeva (with Philippe Sollers) in conversation with *Le Nouvel Observateur*, 'When Freedom Saves Couples', *Le Nouvel Observateur*, No 1657, Paris, 8-16 August, 1996.

toni morrison, 'black matters', *playing in the dark: whiteness and the literary imagination*, 1992, selection by okwui enwezor

I am moved by fancies that are curled

Around these images, and cling:

The notion of some infinitely gentle

Infinitely suffering thing.

— T. S. Eliot from 'Preludes, TV'

These chapters put forth an argument for extending the study of American literature into what I hope will be a wider landscape. I want to draw a map, so to speak, of a critical geography and use that map to open as much space for discovery, intellectual adventure and close exploration as did the original charting of the New World — without the mandate for conquest. I intend to outline an attractive, fruitful and provocative critical project, unencumbered by dreams of subversion or rallying gestures at fortress walls [...]

I am interested in what prompts and makes possible this process of entering what one is estranged from — and in what disables the foray, for purposes of fiction, into corners of the consciousness held off and away from the reach of the writer's imagination. My work requires me to think about how free I can be as an African-American woman writer in my genderized, sexualized, wholly racialized world. To think about (and wrestle with) the full implications of my situation leads me to consider what happens when other writers work in a highly and historically racialized society. For them, as for me, imagining is not merely looking or looking at; nor is it taking oneself intact into the other. It is, for the purposes of the work, becoming [...]

For some time now I have been thinking about the validity or vulnerability of a certain set of assumptions conventionally accepted among literary historians and critics and circulated as 'knowledge'. This knowledge holds that traditional, canonical American literature is free of, uninformed and unshaped by the four-hundred-year-old presence of, first Africans and then African-Americans in the United States. It assumes that this presence — which shaped the body politic, the Constitution, and the entire history of the culture — has had no significant place or consequence in the origin and development of that culture's literature. Moreover, such knowledge assumes that the characteristics of our national literature emanate from a particular 'Americanness' that is separate from and unaccountable to this presence. There seems to be a more or less tacit agreement among literary scholars that, because American literature has been clearly the preserve of white male views, genius and power, those views, genius and power are without relationship to and removed from the overwhelming presence of black people in the United States. This agreement is made about a population that preceded every American writer of renown and was, I have come to believe, one of the most furtively radical impinging forces on the country's literature. The contemplation of this black presence is central to any understanding of our national literature and should not be permitted to hover at the margins of the literary imagination.

These speculations have led me to wonder whether the major and championed characteristics of our national literature — individualism, masculinity, social engagement versus historical isolation; acute and ambiguous moral problematics; the thematics of innocence coupled with an obsession with figurations of death and hell — are not in fact responses to a dark, abiding, sighing

Africanist presence. It has occurred to me that the very manner by which American literature distinguishes itself as a coherent entity exists because of this unsettled and unsettling population. Just as the formation of the nation necessitated coded language and purposeful restriction to deal with the racial disingenuousness and moral frailty at its heart, so too did the literature, whose founding characteristics extend into the twentieth century, reproduce the necessity for codes and restriction. Through significant and underscored omissions, startling contradictions, heavily nuanced conflicts, through the way writers peopled their work with the signs and bodies of this presence — one can see that a real or fabricated Africanist presence was crucial to their sense of Americanness. And it shows.

My curiosity about the origins and literary uses of this carefully observed, and carefully invented, Africanist presence has become an informal study of what I call American Africanism. It is an investigation into the ways in which a non-white, African-like (or Africanist) presence or persona was constructed in the United States, and the imaginative uses this fabricated presence served. I am using the term 'Africanism' not to suggest the larger body of knowledge on Africa that the philosopher Valentine Mudimbe means by the term 'Africanism', nor to suggest the varieties and complexities of African people and their descendants who have inhabited this country. Rather I use it as a term for the denotative and connotative blackness that African peoples have come to signify, as well as the entire range of views, assumptions, readings and misreadings that accompany Eurocentric learning about these people. As a trope, little restraint has been attached to its uses. As a disabling virus within literary discourse, Africanism has become, in the Eurocentric tradition that American education favours, both a way of talking about and a way of policing matters of class, sexual licence and repression, formations and exercises of power, and meditations on ethics and accountability. Through the simple expedient of demonizing and reifying the range of colour on a palette, American Africanism makes it possible to say and not say, to inscribe and erase, to escape and engage, to act out and act on, to historicize and render timeless. It provides a way of contemplating chaos and civilization, desire and fear, and a mechanism for testing the problems and blessings of freedom [...]

These remarks should not be interpreted as simply an effort to move the gaze of African-American studies to a different site. I do not want to alter one hierarchy in order to institute another. It is true that I do not want to encourage those totalizing approaches to African-American scholarship which have no drive other than the exchange of dominations — dominant Eurocentric scholarship replaced by dominant Afro-centric scholarship. More interesting is what makes intellectual domination possible; how knowledge is transformed from invasion and conquest to revelation and choice; what ignites and informs the literary imagination, and what forces help establish the parameters of criticism.

Above all I am interested in how agendas in criticism have disguised themselves and, in so doing, impoverished the literature it studies. Criticism as a form of knowledge is capable of robbing literature not only of its own implicit and explicit ideology but of its ideas as well; it can dismiss the difficult, arduous work writers do to make an art that becomes and remains part of and significant within a human landscape. It is important to see how inextricable Africanism is or ought to be from the deliberations of literary criticism and the wanton, elaborate strategies undertaken to erase its presence from view.

What Africanism became for, and how it functioned in, the literary imagination is of paramount interest because it may be possible to discover, through a close look at literary 'blackness', the nature — even the cause — of literary 'whiteness'. What is it for? What parts do the invention and development of whiteness play in the construction of what is loosely described as 'American'? If such an inquiry ever comes to maturity, it may provide access to a deeper reading of American literature — a reading not completely available now, not least, I suspect, because of the studied indifference of most literary criticism to these matters.

One likely reason for the paucity of critical material on this large and compelling subject is that, in matters of race, silence and evasion have historically ruled literary discourse. Evasion has fostered another, substitute language in which the issues are encoded, foreclosing open debate. The situation is aggravated by the tremor that breaks into discourse on race. It is further complicated by the fact that the habit of ignoring race is understood to be a graceful, even generous, literal gesture. To notice is to recognize an already discredited difference. To enforce its invisibility through silence is to allow the black body a shadowless participation in the dominant cultural body. According to this logic, every well-bred instinct argues against noticing and forecloses adult discourse. It is just this concept of literary and scholarly *mœurs* (which functions smoothly in literary criticism, but neither makes nor receives credible claims in other disciplines) that has terminated the shelf life of some once extremely well-regarded American authors and blocked access to remarkable insights in their works [...]

Another reason for this quite ornamental vacuum in literary discourse on the presence and influence of Africanist peoples in American criticism is the pattern of thinking about racialism in terms of its consequences on the victim — of always defining it asymmetrically from the perspective of its impact on the object of racist policy and attitudes. A good deal of time and intelligence has been invested in the exposure of racism and the horrific results on its objects. There are constant, if erratic, literalizing efforts to legislate these matters. There are also powerful and persuasive attempts to analyze the origin and fabrication of racism itself, contesting the assumption that it is an inevitable, permanent and eternal part of all social landscapes. I do not wish to disparage these inquiries. It is precisely because of them that any progress at all has been accomplished in matters of racial dis-

course. But that well-established study should be joined with another, equally important one: the impact of racism on those who perpetuate it. It seems both poignant and striking how avoided and unanalyzed is the effect of racist inflection on the subject. What I propose here is to examine the impact of notions of racial hierarchy, racial exclusion and racial vulnerability and availability on non-blacks who held, resisted, explored or altered those notions. The scholarship that looks into the mind, imagination and behaviour of slaves is valuable. But equally valuable is a serious intellectual effort to see what racial ideology does to the mind, imagination and behaviour of masters [...]

Like thousands of avid but nonacademic readers, some powerful literary critics in the United States have never read, and are proud to say so, any African-American text. It seems to have done them no harm, presented them with no discernible limitations in the scope of their work or influence. I suspect, with much evidence to support the suspicion, that they will continue to flourish without any knowledge whatsoever of African-American literature. What is fascinating, however, is to observe how their lavish exploration of literature manages not to see meaning in the thunderous, theatrical presence of black surrogacy – an informing, stabilizing and disturbing element – in the literature they do study. It is interesting, not surprising, that the arbiters of critical power in American literature seem to take pleasure in, indeed relish, their ignorance of African-American texts. What is surprising is that their refusal to read black texts – a refusal that makes no disturbance in their intellectual life – repeats itself when they re-read the traditional, established works of literature worthy of their attention [...]

An instructive parallel to this willed scholarly indifference is the centuries-long, hysterical blindness to feminist discourse and the way in which women and women's issues were read (or unread). Blatant sexist readings are on the decline, and where they still exist they have little effect because of the successful appropriation by women of their own discourse [...]

My early assumptions as a reader were that black people signified little or nothing in the imagination of white American writers. Other than as the objects of an occasional bout of jungle fever, other than to provide local colour or to lend some touch of verisimilitude or to supply a needed moral gesture, humour or bit of pathos, blacks made no appearance at all. This was a reflection, I thought, of the marginal impact that blacks had on the lives of the characters in the work as well as the creative imagination of the author. To imagine or write otherwise, to situate black people throughout the pages and scenes of a book like some government quota, would be ludicrous and dishonest.

But then I stopped reading as a reader and began to read as a writer. Living in a racially articulated and predicated world, I could not be alone in reacting to this aspect of the American cultural and historical condition. I began to see how the literature I revered, the literature I loathed, behaved in its encounter with racial ideology. American literature could not help being shaped by that encounter. Yes, I wanted to identify those moments when American literature was complicit in the fabrication of racism, but equally important, I wanted to see when literature exploded and undermined it. Still, those were minor concerns. Much more important was to contemplate how Africanist personae, narrative and idiom moved and enriched the text in self-conscious ways, to consider what the engagement meant for the work of the writer's imagination.

How does literary utterance arrange itself when it tries to imagine an Africanist other? What are the signs, the codes, the literary strategies designed to accommodate this encounter? What does the inclusion of Africans or African-Americans do to and for the work? As a reader my assumption had always been that nothing 'happens': Africans and their descendants were not, in any sense that matters, there; and when they were there, they were decorative – displays of the agile writer's technical expertise. I assumed that since the author was not black, the appearance of Africanist characters or narrative or idiom in a work could never be about anything other than the 'normal', unracialized, illusory white world that provided the fictional backdrop. Certainly no American text of the sort I am discussing was ever written for black people – no more than *Uncle Tom's Cabin* was written for Uncle Tom to read or be persuaded by. As a writer reading, I came to realize the obvious: the subject of the dream is the dreamer. The fabrication of an Africanist persona is reflexive; an extraordinary meditation on the self; a powerful exploration of the fears and desires that reside in the writerly conscious. It is an astonishing revelation of longing, of terror, of perplexity, of shame, of magnanimity. It requires hard work not to see this.

It is as if I had been looking at a fishbowl – the glide and flick of the golden scales, the green tip, the bolt of white careening back from the gills; the castles at the bottom, surrounded by pebbles and tiny, intricate fronds of green; the barely disturbed water, the flecks of waste and food, the tranquil bubbles travelling to the surface – and suddenly I saw the bowl, the structure that transparently (and invisibly) permits the ordered life it contains to exist in the larger world. In other words, I began to rely on my knowledge of how books get written, how language arrives; my sense of how and why writers abandon or take on certain aspects of their project. I began to rely on my understanding of what the linguistic struggle requires of writers and what they make of the surprise that is the inevitable concomitant of the act of creation. What became transparent were the self-evident ways that Americans choose to talk about themselves through and within a sometimes allegorical, sometimes metaphorical, but always choked representation of an Africanist presence.

Toni Morrison, 'Black Matters', *Playing in the Dark, Whiteness and the Literary Imagination.* Harvard University Press, Massachusetts, 1992

david robbins interviewed by his landlord dennis wilford 'on concrete comedy', 1991. selection by matthew higgs

Dennis Wilford Were you aware of Karl Valentin's work before coming to Europe?

David Robbins No. I learned about Valentin in 1988, when I spent time in Munich. People in the States still don't really know about Karl Valentin. I'm sure there are plenty of people in Europe who've never heard of him either, though he's well known in Germany. Valentin was a German comedian and musician enormously popular in his home country from around 1913 till the end of his life in 1948. His career included comic work in legitimate theatre, nightclub appearances and radio, he made dozens of records and films — and he made objects, which have been exhibited since the early 1930s in his own museum, originally called the Panoptikum, now the Karl Valentin Museum, in the heart of Munich. Both Duchamp and Man Ray knew about his objects. To me, Valentin is a major figure, not only because he's the earliest link between comic performance and the production of conceptual objects, but because he showed that objects could be made with a spirit and intention that had nothing to do with having them end up as art. Valentin was part of the weave I was interested to participate in. He was a cornerstone of this alternative history — rather, this alternative history of an alternative endeavour.

Karl Valentin, c. 1930

The other major figure for me was Robert Benchley who, graduated from Harvard and living in Manhattan in the 1920s, was more cosmopolitan than Valentin. Benchley was one of the most important American humorists of the first half of the century, yet even in America his work is not very well known by those generations born after World War II. He was an Algonquin wit, a highly regard-ed humorist of the page for *The New Yorker* (James Thurber once wrote that the great humorists of his own era were afraid that everything they were doing had probably been done better by Benchley in 1924), a respected theatre critic and an actor. Benchley also wrote and more or less directed wonderfully funny films, starring himself. His first film was a talkie made in 1928, *The Treasurer's Report*, which some film historians cite as the first all-talking film. It's still funny, more than sixty years later, which is quite a feat, actually; lots of silent films are still 'funny', or at least engaging, but very few early sound films have remained funny.

Benchley made over forty short comic films, very often with a dubiously educational, scientific or anthropological tone to them, beginning in 1928 and continuing through the 1940s — *How to Behave*, *How to Vote*, *The Romance of Digestion* ... *How to Sleep* won an Academy Award in 1938. But even though he was successful in both film and publishing, Benchley never identified himself completely with either context. He once told an interviewer, 'I am not a writer and not an actor. I don't know what I am.' He was just a guy who did interesting things, see, which was exactly the sort of open-endedness I wanted to retain for my own activities, so Benchley was a useful model for a certain attitude towards production. Benchley also got me thinking about props. For exam-ple, in his 1938 film *The Courtship of the Newt*, in which he more or less plays himself (actually, he always played himself), dressed up in a doctor's white coat, he is surrounded by large, scientific-looking diagrams and illus-

Robert Benchley, with props from How to Write a Short Story, c. 1930

trations that are completely ridiculous, labelled, for example, 'Fig.2; Newt's face: front elevation', and an arrow, pointing to the side of an oval with dot eyes, indicating 'no ear'. Or in *How to Figure Income Tax*, a tax form as big as he was. He explored what kind of props might be created specifically for short comic films.

Wilford So Benchley, like Valentin, was a comic original who used objects in an original way.

Robbins Benchley and Valentin got me started looking for other figures who might have participated in what I was interested in, and I began to weave together a highly selective history — an object here, a film there, a piece of writing, a 'work' made by an artist'. A history which existed but which hadn't been recognized.

Wilford Who figures in this history?

Robbins It's a history constructed as much from entertainment's as from art's history. That's important. It trespasses contextual borders. And because it's such a specific and unusual history, someone can be important to it for producing a single work. Jack Benny, for instance, I'm thinking of a specific object that he'd had made in the 1930s. He and Fred Allen had a famous radio feud. although they were said to be good friends. At some point Fred Allen came out to Los Angeles to visit Benny, and Benny arranged a little greeting for him and, of course, for the press. Benny had had a sign made which read 'Jack Benny Welcomes Fred Allen'. only the sign was designed in such a way that the letters descended in size, line by line, so that 'Jack Benny' was quite large. 'Welcomes' a little smaller and 'Fred Allen' quite small. Allen amiably stood in front of it and had himself photographed.

What intrigued me was the philosophical and psychological condition of this sign. What was its location, as an object? It was some-thing like a prop, in that it was produced in order to be photographed, but it was both more ambitious and more specific than a common theatrical prop. It was site-specific, yet the site is multi-contextual, existing at once within the contexts of public theatre.

photography, the press and radio. Separate one of these contexts from another and you destroy the reason for having the sign made in the first place. So this peculiar welcome sign managed to tie together four contexts in a nonchalant, comic manner. Fifty years later this would be termed post-modern.

I became very interested in how an object like that welcome sign, or Benchley's props, or Valentin's objects existed in relation to some of the things made decades later by, for example, Marcel Broodthaers or Piero Manzoni, who consistently produced another sort of comic artefact in another context, the art context. How were they similar, how were they different? Manzoni's *Socle du Monde*, for example, or his sealed cans of artist's shit, or Broodthaers' *Musée d'Art Moderne, Département des Aigles* — these

Piero Manzoni, Socle du Monde, 1961, collection, Herring Kunstmuseum, Denmark

are deeply comic gestures; in fact, to my mind, the brilliant comedy quite overpowers the art. Lurking somewhere in the back-

ground of all this was Duchamp's question about whether or not it was possible to make an *inutile* object that was not an art object. For me, entertainment had answered that question in the affirmative, and I then went on to make it more specific: the comic object.

Wilford Which artists would you include in this history?

Robbins A fair number of artists have touched upon this psychological vector in their work at one point or another, but only a handful stayed with it. Finally it's the proper location for very few. It's not a sensibility that you acquire. But so far as the history of this particular endeavour is concerned, we might include Duchamp, most of Manzoni, arguably all of Nauman, Broodthaers when he's not too poetical ... Actually, visual artists produced rather a lot of excellent public comedy in the 1960s. Öyvind Fahlström staged a public demonstration in New York in 1966 where people carried signs with either a huge photo of Mao or a huge photo of Bob Hope on them. Ed Ruscha produced some severe and deadpan gestural humour in early books like *Every Building on the Sunset Strip*. Warhol did an enormous amount of high/low comedy in mass media, too much to mention here. Well, I'll mention a

Marcel Broodthaers, Musée d'Art Moderne, Département des Aigles, Section des Figures, 1972

little known, particularly perverse one: the perfume called 'You're In'. Comedic gestures that redefined public theatre via the media. Towards the end of the decade absurd and threatening politicized gestures were added to

the mix. The Diggers did an Angry Hippie version in San Francisco, and then Abbie Hoffman and the Yippies took it national with a Revolution version. At the very end of the decade John Lennon and Yoko Ono become very important to this particular history, not least because they so perfect-ly embodied the fusion/confusion of entertainment and art. John and Yoko made some major comedic gestures in the late 1960s with manifestations like the Amsterdam Bed-In, and posing together in a big white cloth bag labelled Baggism. John and Yoko's activities as public figures during that time provided the bridge from the art world and Fahlström in the mid 1960s, through the politicized counter culture's forays into mass media, and back to the art world in the 1970s with, in Europe, Sigurdur Gudmundsson and Braco Dimetrijevic and in America, William Wegman, Chris Burden and Eleanor Antin.

Bruce Nauman, Walking in an Exaggerated Manner Around the Perimeter of a Square, 1967–68

Wilford How can you so casually link all these people, Marcel Broodthaers with Jack Benny, Robert Benchley with Yoko Ono?

Robbins Well, that's the whole point, of course. To me the breakthrough was to recognize that what had appeared to be two traditions – represented in the art context by someone like Broodthaers and in the entertainment context by Jack Benny – was actually *the same impulse manifested in and thus tailored for the conditions specific to two contexts*. The impulse interested me much more than either of the two contexts, so I framed the impulse.

Wilford But for the comic object to function differently from an art object, it must structure the audience in a different way. Certainly the relation of the entertainer to the audience is structured differently from the relation of the artist to the audience. How does concrete comedy structure the audience?

Robbins That's the big question. If one is interested in participating in a tradition shared by both Marcel Broodthaers and Jack

Benny, what exactly is the tradition? If one's work is genuinely between contexts, or overlaps two contexts, how does the audience locate you? If you've gene-spliced two contexts, you can approach from either, but it's more radical to consider concrete comedy from within the history of comedy than from within the history of art. The latter places too much emphasis on art history, on formal and material invention, on whether these objects satisfy in the way art satisfied; in fact, comic objects don't even aspire to art's satisfactions, but explore another, possibly parallel, hopefully uncharted territory. Considered from within the history of comedy, concrete comedy can be seen as the radical thing it is: producing sophisticated comic objects and gestures that have the per-manence of art, and by this means inventing and recording a non-fiction comic life.

Wilford But why not just accept that your activity is another kind of art?

John Lennon and Yoko Ono, Bed-In for Peace, 1969

Robbins Simply because I want to draw upon another part of the brain which gives me more satisfaction. It's nothing more than

that. But it's nothing less, either. The desire to imbue comic structures with the permanence of art is a complicated desire, because the only context that currently exists for displaying contempla-tive objects is the art context. This raises interesting questions about whether or not art in the service of something other than art remains art. If one defines art as the invention of behaviour, and the behaviour one happens to invent includes but is not limited to art, what then is the rela-tion of art to one's behaviour? If we position art within a multicontextual, behavioural, attitudinal activity like comedy, is what gets produced still art?

Just because an object is contemplative doesn't mean that it has to be art: we know from ponder-ing entertainment that not all *inutile*, contemplative objects necessarily aspire to the philosophical conditions, structural dynamics

David Robbins, Comic Object/Portable Dilemma, 1992

or social role of art objects.

I seem to be refusing to make entertainment in the entertainment context, and refusing to make art in the art context. This is interesting. My position in designating these objects to be something other than art is exactly the inverse of the modernist artist, whose power lay in designating as art things or circumstances previously not considered to be art: an obvious and famous example of this being Rauschenberg's telegram declaring 'This is a portrait of Iris Clert if I say so.'. I am using the same designatory power to set an activity outside of art, to insist on the separateness of that activity, and to make visi-

David Robbins, The Off-Target, 1994

ble that activity's own structural life and goals.

In this process, the individual object is arithmetic. Exhibitions are algebra. My relation to the production of either is calculus.

Wilford I have a sense of the calculus, but I want a better sense of the arithmetic. How does a comic object differ from an art object?

Robbins I'm still exploring the differences between them, but I'm happy to tell you what I've learned so far.

First of all, it's important to say what they are not: Comic objects are not art jokes or jokes about art. They are not concerned with art or art history.

Unlike art objects, comic objects do not attempt to distil or absorb reality. Comic objects displace reality. Comic objects are essentially performative, rather than, like art objects, metaphorical, descriptive or analogical. Because comedy is essentially a behavioural medium, comic objects exist to reflect the behavioural choices that produced them — which means that the gesture of making them frames or causes to exist a deep comic structure, gradually discernible and rewarding repeated viewing.

David Robbins, Situation Comedy 3, 1993–94

Wilford 'Gradually discernible and rewarding repeated viewing.' Sure sounds like art.

Robbins Yes. But here let us recall the humble homonym.

Comic objects are more porous than art objects. They flow into and out of one another through an independent set of referents which they share and which are not art historical. They refer to the decisions and actions — the theatre of behaviour — which brought them into existence. They are mirrors made to reflect a context.

Wilford Their own context.

Robbins Yes, which they simultaneously participate in and construct.

Wilford So they — and you — are trying to invent a context.

Robbins That's the calculus. If I manage to do it, you'll appreciate it — as I always say; you'll love it in ten years, why not save yourself all that time and love it now? And if I fail ... well, actually the fool's position is of such a nature that he or she actually cannot fail.

Wilford Why not?

Robbins Because comedy has a separate and unique relation to the idea of success. Comedy is to a large degree based on human folly, getting things wrong, or at least 'not right', so comedy is very much about incorporating the possibility of failure into one's plans and actions. But in com-edy — and only in comedy — failure is re-wired as a kind of success. Take the idea of the fool. The fool is *supposed* to fail, that's part of the fool's function, his 'project', if I may borrow that word from Conceptual Art. And because

David Robbins, Behavior Study, 1992

it is his function, the fool in fact *cannot* fail. Real, actual failure becomes a moot point for the fool. Comic structures are in this way, if you'll excuse a twisted pun, foolproof. Which doesn't mean that one is trying to fail, it simply means that, for the fool, failure ... isn't. Unique within the range of human activities, only the fool, by the very nature of his endeavour, can redeem failure.

Wilford Comedy is life insurance, then.

Robbins Life's work: insurance, yes.

David Robbins interviewed by his landlord Dennis Wilford, 'On Concrete Comedy', 1991, *Foundation Papers from the archives of the Institute for Advanced Comic Behavior*, Feature, New York: Jay Gorney Modern Art, New York: Galerie Xavier Hufkens, Brussels, 1992

edward saïd, 'intellectual exile: expatriates and marginals', 1993, selection by francesco bonami

Exile is one of the saddest fates. In premodern times, banishment was a particularly dreadful punishment since it meant not only years of aimless wandering away from family and familiar places but also being a permanent outcast, someone who never felt at home and was always at odds with the environment, inconsolable about the past, bitter about the present and future. There has always been an association between the idea of exile and the terrors of being a leper, a social and moral untouchable. During the twentieth century, exile has been transformed from the exquisite, and sometimes exclusive, punishment of special individuals – such as Ovid, who was banished from Rome to a remote town on the Black Sea – into a cruel punishment of whole communities and peoples, often as the inadvertent result of impersonal forces such as war, famine and disease [...]

There is a popular but wholly mistaken assumption that to be exiled is to be totally cut off, isolated, hopelessly separated from your place of origin. If only that surgically clean separation were possible, because then at least you could have the consolation of knowing that what you have left behind is, in a sense, unthinkable and completely irrecoverable. The fact is that for most exiles the difficulty consists not simply in being forced to live away from home, but rather, given today's world, in living with the many reminders that you are in exile, that your home is not in fact so far away, and that the normal traffic of everyday contemporary life keeps you in constant but tantalizing and unfulfilled touch with the old place. The exile therefore exists in the median state, neither completely at one with the new setting nor fully disencumbered of the old, beset with half involvements and half detachments, nostalgic and sentimental on one level, and adept mimic or a secret outcast on another. Being skilled at survival becomes the main imperative, with the danger of becoming too comfortable and secure constituting a threat that is constantly to be guarded against [...]

The intellectual who considers him or herself to be a part of a more general condition affecting the displaced national community is [...] likely to be a source not of acculturation and adjustment but rather of volatility and instability.

This is by no means to say that exile doesn't also produce marvels of adjustment. The United States today is in the unusual position of having two extremely high former officers in recent presidential administrations – Henry Kissinger and Zbigniew Brzezinski – who were (or still are, depending on the observer's outlook) intellectuals in exile, Kissinger from Nazi Germany, Brzezinski from Communist Poland. In addition, Kissinger is Jewish, which puts him in the extraordinarily odd position of also qualifying for potential immigration to Israel, according to its Basic Law of Return. Yet both Kissinger and Brzezinski seem, on the surface at least, to have contributed their talents entirely to their adopted country, with results in eminence, material rewards and national (not to say worldwide) influence that are light-years away from the marginal obscurity in which Third World exile intellectuals live in Europe or in the US. Having served in government for several decades, the two prominent intellectuals are now consultants to corporations and other governments [...]

An intellectual may work out an accommodation with a new or emergingly dominant power in several ways, including the rather shady art of political trimming, a technique of not taking a clear position but surviving handsomely nonetheless. But what I want to focus on here is the opposite: the intellectual who because of exile cannot or, more to the point, will not make the adjustment, preferring instead to remain outside the mainstream, unaccommodated, unco-opted, resistant. There are some preliminary points that need to be made.

One is that while it is an actual condition, exile is also for my purposes a metaphorical one. By that I mean that my diagnosis of the intellectual in exile derives from the social and political history of dislocation and migration I discussed earlier, but is not limited to it. Even intellectuals who are lifelong members of a society can, in a manner of speaking, be divided into insiders and outsiders: those on the one hand who belong fully to the society as it is, who flourish in it without an overwhelming sense of dissonance or dissent, those who can be called yea-sayers: and, on the other hand, the nay-sayers, the individuals at odds with their society and therefore outsiders and exiles so far as privileges, power and honours are concerned. The pattern that sets the course for the intellectual as outsider, which I believe is the right role for today's intellectual as outsider, is best exemplified by the condition of exile, the state of never being fully adjusted, always feeling outside the chatty, familiar world inhabited by natives (so to speak), tending to avoid and even dislike the trappings of accommodation and national well-being. Exile for the intellectual in this metaphysical sense is restlessness, movement, constantly being unsettled and unsettling others. You can't go back to some earlier and perhaps more stable condition of being at home; and, alas, you can never fully arrive, be at one with your new home or situation. Second – and I find myself somewhat surprised by this observation even as I make it – the intellectual as exile tends to be happy with the idea of unhappiness, so that dissatisfaction bordering on dyspepsia, a kind of curmudgeonly disagreeableness, can become not only a style of thought, but also a new, if temporary, habitation. The intellectual as ranting Thersites perhaps. A great historical prototype for what I have in mind is a powerful eighteenth-century figure, Jonathan Swift, who never got over his fall from influence and prestige in England after the Tories left office in 1714, and spent the rest of his life as an exile in Ireland. Swift was an almost legendary figure of bitterness and anger – *saeve indignatio*, he said of himself in his own epitaph – furious at Ireland, yet defending it against British tyranny, a man whose towering Irish works *Gulliver's Travels* and *The Drapier's Letters*

show a mind flourishing, not to say benefiting, from such productive anguish [...]

Because the exile sees things in terms both of what has been left behind and what is actual here and now, he or she has a double perspective, never seeing things in isolation. Every scene or situation in the new country necessarily draws on its counterpart in the old country. Intellectually this means that an idea or experience is always counterposed with another, sometimes making them both appear in a new and unpredictable light: from that juxtaposition one gets a better, perhaps even more universal idea of how to think, say, about a human-rights issue in one situation as compared to another. I have felt that most of the alarmist and deeply flawed discussions of Islamic fundamentalism in the West have been intellectually invidious precisely because it has not been compared with Jewish or Christian fundamentalism, both equally prevalent and reprehensible in my own experience of the Middle East. Double or exile perspective impels a Western intellectual to see what is usually thought of as a simple issue of judgement against an approved enemy as part of a much wider picture, with the requirement now of taking a position as a secularist (or not) on all theocratic tendencies, not just against the conventionally designated ones.

A second advantage to the exile standpoint for an intellectual is that you tend to see things not simply as they are but as they have come to be that way. You look at situations as contingent, not as inevitable; look at them as the result of a series of historical choices made by men and women, as facts of society made by human beings, and not as natural or God-given, therefore unchangeable, permanent, irreversible.

The great prototype for this sort of intellectual position is provided by the eighteenth-century Italian philosopher Giambattista Vico, who has long been a hero of mine. Vico's great discovery, which derived in part from his loneliness as an obscure Neapolitan professor — scarcely able to survive, at odds with the Church and his immediate surroundings — is that the proper way to understand social reality is to understand it as a process generated from its point of origin, which one can always locate in extremely humble circumstances. This, he said in his great work *The New Science*, means seeing things as having evolved from definite beginnings, as the adult human being derives from the babbling child.

Vico argues that this is the only point of view to take about the secular world, which he repeats over and over again is historical, with its own laws and processes, not divinely ordained. This entails respect, but not reverence, for human society. You look at the grandest of powers in terms of where it came from and where it might be headed; you are not awed by the august personality or the magnificent institution, which often compels silence and stunned subservience from a native, someone who has always seen (and therefore venerated) the grandeur but not the perforce humbler human origins from which it derived. The intellectual in exile is necessarily ironic, sceptical, even playful — not cynical.

Finally, as any real exile will confirm, once you leave your home, you cannot simply take up life wherever you end up and become just another citizen of the new place. Or if you do, there is a good deal of awkwardness involved in the effort, which scarcely seems worth it. You can spend a lot of time regretting what you lost, envying those around you who have always been at home, near their loved ones, living in the place where they were born without ever having to experience not only the loss of what was once theirs but above all the torturing memory of a life to which they can never return. On the other hand, as Rilke once said, you can become a beginner in your circumstances, and this allows you an unconventional style of life and, above all, a different, often very eccentric career.

For the intellectual an exile displacement means being liberated from the usual career, in which 'doing well' and following in time-honoured footsteps are the main milestones. Exile means that you are always going to be marginal, and that what you do as an intellectual has to be invented because you cannot follow a prescribed path. If you can experience that fate, not as a deprivation and as something to be bewailed, but as a sort of freedom, a process of discovery and doing things according to your own pattern, as various interests seize your attention and as the particular goal you set for yourself dictates, that is a unique pleasure [...]

Most of us may not be able to duplicate the destiny of the exiles [...] but their significance for the contemporary intellectual is nevertheless very pertinent. Exile is a model for the intellectual who is tempted, and even beset and overwhelmed, by the rewards of accommodation, yea-saying, settling in. Even if one is not an actual immigrant or expatriate, it is still possible to think as one, to imagine and investigate in spite of barriers, and always to move away from the centralizing authorities towards the margins, where you see things that are usually lost on minds that have never travelled beyond the conventional and the comfortable.

Furthermore, a condition of marginality, which may seem irresponsible and unserious, at least frees you from having always to proceed with caution, afraid to overturn the apple cart, anxious about upsetting fellow members of the same corporation. No one is ever free of attachments and sentiments, of course. Nor do I have in mind here the so-called free-floating intellectual, whose technical competence is on loan and for sale to anyone. I am saying, however, that to be as marginal and as undomesticated as someone who is in real exile is for an intellectual to be unusually responsive not to the potentate but to the traveller, not the captive of habit and what is comfortably given but attracted to the provisional and sporty, committed not to maintaining things by an authority we have always known but to innovating by force of risk, experiment, innovation. Not the logic of the conventional but the audacity of daring and moving, moving, moving, representing change, not standing still.

Edward Saïd, 'Intellectual Exile: Expatriates and Marginals', *Grand Street*, No 47, New York, Autumn 1993, pp. 113-124.

eve kosofsky sedgwick, 'queer performativity: warhol's shyness/warhol's whiteness', 1996, selection by dan cameron

The jokes that mean the most to you are the ones you don't quite get; that's one true fact I've figured out over the years. Another is, the people with the most powerful presences are the ones who aren't all there. Like going to hear Odetta at the Cookery some years ago and having her – I don't know what was going on with her – in the middle of one song, still *singing*, wander off for a brief tour of the restaurant kitchen, her machine-like, perseverating voice winding from its distance outward towards the excruciated and rapt audience: now *that* was *presence*: presence like the withdrawal of a god.

Andy Warhol had presence of that revelatory kind – revelatory not in the sense that it revealed 'him' but rather that he could wield it as a sharp, insinuating heuristic chisel to pry at the faultlines and lay bare the sedimented faces of his surround. As with Odetta at the Cookery, excruciation – the poetics, politics, semiotics and somatics of shame – provided the medium for this denuding sculpture at once so intimate, so public. Shame, in Warhol's case, as crystallized in a bodily discipline of florid shyness: 'There are different ways for individual people to take over space – to command space. Very shy people don't even want to take up the space that their body actually takes up, whereas very outgoing people want to take up as much space as they can ... I've always had a conflict because I'm shy and yet I like to take up a lot of personal space. Mom always said, "Don't be pushy, but let everybody know you're around." I wanted to command more space than I was commanding, but then I knew I was too shy to know what to do with the attention if I did manage to get it. That's why I feel that television is the media I'd most like to shine in.'[1]

From shame to shyness to shining – and, inevitably, back and back again: the candour and cultural incisiveness of this itinerary seem to make Warhol an exemplary figure for a new project, an urgent one I think, of understanding how the dysphoric affect of shame functions as a nexus of production: production, that is, of meaning, of personal presence, of politics, of performative and critical efficacy. What it may mean to be a (white) queer in a queer-hating world, what it may mean to be a white (queer) in a white-supremacist one, are two of the explorations that, for Warhol, this shyness embodied.

Both *POPism* and *The Philosophy of Andy Warhol* include extended arias specifically on the shy and, *not* incidentally, on the queer and on the white, in which the illusion of Warhol's presence gets evoked in a shimmeringly ambiguous, shame-charged linguistic space of utterance and address. In *POPism*, in a scene from the Factory in 1966, Warhol describes Silver George impersonating Andy Warhol over the phone: "You want me to describe myself?", Silver George was saying. He looked at me as if to say, "You don't care if I do this, right?", I asked who it was and when he said it was a high school paper I motioned for him to go ahead. "Well, I wear what everybody else around the Factory wears", he said, looking over at me as a reference. "A striped T-shirt – a little too short – over another T-shirt, that's how we like them ... and Levi's ..." He listened for a few moments. "Well, I would call myself – youthful-looking. I have a slightly faggy air and I do little artistic movements ..." I looked up from painting. I'd thought all they wanted was a fashion description, but it didn't matter ... "Well, I have very nice hands", he said, "very expressive ... I keep them in repose or touching each other, or sometimes I wrap my arms around myself. I'm always very conscious of where my hands are ... But the first thing you notice about me is my skin. It's translucent – you can really see my veins – and it's gray, but it's pink, too ... My build? Well, it's very flat, and if I gain any weight, it's usually all in my hips and stomach. And I'm small-shouldered and I'm probably the same dimension at my waist as I am at my chest ..." Silver George really had momentum now ... "And my legs are very narrow and I have tiny little ankles – and I'm a little birdlike from my hips down – I sort of narrow in and taper down toward my feet ... 'Birdlike', right ... and I carry myself very square, like a unit. And I'm rigid – very conservative about my movements; I have a little bit of an old-lady thing there ... And my new boots have sort of high heels, so I walk like a woman, on the balls of my feet – but actually, I'm very ... hardy ... Okay?... No, it was no trouble ..." When Silver George hung up, he said they were really thrilled because they'd heard I never talked and here I'd just said more to them than anybody they'd every interviewed. They'd also said how surprised they were that I could be so objective about myself.'[2]

What Warhol does in publishing this account in 1980 under his own name – his own and Pat Hackett's, not to let things get too over-simplified! – is a bit like what he's done in *Philosophy* in 1975, retelling a phone conversation between himself, as 'A', and one of the several interlocutors he brings together under the designation 'B': 'Day after day I look in the mirror and I still see something – a new pimple. If the pimple on my upper right cheek is gone, a new one turns up on my lower left cheek, on my jawline, near my

Andy Warhol, Self-portrait (detail), 1978

ear, in the middle of my nose, under the hair on my eyebrows, right between my eyes. I think it's the same pimple, moving from place to place. I was telling the truth. If someone asked me, "What's your problem?", I'd have to say, "Skin". I dunk a Johnson & Johnson cotton ball into Johnson & Johnson rubbing alcohol and rub the cotton ball against the pimple ... "When the alcohol is dry", I said, "I'm ready to apply the flesh-coloured acne-pimple medication that doesn't resemble any human flesh I've ever seen, though it does come pretty close to mine ... So now the pimple's covered. But am I covered? I have to look into the mirror for some more clues. Nothing

is missing. It's all there. The affectless gaze. The diffracted grace ..."³ [...]

I can't do justice to the comic sublimity of these passages, in which an uncanny and unmistakable presence wills itself into existence in the flickering, holographic space of Warhol's hunger to own the rage of other people to describe him – to describe him as if impersonally, not to say sadistically. The effect of this shy exhibitionism is, among other things, deeply queer. ('Remember the 50s?' Lily Tomlin used to ask in a comedy routine. 'Nobody was gay in the 50s; they were just shy.') Some of the infants, children and adults in whom shame remains the most available mediator of identity are the ones called shy. And *queer*, as I've suggested elsewhere, might usefully be thought of as referring in the first place to this group or an overlapping group of infants and children, those whose sense of identity is for some reason tuned most to the note of shame [...]

It seems clear enough that Warhol can be described as a hero of certain modern possibilities for embodying the transformations of 'queer' shyness and for amplifying its heuristic power to expose and to generate meaning. Warhol's career offers seemingly endless ways of exploring the relation of queer shame/shyness to celebrity; to consumer culture; to prosopopoeia, the face and the portrait.

But Warhol's shyness is, along with a heuristic of being queer, also a heuristic of being 'white'. As such, it radically complicates any simple re-appropriation of shame/shyness as being in a particular or given relation to a political telos. (And this makes sense to me: even if I just introspect about my own shyness and the politics it has made possible, the politics it has made necessary, the politics it has made prohibitively difficult, I see that it has been powerfully formative, and to very complex effect.) No one is as white as Warhol: he offers himself, willy-nilly but also with a certain defiant deliberation, as the literalizing allegory of whiteness, of the 'flesh colour' 'that doesn't resemble any human flesh I've ever seen, though it does come pretty close to mine'. Whiteness and shame are closely intertwined for Warhol – as maybe for anyone involved, at any angle, in the exacerbated race relations around urban space, civil rights, sexuality and popular culture in the United States by the early 1960s. The exponentially increased salience of the stigma of 'black' skin also concomitantly made the representational status of 'white' skin vastly more problematical. To the extent that the stigma process signals the presence of a shame dynamic, to the extent also that shame definitionally functions doubly as both florid contagion *across* the skin sac and florid 'self'-consciousness as delimited *by* the skin sac: to that extent, whatever a person's ideological politics of race might be, that person, even if 'white', if shame-prone, is likely to inhabit a self at least partly constituted as a self by shame of the skin. Go back to those two long arias: remember how the skin, the whiteness of the skin (as an index of colour or no colour, of luminescence, of transparency/opacity and of the natural/unnatural) is central in both those scenes of embarrassingly/hilariously alienated subjectivity.

There is a history, at least a century long, of racist uses of shame and the blush specifically as related to skin colour and race.⁶ It derives from Darwin: shame getting equated with 'ability to' blush (meaning here to *be seen to* blush), which is then made to constitute the exact differential between 'white' and 'nonwhite' peoples, treated as being 'the same as' the differential between more and less evolved species, that is, between fully and not-quite-fully human. Yet Warhol's pallor – whether because it represents his childhood illness or his self-described 'bad chemicals' or because it represents an immigrant and specifically ethnic, working-class origin – is precisely *not* transparent to the blush of 'the human'. His *un*blushing white skin, in its very allegorical excessiveness, resists being normalized or universalized. In Warhol's face *the blush*, per se, is figured only in the hysterically condensed form of that wandering pimple; it's a 'beauty problem'. Because of the intractable literality of his whiteness, Warhol's physical instruments for efflorescing his shame/shyness, paradoxically, are therefore the race-transcending ones of the dippy musculature, the Shirley Temple mannerisms, the averted gaze. What Warhol allows to be called his 'faggy air' is also the air of his literalizing shame of whiteness. Yet it is not an 'air' available for identification only to white people (I think of Michael Jackson) – in fact, as José Muñoz has suggested in his essay on Warhol's relation to Jean-Michel Basquiat and Basquiat's identifications with him, this demeanour may even be *more* resonant for nonwhite (gay) men with their particular histories of expertise in negotiating indignity with dignity.

Warhol's casual and more-than-casual racism: how to situate it in this connection? I would just briefly call special attention here to his distinctive (and, of course, in some ways profoundly limiting) strategy of 'childlikeness'. It's especially clear when he uses 'childlikeness' as a tone in which, again, to literalize race as colour. A logic implicit in his language appears to me to go something like this: as his chalk-and-silver pallor is to the racial construct called 'whiteness', so *the colour brown*, and things coloured brown, is to the racial construct called 'blackness'. I associate this tacit homology with the highly undisarming 'candour' of his embarrassed relation to chocolate and even to excrement. Significantly, both represent gay/homophobic signifiers even at the same time as they can be used as racial/racist ones. For instance, Michael Moon has written about Warhol's childhood memory (found in *Philosophy*) of receiving a Hershey Bar from his mother 'every time I finished a page in my colouring book'.⁷ At the time *Philosophy* was written, Moon points out, '"the Hershey highway" was current gay slang ... for the rectum, and for ... the range of sexual practices – rimming (analingus), fucking, fisting and scat – associated with it ... Watching and photographing other men "taking the Hershey highway" (among other kinds of sexual activities) as an adult in the 1970s ... may have contributed to his impetus to make his representative scene of early bliss close with an encoded anal exchange between himself and his mother'⁸ [...]

To sum up, shame, like other affects, is not a discrete intrapsychic structure but a kind of free radical that (in different people and

also in different cultures) attaches to and permanently intensifies or alters the meaning of – of almost anything: a zone of the body, a sensory system, a prohibited or indeed a permitted behaviour, another affect such as anger or arousal, a named identity, a script for interpreting other people's behaviour towards oneself. Thus, one of the things that anyone's character or personality is, is a record of the highly individual histories by which the fleeting emotion of shame has instituted far more durable, structural changes in one's relational and interpretive strategies towards both self and others.

Which means, among other things, that therapeutic or political strategies aimed directly at getting rid of individual or group shame, or undoing it, have something preposterous about them: they may 'work' – they certainly have powerful effects – but they can't work in the way they say they work. (I am thinking here of a range of movements that deal with shame variously in the form of, for instance, the communal *dignity* of the civil rights movement; the individuating *pride* of 'Black is Beautiful' and gay pride; various forms of nativist *ressentiment*; the menacingly exhibited *abjection* of the skinhead; the early feminist experiments with the naming and foregrounding of *anger* at being shamed; the incest survivors' movement's epistemological stress on *truth-telling* about shame; and, of course, many, many others.) The forms taken by shame are not distinct 'toxic' parts of an identity that can be excised; they are instead integral to and residual in the processes by which identity itself is formed. They are available for the work of metamorphosis, reframing, refiguration, *trans*figuration, affective and symbolic loading, and deformation; but are unavailable for effecting the work of purgation and de-ontological closure.

Eve Kosofsky Sedgwick, 'Queer Performativity: Warhol's Shyness/Warhol's Whiteness', *Pop Out, Queer Warhol*, ed. Jennifer Doyle, Jonathan Flatley, José Esteban Muñoz, Duke University Press, Durham, North Carolina, 1996

Notes

Thanks to Hall Sedgwick for the Odetta story. This essay is part of a larger project on shame, performance and performativity. Some of its language overlaps with another, related essay of mine that emerges from the same project, 'Queer Performativity: Henry James's *Art of the Novel*', GL9 1, no 1, Summer 1993 pp. 1–16. 1. Andy Warhol, *The Philosophy of Andy Warhol*, Harcourt Brace Jovanovich, New York, 1975, pp. 246–47. 2. Andy Warhol and Pat Hackett, *POPism: The Warhol Sixties*, Harcourt Brace Jovanovich, New York, 1980, pp. 199–200. 3. Warhol, op. cit., *Philosophy*, pp. 7–10. 6. On this, see, for example, James Ridgeway, *Blood in the Face*, Thunder's Mouth, New York, 1990, and Mary Ann O'Farrell's essay 'Dickens's Scar: Rosa Dante and *David Copperfield*', which she was kind enough to share with me in manuscript and which has considerably influenced my work here. 7. Warhol, op. cit., *Philosophy*, p. 18. 8. Michael Moon, 'Screen Memories, or, Pop Comes from the Outside', *Pop Out, Queer Warhol*, 1996.

césar aira is an Argentinian novelist, playwright, essayist and translator. His many novels include: *Moreira*, 1975, and *El bautismo* (*The baptism*), 1991. Aira's translations include the books of Raymond Chandler and Stephen King. **arjun appadurai** is Samuel N. Harper Professor of Anthropology at the University of Chicago and Associate Editor of *Public Culture*. He specializes in the historical anthropology of South Asia. He is the author of *Modernity at Large: Cultural Dimensions of Globalization*, 1996. **nicolas bourriaud** is a French art critic and curator. He is Editor of *Documents sur l'art* and contributes regularly to *Flash Art* and *art press*. His exhibitions include a section of Aperto, XLV Venice Biennale, 1993, and 'Traffic', CAPC Bordeaux, 1996. His book, *L'esthétique relationnelle* (Relational aesthetics), 1998, examines contemporary issues in art and aesthetics. **gilles deleuze** was a French philosopher and theorist. His book *Anti-Oedipus: Capitalism and Schizophrenia*, 1972, written with Félix Guattari, brought him international attention. Deleuze's work was grounded in creative opposition to conventional truths and analyzed particularly psychology, cinema, art and literature. **chris kraus** is an American novelist, filmmaker and teacher. Her films include *Gravity and Grace*, 1995, a feature-length comedy about flying saucers, art and the end of the world. Kraus' novel, *I Love Dick*, 1997, was published by Semiotext(e) Native Agents, a series she started and has edited since 1992. **julia kristeva** (with Philippe Sollers). Julia Kristeva is a psychoanalyst, writer and teacher at the University of Paris-VII. She is an editor of the structuralist journal *Tel Quel*. Publications span psychoanalysis and fiction, and include *Les nouvelles maladies de l'âme* (*The new maladies of the soul*), 1993, and *Les Samourais* (*The samurais*), 1990. Philippe Sollers is a French novelist, art critic and founder of *Tel Quel* (Paris, 1960). Published works include *L'écriture et l'expérience des limites* (*Writing and the experience of its limits*), 1971, and *Femmes* (*Women*), 1983. **toni morrison** is Robert F. Goheen Professor in the Council of the Humanities at Princeton University, New Jersey. In 1993 she was awarded the Nobel Prize for Literature; her novels include *Song of Solomon*, 1977, and *Jazz*, 1992. **david robbins** is a Chicago-based artist, writer and teacher at The Art Institute of Chicago. His published work includes *The Ice Cream Social*, 1988, and *The Dr. Frankenstein Opinion*, 1993. **edward saïd** is Professor of Comparative Literature at Columbia University, New York and Editor of the *Arab Studies Quarterly*. He rose to prominence with the publication of *Orientalism*, 1978, his analysis of Western perceptions of and cross-influences from the East. **eve kosofsky sedgwick** is Newman Ivey White Professor of English at Duke University, North Carolina. She writes poetry, articles and reviews covering aspects of gay studies and the history of the novel. Publications include *Between Men: English Literature and Male Homosocial Desire*, 1985, and a volume of poetry, *Fat Art, Thin Art*, 1994.

Ana Laura Aláez Tariq Alvi Francis Alÿs Janine Antoni Oladélé Ajiboyé Bamgboyé Matthew Barney Maurizio Cattelan Fandra Chang Chen Zhen Martin Creed Tacita Dean Jeremy Deller Philip-Lorca diCorcia Stan Douglas Olafur Eliasson Sharon Ellis Tony Feher Teresita Fernández Ceal Floyer Tom Friedman Giuseppe Gabellone Anna Gaskell Kendell Geers Liam Gillick Dominique Gonzalez-Foerster Douglas Gordon Rodney Graham Joseph Grigely Group AES Mark Handforth Kay Hassan Richard Hawkins José Antonio Hernàndez-Diez Thomas Hirschhorn Christine & Irene Hohenbüchler Carsten Höller & Rosemarie Trockel Huang Yong Ping Pierre Huyghe Fabrice Hybert Inventory JODI Simone Aaberg Kærn KCHO William Kentridge Ben Kinmont Suchan Kinoshita Koo Jeong-a Udomsak Krisanamis Elke Krystufek Matts Leiderstam Liew Kung Yu Lin Tianmiao Lin Yilin Greg Lynn Christina Mackie Fabián Marcaccio Steve McQueen Tracey Moffatt Mariko Mori N55 Nikos Navridis Shirin Neshat Ernesto Neto Rivane Neuenschwander Paul Noble Chris Ofili Olu Oguibe Gabriel Orozco Jorge Pardo Marta María Pérez Bravo Liza May Post Égle Rakauskaité Tobias Rehberger Rosângela Rennó Pipilotti Rist Matthew Ritchie Liisa Roberts Bülent Şangar Yinka Shonibare Pablo Siquier Andreas Slominski Peter Spaans Superflex Sarah Sze Fiona Tan Sam Taylor-Wood Pascale Marthine Tayou Diana Thater Rirkrit Tiravanija Sophie Tottie Piotr Uklanski Mika Vainio Eulàlia Valldosera Kara Walker Wang Du Gillian Wearing Elin Wikström Lisa Yuskavage Zhang Peili Zhou Tiehai

100 artists

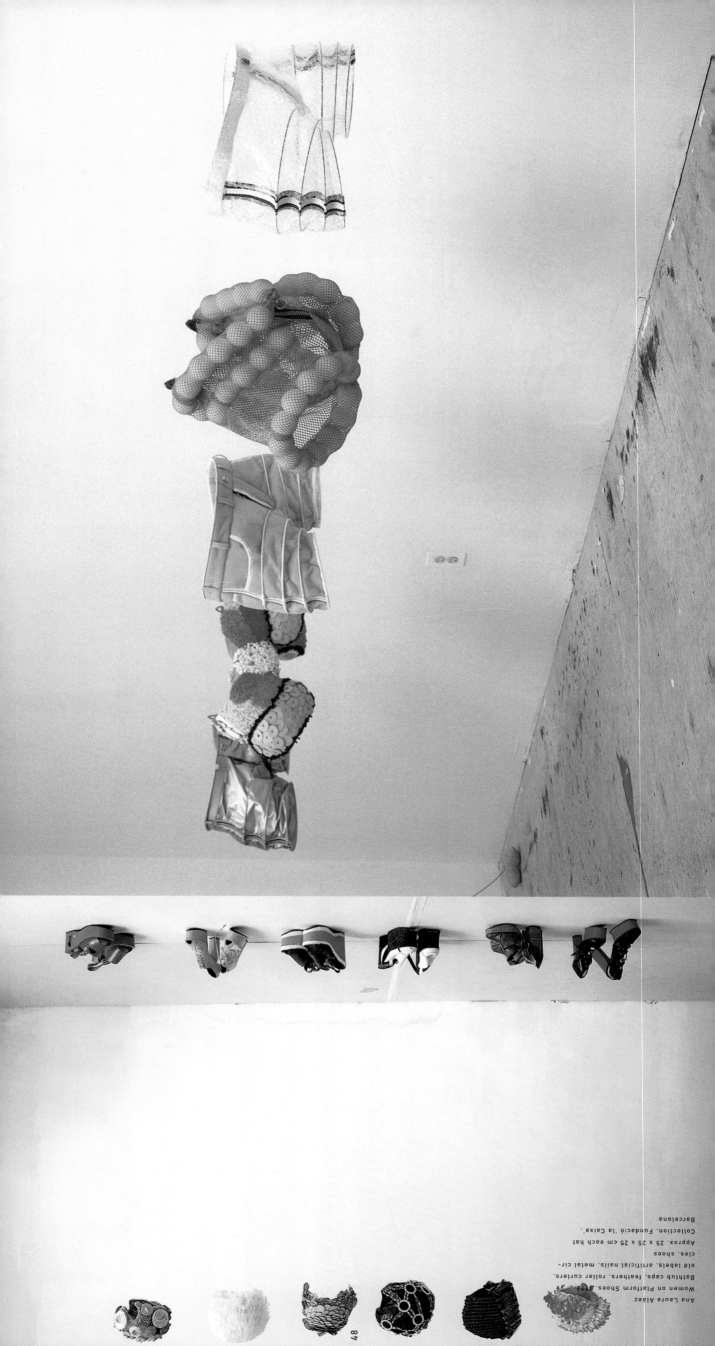

Ana Laura Aláez
Butterflies, 1994
Hot pants, plastic, latex, polyspan
6 parts, approx. 40 x 60 x 30 cm each

Ana Laura Aláez
Bubbles (detail), 1996
Cibachrome photograph
180 x 127 cm

ana laura aláez

There are different ways of experiencing seduction. We can see it as a sort of deceit, an artifice, a comedy of empty appearances, a wrapping that disguises and mystifies reality. In this sense, it can be perceived as a negative phenomenon that distances us from reality. However, if we take into account its strategic powers in the field of symbolic interchange, if we acknowledge its ability to manipulate signs, we might also come to appreciate the pleasure associated with the slippery, glossy surface of things. Ana Laura Aláez is fully aware of the range of density and lightness that seduction has at its disposal. When she works with icons from the worlds of cinema or comics, the colour of make-up and the other adornments that we use to decorate our bodies, she is presenting them as artificial devices for the creation of a second skin, as fantasies that allow us to re-invent ourselves. And in so doing, she is promoting the construction of new identities.

Her piece *Women on Platform Shoes*, 1992, becomes a paradigm of the body as a support for ornamentation and artifice. Six wigs hanging from the ceiling and six matching pairs of platform shoes below stand for the desire to enhance one's figure, and the power of adornment to fashion one's identity. These elliptical bodies emphasize the capacity of fiction to alter one's natural state and to transcend concrete physical facts, flying in the face of Napoleon's formulation, subsequently picked up on by Freud, that 'biology is destiny'. *Juanitas*, 1997, takes this urge for transformation and simulation to an extreme: Aláez appears in the guise of her gallerist, Juana de Aizpuru. By placing herself in the position both of object and subject, wearing a wig made of ham (*Pink Self-Portrait*, 1995), or appearing in a coquettish vest of hearts while blowing soap bubbles (*Bubbles*, 1996, a diptych in which Aláez pairs herself with the image of another woman dressed in the same costume). Aláez is presenting the body as something light and funny, far removed from the language of scatology and putrefaction commonplace in so much contemporary work. In the same spirit, *Butterflies*, 1994, operates as a metaphor for the possibility of flight via the fantasy of clothes.

In her more recent installations, such as the emblematic *She Astronauts*, 1997, Aláez is exploring the dizzying area between reality and the simulacrum in the sacred, white space of the gallery, transformed here into a limpid, galactic fashion boutique. Among the various garments on show, Aláez includes works by other artists of the same generation, stripping them of their fetishistic status as artworks and integrating them into a new semantic context (a designer dress shop). The figure of the astronaut symbolizes a desire to create new spaces, and in this case it is the music, imagination, camouflage and generosity implicit in club culture that is presented as a world that might generate new possibilities for art and life: a life filled with optimism, where 'new loving settings for communication' are waiting to be created.

Rosa Martínez

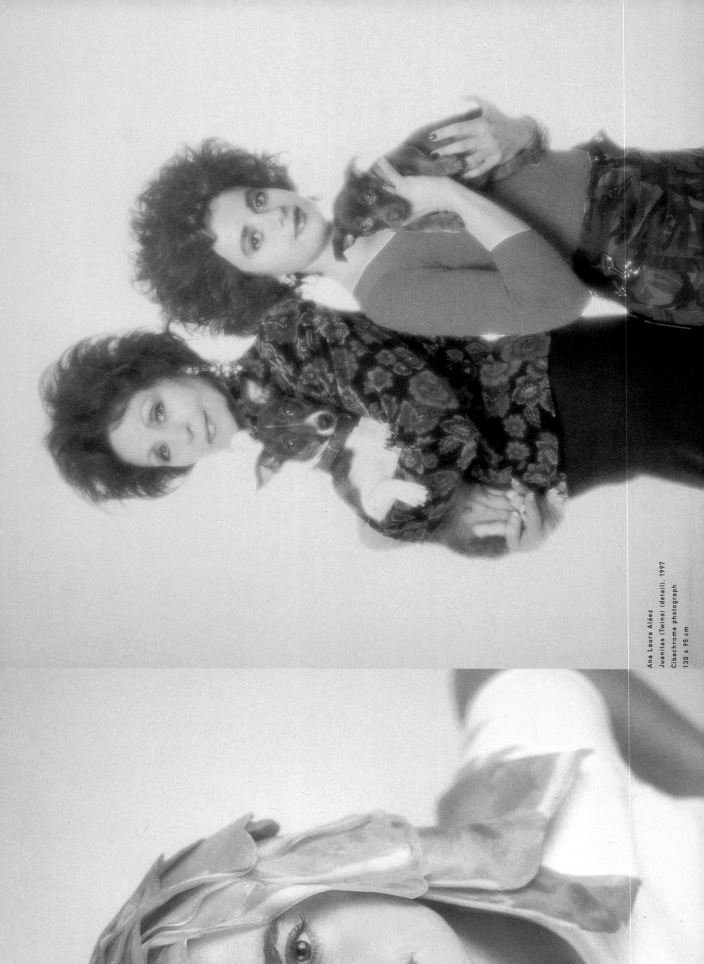

Ana Laura Aláez
Juanitas (Twins) (detail), 1997
Cibachrome photograph
130 x 95 cm

Ana Laura Aláez
Pink Self-Portrait, 1995
Cibachrome photograph
50 x 50 cm

50

ana laura aláez

Born Bilbao, 1964. Lives and works in Madrid and New York.

selected solo exhibitions: 1992 'Superficie', with Alberto Peral, Espacio 13, Fundació Joan Miró, Barcelona 1995 'Planets', Juana de Aizpuru Gallery, Madrid 1996 'Acid Spiral', Anders Tornberg Gallery, Lund, Sweden

selected group exhibitions: 1992 'Autobiography', Sala Amadís, Madrid 1994 'Arte y Mujer', Anthropological Museum, Madrid; 'Diez en tres', Centro Eusebio Sempere, Palacio Gravina, Alicante 1995 'North-Centre-South', Juana de Aizpuru Gallery, Madrid 1996 'Young Spanish Artists', Castello di Rivoli, Turin, Italy; 'Thinking of You', Konsthallen, Göteborg, Sweden 1997 'Sous le Manteau', Thaddaeus Ropac Gallery, Paris; 'Take off', Krinzinger Gallery, Vienna; 'On life, beauty, translations and other difficulties', 5th Istanbul Biennale **selected bibliography:** 1993 José Ramón Danvila, 'Aláez and Garcia, Visual Objectives', *El Punto de las Artes*, Madrid, 7 May; Pablo Jimenez, 'Two Visions of the Dimensional', *ABC de las Artes*, Madrid, 5 June 1994 José Ramón Danvila, 'Ana Laura Aláez', *El Guía*, Barcelona, December 1995 José Ramón Danvila, 'Ana Laura Aláez: Feminine Utopias', *El Punto de las Artes*, Madrid, 17 February; Pablo Jimenez, 'Ana Laura Aláez: Weapons of a Woman', *ABC de las Artes*, Madrid, 3 March; Rosa Martínez, 'Psycho-fantasy of Desire', *La Guía del Ocio*, Barcelona, December 1996 Fernando Huici, 'Ana Laura Aláez', *El Pais*, Madrid, 3 February; José Ramón Danvila, 'Three Positions, Three – About Artifice', *El Punto de las Artes*, Madrid, 19 July; José Ramón Danvila, 'Cheek, Freshness and Costume', *El Mundo*, Madrid, July 1997 Rosa Martínez, 'I'll be your mirage. You'll be my illusion', *She Astronauts*, Fundació 'la Caixa', Barcelona

Ana Laura Aláez
She Astronauts, 1997
Iron, silicon, plaster, zinc, crochet, glass, photographs, videotape, shirts, fashion clothes, belts, telephone, mirror, table, seat, show cases, clothes hangers, door
Approx. 400 x 1000 x 2800 cm
Installation, Fundació 'la Caixa', Barcelona

tariq alvi

'The premise behind this book I once read about the evolution of sex was that our greatest desire was to survive and to pass on our genetic material to the next generation. That's what we are programmed to do. All life, not just human life, is based on this. I was thinking about the actual desire behind making art, what is the essence of it when you take away the image ... I lined up the idea of sexuality without desire to make or do – regardless of what that making or doing resulted in. It doesn't really matter what you do, in a way; it's only a desire to survive. Art is made out of a desire to pass on and a need to survive, to pass on some part of yourself into the next generation, a passing on of ideas rather than chil-dren.'[1] In this statement, Tariq Alvi demonstrates a disarmingly simple logic, yet one that is oddly compelling. It is almost as if no one has thought these thoughts before. Perhaps Alvi is right – at the end of the day all we really want is to be remembered.

For the last five years Alvi, born in Newcastle, Great Britain, has chosen to live and work in The Netherlands. To acknowledge the consequences of this self-imposed 'exile' – his determinedly singular diaspora – is key to our subsequent engagement with Alvi's work. The heightened sensations of physical, emotional and psychological displacement that have resulted from this shift contin-ue to underscore the de-centred, discordant pitch of his work. Yet despite this, Alvi archly exploits his 'alien' status – acting out the sardonic role of the 'outsider'. In doing so he gains a modicum of freedom – or licence – that in turn allows him to take liber-ties – not only with his own persona as an artist, but with the often explicit and charged material (both sexual and otherwise) that he employs in his complex, open-ended installations.

Alvi's installations accept that things are complicated. Riddled with desirous grey areas, the installations refute formal ideologies. Instead they celebrate fantasy and chaos. They are 'works-in-progress' in which Alvi free-associates visually. In works such as his *Dogboard* series, 1995, or *Somewhere Between*, 1997, the acute juxtapositions of boxy dogs, teenage hustlers, gaudy jewellery, infanticidal parents, printed ephemera, cheap watches, amateur pornography, rainbow-coloured maps and club flyers oscillate wildly between the sacred and profane – corrupting any semblance of political correctness along the way. Focus, such as it is, is diffused.

Provocative in the true sense of the word, Alvi incites the confusion that is the everyday.

Matthew Higgs

1 Two slightly different versions of this statement by Alvi exist. In 'Artist Abducted by Aliens – Interview with Tariq Alvi'. *Casco Issues 2*, Utrecht, The Netherlands, 1997, and

Dislocations, Rovaniemi Art Museum, Finland, 1997.

Tariq Alvi
Untitled, 1997
Ink on map
35.5 x 45.5 cm

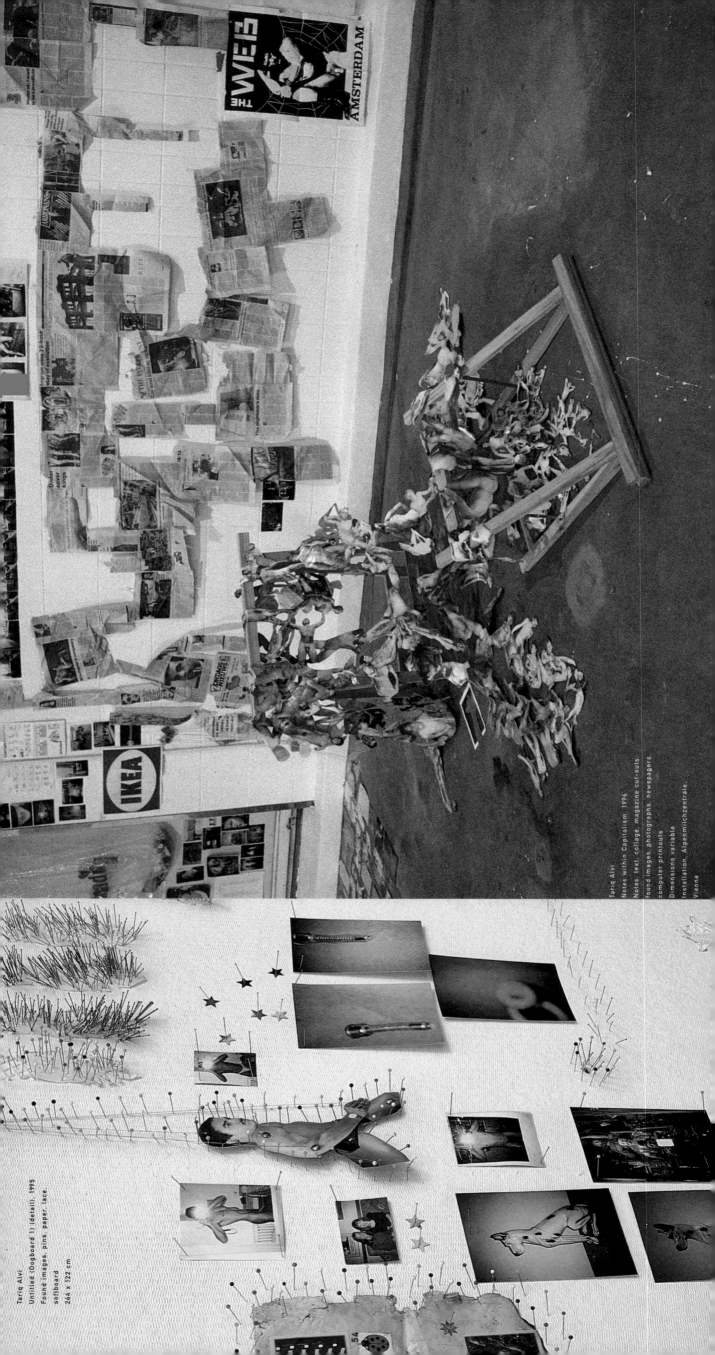

Tariq Alvi
Notes within Capitalism, 1996.
Notes, text, collage, magazine cut-outs,
found images, photographs, newspapers,
computer printouts
Dimensions variable
Installation, Alpenmilchzentrale,
Vienna

Tariq Alvi
Untitled (Dogboard 1) (detail), 1995
Found images, pins, paper, lace
softboard
244 x 122 cm

54

tariq alvi Born Newcastle-upon-Tyne, England, 1965. Lives and works in Rotterdam.

group exhibitions: 1993 'Travel Albums', Towner Art Gallery and Local Museum, Eastbourne, England 1995 'Quarters', Old Bonnefanten Museum, Maastricht; 'Wrong Sun', W139, Amsterdam 1996 'Peiling 5', Stedelijk Museum, Amsterdam; 'Make Me Clean Again', Alpenmilchzentral, Vienna; 'Draw', The Agency, London; 'Mothership Connection', Stedelijk Bureau, Amsterdam 1997 'Dislocations', Northern Photographic Triennial, Rovaniemi Art Museum, Finland; 'Booster Up Dutch Courage', Los Angeles International 1998 'Same Player Shoots Again', Artis, Den Bosch, The Netherlands **selected bibliography:** 1995 Tariq Alvi, Femke Snelting, 'Dubbing Nation', *Wonderstories*, No 1, Maastricht 1996 Tariq Alvi, 'Mothership Connection', *Stedelijk Bureau Bulletin*, Amsterdam 1997 Lisette Smits, Mariette Dölle, 'Artist Abducted by Alien', *Casco Issues*, No 2, Casco Gallery, Utrecht, The Netherlands

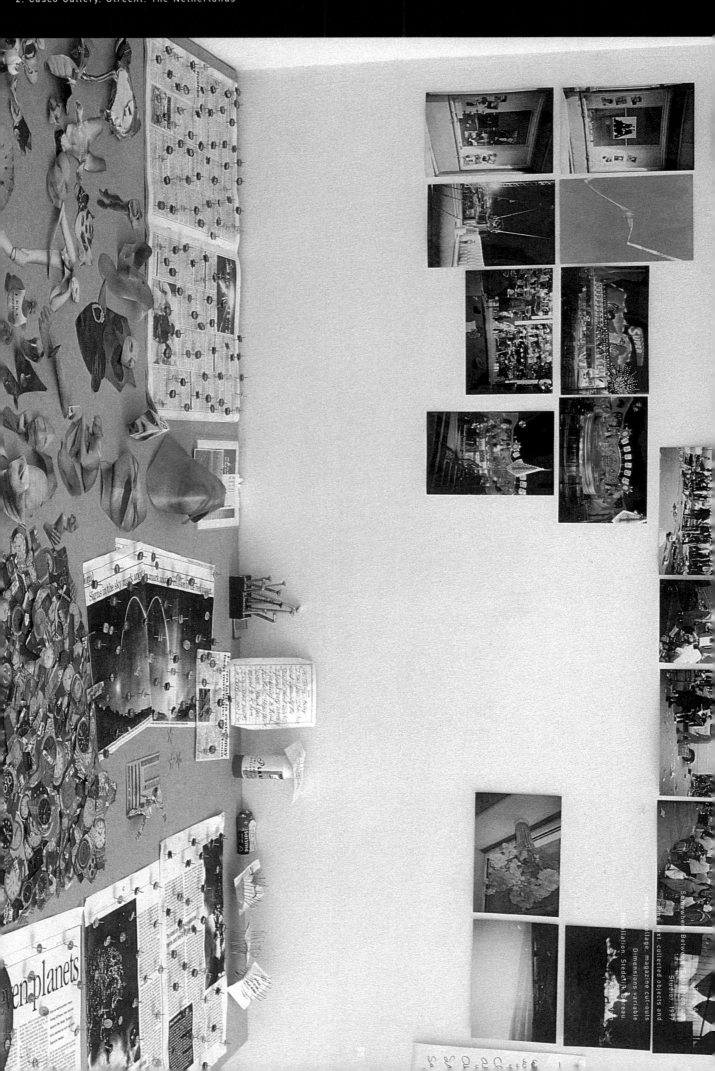

Redesigned at the beginning of the so-called "revolutionary era" as a setting for huge propagandistic spectacles, the Zocalo (main plaza) of Mexico City became with time the ideal space to express public discontent. In the midst of the social upheaval of 1968, thousands of bureaucrats were herded into the Zocalo to demonstrate in favor of the government. Showing their frustration in an act which was both rebellious and ridicolous, they turned their backs on the official tribune and began to bleat like a vast flock of sheep.
Pablo Vargas Lugo

francis alÿs

The Loop, 1997. Made for the exhibition 'InSITE', 1997 held in the outlying towns around Tijuana, Mexico, and neighbouring San Diego, USA, *The Loop* is the fruit of an institutional commission. The issue of the border and the historically complicated relations between Mexico and the US inevitably served as a general framework for this exhibition. Alÿs' contribution was a journey that started in Tijuana and ended in San Diego – eschewing the Mexico-US border, however, Alÿs went 'the long way', which took one month and five days rather than the few hours it would have taken had he chosen a direct route. The trek included stops in Mexico, Panama, Santiago, Auckland, Sydney, Singapore, Bangkok, Rangoon, Hong Kong, Shanghai, Seoul, Anchorage, Vancouver and Los Angeles. The artist never stayed in any city along the way for more than five days, with the exception of his first stop in Mexico. For thirty-five days (the entire duration of the hectic, alienated haul) Alÿs maintained assiduous e-mail contact with one of the exhibition's curators. The resulting correspondence – a sort of fast-paced, poetic mini-diary – along with all the documentation relevant to the trip was exhibited as an archive, open to the public, on the occasion of the exhibition in Tijuana.

Alÿs' work poses a broad sweep of questions. (The possible relation between the artist's journey and what might be interpreted as a nod to the legacy of the Situationist's *dérives* will have to wait for discussion elsewhere.) Alÿs' journey clearly mirrors the tragic absurdity of the Mexico-US border, one of the longest in the world, which divides two countries committed to multiple agreements of mutual co-operation but which is resolutely opposed to anything but the most controlled exchange of citizens. While we read on the invitation card that the project would 'remain free from all critical content, save for the actual physical movement of the artist', the statement, paradoxically, only serves to heighten any suspicions we may have regarding the work's political agenda. When analyzed from a different perspective, *The Loop* appears to be caught in an extremely caustic relation with the institution that originally commissioned it because the artist was engaged by the institution as a 'professional' tourist. In a way, Alÿs was paid to transform the budget of the show in a painful exercise of leisure. The contractual nature of the work is foregrounded by its parody of the relation between artist and institution – the fact that the institution signed a contract with the artist as if he were a service provider, to which he responded by transforming his work into a non-recuperable activity. The only product presented by the artist in the exhibition was literally a by-product: the archive of the electronic correspondence that he kept with the organizers.

To conclude this necessarily hasty run through the potential consequences of this project, we might return briefly to the archive and its relation both to issues of memory and the experience and the notion of the artwork *per se*, observing that the archive clearly transforms the aesthetic experience into a process of investigation: replacing in the audience an attitude of contemplation with a systematic scepticism.

Carlos Basualdo

Francis Alÿs, with Felipe Sanabria
El Colector (*Live* collection), 1991–92
Magnets, metal
27 × 18 × 28 cm

57

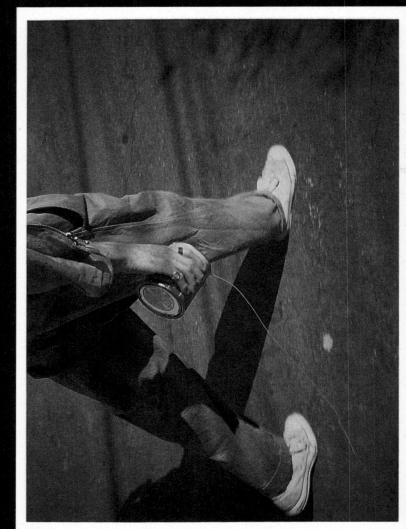

Jeg vil gå rundt i byen i syv dage under påvirkning af et nyt narkotisk stof hver dag. Min tur vil blive dokumenteret i form af bl.a. fotografier, notater og andre medier, som synes relevante.

I will walk in the city over the course of seven days, under the influence of a different drug each day. My trip will be recorded through photographs, notes, or any other media that become relevant.

Francis Alÿs

Narkoturisme/København. 6-12 maj

1996 (Narcotourism/Copenhagen. 6-12

May 1996)

1996

Performance

Copenhagen, Denmark

Francis Alÿs

La Gotera (The leak). 1995

Performance

Tin of paint

São Paulo, Brazil

LA GOTERA. Salgo de la galería y deambulo por los barrios de la ciudad con una lata de pintura perforada. Regreso a la galería, orientado por los trazos dejados por las gotas de pintura en el piso. Mi acción termina cuando cuelgo la lata de pintura vacía en el espacio de exhibición. Esta historia es un intento por ilustrar las contradicciones de mi práctica.

THE LEAK. Having left the gallery, I wander through the neighborhoods carrying a leaking can of paint. My dripping action ends when, having found my way back to the gallery thanks to my previous paint marks, I hang the empty can on the wall of the exhibition space. This story is an attempt to illustrate the contradictions of my practice.

Photo: Kurt Hollander

Durante la V Bienal de la Habana, Francis Alÿs calza sus zapatos magnéticos y a través de sus paseos por las calles, recoge cualquier residuo metálico encontrado sobre su camino. Por esta recolección diaria va ampliándose su nuevo territorio, y asimila los barrios que va descubriendo.

During the Fifth Havana Biennal, Francis Alÿs puts on his magnetic shoes & takes daily walks through the streets, collecting scraps of metal lying in his path. With each trip he incorporates the newly-discovered neighbourhood.

Francis Alÿs

Zapatos Magnéticos (Magnetic shoes)

1994

Performance

Magnet, rubber, size 11 shoes

5th Havana Biennale

francis alÿs

Born Antwerp, Belgium, 1959. Lives and works in Mexico City. **selected solo exhibitions:** 1986 Cristallen Bol, Brussels 1991 Salón des Aztecas, Mexico City 1992 Espace L'Escaut, Brussels 1994 'Francis Alÿs – Raymond Pettibon', Expo-Arte, Guadalajara, Mexico 1995 Jack Tilton Gallery, New York 1996 Museo de Arte Contemporáneo de Oaxaca, Mexico 1997 Museo de Arte Moderno, Mexico **selected group exhibitions:** 1989 Casa de la Cultura Santo Domingo, Mexico City 1991 Blue Star Art Space, San Antonio, Texas 1992 'México hoy', Casa de las Américas, Madrid 1994 5th Havana Biennial 1995 'Longing and Belonging: From the Faraway Nearby', Site Santa Fe, New Mexico 1996 'NowHere', Louisiana Museum, Humlebæk, Denmark 1997 'InSITE', Tijuana, Mexico and San Diego; 'Antechamber', Whitechapel Art Gallery, London **selected bibliography:** 1994 Thomas McEvilley, 'Francis Alÿs: Calling the Unaccountable to Account', *Francis Alÿs: The Liar, The Copy of the Liar*, Galeria Ramis Barquet, Mexico 1995 Yishai Jusidman, 'Francis Alÿs', *Artforum*, New York, January; Raphael Rubinstein, 'Francis Alÿs', *Art in America*, New York, November 1996 Bruce Ferguson, 'Francis Alÿs', *Flash Art*, Milan, May/June 1997 Medina Cuauhtemoc, 'Francis Alÿs: Tu Subrealismo', *Third Text*, London, Summer; Michael Darling, 'Francis Alÿs and the Return to Normality', *frieze*, London, March/April; Joëlle Rondi, 'Various places', *art press*, Paris, June; Kim Levin, 'Voice Choices', *The Village Voice*, New York, 22 October 1998 Rubén Gallo, 'Francis Alÿs at Jack Tilton', *Flash Art*, Milan, January/February; Serge Guilbaut, 'Rodney Graham and Francis Alÿs', *Parachute*, No 87, Montreal

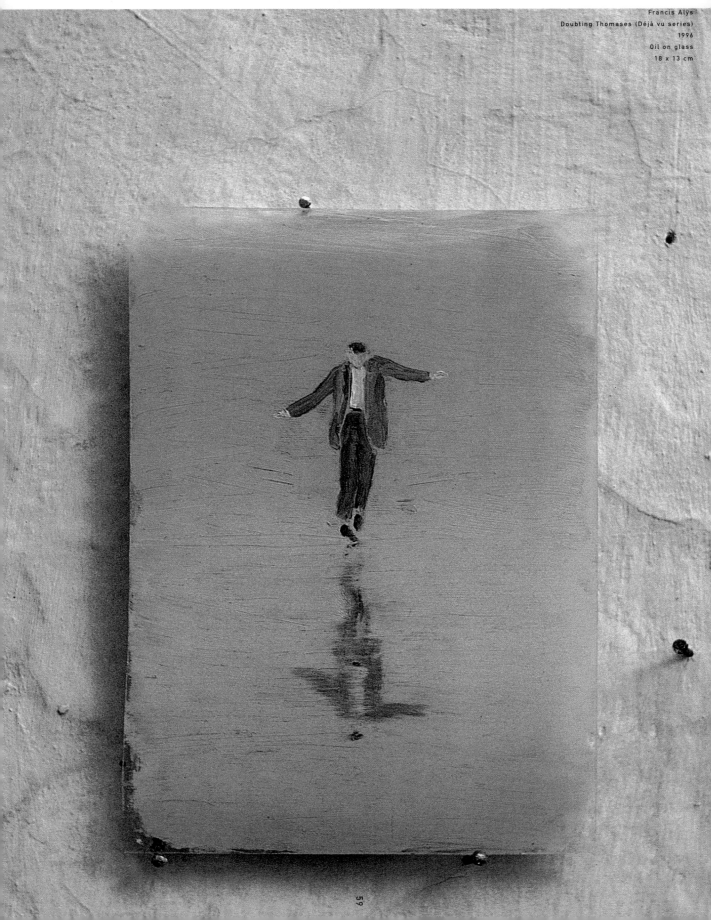

Francis Alÿs
Doubting Thomases (Déjà vu series)
1996
Oil on glass
18 x 13 cm

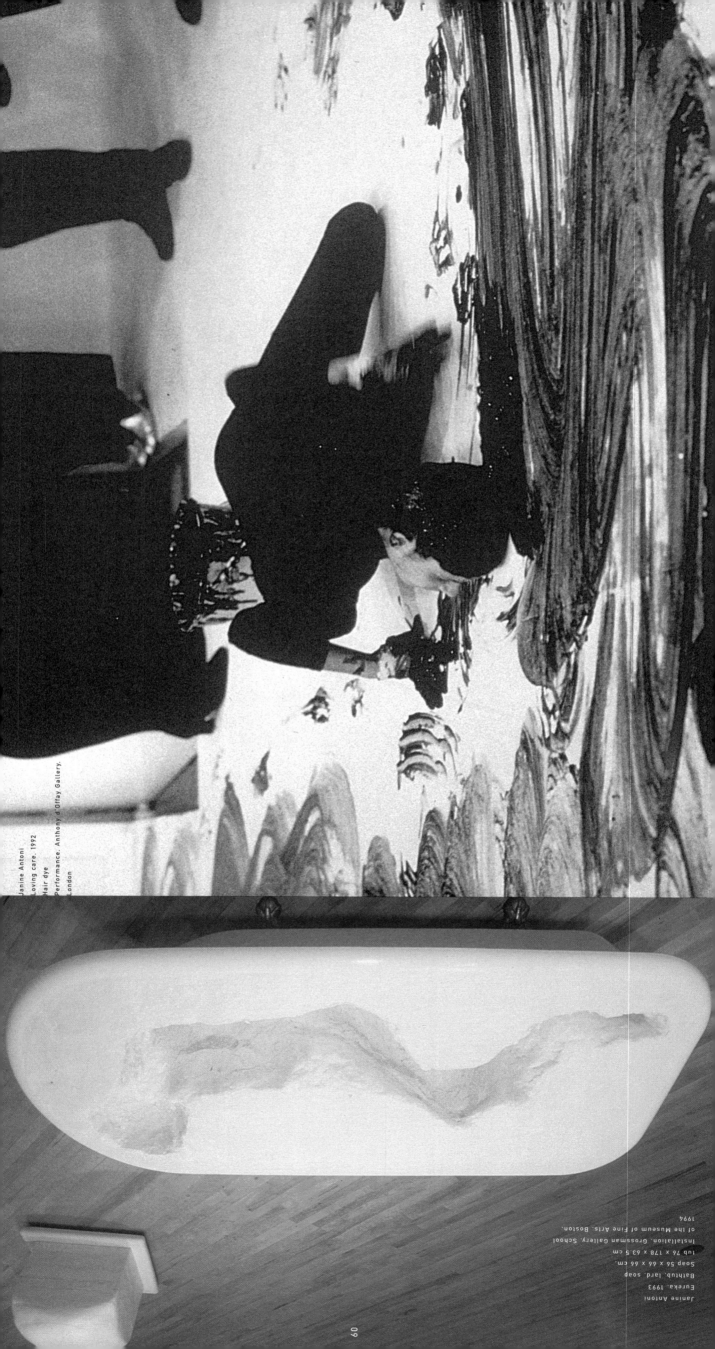

Janine Antoni
Loving care. 1992
Hair dye
Performance. Anthony d'Offay Gallery,
London

Janine Antoni
Eureka. 1993
Bathtub, lard, soap
Soap 56 x 66 x 66 cm,
tub 76 x 178 x 63.5 cm
Installation. Grossman Gallery, School
of the Museum of Fine Arts, Boston,
1994.

janine antoni

Since 1992, when she re-sculpted two minimalist cubes of lard and chocolate by chewing them, Janine Antoni's work displays a liberating reinterpretation of male art, as well as an affinity for and broad knowledge of feminist art. These factors, along with Antoni's existential approach, have earned her recognition as one of the most significant artists of the 1990s. Describing the sculptural process she applied in *Gnaw*, 1992, Antoni states that the bite is 'both intimate and destructive', which sums up her relationship with Minimalism itself: a legacy that defines her as an artist but excludes her as a woman. In her performance *Loving Care*, 1992, her long hair was used as a paintbrush to paint the floor of the gallery. As well as condemning the way woman is used as an instrument in the work of Yves Klein and in the phallic power of Abstract Expressionism, *Loving Care* alludes to feminine self-abnegation, whether in the home, in art or in the name of beauty. In *Eureka*, 1993, she filled a bath with lard and displaced an equivalent amount of lard to her body mass, turning it into a block of soap. Here we find the hallmarks of her work: the use of her own body as a material, the use of everyday actions as sculptural processes, and physical substantiation of the relationship between presence and absence as the essential, fleeting metaphor of our existence.

Janine Antoni's most elaborate, most poetically and conceptually dense work to date is undoubtedly *Slumber*, 1994: at night, the artist sleeps in the gallery in which there is a bed, a loom and an encephalogram which records her eye movements as she sleeps. The following day, she weaves part of the pattern from the encephalogram into her blanket using shreds from her nightgown which she always buys in the city in which the work is exhibited. The power of dreams to weave the reality that envelops us, and the interconnection between unconscious, tradition and technology which, in the words of the artist, 'creates machines for one's body to make drawings', are some of the multiple meanings of this work.

In *Mom and Dad*, 1994 and *Mom*, 1995, Janine Antoni uses photography as her medium, and her parents as the subjects. *Mom and Dad* is made up of three images in which she questions the 'identity shifts' between the father and mother figures, and the roles of authority assigned to each sex. *Mom*, which depicts the artist's mother dressed in white gazing at the light in a window, is strongly reminiscent of Annunciation paintings. But peeping out from beneath her white dress are three feet: this third, adult foot, announces the presence of the artist herself hiding beneath her mother's dress. Antoni explores her unconscious fantasies, and also evokes childhood memories. In more recent works: in *Swoon*, 1997, she uses video and a stage setting to further explore sexual codes, here applied to male and female roles in classical ballet.

Rosa Martínez

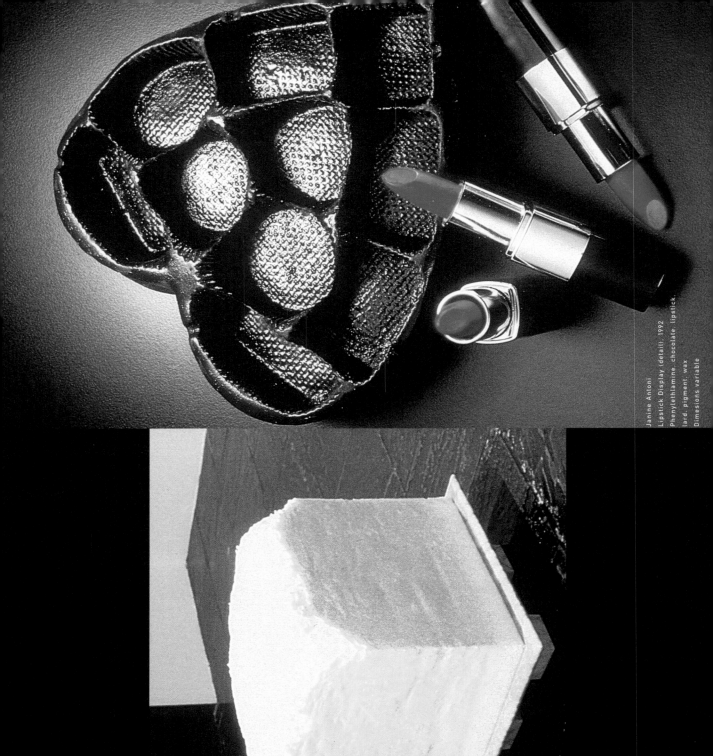

Janine Antoni
Lipstick Display (detail). 1992
Phenylethlamine. chocolate. lipstick.
lard. pigment. wax
Dimesions variable

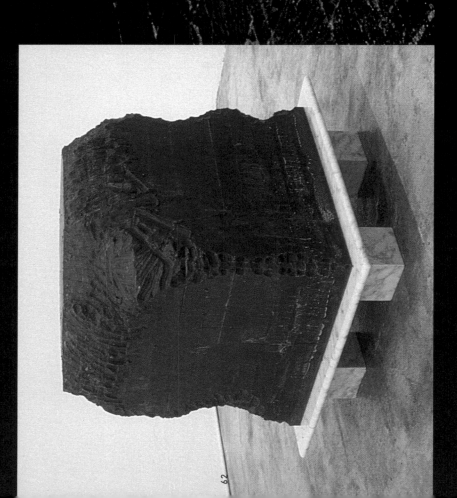

Janine Antoni
Lard Gnaw. 1992
Lard
600 lb (before biting)

Janine Antoni
Chocolate Gnaw. 1992
Chocolate
600 lb (before biting)

janine antoni

Born Freeport, Bahamas, 1964. Lives and works in New York. **select-ed solo exhibitions:** 1992 'Gnaw', Sandra Gering Gallery, New York 1994 'Hide and Seek', Anders Tornberg Gallery, Lund, Sweden; 'Slumber', Anthony d'Offay Gallery, London 1996 'Activitats Esculturals', Sala Montcada, Fundació 'la Caixa', Barcelona 1997 'Swoon', Capp Street Projects, San Francisco **selected group exhibitions:** 1991 'Burning in Hell', Franklin Furnace, New York 1992 'Post Human', FAE Musée d'Art Contemporain, Lausanne, Switzerland and tour 1993 Aperto, XLV Venice Biennale; Biennial, Whitney Museum of American Art, New York; Museum of Contemporary Art, Seoul, South Korea 1994 'Bad Girls', New Museum of Contemporary Art, New York 1995 'Cocido y Crudo', Museo Nacional Centro de Arte Reina Sofía, Madrid; 'Volatile Colonies', 1st Johannesburg Biennale; 'It's How You Play the Game', Exit Art/The First World, New York 1996 'Young Americans I', Saatchi Gallery, London; Hugo Boss Prize, Guggenheim Museum SoHo, New York 1997 'On life, beauty, translations and other difficulties', 5th Istanbul Biennale **selected bibliography:** 1992 Lois E. Nesbit, 'Janine Antoni at Sandra Gering', *Artforum*, New York, Summer; Roberta Smith, 'Women Artists Engage the "Enemy"', *The New York Times*, 16 August; Simon Taylor, 'Janine Antoni at Sandra Gering', *Art in America*, New York, October 1993 Laura Cottingham, 'Janine Antoni', *Flash Art*, Milan, Summer 1994 Roberta Smith, 'Janine Antoni', *The New York Times*, 11 March; Simon Taylor, 'Antoni's Principle', *World Art*, New York, June; Roberta Smith, 'Body of Evidence', *Vogue*, New York, August 1996 Kay Larson, 'Women's Work (or is it Art?) is Never Done', *The New York Times*, 7 January; Peter Schjeldahl, 'Who's the Boss?', *The Village Voice*, New York, 24 December 1997 Kay Larson, 'A Month in Shaker Country', *The New York Times*, 10 August

Janine Antoni
Swoon (detail), 1997
9 min video installation, loop
colour, sound
Dimensions variable

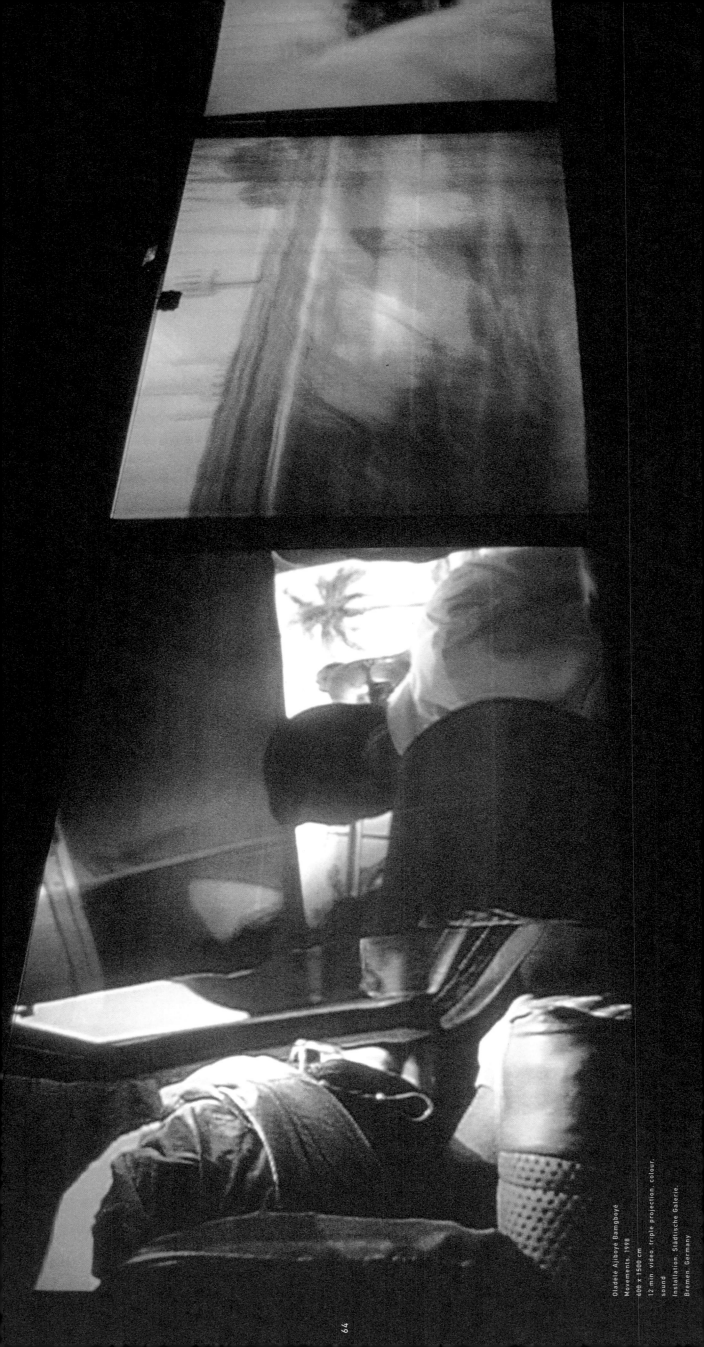

Oladélé Ajiboyé Bamgboyé
Movements, 1998
400 x 1500 cm
12 min video, (triple projection, colour, sound
Installation, Städtische Galerie,
Bremen, Germany

oladélé ajiboyé bamgboyé

Photography has often presented itself as a method of stripping bare and revealing the world as image, in its naked efflorescence and substantiality, while assiduously working to manifest and monumentalize it as the real. If these contradictory motives of representation have been grist to the mill of image-making, in turn providing different keys to perception in the high, hot register of voyeurism, consumerism, glamour, taste – or in the more mundane sphere of documentary record – contemporary artists have stepped in with a vengeance to exploit its rich possibilities. Oladélé Ajiboyé Bamgboyé explores the fertile but fraught terrain of black masculinity: its relationship to popular culture, its mythologization and objectification within the popular imagination. He deploys photography as an analytical instrument, enmeshing us in the performative rituals in which the black male body appears as an object of intense fetishistic desire, a package of commodified pleasure yet a repulsive sign of sexual degeneracy.

Playing hide-and-seek with queer and straight sexuality, his art assumes positions of critical ambivalence, eluding the centrality of gender as a reproductive construct. His works are highly critical of the recent spate of deadpan, documentary-style photographs adopted by many artists. Employing both colour and black-and-white photography and different printing techniques, they are not merely descriptive, but rife with associative meaning. Part of his critical address is to use his own naked body as a theatre for his investigative performances by layering, eliding and deconstructing various fragments and exposures to create lush, sculpted palimpsests and dense environments of tangled and disappearing parts. The relationships between gaze, photographic apparatus and the object are thus rendered contingent and contested.

Although these staged performances produce highly erotic images that are as beautiful as they are theatrical, they ironically refuse to iconize the real, choosing instead to highlight its deficiency. Bamgboyé's work is not limited to exploiting the particularities of the black male body as an ideal. He uses its interaction with a complex set of codes as a way to invent, contextualize, define and remake its identity while retaining its individuality, avoiding the trap of essentialism. In this way one could say that his work is perhaps more about subjectivity than it is about identity.

In other works, especially in his videos and short films, Bamgboyé explores, through the motif of return, the variety of ways in which immigrants seek to retrieve a sense of place and self through the time-lag of memory. His films, such as *Homeward: Bound*, 1995, often juxtapose as diptych-projections the landscape of his native Nigeria and that of Scotland where he was raised, to deal with what W. E. B. DuBois has called a 'double consciousness'. Here, territories merge, time expands, memory becomes complicated in a flood of signs – alien/native, self/other, immigrant/non-immigrant – all of which present identity as a constantly mutating presence, as a question that we seek ways to answer and even sometimes to perform.

Okwui Enwezor

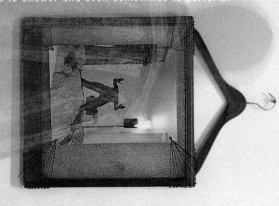

Oladélé Ajiboyé Bamgboyé
Lighthouse – Revisited, 1996
Archival silver gelatin prints, found
frames, string, coat hangers
6 parts, 7 x 58 x 72 cm each
Installation, Haus der Kulturen
Berlin, 1997

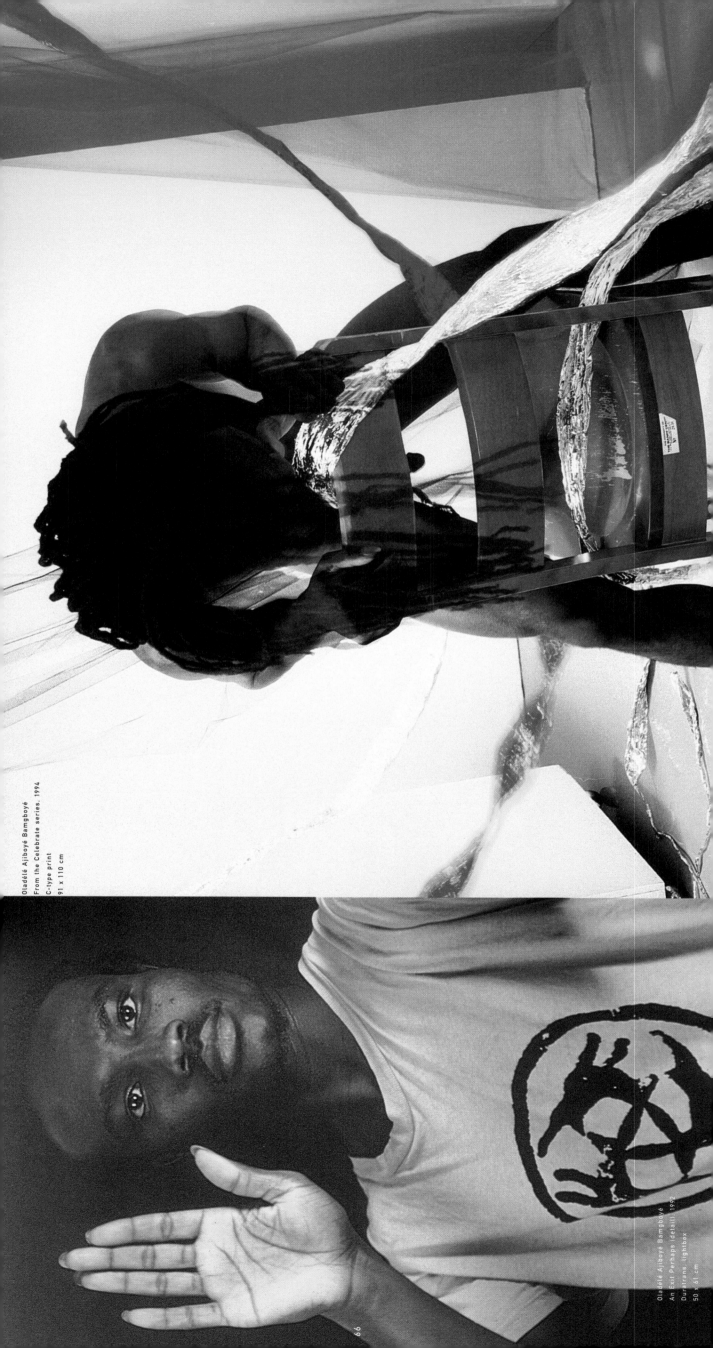

Oladélé Ajiboyé Bamgboyé
From the Celebrate series, 1994
C-type print
91 x 110 cm

Oladélé Ajiboyé Bamgboyé
An Exit Perhaps (detail) 1992
Duratrans lightbox
50 x 41 cm

oladélé ajiboyé bamgboyé

Born Nigeria, 1963. Lives and works in London. **website:** http://www.kulturbox.de/univers/doc/bamgbo/e_bamgbo.htm **selected solo exhibitions:** 1998 'Well Without End', Künstlerhaus Bethanien, Berlin; 'Recent video and photoworks', Gallery 1, Culturgest, Lisbon **selected group exhibitions:** 1996 'Prospect 96', Schirn Kunsthalle, Frankfurt; 'In/Sight – African Photographers 1940 – Present', Solomon R Guggenheim Museum, New York 1997 Documenta X, Kassel, Germany; 'Trade Routes: History and Geography', 2nd Johannesburg Biennale 1998 'Transatlantico', Centro Atlantico de Arte Moderno, Grand Canaries, Spain **selected bibliography:** 1991 Andrea Fatona, 'Black Male Sexuality', *Video Out*, Vancouver, Autumn 1995 Martine Attille, 'Scared of You', *Women's Art Magazine*, London; Octavio Zaya, 'Odalélé Bamgboyé', *Flash Art*, Milan, Winter 1996 Peter Weiermair, 'Oladélé Ajiboyé Bamgboyé', *Be-Magazine*, No 1, Berlin; Okwui Enwezor, Octavio Zaya, 'Contemporary African Art', *Flash Art*, Milan, January; Okwui Enwezor, 'Occupied Territories: Power, Access and African Art', *frieze*, London, February 1998 Franklin Sirmans, 'Johannesburg Biennale', *Flash Art*, Milan, January/February; O. Donald Odita, 'Movement and Real Time in the Work of Oladélé Ajiboyé Bamgboyé', *Jornal de Exposição*, No 32, Lisbon, January/March; Oladélé Bamgboyé, 'The Aesthetics of the Mistaken Identity', *Jornal de Exposição*, No 32, Lisbon, January/March

Oladélé Ajiboyé Bamgboyé
Homeward Bound, 1995
11 min video projection, colour/sound
2 projections, 350 x 250 cm each
Installation, Ikon Gallery, Birmingham

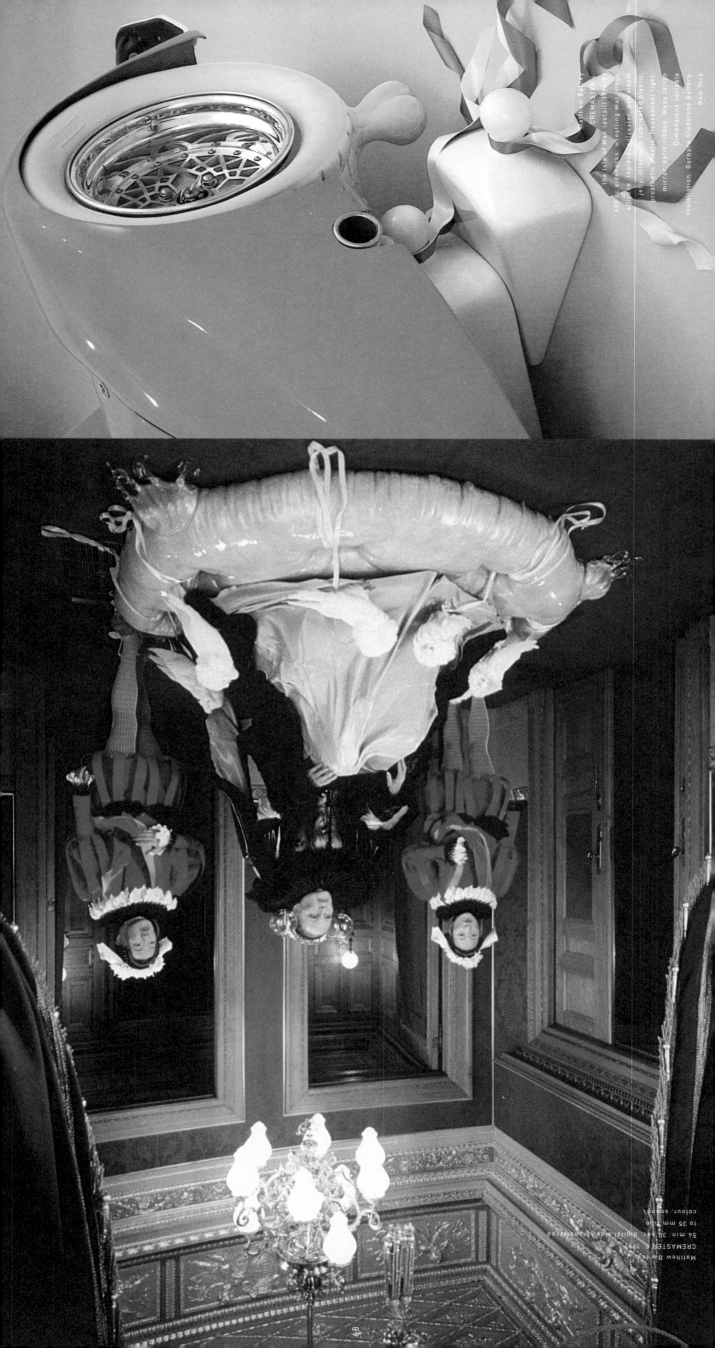

Matthew Barney
CREMASTER 4 (detail) 1994-95
the Isle of Man
600 cc sidecar, wrestling mat, vinyl,
prosthetic plastic, fluorescent light,
silicone, laplac, polyester, petroleum
jelly, internally lubricated plastic,
mirror, satin ribbon, Manx tartan
Dimensions variable
Installation, Barbara Gladstone Gallery,
New York

Matthew Barney
CREMASTER 5, 1997
54 min. 30 sec. digital video transferred
to 35 mm film
colour, sound

matthew barney

CREMASTER Series. The boundaries of disciplines, until recently separate fields, are collapsing. Matthew Barney's CREMASTER straddles sculpture, painting, opera, dance, film … His work also oscillates between object and process, geometric and organic issues, abstraction and figuration, body and prosthesis virtualization and actualization, inside and outside of the self and the world. To quote at length Nancy Spector, curator of the complete CREMASTER series, a forthcoming exhibition at the Guggenheim Museum in New York:

'Envision a biological, metabolic and emphatically corporeal force converting into tangible form. Matthew Barney's CREMASTER series (is) an epic five-part film cycle accompanied by related sculptures, photographs and drawings. The series describes the evolution of form through elaborate biochemical and psychosexual metaphors. Taking the male cremaster muscle (which controls testicular contractions in response to external stimuli) as its conceptual departure point, the films circulate around anatomical conditions of "ascension" and "descension" to describe mythological organisms suspended in states of latency. In Barney's eccentrically erotic universe, nothing is construed as simply one thing or the other. Rigid dualistic categories — male/female entropy/order, motion/inertia — give way to self-enclosed systems capable of yet unimagined states of potentiality.

'Eschewing chronological order, Barney has completed numbers 4, 1 and 5 of the CREMASTER films thus far, each of which narrate fantastical allegories of growth, transformation and physical transcendence through a variety of skewed cinematic and theatrical conventions. In CREMASTER 1 — a chilling fusion of Busby Berkeley's spectacular, kaleidoscopic dance routines and Leni Riefenstahl's choreographic vision of Third Reich athletics — smiling chorus girls congregate to form shifting outlines of human reproductive organs on the blue astroturf of a Boise, Idaho, football stadium. Their gliding movements are determined from above by a blonde starlet, a fully "ascended" creature, who miraculously inhabits two Goodyear blimps simultaneously and creates anatomical diagrams by lining up rows of grapes […] CREMASTER 4 unfolds on the Isle of Man — a topographical body punctured by orifices and passageways — where a feverish motorbike race traverses the landscape, a dandified, tap-dancing satyr writhes his way through a treacherous underwater canal and three burly, seemingly ambigendered fairies picnic on a grassy knoll. Part vaudeville, part Victorian comedy of manners and part road-movie, this film portrays sheer drive in its eternal struggle to surpass itself. The final installment of the filmic chain, CREMASTER 5 is set against the Baroque backdrop of an eighteenth-century opera house. Performed as a lyric opera complete with ribboned Jacobin pigeons, a love-lorn queen (played by Ursula Andress) and her tragic hero, this narrative of "descension" flows from the gilded proscenium arch of the theatre, to the aqueous underworld of Budapest's Lanchid River, to humid thermal baths inhabited by vaguely hermaphroditic water-sprites. Here, the hero's resistance to self-division reaches its final conclusion in death and apotheosis, only to circle back upon itself in this ever-ongoing, inevitably frustrated search for formal equilibrium.' (Nancy Spector)

Hans Ulrich Obrist

Matthew Barney
BLIND PERINEUM, 199
87 min. 5 sec. video, colour, soun

Matthew Barney
DRAWING RESTRAINT 7, 1993
Draw Track, 1993
18 min. 51 sec. video, colour, sound

matthew barney
Born San Francisco, 1967. Lives and works in New York.

selected solo exhibitions: 1988 'Scab Action', Open Center, New York 1991 'Matthew Barney: New Work', Museum of Modern Art, San Francisco; Barbara Gladstone, New York 1995 'Pace Car for the Hubris Pill', Museum Boymans-Van Beuningen, Rotterdam and tour 1996 'Transexualis and Repressia', Museum of Modern Art, San Francisco 1997 Barbara Gladstone Gallery, New York 1998 'Matthew Barney', Regen Projects, Los Angeles **selected group exhibitions:** 1990 'Viral Infection: The Body and its Discontents', Hallwalls Contemporary Arts Center, Buffalo, New York 1991 Barbara Gladstone Gallery, New York 1992 Documenta IX, Kassel, Germany 1993 Aperto, XLV Venice Biennale; Biennial, Whitney Museum of American Art, New York 1994 'Hors Limites', Centre Georges Pompidou, Paris 1995 Biennial, Whitney Museum of American Art, New York 1996 Hugo Boss Prize, Guggenheim Museum SoHo, New York; 'Jurassic Technologies Revenant', 10th Sydney Biennale 1997 Lyon Biennale **selected bibliography:** 1991 Roberta Smith, 'Matthew Barney's Objects and Actions', *The*

New York Times, 25 October 1992 Francesco Bonami, 'Matthew Barney: The Artist as a Young Athlete', Flash Art, Milan, January/February; Stuart Morgan, 'Body Language', frieze, London, September/October; Benjamin Weil, 'Matthew Barney', Flash Art, Milan, January/February 1993 Jeff Rian, 'What's All This Body Art?', Flash Art, Milan, January/February; Neville Wakefield, 'Matthew Barney's Fornication with the Fabric of Space', Parkett, No 39, Zurich 1995 Peter Schjeldahl, 'The Isle of Male', The Village Voice, New York, 9 May; Stuart Morgan, 'Of Goats and Men', frieze, London, January/February; Thyrza Nichols Goodeve, 'Matthew Barney '95: Suspension (Cremaster), Secretion (Pearl), Secret (Biology)', Parkett, No 45, Zurich 1996 Jerry Saltz, 'The Next Sex', Art in America, New York, October 1997 David Frankel, 'Hungarian Rhapsody', Artforum, New York, October

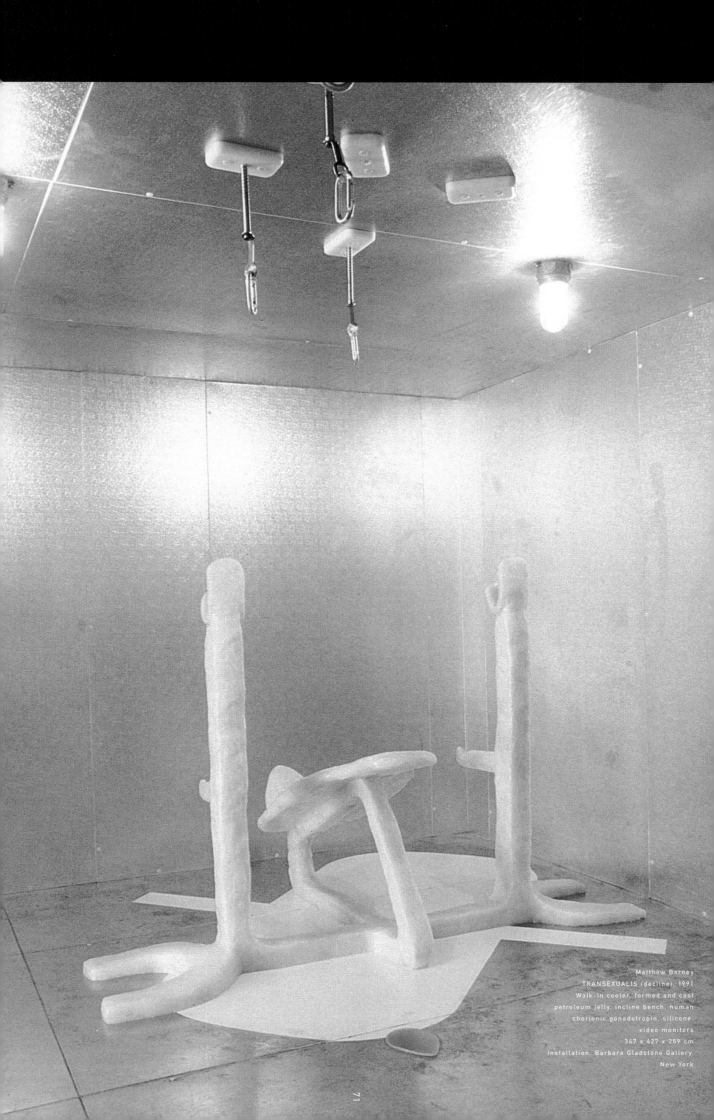

Matthew Barney
TRANSEXUALIS (decline), 1991
Walk-in cooler, formed and cast
petroleum jelly, incline bench, human
chorionic gonadotropin, silicone
video monitors
367 × 427 × 259 cm
Installation, Barbara Gladstone Gallery,
New York

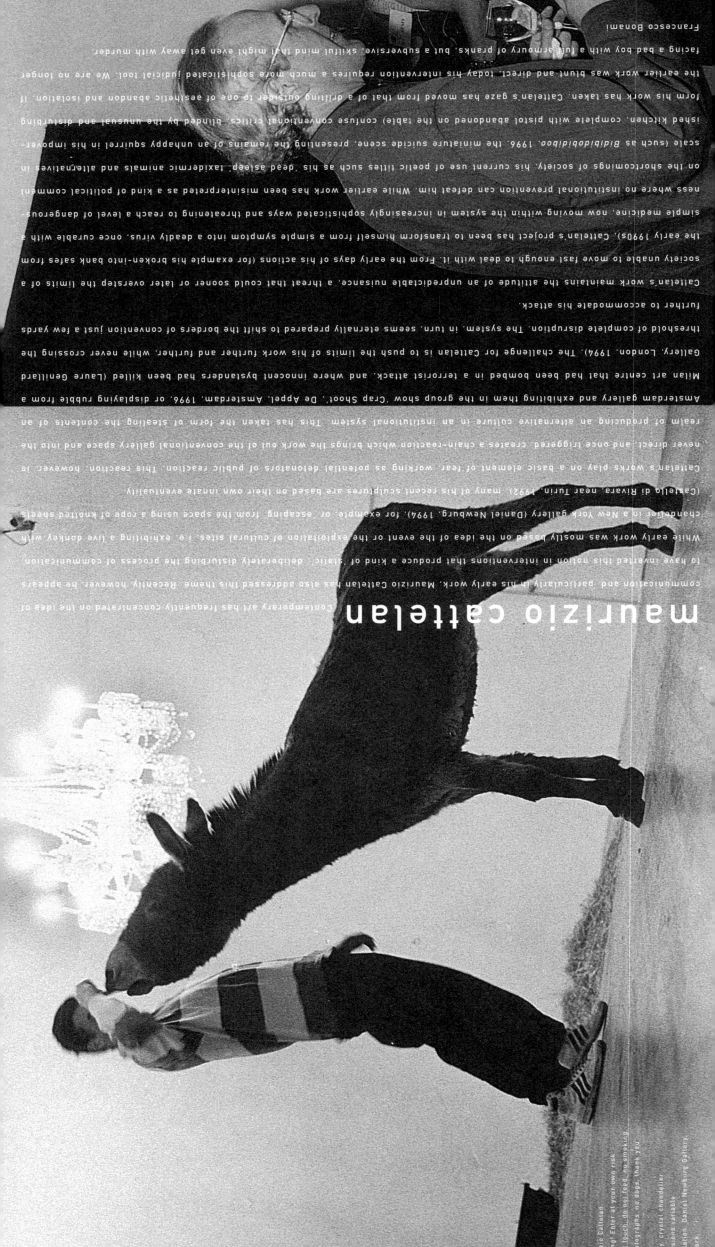

maurizio cattelan

Contemporary art has frequently concentrated on the idea of communication and, particularly in his early work, Maurizio Cattelan has also addressed this theme. Recently, however, he appears to have inverted this notion in interventions that produce a kind of 'static', deliberately disturbing the process of communication.

While early work was mostly based on the idea of the event or the exploitation of cultural sites, i.e. exhibiting a live donkey with chandelier in a New York gallery (Daniel Newburg, 1994), for example, or escaping from the space using a rope of knotted sheets (Castello di Rivara, near Turin, 1992), many of his recent sculptures are based on their own innate eventuality.

Cattelan's works play on a basic element of fear, working as potential detonators of public reaction. This reaction, however, is never direct, and once triggered, creates a chain-reaction which brings the work out of the conventional gallery space and into the realm of producing an alternative culture in an institutional system. This has taken the form of stealing the contents of an Amsterdam gallery and exhibiting them in the group show 'Crap Shoot', De Appel, Amsterdam, 1996, or displaying rubble from a Milan art centre that had been bombed in a terrorist attack, and where innocent bystanders had been killed (Laure Genillard Gallery, London, 1994). The challenge for Cattelan is to push the limits of his work further and further, while never crossing the threshold of complete disruption. The system, in turn, seems eternally prepared to shift the borders of convention just a few yards further to accommodate his attack.

Cattelan's work maintains the attitude of an unpredictable nuisance, a threat that could sooner or later overstep the limits of a society unable to move fast enough to deal with it. From the early days of his actions (for example his broken-into bank safes from the early 1990s), Cattelan's project has been to transform himself from a simple symptom into a deadly virus, once curable with a simple medicine, now moving within the system in increasingly sophisticated ways and threatening to reach a level of dangerousness where no institutional prevention can defeat him. While earlier work has been misinterpreted as a kind of political comment on the shortcomings of society, his current use of poetic titles such as 'dead asleep', taxidermic animals and alternatives in scale (such as Bidibidobidiboo, 1996, the miniature suicide scene, presenting the remains of an unhappy squirrel in his impoverished kitchen, complete with pistol abandoned on the table) confuse conventional critics, blinded by the unusual and disturbing form his work has taken. Cattelan's gaze has moved from that of a drifting outsider to one of aesthetic abandon and isolation. If the earlier work was blunt and direct, today his intervention requires a much more sophisticated judicial tool. We are no longer facing a bad boy with a full armoury of pranks, but a subversive, skilful mind that might even get away with murder.

Francesco Bonami

Maurizio Cattelan
Warning! Enter at your own risk
Do not touch, do not feed, no smoking
no photographs, no dogs, thank you
1994
Donkey, crystal chandelier
Dimensions variable
Installation, Daniel Newburg Gallery,
New York

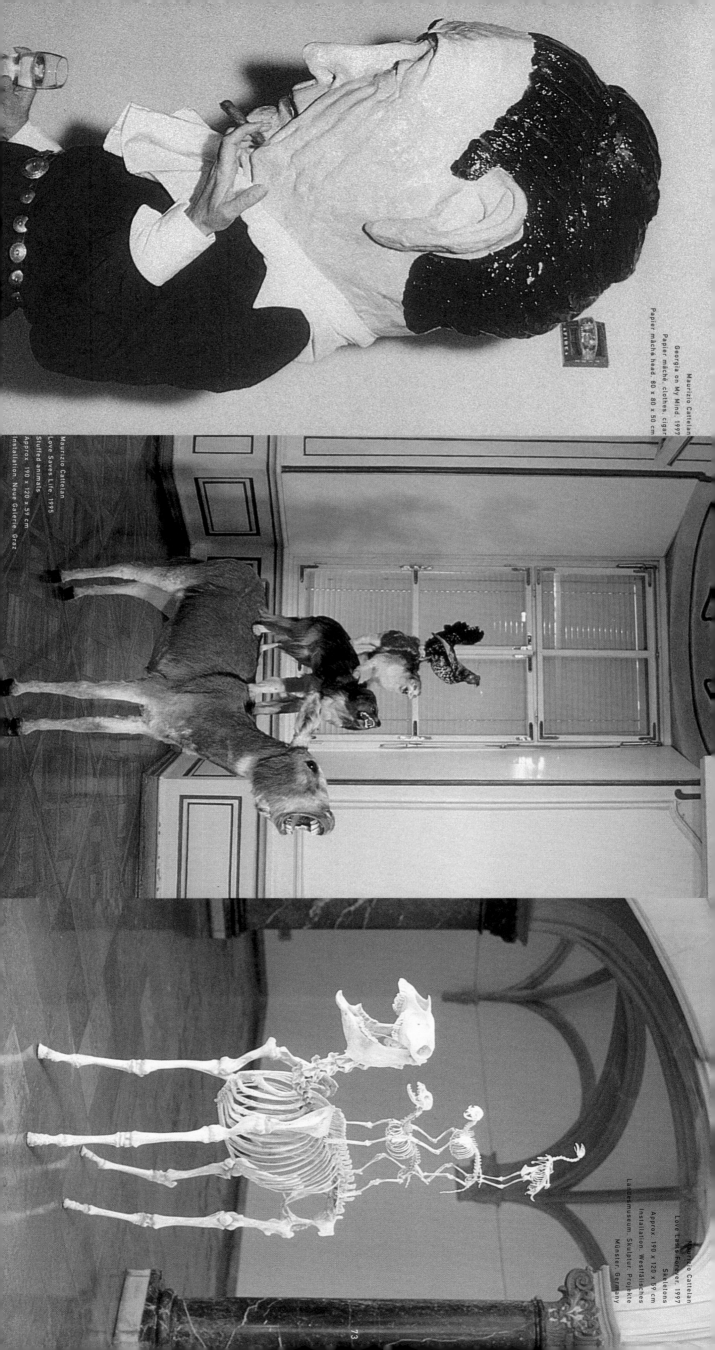

Maurizio Cattelan
Georgia on My Mind, 1997
Papier mâché, clothes, cigar
Papier mâché head, 80 x 80 x 50 cm

Maurizio Cattelan
Love Saves Life, 1995
Stuffed animals
Approx. 190 x 120 x 59 cm
Installation, Neue Galerie Graz

Maurizio Cattelan
Love Lasts Forever, 1997
Skeletons
Approx. 190 x 120 x 59 cm
Installation, Westfälisches
Landesmuseum, Skulptur Projekte
Münster, Germany

73

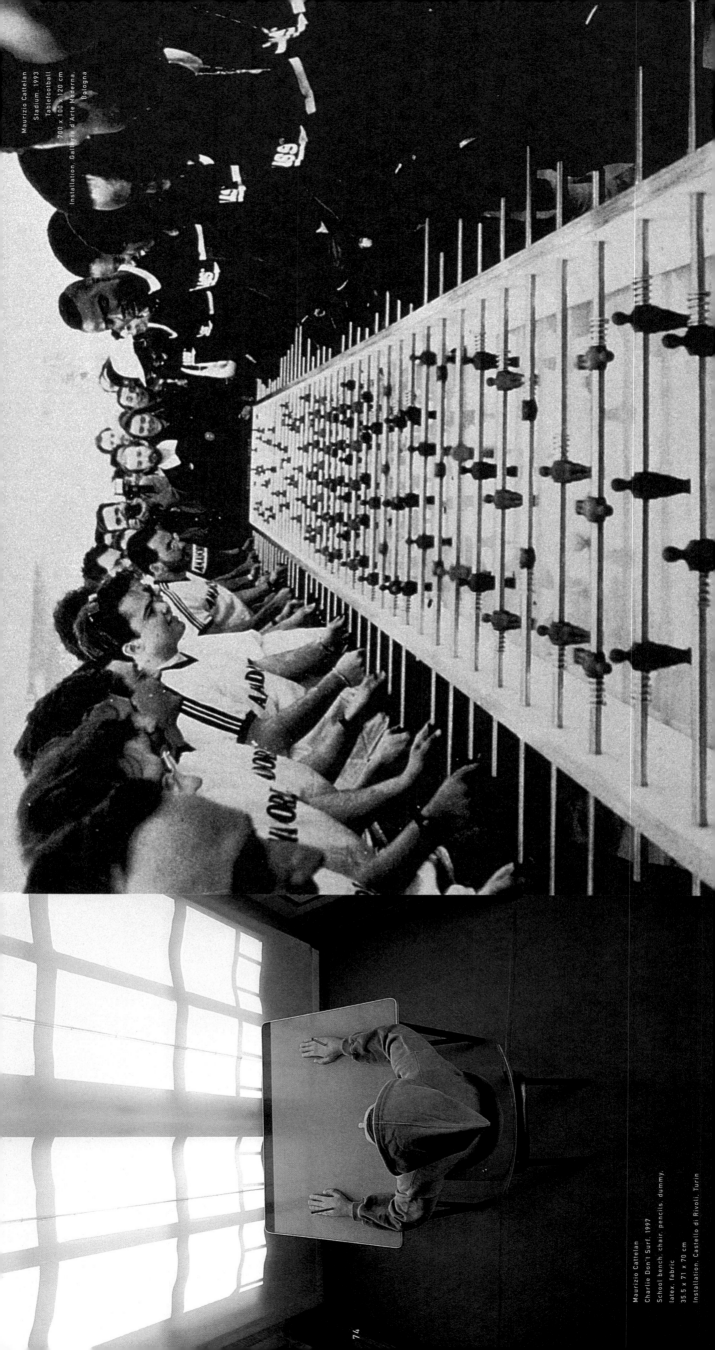

Maurizio Cattelan
Stadium, 1993
Tablefootball
700 x 100 x 120 cm
Installation, Galleria d'Arte Moderna,
Bologna

Maurizio Cattelan
Charlie Don't Surf, 1997
School bench, chair, pencils, dummy,
latex, fabric
35.5 x 71 x 70 cm
Installation, Castello di Rivoli, Turin

74

maurizio cattelan

Born Padua, Italy, 1960. Lives and works in Milan.

selected solo exhibitions: 1990 'Strategie', Galleria Neon, Bologna 1993 Galleria Massimo De Carlo, Milan 1994 Daniel Newbury Gallery, New York; Galerie Analix, Geneva 1996 Laure Genillard Gallery, London 1997 Secession, Vienna **selected group exhibitions:** 1990 'Take Over', Galleria Inga Pin, Milan and tour 1991 'Briefing', Galleria Inga Pin, Milan 1992 'Twenty Fragile Pieces', Galerie Analix, Geneva 1993 Hôtel Carlton Palace, Chambre 763, Paris; Aperto, XLV Venice Biennale 1994 'Incertaine Identité', Galerie Analix, Geneva; 'L'hiver de l'amour', ARC, Musée d'Art Moderne de la Ville de Paris; P.S. 1 Museum, New York 1995 'Photomontage', Le Consortium, Dijon; Kwangju Biennale, South Korea 1996 'Campo 6, Il Villaggio a Spirale', Galleria Civica d'Art Moderna e Contemporanea, Turin; Bonnefanten Museum, Maastricht; 'a/drift', Center for Curatorial Studies, Bard College, New York; 'L'Ameau corps', Musée d'Art Contemporain, Marseilles; 'Traffic', CAPC, Musée d'Art Contemporain, Bordeaux; 'Once removed', Laure Genillard Gallery, London 1997 XLVII Venice Biennale; Skulptur. Projekte Münster, Germany; 'Truce: Echoes of Art in an Age of Endless Conclusions', Site Santa Fe, New Mexico; 'On life, beauty, translations and other difficulties', 5th Istanbul Biennale **selected bibliography:** 1988 Giacinto Di Pietrantonio, 'Maurizio Cattelan', *Flash Art Italia*, Milan, April/May 1994 Francesco Bonami, 'Maurizio Cattelan', *Flash Art*, Milan, October 1995 Francesco Bonami, 'El desierto de los Italianos', *Atlantica*, No 10, Grand Canaries, Spain; Jeff Rian, 'Maurizio Cattelan', *frieze*, London, Summer; Olivier Zahm, 'Maurizio Cattelan', *Artforum*, New York, Summer 1996 Jeff Rian, 'Maurizio Cattelan', *Flash Art*, Milan, October; Olivier Zahm, 'World Tour', *Purple Prose*, No 11, Paris; Angela Vettese, 'Art in Milan', *Parkett*, No 46, Zurich 1997 Elizabeth Janus, 'Maurizio Cattelan', *frieze*, London, May; Dan Cameron, 'XLVII Venice Biennale', *Artforum*, New York, September

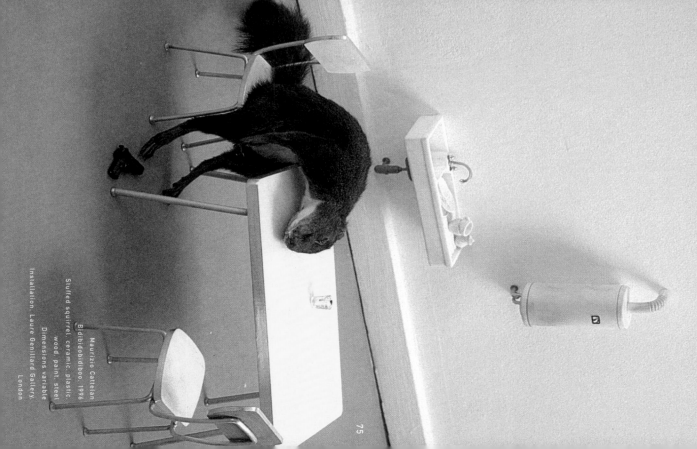

Maurizio Cattelan
Out of the Blue
1997
Latex, clothes dummy
h. 186 cm
Installation, Skulptur Projekte
Münster, Germany

Maurizio Cattelan
Bidibidobidiboo, 1996
Stuffed squirrel, ceramic, plastic,
wood paint, steel
Dimensions variable
Installation, Laure Genillard Gallery,
London

75

fandra chang

Since 1987, Los Angeles artist Fandra Chang has continually re-invented her practice, layering colour and form so that the one camouflages, maps, assimilates or betrays the other. Her art entails a complex and variable process. In recent works, she has rolled brightly coloured ink onto a mesh screen, and then photographed the screen to produce both positive and negative images. These disparate elements – the original and its distorted and/or coloured copies – are layered under a thick sheet of Plexiglas on which a positive or negative image may or may not also be printed. On other occasions, she has either juxtaposed actual, natural materials (such as wood) with their 'mirror images', (i.e. thin wood veneer), or she has produced an exact replica of an exquisitely fraying scrap of fabric through various photographic permutations, variously toned gold and silver.

Though they have been tainted by over-use, words like 'apparitional', 'hallucinatory', and 'hypnotic', are perfectly appropriate here. From a distance, grouped in pairs or series, these works seem like tasteful, minimalist fare. At close range, however, they are all intemperate shimmer and gossamer flash, like cobwebs or craquelure. Here, then, perceptual trickery becomes high drama. The Plexiglas has a subduing effect: it smothers the drama, as in a vitrine; or distances it in the manner of a TV screen, with its hard, reflective surface.

Watching TV, we tend to surrender to illusion. When it comes to art, we are more suspicious of special effects. There is no casual viewing of this work. There is only intense scrutiny, occasioned by the desire to know how it works. One of the many pleasures here is that Chang frustrates the very desires she pricks: even when we've been made privy to the work's secrets, we remain mystified. That is not to say that the artist is concerned with metaphysics. In fact, her work is pragmatic in so far as it confronts problems that can be solved – at least in theory.

Modernism's classic problem is the relationship between repetition and difference. Chang skews this formalist conundrum into psychologically charged territory, such that her work becomes a matter of thwarted *déjà vu*: here is what only looks like more of the same. The problem of technology is likewise at issue: *Bit Fall*, 1994, for example, resembles a chain of computer screens whose raster grids have been disrupted by rogue magnetic fields, causing drop-outs and bit rot. Again Chang conjures order only to sabotage it. More properly, she enlivens an historicized practice with strange and beautiful moments of serendipity.

Susan Kandel

Fandra Chang
Untitled (Square canvas), 1997
Ink on canvas, film-laminated
Plexiglas, adonized aluminium board
10 parts, 7 parts 25.5 x 25.5 x 2 cm
3 parts 15 x 15 x 2 cm

Fandra Chang
Between Map & Territory 6.3, 1996
Spray paint, fabric, film, Plexiglas,
board
5 parts, 24 x 24 x 2 cm

Fandra Chang
Untitled, 1996
Ink on fabric, Plexiglas, board
6 panels, 33 x 23 x 2 cm each

Fandra Chang
Bit 5.1, 1995
Ink on screen, paper, fabric, plywood
75 x 75 x 6.5 cm

78

fandra chang

Born Taipei, Taiwan, 1964. Lives and works in Los Angeles. **solo exhibitions:** 1992 Shea & Bornstein Gallery, Santa Monica, California 1993 Patricia Shea Gallery, Santa Monica, California 1996 Shoshana Wayne Gallery, Santa Monica, California **selected group exhibitions:** 1988 Anne Plumb Gallery, New York 1989 'Dark As a Space', Marc Richards Gallery, Los Angeles 1990 'Phoenix Triennial', Phoenix Art Museum, Arizona 1991 'Five Days', Thomas Solomon's Garage, Santa Monica, California 1993 'Los Angeles: Not Paintings?', Santa Barbara Contemporary Arts Forum, California; University of North Texas, Denton 1994 'Planes/Structures', Otis Art Gallery, Los Angeles and tour 1995 'Painting Outside Painting', The Corcoran Gallery of Art, Washington DC 1996 'Face-to-Face: Recent Abstract Art', MIT List Visual Arts Center, Cambridge, Massachussetts 1997 'Polly Apfelbaum, Mary Beyt and Fandra Chang', Galerie Ludwig, Krefeld, Germany **selected bibliography:** 1992 Colin Gardner, Reviews, *Artforum*, New York, March; Susan Kandel, Reviews, *Arts Magazine*, New York, April 1993 David Pagel, 'Fandra Chang', *Art issues*, Los Angeles, May/June 1994 David Pagel, 'Urban Diversions', *The Los Angeles Times*, 6 August 1995 David Pagel, 'Abstractions Over Time', *The Los Angeles Times*, 4 May 1996 Susan Kandel, 'Exploring Enigmatic World Under Glass', *The Los Angeles Times*, 12 September; Howard Risatti, Review, *Artforum*, New York, April; Roberta Smith, 'Testing the Limits at the Corcoran', *The New York Times*, 6 January; Jan Tumlir, 'Fandra Chang and Adam Ross at Shoshana Wayne Gallery', *Artweek*, New York, November 1998 Eregine Bahsa, 'Fandra Chang: Manufacturing Revelations', *art/text*, Sydney, February/April

Fandra Chang
Bit Fall, 1994
Ink on screen, paper, fabric, plywood
79.5 x 84 x 6.5 cm

chen zhen

Chen Zhen's method of continuous regeneration and renovation creates complex works of rich multiplicity, addressing a wide span of issues and using a broad diversity of materials. One of the leading figures of the Chinese avant garde movement in the 1980s, Chen moved to Paris in 1986 and now works internationally. Calling himself a 'spiritual run-away', he takes as his starting point the 'transexperience' of different cultures that he has accumulated in his constant travels between East and West. His focus is a critique of Western consumer society and its global influences, a questioning of the destiny of humanity itself.

Suffering from a chronic illness, Chen uses the malfunction of his body as a metaphor for the loss of harmony between nature and the man-made world. As a kind of therapy, he invents new languages to 'rescue' the unharmonious world, collecting materials, especially consumerist commodities, and recycling them in a new way. He burns newspapers, magazines and books, for example, re-manipulating commercial, cultural and political signs in order to create new relationships between them. In this way he brings fresh life to the debris of our post-industrial world in a process that, to quote the artist, 'has to do with the future of Man'.

Chen's cultural critique brings together Eastern and Western ideas in order to confront issues of globalization, the invasion of Western economics and culture into China, and the influence of China on the West from the critical perspective of a nomad who runs back and forth between the two. In *Daily Incantations*, 1996, he combines his memory of life in his native Shanghai and his recent experience of revisiting this city and seeing it radically modernized, littered with Western post-industrial garbage, to make

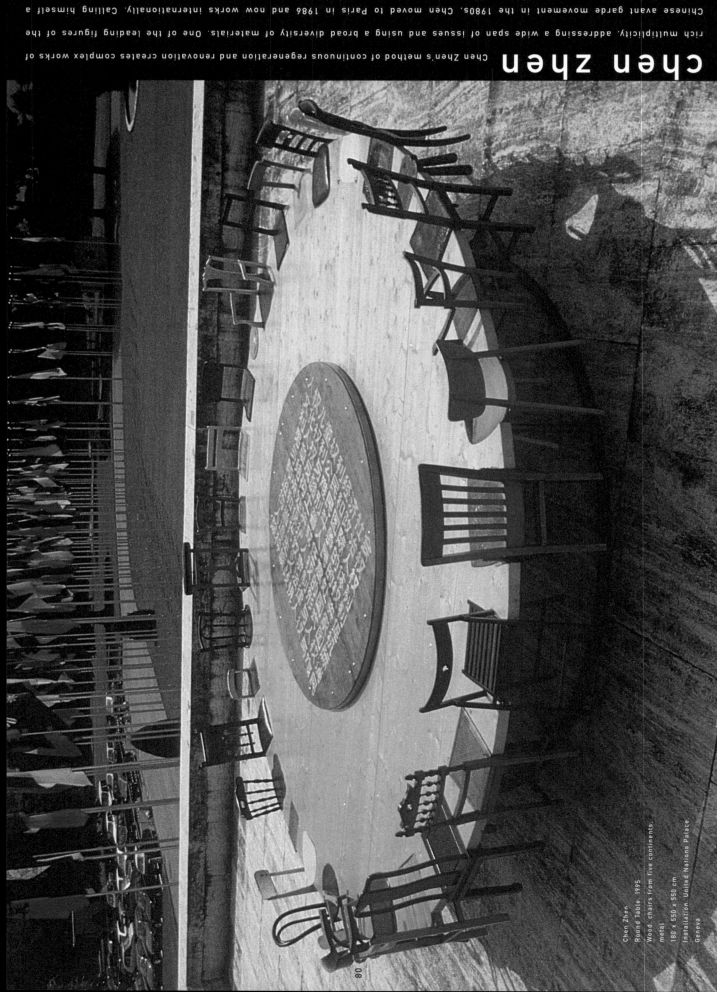

Chen Zhen
Round Table 1995
Wood chairs from five continents,
metal
180 x 550 x 550 cm
Installation, United Nations Palace,
Geneva

a new 'musical instrument' in the form of a *Bian Zhong* (a traditional Chinese instrument). This is a machine for 'daily incantation', which mixes Communist and capitalist fetish objects from Chinese nightstools to PCs.

Chen's concept of transexperience raises a crucial issue of globalization: the possibility of cultural understanding and harmony. Instead of identifying with the naïve ideal of equality and dialogue between nations, as represented by the utopian concept of the United Nations, Chen acknowledges that cultural misunderstanding is inescapable. The real challenge is how to negotiate this, and what to invent in order to foster a more harmonious co-existence of different cultures. In *Round Table*, 1995, conceived specifically for the celebration of the UN's fiftieth anniversary, he set up a Chinese-restaurant-style round table in front of the UN Palace in Geneva. Engraved in its centre were the primary issues of the UN mandate, and placed around it were twenty-nine chairs from five continents, representing the nations of the world. Because the chairs were attached to the table, however, they could not be used – a gesture that ironically undermines the utopian scene of harmony between nations. The only solution is to accept the fact of eternal misunderstanding and negotiate within its limitations.

Hou Hanru

left, Chen Zhen
Prayer Wheel –
Money Makes the Mare Go
(Chinese slang) (detail), 1997
Chinese abacus, calculators, cash registers, metal, wood, sound system
600 x 800 x 250 cm
Installation, P.S.1 Museum, New York

Chen Zhen
Opening of Closed Center, 1996
Wood, metal, found objects
345 x 300 x 250 cm

chen zhen

selected solo exhibitions:

Born Shanghai, China, 1955. Lives and works in Paris and Shanghai. 1990 Hanger 028, Paris. 1991 Ecole Nationale Supérieure des Beaux-Arts, Paris. 1994 La Maison de la Centre National d'Art Contemporain, Grenoble. 1993 Centraal Museum, Utrecht, The Netherlands. 1994 New Museum of Contemporary Art, New York. 1996 Deitch Projects, New York.

selected group exhibitions:

1991 East Asian-American Art Center, New York. 1992 Allocations/Allocaties: Art for a Natural and Artificial Environment, Floriade, den Haag-Zoetermeer, The Netherlands. 1993 Prospect 1993: Kunstverein and Schirn Kunsthalle, Frankfurt. Kwangju biennial tutor, Taejon Expo 93, South Korea. XLV Venice Biennale. 1994 L'oeuvre a-t-elle lieu?, Witte de With Centre for Contemporary Art, Rotterdam. 1995 XLVI Venice Biennale. Shopping, TAPC, Musée d'Art Contemporain, Bordeaux. 1996 Shanghai Art Biennial, Shanghai Art Museum

selected bibliography:

1990 Herve Legros, Beaux-Arts, July. 1992 Eleanor Heartney, 'Skeptics in Utopia', Art in America, New York, July. 1993 Hou Hanru, 'Zen and the Art of ...Portrait of China Fifth Art, Milan, November/December 1994 Holland Cotter, 'Installations Addressing Ethnic Identity - Chen Zhen...', The New York Times, 20 May. Kim Levin, 'Chen Zhen/Huang Yong Ping', The Village Voice, New York, 31 May. 1996 ..., The New Artforum, New York, January; Roberta Smith, 'Culture And Commerce Live Side by Side in Soho', The New York Times, 13 September. 1997 Kay Larson, 'A Month in Shaker Country', The New York Times, 10 August; Octavio Zaya, 'Meditations On Spirituality in Art', Atlantica, No 17, Grand Canaries, Spain. 1998 Eleanor Heartney, 'The Return of the Real-Black Alternative Art in America, New York, January

Chen Zhen
Daily Incantations 1996
Chinese chamberpots, wood, metal,
objects, sound system
700 x 350 x 480 cm
Installation, Deitch Projects, New York

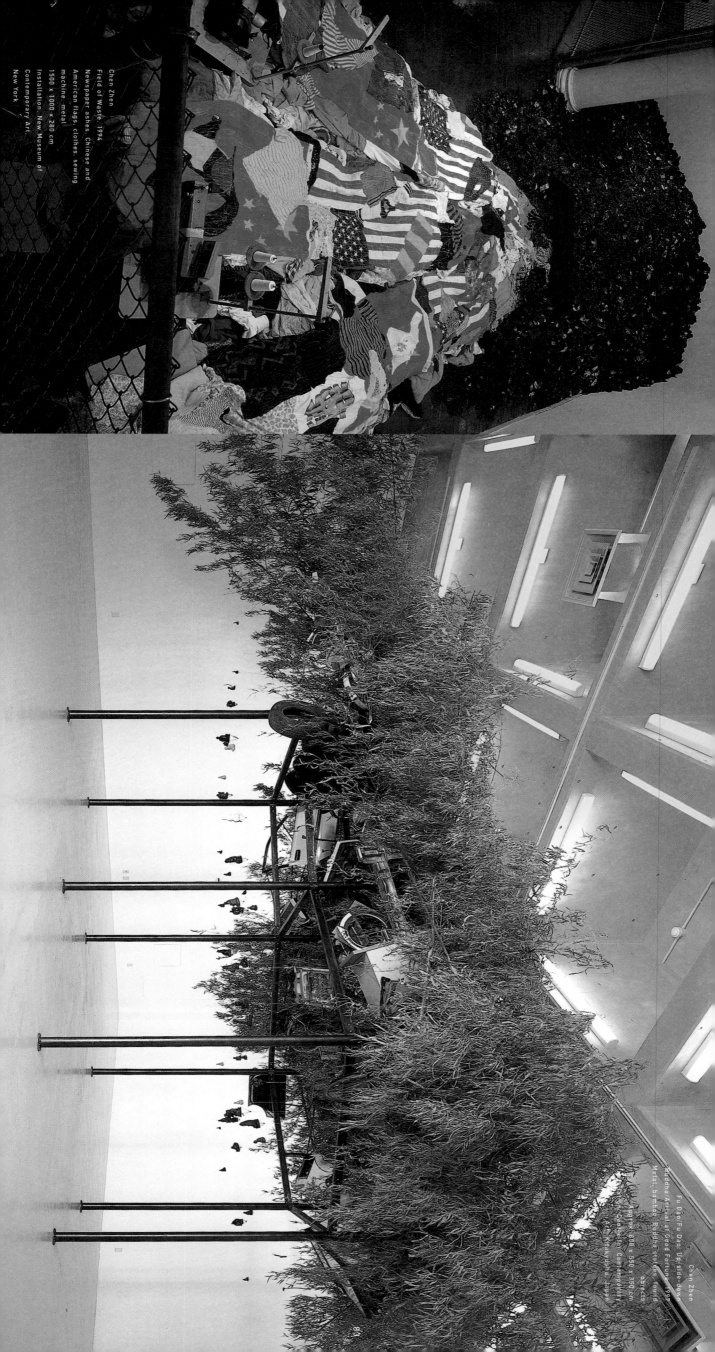

Chen Zhen
Field of Waste, 1994
Newspaper, ashes, Chinese and
American flags, clothes, sewing
machine, metal
1500 x 1000 x 280 cm
Installation, New Museum of
Contemporary Art,
New York

Chen Zhen
Fu Dao/Fu Dao, Upside-down
Buddha/Arrival at Good Fortune, 1997
Metal, bamboo, Buddha statues,
electrical appliances, objects
800 x 550 x 590 cm
Installation, Deitch Projects, New York
NICAF, Yokohama, Japan

83

this page. Martin Creed
Work No 200: 1/2 the air in a given
space, 1998
White balloons
Dimensions variable
Installation, Galerie Analix, Geneva

martin creed

The *Collins Dictionary of Art Terms & Techniques* defines 'realism' as, amongst other things, 'the depiction of real objects without distortion or stylization'. By this – admittedly selective – definition alone it is possible to confirm that Martin Creed is a realist. His deployment of real objects – doorstops, metronomes, ceramic tiles and items of furniture – into what might be termed 'object situations' (e.g. *Work No 142: A large piece of furniture partially obstructing a door*) provide us with (Collins again) 'a frank picture of everyday life'. Creed's fundamentalism extends to acknowledge not only his own limitations as an artist (what can I actually achieve?) but also signals the limitations of art itself. *Work No 143:* Creed's 1996 mission statement – a manifesto of sorts – goes some way to clarifying his position. It deduces that:

the whole world + the work = the whole world.

Creed's lower-case conundrum leaves 'the work' nursing a bruised ego – its (numerical) 'value' reduced to zero. In doing so he begs the question: if art has no value – then why make art? Short of an answer, Creed carries on regardless, pursuing a contradictory impulse – a paradoxical desire to produce both *something* and *nothing.*

If Creed's works are ultimately concerned with, to quote the artist, 'nothing in particular', his parsimonious use of materials – masking tape, elastoplast, blu-tack and balloons – combined with an almost puritanical simplicity (e.g. *Work No 79: Some Blu-tack kneaded, rolled into a ball and depressed against a wall*) at least provide him with a potentially endless source of inspiration. This 'making do' aesthetic frequently produces sublime results, for example, *Work No 200: 1/2 the air in a given space.*

Sensing no conflict of interests with his practice as an artist, Creed formed the band Owada in 1994, to act out an aural equivalence to his often tragi-comic artworks. Moving on from earlier sound pieces (e.g., *Work No 97: A metronome working at a moderate speed*), Owada have been fairly accurately described as sounding 'like something between Steve Reich and the Ramones'. Creed, accompanied by Keiko Owada on bass and Adam McEwen on drums, exploits the back-to-basics format of the rock trio – a 'site' where the opportunity for individual indulgence is inevitably diminished. Owada's 'songs' parody pop's controlling structures (e.g., *start middle end,* which defines its component parts). Owada's frugal compositions (the lyrics to *1–100* are just that: 'one, two, three, four, five … ') self-consciously and systematically undermine pop's elusive mystery. They expose the standard 'verse-chorus-verse' mechanics of the songwriter's craft – for instance *one whole song* periodically informs the listener of the song's imminent termination. By addressing rock's traditional histrionics Owada foreground the otherwise unbridged performer/audience divide into the bargain.

Martin Creed plays out a decidedly informal brand of formalism, its humane matter-of-factness ultimately preventing it – again to quote the artist – from 'going up its own arse'.

Matthew Higgs

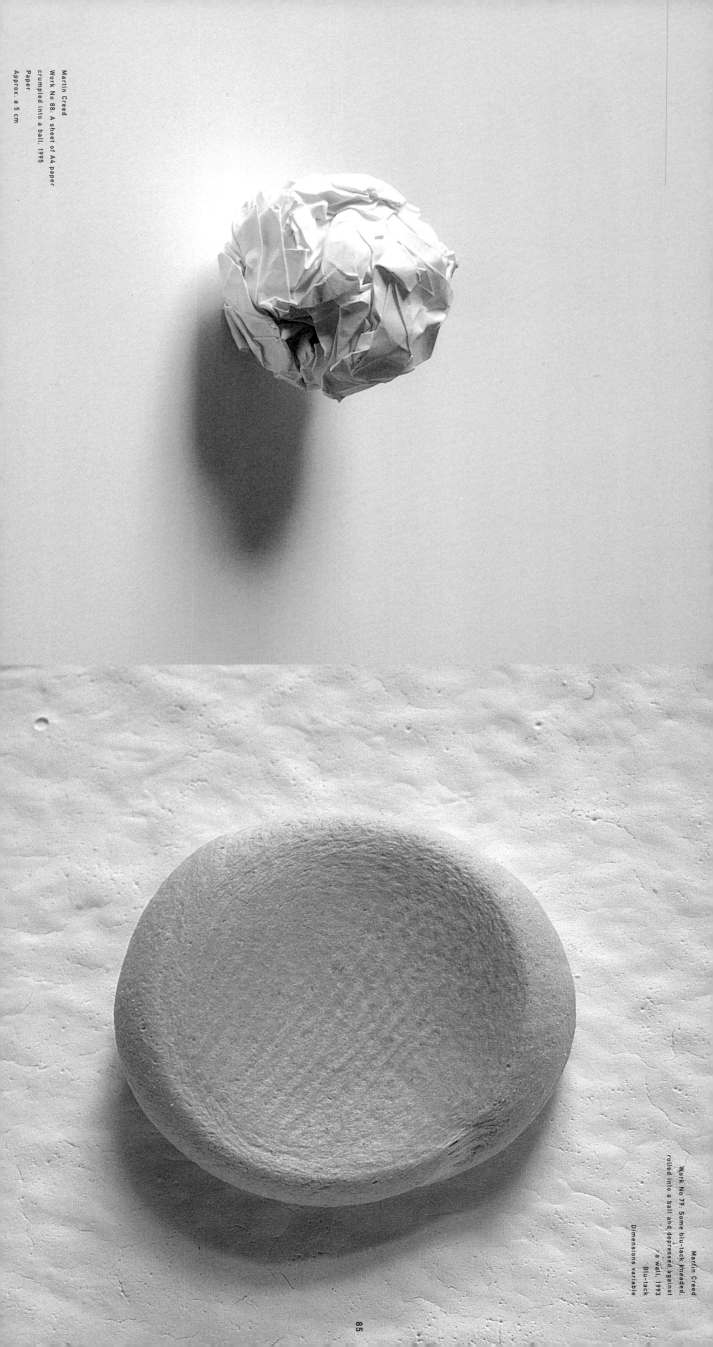

Martin Creed
Work No 88: A sheet of A4 paper
crumpled into a ball, 1995
Paper
Approx. ø 5 cm

Martin Creed
Work No 79: Some blu-tack kneaded,
rolled into a ball and depressed against
a wall, 1993
Blu-tack
Dimensions variable

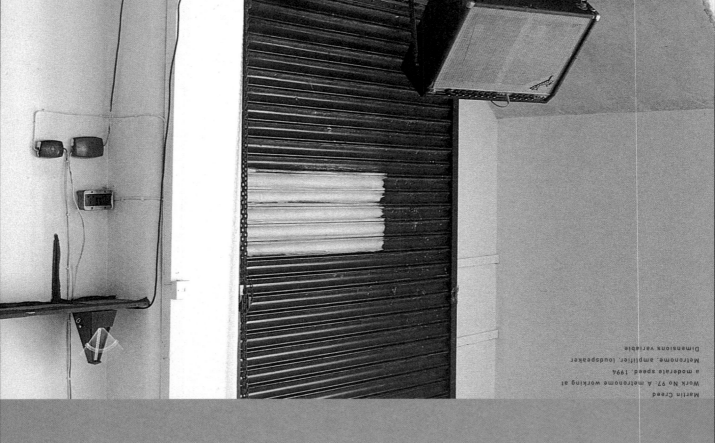

Moderato

mp or mf

martin creed

Born Wakefield, England, 1968. Lives and works in London. **solo exhibitions:** 1993 Starkmann Limited, London 1994 Marc Jancou Gallery, London 1995 Galerie Analix, Geneva; Camden Arts Centre, London; Galeria Paolo Vitolo, Milan 1997 Victoria Miro Gallery, London 1998 Galerie Analix, Geneva **group exhibitions:** 1989 The Black Bull, London 1992 'Outta Here', Transmission Gallery, Glasgow 1994 'Conceptual Living', Rhizome, Amsterdam; 'Modern Art', Transmission Gallery, Glasgow 1995 'Snow Job', Forde, Geneva; 'Zombie Golf', Bank, London; 'Fuori Fase', Viafarini, Milan 1996 'life/live', ARC, Musée d'Art Moderne de la Ville de Paris, Centro Cultural de Belém, Lisbon; East International, Sainsbury Centre for Visual Arts, Norwich; 'weil morgen', Eisfabrik, Hannover 1997 'Dimensions Variable', City Art Museum, Helsinki and tour; 'Supastore de Luxe No. 1', Up & Co., New York 1998 11th Sydney Biennale; 'Sunday', Cabinet Gallery, London; 'Not Today', Gavin Brown's enterprise, New York **selected bibliography:** 1992 Matthew Collings, 'Matthew Collings on some kind of sculpture show at Laure Genillard', *City Limits*, London, January 1994 Geraldine Norman, 'Imprints that raise a gallery of questions', *The Independent*, London, 11 July; Simon Grant, 'Martin Creed, Sam Samore', *ES Magazine*, London, 8 July 1995 Erika Lederman, 'Unlimited Works at Starkmann Limited', *Art Monthly*, London, April; Emanuela De Cecco, 'Spotlight – Fuori Fase', *Flash Art*, Milan, April/May 1996 Michael Gibbs, 'The Speed of Light, The Speed of Sound', *Art Monthly*, London, December/January; Gilda Williams, 'Martin Creed Tabula Rasa', *Art Monthly*, London, April 1997 Carl Freedman, 'Generation W(eird)', *The Guardian*, London, 27 May; Alex Coles, 'Martin Creed – No Entry', *art/text*, Sydney, February/April

Tacita Dean

Rozel Point, Great Salt Lake, Utah, 1997

Colour photograph

Spiral Jetty detailed directions:

1 Go to the Golden Spike National Historic Site (GSNHS), 30 miles west of Brigham City, Utah. The Spiral Jetty is 15.5 dirt-road miles southwest of the GSNHS.

To get there (from Salt Lake City) take I-80 north approximately 65 miles to the Corinne exit, just west of Brigham City, Utah. Exit and proceed 2.5 miles west, on State Highway 83, to Corinne. Proceed through Corinne, and drive another 17.7 miles west, still on highway 83, to Lampo Junction. Turn west off highway 83 at Lampo, and drive 7.7 miles up the east side of Promontory Pass to the GSNHS.

2 From the Visitor Center at the GSNHS, drive 5.6 miles west on the main dirt road running west from the Center. Remember to take the county dirt road … not the railroad grade.

3 Five point six miles will bring you to an intersection. From this vantage you can see the lake. And looking southwest, you can see the low foot hills that make up Rozel Point, 9.9 miles distant.

4 At this intersection the road forks: One road continues west and the other goes south. Take the south fork. Both forks are Box Elder County Class D (maintained) roads.

5 Immediately you cross a cattle guard. Call this cattle guard 1. Including this one, you will cross four cattle guards before you reach Rozel Point and the Spiral Jetty.

6 Drive 1.3 miles south. Here you will see a corral on the West side of the road. Here too, the road again forks. One fork continues south along the Promontory Mountains. This road leads to a locked gate. The other fork goes southwest toward the bottom of the valley and Rozel Point. Turn onto the southwest fork, just north of the corral. This is also a Box Elder County Class D road.

7 After you turn southwest, you will go 1.7 miles to cattle guard 2. Here, besides the cattle guard, you will find a fence but no gate.

8 Continue southeast 1.2 miles to cattle guard 3, a fence, a gate and a sign on the gate which reads, 'Promontory Ranch'.

9 Another 0.5 miles will bring you to a fence but no cattle guard and no gate.

10 Continue 2.3 miles south/southwest to a combination fence, cattle guard 4, iron-pipe gate … and a sign declaring the property behind the fence to be that of the Rafter S Ranch. Here, too, is a 'No Trespassing' sign.

11 If you choose to continue south for another 2.3 miles, and around the east side of Rozel Point, you will see the Lake and a jetty (not the Spiral Jetty) left by oil drilling exploration in the 1950s. As you approach the Lake, you will see an abandoned, pink and white trailer (mostly white), an old army amphibious landing craft, an old Dodge truck … and other assorted trash.

The trailer is the key to finding the road to the Spiral Jetty. As you drive slowly past the trailer, turn immediately to the west, passing on the south side of the Dodge, and onto a two-track trail that contours above the oil-drilling debris below. This is not much of a road! In fact, at first glance it might not look to be a road at all. Go slow! The road is narrow; brush might scratch your vehicle, and the rocks, if not properly negotiated, could high centre your vehicle.

12 Drive 0.6 miles west/northwest around Rozel Point and took toward the Lake. The Spiral Jetty should be in sight.

Utah Arts Council

tacita dean

Constructed in April 1970, Robert Smithson's *Spiral Jetty*, his best known and most extensively documented work, has for the last twenty-five years been submerged beneath the surface of the Great Salt Lake in Utah. Smithson's tragi-heroic gesture, a kind of parting shot for the twentieth century, remains shrouded in myth.

In June 1997, after having spent two weeks holed up at the Sundance Filmmakers and Screenwriters' workshops, Tacita Dean embarked on a pilgrimage of sorts to Rozel Point on the shores of the Great Salt Lake – the site of Smithson's *Jetty*. Dean's curiosity had been aroused earlier whilst in New York, where she had been informed, quite by chance, that the *Jetty* may have once again become visible. Smithson was not someone who had particularly preyed upon Dean's mind. However, given that her earlier film-work *Disappearance at Sea*, 1996, concerned itself not only with the strange disappearance of its central 'character', the yachtsman Donald Crowhurst, but also with the equally mysterious vanishing at sea of the Dutch Conceptual Artist Bas Jan Ader, it is easy to see why, in hindsight, she became attracted both to the fate of Smithson (who died in a plane crash in 1973), and to that of the *Jetty*.

Following the detailed directions supplied by the Utah Arts Council, Dean and Gregory Sax – a fellow screenwriter along for the ride – set off by road in pursuit of their elusive quarry. The absent image of Smithson's *Jetty* is ever present in the aural travelogue that eventually resulted from the trip. *Trying to Find the Spiral Jetty*, 1997, is a twenty-seven-minute sound work presented as an imageless 'road movie'. Contrived as an in-car commentary – a rambling, often fragmented conversation between Dean and Sax – it turns us into backseat passengers, witnesses to an elaborately constructed fiction. It is fairly apparent that what appears to be occurring in 'real time' is in fact an edited version of events. In reality, Dean only recorded the final stages of the journey: the remainder of the recording was made after the fact via a transatlantic exchange of DAT tapes between Dean and Sax, each party acting out their respective roles from memory.

From this sly artifice Dean weaves a curiously satisfying web of truths, half-truths and bare-faced lies that cumulatively manage to soften the blow of the work's final and inevitably frustrating denouement. On reaching what they believed to be Rozel Point, the *Jetty* was nowhere to be seen. Either they had simply taken a wrong turn, or the rising waters of the Lake had refused to give up Smithson's talismanic spiral. The journey, as such, was over.

Trying to Find the Spiral Jetty is perhaps Dean's most assured work to date: neatly dovetailing her recurring concerns – concealment, serendipity, storytelling, duration and process – it bears out the old adage that it's not the arrival, but the journey that counts.

Matthew Higgs

Tacita Dean
Disappearance at Sea, 1996,
14 min. cinemascope film, colour,
sound

Tacita Dean
Roaring Forties: Seven Boards in Seven
Days II (Saturday), 1997
Chalk on blackboard
240 x 240 cm

Fridays
boat
(for long)

clew the sail (long take

Lincoln

pan to action
from out of frame

Brian dead

Heavy swell off the Roaring Forties

slow - ? on swell

fuller volumes

Tacita Dean
Roaring Forties: Seven Boards in Seven
Days VI (Friday), 1997
Chalk on blackboard
240 x 240 cm

tacita dean

Born Canterbury, England, 1965. Lives and works in London.

solo exhibitions: 1994 'The Martyrdom of St Agatha and Other Stories', Galerija Stuc, Ljubljana; Umetnostna Galerija, Maribor, Slovenia 1996 Art Room, Tate Gallery, London 1997 Witte de With Centre for Contemporary Art, Rotterdam; 'The Drawing Room', The Drawing Center, New York **selected group exhibitions:** 1992 BT New Contemporaries, Newlyn Orion, Penzance and tour 1993 Barclays Young Artist Award, Serpentine Gallery, London 1994 'Watt', Witte de With Centre for Contemporary Art and Kunsthal, Rotterdam 1995 'Mysterium Alltag', Hammoniale der Frauen, Kampnagel, Hamburg; 'Kine[kunst]'95', Casino Knokke, Belgium **selected bibliography:** 1994 Adrian Searle, 'Behind the Mask', *The Independent*, London, 25 October 1995 Ian Hunt, 'Mise en Scène', *frieze*, London, January/February; Jaki Irvine, 'Mise en Scène', *Third Text*, London, Spring 1996 Adrian Searle, 'Noises Off', *The Guardian*, London, 27 August; Sarah Greenberg, 'Berwick Ramparts Project', *Art Monthly*, London, September; Melissa Feldman, 'Foley Artist', *Art Monthly*, London, October; Jennifer Higgie, 'Tacita Dean: Tate Gallery', *frieze*, London, November/December 1997 Gianmarco Del Re, 'Tacita Dean: Tate Gallery', *Flash Art*, Milan, May/June; Roberta Smith, 'The Celluloid Cave', *The New York Times*, 27 June; Francis Richard, 'Tacita Dean, The Drawing Room', *Artforum*, New York, November

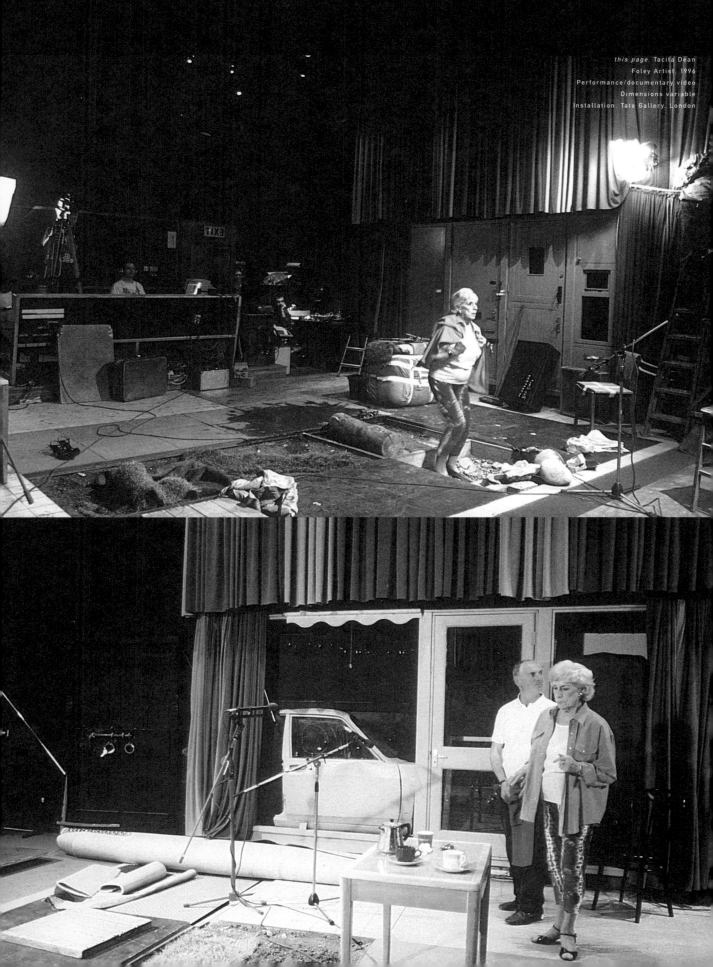

this page. Tacita Dean
Foley Artist, 1996
Performance/documentary video
Dimensions variable
Installation, Tate Gallery, London

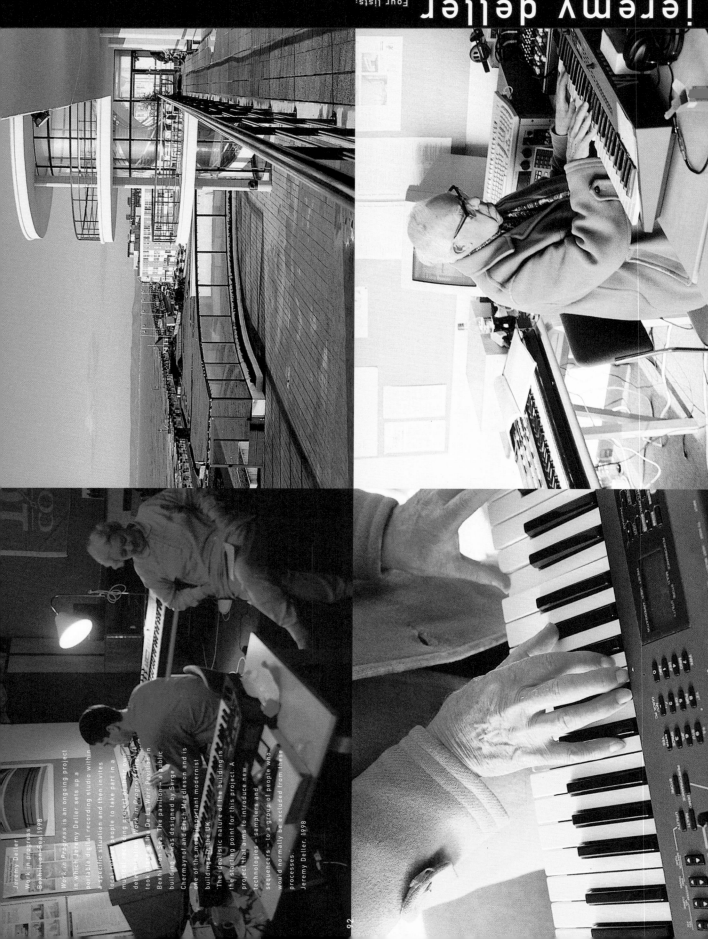

jeremy deller Four lists:

Jeremy Deller's Top Ten 'Top Ten ...

... things about the Queen; ... jumble sales in West Wickham; ... "baggy tunes" played upstairs at Langtrey's between 1989-1991; ... bicycle rides; ... stories about Paul Gascoigne; ... silk ties; ... British pop songs played at "Blow Up," in Camden; ... Dulwich girls; ... afternoons spent on Bromley High Street; ... National Trust properties.'

Top Tens was originally published by Imprint 93 in June 1994 as a sixteen-page booklet on the occasion of an exhibition held at the Cabinet Gallery, London. Each of the ten contributing artists and the gallery's two directors were asked to submit a list that identified their own particular 'Top Ten'. The resulting lists included: Jeff Luke's 'Top Ten Celebrities Spotted in Public'; Maggie Roberts' 'Top Ten Moments in Sci-Fi Films' and James Pyman's 'Top Ten The Birthday Party/Nick Cave & The Bad Seeds Concerts'.

Jeremy Deller, unable to commit himself to a single category, elected to list ten possible 'Top Ten' categories for potential consideration.

Jeremy Deller's 'Desert Island Discs'
KLF, Last Train To Transcentral; The Smiths, Panic; The Stone Roses, I Am The Resurrection; Happy Mondays, Hallelujah; Slade, C'Mon Feel the Noise; Flowered Up, Weekender; David Bowie, Life on Mars.

Desert Island Discs was originally published by Imprint 93 in June 1995 as an A3 poster work on the occasion of an exhibition held at Film Racing, London. Each of the twenty-nine contributors to the exhibition was asked to list the eight records that ... if they

Work in Progress
Bexhill-on-Sea 1998
Jeremy Deller

Work in Progress is an ongoing project in which Jeremy Deller sets up a portable digital recording studio within a specific situation and then invites local people to take part in a music-making project.

Work in Progress took place in the De La Warr Pavilion in Bexhill-on-Sea. The pavilion, a public building, was designed by Serge Chermayof and Erich Mendleson and is one of the most important modernist buildings in the UK.

The idealistic nature of the building is the starting point for this project. A project that aims to introduce new technologies – samplers and sequencers – to a group of people who would normally be excluded from these processes.

Jeremy Deller, 1998

were to ever become stranded alone on a desert island – they could not live without. In addition – following the format of the long

running BBC radio show of the same name – they were each allowed to select a single book and nominate one luxury item. Jeremy

Deller chose the London 'A-Z' (detailed city map) as his book and the whole of South London as his luxury.

Jeremy Deller's 'Seven Wonders of the World'

Blackpool; Elizabeth R.; The Sound of Manchester; Spike Milligan; Swimming; The Bicycle; Battersea Power Station.

Seven Wonders of the World was originally published and distributed by Imprint 93 in May 1996 as a thirty-two-page booklet on the

occasion of 'NowHere', five exhibitions held concurrently at the Louisiana Museum in Humlebæk, Denmark. Imprint 93 had been

invited to contribute to Iwona Blazwick's exhibition 'Work in Progress'. Everyone who had previously contributed to Imprint 93,

either as artist, gallerist or curator, was asked to propose their own alternatives to the classical Seven Wonders of the World.

Jeremy Deller's 'Last Supper'

All the girls I loved but never told. Fifteen grammes of pure MDMA.

Last Supper was originally published and distributed by Imprint 93 in October 1996 as a five-page pamphlet on the occasion of

'life/live' an exhibition curated by Hans Ulrich Obrist and Laurence Bossé, ARC, Musée d'art Moderne de la Ville de Paris. All pre-

vious contributors to Imprint 93 were invited to respond to the following proposition: 'Imagine you are on Death Row, about to be

executed. What would you choose for your last supper?'

Matthew Higgs

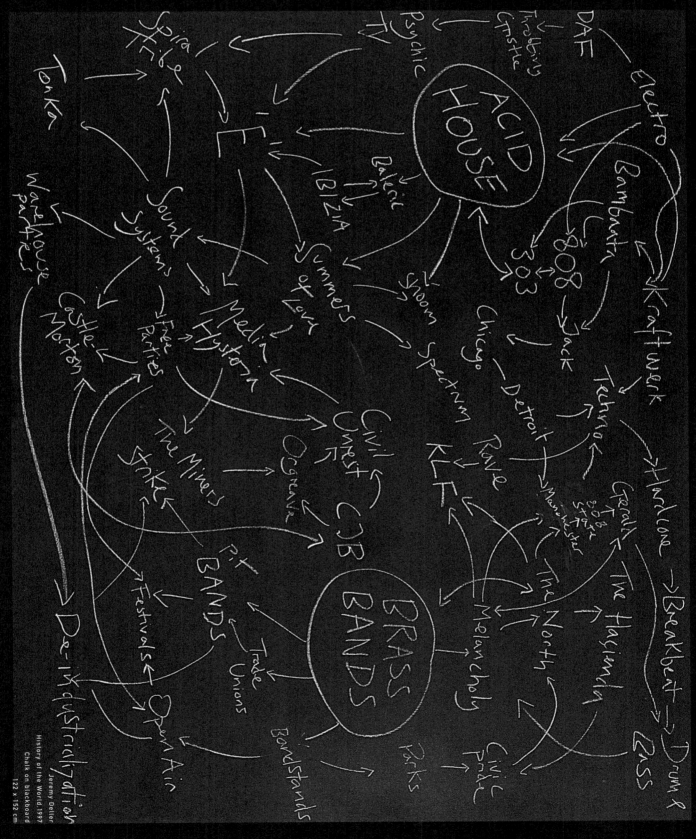

History of the World, 1997
Jeremy Deller
Chalk on blackboard
122 × 152 cm

POLICE

FIAT

Jeremy Deller
I Love Joyriding, 1995
Adhesive sticker
6 x 24 cm
Installation, Middlesborough, England

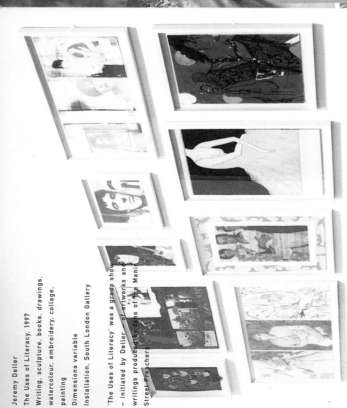

SUBURBIA

Jeremy Deller, with Alan Kane
Suburbia, 1995
Cotton
183 x 274.5 cm
Installation, Phoenix Hotel, San Francisco

MANIC STREET PREACHERS

Jeremy Deller
The Uses of Literacy, 1997
Writing, sculpture, books, drawings,
watercolour, embroidery, collage,
painting
Dimensions variable
Installation, South London Gallery

'The Uses of Literacy' was a group show
– initiated by Deller – of artworks and
writings produced by fans of the Manic
Street Preachers

jeremy deller Born Dulwich, London, 1966. Lives and works in L...

solo exhibitions: 1992 'Remember Even When Things Are Going Badly We Are Still British...
York 1993 Centre 181 Gallery, London 1996 'At Home', Cabinet Gallery, London; 'Migrateurs', ARC, Musée...
de Paris 1997 'The Uses of Literacy', Norwich Art Gallery 1998 'L'oreille est Le Chemin du Co...

selected group exhibitions: 1992 'Instructions', Gió Marconi Gallery, Milan...
Racing, London 1994 'Shop Group Show', Kunstverein, Hamburg 1995 'Sex, Drugs and Rock and R...
Francisco; 'East', Norwich Art Gallery and Sainsbury Centre, Norwich 1996 'Popocultural', South London...
Musée d'Art Moderne de la Ville de Paris, Centro Cultural de Belém, Lisbon 1997 'Bring Your Own Wal...
1998 'Nuit Blanche', ARC, Musée d'Art Moderne de la Ville de Paris **selected bibliograp**...
'Keith Moon Was My Father', *Documents*, New York, June 1994 Geraldine Norman, 'A Cabinet of Curio...
London, 11 July 1995 Geraldine Norman, 'Time for Cocktails at the Cutting Edge of Art', *The Indep*...
1996 Godfrey Worsdale, 'Jeremy Deller: Cabinet Gallery', *Art Monthly*, London, April; Dave Beech, 'Tal...
Lover', *Texte zur Kunst*, Cologne, May; David Barratt, 'Co-Operators: Southampton City Art Gallery', *f*...
Freedman, 'Jeremy Deller: Cabinet Gallery', *frieze*, London, June/July/August; Judith Findlay, 'Jeremy...
Flash Art, Milan, Summer 1997 Carl Freedman, 'Where There's Muck', *frieze*, London, November/Decemb...
Art', *Art Monthly*, London, October

a live recording by the williams Fairey Band

with 12-page souvenir booklet

Philip-L
Roach Davis; 30 years old; C

Ektacolour print mounted

philip-lorca dicorcia

Though he has been working for t

decades, it was not until the early 1990s that Philip-Lorca diCorcia achieved a certain notoriety, with a series of alte

deadpan and swoony photographs of male prostitutes, drifters and addicts. Shot on the streets, in alleys and mot

Hollywood, these lushly coloured images are juicy, theatrical and damning — this, in the sense that they revel in the s

the dream machine while disclosing its utter poverty.

Though they conjure both, these are neither documentations *à la* Nan Goldin nor set-ups in the manner of Jeff Wall. B

of them as both fortuitous and not: diCorcia chose the sites, arranged the lighting, plotted the camera angles, then s

subjects. However, those subjects — whose names, hometowns and price-per-pose are specified in the titles — tra

brief encounters into real-life pulp fiction.

For $25.00, Ralph Smith — twenty-one years old, from Fort Lauderdale, Florida — basks in the unholy glow of a turq

sign; for $40.00, Joe Reeves — thirty-seven years old, from San Fernando, California — stands behind a curtain o

vision of male pulchritude; for $40.00, William Charles Everlove — twenty-six years old, from Stockholm via Ariz

radio to his ear, the picture of urban anomie, highlighted in red, white and blue.

Clearly, these figures are selling themselves cheap. But what each is getting — an arena in which to act out what i

— may make the exchange worthwhile. Indeed, what diCorcia is getting only looks like exploitation; his is a sly, but

intervention into the mechanics, as well as the politics, of self-identification.

In 1993 diCorcia began an on-going series of street photographs, shot in such cities as LA, New York, Rome, Paris

These images shed the lingering artifice of the earlier work, taking up the codes of realism only to disavow any

A 1997 image juxtaposes two businessmen passing under a marquee of a theatre showing *The Waste Land* with a

the other direction, who passes under a sign for a Single Room Occupancy hotel. This is not a record, but a poet

balkanized city. As Garry Winogrand put it *vis-à-vis* his own street photographs, here is the 'illusion of a desc

above, Philip-Lorca diCorcia
William Charles Everlove; 26 years old;
Stockholm via Arizona; $40, 1990–92
Ektacolour print mounted on 4-ply
board
67 x 101.5 cm

below, Philip-Lorca diCorcia
Ralph Smith; 21 years old; Ft.
Lauderdale, FL; $25, 1990–92
Ektacolour print mounted to 4-ply board
76 x 101.5 cm

above, Philip-Lorca diCorcia
New York, 1997
Ektacolour print, paper
67 x 101.5 cm

below, Philip-Lorca diCorcia
Hong Kong, 1996
Ektacolour print mounted on 4-ply
board
67 x 101.5 cm

philip-lorca dicorcia

Born Hartford, Connecticut, 1953. Lives and works in New York. **selected solo exhibitions:** 1985 'Fotographie', Zeus Arts, Milan 1991 Photographers' Gallery, London 1993 'Strangers', The Museum of Modern Art, New York 1995 Galerie Klemens Gasser, Cologne 1996 'Street Work', PaceWildensteinMacGill, New York 1997 Museo Nacional Centro de Arte Reina Sofía, Madrid 1998 'Hollywood Pictures 1990–92', PaceWildenstein, Los Angeles **selected group exhibitions:** 1985 'Contemporary Photography VI', Fogg Art Museum, Harvard University, Cambridge, Massachusetts 1987 'New Photography 2', The Museum of Modern Art, New York 1990 'Witnesses: Against Our Vanishing', Artists Space, New York 1991 'Pleasures and Terrors of Domestic Comfort', The Museum of Modern Art, New York and tour 1992 'The Sexual Self', Galerie Tanja Grunert, Cologne 1993 'Prospect 93', Kunstverein and Schirn Kunsthalle, Frankfurt 1994 'Flesh and Blood', Fotofeis, Edinburgh and tour 1995 International Foto Triennale, Galerie dar Stadt Esslingen, Germany 1997 Biennial, Whitney Museum of American Art, New York; 'Family and Friends', Museum of Contemporary Photography, Chicago **selected bibliography:** 1993 Koko Yamagishi, 'Philip-Lorca diCorcia – Portraits of Contemporary Americans', *Déjà-Vu*, No. 15, Japan 1996 Stuart Morgan, 'Deliberate Fictions', *frieze*, London, November/December; Mark Stevens, 'In the Moment', *New York Magazine*, 14 October; 'Philip-Lorca diCorcia', *The New Yorker*, 30 September 1997 Joyce Carol Oates, 'Philip-Lorca diCorcia', *DoubleTake*, Durham, North Carolina, Winter; Michael Kimmelman, 'Assignment Times Square', *The New York Times Magazine*, 18 May; Michael Kimmelman, 'Biennial Narratives Snagged on the Cutting Edge', *The New York Times*, 21 March

Philip-Lorca diCorcia
Los Angeles, 1997
Ektacolour print mounted on 4-ply board
67 x 101.5 cm

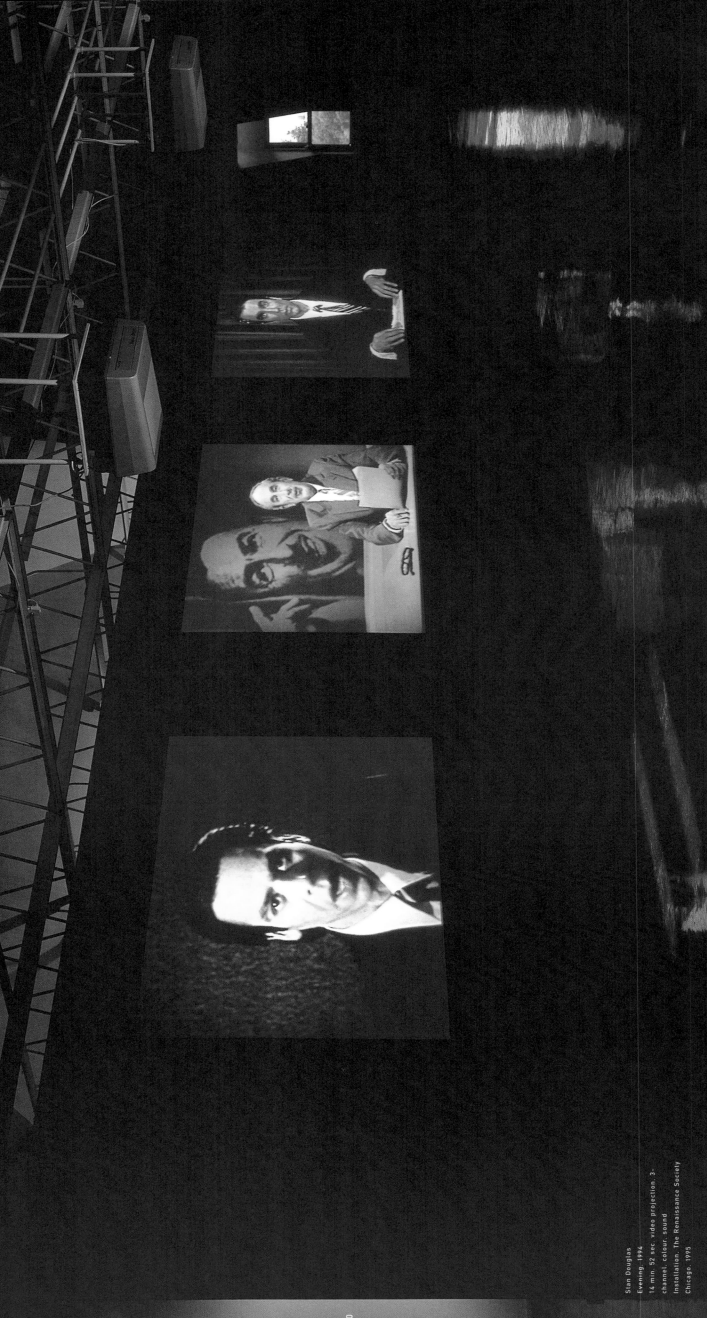

Stan Douglas
Evening, 1994
14 min 52 sec, video projection. 3-
channel, colour, sound
Installation, The Renaissance Society
Chicago, 1995

stan douglas

Stan Douglas' work marks, and in many ways
its crossroads. While its earliest parameters were set by its considerable technical limitations dur
efforts of video artists in the 1980s seemed to be given over to exploring the same panorama of
filmmakers and music-video directors were also pioneering. When Douglas' work was first introd
Documenta IX in 1992, the number of artists who were interested in merging a socio-cultural cri
video's technological frontiers were considerably fewer than today. As video moves away, however,
as a young medium, it will become as central to visual literacy in the twenty-first century as photog
rules of art history more or less require that an artist emerge who can apply its complex fluidity to
of processing knowledge, and Douglas' increased prominence appears to stem from the fact that he i
comfortably occupy that position.

Based in Vancouver, Douglas questions historical relationships from a number of distinct vantage
media practices and frontier narratives. Set to a score by Arnold Schönberg, which was originally co
film, *Pursuit, Fear, Catastrophe: Ruskin BC*, 1993, tells the story of a young Japanese Canadian, Hiro,
find him, his room-mate Theodore, also of Japanese origin, is frustrated and dispirited by the indiffe
scene shifts dramatically in the work *Evening*, 1994, which permits the viewer to contrast three differe
broadcasting from three recent periods, each of which shows the progressive degeneration of journal
nadir. In both of these examples, Douglas' desire to have the medium appear to speak for itself plac
relationship to the historical past. Details and nuances that were once overlooked are now glaringly ap
ulate on the degree to which our own period both reveals and conceals its biases and blind spots.

By allowing his appropriated media forms gradually to reveal their own inherent strengths and limitatio
point where the viewer's ability to analyze and critique his or her own experience becomes entwined w
constantly shifting illusion. In his most ambitious work to date, *Der Sandmann*, 1995, Douglas uses the
jector to create the impression of a filmset in which past and present invariably overlap and collide. T
standing on the ruins of our forerunners' crimes, he seems to be saying, does not exonerate us from fully
applying its lessons to our equally uncertain present.

Dan Cameron

Stan Douglas
Hors-champs, 1992
13 min video projection, black and white sound
Dimensions variable
Installation, Institute of Contemporary Arts, London, 1994
Collection: Centre Georges Pompidou, Paris

Stan Douglas
As Is, from Monodramas, 1991
30–60 sec, video, colour, sound

stan douglas

Born Vancouver, 1960. Lives and works in Vancouver.

selected solo exhibitions:

1983 Sidewards, Ridge Theater, Vancouver 1988 Samuel Beckett: Teleplays, Vancouver Art Gallery and tour 1993 'Monodramas', Galerie Christian Nagel, Cologne; 'Hors-champs', Transmission Gallery, Glasgow 1994. Stan Douglas', Institute of Contemporary Arts, London; Viewpoint Photography Gallery, Salford, England; Centre Georges Pompidou, Paris; Museo Nacional Centro de Arte Reina Sofia, Madrid; Kunsthalle, Zurich; Witte de With, Rotterdam 1995 David Zwirner, New York; Marstall, DAAD, Berlin; 'Evening and Hors-champs', The Renaissance Society, University of Chicago 1996 Museum Haus Lange, Haus Esters, Krefeld, Germany; 'Stan Douglas Photographs', Zeno X Gallery, Antwerp, Belgium 1997 'Evening', Museum of Contemporary Art, Chicago

selected group exhibitions:

1983 Vancouver: Art and Artists 1981–83', Vancouver Art Gallery 1989 'Photo Kunst', Staatsgalerie, Stuttgart; 'Biennial Exhibition of Contemporary Art', Musée des Beaux Arts du Canada, Ottawa 1990 Aperto, XLIV Venice Biennale; 'Re-enactment, Between Self and Other', The Power Plant, Toronto 1991 'The Projected Image', Museum of Modern Art, San Francisco 1992 Documenta IX, Kassel, Germany 1993 'Out of Place', Vancouver Art Gallery 1994 Beeld/Beeld', Museum van Hedendaagse Kunst, Ghent 1995 Lyon Biennale; Carnegie International, The Carnegie Museum of Art, Pittsburgh 1996 Hugo Boss Prize, Guggenheim Museum Soho, New York; 'Jurassic Technologies Revenant', 10th Sydney Biennale 1997 'Trades Routes: History and Geography', 2nd Johannesburg Biennale; Documenta X, Kassel, Germany; Skulptur, Projekte Münster, Germany; Lyon Biennale; Kwangju Biennale, South Korea

selected bibliography:

1985 Scott Watson, 'The Afterlife of Interiority', Panoramic Rotunda', C Magazine, Vancouver, Summer 1992 David Joselit, 'Projected Identities', Art in America, New York, November 1993 Lynne Cooke, 'Broadcast Views, Stan Douglas interviewed by Lynne Cooke', frieze, London, September/October 1994 José Lebrero Stals, 'Global Art', Flash Art, Milan, Summer 1995 James Casebere, 'Mobius Strip' (interview with Stan Douglas), Blind Spot, No 6, Vancouver; Peter Schjeldahl, 'In Love Again', The Village Voice, New York, 11 April; Sabine B. Vogel, 'Review', Kunsthalle Zürich', Artforum, New York, January 1996 Roberta Smith, 'Past and Present, Dancing Towards Progress', The New York Times, 27 December 1997 Ronald Jones, 'Stan Douglas', frieze, London, March/April 1998 Scott Watson, Diana Thater, Carol J. Clover, Stan Douglas, Phaidon Press, London

Stan Douglas
Der Sandmann
1995
9 min. 50 sec. looped video projection.
black and white, sound
Dimensions variable

Stan Douglas
Onomatopoeia
1985–86
Black and white slide projection slides.
slide projector, screen, player piano.
music roll
Dimensions variable
Installation. David Zwirner Gallery.
New York. 1997
Collection. Vancouver Art Gallery

olafur eliasson

Olafur Eliasson's sculptures and light works are concerned with the relationship between nature and technology. He stresses romantic issues through the use of technological devices whose goal is to distort pure feeling to a point that will generate a new, mutant sensibility, more intense than that already nested in the collective imagination.

An Icelandic artist now based in Cologne, Eliasson has formulated his project around rebuilding fragments of his lost homeland in different parts of the world. Using special effects to produce fake phenomena, he aims to find the secret formula within natural events which produces pure human reaction. For Eliasson, immaterial sensations such as temperature, smell, taste, air and magnetic waves become sculptural elements when harnessed within an art context.

Historically, Eliasson's work can be traced back to a Scandinavian tradition which dwelt on the melancholia of the modern individual alone in the face of nature. His precursors range from the heroic landscapes of Edwin Church and Thomas Moran, to Caspar David Friedrich's idea of the sublime and human longing, to Buckminster Fuller's visionary architecture. His sculptures like *The Moss Wall*, 1995, *By means of sudden realization*, 1996, *Your strange certainty still kept*, 1996, or *Your Sun Machine*, 1997, are not outdoor pieces adapted to an interior, but outdoor pieces surrounded by a different architecture from that organized by nature around buildings. The 'outside' becomes the work and the 'inside' functions as the base, the vitrine. His ultimate ideal is perhaps to create a series of conduits that will join the inside with the outside both in terms of physical space and in terms of mental perception.

Eliasson is an aesthetic documentarist: his analysis of reality is simultaneously objective and emotional, and his belief is that what we see and what we feel are two separate, parallel tracks that will only come together when a certain mental awareness is stimulated by our impact with the environment, organized around and inside us by the artist. Symbolically, he is forging an unlikely truce between two conflicting worlds — the natural and the technological. His work questions the artist's conceptualization of the 'organic' and suspicion of the 'industrial'. How, he asks, in a modern reality that is entering the realm of virtuality and destabilizing the very tangibility of existence, can the artist escape the temptation of embracing the electronic era to the point of oblivion?

Eliasson's *modus operandi* in answering this question is to make a series of experiments which negotiate between the natural world to which he belongs and the modern generation of which he is part. If he has found a solution, it is in the attempt to reverse the equation, forcing nature to come to terms with the exploitative master of our times: technology.

Francesco Bonami

left: Olafur Eliasson
The Curious Garden (detail), 1997
Yellow light
Dimensions variable
Installation, Kunsthalle, Basel

Olafur Eliasson
The Curious Garden (detail), 1997
Metal, plastic foil, trees
Dimensions variable
Installation, Kunsthalle, Basel

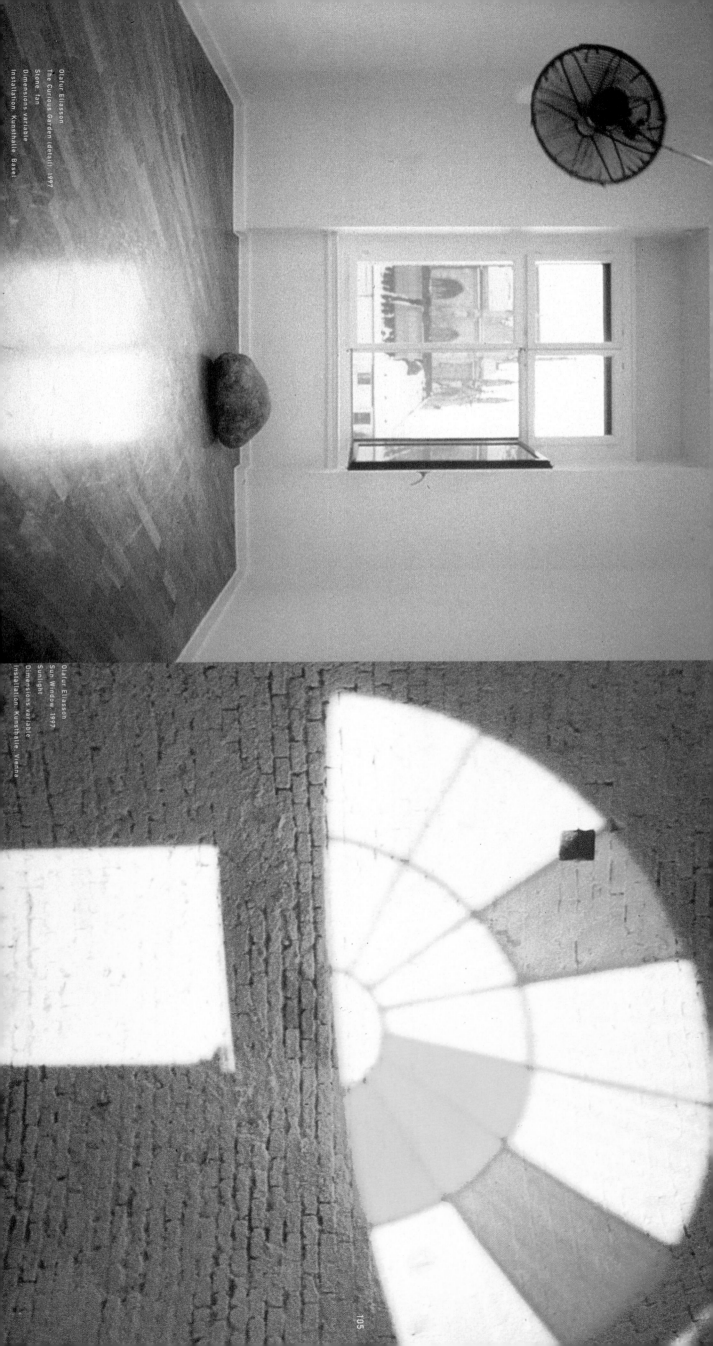

Darling. Cultural Exchange. *Los Angeles Weekly*. 9 May. Ralf Christofori. 'Die natürliche Ordnung der Dinge'. *neue bildende*
atmospheres. *siksi*. No 3. Helsinki: Hans Rudolf Reust. Olafur Eliasson: Basel Kunsthalle. *Artforum*. New York. Summer. Michael
May/June: Christiane Schneider. 'Olafur Eliasson'. *frieze*. London. January/February. 1997 Francesco Bonami.
Eliasson at Tanya Bonakdar. *Art in America*. New York. December. Francesco Bonami. 'Olafur Eliasson'. *Flash Art*. Milan.
Olafur Eliasson. *Zitty*. No 25. Berlin 1996 John Rapko. 'Glow'. *Artweek*. New Langton Arts. July. Paul Smith. Olafur
'Nuit Blanche'. ARC. Musée d'Art Moderne de la Ville de Paris **selected bibliography:** 1995 Tabea Metzel.
Endless Conclusions'. Site Santa Fe. New Mexico 1998 11th Sydney Biennale. 'Sightings'. Institute of Contemporary Arts. London
ties. 5th Istanbul Biennale. 'Trade Routes'. History and Geography. 2nd Johannesburg Biennale. 'Truce'. Echoes of Art in an Age of
Campo 95. Venice. 1996 Manifesta 1. Rotterdam. XXIII São Paulo Biennial. 1997 On life, beauty, translations and other difficul-
1989 Ventilator Projects'. Charlottenborg Konsthall. Copenhagen 1994 'Europa'. Ausstellung Münchner Galerien. Munich 1995
selected group exhibitions: The Curious Garden'. Kunsthalle. Basel
Gallery. New York. 1997
angenehme Übung zu deren Eigenschaften. neugerriemschneider. Berlin 1996 Your Strange Certainty Still Kept'. Tanya Bonakdar
diese Nacht. Lukas & Hoffmann. Cologne 1995 Thoka'. Kunstverein. Hamburg. eine Beschreibung einer Reflexion. oder aber eine
solo exhibitions: 1991 Overgarden Galleri. Copenhagen 1994 'Einige erinnern sich. dass sie auf dem Weg waren
Born Copenhagen. 1967. Lives and works in Cologne. **selected**

olafur eliasson

Olafur Eliasson
Your Windless Arrangement. 1997
Wood. fans. metal
300 x 450cm
Installation. Louisiana Museum.
Humlebæk. Denmark

106

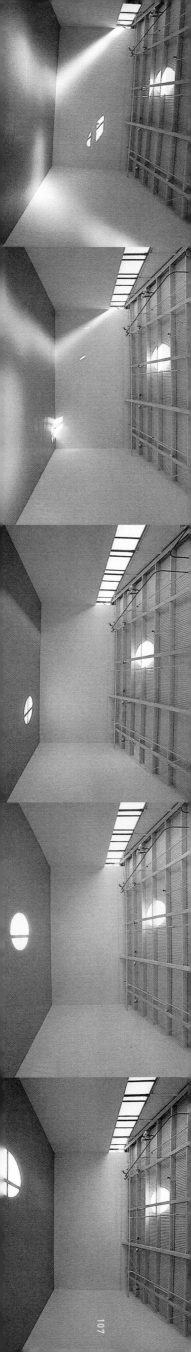

sharon ellis

Sharon Ellis' paintings of Brobdingnagian lilies worshipping in the moonlit sk[y], Rorschach-esque galaxies as razzle-dazzle as Disneyland's Electric Light Parade, and beanstalks of transparent chartreuse, slithering up and over the horizon, flirt with that most affable of genres – landscape – only to twist it into something defiantly overwrought.

Like fever dreams, Ellis' large, alkyd-on-canvas images infuse memory with desire. Here everything is at once crystalline an[d] impossible to fathom; roots turn into fine lace and lace into barbed wire; dew drops become rain drops become black tears, spillin[g] up instead of down, a symptom of nature's chilling perversity.

Yet the natural world enters into these paintings only by proxy, which is to say that Ellis is concerned with nature as it has bee[n] re-invented by culture. In her 1994-95 series *The Four Seasons*, this is already clear. *Summer's* luminous green waves, for example, are repeated in rhythmic intervals like wallpaper patterns. *Autumn's* brilliant sunset conjures nothing so much as a scree[n] saver programme.

In more recent work, the allusions continue to proliferate like weeds, the wretched excesses of the pop imaginary mixing it up wit[h] familiar elements from art history. Yet perhaps most interesting is the way Ellis struggles to transcend these very references (th[e] woozy forms of 1960s psychedelia, heavy metal esoterica, the ersatz depths of computer imaging, Romanticism's doomsday sent[i]ment) to get at something truly idiosyncratic.

Beauty is many things: an ideal, a gift, a threat. Ellis deploys it as a strategy: intricate form plus saturated colour plus symmetr[i]cal composition plus exquisite, uninflected surface. But as self-conscious as these beautiful paintings are, they do not succumb [to] irony, which is what differentiates them from, for example, Alexis Rockman's hyperbolic renderings of desecrated beaches an[d] forests, or Lari Pittman's manically perfectionist doodles. This is not to say that Ellis' art is not decadent. It is, in the sense th[at] decadence implies a rejection of the banalities of nature in favour of the extravagances of artifice. One thinks here of De[s] Esseintes, the anti-hero of Huysmans' *À Rebours*, 1884, who possessed a tortoise whose shell was inlaid with gold and preciou[s] gems; a collection of liquors, each corresponding to a musical instrument on which a synaesthetic symphony of the taste bud[s] could be played; who favoured all-black meals; and whose walls were bound like books in large-grained, crushed morocco. Elli[s]

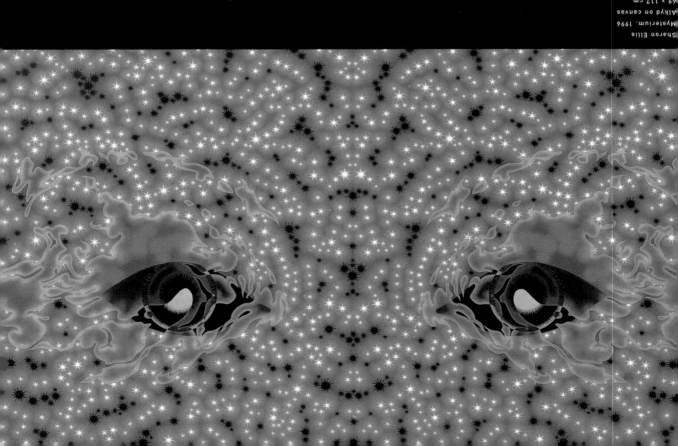

Sharon Ellis
Mysterium, 1996
Alkyd on canvas
69 x 117 cm

right. Sharon Ellis
Night. 1997
Alkyd on canvas
102 x 76 cm

far right. Sharon Ellis
Lunarium. 1996
Alkyd on canvas
66 x 56 cm

Sharon Ellis
Spring. 1994
Alkyd on canvas
71 x 102 cm

sharon ellis

Born Great Lakes, Illinois, 1955. Lives and works in Los Angeles. **selected solo exhibitions:** 1985 Beulah Land, New York 1990 Los Angeles Contemporary Exhibitions, Los Angeles 1991 Dorothy Goldeen Gallery, Santa Monica, California 1996 'The Four Seasons', Museum of Art, Long Beach, California 1999 Christopher Grimes Gallery, Santa Monica, California **selected group exhibitions:** 1990 'Six Painters', Matthew Scott Gallery, Los Angeles 1992 'California North and South', The Aspen Art Museum, Colorado 1993 'Serious Beauty', Metropolitan Momentary Contemporary Art Museum, Los Angeles; 'The Imp of the Perverse', Sally Hawkins Gallery, New York 1994 'Current Abstractions', Municipal Art Gallery, Los Angeles 1995 'Postmarked LA', PPOW, New York; 'A Vital Matrix', Domestic Setting Gallery, Los Angeles 1996 Galeria Camargo Vilaca, São Paulo 1998 'California Current', Rare, New York **selected bibliography:** 1990 Michael Anderson, 'Los Angeles Reviews', *Contemporanea*, New York, October 1991 Alisia Tager, 'Colors', *Lapiz*, Madrid, October 1993 David Pagel, 'Sharon Ellis', *The Los Angeles Times*, 16 September 1994 Jan Tumlir, 'Processes and Properties', *Artweek*, New York, March 1995 Tobey Crockett, 'Sharon Ellis', *Art in America*, New York, November; Susan Kandel, 'Sharon Ellis: An Eye for Post-Symbolism', *The Los Angeles Times*, 29 May 1996 Susan Kandel, 'Sharon Ellis', *The Los Angeles Times*, 24 October 1997 David Pagel, 'Out of This World', *Art issues*, Los Angeles, January/February; Sue Spaid, 'Cosmopolitan Nights', *art/text*, Sydney, Spring; Jan Tumlir, 'Sharon Ellis @ Christopher Grimes Gallery', *X-Tra*, No 1, Los Angeles

Sharon Ellis
Winter, 1994
Alkyd on canvas
71 x 102 cm
Collection, Long Beach Museum of Art,
California

Tony Feher
Untitled, 1996
Plastic bottles, water, food dye,
wire, rope
Dimensions variable

tony feher

Tony Feher's art begins with a close examination of the world around him, in particular the way in which value relations seem predicated on largely unexamined principles of use and scarcity. Focusing on the intrinsic beauty of things that have been discarded, Feher prepares for a work by scavenging his environment for the constituent parts of his sculptures. Acquiring both actual and intended rubbish as a way of investigating both the usefulness of the material and its inherent formal beauty, he then sets about re-conceiving his recycled objects in the form of densely packed tableaux. Regardless of whether they are arranged in tight clusters or strung along a rope, or even if they are mixed together into variegated accumulations of widely differing shapes, sizes and colours, the link between all of Feher's works is the sense of having been created out of nothing.

Although Feher's work is intended to be as simple and direct as possible in compositional terms, the end result invariably reveals to the viewer a level of private signification that seems deeply rooted in the visual poetry of childhood. In a sense, Feher is constructing paradigms for the way in which we first see the world when the desire to make and build things is still in its most nascent state. For example, to draw our attention to the aesthetic significance of a row of bottles that have been filled with varying amounts of water (*Untitled*, 1997), so that the gradually rising and falling line created by the differing levels becomes a kind of drawing in space, is to acknowledge that a genuine expression of the sublime requires little more than the disposition of the viewer to see the world as an endlessly unfolding set of wonders. This is not to make the case for Feher as the Joseph Beuys of the dustbin, but it does entail a recognition of the radical transformation that sculpture has undergone over the past ten years, especially in the wake of Felix Gonzalez-Torres' explorations of systems of social exchange, such as *Untitled (Memorial Day Weekend)*, 1989, a stack of prints of which there were endless copies to be taken away by viewers. Like Gonzalez-Torres, Feher rejects the notion of sculpture as something that the artist merely produces. Instead, he prefers to explore the possibility that sculpture surrounds us constantly, and that our reliance upon artists is predicated on their skill at pointing out the beauty that is already there. Although Tony Feher has been actively exploring these channels of expression for several years, the times have clearly caught up with him, in the sense that more artists seem to be investing their energy in changing public perceptions about art than in attempting to incorporate mostly formal innovations into their working process. After prolonged exposure to Feher's art, one tends not to see the world in quite the same way as before: previously overlooked nuances of perception take on greater importance in the wake of our discovery that the world is more or less full of phenomenal experiences that are one small step away from being art.

Dan Cameron

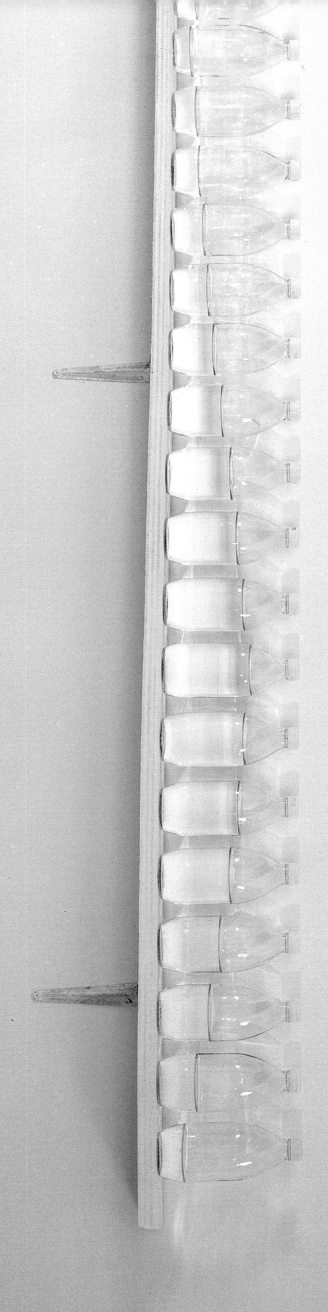

Tony Feher
Untitled, 1997
Bottles, water, wood
20.5 x 12.5 x 239 cm

tony féher

Born Albuquerque, New Mexico, 1956. Lives and works in New York.

selected solo exhibitions: 1993 Wooster Gardens, New York 1994 The Contemporary, New York 1995 Acme, Santa Monica, California 1996 'Broadway Window Project', New Museum of Contemporary Art, New York 1997 D'Amelio Terras, New York

selected group exhibitions: 1980 'Foundation Show'. Art Museum of South Texas, Corpus Christi, Texas 1990 Andrea Rosen Gallery, New York 1991 'Gulliver's Travels'. Galerie Sophia Ungers, Cologne 1993 'Fiutra Book Collection', Air de Paris, Nice; 'Yours'. Wooster Gardens, New York 1994. 'Spring 1994 Exhibitions with Thomas Busch', P.S. 1 Museum, New York 1995 'Thresholds'. Serralves Foundation. Porto, Portugal. 1996 Paula Cooper Gallery, New York

selected bibliography: 1991 Barry Schwabsky. 'Mitchell/Feher/Hayes'. Arts Magazine, New York, November. Roberta Smith. 'Three Artists Who Favour Chaos'. The New York Times, August 1993 Kim Levin. 'Voice Choices'. The Village Voice, New York, 16 November. Roberta Smith. 'Group Shows in Soho for a Weekend of Gallery Hopping, Things of Beauty'. The New York Times, 15 January 1995 Nico Israel. 'Tony Feher: Richard Anderson Gallery'. Artforum, New York, March. Kim Levin. 'Choices: Art Short List. Tony Feher'. The Village Voice, New York, 21 November. Roberta Smith. 'The Lasting Impact of Some Witty 1970s Ephemera'. The New York Times, 12 November. Jose Luis Brea. 'Threshold'. Artforum, New York, November 1996 Stephanie Cash. 'Tony Feher at Richard Anderson'. Art in America, New York, April 1997 Holland Cotter. 'Art and Aids: The Stuff Life is Made of ...'. Art in America, New York, April

Tony Feher
Long Term Pillow 1997
Sand mix, plastic flowers
18.5 x 38 x 35.5 cm

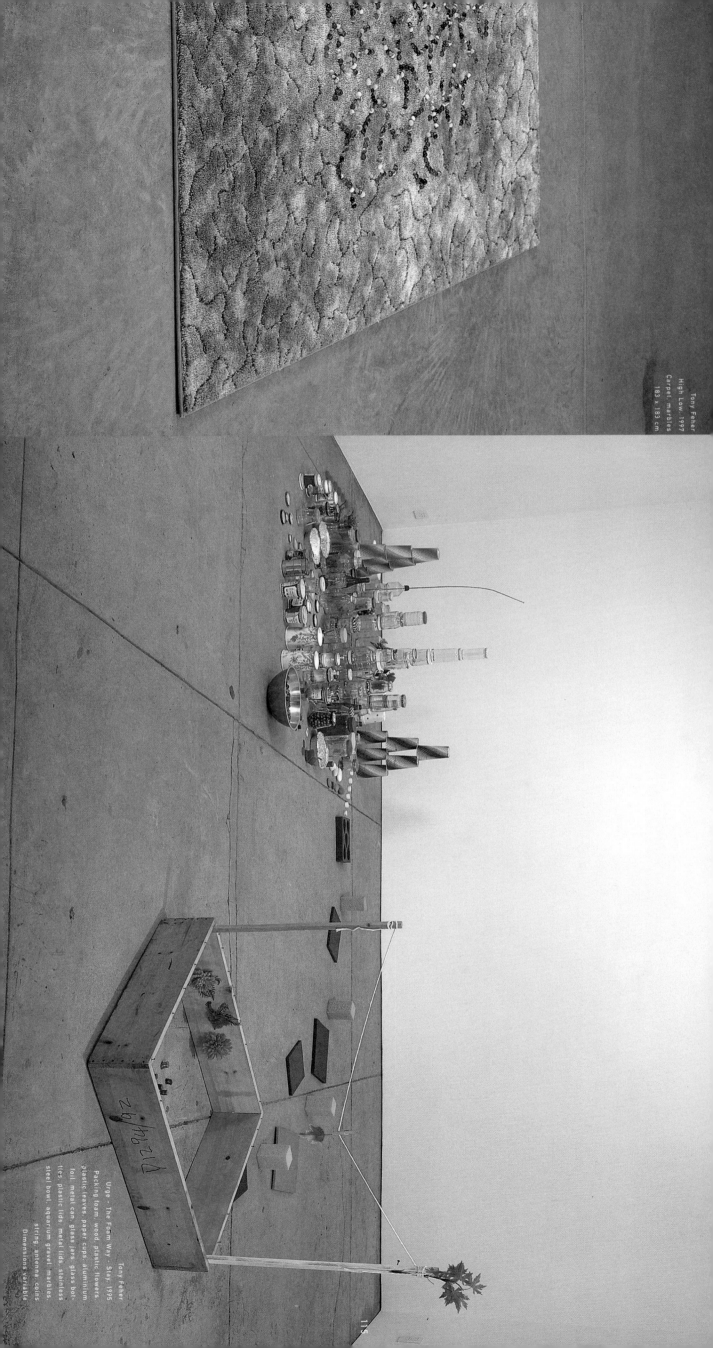

Tony Feher
High Low. 1997
Carpet, marbles
183 x 183 cm

Tony Feher
Urge - The Foam Way - Stay. 1995
Packing foam wood, plastic flowers,
plastic leaves, paper cups, aluminium
foil metal can, glass jars, glass bot-
tles, plastic lids, metal lids, stainless
steel bowl, aquarium gravel, marbles,
string, antenna, coins
Dimensions variable

115

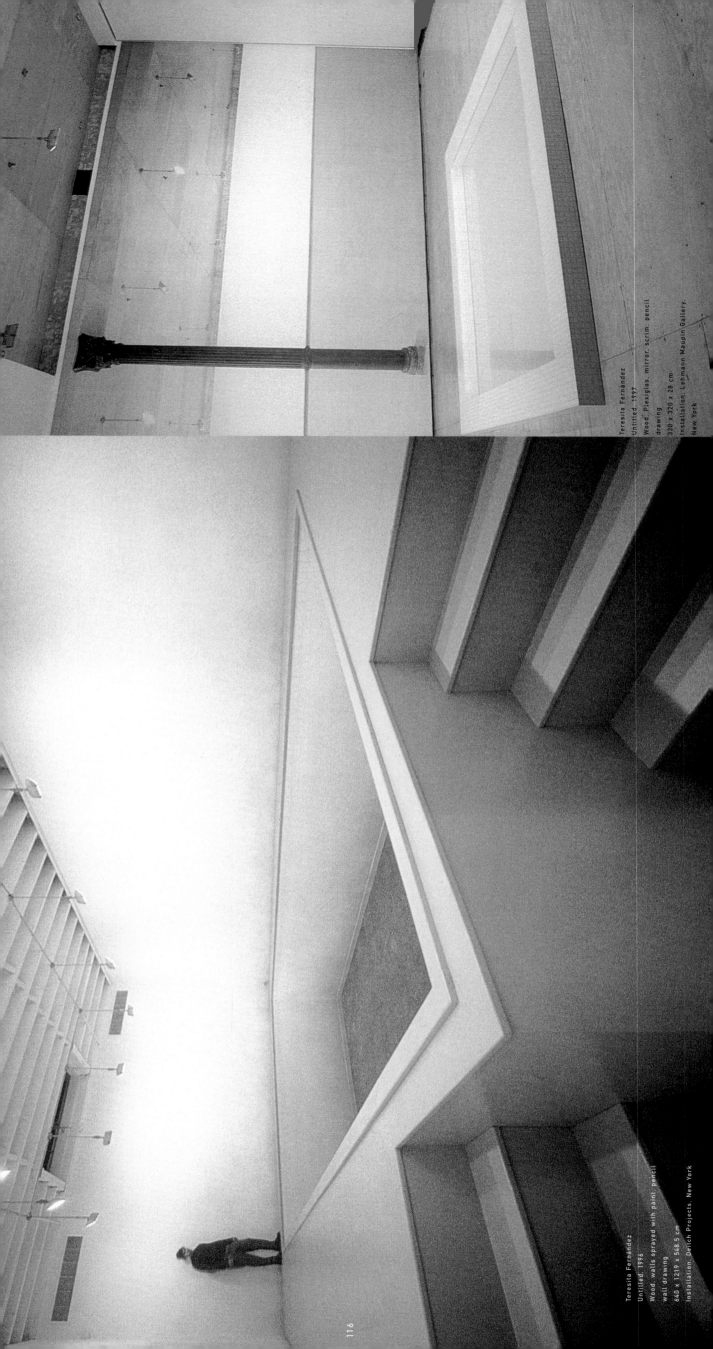

Teresita Fernández
Untitled, 1997
Wood, Plexiglas, mirror, scrim, pencil
drawing
320 x 320 x 28 cm
Installation, Lehmann Maupin Gallery,
New York

Teresita Fernández
Untitled, 1996
Wood, walls sprayed with paint, pencil
wall drawing
640 x 1219 x 548.5 cm
Installation, Deitch Projects, New York

teresita fernández

Untitled, 1996. Untitled, 1996 brings together most of the hallmark elements of Teresita Fernández' work. On entering the New York gallery where the piece was exhibited, you could just discern two precarious flights of sky-blue wooden steps rising to a height of more than a metre and a half above the gallery floor. These led up to a narrow ledge in the same light blue, which ran all around the walls of the gallery space like a catwalk, redefining the venue as a blank rectangle.

Walking around the ledge, the viewer could not resist leaning over to contemplate the space contained within: a void, the bottom of which was nothing more than the gallery floor. The walls of the gallery above the ledge had been painted in the same tones of blue, fading in intensity the closer they got to the ceiling. The impression was of being in an empty swimming pool fitted into another inverted one. This perceptual *mise-en-abîme* was exacerbated by the vague feeling of violated intimacy that one experienced while walking along the ledge. A disquieting sensation of displacement, mixed with a feeling of exposure and unprotectedness, was induced by the gazes of the other spectators proceeding along their own sections of the ledge. This was compounded by a slight dizziness when looking into the empty gallery below.

Fernández conceived the piece with the architectural particularities of this commercial gallery in mind, transforming it by her intervention into a kind of vast, quietly vertiginous hollow, almost greedy and impossible to fill. By the time you became aware that the function of the gallery had been at once dubiously obeyed as well as exposed by the work, your own self-perception had been dramatically altered by these subtle tactics. Eventually, you searched the walls for some point of orientation, which was ultimately elusive: the piece offered only the illusion of encountering yourself from head to toe inside the space. By undermining any sense of stability, the empty space both repelled one and became irresistible. Consequently you were confronted with a profound sensation of floorlesssness – the absence of a solid, compact, underlying surface that could hold you, body and mind. Rather than mimicking its swimming-pool model, the schematic character of the piece evoked it, as if it were a memory. The mnemonic dimension of *Untitled,* 1996, with its lack of precision, heightened the physical sensation of disorientation – spatial as well as temporal, fluctuating between the present and some half remembered past. *Untitled,* 1996, was simultaneously an institutional critique of the gallery format, a work that altered the senses, and a subtle mechanism capable of modifying one's homogeneous perception of time.

Carlos Basualdo

Teresita Fernández
Untitled, 1997
Paint, tinted glass, pencil drawing
335 x 609.5 cm

Teresita Fernández
Landscape (Projected) 1997
Oculus light; pipes: fabric, paint, sound
610 x 915 x 305 cm
Installation, The Contemporary,
Baltimore, Maryland

teresita fernández

Born Miami, 1968. Lives and works in New York and Miami. **selected solo exhibitions:** 1995 Museum of Contemporary Art, Miami 1996 Deitch Projects, New York 1997 Masataka Hayakawa Gallery, Tokyo; The Corcoran Gallery of Art, Washington DC **selected group exhibitions:** 1993 'Thirty and Under', Ground Level Gallery, Miami Beach, Florida 1995 'Selections Spring '95', The Drawing Center, New York 1996 'Enclosures: Installations by Teresita Fernández, Nedko Solakov and Hale Tenger', New Museum of Contemporary Art, New York 1997 'X-Site', The Contemporary, Baltimore; 'The Cystal Stopper', Lehmann Maupin Gallery, New York 1998 'Seamless', De Appel, Amsterdam; 'Threshhold', The Power Plant, Toronto **selected bibliography:** 1995 Judy Cantor, 'Room with a View', *New Times*, Miami, 20 July 1997 Owen Drolet, 'Teresita Fernández', *Flash Art*, Milan, May; Carey Lovelace, 'Weighing in on Feminism', *ARTnews*, New York, May; Monica Amor, 'Teresita Fernández at Deitch Projects', *Art Nexus*, Vol 23, Bogotá, Colombia; Jan Avgikos, 'The Crystal Stopper', *Artforum*, New York, September; John Dorsey, 'X-Site', *The Sun*, Baltimore, 28 October; Margaret Sundell, 'The Crystal Stopper', *Art Nexus*, No 25, Bogotá, Colombia, July/September; Mike Giuliano, 'Global Warnings', *The City Paper*, Baltimore, 3 December 1998 Carlos Basualdo, 'X-Site '97', *Artforum*, New York, March; Jade Dellinger, 'Cityscape: Florida', *Flash Art*, Milan, March/April; Adam J. Lerner, 'Teresita Fernández/Quisqueya Henriquez', *Art*

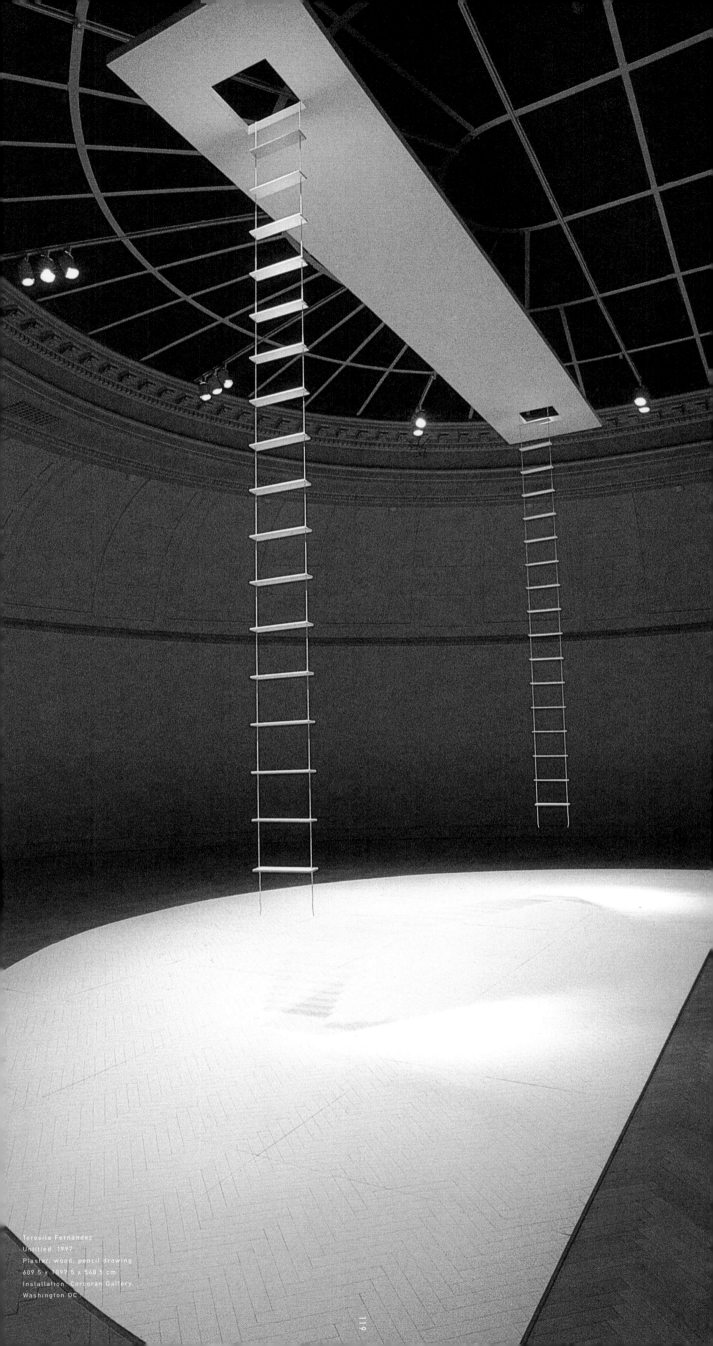

Ceal Floyer
Carousel, 1996
10" record, hi-fi, MDF
Dimensions variable
Installation, Irish Museum of Modern
Art, Dublin, 1997

ceal floyer

'Working notes (1996–98). *View*, 1998: "Site specific" response for "Genius loci", Kunsthalle, Bern, based on site visit [...] The rooms on the basement level are lit by high windows (sill is three metres from floor). My proposal is to supplement this room with a "view" and simultaneously supply the room/the visitor with the simplest necessary means to achieve this: that the visitor might be in a position to view. The tool/prop used – a ladder – will be the sole sculptural presence in the room. A kind of visual "crutch" [...] The work, I hope, oscillates within/manifests the tension between the sculptural presentation inside the gallery space and the hypothetical (meaning that it is not essential or even desirable that the viewer climb the ladder and look through the window) expansive alternative offered, and the fact that the method of activity and the "thing" ultimately obtained share the same word/name – view.

'*Monochrome Till Receipt (White)*, 1998: [A white cashier's receipt lists purchased items of merchandise, which are all the colour white.] Allusion to the visual or perceptual experience offered by the tradition of monochrome painting. As vernacular and banal as the till receipt is, it is nonetheless granted wall status. Mounted directly onto the white (gallery) wall surface, an affiliation with the space of painting and a notion of a "colour field" is implied. The modesty of the final "object" belies the obsessiveness of the project: purchasing – in this case – only white goods [...] "subjects" being monochrome rather than the "object" (receipt – purple text and figures printed on "off white" paper). Necessitates a shift to a different focal plane [...] the acceptance of a journey into a non-visual space – a kind of cognitive aesthetic.

'*Blind*, 1997: For the most part a pure white screen, the video experience is one of blindness in that there is "nothing" to see. Only when the image finally "appears" is it apparent that it was there all along, that the whiteness *IS* the image (the window frame structure being visible to varying degrees only when a draught sucks the blind towards it). In this sense the piece operates in a "retrospective" kind of way, in that the image, if and when seen, makes sense of the blankness and vice versa [...] Real time/durational aspect important: the potential tedium/irritation brought on by lack of stimulus is a necessary aspect of the work [...] Simultaneously abstract and figurative, whilst remaining a straight (video) representation of the blind.

'*Carousel*, 1996: Ten-inch vinyl sound recording of one complete cycle of a standard slide projector (eighty slides). In an otherwise empty room [...] No image is alluded to [...] The (art) "object" interested me more than just the notion of the absent image or any sense of illusion or "trickery"; the replacement of one type of reproductive technology by another. The work derives from the observation of the implicit logic of one coinciding with the formal nature of the other (i.e., both are circular and the same size, both black, both rotate, etc.).

'*Garbage bag*, 1996: Free-standing sculpture, positioned next to a doorway. Medium: black plastic garbage bag, sufficient air that it holds its manufactured form.' (Artist's statement)

Matthew Higgs

Ceal Floyer
View, 1998
Ladder
Approx. 350 cm
Installation, Kunsthalle, Bern

```
              SAINSBURY'S
              WHITECHAPEL
           CAMBRIDGE HEATH ROAD
          MILE END GATE , E1 5SD
          TELEPHONE 0171 247 2604
                                  £
     COTTAGE CHEESE             1.59
     EXTRA REWARD POINTS
      *    25 POINTS *
     * WASTE BIN               0.99
     JS FROMAGE FRAIS          0.62
     PHILADELPHIA              1.19
     RICE NOODLES              0.89
   WHITE ONIONS
     1.37 lb @ £0.99/lb        1.36
     * POLO MINTS              0.18
     JS COD-IN-SAUCE           0.99
     * CANDLE BULB             2.09
     MOZZARELLA 125G           0.69
     PICKLED EGGS              0.85
     PLAIN FLOUR               0.40
     SWTZ MEAT TEND.           1.19
     PURE LARD 250G            0.20
     GARLIC                    0.29
   MOOLI
     1.06 lb @ £0.95/lb        1.01
     PASTEURISED MILK          0.28
     MALDON SEASALT            0.93
     B/IN/BAG B/RICE           1.15
     THAI COCNT MILK           0.79
     HOVIS PREM BREAD          0.59
     WHITE SAUCE MIX           0.36
     TAPIOCA 500G              0.89
     BUTTON MSHROOMS           0.99
     ICING SUGAR               0.65
     NATURAL YOGURT            0.43
     *COTTONWOOL ROLL          0.85
     JS SINGLE CREAM           0.27
     * BODY FIRMING            3.99
     * SHOE WHITNER            1.25
     * NAIL BRUSH              1.29
     * COLGATE PUMP            2.35
     * ACDO GO/WHITE           1.69
     * JS CANDLES              0.85
     * LILLETS SUPER           4.49
     * JIF CREAM CLNR          0.75
     * KITCHEN TOWEL           1.05
     * SPORT SOCKS X2          4.25
     * KLEENEX ULTRA           1.39
     * TOPS FLOSS 50M          1.45
     * JS DOYLEYS X15          0.65
     *JS WTE PLTE X25          2.09
     * JS NAPKINS X25          0.89
     * SHOE LACES              1.05
     * BABY POWDER             2.29
     EXTRA REWARD POINTS
      *    75 POINTS *
     * BIG S/BIN LNRS          0.99
     * DOVE CLEANS SP          0.79
     *ANADIN EXT X12           1.45
     * LIVER SALTS             1.95
     * PERSIL N/BIO/C          4.65

        50 ITEMS PURCHASED
        BALANCE DUE           64.31

   DEBIT CARD                  64.31
        6759600923647970S8  02 10/98

   EXTRA POINTS TO COLLECT      100

      DATE: 29 JAN 98  TIME: 15:32
       LOC: 015 OP:  813 TRANS: 1661

     TO COLLECT SAINSBURY'S POINTS
     REGISTER FOR A REWARD CARD
               TODAY

          BAGS MORE REWARDS
          SEE IN-STORE LEAFLET
           FOR OFFER DETAILS
```

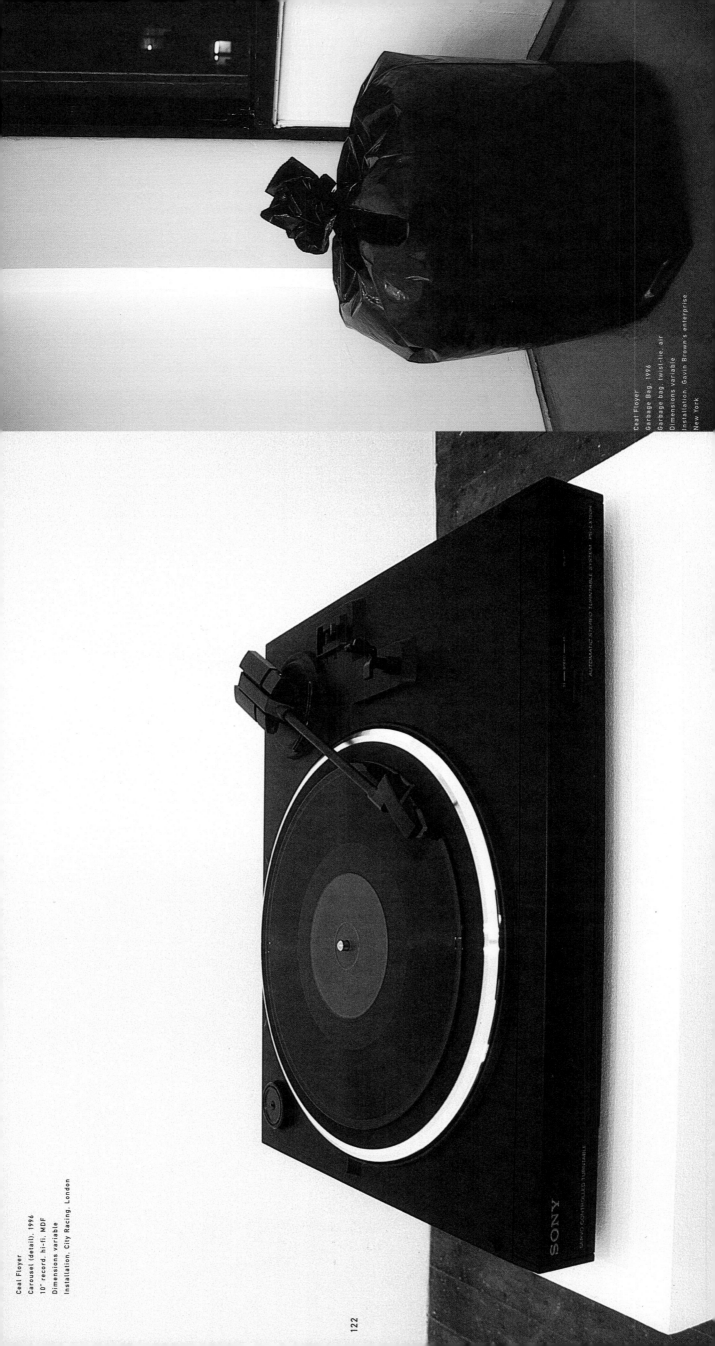

Ceal Floyer
Carousel (detail), 1996
10" record, hi-fi, MDF
Dimensions variable
Installation, City Racing, London

Ceal Floyer
Garbage Bag, 1996
Garbage bag, twist-tie, air
Dimensions variable
Installation, Gavin Brown's enterprise,
New York

122

ceal floyer

Born Karachi, Pakistan, 1968. Lives and works in London and Berlin. **selected solo exhibitions:** 1995 Picture Gallery, Science Museum, London 1996 Gavin Brown's enterprise, New York 1997 Lisson Gallery, London 1998 Cabinet Gallery, London **selected group exhibitions:** 1992 'Hit & Run', Tufton Street, London; 'Fast Surface', Chisenhale Gallery, London 1994 'Fast Forward', Institute of Contemporary Arts, London 1995 XLVI Venice Biennale; 'The Vision of Art in a Paradoxical World', 4th Istanbul Biennale 1996 'life/live', ARC, Musée d'Art Moderne de la Ville de Paris, Centro Cultural de Belém, Lisbon 1997 'Urban Legends – London', Staatliche Kunsthalle, Baden-Baden, Germany; 'Material Culture: The Object in British Art in the 1980s and 1990s', Hayward Gallery, London; 'Projects', Irish Museum of Modern Art, Dublin 1998 'Genius loci', Kunsthalle, Bern **selected bibliography:** 1993 Margaret Garlake, 'From the Infanta to the Lemon', *Art Monthly*, London, July/August 1995 Sotiris Kyriacou, 'Ceal Floyer/Freddy Contreras', *Art Monthly*, London, June; Allan Schwarzman, 'Laguna lacuna', *Artforum*, New York, September 1996 David Barrett, 'Playing Dumb: On Ceal Floyer', *Art Monthly*, London, February 1997 Brian Muller, 'Ceal Floyer', *Flash Art*, Milan, May/June; Godfrey Worsdale, 'Soundings: Ceal Floyer', *Artist's Newsletter*, Sunderland, June; David Batchelor, Carl Freedman, 'Living in a Material World', *frieze*, London, Summer; Michael Archer, 'Ceal Floyer, City Racing', *Art Monthly*, London, June; Brian Muller, 'Ceal Floyer: Seeing the Light', *Contemporary Visual Arts*, No 16, London 1998 David Green, 'Minimal interventions', *Contemporary Visual Arts*, No 17, London

Blind, 1997
30 min. video loop installation, colour
Installation, Irish Museum of Modern Art, Dublin

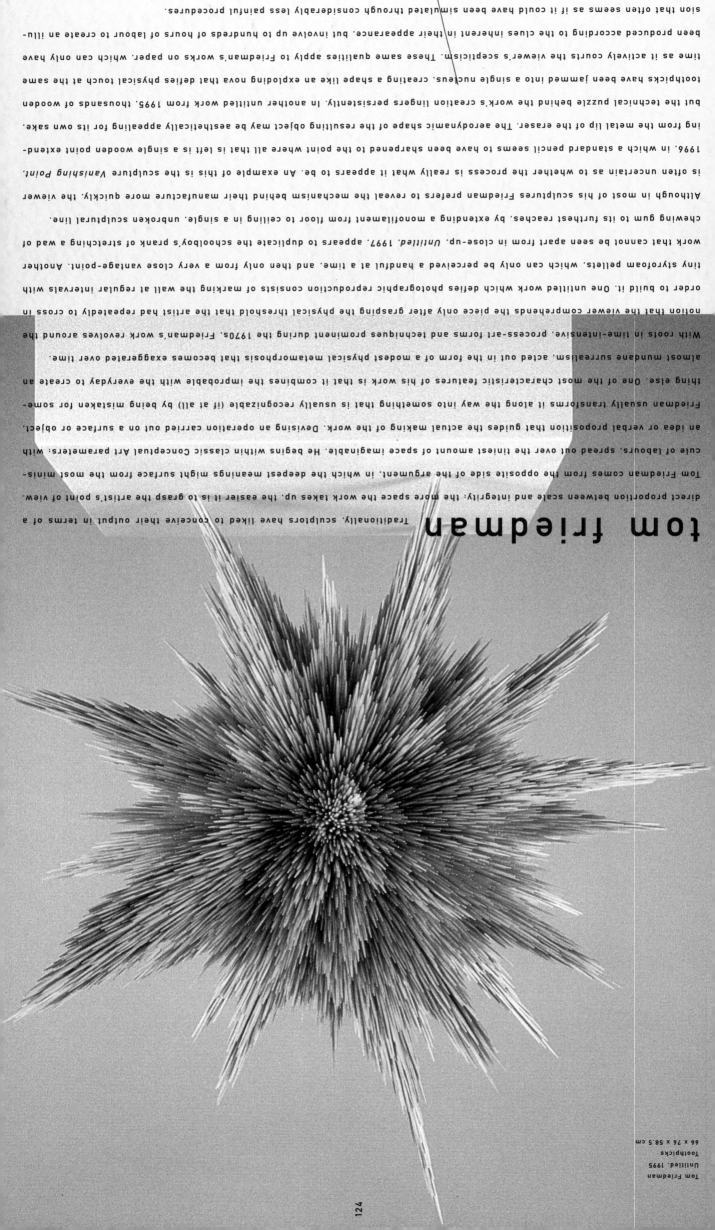

tom friedman

Traditionally, sculptors have liked to conceive their output in terms of a direct proportion between scale and integrity; the more space the work takes up, the easier it is to grasp the artist's point of view. tom Friedman comes from the opposite side of the argument, in which the deepest meanings might surface from the most minis-cute of labours, spread out over the tiniest amount of space imaginable. He begins within classic Conceptual Art parameters: with an idea or verbal proposition that guides the actual making of the work. Devising an operation carried out on a surface or object, Friedman usually transforms it along the way into something that is usually recognizable (if at all) by being mistaken for some-thing else. One of the most characteristic features of his work is that it combines the improbable with the everyday to create an almost mundane surrealism, acted out in the form of a modest physical metamorphosis that becomes exaggerated over time.

With roots in time-intensive, process-art forms and techniques prominent during the 1970s, Friedman's work revolves around the notion that the viewer comprehends the piece only after grasping the physical threshold that the artist had repeatedly to cross in order to build it. One untitled work which defies photographic reproduction consists of marking the wall at regular intervals with tiny styrofoam pellets, which can only be perceived a handful at a time, and then only from a very close vantage-point. Another work that cannot be seen apart from in close-up, Untitled, 1997, appears to duplicate the schoolboy's prank of stretching a wad of chewing gum to its furthest reaches, by extending a monofilament from floor to ceiling in a single, unbroken sculptural line.

Although in most of his sculptures Friedman prefers to reveal the mechanism behind their manufacture more quickly, the viewer is often uncertain as to whether the process is really what it appears to be. An example of this is the sculpture Vanishing Point, 1996, in which a standard pencil seems to have been sharpened to the point where all that is left is a single wooden point extend-ing from the metal lip of the eraser. The aerodynamic shape of the resulting object may be aesthetically appealing for its own sake, but the technical puzzle behind the work's creation lingers persistently. In another untitled work from 1995, thousands of wooden toothpicks have been jammed into a single nucleus, creating a shape like an exploding nova that defies physical touch at the same time as it actively courts the viewer's scepticism. These same qualities apply to Friedman's works on paper, which can only have been produced according to the clues inherent in their appearance, but involve up to hundreds of hours of labour to create an illu-sion that often seems as if it could have been simulated through considerably less painful procedures.

Dan Cameron

tom Friedman
Untitled, 1995
Toothpicks
66 x 76 x 58.5 cm

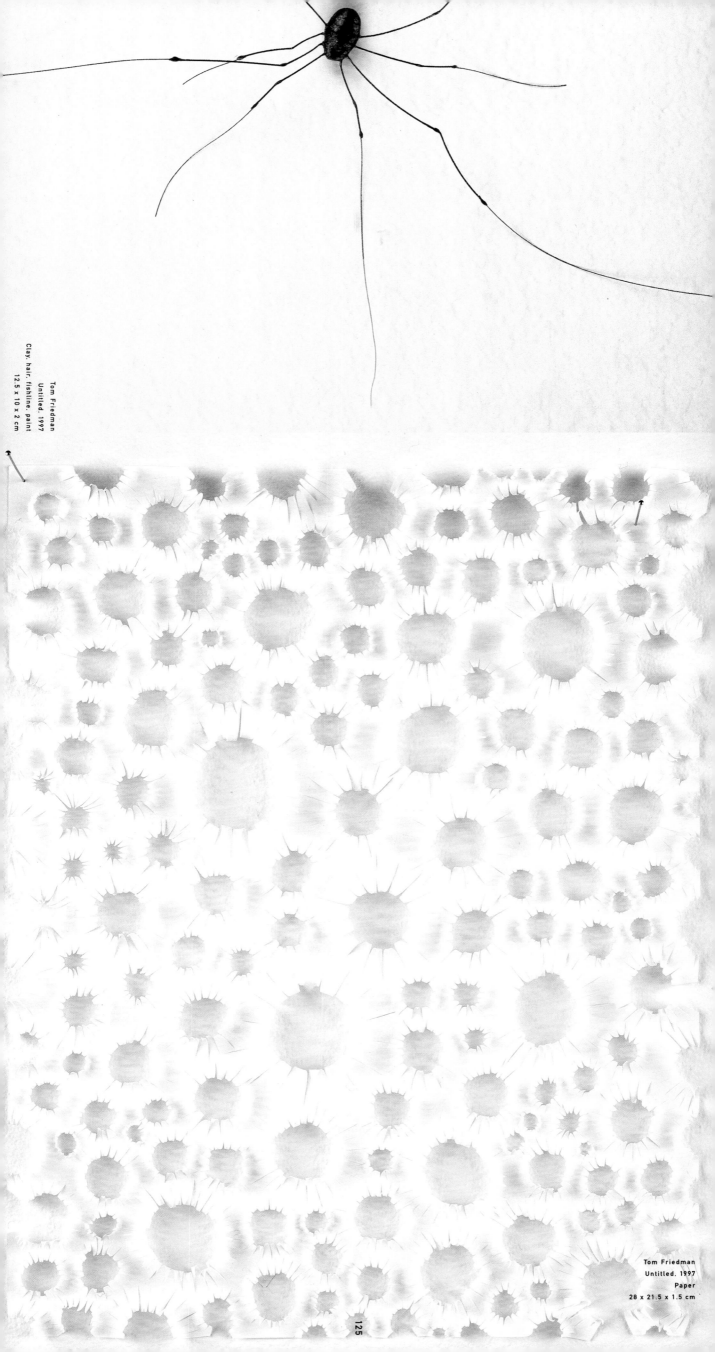

Tom Friedman
Untitled, 1997
Clay, hair, fishline, paint
12.5 x 10 x 2 cm

Tom Friedman
Untitled, 1997
Paper
28 x 21.5 x 1.5 cm

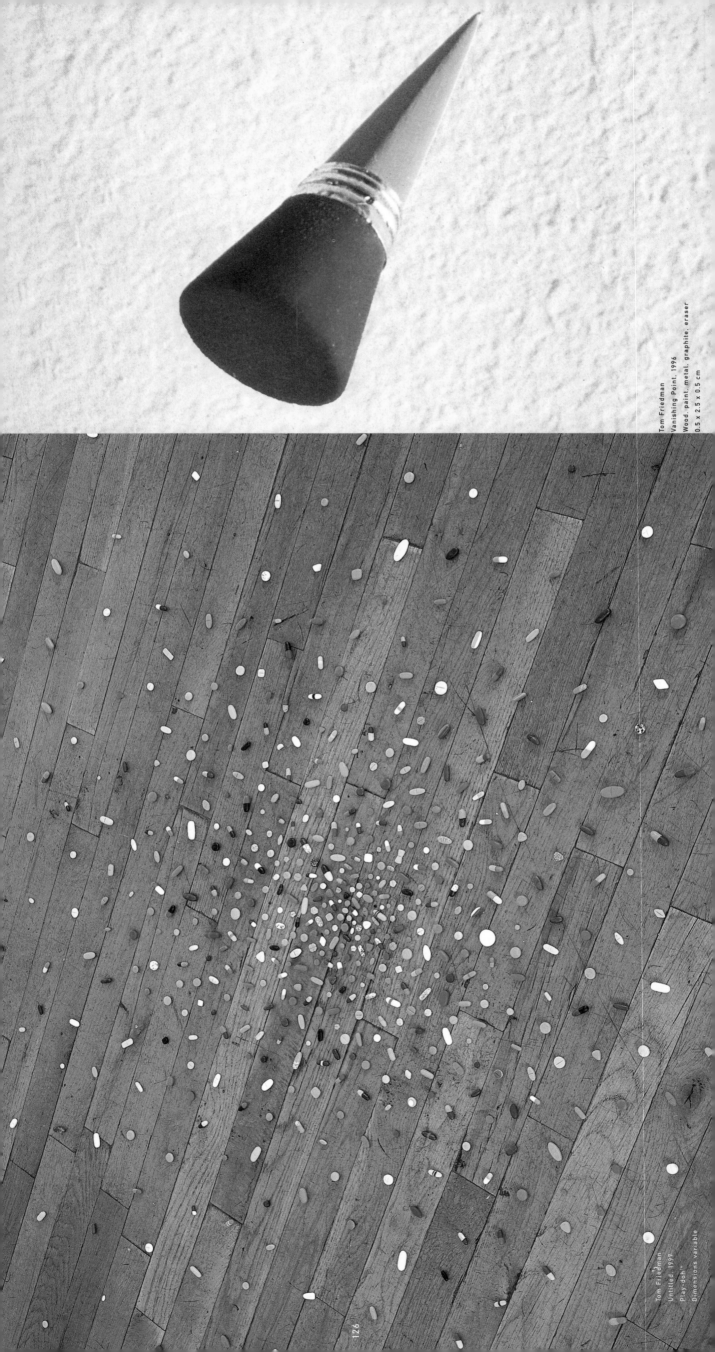

Tom Friedman
Vanishing Point, 1996
Wood, paint, metal, graphite, eraser
0.5 x 2.5 x 0.5 cm

Tom Friedman
Untitled, 1997
Play-doh™
Dimensions variable

tom friedman

Born St Louis, Missouri, 1965. Lives and works in Conway, Massachussetts.

selected solo exhibitions: 1991 Feature, New York 1993 Feature, New York 1994 Galerie Analix, Geneva 1995 'Projects 50: Tom Friedman', The Museum of Modern Art, New York 1996 Stephen Friedman Gallery, London 1997 'Ynglingagatan 7', Stockholm, Sweden 1998 Tomio Koyama Gallery, Tokyo **selected group exhibitions:** 1990 'The Thing Itself', Feature, New York 1991 'Itch', NAME Gallery, Chicago 1992 'Lying on Top of a Building the Clouds Seemed No Nearer Than When I Was Lying in the Street', Galerie Monika Sprüth, Cologne 1993 'Times', Anderson O'Day Gallery, London 1994 Galerie Jennifer Flay, Paris; 'Rien à Signaler', Galerie Analix, Geneva 1995 'I Gaze a Gazely Stare', Feature, New York; 'Oltre la Normalità Concentrica', Palazzo di Zara, Padua, Italy 1996 XXIII São Paulo Biennial; 'Subversive Domesticity', Edwin A. Ulrich Museum of Art, Wichita State University, Kansas; 1997 'A Lasting Legacy: Selections from the Lannan Foundation Gift', The Geffen Contemporary, Museum of Contemporary Art, Los Angeles; 'Lovecraft', Centre for Contemporary Art, Glasgow, Scotland; Cabinet Gallery, London **selected bibliography:** 1991 Roberta Smith, 'Art in Review', *The New York Times*, 13 September 1992 Wolf Kahn, 'Connecting Incongruities', *Art in America*, New York, November; Roberta Smith, 'Art in Review (Casual Ceremony)', *The New York Times*, 3 January 1993 Dike Blair, 'Tom Friedman, Feature', *Flash Art*, Milan, November/December; Lois Nesbit, 'Tom Friedman, Feature', *Artforum*, New York, Summer 1995 Holland Cotter, 'Beneath the Barrage, The Modern's Little Show', *The New York Times*, 7 April; Bruce Hainley, 'Next to Nothing: The Art of Tom Friedman', *Artforum*, New York, November; Jeffrey Kastner, 'lo-fi', *frieze*, London, September/October; Peter Schjeldahl, 'Struggle and Flight', *The Village Voice*, New York, 18 April 1996 Peter Schjeldahl, 'Hudson's Way', *The Village Voice*, New York, 2 July 1997 David A. Greene, 'Captain of Industry', *The Village Voice*, New York, 18 November; David Pagel, 'Review', *Los Angeles Times*, 14 February

right, Tom Friedman
Untitled, 1995
Ink, colour pencil on paper
106.5 x 106.5 cm

Tom Friedman
Untitled (detail), 1997
Monofilament
h. 406.5 cm

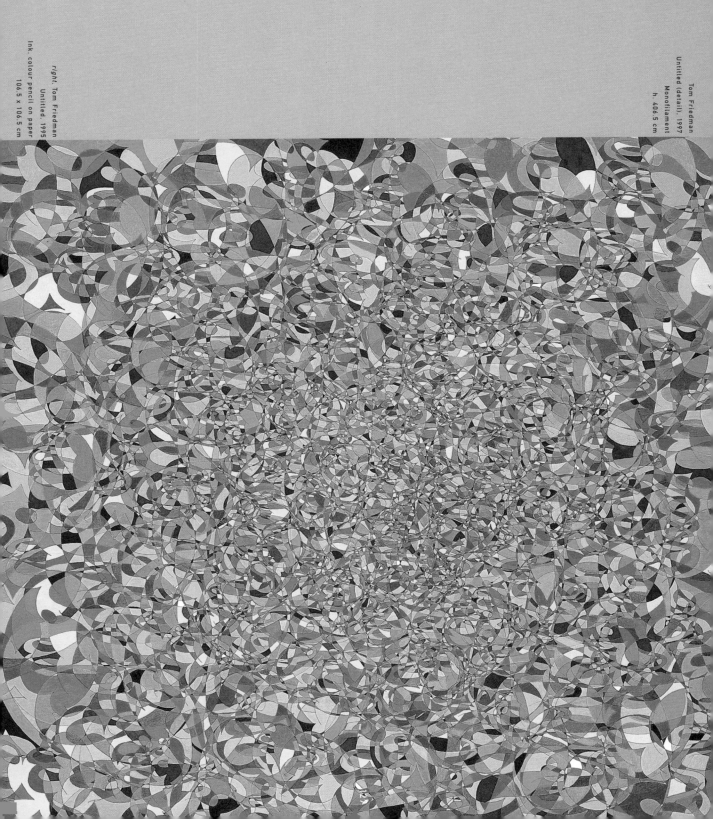

Giuseppe Gabellone
Untitled, 1996
Colour photograph
120 x 180 cm

opposite: Giuseppe Gabellone
Untitled, 1996
Rafia
100 x 100 x 100 cm (closed),
3150 x 300 cm (open)

giuseppe gabellone

The roots of Giuseppe Gabellone's art lie in the recent history of Italian contemporary art as exemplified by figures such as Piero Manzoni, Pino Pascali and Mario Merz. However, he belongs to a younger, less politicized generation whose world is filled with digital and electronic information and for whom mobility is a form of nomadism whereby the mind can move between different realities without experiencing different spaces or real contexts. Thus he is anthropologically programmed both by a specific past, and by a new, computer-generated culture.

In order to create his works, Gabellone makes complex installations whose only function is to act as subjects for his photographs. After he has photographed them they are methodically destroyed. In this sense, his work can be described as abstract: these images do not act as documentation but as a sort of sculptural memory, a representation of labour, a kind of real virtuality, where the idea is created in the space simply to serve a two-dimensional representation.

Gabellone's early videos involved the use of time in a plastic way: the narrative does not exist outside the time-flow of the action performed on the screen. Using unedited footage, the making of the sculpture in the space becomes the image itself, and the monitor the pedestal. What is shown is not a series of fragments but the whole work displayed as a sequence in real time. Even in recent works such as the straw cube, *Untitled*, 1995, or the huge bundle, *Untitled*, 1996, the sculptural element is present through its possible duality, a moment in space that can be contracted or extended independently from its formal function. The final size is then just one of the possibilities, a fantasy or mental projection. In these works Gabellone pushes the viewer into the projection of his or her imagination in a way that recalls Manzoni's *Infinite Line*, 1960, or *Socle du Monde*, 1961.

Ultimately, Gabellone's enquiry revolves around the idea of classic sculpture and its possible perception within a modern reality in which perceptions can be systematically manipulated. His work proposes a formal 'cultural revolution' in the sense that the artist himself unleashes within his work forces that will change the perception of the sculpture from the inside, through the use of conventional drawings and materials. Initially a classical approach is adopted, only to be shattered by rendering it obsolete. Yet, using the same materials without melancholic indulgence, and avoiding any futuristic indulgence or the kind of language/title devices adopted by most of the Italian artists of the last few generations, Gabellone focuses on the almost impossible assumption that the convergence of a visual idea of time into a physical space can create a new, revolutionary sculptural syntax.

Francesco Bonami

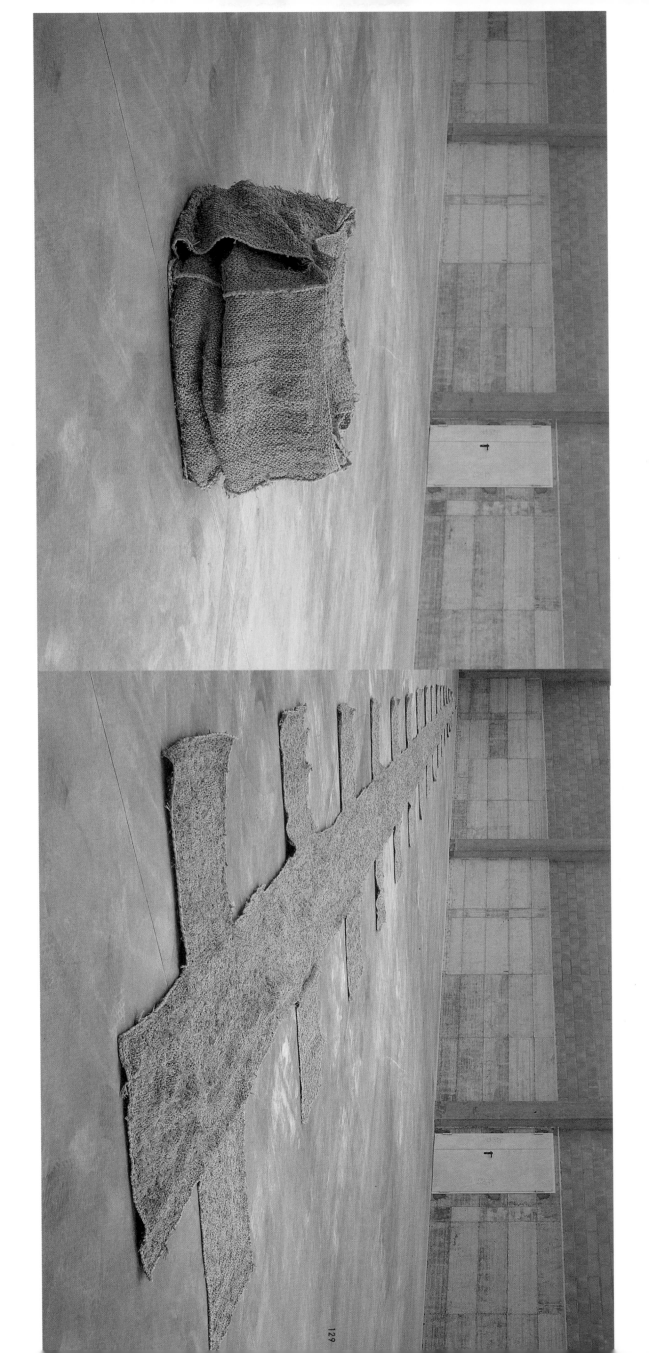

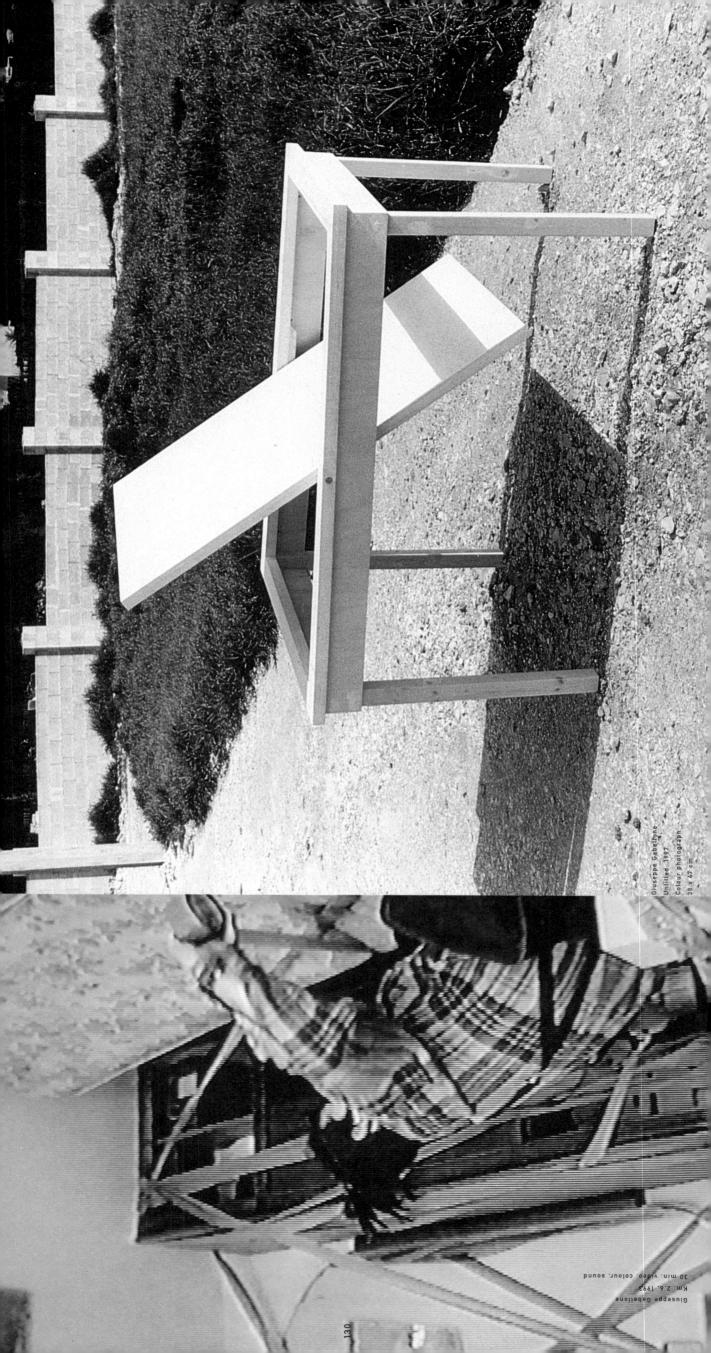

Giuseppe Gabellone
Untitled 1997
Colour photograph
38 x 47 cm

Giuseppe Gabellone
Km. 2.6, 1997
30 min. video, colour, sound

130

giuseppe gabellone

Born Brindisi, Italy, 1973. Lives and works in Brindisi and Milan. **solo exhibitions:** 1996 Studio Guenzani, Milan 1997 Laure Genillard Gallery, London **selected group exhibitions:** 1994 'We are Moving', Viafarini, Milan 1995 'Aperto/Italia '95', Trevi Flash Art Museum, Italy 1996 'Campo 6, Il Villaggio a Spirale', Galleria Civica d'Arte Moderna e Contemporanea, Turin; Bonnefanten Museum, Maastricht 1997 'Vertical Time', Barbara Gladstone Gallery, New York; 'Delta', ARC, Musée d'Art Moderne de la Ville de Paris; 'Truce: Echoes of Art in an Age of Endless Conclusions', Site Santa Fe, New Mexico; XLVII Venice Biennale **selected bibliography:** 1995 Jen Budney, 'Aperto', *Flash Art*, Milan, Summer; Jen Budney, 'The Italian Apertos', *Flash Art*, Milan, October; Helena Kontova, 'Uno, cento, mille Aperto', *Flash Art Italia*, Milan, June/July 1996 Francesco Bonami, *Echoes*, The Monicelli Press, New York; Davide Bertocchi, 'Via Fiuggi, Next Generation', *Flash Art*, Milan, February/March; 'Miltos Manetas, Vanessa Beecroft, Giuseppe Gabellone', *Purple Prose*, No 10, Paris; Giacinto Di Pietrantonio, 'Giuseppe Gabellone', *Flash Art*, Milan, October/November; Guido Curto, 'Campo 6', *Flash Art Italia*, Milan, December/January 1997 Marco Meneguzzo, 'Campo 6', *Artforum*, New York, January; Tania Guha, 'Giuseppe Gabellone', *Time Out*, London, 7 May; Giacinto Di Pietrantonio, 'Giuseppe Gabellone', *Flash Art*, Milan, Summer; David Clemmer, 'Truce', *Flash Art*, Milan, November/December

anna gaskell

The recognition that Lewis Carroll's inspiration for *Alice in Wonderland* was hardly cut from the same psychological cloth as the pre-pubescent girl who forms its erstwhile subject has both added to and taken away from readers' appreciation of the story, ever since it was first published. In a series of photographs that have effectively catapulted her to the forefront of current artistic developments in the US, Anna Gaskell sets out to reconstruct aspects of Alice's narrative with a keen visual sense of being perpetually on the threshold. In Gaskell's photos, the world, adulthood and the seemingly endless array of dangers and pitfalls that await the hapless (female) subject are all hovering just outside the frame, while her subjects frolic about in blissful obliviousness.

Gaskell's intentions in creating the first of these series, *Wonder Series*, 1995–97, seem to have been grounded in an explicitly gendered narrative about inter-female relationships, as well as the visual articulation of a virtually unreachable world in which the imagination is allowed freely to express itself. Working with two nearly identical models on the grounds of what appears to be a well-manicured Connecticut estate, Gaskell uses her camera to capture unorthodox angles and create unusual framings of the figures. Heads are often cropped, legs enter from the side or top of the photo, and the perspective is generally one of exaggerated subjectivity as we seem either to glimpse one girl from her companion's viewpoint, or both interlocked in playful struggle. One of the most powerful visual subtexts in this series comes from the viewer's realization that even within this civilized framework, the girls appear to be driven by their innermost animal natures. Carried away by the passion of the moment in a garden where the scent of flowers is probably the only trace of nature untamed, their gestures and faces give way at times to the faintest hint of savagery.

In a newer series, *Override*, 1997, Gaskell has added to the visual complexity of the work without diminishing its emotional tension. Deploying five models in place of the twin-like pair, Gaskell has also moved the action to the edge of a fictional wood. Here the images take on a more explicitly suburban angst, with the possibility of actual violence lingering at the edges. Mesmerized by our voyeuristic positioning relative to the subjects, we cannot help but find the ambiguous activities of the girls both compelling and disturbing, as if the absence of adults might lead to an outbreak of genuinely sadistic behaviour. While Gaskell's current work evokes Lewis Carroll as a direct antecedent, it has become simultaneously more cinematic, and more consciously attuned to the borderline where civilization leaves off and the darker recesses of the psyche are given free reign.

Anna Gaskell
Untitled #5 (Wonder Series), 1996
C-print
127 x 101.5 cm

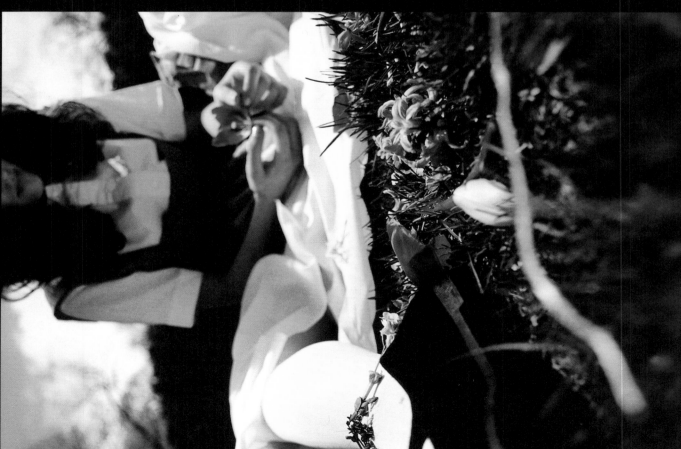

right, Anna Gaskell
Untitled #14 (Wonder Series), 1997
C-print
25.5 x 20.5 cm

far right, Anna Gaskell
Untitled #12 (Wonder Series), 1996
C-print
25.5 x 20.5 cm

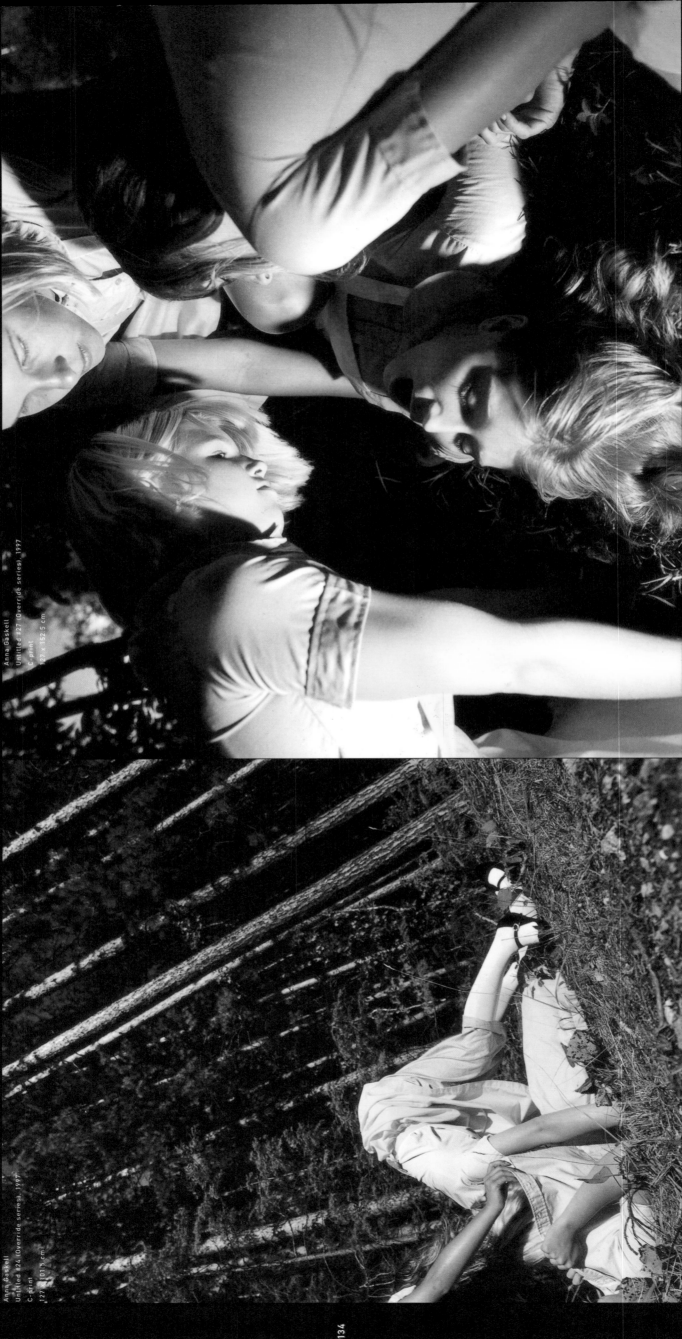

Anna Gaskell
Untitled #27 (Override series), 1997
C-print
127 x 152.5 cm

Anna Gaskell
Untitled #24 (Override series), 1997
C-print
127 x 101.5 cm

anna gaskell

Born Des Moines, Iowa, 1969. Lives and works in New York. **solo exhibitions:** 1997 Casey Kaplan, New York 1998 Museum of Contemporary Art, Miami **selected group exhibitions:** 1992 'August Coup', Lorenzo Rodriguez Gallery, Chicago 1995 'Currents', The Eighth Floor, New York 1996 'Baby Pictures', Bravin Post Lee, New York 1997 'Stills: Emerging Photography in the 1990s', Walker Art Center, Minneapolis; P.S. 1 Museum, New York 1998 'Exterminating Angel', Galerie Ghislaine Hussenot, Paris; 'Sightings', Institute of Contemporary Arts, London **selected bibliography:** 1996 Roberta Smith, 'The World Through Women's Lenses', *The New York Times*, 13 December 1997 Jerry Saltz, 'Anna Gaskell', *Time Out*, New York, 11 December; Kim Levin, 'Voice Choices: Anna Gaskell', *Village Voice*, New York, 9 December; Roberta Smith, 'Painting and Photos with Tales to Tell, Often About the Oddities of Growing Up', *The New York Times*, 5 December; David Frankel, 'Focus: The Name of the Place', *Artforum*, New York, May; Jerry Saltz, 'Cecily Rose Brown, Bonnie Collura, Anna Gaskell', *Time Out*, New York, 5 March; Holland Cotter, 'Art in Review: The Name of the Place', *The New York Times*, 31 January; Jerry Saltz, 'The Name of the Place', *Time Out*, New York, 30 January 1998 Jan Avgikos, 'Anna Gaskell', *Artforum*, New York, February; Michael Cohen, 'Global Art: Anna Gaskell', *Flash Art*, Milan, January/February.

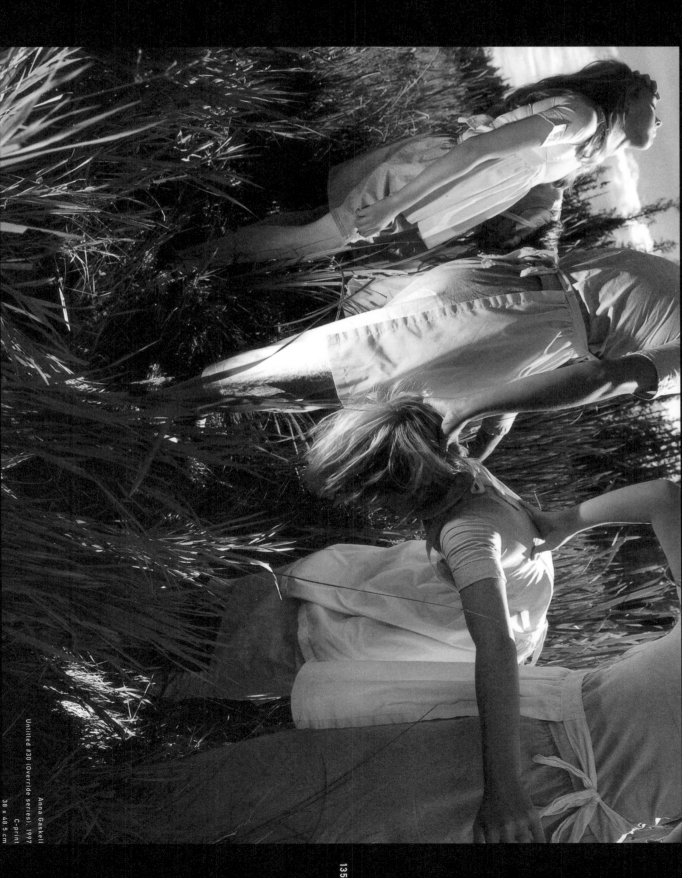

Anna Gaskell
Untitled #30 (Override series), 1997
C-print
38 x 48.5 cm

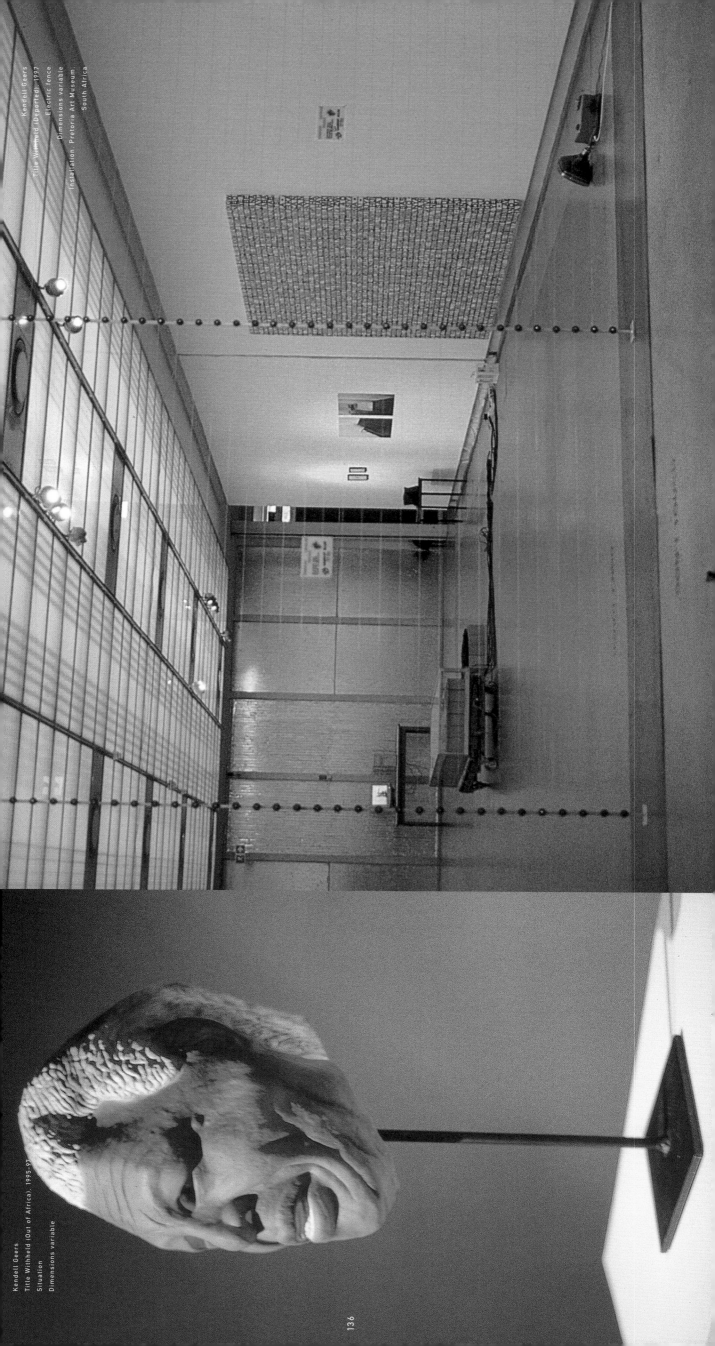

Kendell Geers
Title Withheld (Deported) 1997
Electric fence
Dimensions variable
Installation, Pretoria Art Museum
South Africa

Kendell Geers
Title Withheld (Out of Africa), 1995-97
Situation
Dimensions variable

Kendell Geers
Title Withheld (Deported (detail)) 1992
Electric fence
Dimensions variable
Installation, Pretoria Art Museum,
South Africa

kendell geers

It is a strange coincidence that Kendell Geers was born in 1968, the year the Dada master Marcel Duchamp died. For Geers himself is a remade Dadaist who has emerged in the transitional period between the last years of apartheid and the post-apartheid era of 'New' South Africa. His dadaist aim to 'scratch where it does not itch' is perhaps even more relevant in the context of this New South Africa, a symbol of spectacular human liberation at the end of the century.

While the country dreams of becoming a multiracial 'rainbow', a new and beautiful phoenix rising out of the ashes of a dark history of inhumanity, Geers adopts an anarchic position, dealing with the reality of a post-apartheid society. This reality is a struggle between the hope for social order and justice, and everyday chaos and violence; between democracy and equality, and separation and inequality; between the desire for reconciliation, and the impossibility of absolving historic guilt.

Rather than seeing his objects, installations and multimedia pieces as artworks for aesthetic pleasure or cultural evaluation, Geers intends them to reveal 'the black hole in the Rainbow Nation'. Inheriting the Dada spirit that oscillates between the intellectual's commitment to social rebellion and critique, and the smart, cynical games of words and forms, Geers has made works from materials that are both banal and horrifying. The series *Title Withheld*, makes use of a broken beer-bottle neck, a damaged brick that had been thrown through the window of a room and a page from a pornographic magazine with traces of sperm. By siting his works as interventions in specific spaces, he heightens this disturbing quality. He has designed black flags with red A-K motifs, for example, hanging them on poles where national flags are supposed to fly. Or he has installed an electric fence in the centre of a group exhibition to prevent people from moving through the gallery. The isolated, aloof art space is made to merge with the realm of everyday life and a social reality in which violence, racial hatred and social injustice are not mere words.

Geers cannot simply be called an 'artist'. He is an activist *par excellence*, operating between the rarefied world of art and the cruel reality of a transitional society by exposing the most uncomfortable sides of both. Not limiting himself to the production of 'art work', he adopts a significant and effective tactic of provocation in actions that constantly confront the real. Publicly refusing to serve in the South African Defence Force during apartheid, he was forced into exile; he dresses in black as an expression of his identity as 'Black inside'. His 1997 exhibition, 'Guilty', was censored even before the opening because it was suspected that his intention was to expose the guilt of the institutions involved. And when he met Nelson Mandela, he wore a mask bearing the features of that political hero. The revelation of people's fear of their own faces is, to Geers, a necessity of art. His strategy works.

Hou Hanru

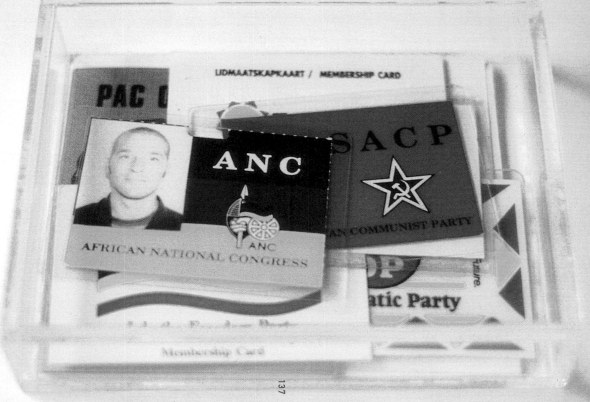

Kendell Geers
Untitled (ANC, AVF, AWB, CP, DP, IFP,
NP, PAC, SACP), 1994
Performance/situation

PO**CONGAVOAPE**

kendell geers
Birthplace withheld at artist's request, 1968. Lives and works in Johannesburg. **selected solo exhibitions:** 1988 Box Theatre, University of the Witwatersrand, Johannesburg 1993 'Threshold: The Exhibition', Everard Read Contemporary, Johannesburg 1994 'We are Johannesburg Artists and Nothing More', Michaelis Art Gallery, Cape Town 1995 'WC', Villa Arson, Nice 1996 '16 June 1976', Goodman Gallery, Johannesburg 1997 'Memento Mori', de Vleeshal, Middelburg, The Netherlands 1998 'GUILTY', Fort Klapperkop, Pretoria, South Africa **selected group exhibitions:** 1992 'Vita Art Now', Johannesburg Art Gallery 1993 XLV Venice Biennale: Sala 1, Rome 1994 5th Havana Biennial: 'Zuiderkruis', Stedelijk Museum, Amsterdam 1995 'Volatile Colonies', 1st Johannesburg Biennale: Aperto, XLVI Venice Biennale 1996 'Simunye (We Are One)', Adelson Galleries, New York: 'Crapshoot', De Appel, Amsterdam 1997 'Trade Routes: History and Geography', 2nd Johannesburg Biennale: 'Cross/ing', University of South Florida Art Gallery, Tampa: 'Purple and Green',Art Museum, Pretoria, South Africa **selected bibliography:** 1993 Colin Richards, 'About Face: Aspects of Art History and Identity in South African Visual Culture', *Third Text*, London, Autumn/Winter 1994 Andrew Solomon, 'Separate and Equal', *The New York Times Magazine*, 27 March: Jean-Yves Jounnais, 'The Hottentot Venus', *art press*, Paris, May: Benjamin Weil, 'Crossing the Boundaries: Two Examples in South African Art', *Atlantica*, No 8, Grand Canaries, Spain 1995 Benjamin Weil, 'South African Art - Out of Time', *Flash Art*, Milan, January/February: Ruth Rosengarten, 'Inside Out', *frieze*, London, Summer: Thomas McEvilley, 'Report from Johannesburg — Towards a World-Class City?', *Art in America*, New York, September 1996 Okwui Enwezor, 'Occupied Territories: Power, Access and African Art', *frieze*, London, January/February: Colin Richards, 'Retaining This Fire', *Atlantica*, No 11, Grand Canaries, Spain: Okwui Enwezor, Octavio Zaya, 'Moving In', *Flash Art*, Milan, January/February

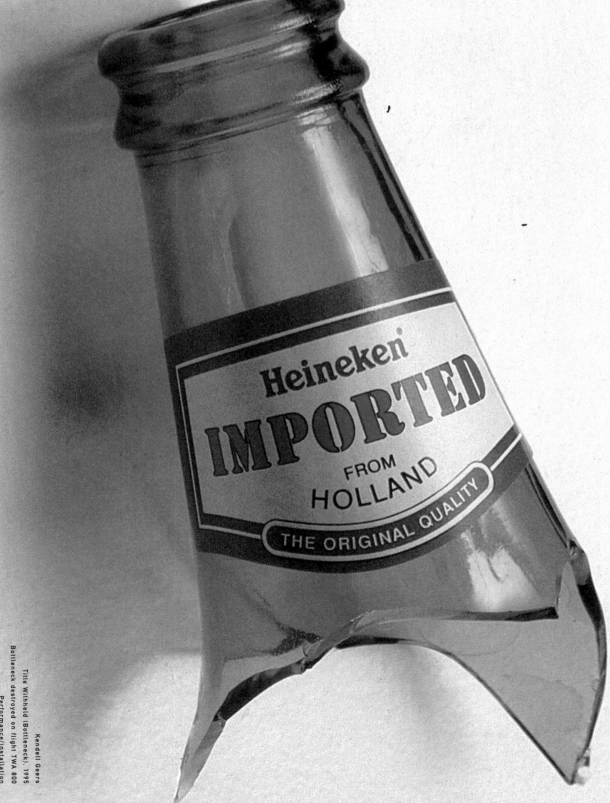

Kendell Geers
Title Withheld (Quinta Bienal de la
Habana), 1994
Crates from 5th Havana Biennial
1000 x 500 x 500/cm
Installation, Wifredo Lam Centre,
5th Havana Biennial

Kendell Geers
Title Withheld (Bottleneck), 1995
Bottleneck destroyed on flight TWA 800
Performance/installation

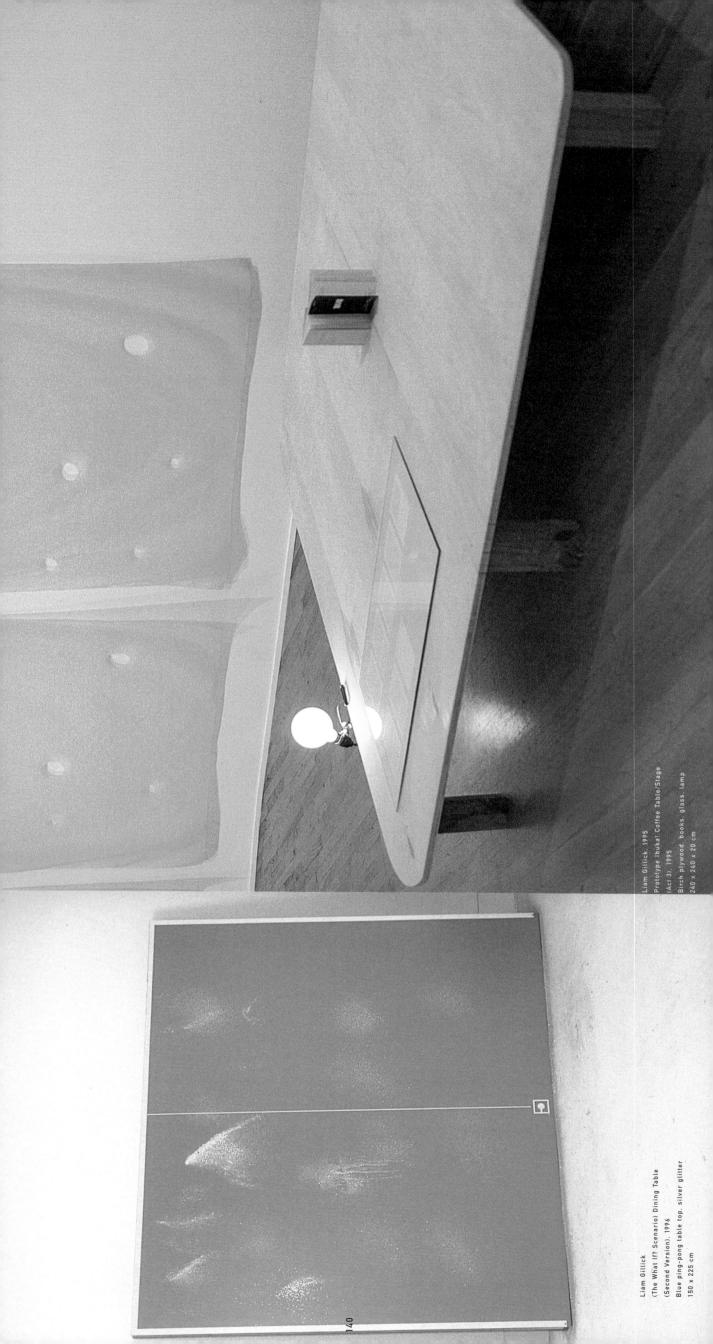

Liam Gillick, 1995
Prototype Ibuka! Coffee Table/Stage
(Act 3), 1996
Birch plywood, books, glass, lamp
240 x 240 x 20 cm

Liam Gillick
(The What If? Scenario) Dining Table
(Second Version), 1996
Blue ping-pong table top, silver glitter
150 x 225 cm

liam gillick

Liam Gillick makes things that seem familiar, although in fact they are not. In the last few years, his minimal and post-minimal look-alikes have included: free-standing cubes framed in aluminum, or panels made of coloured Plexiglas squares suspended from the ceiling; rip-stop nylon wall hangings, either cut into ribbons or punctured with round holes; a blue ping-pong table (*sans* net) covered in glitter and up-ended; a monochrome wall painting that ends at the half-way point of its ascent; and a low, birch plywood table with four differently rounded corners in the middle of which are placed two books and, under glass, fragments thereof.

Yet these things, however seductive, are red herrings: Gillick is less an object-maker than a strategist whose true medium is the idea. Here, then, are not things-as-things, but rather outlines, scripts, props, archives, stage sets, posters and other such elements through which to contemplate a panoply of what the artist calls (with characteristic straight face), 'what if? scenarios'.

Some of these scenarios are (and others are not) threaded through a series of texts penned by Gillick. The 1995 *Erasmus is Late*, concerns an ill-fated dinner party at the London home of Erasmus Darwin (Charles' opiate-addled brother), which flashes between 1810 (on the epochal night before the mob metamorphoses into the working class) and 1997, two years into the then-future. *Ibuka!*, 1995, is a song-and-dance spectacular for which none of the words or music have been written, and the title of which derives from the name of one of the guests at the aforementioned time-warp dinner party — Masaru Ibuka, the little-recognized co-founder of Sony. (Other guests include Marshall McLuhan's mother, Elsie; Beach Boy Brian Wilson's father, Murry; and John F. Kennedy's Secretary of Defence, Robert McNamara, around whom Gillick had already created, among other things, a short animated film.)

To elaborate: Gillick figures things as historical artefacts, and history, in turn, as an elastic band — something that can be flipped inside out, or stretched at whim to assume other shapes, all of which lead back to where they began. From this follows his obsession with parallel activities (he is himself an artist, writer, curator and theorist), time slips, and wormholes, those short-cuts through space in which matter is not destroyed, are simply re-routed.

His latest body of work, *Discussion Island*, 1997, is a kind of bureaucratic-managerial wet dream in which space is organized to control behaviour. Thus, utilitarian-looking structures (bare light bulbs in an aluminum frame descending from the ceiling; sheets of multi-coloured Plexiglas squares propped up on spindly metal poles) delineate dedicated zones: an 'assessment think tank', for example, or platforms devoted to 'moderation', 'conciliation' and 'revision'. Hyper-efficient and manically overwrought, Gillick's art generates situational ethics for the end of the millennium.

Susan Kandel

Liam Gillick
Ibuka! Part 1, 1995
Table, name plates
Dimensions variable

Liam Gillick
Discussion Island: Arrival Rig, 1997
Aluminium, light units,
steel cable fittings
122 x 122 x variable cm

left, Liam Gillick
The What If? Scenario) Cantilevered
Delay Platform 1996
Plexiglas, aluminium, angles,
aluminium fittings
122 x 122 x variable cm

right, Liam Gillick
Discussion Island, Platform (Sic), 1997
Plexiglas, aluminium,
steel cable, fittings
122 x 122 x variable cm

liam gillick

Born Aylesbury, England, 1964. Lives and works in London. **selected solo exhibitions:** 1989 '84 Diagrams', Karsten Schubert Ltd, London 1991 'March Documents', APAC, Nevers, France 1993 'An Old Song and a New Drink', Air de Paris, Nice, Café Beaubourg, Paris 1994 'McNamara', Schipper & Krome, Cologne 1995 'Part Three', Basilico Fine Arts, New York; 'Documents', Kunstverein, Elsterpark, Leipzig, Austria 1996 'The What If? Scenario', Robert Prime Gallery, London 1997 'Discussion Island', Basilico Fine Arts, New York; 'Another Shop in Tottenham Court Road', Transmission Gallery, Glasgow 1998 Robert Prime Gallery, London **selected group exhibitions:** 1990 'The Multiple Projects Room', Air de Paris, Nice 1992 Andrea Rosen Gallery, New York 1992 'Etats Specifique', Musée d'Art Moderne, Le Havre, France and tour 1993 'Wonderful Life', Lisson Gallery, London; 'Backstage', Kunstverein, Hamburg 1994 'Don't Look Now', Thread Waxing Space, New York; 'Surface de Reparations', FRAC, Bourgogne, Dijon; 'The Institute of Cultural Anxiety', Institute of Contemporary Arts, London 1995 'Stoppage', Villa Arson, Nice, CCC, Tours; 'Karaoke', South London Art Gallery, London; 'Brilliant', Walker Art Center, Minneapolis 1996 'Traffic', CAPC, Musée d'Art Contemporain, Bordeaux 1996 'Der UMBAU Raum', Kunstlerhaus, Stuttgart; 'Departure Lounge', The Clocktower, New York; 'life/live', ARC, Musée d'Art Moderne de la Ville de Paris, Centro Cultural de Belém, Lisbon; 'All in One', Schipper & Krome, Cologne 1997 'Enter: Audience, Artist, Institution', Kunstmuseum, Luzern; 'I met a man who wasn't there ... ', Basilico Fine Arts, New York; Documenta X, Kassel, Germany **selected bibliography:** 1992 Francesco Bonami, 'Twelve British Artists', *Flash Art*, Milan, November; Peter Schjeldhal, 'Twelve British Artists', *frieze*, London, November/December 1993 Alison Sarah Jacques, 'Interview with Liam Gillick', *Flash Art*, Milan, January 1994 Benjamin Weil, 'Backstage', *Flash Art*, Milan, January/February 1995 Eric Troncy, 'Liam Gillick', *Flash Art*, Milan, Summer; Martin Maloney, 'Grunge Corp', *Artforum*, New York, October 1996 Godfrey Worsdale, 'Liam Gillick', *Art Monthly*, London, June; Jennifer Higgie, 'Liam Gillick, Robert Prime Gallery', *frieze*, London, September/October; Gilda Williams, 'Liam Gillick, Robert Prime Gallery', *art/text*, Sydney, October; Jan Avgikos, 'Liam Gillick, Basilico Fine Arts', *Artforum*, New York, Summer

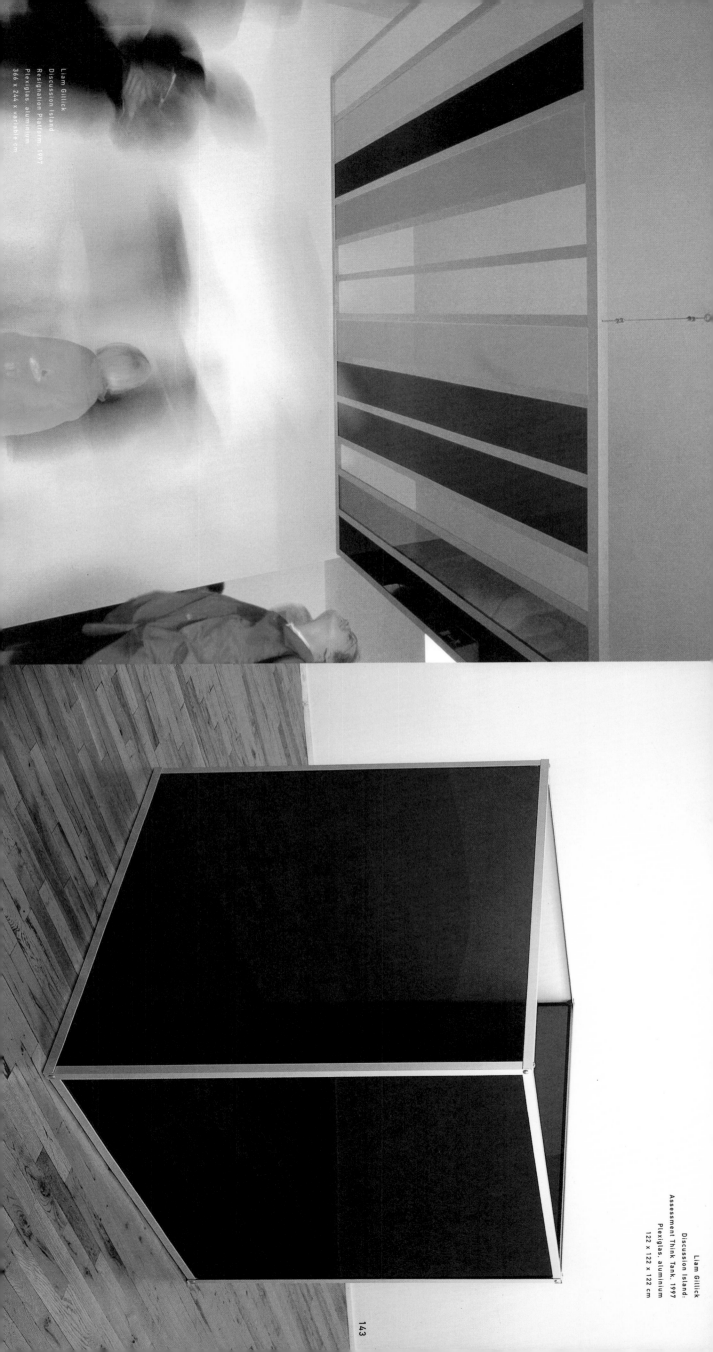

Liam Gillick
Discussion Island
Resignation Platform, 1997
Plexiglas, aluminium
366 x 244 x variable cm

Liam Gillick
Discussion Island:
Assessment Think Tank, 1997
Plexiglas, aluminium
122 x 122 x 122 cm

Liam Gillick
Discussion Island:
Assessment Think Tank, 1997
Plexiglas, aluminium
122 x 122 x 122 cm

143

dominique gonzalez-foerster

Dominique

Gonzalez-Foerster's work addresses time and biography. These concerns are given expression in room-sized mises-en-scènes, of which she has produced more than sixty since the early 1990s, each telling its own story. The interactive CD-rom, Residence: Color, 1995, brings together her installations from 1988–95, categorized into the 'Public Room', the 'Biographical Institute', the 'Residential Apartments' and the 'Color Rooms'. Gonzalez-Foerster sees the interior as a natural setting for the expression of artistic intention, in the same way that an individual's home more or less consciously reflects an image of its occupant, like a kind of exhibition'. In the transition from an inner mental state to the surrounding reality of everyday life, our inherited values, our desires and wishes, are revealed.

The early rooms reflect the artist's fascination with historical figures such as Lou Andreas Salomé and Marie Curie. These can be seen both as portraits and as indirect self-portraits, 'personalities the artist 'assumes' herself'. More recent interiors have concentrated increasingly on time: on capturing a moment of absolute presence. The rooms have taken on an immaterial character, a minimal expression that is not so much about abstraction as about bringing a specific mood into focus. Colour and sound are used to capture a certain atmosphere, while scattered items and furniture serve as direct keys to a story.

Gonzalez-Foerster also constructs unfurnished, sci-fi-inspired mental spaces consisting solely of light and sound. A ringing telephone, murmuring, or music are used to express emotion, to create expectation and suspense. Wandering through these coloured spaces is like a filmic experience, the various situations acting as sets for imaginary narratives. Historical fact, subjective memories and pure fiction are interwoven with present reality.

Gonzalez-Foerster places viewers at the centre of events, for them to relate the stories to their own lives. Her newly completed work, Home Cinema, 1998, stages biographical moments in a gallery situation. In this work, each day she shows a different set of slides, which resemble ordinary snap-shots from a family photo album. They are not so private as to shut the viewer out; nor do they direct a specific reading of their content. The title relates to the way in which, with the advent of radio, stereo, TV, video and computers, we no longer need to leave home in order to travel and experience events and images 'live'.

HOME CINEMA

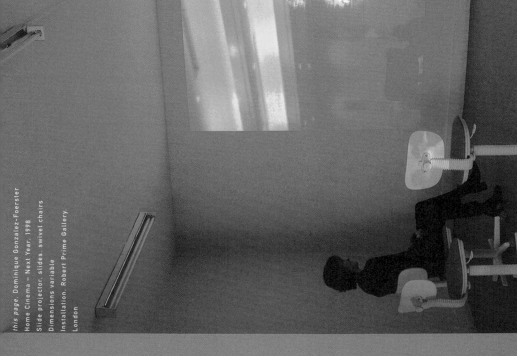

this page, Dominique Gonzalez-Foerster
Home Cinema – Next Year, 1998
Slide projector, slides, swivel chairs
Dimensions variable
Installation, Robert Prime Gallery,
London

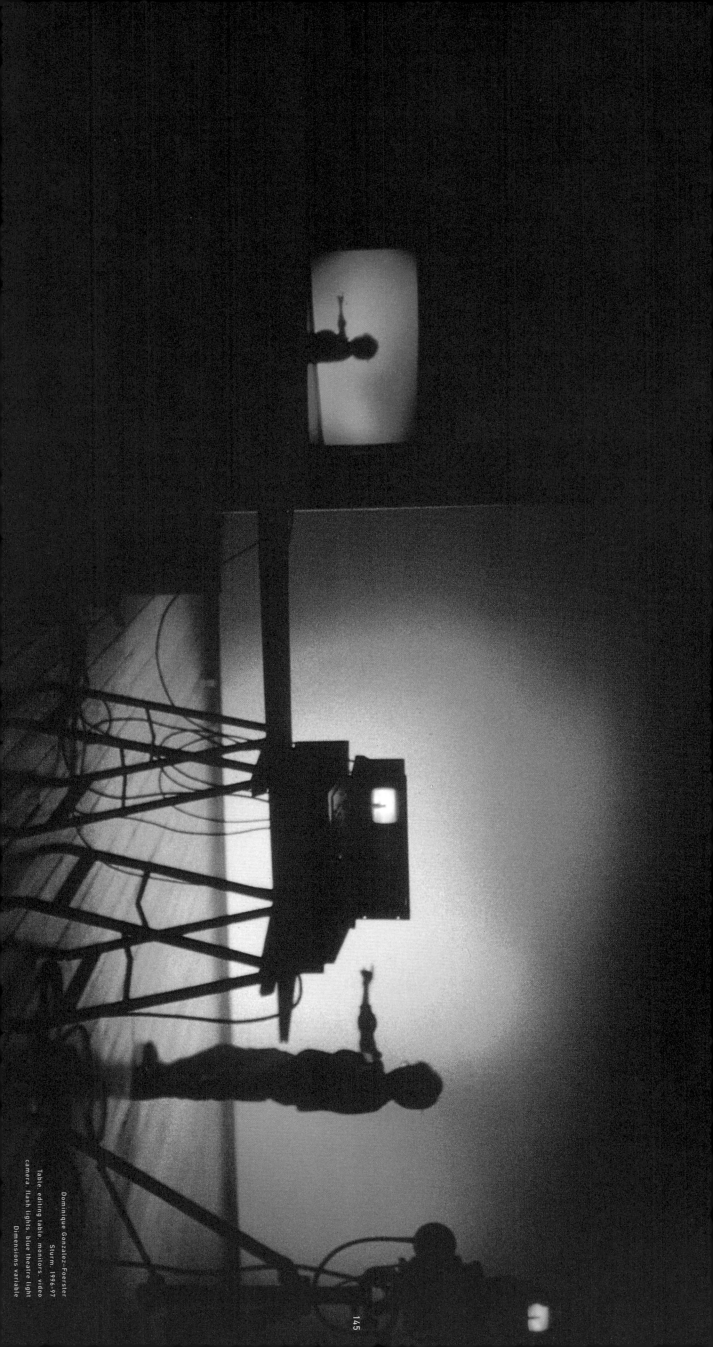

Dominique Gonzalez-Foerster
Sturm, 1996–97
Table, editing table, monitors, video
camera, flash lights, blue theatre light
Dimensions variable

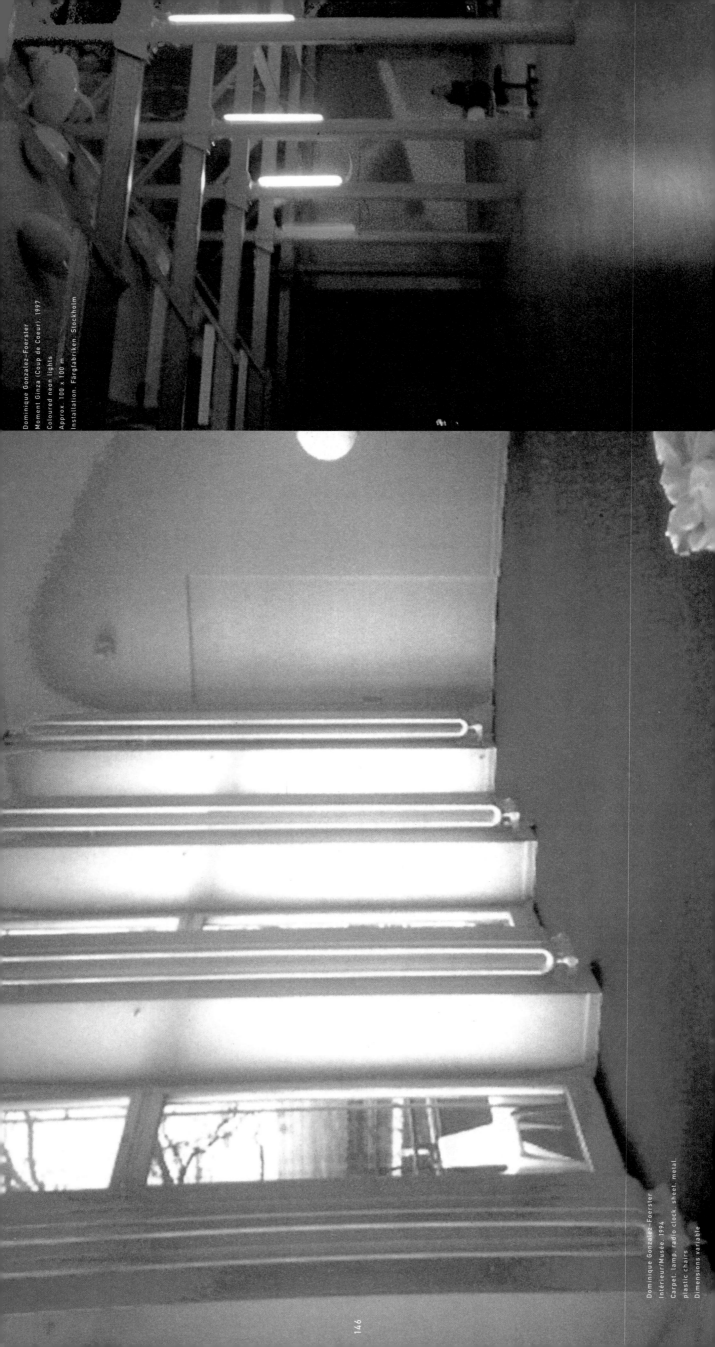

Dominique Gonzalez-Foerster
Moment Ginza (Coup de Cœur), 1997
Coloured neon lights
Approx. 100 x 100 m
Installation, Färgfabriken, Stockholm

Dominique Gonzalez-Foerster
Intérieur/Musée 1994
Carpet, lamp, radio clock, sheet metal,
plastic chairs
Dimensions variable

dominique gonzalez-foerster

Born Strasbourg, 1965. Lives and works in Paris. **selected solo exhibitions:** 1988 'Bienvenue à ce que vous croyez voir', Galerie Gabrielle Maubrie, Paris 1990 'The Mind of a Mnemonist', Esther Schipper, Cologne 1991 'Le Mystère de la Chambre Jaune', Esther Schipper, Foire d'Art Actuel, Brussels 1992 'Et la Chambre Orange', Villa Arson, Nice 1993 'Numéro bleu', ARC, Musée d'Art Moderne de la Ville de Paris 1994 'Intérieurs', Stedelijk Museum, Amsterdam 1995 'Fille/Garçon', Gallery Koyanagi, Tokyo 1996 'residence:color', Galerie Jennifer Flay, Paris; Robert Prime Gallery, London; 'Zone de Tournage', Fri-Art, Kunsthalle, Fribourg 1997 Kunstmuseum/Inova, Milwaukee; 'Moment', Gallery Koyanagi, Tokyo 1998 '88:88', Kunstmuseum, Krefeld, Germany

selected group exhibitions: 1988 'E3', Institute of Modern Art, Brisbane 1989 'De l'instabilité', Centre National des Arts Plastiques, Paris 1990 'French Kiss', Halle-Sud, Geneva 1991 'Itinerari', Castello di Rivara, Turin; 'No Man's Time', Villa Arson, Nice 1992 'Exhibit A', Serpentine Gallery, London 1993 'Backstage', Kunstverein, Hamburg 1994 'L'Hiver de l'Amour', ARC, Musée d'Art Moderne de la Ville de Paris; P.S. 1 Museum, New York 1995 'Hotel Mama', Kunstraum, Vienna 1996 'Traffic', CAPC, Musée d'Art Contemporain, Bordeaux 1997 'Niemandsland', Haus Lange/Haus Esters, Krefeld, Germany

selected bibliography: 1989 Arielle Pelenc, 'Dominique Gonzalez-Foerster', *art press*, Paris, March 1990 Nicolas Bourriaud, 'Nouvelle Vague', *Beaux-Arts*, No 78, Paris; Liz Stirling, 'Dominique Gonzalez-Foerster - Gabrielle Maubrie', *art/text*, Sydney, May; Jutta Koether, 'Dominique Gonzalez-Foerster/Esther Schipper', *Artforum*, New York 1991 Eric Troncy, 'No Man's Time', *Flash Art*, Milan, November/December 1992 Isabelle Graw, 'Comments on the Daughter of a Taoïst', *Texte zur Kunst*, Cologne, Spring; Benjamin Weil, 'Remarks on Installations', *Flash Art*, Milan, June/July; Jason B. Flinn, 'Cabinet de Pulsions', *Tema Celeste*, Milan, Summer; Benjamin Weil, 'Dominique Gonzalez-Foerster - A Broken Interview', *Flash Art*, Milan, April/May 1997 Åsa Nacking, 'If you can I can', *Paletten*, Göteborg, January

Dominique Gonzalez-Foerster
Virtual Room, 1995
(from *residence:color*, 1985-95)
CD-rom

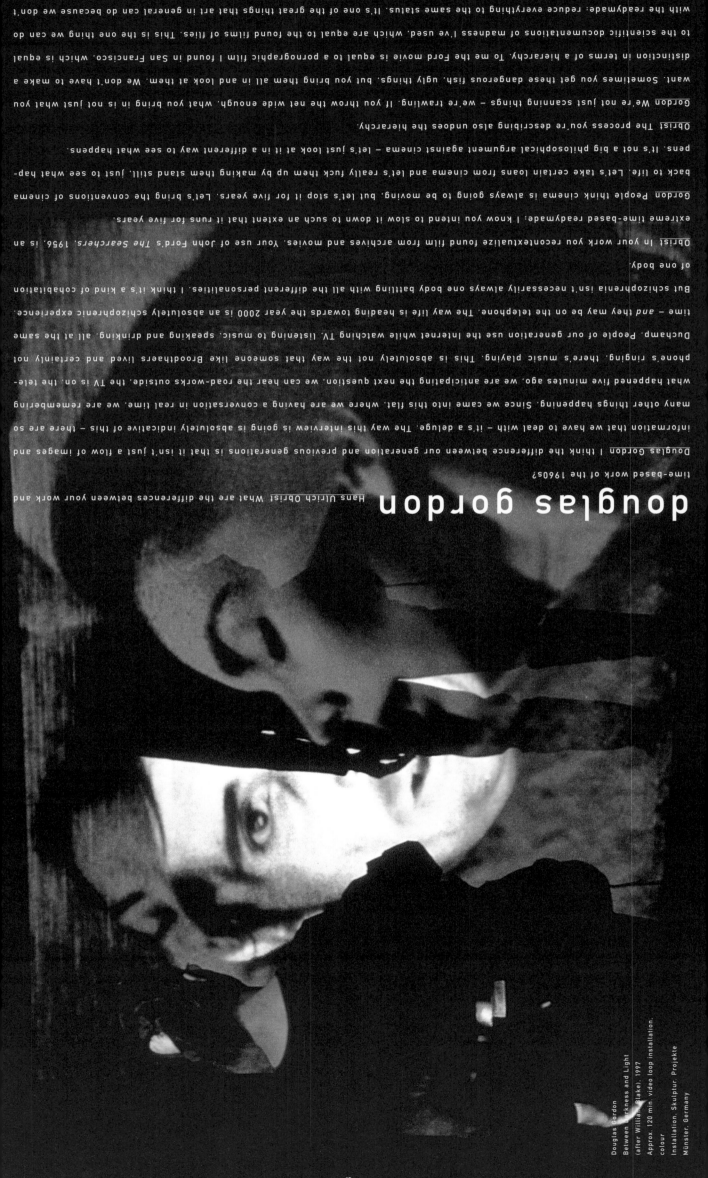

douglas gordon

Hans Ulrich Obrist What are the differences between your work and time-based work of the 1960s?

Douglas Gordon I think the difference between our generation and previous generations is that it isn't just a flow of images and information that we have to deal with – it's a deluge. The way this interview is going is absolutely indicative of this – there are so many other things happening. Since we came into this flat, where we are having a conversation in real time, we are remembering what happened five minutes ago, we are anticipating the next question, we can hear the road-works outside, the TV is on, the telephone's ringing, there's music playing. This is absolutely not the way that someone like Broodthaers lived and certainly not Duchamp. People of our generation use the Internet while watching TV, listening to music, speaking and drinking, all at the same time – *and* they may be on the telephone. The way life is heading towards the year 2000 is an absolutely schizophrenic experience. But schizophrenia isn't necessarily always one body battling with all the different personalities. I think it's a kind of cohabitation of one body.

Obrist In your work you recontextualize found film from archives and movies. Your use of John Ford's *The Searchers*, 1956, is an extreme time-based readymade. I know you intend to slow it down to such an extent that it runs for five years.

Gordon People think cinema is always going to be moving, but let's stop it for five years. Let's bring the conventions of cinema back to life. Let's take certain loans from cinema and let's really fuck them up by making them stand still, just to see what happens. It's not a big philosophical argument against cinema – let's just look at it in a different way to see what happens.

Obrist The process you're describing also undoes the hierarchy.

Gordon We're not just scanning things – we're trawling. If you throw the net wide enough, what you bring in is not just what you want. Sometimes you get these dangerous fish, ugly things, but you bring them all in and look at them. We don't have to make a distinction in terms of a hierarchy. To me the Ford movie is equal to a pornographic film I found in San Francisco, which is equal to the scientific documentations of madness I've used, which are equal to the found films of flies. This is the one thing we can do with the readymade: reduce everything to the same status. It's one of the great things that art in general can do because we don't have to work with the established system. It's the first job of the artist to collapse the system, and then out of that collapse, allow people to pick up and identify whatever it is they find interesting. They don't need to know it's art; it can just look interesting or smell good or taste nice. Whatever it takes for people to think again.

Douglas Gordon
Between Darkness and Light
(after William Blake), 1997
Approx. 120 min. video loop installation.
colour
Installation, Skulptur. Projekte
Münster, Germany

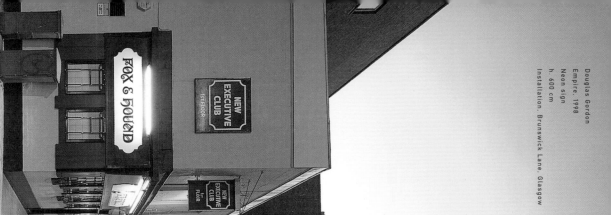

Douglas Gordon
Empire, 1998
Neon sign
h. 600 cm
Installation, Brunswick Lane, Glasgow

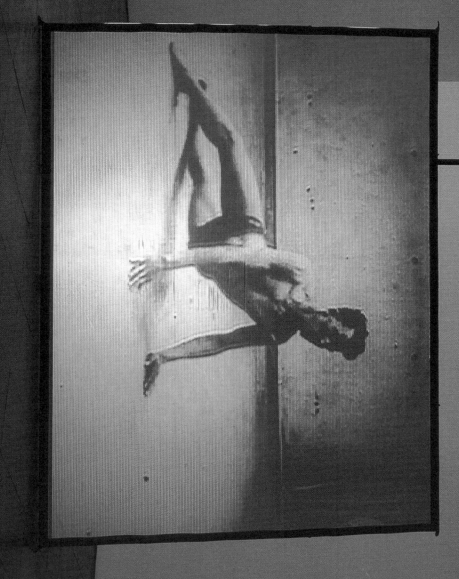

Douglas Gordon
10ms⁻¹, 1994
Looped video installation, colour
228.5 x 306 cm
Collection, Tate Gallery, London

...hot is cold, day is night, hate is lund, everywhere is nowhere, something is nothing, pain is pleasure, blindness is sight, hell is heaven, confinement is freedom, black is white, inside is outside, famine is surplus, bad is good, nature is synthetic, life is death, fiction is reality, equilibrium is crisis, doubt is faith, hypocrisy is honesty, feminine is masculine, open is closed, neglect is cultivation, laughing is crying, contaminated is pure, blessing is damnation, construction is demolition, blunt is sharp, sweet is bitter, satisfaction is frustration, depression is elation, nightmares are dreams, flying is falling, water is blood, truth is a lie, hate is love, trust is suspicion, shame is pride, sanity is lunacy, outside is inside, forward is backward, shit is food, dark is light, right is wrong, left is right, future is past, old is new, losing is winning, work is play, attraction is repulsion, screaming is silence, desire is fulfilment, I am you, you are me, fulfilment is desire, silence is screaming, repulsion is attraction, play is work, winning is losing, new is old, past is future, right is left, wrong is right, light is dark, food is shit, backward is forward, inside is outside, lunacy is sanity, pride is shame, suspicion is trust, love is hate, lies are truth, blood is water, falling is flying, dreams are nightmares, elation is depression, frustration is satisfaction, bitter is sweet, sharp is blunt, demolition is construction, damnation is blessing, pure is contaminated, crying is laughing, cultivation is neglect, closed is open, masculine is feminine, honesty is hypocrisy, faith is doubt, crisis is equilibrium, reality is fiction, death is life, synthetic is natural, good is bad, surplus is famine, outside is inside, white is black, freedom is confinement, heaven is hell, sight is blindness, pleasure is pain, nothing is something, nowhere is everywhere, found is lost, night is day, cold is hot...

Douglas Gordon
Text for someplace other than this, 1996
Vinyl or painted lettering on wall
Dimensions variable
Installation, Tate Gallery, London 1997
Collection, Van Abbemuseum,
Eindhoven

Douglas Gordon
A Divided Self II, 1996
Video, colour

150

douglas gordon

Born Glasgow, 1964. Lives and works in Glasgow, Hannover and Berlin. **selected solo exhibitions:** 1993 'Migrateurs', ARC, Musée d'Art Moderne de la Ville de Paris 1995 'Entr'Acte 3', Stedelijk Van Abbemuseum, Eindhoven, The Netherlands 1996 '24-hour Psycho', Akademie der bildende Künste, Vienna; Contemporary Art Space, Canberra; Museum für Gegenwartskunst, Zurich 1997 '5 Year Drive-By', Kunstverein, Hannover **selected group exhibitions:** 1989 'Windfall '89', Bremen, Germany 1991 Barclays Young Artist Award, Serpentine Gallery, London; 'Walk On', Jack Tilton Gallery, New York; Fruitmarket Gallery, Edinburgh 1992 'Speaker Project', Institute of Contemporary Arts, London; 'Guilt by Association', Museum of Modern Art, Dublin; '5 Dialogues', Museum of Natural History, Bergen, Norway 1993 Prospekt '93, Kunsthalle, Frankfurt; 'Wonderful Life', Lisson Gallery, London 1994 'Watt', Witte de With and Kunsthal, Rotterdam; 'The Institute of Cultural Anxiety', Institute of Contemporary Arts, London; 'Points de vue: Images d'Europe', Centre Georges Pompidou, Paris 1995 XLVI Venice Biennale; Kwangju Biennale, South Korea; Lyon Biennale 1996 Manifesta 1, Rotterdam; 'Jurassic Technologies Revenant', 10th Sydney Biennale; 'life/live', ARC, Musée d'Art de la ville de Paris, Centro Cultural de Belém, Portugal; The Turner Prize, Tate Gallery, London 1997 XLVII Venice Biennale; Skulptur. Projekte Münster, Germany; 'Material Culture: The Object in British Art in the 1980s and 1990s', Hayward Gallery, London; 'Quelques motifs de déclarations Amours', Fondation Cartier pour l'art Contemporain, Paris 1998 Artangel, London; DIA Center for the Arts, New York **selected bibliography:** 1993 Thomas Lawson, 'Hello, it's me', *frieze*, London, March/April; Ross Sinclair, 'Douglas Gordon', *Art Monthly*, London, June 1995 Angela Kingston, 'Douglas Gordon', *frieze*, London, March/April 1996 Liam Gillick, 'The Corruption of Time', *Flash Art*, Milan, May/June 1997 Richard Flood, '24-hour psycho', *Parkett*, No. 49, Zurich; Tobia Bezzola, 'De Spectaculis or Who Is Kim Novak Really Playing?', *Parkett*, No. 49, Zurich; Russell Ferguson, 'Divided Self', *Parkett*, Zurich, No. 49; Yvonne Volkart, 'Douglas Gordon, Museum für Gegenwartskunst', *Flash Art*, Milan, Summer; Iwona Blazwick, 'In Arcadia', *Art Monthly*, London, September; Daniel Birnbaum, 'Sweet Nothings', *frieze*, London, September/October

Douglas Gordon
Predictable Incident in Unfamiliar
Surroundings, 1995
Video installation, colour

rodney graham

Certainly Rodney Graham's enormous photographs of upside-down trees aren't the most subtle examples of his longtime fascination with inverted logics, skewed vision and time warps. But they have the virtue of clarity – something you can't claim for this Canadian artist's work as a whole, which tends towards obscurity, if not out-and-out perversity.

Perversity, of course, is all to the point, as Graham's strategy (he doesn't have a subject so much as a methodology) involves inserting himself into textual systems so as to unsettle their sense of closure and/or their promise of revelation. He might create dead-on versions of Donald Judd's modular wall units only to use them as slip-cases for Freud's writings on jokes (*Jokes*, 1988); or appropriate an eight-page story by Poe, and integrate it into his own, 312-page expanded version, written in a scrupulous impersonation of the master's neo-Gothic style (the 1984–87 *System of Landor's Cottage*). Scale is clearly at issue here: Graham bloats to gargantuan proportions what is ostensibly a supplement, and then blithely doubles back, including as part of this latter work a model of the cottage where Poe lived the last years of his life. *Coruscating Cinnamon Granules*, 1996, likewise oscillates between the domestic and the cosmic. A four-minute, 16 mm film loop shown inside a booth constructed to mimic the proportions of Graham's own kitchen, it features a close-up of an electric stove, sprinkled with cinnamon. As the coil heats up, the spice glistens like stars in a miniature galaxy, until it is burnt off and the floating element reverts inevitably to its rather more homely ele-

Rodney Graham
Vexation Island, 1997
9 min. Laserdisc video loop-projection.
colour, sound
200 x 400 x 550 cm
Installation, Canadian Pavilion XLVII
Venice Biennale

Rodney Graham
Vexation Island, 1997
9 min. Laserdisc video-loop projection.
colour, sound

152

This piece plays out a certain anxiety vis-à-vis modernist art, which swings between total silence and the sort of absurdly complex interpretive scenarios that would seem to guarantee a work's 'meaningfulness'. It likewise proposes the loop as the mechanism that best exemplifies this and all manner of repetition-compulsions. Graham has used the loop (two elements replacing one another in succession, *ad infinitum*) on many occasions and in many forms. These range from the 1983 bookwork *Lenz*, in which he looped a section near the beginning of C. R. Mueller's English translation of Georg Büchner's unfinished 1835 novel, *Lenz*, onto another section of the text with no loss of coherence, but a radical shift in meaning: the protagonist is stranded again and again (the four-page segment was printed eighty-three times) in the bleak mountain landscape. Or 1997's *Vexation Island*, a 35 mm colour film loop featuring the artist as an eighteenth-century Englishman, marooned on a desert island, who wakes from a stupor to shake a tree to bring down a coconut that strikes him on the head and knocks him out, until he wakes again. Equal parts slapstick and Rousselian machine, *Vexation Island* transforms Nietzsche's eternal return of the same into a sumptuous, if exceedingly short, costume drama come travel poster. It is vintage Graham.

Susan Kandel

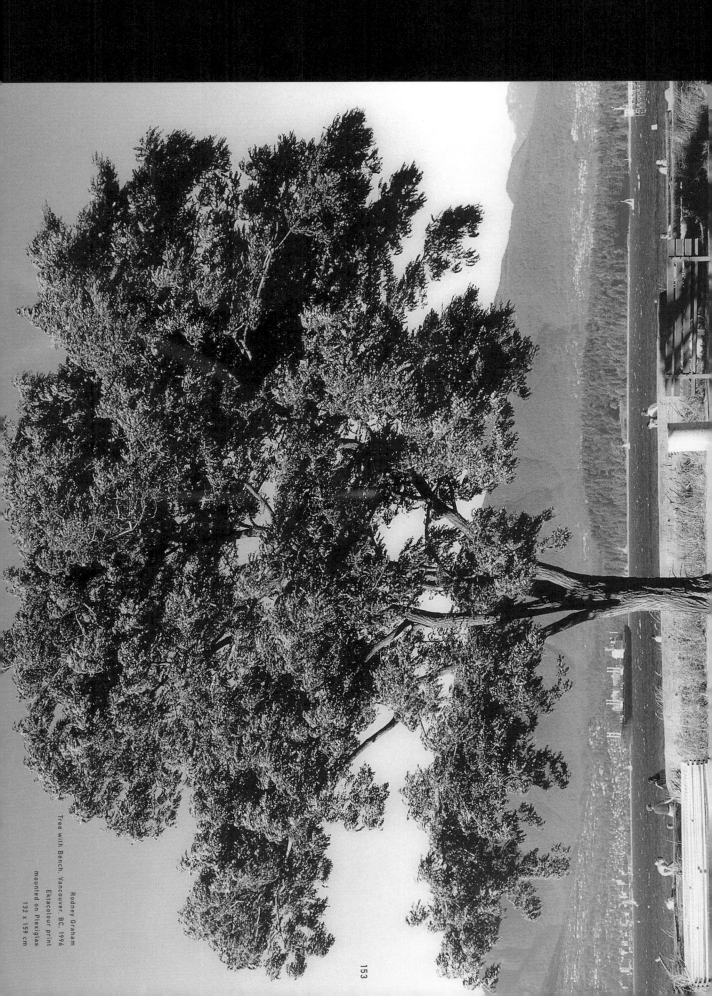

Rodney Graham
Tree with Bench, Vancouver, BC. 1996
Ektacolour print
mounted on Plexiglas
132 x 159 cm

Rodney Graham
Halcion Sleep, 1994
26 min. laser disc/video projection,
colour, sound

Rodney Graham
Coruscating Cinnamon Granules
(detail), 1996
4 min. 16mm film loop,
black and white, cinema seats
305 x 274.5 x 457 cm
Installation, Lisson Gallery, London,
1997

rodney graham

Born Vancouver, Canada, 1949. Lives and works in Vancouver.

selected solo exhibitions: 1979 'Illuminated Ravine', Simon Fraser University, Burnabay, Canada 1986 Galerie Johnen & Schöttle, Cologne 1987 Art Gallery of Toronto 1988 Christine Burgin Gallery, New York 1989 Stedelijk Van Abbemuseum, Eindhoven, The Netherlands 1990 'Books', Lisson Gallery, London 1992 'Les Dernières Merveilles de la Science', Yves Gevaert, Brussels 1995 'School of Velocity and Parsifal', The Renaissance Society, University of Chicago 1997 Canadian Pavilion, XLVII Venice Biennale 1998 Galerie Johnen & Schöttle, Cologne **selected group exhibitions:** 1973 'Pacific Vibrations', Vancouver Art Gallery 1985 'Barbara Ess, Rodney Graham, Ken Lum', Galerie Rudiger Schöttle, Munich; 'Thought Objects', Cash/Newhouse Gallery, New York 1987 'Cinema Objects', De Appel, Amsterdam; Skulptur, Projekte Münster, Germany 1990 'Weltersehen', Museum Haus Lange, Haus Esters, Krefeld, Germany; Centre International d'Art Contemporain, Montreal 1991 'Lost Illusions: Recent Landscape Art', Vancouver Art Gallery; 'Real Allegories', Lisson Gallery, London; 'Vanitas', Galerie Crousel-Robelin, Paris 1992 Documenta IX, Kassel, Germany; 'Books, Prints, Objects', Van Abbemuseum, Eindhoven, The Netherlands 1993 XLV Venice Biennale 1994 'Dan Graham, Rodney Graham, Jenny Holzer: Fotograflen und Multiples', Galerie Rudiger Schöttle, Munich 1995 'About Place: Recent Art of the Americas', Institute of Contemporary Art, Chicago 1996 'Rodney Graham, Geoffrey James, Richard Long', Angles Gallery, Santa Monica, California 1997 'Wood', Fisher Landau Center, Long Island City, New York **selected bibliography:** 1987 Eleanor Heartney, 'Sighted in Münster', *Art in America*, New York, September; Donald Kuspit, Max Wechsler, Dan Cameron, Pier Luigi Tazzi, Ingrid Rein, 'The Critic's Way', *Artforum*, New York, September 1988 Carolyn Christov-Bakargiev, 'Something Nowhere', *Flash Art*, Milan, May/June; Claudia Hart, 'Rodney Graham: Christine Burgin Gallery, New York', *Artforum*, New York, Summer; Roberta Smith, 'Art: an Array of Styles and Trends in Galleries', *The New York Times*, 26 February 1990 José Luis Brea, 'Neo-Baroque: A Wind without a North', *Flash Art*, Milan, October 1995 Ronald Jones, 'Rodney Graham', *frieze*, London, Summer 1997 Michael Archer, 'Rodney Graham: Lisson Gallery', *Artforum*, New York, March 1998 Alexander Alberro, 'Rodney Graham's Vexation Island Loop Dreams', *Artforum*, New York, February

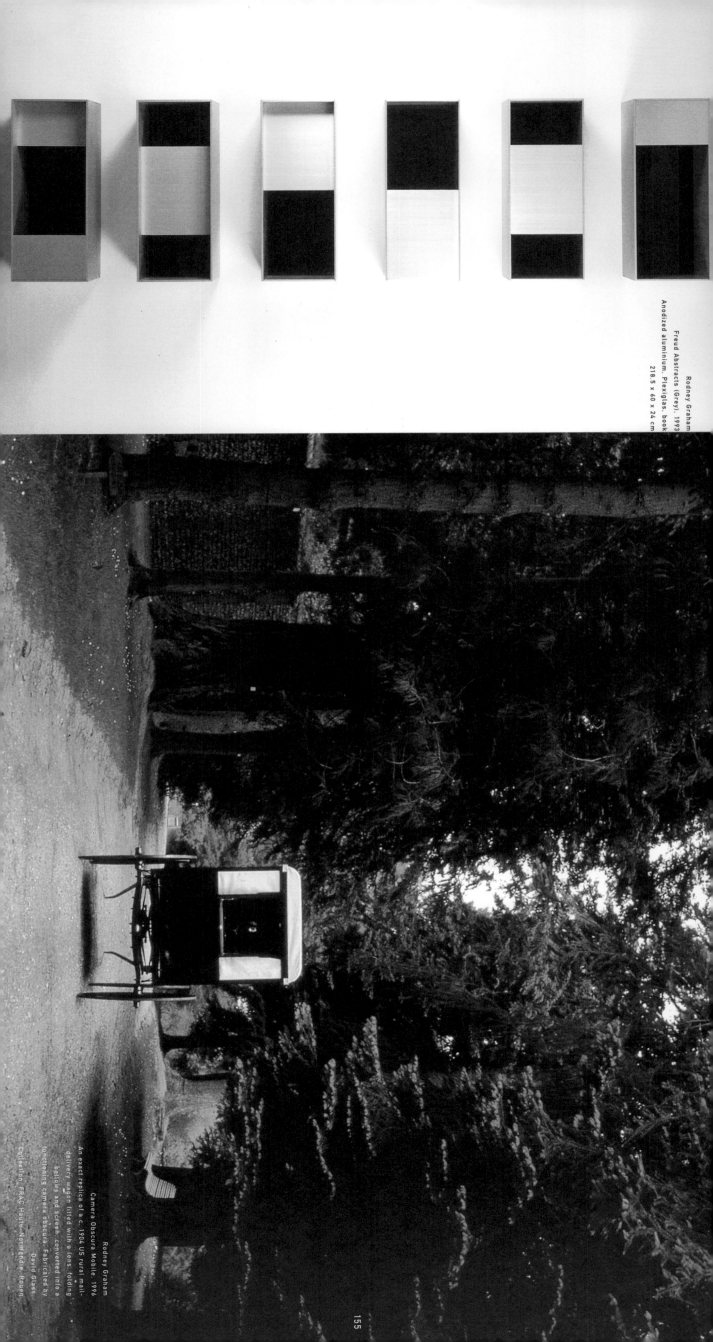

Rodney Graham
Freud Abstracts (Grey), 1993
Anodized aluminium, Plexiglas, book
218.5 x 60 x 24 cm

155

Rodney Graham
Camera Obscura Mobile, 1996
An exact replica of a c. 1904 US rural mail-
delivery wagon fitted with a lens, folding
bellows and screen, converted into a
functioning camera obscura. Fabricated by
David Glass.
Collection: FRAC Haute-Normandie, Rouen

joseph grigely

One of the clichés of modern art is that it is constantly transforming weaknesses into strengths, and making use of that transformation to question the values that lead to such dichotomies in the first place. Certainly one of the most compelling features of Joseph Grigely's art is that it begins from a position of one who is outside the standard channels of social communication by virtue of being deaf. Recognizing that most hearing people find it all but impossible to learn to communicate through the use of manual signing, Grigely has developed a system by which he can carry on extended conversations with non-deaf persons through the continual production of handwritten notes, to which he is able to respond through speech. Deeply interested in the particular social dynamic that such a situation produces, Grigely has developed a body of work based on the notes themselves.

His installations may take on different forms, but there are two elements that seem especially prevalent. The first is the gallery reconstruction of a social setting, usually similar to that which originally formed the backdrop for a particularly engaging conversation. A table, some chairs, a filled ashtray, a few wine bottles and/or beer cans, and the ubiquitous casual arrangement of notecards, napkins and other fragments of paper provide a tableau where the viewer can enter, attempt to re-live the scenario, or simply contemplate the spontaneous nature of the scene.

The second mode of presentation is Grigely's classification and arrangement of handwritten communications according to certain shared characteristics. Like behavioural studies in miniature, the notes function both as peep-holes into the individual's frame of mind as well as documents of certain paradoxical or otherwise noteworthy occurrences. In recent installations he has gathered together a number of seemingly unconnected notes, for which he produces another text to explain the basis of the comparison between the two. An astute social observer, Grigely is not so much interested in reconstructing what took place as he is in locating threads of connection between diverse individuals and circumstances, based on their all having been forced to reconsider their habitual modes of communication in order to initiate and maintain communication with him. Although it is clearly an art based on social nuance and (mis)interpretation, it is also significant in that it transforms the position of the one who is typically described as having a handicap into the author of a work based on transcending the limitations that such a condition normally places on social interaction. As social philosopher, humourist and practitioner of the art of the found object (or situation), Grigely helps us to appreciate that art, which ostensibly makes communication its reason for existence, is still at the early stages of opening itself up to the richness of possibility for forms of communication that are still being invented.

Dan Cameron

Paula H, New York, 24 May 1996, 1997,
Joseph Grigely,
R-print,
8 x 12 cm

She said her
name is the
sound of a CAT

We can
divide into
the bathroom +
fool around

this page: Joseph Grigely
Barbican Conversations, 1998
Posters, ink and pencil conversations
on paper
Dimensions variable
Installation, Barbican Centre, London

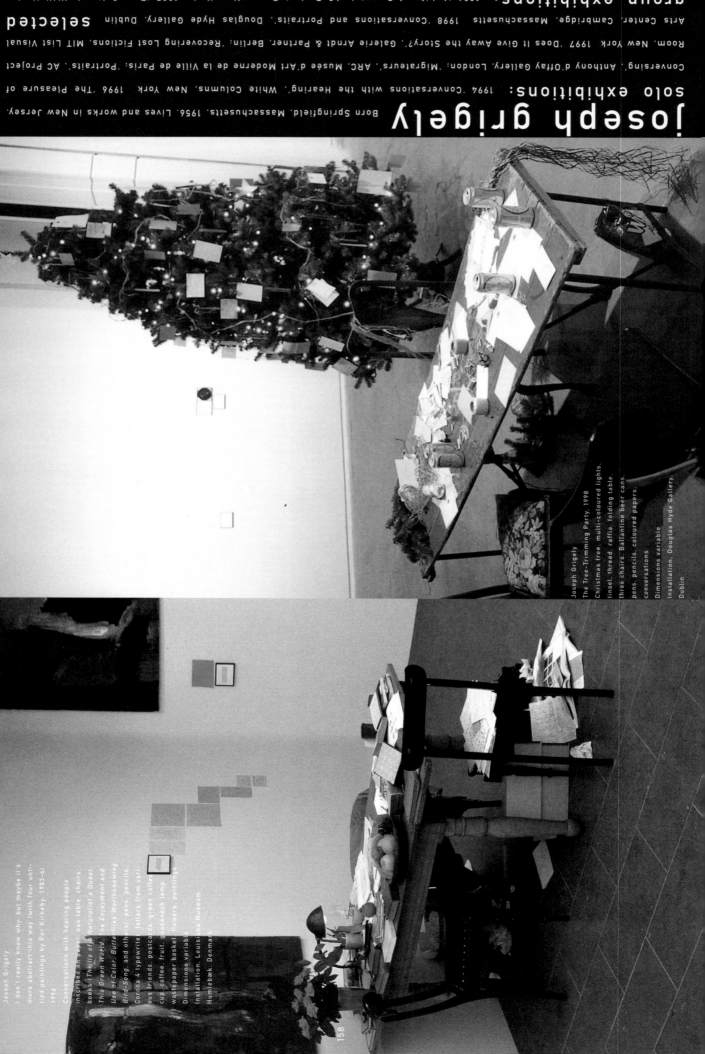

joseph grigely

Born Springfield, Massachusetts, 1956. Lives and works in New Jersey.

solo exhibitions: 1994 'Conversations with the Hearing'. White Columns, New York. 1996 'The Pleasure of Conversing'. Anthony d'Offay Gallery, London. 'Migrateurs'. ARC, Musée d'Art Moderne de la Ville de Paris. 'Portraits'. AC Project Room, New York. 1997 'Does it Give Away the Story?'. Galerie Arndt & Partner, Berlin. 'Recovering Lost Fictions'. MIT List Visual Arts Center, Cambridge, Massachusetts. 1998 'Conversations and Portraits'. Douglas Hyde Gallery, Dublin.

group exhibitions: 1994 'A Life of Secrets'. AC Project Room, New York. 1995 'TransCulture'. XLVI Venice Biennale. Naoshima Museum of Contemporary Art, Japan. 1996 'de Rode Poort'. Museum van Hedendaagse Kunst, Ghent; 'Nowhere'. Louisiana Museum, Humlebæk, Denmark. 1997 'Blueprint'. De Appel, Amsterdam. 1998 'Voiceover. Sound and Vision in Recent Art'. Arnolfini, Bristol.

selected bibliography: 1994 Holland Cotter. 'Joseph Grigely and Lee Gordon'. The New York Times, 25 March. Raphael Rubinstein. 'Joseph Grigely at White Columns'. Art in America. New York. December 1996 Kate Bush. 'Small Talk'. frieze. London, March/April; David A. Greene. 'Aural Report'. The Village Voice. New York, 18 June. Brigitte Ollier. 'Joseph Grigely, le discours manuel'. Libération, 4–6 May. Paris. Raphael Rubinstein. 'Visual Voices'. Art in America. New York, April. Jérôme Sans. 'Joseph Grigely'. Artforum. New York, November. Holland Cotter. 'A Benefit Exhibition for D.E.A.F., Inc.'.

Joseph Grigely
The Tree-Trimming Party, 1998
Christmas tree, multi-coloured lights,
tinsel, thread, raffia, folding table,
three chairs, Ballantine beer cans,
pens, pencils, coloured papers,
conversations
Dimensions variable
Installation, Douglas Hyde Gallery,
Dublin

Joseph Grigely
I don't really know why, but maybe it's
more abstract this way (with four unti-
tled paintings by Per Kirkeby, 1983-4).
1996
Conversations with hearing people
inscribed on four oak table chairs,
books (Thrills of the Naturalist's Quest,
This Green World, The Enjoyment and
Use of Color, Butterflies Worthwhile,
Bird-Song, and others), pens, pencils,
Corona 4 typewriter, letters from vari-
ous friends, postcards, green coffee
cup, coffee, fruit, gooseneck lamp,
wastepaper basket, flowers, paintings
Dimensions variable
Installation, Louisiana Museum,
Humlebæk, Denmark

One night when I was in New York—it was close to midnight—I was heading back to my car in Soho, when a man gestured to me. He rubbed his stomach with his hand and seemed to say "food," but I wasn't too sure if this is what he really said. So I asked him to write. I know this seems a little strange, but I really wanted to know what he was saying. When you're deaf and panhandlers ask for money, their gestures tend to vary and say different things—and so I wanted, for once, to know what words went with this gesture of rubbing one's stomach with one's hand.

The man seemed a little surprised by my request, but he took it seriously and started to write. The letters came slowly: M-O-N and then he stopped. He seemed confused, as if he wasn't sure what came next. There was a long pause, and then he crossed out the unfinished word and tried to start again. He wrote an M, but stopped & didn't continue. He paused again. And then he crossed out the M.

He then moved over to a railing, leaned on it, and tried a third time: another M. By now I sensed anxiety on his part. He stole pained glances at passersby, perhaps hoping that someone would help him in his effort to communicate. He looked back down at the M he had made and tried to erase it—but my pencil didn't have an eraser, and so he did with this M what he did with the previous M: he crossed it out.

At this point he could have given up; people were walking by, time was being lost, and this word that begins with an M would not write itself. But one thing I have learned about homeless people is that they have an immense respect for the disabled. Perhaps he sensed this. Perhaps not. But he did not quit.

He tried again. It was his fourth effort now to give words to his gesture. He wrote an M, but this time he tried a new direction, one that shifted from object to subject: I. A pause. Then: MY. And then: another pause. And finally: he crossed it all out.

This was the end, and, in a sense, it said more than enough, more, perhaps, than mere words themselves could have said. What was his life like? Metonymized by effort and erasure, by inscription and cancellation, one can begin to imagine what was otherwise unimaginable. Hopes, jobs, things like that. The letters crossed out. The gesture that began it all, the gesture to which we return.

Joseph Grigely
Untitled Conversation
(The Panhandler), 1995
Pencil on paper with framed text
30.5 x 17.5cm

Joseph Grigely
Untitled Conversation
(Paula's Birthday Party)
(detail), 1996
Ink on paper tablecloth
96.5cm

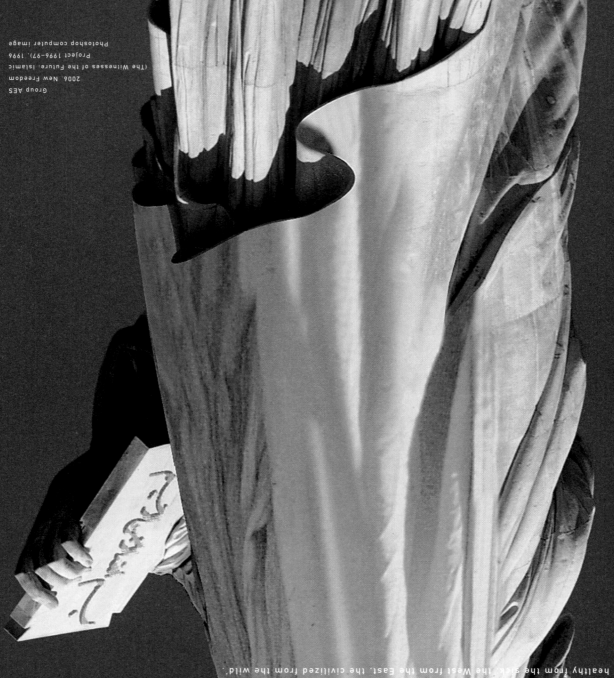

Group AES
2006, New Freedom
(The Witnesses of the Future: Islamic
Project 1996–97), 1996
Photoshop computer image

Hou Hanru

At the end of the millennium, an inevitable common anxiety is: what will our world become in the next century? Some envisage the future as a utopic global village, in which all human beings will benefit from universal economic and technological advances. Others imagine a cataclysmic confrontation between different communities as a result of the decline of Western domination. In a radical example of the latter approach, the American futurologist Samuel Huntington predicts a series of 'action-movie' wars between the three major religious civilizations: the Christian West, Islam and Confucianism. To preserve Western interests (mainly the expansion of multi-national capitalism and liberal values), he suggests that Western countries should act together with other non-Islamic and non-Confucian countries to fight against these powers.

Coming out of Moscow, and therefore familiar with fearful Cold War-style propaganda, Group AES, composed of three Russian Jewish artists, aim in their series The Witnesses of the Future: Islamic Project, 1996–97, to reveal the absurdity of the Huntington theory of the 'Clash of Civilizations'. Their strategy is to take his ideas to an exaggerated extreme by proposing 'the worst imaginable scenario'. Using computer-generated imagery, they have produced cityscapes of the main Western capitals from New York to Paris, Rome to Sydney, Moscow to Berlin, envisaged as they might be in the year 2006 under Islamic occupation. Western historical monuments are turned into mosques, surrounded by Islamic gunmen and nomadic tents. Even the Statue of Liberty is covered from top to bottom by an Islamic veil, the Declaration of Independence in her hand replaced by the Koran. To emphasize this ironic strategy, the artists set up the 'AES Travel Agency to the Future' in 1997, in which these scenarios are put on sale in the form of postcards, mugs, T-shirts etc., while questionnaires are distributed to visitors.

This hi-tech game of guess-the-future, central to the group's strategy, is an attempt to challenge our presumptions about the world. It aims not only to deconstruct the logic of fear as the ideological foundation of geo-political power games but also leads to a disintegration of the psychological constructs behind our perception of images and their meanings. On one hand, Group AES use shocking images to achieve visual impact; on the other, they set up sophisticated situations in which the spectator is invited to participate directly in the suspension of conventional morality. In The Suspects: Seven Innocent, Seven Sinners, 1997–98, for example, the spectator is invited to distinguish seven murderous girls from seven innocent ones, a task made impossible by the standard, neutral portraits.

In a new project, The Berlin Wall - 2 New, Nice and Improved, 1997, Group AES propose to rebuild the Berlin Wall with fluorescent, hi-tech materials. To celebrate the erection of the new wall, they chant: 'Lord! Divide the poor from the rich, the South from the North, the healthy from the sick, the West from the East, the civilized from the wild'.

group aes

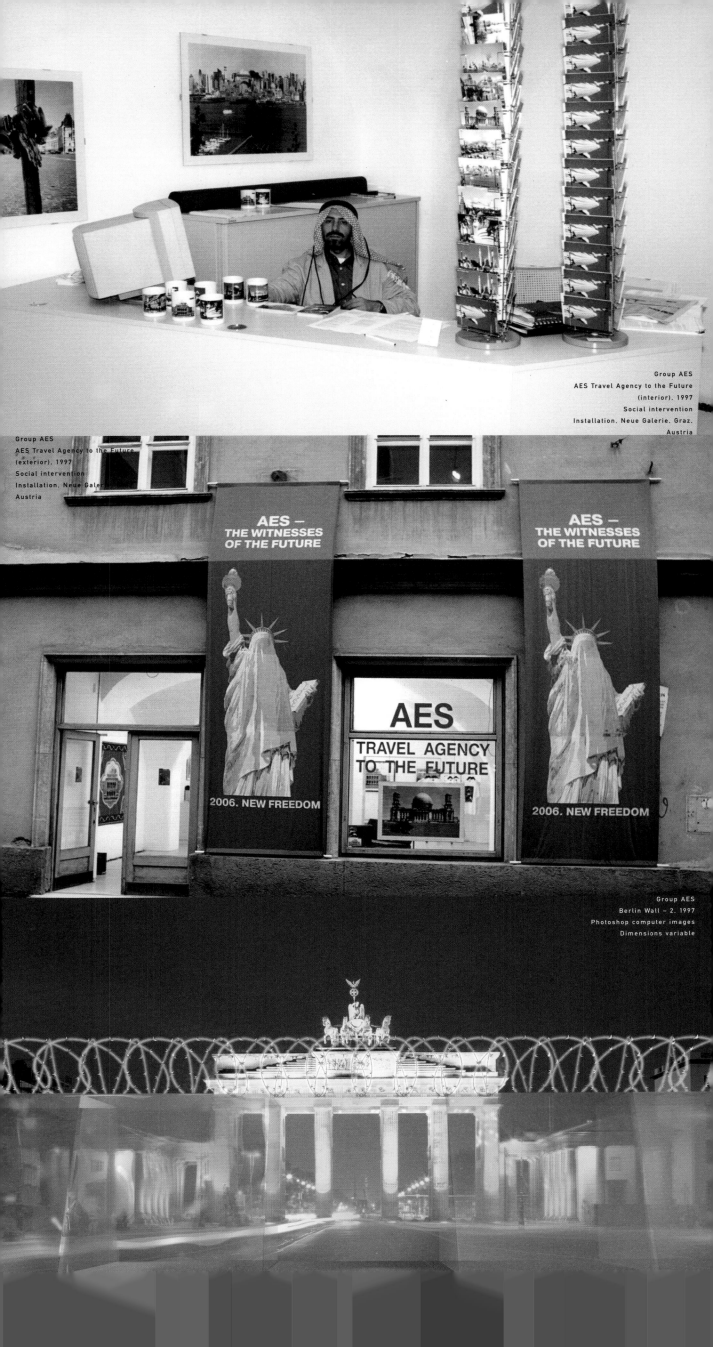

Group AES
AES Travel Agency to the Future
(interior), 1997
Social intervention
Installation, Neue Galerie, Graz,
Austria

Group AES
AES Travel Agency to the Future
(exterior), 1997
Social intervention
Installation, Neue Gale...
Austria

Group AES
Berlin Wall — 2, 1997
Photoshop computer images
Dimensions variable

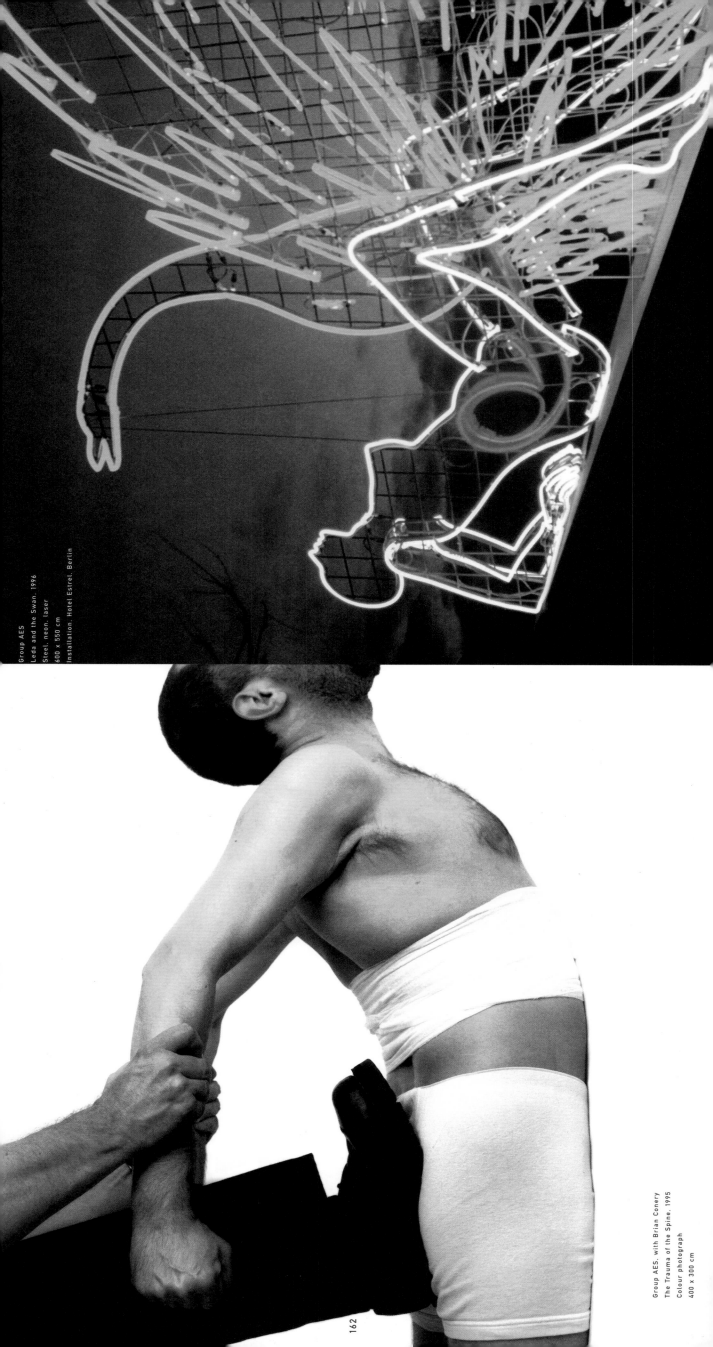

Group AES
Leda and the Swan. 1996
Steel, neon, laser
600 x 550 cm
Installation, Hotel Estrel, Berlin

Group AES, with Brian Conery
The Trauma of the Spine. 1995
Colour photograph
400 x 300 cm

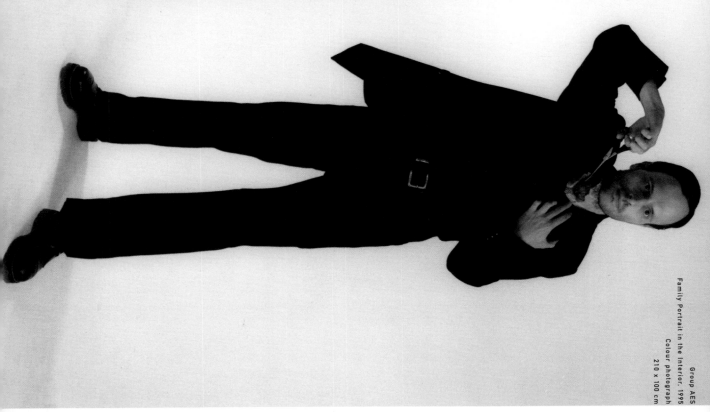

Group AES
Family Portrait in the Interior, 1995
Colour photograph
210 x 100 cm

group aes

Tatyana Arzamasova, born Moscow, 1955; Lev Avzovitch, born Moscow, 1958; Avgeny Svyatsky, born Moscow, 1957. Group AES lives and works in Moscow. **selected solo exhibitions:** 1995 'Body Space', State Centre of Contemporary Art, Moscow; '19th Century Russian Landscape', Internationale Austausch Ateliers Region Basel and tour 1997 'AES Travel Agency to the Future', Neue Galerie, Graz, Austria, Mason Gross School of Art, Rutgers University, New Jersey **selected group exhibitions:** 1995 'Autumn Exhibition', Guelman Gallery, Moscow; 'Zeitgenossische Fotokunst aus Moskau', Neuer Berliner Kunstverein, Berlin 1996 'Contemporary Russian Photography', La Base Centre of Contemporary Art, Paris 1997 'The World of the Perceptible Things in Pictures – End of the 20th Century', State Pushkin Museum of Fine Arts, Moscow **selected bibliography:** 1991 Victor Misiano, 'Old-Fashioned Passion', *Flash Art*, Milan, May/June 1992 Konstantin Akinsha, 'After the Coup. Art for Art's Sake', *ARTnews*, New York, January 1993 Susan Reid, 'End of an Empire', *Circa*, Belfast, Spring 1996 Alexander Balashov, 'The Criticism of Diagnosism', *Khoudozhestvennyi Journal*, No 12, Moscow; Oleg Kireev, 'AES: Moscow–Berlin, then Everywhere, in Guelman Gallery', *Khoudozhestvennyi Journal*, No 12, Moscow; Alexander Petrotchenkov, 'Moscow, Berlin, then Everywhere', *Domashni Computer*, No 5, Moscow 1997 Archi Galentz, 'AES interview', *Filmzeit*, Berlin, March/April; A. Akarov, 'The Great Muslim Project', *Camera-Obscura*, No 1, Los Angeles; Mika Hannula, 'The World According to Mr Huntington', *Siksi*, Helsinki, Spring; Rainer Metzger, 'Winn der Surfer zweimal nachdenkt', *Der Standard*, Vienna, 29 September 1998 William Zimmer, 'Eastern Europeans Envision the Future', *The New York Times*, 1 February; Blake Eskin, 'Russian–Jewish Art Angers Rutgers Muslims', *Forward*, New York, 20 February

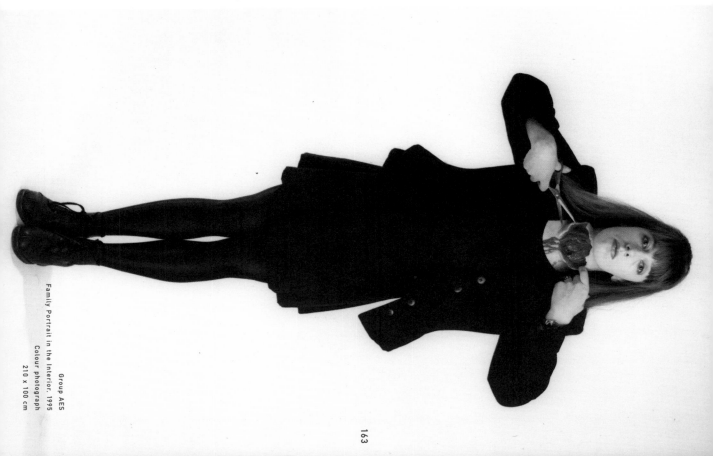

Group AES
Family Portrait in the Interior, 1995
Colour photograph
210 x 100 cm

mark handforth

Carlos Basualdo

Miami Kiosk, 1998. Miami Kiosk is an enormous aluminium dish (488 cm in diameter) made out of twelve triangular sections that have been screwed together. Its surface is shiny and slightly irregular. Alternate plates are painted white on the underside to create a patchwork-like effect. The work suggests not so much a formalist structure as the kind of curious structure one might encounter at a fun fair or amusement park. In Miami in 1996, Handforth exhibited a similar piece made from fibreglass, Untitled (dish). Its vaguely utilitarian function was alluded to by the presence of a pillow, a blanket and a handful of magazines strewn across the bottom of the interior, elements that invite the viewer to lean into the dish and take a peek or perhaps leaf through the magazines. In contrast, the possible utilitarian function of Miami Kiosk is rather ambiguous. For example, there is nothing that would overtly prompt a viewer to touch it or, indeed, to interact physically with it, yet a mysterious attraction makes it difficult to resist the temptation to use the piece in some way. Photographs given to me by the artist show a group of children, obviously enjoying themselves, having adopted this povera version of a flying saucer as a swing. On one visit to the gallery, I found a selection of toys scattered inside the piece. The gallery assistant assured me that the playthings had nothing to do with the work per se — they had been left behind by the gallerist's children who had taken to playing in the piece.

The monumentality of Untitled (dish) seems to contradict and be contradicted by the possible uses of the work. Its utilitarian (in the strictest sense of the word) aspect consists of stimulating leisure, which makes it an indirect parody of the productive notion of utility. However, thanks to the relative cleanness of the materials with which the piece is constructed, this oscillation between artwork and design object was explicit in the work. In Miami Kiosk, in contrast, this relation is scarcely hinted at. There is nothing in Miami Kiosk to imply a possible use for the piece, and nothing, except for the fact that it has been exhibited in a gallery, even to suggest it is a sculpture. The observer might be led to believe that its tautology of form and materials — the fact that it looks like a giant plate or aluminium pan — is a nod towards early Claes Oldenberg and, indeed, to Pop Art in general. Yet the 'poor' status of the piece, the sort of glamour-free dull zone the work inhabits, is equally reminiscent of the cheap and cheerful decor of some provincial discothèque. It is as if the dual suspension of the work's aesthetic/utilitarian dimensions is an involuntary effect that somehow reveals its extreme fragility and the marked conventionality in which this type of distinction is rooted.

Mark Handforth
Miami Kiosk, 1997
Aluminium
ø 488 cm
h. 122 cm
Installation, Gavin Brown's enterprise,
New York

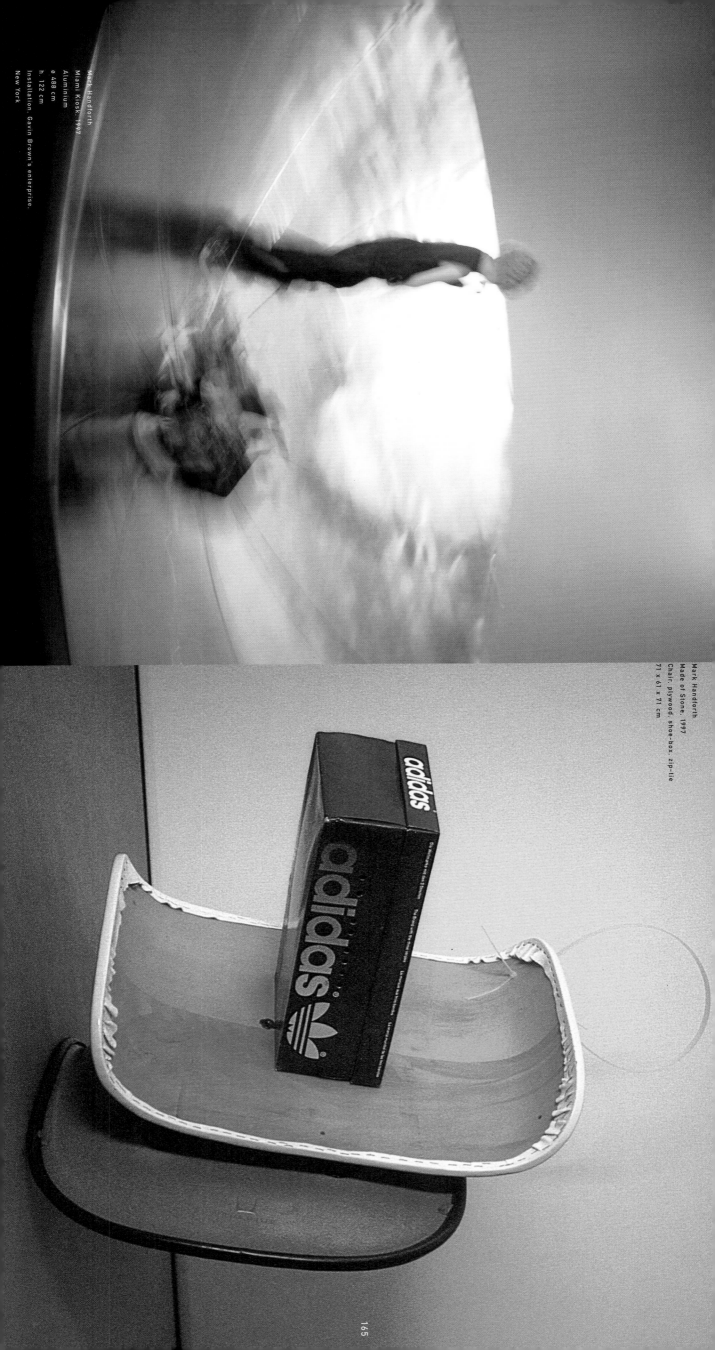

Mark Handforth
Miami Kiosk, 1997
Aluminium
ø 488 cm
h. 122 cm
Installation, Gavin Brown's enterprise,
New York

Mark Handforth
Made of Stone, 1997
Chair, plywood, shoe-box, zip-tie
71 x 61 x 71 cm

165

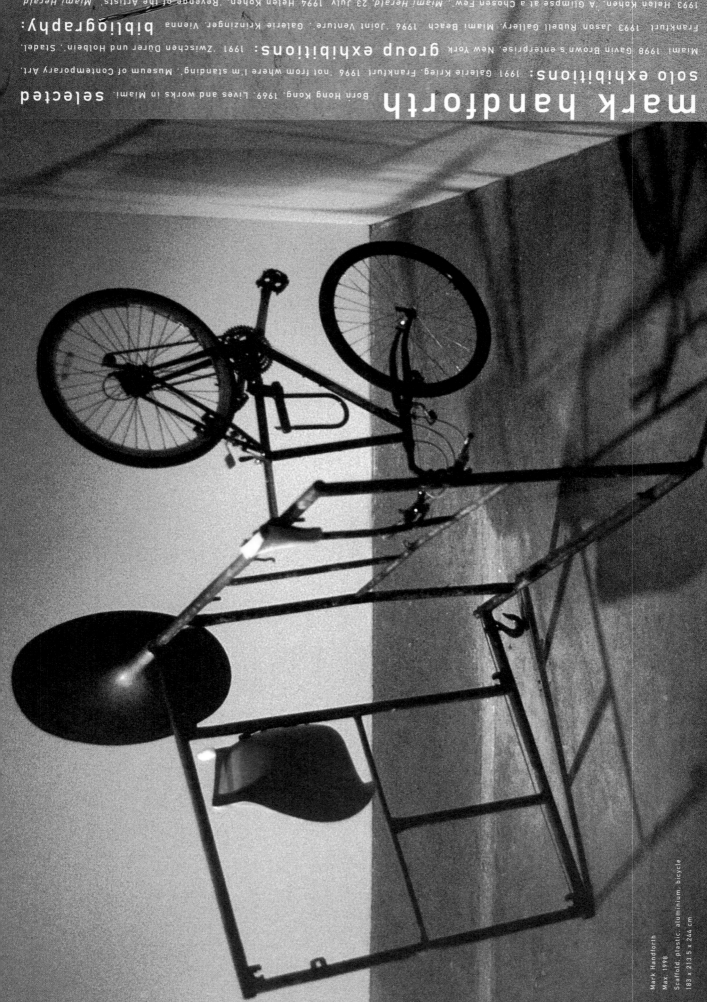

Mark Handforth
Golden Rod, 1998
Running spike ski pole,
zip-tie, arrow, running shoe
30.5 x 30.5 x 84 cm

mark handforth

selected

Born Hong Kong, 1969. Lives and works in Miami.

solo exhibitions: 1991 Galerie Krieg, Frankfurt. 1996 'not from where I'm standing', Museum of Contemporary Art, Miami. 1998 Gavin Brown's enterprise, New York. 1991 'Zwischen Dürer und Holbein', Städel, Frankfurt. 1993 Jason Rubell Gallery, Miami Beach. 1996 'Joint Venture', Galerie Krinzinger, Vienna

group exhibitions:

bibliography: 1993 Helen Kohen, 'A Glimpse at a Chosen Few', Miami Herald. 1994 Helen Kohen, 23 July, 'Revenge of the Artists', Miami Herald. 15 April. Cyn Zarko, 'Basic Instinct', Ocean Drive Magazine, Miami, June. 1996 Bettina Busse, Joint Venture, Galerie Krinzinger, Vienna. Judy Cantor, 'Techno Trashing', New Times, Miami. 18 July, Elisa Turner, 'Latest MoCA installation speaks of art without an angle', Miami Herald, 8 June. Michael Kimmelman, 'Ambitious Miami Reaches for a Place in the Sun', The New York Times, 31 March. Bonnie Clearwater, 'not from where I'm standing', Museum of Contemporary Art, Miami. 1998 Jade Dellinger, 'Cityscape', Flash Art, Miami March/April.

Mark Handforth
Max, 1998
Scaffold, plastic, aluminium, bicycle
183 x 213.5 x 244 cm

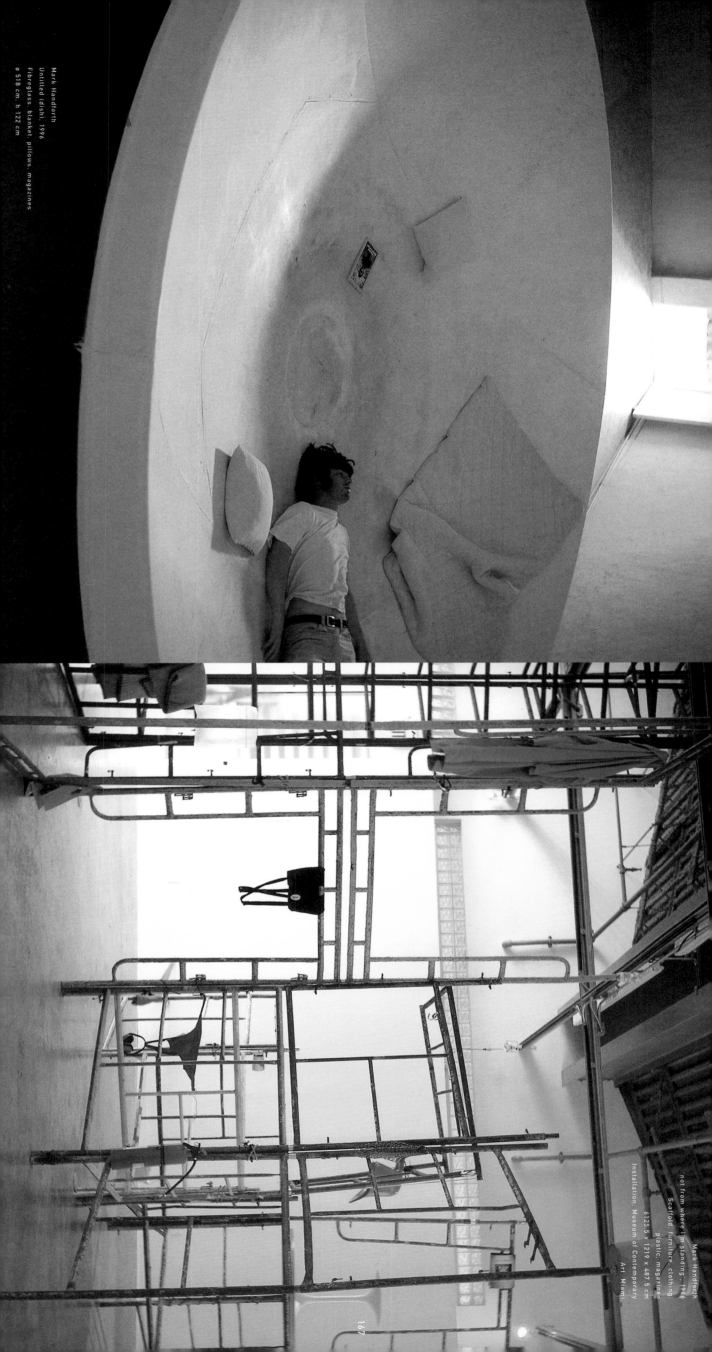

Mark Handforth
Untitled (dish), 1996
Fibreglass, blanket, pillows, magazines
ø 518 cm, h 122 cm

Mark Handforth
not from where I'm standing, 1996
Scaffold, furniture, clothing,
plastic, magazines
6125.5 x 1219 x 487.5 cm
Installation Museum of Contemporary
Art, Miami

kay hassan

Throughout the 1980s and the better part of the current decade, it seemed as if contemporary art had arrived at an impasse in South Africa: a re-analysis of art's role within the broader political, social and cultural structure of the country seemed well over-due. Of course, the robust energy of what was then called 'Resistance Art' helped mask this crisis. Placed in the strict service of the revolutionary structures that sought to dismantle and reverse the pernicious effects of the apartheid system, art was hardly in a position to resist the fatal lure of being trapped in ideology. Now, a new attitude appears to be asserting itself.

Today, South Africans are consumed by the idea of memory – tormented by their history and haunted by spectres of the violence that attended their hard-won freedom. Far from being cancelled out, however, history and memory are being ploughed back into the new strategies and language of contemporary artists as an essential ingredient for the exploration of the meaning and limits of freedom. Kay Hassan is at the forefront of this sea-change. Formerly a painter and printmaker, he has recently turned to installation, photography, video and his signature, monumental collages of billboard paper with its pixilated matrix of digital pointillism.

With these materials he explores the full ramifications of history, memory, popular culture and the place of the black image in current art.

Hassan's astute, humanist investigation focuses on issues of displacement, labour, violence and migration. His deeply poetic and touching series *Flight*, 1995-96, installations of bags and bundles, does not restrict its subject to the erasure of populations from their homes in South Africa. It is more concerned with a wider violence, for instance the brutal difficulties faced by populations in Rwanda and Bosnia. It also addresses the consequences of global migration, the drift of populations in flight from economic deprivation or social ostracism.

Shebeen, 1997, first shown at the Walker Art Center in Minneapolis, is a simulation of the speak-easy environment of drinking houses in the black townships. Entering this installation, with its pulsing music and documentary images projected on two adjacent walls, is like embarking on a journey through time.

Shebeen was particularly popular with visitors to the 2nd Johannesburg Biennale in 1997, and perhaps this is because, by inserting this evocation of community into the public sphere, Hassan raises the question of what Cornell West has termed 'Black Joy'. For more than twenty years this theme has remained the prime motivation of Hassan's work. His installations can seem like monuments to Black pain; in *Miners' Quarters*, 1997, he reconstructed the claustrophobic, cell-like spaces in which black migrant workers were forced to live; he has also simulated the shack-like dwellings of millions of displaced black families. But Hassan's work explores the convergence between history and politics, identity and its transcendence, violence and the possibility of pleasure. Never polemic, he directs our thinking towards new readings of spaces, drawing attention to the presence within them of bodies entrapped by the boundaries of violence.

Okwui Enwezor

Kay Hassan
Shebeen (detail), 1997
Slide projection, coloured light, sound
Dimensions variable
Installation, Walker Art Center,
Minneapolis

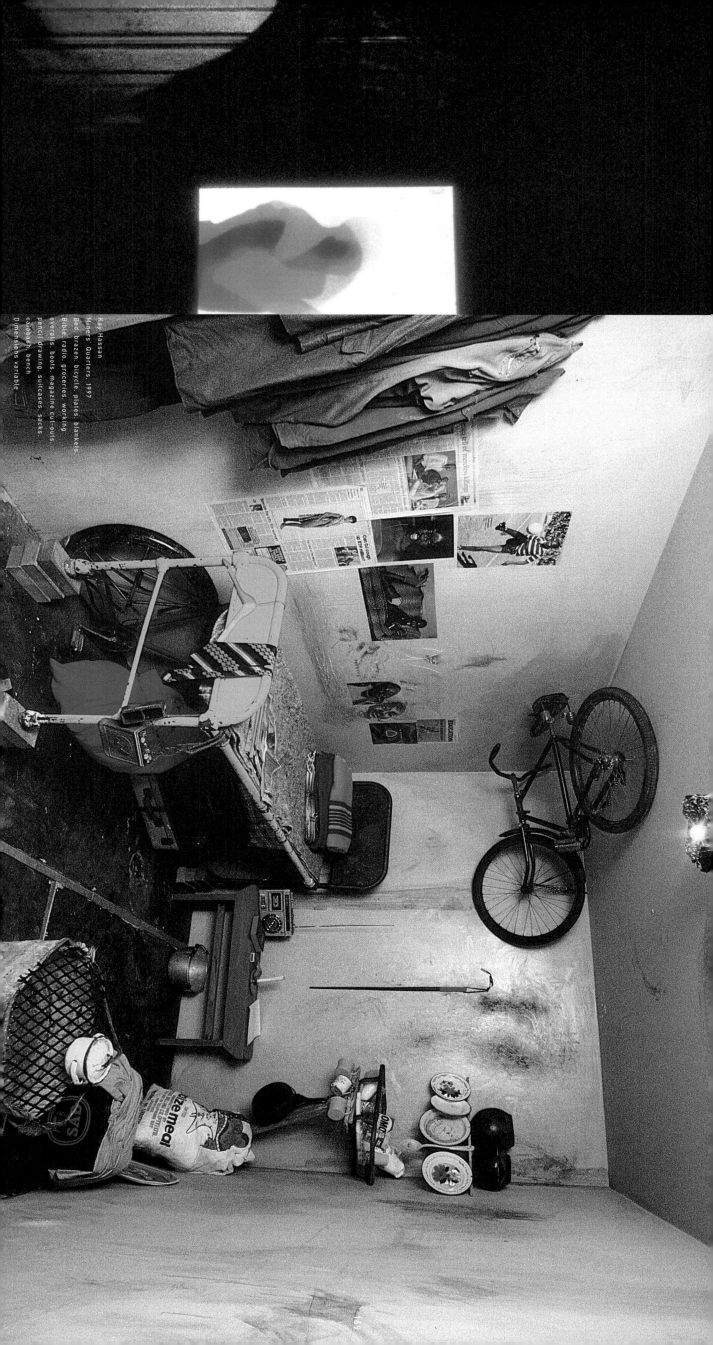

Kay Hassan
Miners' Quarters, 1997
Bed, brazier, bicycle, plates, blankets,
Bible, radio, groceries, working
overalls, boots, magazine cut-outs,
pencil drawing, suitcases, sacks,
calabash, bench
Dimensions variable

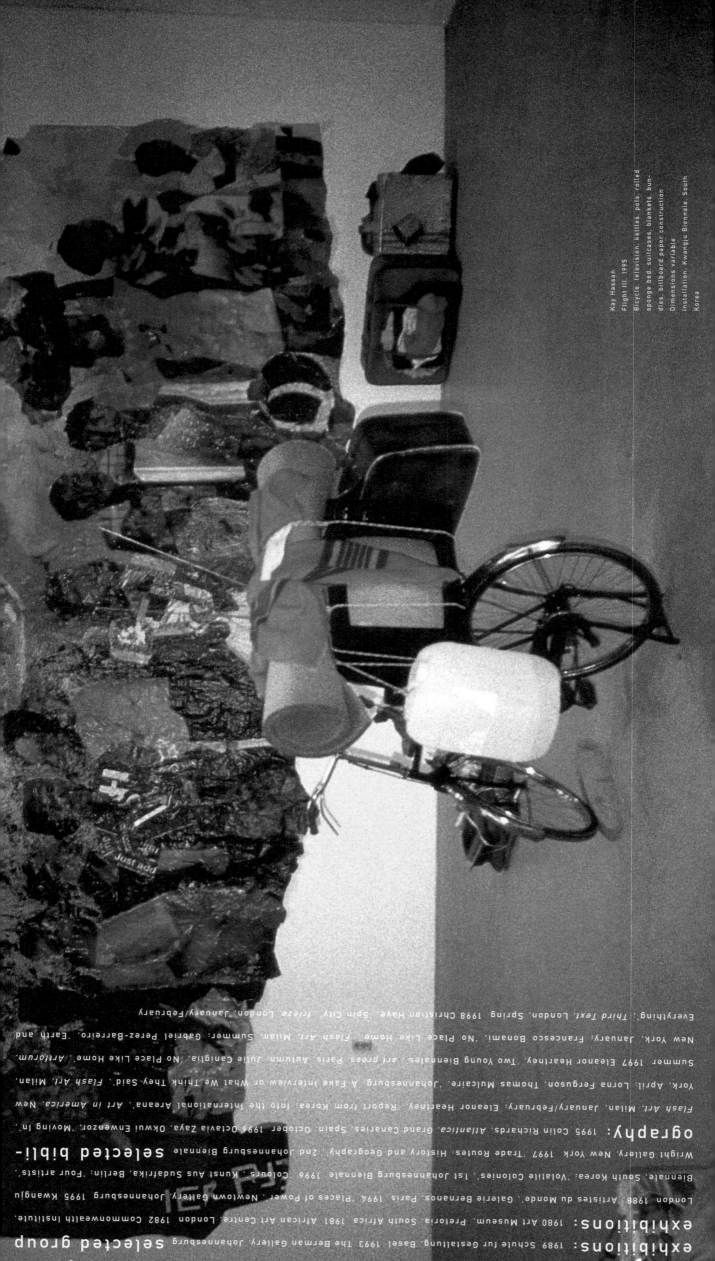

Kay Hassan
Flight III, 1995

Bicycle, television, kettles, pots, rolled sponge bed, suitcases, blankets, bundles, billboard paper construction
Dimensions variable
Installation, Kwangju Biennale, South Korea

kay hassan

Born Alexandria, Johannesburg, 1956. Lives and works in Johannesburg.

solo exhibitions: 1989 Schule fur Gestaltung, Basel. 1993 The Berman Gallery, Johannesburg.

selected group exhibitions: 1980 Art Museum, Pretoria, South Africa. 1981 African Art Centre, London. 1982 Commonwealth Institute, London. 1988 Galerie Bernanos, Paris. 1994 Places of Power', Newtown Gallery, Johannesburg. 1995 Kwangju Biennale, South Korea. 'Volatile Colonies', 1st Johannesburg Biennale. 1996 'Colours: Kunst Aus Sudafrika', Berlin. 'Four artists', Wright Gallery, New York. 1997 'Trade Routes: History and Geography', 2nd Johannesburg Biennale

selected bibliography: 1995 Colin Richards, *Atlantica*, Grand Canaries, Spain, October. 1996 Octavia Zaya, Okwui Enwezor, 'Moving in', *Flash Art*, Milan, January/February. Eleanor Heartney, 'Report from Korea: Into the International Areana', *Art in America*, New York, April. Lorna Ferguson, Thomas Mulcaire, 'A Fake Interview or What We Think They Said', *Flash Art*, Milan. Summer. 1997 Eleanor Heartney, 'Two Young Biennales', *art press*, Paris, Autumn. Julie Caniglia, 'No Place Like Home', *Artforum*, New York, January. Francesco Bonami, 'No Place Like Home', *Flash Art*, Milan, Summer. Gabriel Perez-Barreiro, 'Earth and Everything', *Third Text*, London, Spring. 1998 Christian Haye, 'Spin City', *frieze*, London, January/February

Kay Hassan with Pat Mautloa
Shack (exterior view), 1996
Corrugated iron shack, suitcases, cup-
board, racks, blankets, steel bed
plates, groceries, children's clothes,
Sowetan newspaper
500 x 300 x 200 cm
Installation, Haus der Kulturen
der Welt, Berlin

Kay Hassan with Pat Mautloa
Shack (interior view), 1996
Corrugated iron shack, suitcases, cup-
board, racks, blankets, steel bed
plates, groceries, children's clothes,
Sowetan newspaper
500 x 300 x 200 cm
Installation, Haus der Kulturen
der Welt, Berlin

171

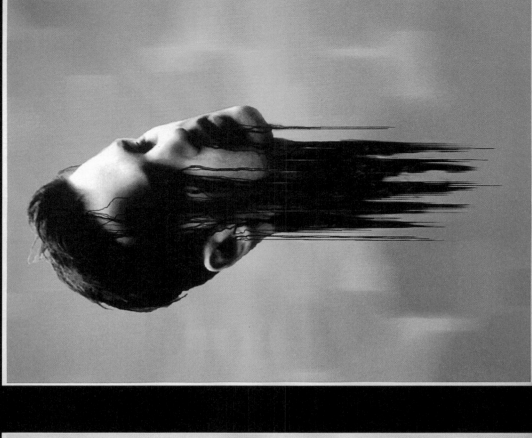

Richard Hawkins
disembodied zombie ben green, 1997
inkjet print
119 x 91.5 cm

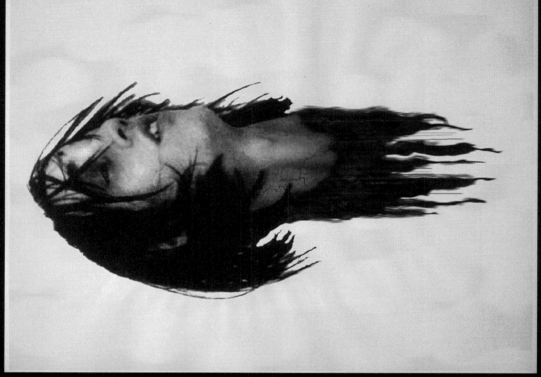

Richard Hawkins
disembodied zombie george green, 1997
inkjet print
119 x 91.5 cm

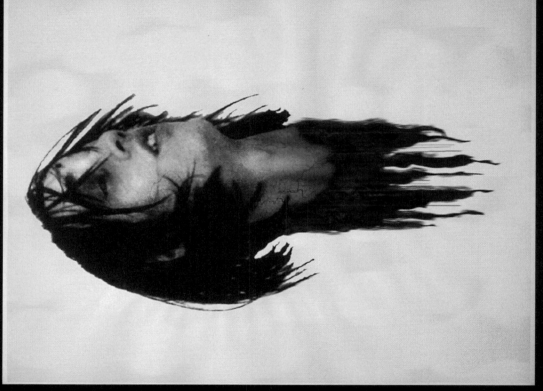

Richard Hawkins
disembodied zombie george frozen, 1997
inkjet print
119 x 91.5 cm

richard hawkins

Proustian reverie, Wildean aplomb and Baudelairean doom infiltrate Richard Hawkins' art. Yet like the filaments of a spider's web, these references are so delicate as to be almost invisible, which is to say Hawkins' pop theatrics tend to obscure his finely honed aestheticism. This is curious given the fact that this artist's meditations upon desire — literally patched together from bits and pieces of men's fashion magazines and gay male pornography — are raw and sometimes embarrassingly personal. Indeed, the earliest collages, with their pink Post-it note marginalia and roughed-up edges, evinced a poignance that at times went so far over the top it approached bathos.

With their studied insouciance and disdain for purity, however, the more recent works are less emblems of frustrated desire than carefully orchestrated, hothouse narratives. As such, they fully exploit the erotics of the fragment. Here, then, are splintered images of the male model (the nineteenth-century dandy lives, all exoticism and untouchability); and, equally alluring and inaccessible, the saturated colours of the fashion spreads themselves, isolated as geometric forms. Textual fragments figure here as well: photographers' names running up the edges of illegible images, upside-down titles of unseen articles, descriptions of invariably transformative jackets and pants. These partial words and truncated phrases are talismans, symbols of withheld information. Spread across the collages, they create their own brand of Romantic poetry, at once mysterious and mundane. As Mallarmé noted, to name something is to destroy it; to suggest it is the dream.

Hawkins' newest works are huge ink-jet prints of, among others, Johnny Depp look-alike/movie-star-in-training Skeet Ulrich and model George Clements, portrayed as disembodied heads set against alternately opalescent and day-glo backgrounds. With grey-blue lips, sunken, kohl-rimmed eyes and hollow cheeks down which rivulets of fake blood cascade, these gay icons conjure all manner of decadent forebears, from Gustave Moreau's decapitated head of John the Baptist to Alice Cooper, straight off the cover of his 1971 album, *Killer*, with a noose tightening around his neck and mascara pooling under his eyes. Cooper's *Grand Guignol* posturing, however, transforms arcana into mass-market fluff. Hawkins reverses this logic, transforming the bit players of the spectacle into the demigods of a personal religion.

Susan Kandel

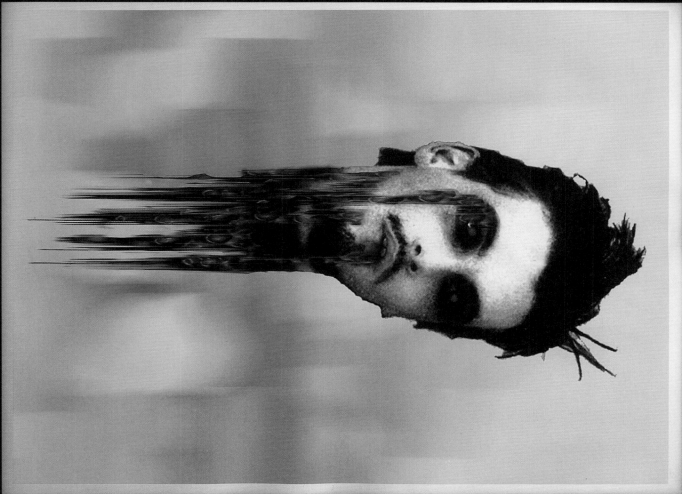

Richard Hawkins
disembodied zombie skeet pink, 1997
Inkjet print
119 x 91.5 cm

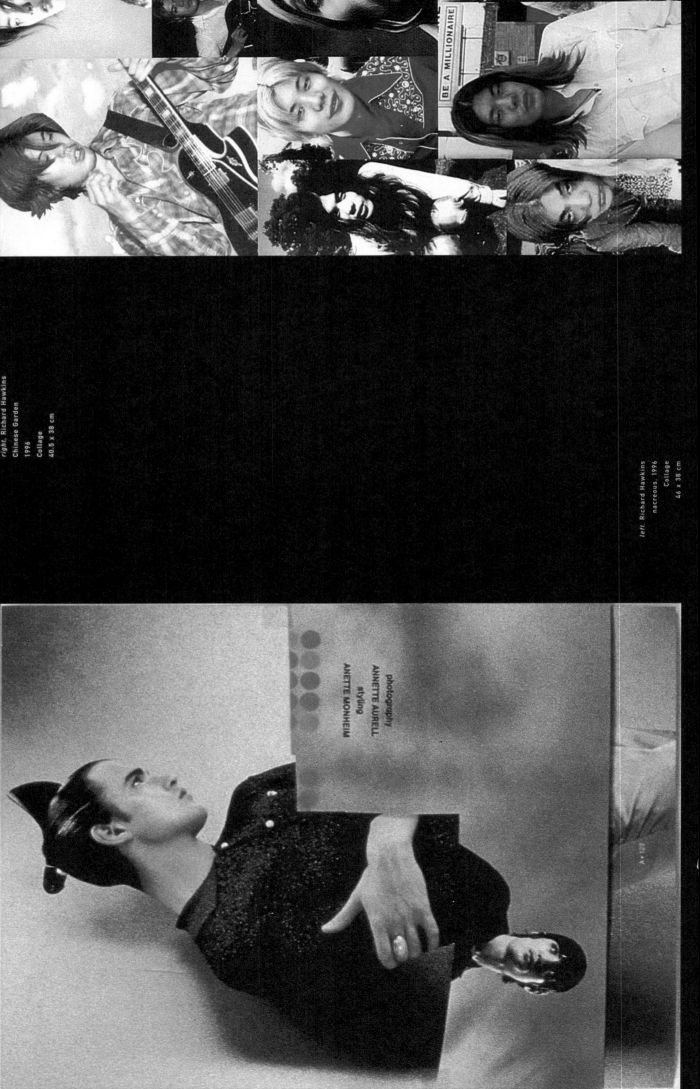

right, Richard Hawkins
Chinese Garden
1996
Collage
40.5 x 38 cm

left, Richard Hawkins
nacreous, 1996
Collage
46 x 38 cm

photography
ANNETTE AURELL
styling
ANETTE MONHEIM

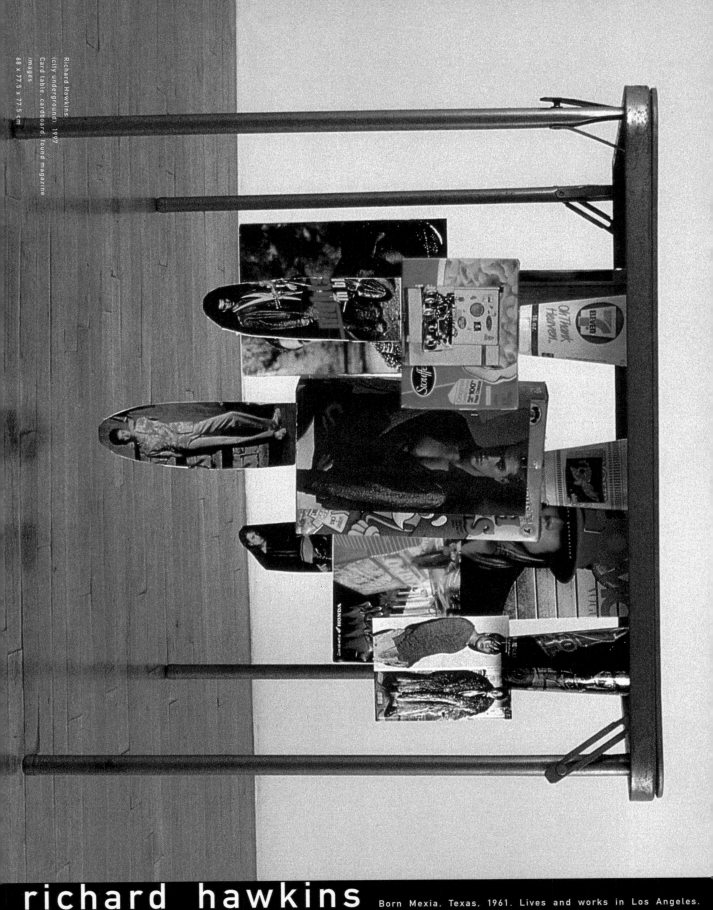

Richard Hawkins
(city underground), 1997
Card table, cardboard, found magazine
images
68 x 77.5 x 77.5 cm

richard hawkins
Born Mexia, Texas, 1961. Lives and works in Los Angeles.

selected solo exhibitions: 1992 Mincher/Wilcox Gallery, San Francisco 1993 Feature, New York 1995 'Ynglingagatan 1', Stockholm 1996 Feature, New York 1997 Richard Telles Fine Art, Los Angeles **selected group exhibitions:** 1989 'HoHoHoMo', Feature, New York 1991 'Stussy', Feature, New York 1992 'Trouble Over So Much Skin', Feature, New York; 'In Pursuit of a Devoted Repulsion', Roy Boyd Gallery, Santa Monica, California 1993 'Trisexual', TRI, Los Angeles; 'Commodity Image', International Center of Photography, New York and tour 1994 'Pure Beauty: Some Recent Work from Los Angeles', American Center, Paris; 'Mechanical Reproduction', Galerie van Gelder, Amsterdam 1995 'Crystal Blue Persuasion', Feature, New York; 'It's Only Rock & Roll', Phoenix Art Museum, Arizona; 'In A Different Light', University Art Museum, Berkeley, California 1996 'How will we behave?', Robert Prime Gallery, London 1997 'Scene of the Crime', Armand Hammer Museum of Art and Cultural Center, University of California, Los Angeles **selected bibliography:** 1991 Amy Gerstler, 'Sweet Oleander', *Artforum*, New York, September 1992 David Pagel, 'Fluff and Force', *The Los Angeles Times*, 3 December 1993 Susan Kandel, 'Richard Hawkins', *The Los Angeles Times*, 27 October; David Pagel, 'TRI-Sexual', *The Los Angeles Times*, 1 April 1994 Michael Duncan, 'LA Rising', *Art in America*, New York, December 1995 David A. Greene, 'Beyond Etch–a–Sketch', *Los Angeles Reader*, April; Susan Kandel, 'Hawkins' Latest on Male Desire: Decorative Not Edgy', *The Los Angeles Times*, 13 April; Susan Kandel, 'Taking an Intriguing Look at Three Distinct Visions', *The Los Angeles Times*, 28 May; Deborah Wilk, 'Youth Culture', *Flash Art*, Milan, Summer 1996 Susan Kandel, 'Richard Hawkins', *The Los Angeles Times*, 28 May 1997 Ann Doran, 'Review', *Time Out*

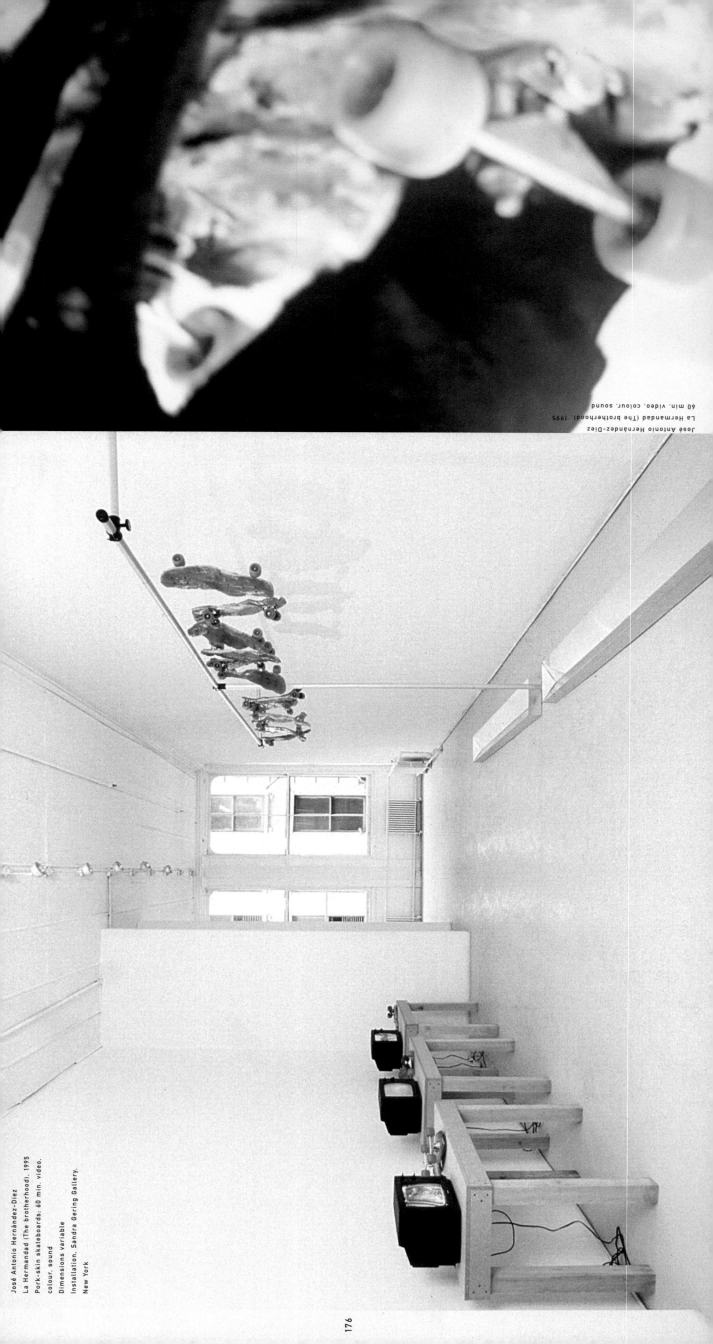

José Antonio Hernández-Diez
La Hermandad (The brotherhood), 1995
60 min. video, colour, sound

José Antonio Hernández-Diez
La Hermandad (The brotherhood), 1995
Pork-skin skateboards; 60 min. video,
colour, sound
Dimensions variable
Installation, Sandra Gering Gallery,
New York

José Antonio Hernàndez-Diez
El Gran Patriarca
(The great patriarch), 1993
Customized robot, mixed media
Dimensions variable

josé antonio hernàndez-diez

The conventions of cinema require that several layers of production detail go into creating an atmosphere of danger and/or fear. Actors, makeup, special effects, script, camerawork, lighting and costumes are only some of the necessary ingredients in making a film, while the impact of the result is measured in terms of its ability to fool the viewer into thinking that what he or she is seeing is real. José Antonio Hernàndez-Diez' approach to sculpture begins from the premise that even though certain cultures only have recourse to more humble means of creating an impact of horror, the end result can be every bit as gruesome as that created in Hollywood.

Born and raised in Caracas, Hernàndez-Diez produced work in the early 1990s that made use of startling juxtapositions between science and religion. While a work like *Sagrada Corazón Vivo (Sacred heart alive)*, 1991, incorporated a cow's heart kept artificially pumping within a Plexiglas crucifix to draw parallels between organ transplants and the popular belief in miracles, *San Guinefort (Saint Guinefort)*, 1992, took the same premise even further. Inside a Plexiglas vitrine, to which holes and transparent glove extensions have been added inviting viewers to reach inside and touch, lies a stuffed German shepherd as an explicit historical reference to a medieval dog who was actually canonized.

Video became the essential ingredient in Hernàndez-Diez' works from the mid 1990s. Two of the best known of these are *La Hermandad (The brotherhood)*, 1994 and *Vas p'al Cielo y Vas Llorando (You're going to heaven, and you'll go crying)*, 1994. In the first piece, the artist has constructed a few dozen skateboards entirely from fried pork skin and distributed them around the viewing space. Some hang on tables or drop from wall brackets, while most hang from a dungeon-like rack that perpetually drip fat onto a waiting tray. Three (others) hold separate video monitors, each of which is continually playing a different tape of a stage in the skateboards' lives: birth (in a frying pan), life (rolling around the streets) and death (being consumed by dogs). For the second work, the artist conducted interviews with street children in Colombia, then asked them to stand as if sleepwalking while calling out each others' names. After filming them with a rotating camera, Hernàndez Díez projected the image sideways onto a transparent screen stretching from a pile of dirt on the floor to the ceiling. As the children pass quickly from 'earth' to 'heaven', they seem to be playing nothing more than a simple game of tag.

Although Hernàndez-Diez' most recent work does not directly incorporate video, the relationship between a cinema of terror and a sculpture remains intact, most notably in a humorous yet disturbing series of simple, particle-board furniture pieces that appear to have been partially chewed by a marauding giant.

Dan Cameron

José Antonio Hernàndez-Diez
El Gran Patriarca (The great patriarch)
(detail), 1993
Customized robot, mixed media
Dimensions variable

José Antonio Hernández-Díez
Vas Pa'l Cielo y Vas Llorando (You're going to Heaven and you'll go crying), 1992
Plastic screen, soil, 11 min. video-loop projection, colour, sound
Dimensions variable

josé antonio hernández-diez

Born Caracas, Venezuela, 1964. Lives and works in Caracas, Venezuela. **selected solo exhibitions:** 1991 San Buenfort y otras devociones'. Sala RG, Caracas. 1995 Sandra Gering Gallery, New York. 1996 Sandra Gering Gallery, New York. **selected group exhibitions:** 1988 IX Festival Internacional de Super 8 y Video, Brussels. 1990 'Los 80, Panorama de las Artes Visuales en Venezuela'. Galerie de Arte Nacional, Caracas. 1991 'Venezuela/Nuevas Cartografías y Cosmogonías'. Galería de Arte Nacional, Caracas. 1992 'I Bienal Barro de America'. Museo de Arte Contemporaneo de Caracas Sofía Imber, Caracas. 1993 Aperto, XLV Venice Biennale. 'The Final Frontier'. New Museum of Contemporary Art, New York. 1994 5th Havana Biennial 1996 XXII São Paolo Biennial. **selected bibliography:** 1991 Paulo Herkenhoff, Geri Smith. 'Latin American Art/The Global Outreach'. ARTnews, New York, April. 1992 Meyer Vaisman. 'José Antonio Hernández-Díez'. Artforum, New York, April. 1993 Laura U. Marks. 'The Final Frontier'. Artforum, New York, December. Adrian Dannatt. 'The Final Frontier'. Flash Art, Milan. October. 1994 Holland Cotter. 'Art in Review'. The New York Times, 12 August. Dan Cameron. 'Ante America'. Third Text, London. Spring 1995 Yasmin Ramirez. 'José Antonio Hernández-Díez at Sandra Gering'. Art in America, New York, September. Anastasia Aukeman. 'Rising Stars Under 40'. ARTnews, special issue, New York.

José Antonio Hernández-Díez
Untitled, 1996
C-print
101.5 x 101.5 cm

José Antonio Hernández-Diez
Untitled, 1996
Formica on wood
2 parts, 150 x 80 cm each

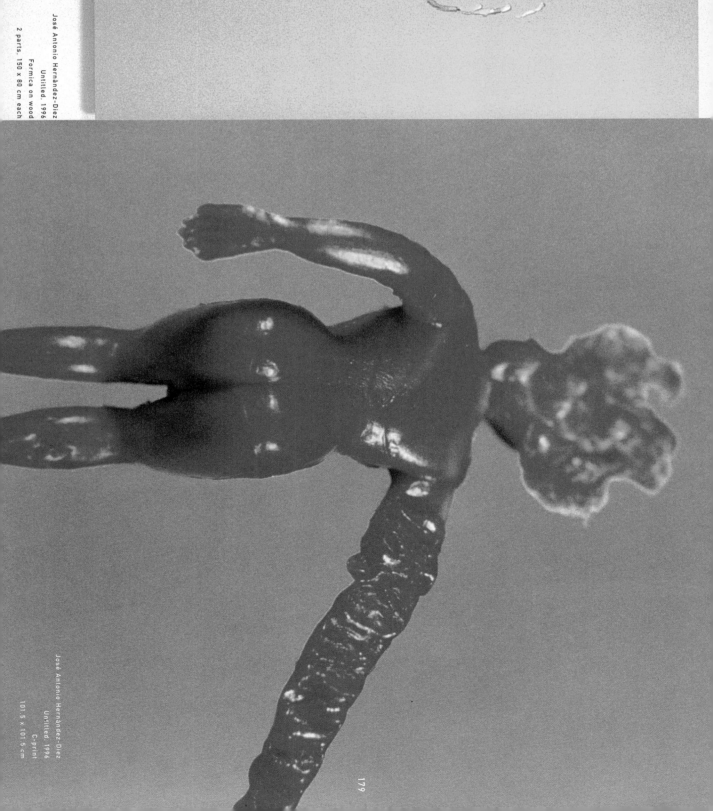

José Antonio Hernández-Diez
Untitled, 1996
C-print
101.5 x 101.5 cm

thomas hirschhorn

At a time of great political entropy in the Western world, Thomas Hirschhorn works to redefine the place of political energy, the sites where humanity continues to work at the project of its future.

His squares and market-places, both theatrical and symbolic, occupy the gallery space in such a way that viewers may go in and out as they please, but a distance is always maintained. Although the installations occupy three-dimensional space, many of the objects within these installations are flat in conception; walking through Hirschhorn's work is a little like walking through a painting which has suddenly taken on a three-dimensional form. The use of bright, conventional lights erases any chance of perceiving a real or even symbolic depth. Personal involvement melts into a social perception of changing things, moving images and disappearing memories.

Hirschhorn channels into his constructions – made of poor materials but assembled with the precision of a watchmaker – all the energy he can collect from the disparate elements of the surrounding political, social and natural context. No romantic feature enters his syntax; light is as powerful as possible in order to escape the quicksands of aesthetic mood and didactic atmosphere. What we see is what we get, but new clues lie like sediment under each of the many forms set within the space. The colours – blue and red – are elementary; major forces of attraction placed along the path that unwinds around the gallery. Contrary to one's first impression that these elements have been scattered randomly, the entire structure is totally controlled both in terms of signs and their interpretation. In this contemporary Lascaux, the cave enclosing the crowded images becomes a membrane, his works like cultural tattoos which the artist has inscribed to preserve them from being transformed into still more artistic souvenirs.

Hirschhorn is interested in the process through which the individual loses positive energy, and declines into a state of social unhappiness. He looks for those spaces where, as members of a community, we lose contact with one another, locking ourselves away into narcissistic enclaves. It is impossible to understand clearly where and when his work begins or ends. Like a weekly market, his sculpture invades the space without taking into consideration the architectural context, radically transforming the site. Each part of the work has a specific function and at the same time a root-like connection with other surrounding parts, but if we are not destined to cross the entire concept we will only be attracted/distracted by the first point of contact. Linearity is abandoned for a sort of nuts-and-bolts pragmatism, which follows the circular process of energies going on in any social structure. The seeming confusion of Hirschhorn's installations is actually a very specific order in which the chaos of the world has undergone a ruthless autopsy. The elements are familiar but the ideology that once connected them has been altered.

Francesco Bonami

Thomas Hirschhorn
Skulptur-Sortier-Station, 1997
Wood, plastic, adhesive tape, Plexiglas,
neon tubes, printed matter, integrated
videos, aluminium foil
240 x 280 x 1000 cm
Installation Skulptur. Projekte
Münster, Germany

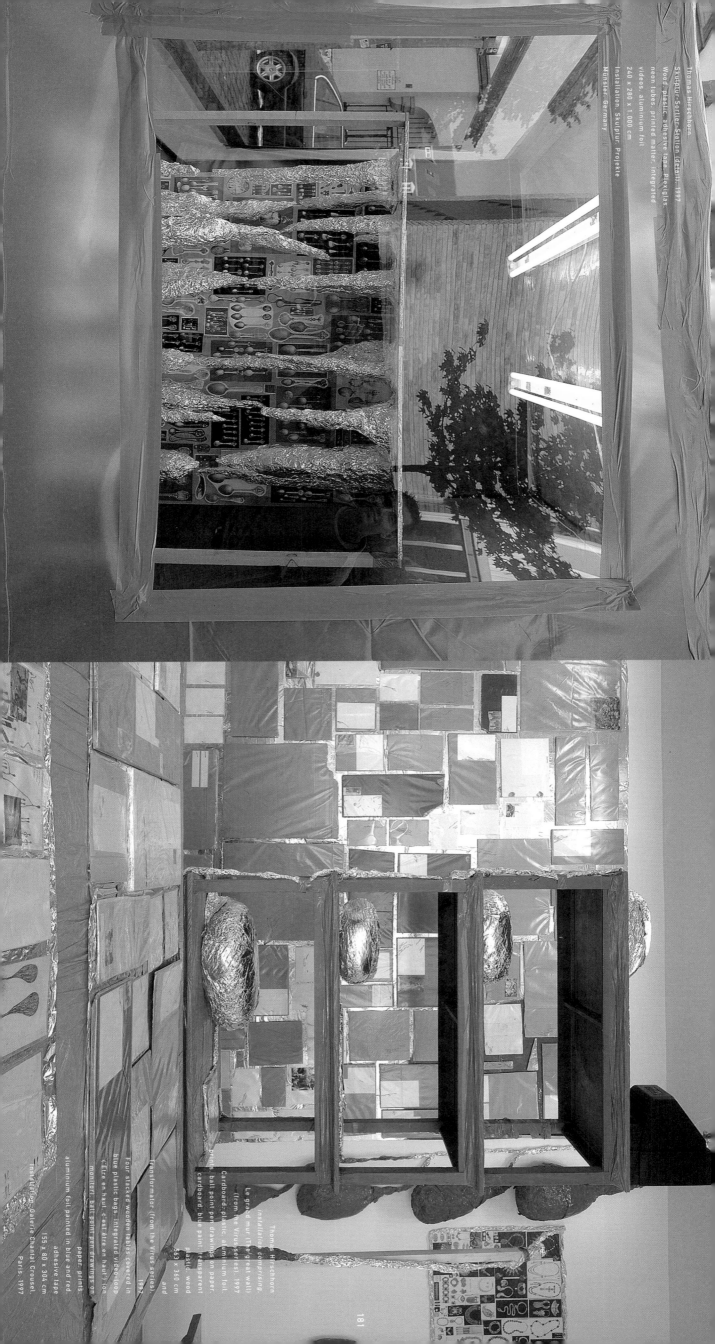

Thomas Hirschhorn
Skulptur-Sortier-Station (detail), 1997
Wood, plastic, adhesive tape, Plexiglas,
neon tubes, printed matter, integrated
videos, aluminium foil
240 x 280 x 1,000 cm
Installation, Skulptur Projekte
Münster, Germany

Thomas Hirschhorn
Installation comprising
Le grand mur (The great wall)
(from the Virus series), 1997
prints, ball-point-pen drawings on paper,
cardboard, blue paint, transparent
plastic, wood
563 x 160 cm
and
Transformator (from the Virus series),
1997
Four stacked wooden tables covered in
blue plastic bags, integrated video-loop
(Être en haut, c'est être en haut! (on
monitor), ball-point-pen drawings on
paper, prints,
aluminium foil painted in blue and red,
adhesive tape
155 x 80 x 304 cm
Installation, Galerie Chantal Crousel,
Paris, 1997

181

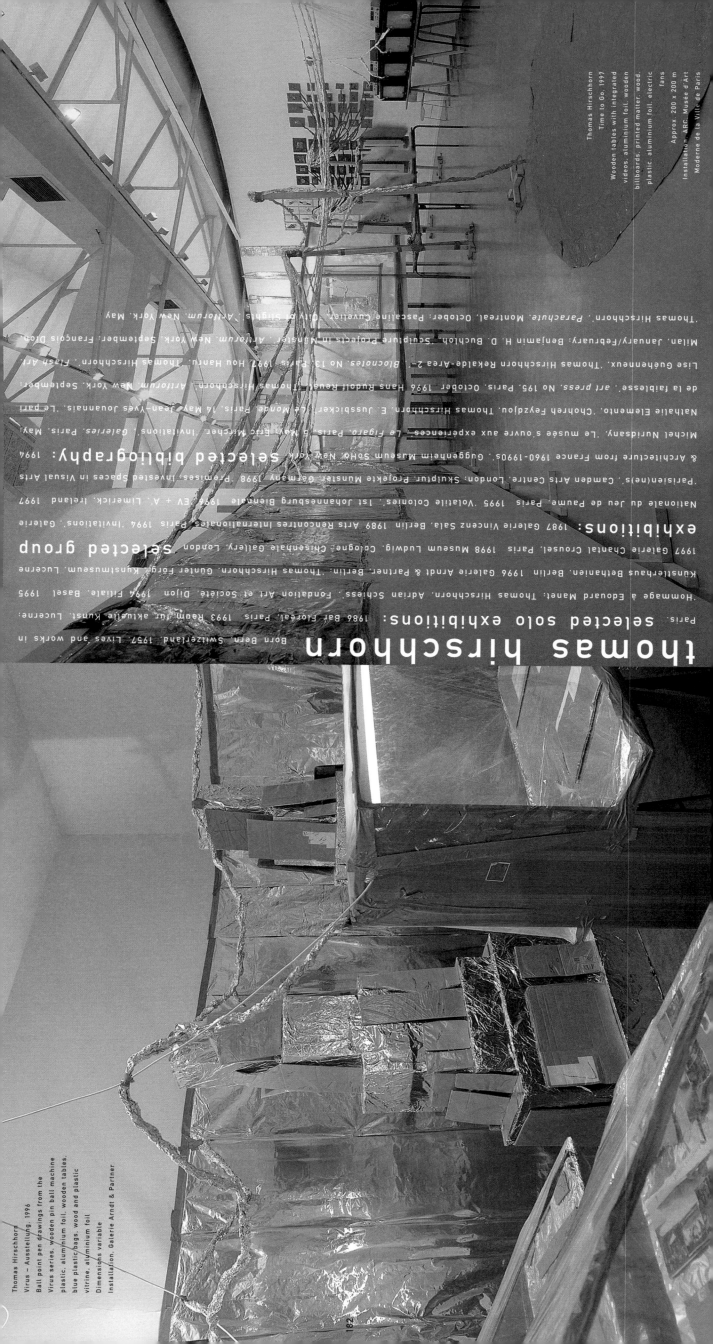

thomas hirschhorn

Born Bern. Switzerland. 1957. Lives and works in
Paris.

selected solo exhibitions: 1986 Bar Floreal. Paris. 1993 Raum für aktuelle Kunst. Lucerne:
Hommage à Edouard Manet. Thomas Hirschhorn. Adrian Schiess. Fondation Art et Société. Dijon. 1994 Filiale. Basel. 1995
Kunsthaus Bethanien. Berlin. 1996 Galerie Arndt & Partner. Berlin. Thomas Hirschhorn. Günter Forg. Kunstmuseum. Lucerne.
1997 Galerie Chantal Crousel. Paris. 1998 Museum Ludwig. Cologne: Chisenhale Gallery. London. **selected group
exhibitions:** 1987 Galerie Vincenz Sala. Berlin. 1989 Arts Rencontres Internationales Paris. 1994 'Invitations'. Galerie
Nationale du Jeu de Paume. Paris. 1995 'Volatile Colonies'. 1st Johannesburg Biennale 1996 'EV + A'. Limerick. Ireland 1997
'Parisien(ne)s'. Camden Arts Centre. London. Skulptur Projekte Munster Germany 1998 'Premises. Invested Spaces in Visual Arts
& Architecture from France 1960-1990s'. Guggenheim Museum Soho. New York. **selected bibliography:** 1994
Michel Nuridsany. 'Le musée s'ouvre aux expériences'. Le Figaro. Paris. 5 May. Birc Mircher. 'Invitations'. Galeries. Paris. May.
Nathalie Elemento. Chohreh Feyzdjou. Thomas Hirschhorn. E. Jussicker. Le Monde. Paris. 14 May. Jean-Yves Jouanais. 'Le pari
de la faiblesse'. art press. No 195. Paris. October. 1996 Hans Rudolf Reust. 'Thomas Hirschhorn'. Artforum. New York. September.
Lise Guéhenneux. 'Thomas Hirschhorn Rekalde-Area 2 – Bioconotes. No 13. Paris 1997 Hou Hanru. 'Thomas Hirschhorn'. Flash Art.
Milan. January/February. Benjamin H. D. Buchloh. 'Sculpture Projects in Munster'. New York. September. François Dion.
'Thomas Hirschhorn'. Parachute. Montreal. October. Pascaline Cuvelier. 'City of slights.' Artforum. New York. May

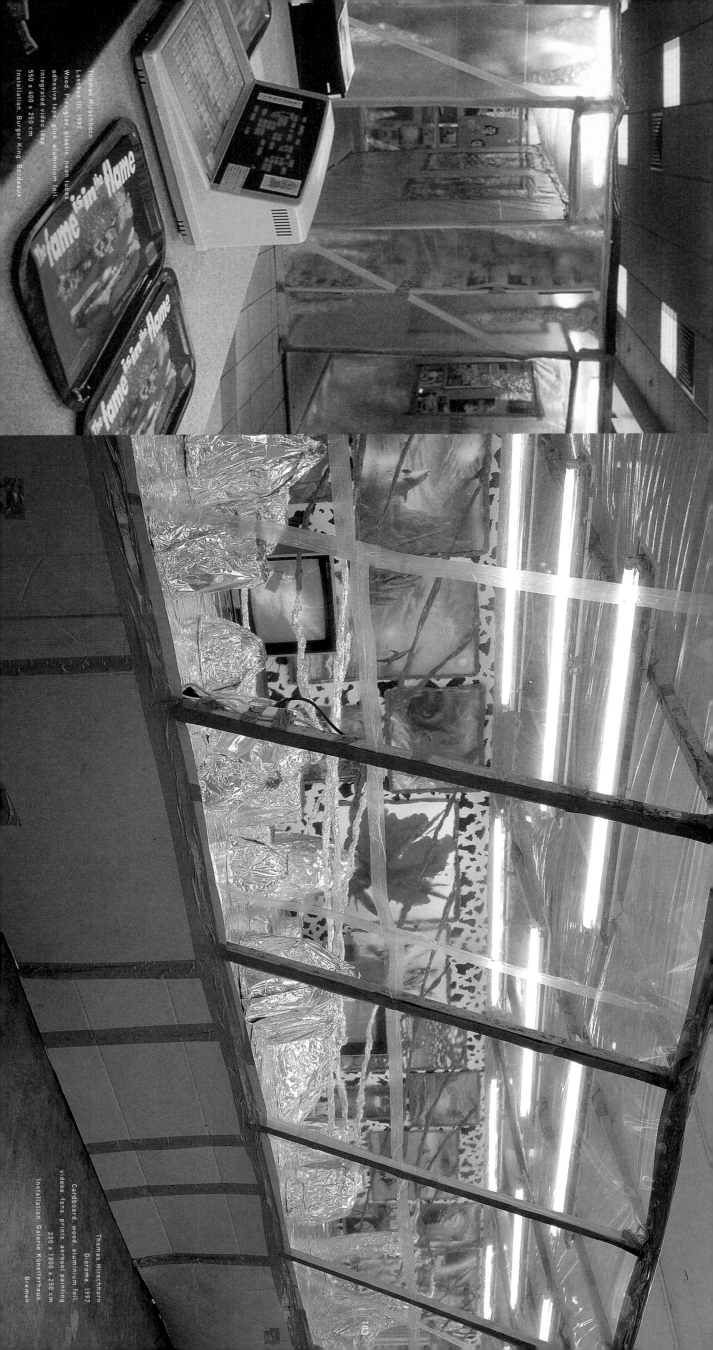

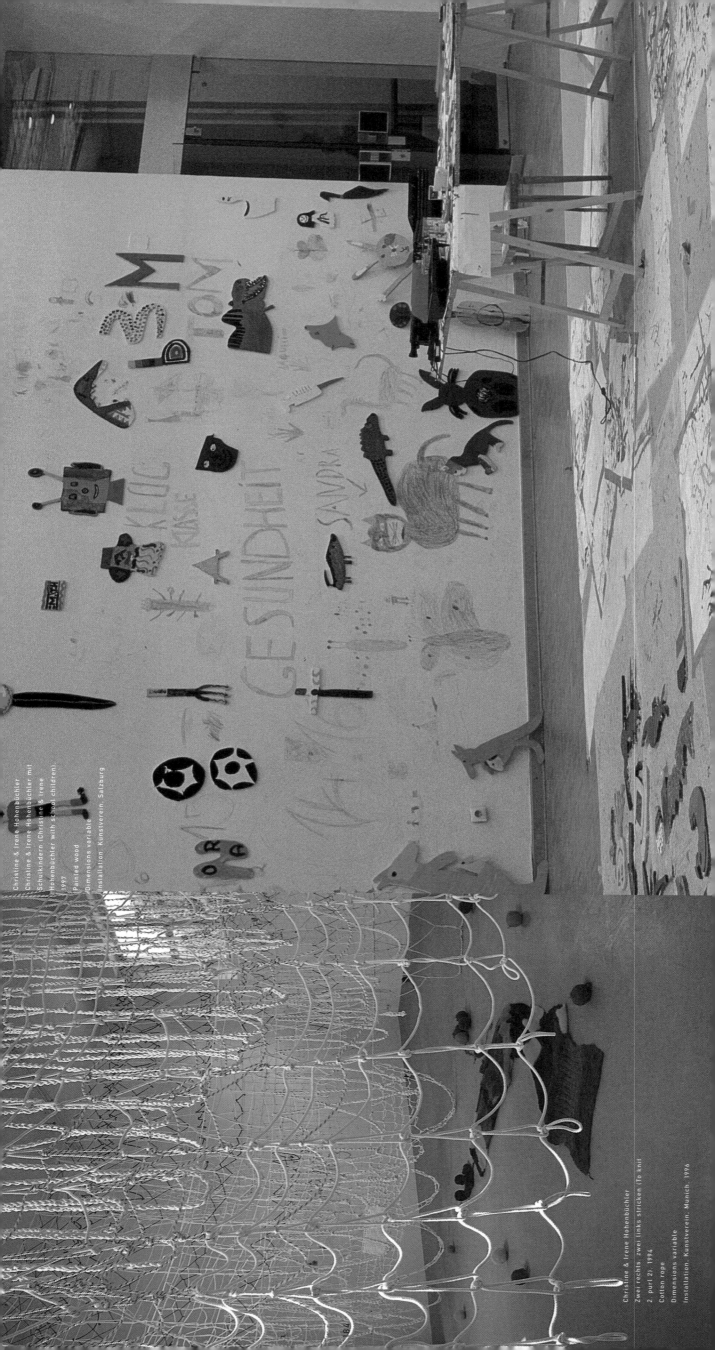

Christine & Irene Hohenbüchler
Christine & Irene Hohenbüchler mit
Schulkindern (Christine & Irene
Hohenbüchler with school children)
1997
(Painted wood)
Dimensions variable
Installation, Kunstverein, Salzburg

Christine & Irene Hohenbüchler
Zwei rechts zwei links stricken (To knit
2, purl 2), 1994
Cotton rope
Dimensions variable
Installation, Kunstverein, Munich, 1996

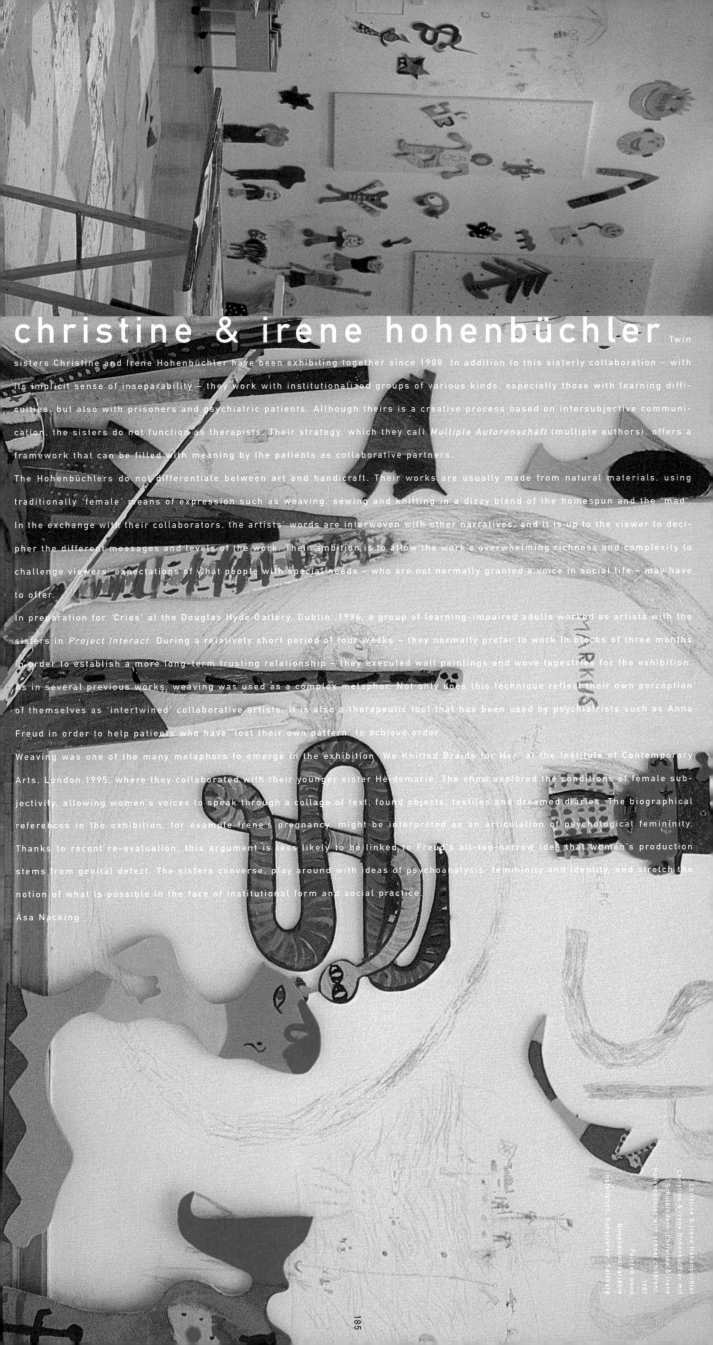

christine & irene hohenbüchler Twin

sisters Christine and Irene Hohenbüchler have been exhibiting together since 1988. In addition to this sisterly collaboration – with
its implicit sense of inseparability – they work with institutionalized groups of various kinds, especially those with learning diffi-
culties, but also with prisoners and psychiatric patients. Although theirs is a creative process based on intersubjective communi-
cation, the sisters do not function as therapists. Their strategy, which they call *Multiple Autorenschaft* (multiple authors), offers a
framework that can be filled with meaning by the patients as collaborative partners.

The Hohenbüchlers do not differentiate between art and handicraft. Their works are usually made from natural materials, using
traditionally 'female' means of expression such as weaving, sewing and knitting in a dizzy blend of the homespun and the 'mad'.
In the exchange with their collaborators, the artists' words are interwoven with other narratives, and it is up to the viewer to deci-
pher the different messages and levels of the work. Their ambition is to allow the work's overwhelming richness and complexity to
challenge viewers' expectations of what people with special needs – who are not normally granted a voice in social life – may have
to offer.

In preparation for 'Crios' at the Douglas Hyde Gallery, Dublin ,1996, a group of learning-impaired adults worked as artists with the
sisters in *Project Interact*. During a relatively short period of four weeks – they normally prefer to work in blocks of three months
in order to establish a more long-term trusting relationship – they executed wall paintings and wove tapestries for the exhibition.
As in several previous works, weaving was used as a complex metaphor. Not only does this technique reflect their own perception
of themselves as 'intertwined' collaborative artists. It is also a therapeutic tool that has been used by psychiatrists such as Anna
Freud in order to help patients who have 'lost their own pattern' to achieve order.

Weaving was one of the many metaphors to emerge in the exhibition 'We Knitted Braids for Her' at the Institute of Contemporary
Arts, London,1995, where they collaborated with their younger sister Heidemarie. The show explored the conditions of female sub-
jectivity, allowing women's voices to speak through a collage of text, found objects, textiles and dreamed diaries. The biographical
references in the exhibition, for example Irene's pregnancy, might be interpreted as an articulation of psychological femininity.
Thanks to recent re-evaluation, this argument is less likely to be linked to Freud's all-too-narrow idea that women's production
stems from genital defect. The sisters converse, play around with ideas of psychoanalysis, femininity and identity, and stretch the
notion of what is possible in the face of institutional form and social practice.

Åsa Nacking

Christine & Irene Hohenbüchler
Christine & Irene Hohenbüchler mit
Schulkindern (Christine & Irene
Hohenbüchler with school children),
1997
Painted wood
Installation, Kunstverein, Salzburg
Dimensions variable

christine & irene hohenbüchler

Born

Vienna 1964. Live and work in Vienna.

selected solo exhibitions:

1988 'Rooseweltischer Garten', HW Poschauko. Luftbad. Vienna 1989 'Les Bricoleurs', Neue Galerie am Landesmuseum Joanneum, Graz, Austria 1991 'Love-in-a-mist'. St Lukas Galerie, Brussels; 'Kunst und Therapie' Symposium, Vienna 1992 '... prodigious, precious ...'; 'Galerie Paul Andriesse, Amsterdam 1993 '... in reminiscence of ...', Galerie Stampa, Basel 1994 zwei rechts, zwei links stricken'. De Vleeshal, Middelburg, The Netherlands; ARC Musée d'Art Moderne de la Ville de Paris 1995 '12'. Galerie Barbara Weiss, Berlin. 'We knitted Braids for her.' Institute of Contemporary Arts, London 1996 'C105', Douglas Hyde Gallery, Dublin 1997

selected group exhibitions:

1988 'Orientalismus'. Galerie Mana, Vienna; Galerie Barbara Weiss, Berlin 1989 'Junge Szene Wien'. Secession. Vienna 1990 'Double Touch'. Galerie Theuretzbacher, Vienna 1991 Galerie Beaux Arts, Paris; 'Love-in-a-Mist (Herbar 1a)'. St Lukas Galerie, Brussels; 'Junge Kunst aus Österreich (Herbar 4)'. Kunstverein, Hamburg; 'Verbotene Verbindungen, Zweifelhafte Beziehungen (Herbar 4)'. International Cultural Centre, Antwerp 1992 'Delicate & Brutal'. Steirischer Herbst. Galerie Freiberger. Walter Buchebner Gesellschaft. Othmar Rychlik. Vienna 1993 'Sonsbeek 93'. Arnheim; Hotel Carlton Palace. Chambre 763. Paris 1994 'Kachel, kooi, lamp, tepel, klomp, kom, etc.'. Galerie Paul Andriesse. Amsterdam; 'Art in Ruins'. Galerie d'Eendt. Amsterdam. 'Lost paradise (Herbar 11)'. Kunstraum. Vienna 1995 'Wild Walls'. Stedelijk Museum. Amsterdam. Kwangju Biennale. South Korea 1996 'Wunderbar'. Kunstraum. Vienna. Kunstverein. Hamburg; 'NoWHere'. Louisiana Museum. Humlebæk. Denmark 1997 Documenta X. Kassel. Germany 1998 'sehen'. loop – Raum für aktuelle Kunst. Berlin

selected bibliography:

1990 Paolo Bianchi. 'Künstlerzwillinge – Christine & Irene Hohenbüchler'. Kunstforum. Cologne. April/May 1992 Ijsbrand J. van Veelen. 'Christine & Irene Hohenbüchler. Paul Andriesse'. Flash Art. Milan October 1993 Cornel Bierens. 'Niet de intrige is het doel der mensheid, maar de integratie'. Metropolis M. Utrecht. March 1994 Christian Kravagna. 'Christine and Irene Hohenbüchler. Raum aktueller Kunst'. Artforum. New York. April 1995 Marius Babias. 'Was macht ihr abends denn so?'. Zitty. Berlin. May; Anke Bangma. 'Wild Walls'. frieze. London. November/December 1996 Janis Jefferies. 'Text. Textile. Sex and Sexuality'. Woman's Art Magazine. London. January/February; Peter Herbstreuth. 'Nach Weimar im Neuen Museum und im Schlossmuseum'. Kunst-Bulletin. Kriens. Switzerland. July/August; Rainer Stange. 'Wunderbar. artist'. Artist Kunstmagazin. Hannover. March; Rainer Stange. 'Christine & Irene Hohenbüchler'. Artist Kunstmagazin. Hannover. April 1997 H.C. Wör. Österreich bewart Christine and Irene Hohenbüchler. Profil. Vienna. January; Horst Christoph. 'Tiroische

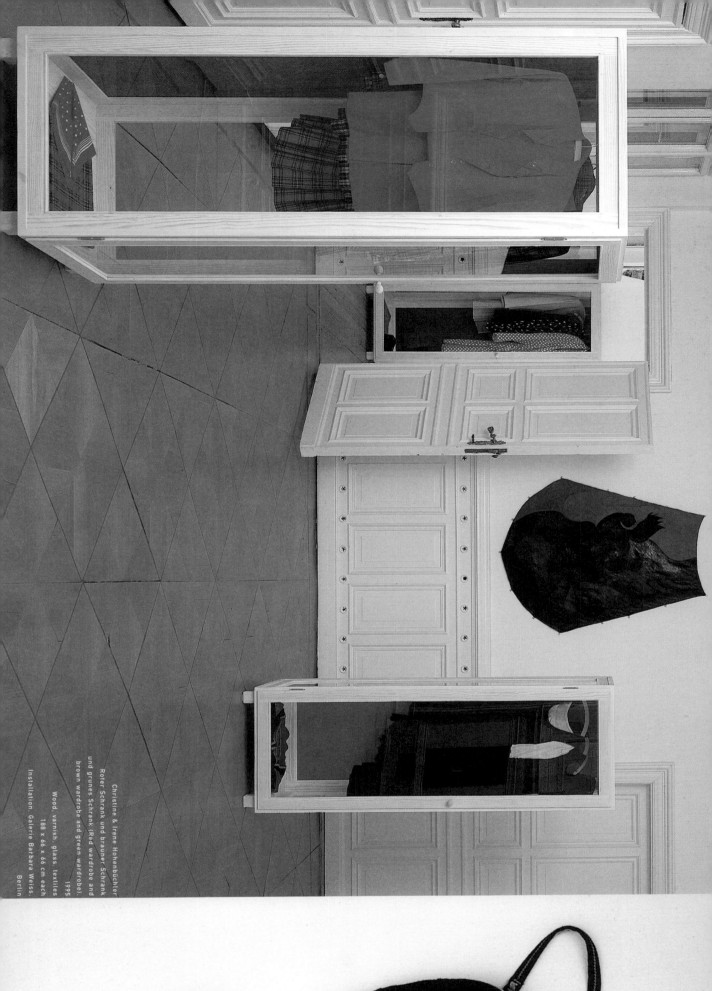

Christine & Irene Hohenbüchler
Roter Schrank und brauner Schrank
und grünes Schrank (Red wardrobe and
brown wardrobe and green wardrobe),
1995
Wood, varnish, glass, textiles
188 x 66 x 66 cm each
Installation, Galerie Barbara Weiss,
Berlin

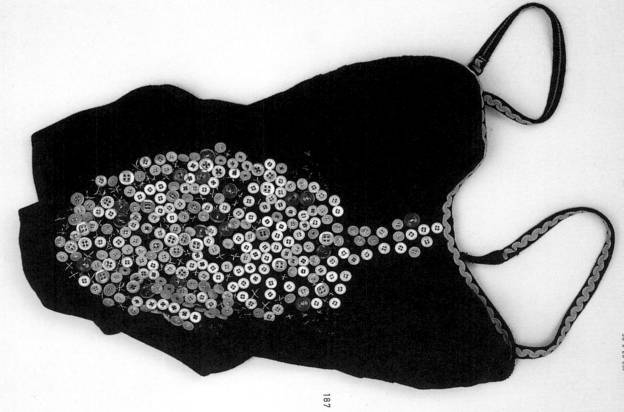

Christine Hohenbüchler
Body No.3, 1995
Cotton, buttons, yarn
56 x 28 cm

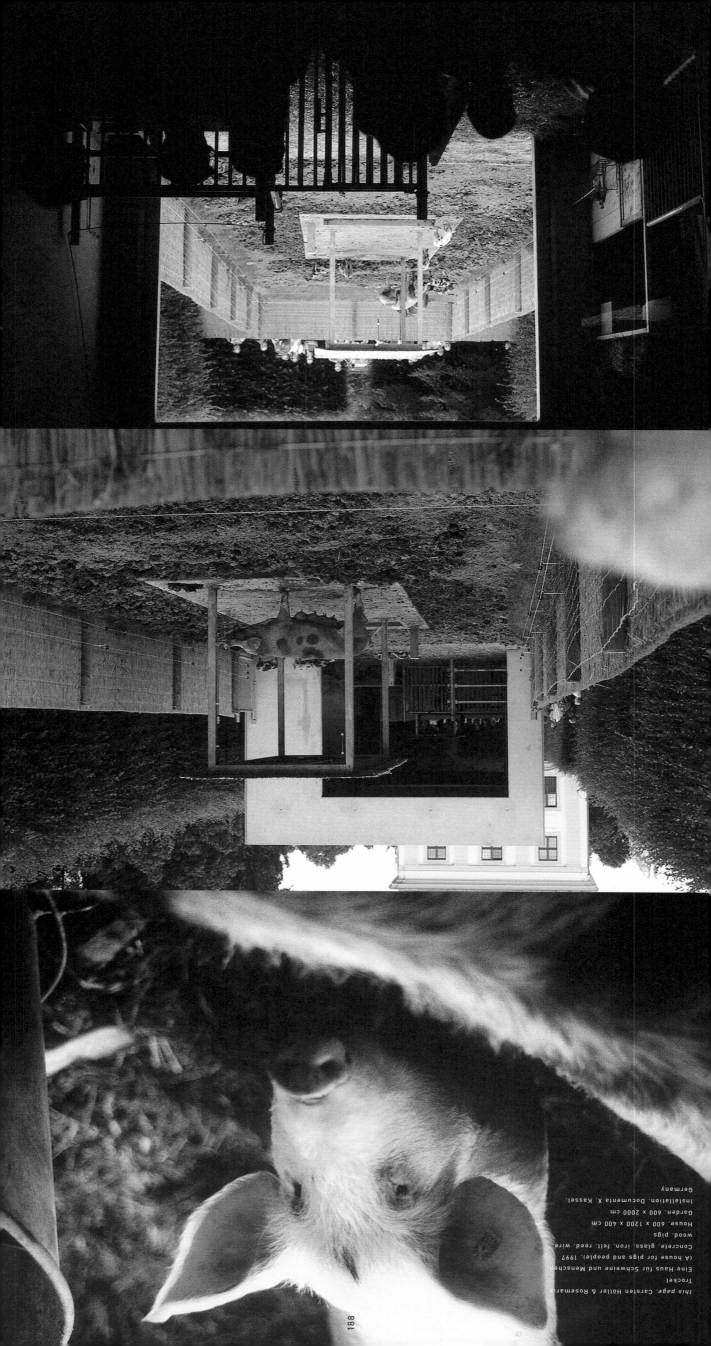

carsten höller & rosemarie trockel

The collaboration between Carsten Höller and Rosemarie Trockel began in 1995 with *Mueckenbus* (Mosquito Bus), which was first

shown in the Deutsches Museum in Bonn, a science museum that has opened its doors to contemporary art. The original intention

was that the gauze tent of the *Mosquito Bus* would contain mosquitoes. Visitors were invited to engage in dialogue with them in

order to test whether the insects could be prevented from biting through telepathic communication. The artists describe the experi-

ment as follows: 'Mosquitoes sting some people more than others. Possibly, however, it is not just that mosquitoes prefer certain

body odours, as is generally accepted, but that they respond to the absence of thoughts projected onto them. For a mosquito it is

less dangerous to sting a person who isn't aware of their presence, than to settle on someone who's thinking about them.' (It was

later decided that the bus would not actually contain mosquitoes, for fear of the possibility of HIV transmission.)

What was interesting was the intensity with which the scientific community engaged with Höller and Trockel's work. Detlev Linke,

a neurosurgeon at Bonn University, spoke of the 'discourse of mosquitoes' in relation to the *Mosquito Bus*:

'Long-distance communication with no known technical aid generally seems implausible because the operators in the various ner-

vous systems are so different from one another. To reach a comparison between the operators, we must assume that these are ner-

vous systems that correspond to one another. It might also be that very different nervous systems (for example those of the mos-

quito and the human being) might enter into correspondence, which would be apparent even if the internal states could not be

mapped on to one another, but if the relationship between one's own brain and the operator of both systems showed a similar quo-

tient.'

More recent collaborations between Trockel and Höller have brought live animals into the exhibition context. *Eine Haus fur

Schweine und Menschen (House for pigs and people)* at Documenta X, Kassel, 1997, was divided in the middle by a two-way mirror.

People could enter on one side and observe a group of pigs on the other. The pigs could see only their own reflection in the glass.

The work deals with the issue of looking and being looked at, observing and being observed. Rupert Sheldrake, a British scientist

whose research deals with issues such as morphogenetics and telepathy, has made an analogy with this kind of work and a more

participatory and horizontal science or art: 'The the sense of being stared at is something most people have experienced and know

about ... Science has ignored the subject, leaving the field wide open for people to carry out investigations of their own and con-

tribute to our understanding.' (Rupert Sheldrake in an interview with the author, 1997.)

Hans Ulrich Obrist

Carsten Höller & Rosemarie Trockel
One, Two, Three, Four and Five, 1997-98
Aluminium, tinted glass, cotton,
leather, paper, wire, plaster, hair,
polyurethane, PVC, hemp, glass, shoes,
wetsuit, nylon.
321.5 x 100.5 x 21.5 cm each

Carsten Höller & Rosemarie Trockel
Two, Three, Four and Five, 1997-98
Aluminium, tinted glass, cotton,
leather, paper, wire, plaster, hair,
polyurethane, PVC, hemp, glass, wire,
buttons, wire
321.5 x 100.5 x 21.5 cm each

carsten höller

Born Brussels, 1961. Lives and works in Cologne.

selected solo exhibitions: 1993 'Killing Children I and II', Lukas & Hoffmann, Berlin. 'Jenny Happy', Buchholz & Buchholz, Cologne 1994 'Du You', Schipper & Krome, Cologne 1996 'Skop', Secession, Vienna 1997 'Amanita-Blue', Goethe House, New York

selected group exhibitions: 1989 'D & S', Kunstverein, Hamburg 1993 'Aperto', XLV Venice Biennale Cologne 1994 ARC, Musée d'Art Moderne de la Ville de Paris 1995 Kwangju Biennale, South Korea. Lyon Biennale 1997 'On life, beauty, translations and other difficulties', Documenta X, Kassel, Germany 5th Istanbul Biennale

selected bibliography: 1995 Yvonne Volkart, 'Carsten Höller', Flash Art, Milan, January/February. Michelle Nicol, 'Carsten Höller – Getting Real', Parkett, No. 43, Zurich. Michelle Nicol, 'Interview', Virus, Milan, April 1996 Yilmaz Dziewior, 'Carsten Höller', Artforum, New York, September 1997 Wolf-Günter Thiel, 'Carsten Höller – Maybe Because I Can Swim, I Decided to Learn to Fly', Flash Art, Milan, May/June

rosemarie trockel

Born Schwerte, Germany, 1952. Lives and works in Cologne.

selected solo exhibitions: 1983 Monika Sprüth Galerie, Cologne 1988 The Museum of Modern Art, New York. Kunsthalle, Basel. Institute of Contemporary Arts, London 1989 Donald Young Gallery, Chicago 1991 Museum of Contemporary Art, Chicago 1992 Museo Nacional Centro de Arte Reina Sofía, Madrid. Museum Ludwig, Cologne 1994 Museum of Contemporary Art, Sydney 1996 Akira Ikeda Gallery, Tokyo 1997 Monika Sprüth Galerie, Cologne. Barbara Gladstone Gallery, New York

selected group exhibitions: 1982 Ausstellung Marla-Hilf, Cologne 1986 Sonsbeek '86, Arnheim 1988 'Refigured Painting: The German Image 1960-88', Guggenheim Museum Soho, New York and tour 1994 XXII São Paulo Biennial 1995 'The Vision of Art in a Paradoxical World', 'Jurassic Technologies Revenant', 10th Sydney Biennale 1997 Kwangju Biennale, South Korea. Documenta X, Kassel, Germany

selected bib- liography: 1987 Jean-Christophe Ammann, Rosemarie Trockel, Kunsthalle, Basel. Institute of Contemporary Arts, London 1988 Laura Cottingham, 'The Feminine De-Mystique', Spider Woman, Artforum, Milan, Summer 1991 Deborah Drier, ..., New York, September. Elizabeth Sussman, Sidra Stich, Rosemarie Trockel, Institute of Contemporary Arts, Boston 1995 Matthew Ritchie, 'Rosemarie Trockel', Flash Art, Milan, January/February

selected combined bibliography: 1996 Christine Fricke, 'Art & Brain', Kunstforum, Cologne. October/January 1997 Christoph Tannert, 'Das Schwein und die Kunst', 'Documenta X' in Kassel. Mensch und Tier vereint im Stall', Berliner Zeitung, Berlin, 21 July; Richard Schusterman, 'A House Divided', 'Politics-Poetics', das Buch zur Documenta X, Cantz Verlag, Ostfildern. 1998 Brauner Ploaczek, 'Palermos grübelnde Hühner, Symbiose: Rosemarie Trockel und Carsten Höller's 'Addina'', Frankfurter Allgemeine Zeitung, Frankfurt, 13 January

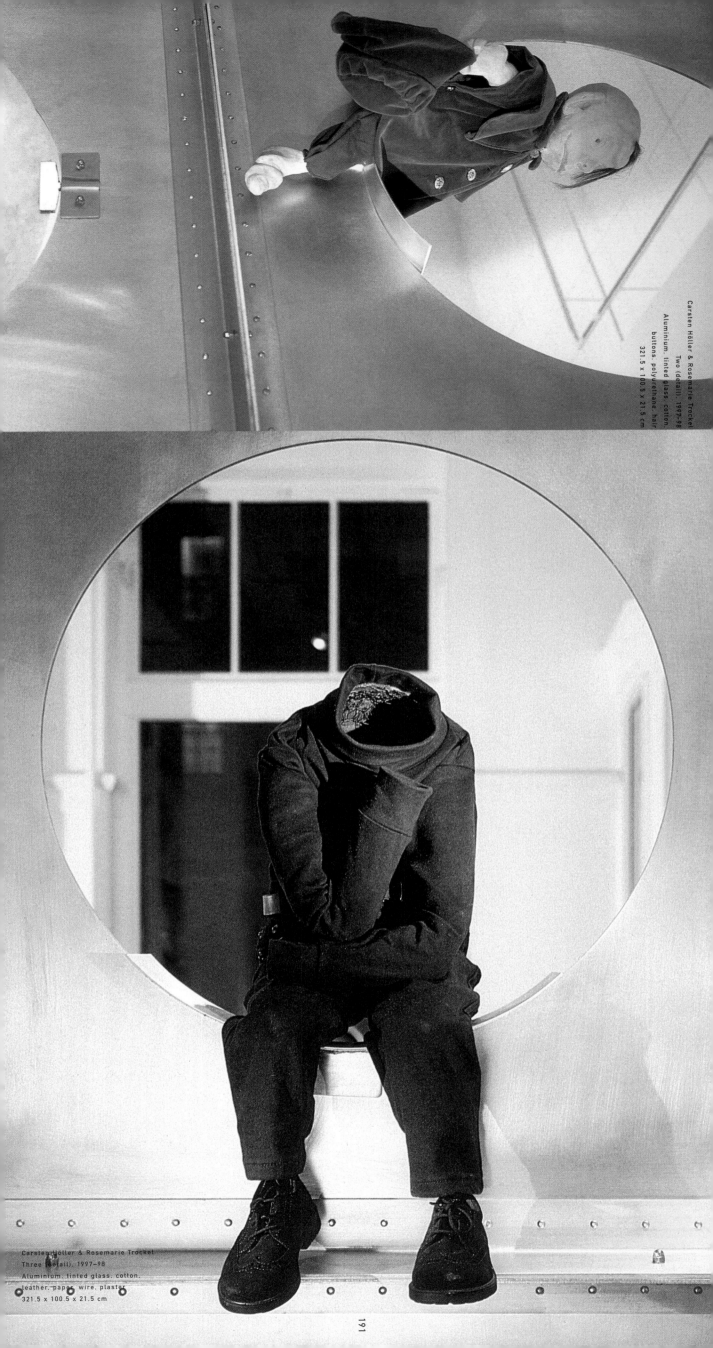

Carsten Höller & Rosemarie Trockel
Two (detail), 1997–98
Aluminium, tinted glass, cotton,
buttons, polyurethane, hair
321.5 x 100.5 x 21.5 cm

Carsten Höller & Rosemarie Trockel
Three (detail), 1997–98
Aluminium, tinted glass, cotton,
leather, paper, wire, plaster
321.5 x 100.5 x 21.5 cm

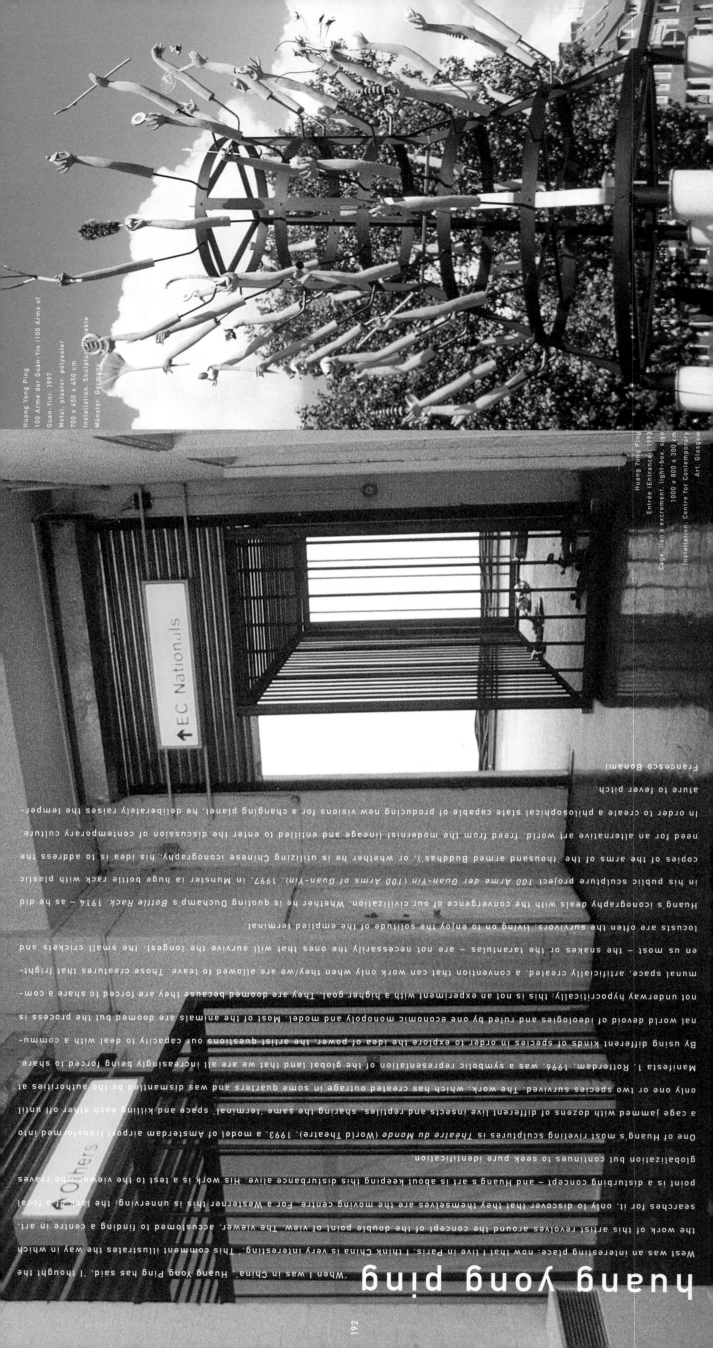

↑ EC Nationals

↑ Others

huang yong ping

'When I was in China', Huang Yong Ping has said, 'I thought the West was an interesting place; now that I live in Paris, I think China is very interesting.' This comment illustrates the way in which the work of this artist revolves around the concept of the double point of view. The viewer, accustomed to finding a centre in art, searches for it, only to discover that they themselves are the moving centre. For a Westerner this is unnerving; the lack of a focal point is a disturbing concept – and Huang's art is about keeping this disturbance alive. His work is a test to the viewer who craves globalization but continues to seek pure pure identification.

One of Huang's most riveting sculptures is *Théâtre du Monde* (World Theatre), 1993, a model of Amsterdam airport transformed into a cage jammed with dozens of different live insects and reptiles, sharing the same 'terminal' space and killing each other off until only one or two species survived. The work, which has created outrage in some quarters and was dismantled by the authorities at Manifesta 1, Rotterdam, 1996, was a symbolic representation of the global land that we are all increasingly being forced to share. By using different kinds of species in order to explore the idea of power, the artist questions our capacity to deal with a commu-nal world devoid of ideologies and ruled by one economic monopoly and model. Most of the animals are doomed but the process is not underway hypocritically; this is not an experiment with a higher goal. They are doomed because they are forced to share a com-munal space, artificially created, a convention that can work only when they/we are allowed to leave. Those creatures that fright-en us most – the snakes or the tarantulas – are not necessarily the ones that will survive the longest; the small crickets and locusts are often the survivors, living on to enjoy the solitude of the emptied terminal.

Huang's iconography deals with the convergence of our civilization. Whether he is quoting Duchamp's *Bottle Rack*, 1914 – as he did in his public sculpture project *100 Arme der Guan-Yin* (100 Arms of Guan-Yin), 1997, in Munster (a huge bottle rack with plastic copies of the arms of the 'thousand armed Buddhas'), or whether he is utilizing Chinese iconography, his idea is to address the need for an alternative art world, freed from the modernist lineage and entitled to enter the discussion of contemporary culture. In order to create a philosophical state capable of producing new visions for a changing planet, he deliberately raises the temper-ature to fever pitch.

Francesco Bonami

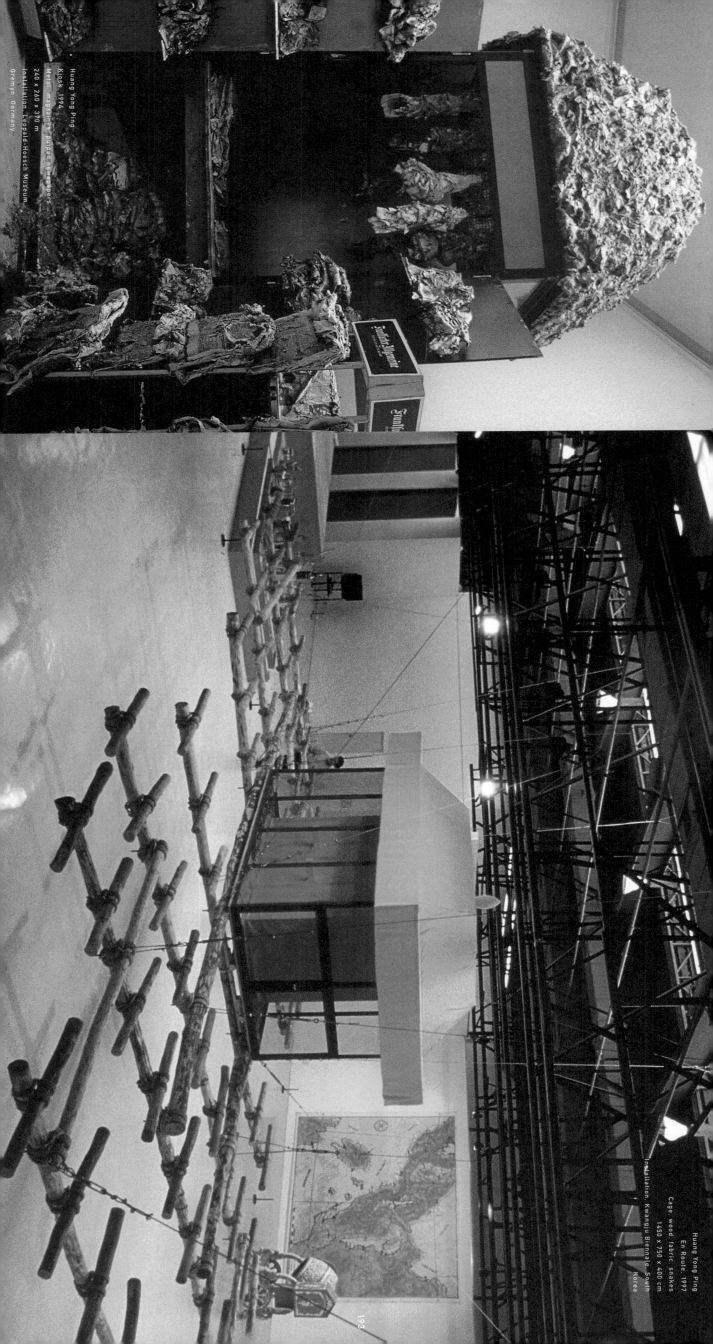

Huang Yong Ping
Kiosk, 1994
Metal magazines, pulped newspapers
240 x 260 x 370 m
Installation, Leopold-Hoesch Museum
Gremyn, Germany

Huang Yong Ping
En Route, 1997
Cage, wood, fabric, snakes
1450 x 750 x 400 cm
Installation, Kwangju Biennale, South Korea

193

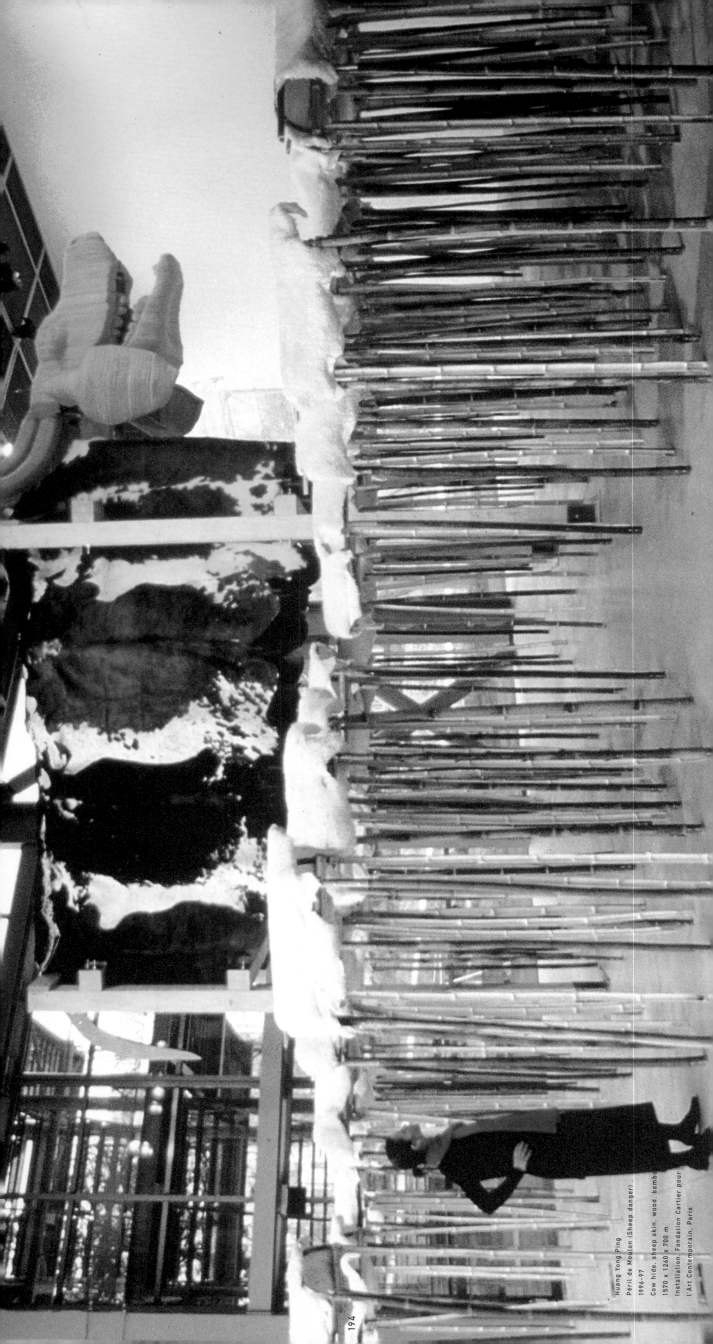

Huang Yong Ping
Péril de Mouton (Sheep danger)
1996–97
Cow hide, sheep skin, wood, bamboo
1570 x 1260 x 700 m
Installation, Fondation Cartier pour
l'Art Contemporain, Paris

194

huang yong ping

Born Xiamen, China, 1954. Lives and works in Paris.

selected solo exhibitions:
1990 'Sacrifice au feu', L'Ecole des Beaux-Arts d'Aix-en-Provence, France 1991 'Réapparition de la Croix-Rouge', Hôpital Ephémère, Paris 1993 '1 & 108', Akademie Schloss Solitude, Stuttgart 1994 'Chinese Hand-Laundry', New Museum of Contemporary Art, New York 1997 Jack Tilton Gallery, New York; De Appel, Amsterdam; 'Péril de Mouton', Fondation Cartier pour l'Art Contemporain, Paris

selected group exhibitions:
1983 'Exhibition of Five Artists', Cultural Palace of Xiamen, China 1986 'Events', Museum of Fine Arts of Fujian, China 1989 'Magiciens de la Terre', Centre Georges Pompidou, Grande Halle de la Villette, Paris 1991 Carnegie International, The Carnegie Museum of Art, Pittsburgh 1992 'Résistance', Watari-um Museum of Contemporary Art, Tokyo 1993 'Fragmented Memory: The Chinese Avant Garde in Exile', Wexner Center for the Arts, Ohio; 'Silent Energy', Museum of Modern Art, Oxford 1994 'Heart of Darkness', Stichting Kröller-Müller Museum, Otterlo, The Netherlands; 'Hors-Limites', Centre Georges Pompidou, Paris 1995 'Unser Jahrhundert, Menschenbilder-Bilderwelten', Museum Ludwig, Cologne 1996 Manifesta 1, Rotterdam 1997 'Trade Routes: History and Geography', 2nd Johannesburg Biennale; Kwangju Biennale, South Korea; 'Truce: Echoes of Art in Age of Endless Conclusions', Site Santa Fe, New Mexico; Skulptur. Projekte Münster, Germany

selected bibliography:
1990 Dominique Aubé, 'Huang Yong Ping', art press, Paris, July/August 1992 Loak' Ung Chan, 'Ten Years of the Chinese Avant Garde', Flash Art, Milan, January/February; David Peitcher, 'Art on the Installation Plan', Artforum, New York, January; Jean-Yves Jouannais, 'Huang Yong Ping', art press, No 170, Paris 1993 Hou Hanru, 'The Pleasure of the Text: Interview with Huang Yong Ping', Flash Art, Milan, November/December 1994 Hou Hanru, 'Huang Yong Ping', Flash Art, Milan, October; Holland Cotter, 'Installations Addressing Ethnic Identity – Chen Zhen/Huang Yong Ping', The New York Times, 20 May; Kim Levin, 'Chen Zhen/Huang Yong Ping', The Village Voice, New York, 31 May 1996 Jérôme Sans, 'Huang Yong Ping', Artforum, New York, May 1997 Ian Hunt, 'Huang Yong Ping', Art Monthly, London, March

Huang Yong Ping
The Pharmacy, 1995–97
Wood, Chinese medicine
Dimensions variable
Installation, Jack Tilton Gallery, New York

pierre huyghe

The question of how the same artistic language can apply to different realities, and how diverse languages can apply to the same reality, appears to be the main concern in Pierre Huyghe's work. Chiefly employing film and photography, Huyghe questions the capacity of a real object or situation to share the same ground as its representation.

In one photograph, *Chantier Barbès*, 1995, workers labour beneath an enlarged image of actors performing similar labours on the same site. Their occupation is both celebrated and objectified as an issue of analysis. Huyghe extracts the language of the workers – their work – and transforms it into the language of representation: the subject becomes both sign and signifier.

In all his works, Huyghe analyzes the perception of an icon and tries to alter it, leaving its structure intact but re-working its outward form. In *Les Incivils*, 1995, his remake of Pier Paolo Pasolini's film *Uccellacci e uccellini* (Hawks and sparrows, 1966), this is particularly challenging because he is dealing with a work that is already about the transformation of social languages and codes. Redeveloping the subject in productions with friends as actors and their own flats as movie sets, Huyghe creates a maze of meanings in which the memory of the original dissolves into its own deformed reflection. Similarly, in his re-make of Hitchcock's *Rear Window*, 1954 (*Remake*, 1995), a homemade version that coincides frame-by-frame with the original, the final result is a kind of skeleton of the Hitchcock film, in which the original idea remains but all the formal aspects have deteriorated.

In these works, Huyghe explores the concept of translation both in terms of language and of image. This has become Huyghe's point of departure for a series of enquires that are leading him into a new realm, where the application of the visual is more ambiguous and more fascinating. In his short film *Blanche-Neige Lucie* (*Snow White Lucie*), 1997, Huyghe tells the story of a voice: that of Lucie Dolène who sang in the French version (made in 1962) of Disney's *Snow White and the Seven Dwarfs*. The film shows an aged Lucie humming the famous song while in an interview with her in French runs as subtitles to the images. In this mirroring of dubbing and translation, both conceptual and real, the artist achieves the essence of his entire work: a lesson in the impossibility of creating a system in which images can be endlessly transformed to match the multiple identities of the viewers, questioning the ideal of translating a meaning to create a universal image.

Francesco Bonami

une petite voix timbrée,
très enfantine,

j'étais complètement
Blanche-Neige,

right. Pierre Huyghe
Remake, 1995
100 min. video projection. colour, sound
Dimensions variable
Collection. FRAC, Languedoc Rousillon,
France

opposite, Pierre Huyghe
Blanche-Neige Lucie (Snow White
Lucie), 1997
3 min, 40 sec. video projection. colour,
sound
Dimensions variable
Collection, FNAC. Paris

Si seulement, tu pouvais t'e voir !

Pierre Huyghe
Atlantic (multi-lingual version, detail
without speakers), 1997

3-channel video projection - 125 min. -
130 min. - 140 min., black and white,
sound
Dimensions variable

pierre huyghe

Born Paris, 1962. Lives and works in Paris. **selected solo exhibitions:** 1995 'L'usage de l'interprète', FRAC Languedoc-Roussillon, Montpellier 1996 'Dubbing', Galerie Roger Pailhas, Paris 1997 'Storytellers', Le Consortium, Dijon 1998 Lotta Hammer Gallery, London; ARC, Musée d'Art Moderne de la Ville de Paris **selected group exhibitions:** 1989 'Bismuth, Huyghe, Veihlan', Galerie Iis Arrivent, St. Etienne, France 1992 'Il Faut Construire l'Hacienda', CCC, Tours 1994 'Surface de Réparation', FRAC Bourgogne, Dijon 1996 'Traffic', CAPC, Musée d'Art Contemporain, Bordeaux 1997 'Coincidences', Fondation Cartier pour l'Art Contemporain, Paris; XLVII Venice Biennale; 'Trade Routes: History and Geography', 2nd Johannesburg Biennale 1998 Manifesta 2, Luxembourg; 11th Sydney Biennale; 'Permises', Guggenheim Museum SoHo, New York **selected bibliography:** 1992 Eric Troncy, 'Being Positive is the Secret of the 1990's', *Flash Art*, Milan, June 1994 Olivier Zahm, 'Pierre Huyghe', *Purple Prose*, Paris, Summer 1995 Nicolas Bourriaud, Catherine Millet, 'La Fluidité de l'Art', *art press*, Paris, January; Natacha Carron, 'L'Usage de l'Interpréte', *Flash Art*, Milan, October; Dominique Gonzalez-Foerster, 'L'état de chantier permanent', *Purple Prose*, Paris, Summer 1996 Nicolas Bourriaud, 'Les relations en temps réel', *art press*, Paris, December; Joe Scanlan, 'Let's play prisoners', *frieze*, London, September/October 1997 Catherine Millet, 'Les Films Pornographiques de Pierre Huyghe', *art press*, Paris, September; Alexis Vaillant, 'Pierre Huyghe revient juste du cinéma', *Kunst-Bulletin*, Zurich, April; Olivier Zahm, 'Pierre Huyghe – Openings', *Artforum*, New York, March

Pierre Huyghe, 1994
Billboard poster
400 x 300 cm
Installation, rue Rochechouart, Paris
Chantier Barbès-Rochechouart

this page. Fabrice Hybert
Storyboard (detail)
1981–93
Mixed media
5000 x 400 cm

Fabrice Hybert

It may simply be expedient to talk about the beginning and the end of a
when all that we ever take in are the intermediate stages. But at the root of the events was a meeting and all the meetings
relatively speaking, beginnings. This beginning, especially, contains a whole story in itself.'
Daumal, Le Mont Analogue, 1981

ice Hybert has been working on the ongoing series of drawings, *Storyboard*, since the beginning of his career in 1981. The
vidual fragments began to condense into a storyboard format in 1988. Its protagonist is in a state of constant transformation,
acterized by Hybert as 'a borderline character, wandering through gaps'.
artist has also set up the company UR (Unlimited Responsibility), whose purpose, as a kind of interface between art and econ-
, is to distribute both material and immaterial goods. The company is financed through grants for research as well as through
production and distribution of products. Hybert is concerned with redistribution, disrupting the flow between fiction and reality.
ertvitesse (*Hybertspeed*), 1989, is a work made up of a table, a wall (in a state between construction and destruction), a train
a building. Hybert explains that *Hybertvitesse* 'introduces a new definition of speed; this telepathic speed no longer contains
presentation of movement, it's about a reworking and mixing-up of the data, about digestion'. This leads us to the *Hybrid Anti-
umatiser* from 1996. An image of a tomato stands as a symbol for the consumptions and digestion of pictures. Hybert shows that
tomatoes (placed against or on top of one another) produce tomato puree. The *Anti-traumatiser* oscillates between object and
cess: in one of the many picture captions which, palimpsest-like, overlay and conceal one another, Hybert explains that one
ould use the trauma in order to avoid being destroyed by the anti-trauma (stress)'. Like many of Hybert's works, the *Anti-trau-
tiser* spans many different media. The work exists as an image and also as a prototype interactive sculpture that can be tested
viewers.
his installation in the French Pavilion at the XLVII Venice Biennale (for which he was awarded the Golden Lion Prize), Hybert
sted and extended the boundaries of the medium of television. The starting-point for the project was a drawing of a mobile tent
uipped with a structure with which signs can be received and emitted. The idea was that anyone could set up his/her own tele-
sion station and the individual stations could be connected to one another. TV cold AND warm, both and instead of either or
stead of nor nor.
ans Ulrich Obrist

Fabrice Hybert
Eliane Pine Carringhton teste un Prototype
d'object en fonctionnement.
Anti-traumatiseur de fruits
(Elaine Pine Carringhton tests a prototype
Fruit anti-traumatiser), 1996
Performance
Muster-Testoo, Leipzig

fabrice hybert

Born Luçon, France, 1961. Lives and works in Paris **selected**

solo exhibitions: 1986 'Mutation', Maison de l'avocat, Nantes 1991 'Vis à vis, le miroir des galeries', Galerie Arlogos, Liège, Belgium 1993 CAPC, Musée d'Art Contemporain, Bordeaux 1994 Kunsthalle Lophem, Bruges, Belgium; Contemporary Art Centre, Moscow 1995 ARC, Musée d'Art Moderne de la Ville de Paris; Musée de Strasbourg 1996 Jack Tillon Gallery, New York 1997 French Pavilion, XLVII Venice Biennale; Eigen + Art, Berlin 1998 Jack Tillon Gallery, New York

selected group exhibitions: 1984 Biennale Internationale de Dessin, St Étienne, France 1989 Riverin-Arlogos Gallery, Montreal 1990 Ateliers de la Foundation Cartier, Paris; 'Le cinq', Tramway, Glasgow 1991 'L'amour de l'art', Lyon Biennale 1992 'Périls et colères', CAPC, Musée d'Art Contemporain, Bordeaux 1993 Aperto, XLV Venice Biennale; 'Hamburg-Paris-Frankfurt', Kunstverein, Hamburg 1994 'Hors limites', Centre Georges Pompidou, Paris 1995 'Take Me (I'm Yours)', Serpentine Gallery, London; Kwangju Biennale, South Korea; Lyon Biennale 1996 'Berechenbarkeil der Welt', Kunstverein, Bonn; Manifesta 1, Rotterdam 1997 Skulptur Projekte Münster, Germany; 'FémininMasculin', Centre Georges Pompidou, Paris; Kwangju Biennale, South Korea **selected bibliography:** 1987 Guy Tortosa, *Fabrice Hybert*, DRAC, Ussel and Limoges; Guy Tortosa, *Change*, DRAC, Poitou-Charente 1989 Guy Tortosa, 'Le poisson et le pêcheur', *Galeries Magazine*, Paris, October 1990 Xavier Girard, 'Portrait de l'artiste en généticien', *art press*, Paris, February; Xavier Girard, 'Portrait', *Beaux-Arts Magazine*, Paris, October; Eric Troncy, 'Fabrice Hybert', *Artscribe*, London, June 1993 Franck Perrin, 'Fabrice Hybert', *Flash Art*, Milan, January/February 1995 Robert Fleck, 'Le label Hybert', *Beaux-Arts Magazine*, Paris, February; Robert Fleck, 'Fabrice Hybert', *Arts Magazine*, New York, April; Hans Ulrich Obrist, *Parkett*, Zurich, April

INVENTORY

Losing **Finding** **Collecting**

Vol.2 No.1 1997

Comply The most common geological formation; the psychological dimension of which invites an enthusiasm for articulating space as layered in its vertical dimension and gridded in its horizontal. Not to be gainsayed, in the manner of desiring one's own repression, there exist very few properly alternate constructions. These are characterised as being peripatetic and marginal in all dimensions (political, economic, sexual, etc.), an example would be Beckett's Molloy. Although much of human culture can often be seen as an admixture of these two competing formations, it is definitely the case that compliance dominates, to such an extent that it has become impossible to conceive of a state beyond it.

Comply A submission, adherence to laws, influences and suggestions. Acceptance taken to the level of a perversion: when obedience is this exact it overwhelms the law giver, leaving them lacking in speech and so in awe of the servile entity that their existence becomes untenable without that which complies.

He that complies against his will is of his own opinion still.

— Butler

[...]

Comply To produce, to destroy and produce anew, this is, for some, the legacy of Modernism which provokes an ironic cynicism or bitter nihilism for which we seem to bear some sort of responsibility. Yet human kind takes a deep breath and continues to submit to this cyclical, anguished state of affairs. As Cioran has remarked 'men wait to live'. In fact they would rather agitate between the restless, Faustian desire for continual development and the frightening consciousness of incompleteness which nags at the very heart of their being; which in turn drives this relentless pressure to make anew. Caught in this eternal return, man continues to comply with this anguished yoke he has shackled himself with: subordinately supplying the materials for his own cage, frustrating the excess movement of energies which are never fully consummated. Why not cast off this ridiculous mantle and embrace this tormented abyss and actively overcome it? Instead of filling domes with the spectacular delusions of such an ignoble human-ity surely a derelict factory chimney, rather than re-employed once more, could serve more as a scab than a symbol; a testament to these accursed material squanderings and repressed psychic conflicts. Perhaps an aggressively tactile response, arrested by such a monstrous emblem, breaking the optical conscious-ness which remorselessly consents to a given nature of things, this scab could inadvertently reveal the perpetual revolt against all project; shatter the rigorous syphoning and channelling of being and agency; declaring itself sovereign in its uselessness, opening a wound in to which new possibilities make them-selves felt.

inventory selected solo exhibitions: 1994 School of Oriental and African Studies, London 1995 Museum of Mankind, London 1996 British Council Gallery, Prague 1997 Canary Wharf, London

selected group exhibitions: 1996 'life/live'. ARC, Musée d'Art Moderne de la Ville de Paris, Centro Cultural de Belém, Lisbon. 'Collected Works'. University of Derby Gallery, England 1997 'Multiple Choice'. Cubitt Gallery, London; 'Collected'. Photographers Gallery, London. 'Sampling the Visible'. Flaxman Gallery, University College London 1998 'A to Z'. The Approach, London. selected bibliography: 1998 Stephen Bury. 'Travel Logs'. Art Monthly, London, January

publications: 1995 Inventory, Vol 1, No 1. London 1996 Inventory, Vol 1, No 2. London; Inventory, Vol 1, No 3. London

inventory

'Inventory is a collective enterprise created by a group of writers, artists and theorists. At present it operates on two fronts: since its beginnings in 1994, the group has produced a number of exhibitions of visual work in a variety of differing contexts and, since 1995, has been publishing a journal. The journal may be seen as an anti-hierarchical catalogue, a critical compendium, an interdisciplinary space from where we have put forward a paradoxical philosophy. It aims to present a passionate sociology embracing the marginal and the everyday, the theoretical and the base, establishing a dialogue with its readers whereby new constellations of thought and image come together, concretized in the material phenomena around us.

The journal and our visual work operate in tandem, informing one another with different forms of information, contexts and readings. Inventory may be thought of as a kind of viral programme, searching for any type of data or interesting phenomena that displays a renegade adaptability, a fusing of disparate elements that have some importance for sociality; our fierce sociology is passionate about everyday life, its arrangements and mutations.

'We have attempted to situate ourselves at a crossroads of theory and practice in that we wish to conjoin and conflict writing and image, found and made, the lost and the discovered, as is implied in our title. The relationship between words and images is of paramount importance, but we do not wish this perspective to have a purely scientific character nor an artistic, literary value. Rather, we wish to employ an emblematics whereby image and text are linked in a methodology that is at once historical, anthropological, poetic ...

'This practice of emblematics is the attempt to redefine the present picture of Postmodernism as an impossible web of heterogeneous fragments. The choreography of these fragments as collage is an outmoded and pointless practice without an agenda and which refuses to be seduced by the shattered image of society. The moment the fragment becomes resuscitated as an emblem, it transforms the social picture from one of irredeemable and alienated activity to one of recognizable yet still complex relationships. This notion of emblematics is only at an experimental, experiential stage as befits the tenor of our voice expressing our difference from any other practice. It is an approach to phenomena in close up, almost too close; a kind of contaminated analysis. We seek that bewitched spot, a *vision sauvage* which, rather than taking material phenomena as a given, would seize an object and reconstellate it, allowing other interpretations, other stories ... ' (Artists' statement)

Matthew Higgs

Defacement.

Models, actors, actresses, famous personages. Rich, powerful, successful: mourn for them, what daily damage is inflicted upon their shining visages!

The defacement of models, actors, etc., by adding spectacles, scars, facial hair, boils, by blacking out teeth and shoving chewed up gum into their happy, caring, seductive eyes. On bill posters, in magazines; in bus stops, the underground, slowly dismembered in the doctor's waiting room: is not this defacement precisely an attack upon perfection? First and foremost; pure resentment. "I don't see why she, why he, why these people should be thus, thus and thus ... How dare they smile down at me like that when I am not thus, thus and thus?"

It's all desire, all envy, and they all deserve everything they get. Except that no one ever admits to vandalism, this insignificant rebellion. Which is the more shaming? The compulsion to gouge, scar, smear, and despoil, or having to admit to being part to such compulsion?

Or are we effacing perfect parents? Does this manifestation of unconscious drives lead straight to iconoclasm? No one should bow down before idols. An attack on the sheer mundaneness of the model (of reality) is being offered through this forcing of fissures into the surface. Fissures through which the 'reality' of dental disaster, tissue stress and optical ineptitude may be seen: no one bows down before bad breath. And so, to the vandal, the visceral pleasure of acting out resentment; the simple unbound joy of being at one with fate, time, decay — triumphant, for a moment, over the vanity of perfection.

To be oppressed (or repressed, when it the more economical way of doing things) by a giant bag of marshmallows is more permanent, and economical, than a regime of boot and steel. To be oppressed by (or repressed in) a calculating combination of the two is a most dangerous prospect, very often fatal for those who lack the combination of a sweet tooth and the banality of a well turned surface.

But let us be positive about this: it is of course very difficult for to combine, with any degree of success, for any length of time, these two wildly incompatible substances without an odour of the ridiculous irreversibly staining the system. However, candy-floss and steel are bound together in a fearsomely functional system of decay inspiring stickiness. Luckily, again, we know how a sudden downpour will inevitably reduce any delusion of fun and freedom to a glutinous mess. You will be left in need of a bath, clutching a stick full of splinters to be promptly discarded in the mud.

Human Sign

Where once a prophet may have stood by the roadside, pointing the way toward salvation, there today stands a different form of medium although the message has altered only sightly. Today, this medium, rather than purely operating through the printed page, the moving image or some other technology, is fashioned from skin, blood and bone. The word is made flesh; yet the voice is silenced. Humankind is meerly a lump of wood, a structural support upon which rests his industriousness, his products and creations. These objects and goods take centre stage, around which everything else revolves, including man himself; reduced to the role of slave in a process he only fecundates. Of course it is possible to observe that the body contains just enough iron to produce one rusty nail, yet should this sobering materialism necessarily remove the anguish and pain of the ignoble rights of the spirit?

'Random is not a function.' This warning pops up in a dialogue box in the Web browser, indicating a Java scrip that cannot be run. That the user encounters it on the internet at www.jodi.org can mean several things. His or her software migh be incompatible with the site, or Joan Heemskerk and Dirk Paesmans, the Dutch-Belgian duo – who live in Barcelona an Amsterdam and go by the name JODI – might have coded the page poorly; or, things might have been set up in precisely this mar ner to trap the unwary in a repeating loop of error messages.

Such are the conflicted pleasures of net.art, especially as practiced at www.jodi.org. Here, at any given moment, one migh encounter something as banal as a hot list cum flow chart, directing one to sites as far-flung as www.serialkillers.net and the Ne York-based ada.web; or as intriguing as a gnostic progression of dingbats, icons and 2.5-dimensional maps that don't run code s much as revel in coding.

JODI have culled from the history of computer graphics, creating a pastiche of 1970s screen colours, 1980s graphical user inter

JODI
404.Chat?cgi<!-Vowels, 1998
Internet

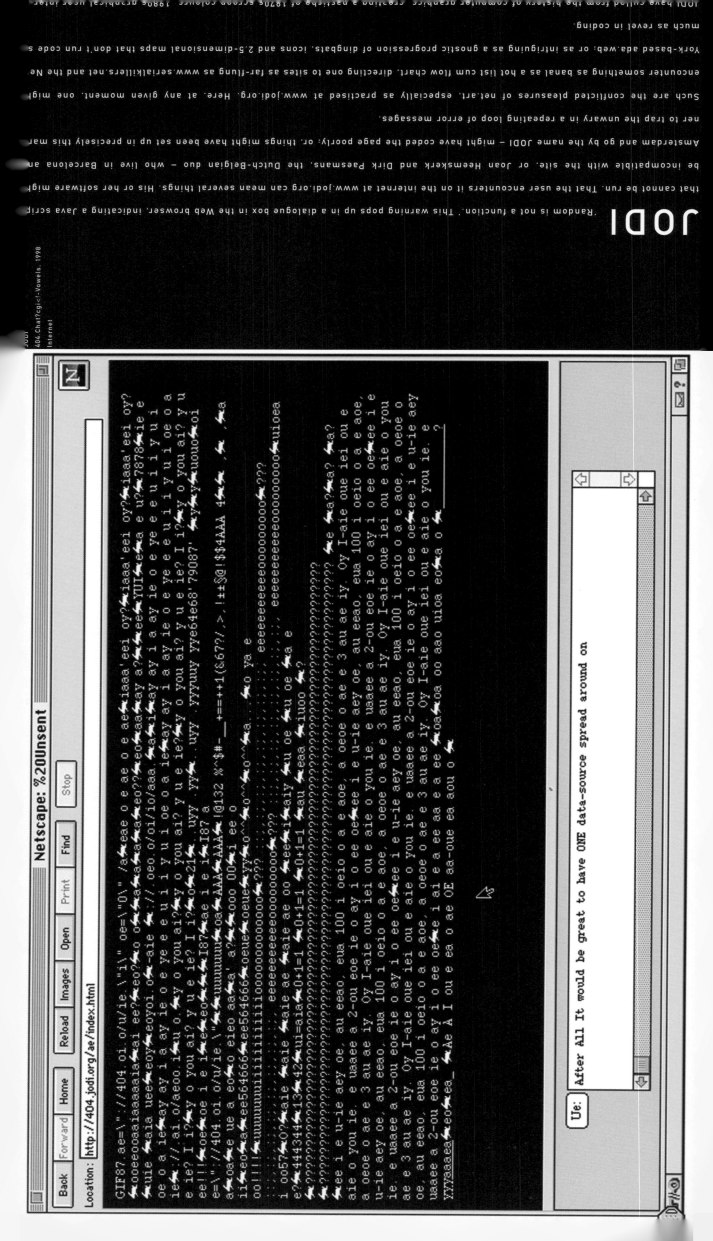

aces and 1990s telematics. Yet it is a mistake to mire the work in a technical discourse, adopting the bizarre neo-Greenbergian

formalism that dictates that net.art must be about the net and only the net. Nor is it correct to reduce this work to a computer

graphics hack of 1960s Conceptualism. www.jodi.org is ludic, entranced with the computer's potential for aesthetic play, but not at

all unserious. Sometimes there are secrets here. A black screen pulses with densely packed, neon green characters. When queried

as to its document source, the hypertext mark-up language (HTML) reveals itself to be a piece of ASCII (American Standard Code

for Information Interchange, i.e. text characters) text art, an artefact from the glory days of IBM's main-frames. And sometimes

there are no secrets, just a heightened awareness of the net's prediliction to suck up time.

It is not an insult to say that hitting this site is something like watching sports on TV: it is unpredictable, in flux and what you come

back for is the new. This site is not about beauty or the sublime; JODI have not — at least thus far — induced the Stendhal Syndrome,

in which one is literally made ill by too much beautiful art. But it has caused problems, the way avant garde art once did. There is

a (perhaps apocryphal) story about Japanese children who experienced epileptic seizures while watching a popular kiddy show; the

producers were said to have been inspired by the steadily blinking screens of www.jodi.org.

Susan Kandel

cdr_Coords:372,559, 1998
CD-rom

Trash

TCD01 SYS

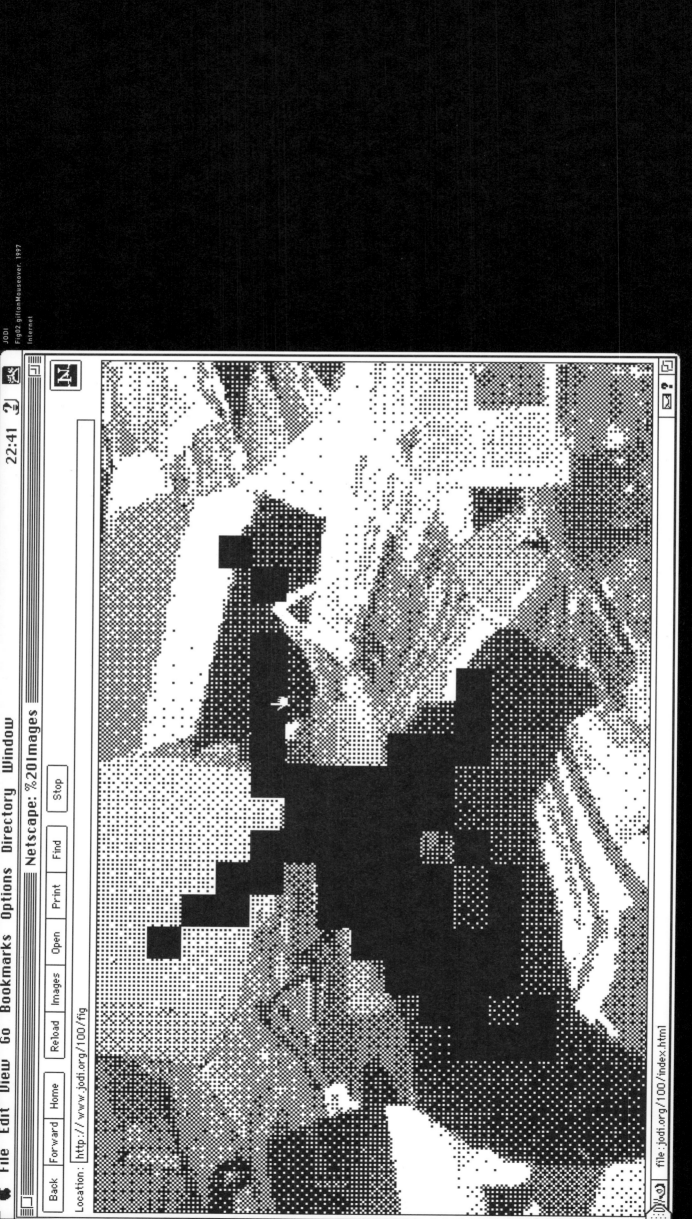

Dirk Paesmans, born Brussels, 1965; Joan Heemskerk, born Kaatsheuvel, The Netherlands, 1968. Live and work in Amsterdam and Barcelona. **website:** http://www.jodi.org **selected group exhibitions:** 199... Documenta X, Kassel, Germany; 'Eighth International Symposium on Electronic Art', School of the Art Institute of Chicago; 'Transmedia 97', Podevil, Berlin; 'WebContest 97', Casa Das Rosas, São Paulo; 'Lop-Lop', Museum Boijmans Van Beuningen, Rotterdam; 'Remote-C', ArsElectronica Center, Linz, Austria; 'Classic Show', Postmasters Gallery, New York; 'LAB-7', CCAW, Warsaw 1998 'µ', ArtiAmicae, Amsterdam

GoodTimes-MSGoTodie, 1996
Internet

Netscape: %20Goodtimes

Back | Forward | Home | Reload | Images | Open | Print | Find | Stop

Location: http://www.jodi.org/goodtimes/items/index.html

```
if (x > .1119) {
    document.overwrite("
}
return num;
var today = new Date();
```

item/goods

½ ¼

SELECT

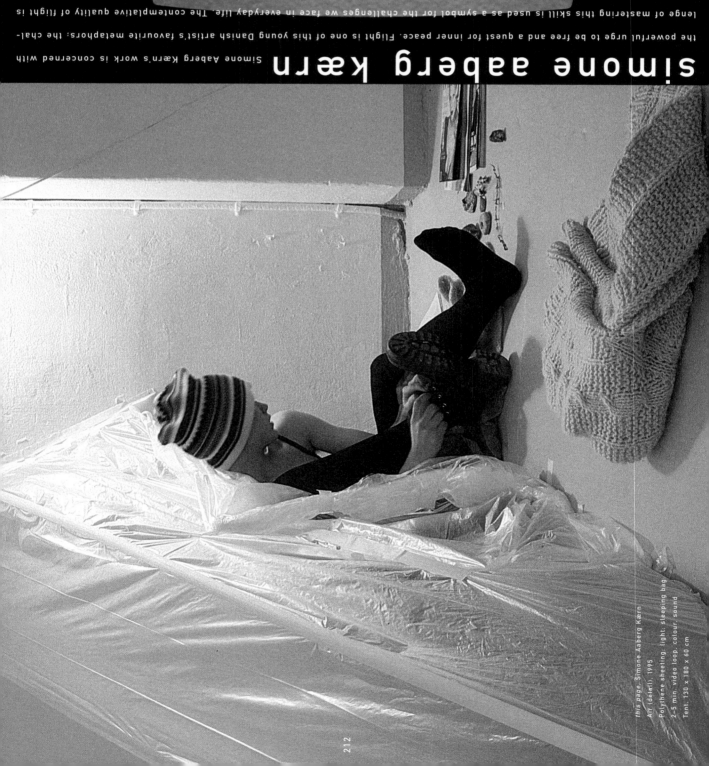

simone aaberg kærn

Simone Aaberg Kærn's work is concerned with the powerful urge to be free and a quest for inner peace. Flight is one of this young Danish artist's favourite metaphors; the challenge of mastering this skill is used as a symbol for the challenges we face in everyday life. The contemplative quality of flight is disrupted by the aggressively repetitive way in which she approaches her projects. The struggle to attain the utopia of learning to fly is at times overshadowed by this destructive force.

On one level, Kærn's art could be seen as a strategy for transcending a personal crisis that included the sudden death of a close member of her family. Her installation Air, 1995, consisted of a tightly guyed tent, which served as her home during the exhibition, and a video loop showing a plummeting sky-diver a moment before the parachute opens. In City Air, 1995, her body, superimposed onto footage of what were then her home cities of Copenhagen and London, moves with the sped pace of comic silent films. The electronic diptych Drop Zone, 1995, a reworking of Air, can be seen as a hopeful ending to her autobiographical project. A method-ical investigation of the dynamics of falling, Drop Zone proposes that there are two kinds of fall, and that the controlled dive – as opposed to free fall – is actually a form of flying.

As Kærn gradually turns her gaze away from herself, her desperation is channelled into other areas, and her works take on a more political character. Royal Greenland, 1995, is based on a documentary film from 1932 borrowed from the Danish National Film Archive. This shows the landscape around Thule, Greenland, along with the rapidly vanishing traditions of the local Inuit popula-tion. We catch a glimpse of the controversial Thule airbase, built by the US just after World War II, which forced the indigenous population into hunting grounds that were incapable of sustaining them. They were brought back a few decades later – to clean up after an American B-52 bomber crashed while carrying nuclear weapons.

In the summer of 1996, Kærn began taking flying lessons, a male-dominated occupation. This awakened a feminist interest in the way in which women have historically gained power over their own lives through active choice and control. Sisters in the Sky: Women Pilots in War Duty during WWII consists of portraits of women aviators executed in oils and is thus situated within a patri-archal painting tradition. Largely based on the artist's own research which involved talking to women who had been pilots during World War II, the work resembles a sociological study showing that if the role of women can be re-coded in crisis situations (where women take on traditionally 'masculine' roles), 'femininity' must be little more than a cultural product.

Åsa Nacking

this page: Simone Aaberg Kærn
Air (detail), 1995
Polythene sheeting; light; sleeping bag
2-5 min. video loop; colour; sound
Tent: 130 x 180 x 60 cm

above and right. Simone Aaberg Kærn
Sisters in the Sky – Women Pilots in War
Duty During WWII · 1997
Video stills from research project

Anna Timofeyeva-Yegorova at her home in
Moscow. Spring 1997. During World War II
she was a Senior Lieutenant in the Russian
Airforce. She was a Deputy Commander
and Navigator of the 805th Ground Attack
Regiment and piloted the Soviet Union's
powerful *Sturmovik Hera.* Her photo-album
documents her achievements.

simone aaberg kærn

Born Copenhagen, 1969. Lives and works in Copenhagen. **selected solo exhibitions:** 1992 'PAUSE', The Bunker at Frederik den V's vej, Copenhagen 1995 'Air', Kunstakademiets kunstforening, Copenhagen **selected group exhibitions:** 1994 'SAGA basement – Opening Exhibition', Colbjørnsensgade, Copenhagen 1995 'Royal Greenland', Project Raum, Zurich; 'Wild at Heart', Joussé Seguin, Paris 1996 'Mennigsdannelse II & III', Nikolaj Contemporary Art Centre, Copenhagen; 'Royal Greenland', Project Raum Holstrasse, Zurich 1997 'Fondazione Sandretto Re Rebaudengo per l'Arte', Turin; 'The Louisiana Exhibition – New Art from Denmark and Scania', Louisiana Museum, Humlebæk, Denmark 1998 'Nuit Blanche', ARC, Musée d'Art Moderne de la Ville de Paris; 'Come Closer', Staatliche Kunstsammlung, Vaduz, Liechtenstein **selected bibliography:** 1994 Christina Madsen, Lene Bay, 'The SAGA of a Basement', *ArtView*, Copenhagen, July/September 1995 Kristine Kern, 'Royal Copenhagen', *Siksi*, No 4, Helsinki; Sanna Kofod Olsen, 'When Political Becomes Personal', *Siksi*, No 4, Helsinki 1996 Lars Bang Larsen, Line Rosenvinge Nissen, 'SAGA Basement Artist-Run Space', *Flash Art*, Milan, Summer; Yvonne Volkart, 'Living Texture', *Flash Art*, Milan, April; Åsa Nacking, Tone O Nielsen, Lars Grambye, *Louisiana revy*, Copenhagen, October 1998 Lars Bang Larsen, 'Up in the Air', *Siski*, No 1, Helsinki; Michael Hübl, 'Draussen und drinnen', *Kunstforum*, Cologne, April/June

Simone Aaberg Kærn
Drop Zone, 1995
Two 1 min. video loops, colour, sound

Like most of the art that has emerged from Cuba in the past ten to fifteen years, KCHO's work comes with a thorough grounding in the use of materials and the sensibility to articulate a political perspective. Unlike virtually all of his contemporaries, however, KCHO's artistic identity is based on a direct response, even challenge, to some of the most fundamental premises concerning the ways that his art both inside and outside Cuba is conceived and developed. Although his early work, begun nearly ten years ago, was known in his native Cuba, only in the last three years has his work been marked by extremely rapid artistic growth, realized through exhibitions in some of the most important art museums in the world. At the same time, it is difficult to experience KCHO's art without also sensing the central role of the unique culture inherent to the island he continues to call home.

Starting with a remarkable facility for drawing and carving, KCHO's early work initially appeared steeped in primitivist concerns, until one grasped the metaphors that quickly became prevalent throughout. One of his best-known early works, an untitled installation in the 1993 Havana Biennial, consisted of the shape of a large boat created by placing hundreds of miniature rafts in formation on the floor. For both local viewers and visitors, the implication was clear: collective effort, on which the Cuban revolution had based all of its ideology, was now being presented as a means of escaping the poverty and political repression that the system has come to represent. Again and again, KCHO's work through the mid 1990s incorporated the image of the handmade raft as a symbol of individual effort pitted against collective indifference, sometimes with powerful emotional resonance. *Lo Mejor del Verano (The best of summer)*, 1994, consisted of dozens of actual rafts that had been confiscated by the Cuban coast guard; these were flown to Madrid, where they were suspended three feet below the ceiling of a room at the Centro Reina Sofia for the exhibition 'Cocido y Crudo'. As the viewer entered, the only thing visible was the reflection of the rafts on the dark, polished floor. A glance upwards revealed the rafts, their bows all pointing in the same direction, and clarified the position of the viewer: 'underwater, and drowning.

In the past few years, KCHO's installations at museums in Montreal, Los Angeles and Tel Aviv have grown more complex. He has taken on Brancusi's *Infinite Column* (1938) as an art-historical paradigm that is every bit as personal for him as the rafts; he has also begun broadening the range of his materials to include clay, metal and an array of found materials. His work continues to articulate a state of internal exile whilst challenging viewers to make connections between the artist's personal experience and the ways in which all of us share in both the complicity of our situation, and the ever-pressing need to find a solution.

Dan Cameron

KCHO
Hablar de lo evidente nuca fue para
nosotros un placer (Speaking of the
obvious was never a pleasure for us),
1997
Bottles, sandbags, wood, rowingboat,
furniture, oars, steel drums, string,
clothes, skateboard, glass, tyre, pegs,
boxes, found objects
2200 × 400 cm
Installation, Israel Museum, Jerusalem

KCHO
Untitled (from Todo Cambia [Everything
changes]), 1997
Clay, wire, wood, reinforcement bars,
nails
240 × 80 × 197 cm

217

KCHO
Untitled (from Todo Cambia [Everything
changes]). 1997
Clay, wire, wood, reinforcement bars,
nails
50 x 30 x 197 cm

KCHO

(Alexis Leyva Machado) Born Nueva Gerona, Isla de la Juventud, Cuba, 1970. Lives and works in Havana.

selected solo exhibitions:

1986 'Cacho expone-Fabelas', Centro de Artes Plásticas de la Isla de la Juventud, Cuba 1992 'Artist of the Month', Museo Nacional Palacio de Bellas Artes, Havana 1993 Galería de Arte Contemporáneo, Mexico City 1995 Fundación Pilar i Joan Miró, Mallorca, Spain 1996 Barbara Gladstone Gallery, New York 1997 'Todo Cambia', Museum of Contemporary Art, Los Angeles

selected group exhibitions:

1991 CODEMA, 4th Havana Biennale; 'Los Hijos de Guillermo Tell', Museo Alejandro Otero, Caracas 1992 'La Ronda Cubana', Van Reekum Museum, Apeldoorn, The Netherlands 1993 1st International Print Biennial, Maastricht 1994 'Cocido y Crudo', Museo Nacional Centro de Arte Reina Sofía, Madrid; XXII São Paulo Biennial; 'La Otra Orilla', 5th Havana Biennale 1995 'The Vision of Art in a Paradoxical World', 4th Istanbul Biennale; Kwangju Biennale, South Korea; 'Volatile Colonies', 1st Johannesburg Biennale 1996 'Cuba Siglo XX, Modernidad Sincretismo', Centro Atlántico de Arte Moderno, Grand Canaries, Spain and tour 1997 'Truce: Echoes of Art in an Age of Endless Conclusions', Site Santa Fe, New Mexico 1998 'Objectivity: International Objects of Subjectivity', Contemporary Art Center of Virginia, Virginia Beach

selected bibliography:

1992 Jay Murphy, 'The Young and Restless in Havana', *Third Text*, London, Autumn 1994 Michael Wise, 'Tweaking the Beard of the Maximum Leader', *The New York Times*, 12 June 1995 José Luis Brea, 'Cocido y Crudo', *Flash Art*, Milan, May/June; Alexandre Melo, 'Transoceanexpress', *Parkett*, No 44, Zurich; Octavio Zaya, 'The Cuban Quagmire', *Flash Art*, Milan, October 1996 Coco Fusco, 'Bridge Over Troubled Waters', *frieze*, London, September/October; Kim Levin, 'Art Short List', *The Village Voice*, New York, 20 March; Yasmin Ramirez, 'KCHO at Barbara Gladstone', *Art in America*, New York, June; Peter Schjeldahl, 'The Floating World', *The Village Voice*, New York, 16 April; Barry Schwabsky, 'KCHO', *Artforum*, New York, Summer

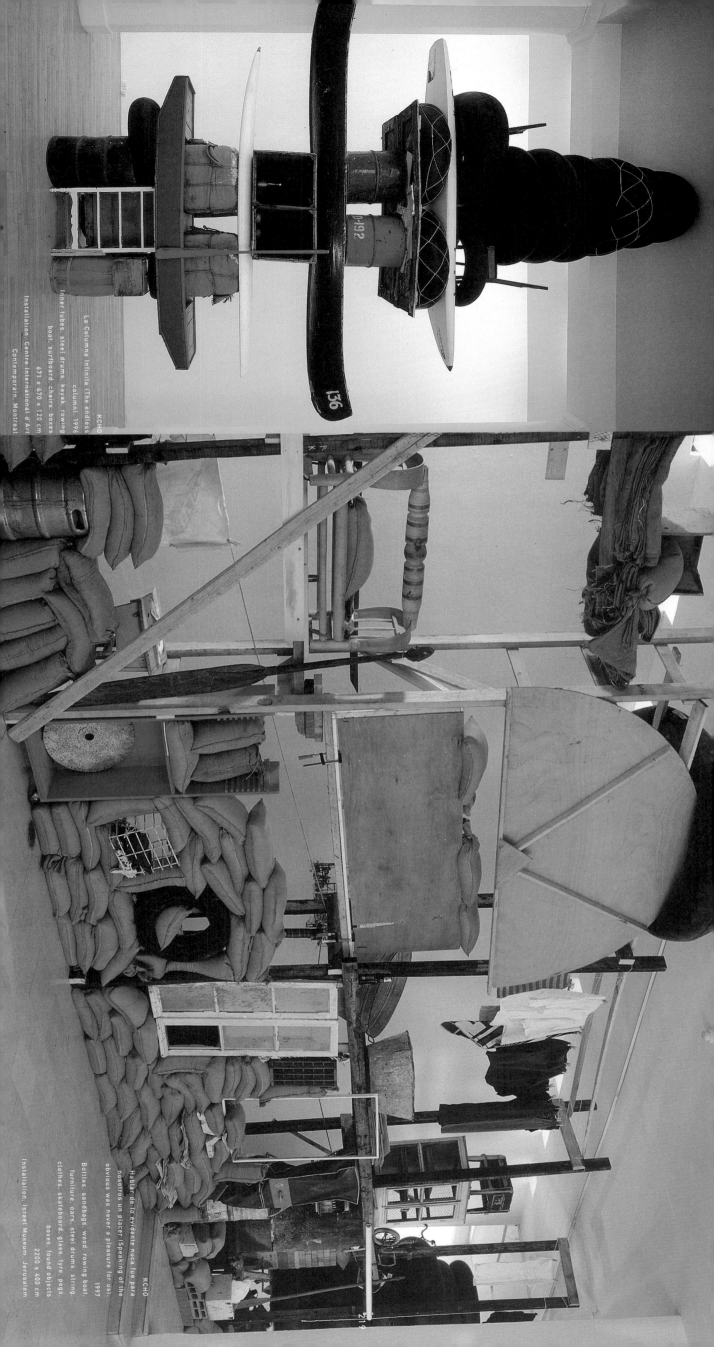

KCHO
La Columna Infinita (The endless column), 1996
Inner tubes, steel drums, kayak, rowing boat, surfboard, chairs, boxes
671 x 470 x 120 cm
Installation, Centre International d'Art Contemporain, Montreal

KCHO
Hablar de lo evidente nuca fue para nosotros un placer (Speaking of the obvious was never a pleasure for us), 1997
Bottles, sandbags, wood, rowing boat, furniture, oars, steel drums, string, clothes, skateboard, glass, tyre, pegs, boxes, found objects
2200 x 400 cm
Installation, Israel Museum, Jerusalem

219

for Angus

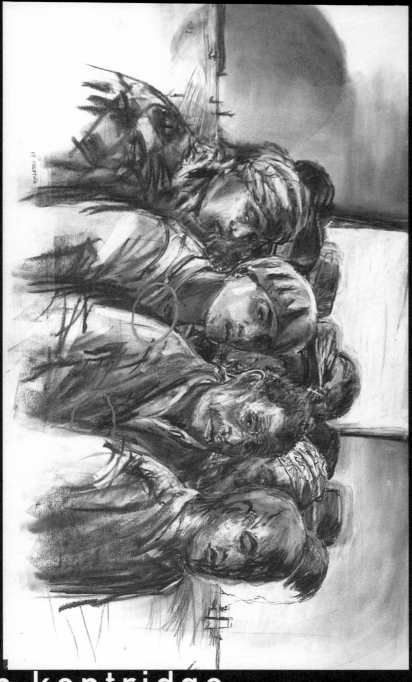

william kentridge

William Kentridge makes intensely complex films, inherent to which are two laborious processes. Using as a guide a central image (whether imagined or borrowed from existing sources), he produces superbly rendered drawings that are successively altered and filmed at each stage of their development. The wondrous, mesmerizing nature of the resulting imagery belies the underlying violence of the subject matter. These notions of violence, and issues of history and memory, link Kentridge's films to works such as Goya's *Disasters of War*, 1810–20. History paintings on celluloid, the films take as their primary reference point the landscape of apartheid South Africa: its memory, industry, racial politics, and the mindset forged by its corrupting and debasing influence.

In the seven films entitled 'Drawings for Projection' produced so far by Kentridge, landscape serves as an emblem both for remembering and disremembering. Often drawn schematically, it is always fluid and changing; always contingent, and, in the words of the critic Robert Condon, under a 'perpetual state of erasure'. Deploring the picturesque as a colonial agent, Kentridge addresses the inherent lie of the horizonless, open, unoccupied veld: a trope very much part of the colonial representation of land as empty and unoccupied prior to European arrival. Critiquing the tendency to behold landscape as a phenomenon of 'pure undisturbed nature', he depicts it as if it were a naked body, eroded, bruised and battered. These drawings are executed with such vigour that the very process becomes tantamount to an archaeological dig: he loosens the land, causing it to reveal itself. Whether it is being mined or used in service of other aspects of industry, landscape in Kentridge's work is under constant exploitation.

Despite the dazzling technical mastery of the films, it is in the drawings that we find the full measure of his art. Reminiscent both of old-master studies and more modern expressionistic works, their authority causes Kentridge's films virtually to sing. The fluidity of his lines and precision of his gestures convey highly intense emotions: violence, tenderness, ambiguity, melancholy are conjured with just a few strokes. One must pay close attention to faces in these drawings: Kentridge renders them so expressionistically, with a hatching technique of criss-crossed lines, that they often seem like masks. If one thinks of Giacometti's drawings and paintings, with their existential tension of modern loneliness, one will have learnt how to relate to Kentridge's spare, power-

n kentridge

Born Johannesburg,1955. Lives and works in Johannesburg

exhibitions: 1979 The Market Gallery, Johannesburg 1981 'Domestic Scenes', The Marke... ...86 Cassirer Fine Art, Johannesburg 1987 'In the Heart of the Beast', Vanessa Devereux, London 199C... ...ngs and graphics', Cassirer Fine Art, Johannesburg 1992 'Drawings for Projection', Goodman Gallery ...evereux, London 1998 Museum of Contemporary Art, San Diego; Stephen Friedman Gallery, London ...russels **selected group exhibitions:** 1985 'Tributaries', touring exhibition ...Neuman Galleries, New York 1990 'Art from South Africa', Museum of Modern Art, Oxford and tou... 1995 'Contemporary Art from South Africa', Haus der Kulturen, Der Walt GmbH, Berlin; 'The Vision of Ar... ...4th Istanbul Biennale; 'Volatile Colonies', 1st Johannesburg Biennale 1996 'Simunye', Adelson Gallery ...RC, Musée d'Art Moderne de la Ville de Paris; Documenta X, Kassel, Germany; 'Trade Routes: History and... ...sburg Biennale; 'Truce: Echoes of Art in an Age of Endless Conclusions', Site Santa Fe, New Mexico; 6th... ...rbara Gladstone Gallery, New York **selected bibliography:** 1989 Sue Williamson ...frica, David Philip, Cape Town/Johannesburg 1990 Michael Godby, Robert Hodgins, *William Kentridge and* ...*Johannesburg*, Witwatersrand University Press, Johannesburg 1993 Esmé Berman, *Painting in South* ...blishers, Pretoria 1996 Sue Williamson, Ashraf Jamal, *Art in South Africa: The Future Present*, David ...esburg 1998 Micheal Godby, 'William Kentridge's History of the Main Complaint', *Negotiating the Past* ...*South Africa*, Oxford University Press, Cape Town; Carolyn Christov-Bakargiev, *William Kentridge*, Palai... ...Okwui Enwezor, 'Swords Drawn', *frieze*, London, March/April

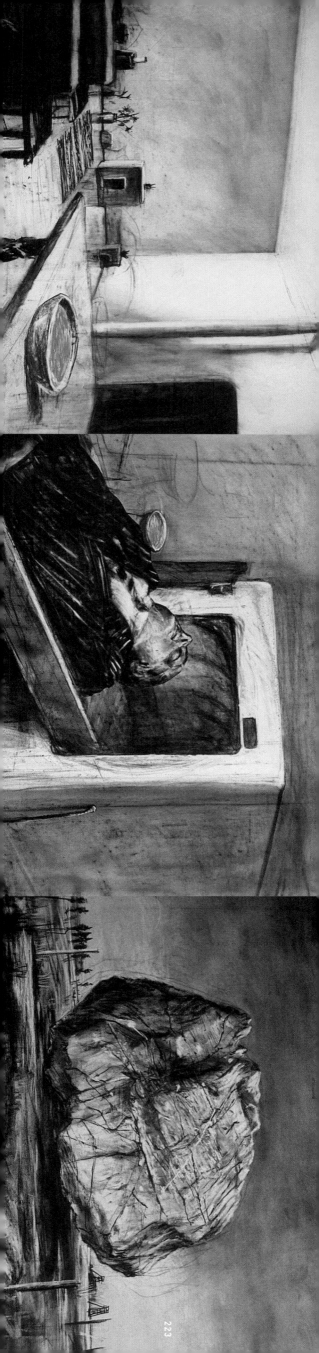

ben kinmont

Promised Relations, or, thoughts concerning a few artists' contracts, 1996.

Ben Kinmont
Exchange, 1995

People coming into agnes b. could trade the shirt off their backs for any shirt in the store. Most customers thought I was a nuisance and looked to the staff for assistance: when it became clear that I was in earnest they chose a shirt. The participant and I signed a new label printed with the project's title. I removed the store's label and price tag, and sewed our co-signed label onto the new shirt. I sewed the store's label and price tag onto the old shirt, which was hung on the store's racks as a new agnes b. shirt for sale. Participants used the video camera to document the exchange. Eventually most of the people coming in were there by word of mouth. The number of shirts given was determined by how long it took me to exchange the labels.

Archive begun 1995. agnes b. pour hommes, New York City, for three days. The store's seamstress and twenty customers participated. Twenty shirts worth $2,934.00 given.

Ben Kinmont
Promised Relations, or, thoughts on a few artists' contracts, 1996–97

'I was writing my own contracts for ownership and exhibition of the archives. In particular, I was trying to develop an economy of perpetuity, one where I could afford the promises set up in the archives, yet still manage living expenses. So I began researching other artists' contracts and Promised Relations was the result. Each of the artists were either work or as a means to clarify an element in the distribution of their work. It was also the first time I ever offered a group show for sale.

AC Project Room, New York. An exhibition project with Marcel Broodthaers, Paula Hayes/Wild Friends, Ed Kienholz, Yves Klein, Komar & Melamid, Seth Siegelaub and Bob Projansky, and Various Times and People. Catalogue printed in an edition of 500 copies.

Carlos Basualdo
art institution and everyday life

Promised Relations is an exhibition, an artwork and a succinct but substantial poetic essay on the relation between society and contemporary art. First and foremost, it is a collection in the form of a booklet, of artists' contracts from the recent past with a line-up of signatories including the likes of Yves Klein, Ed Kienholz, Komar and Melamid, Marcel Broodthaers and Paula Hayes. The Klein text, for example, is the script of a piece for theatre (from the artists' Theatre of the Void, Sunday, 27 November, 1960), wherein two audiences – one real, one composed of actors – take up the positions of two parties in a contract. Paula Hayes signs an agreement with a New York gallery for the construction of a work that turns out to be a garden. Komar and Melamid, meanwhile, draw up a contract for the sale and purchase of souls. Another is the draft of a contract conceived in the early 1970s for legendary American curator and pioneer gallerist Seth Siegelaub and lawyer Bob Projansky, who specialized in artists' rights regarding the sale of an artwork. As we can read in Kinmont's pamphlet, this contract would go on to achieve a certain degree of influence in Californian legislation.

This collection of contracts makes for an oblique and ingenious exhibition of the earlier works with which they are concerned. Among Kinmont's selection criteria was that the contract should include information on the piece that was not readily detectable in the artwork itself. When brought together, the contracts act as a sort of frame for the works to which they refer, pointing to certain determining features that lie beyond their material qualities and their function as show pieces. (Reading between the lines in the book, there is a subtle homage to Siegelaub and his work as a curator, with specific reference to his concept of exhibitions that take place exclusively in catalogue form.) On the other hand, as a project, Promised Relations occupies a position similar to the contracts it features. As a work it is somewhere between historical document and sociological analysis, also managing to include less immediate, more poetic aims. As far as Kinmont is concerned, a contract is nothing more than the formulation of a promise, and it is primarily to this aspect of the relation between two parties to which the artist's work refers. Promised Relations draws on recent history to explore the system of mutual over-determination that underpins the links between art, exchange and legiti-macy. Additionally (and this, in the final analysis, is the same thing), it is a reflection on the ever-fluctuating confines between art institution and everyday life.

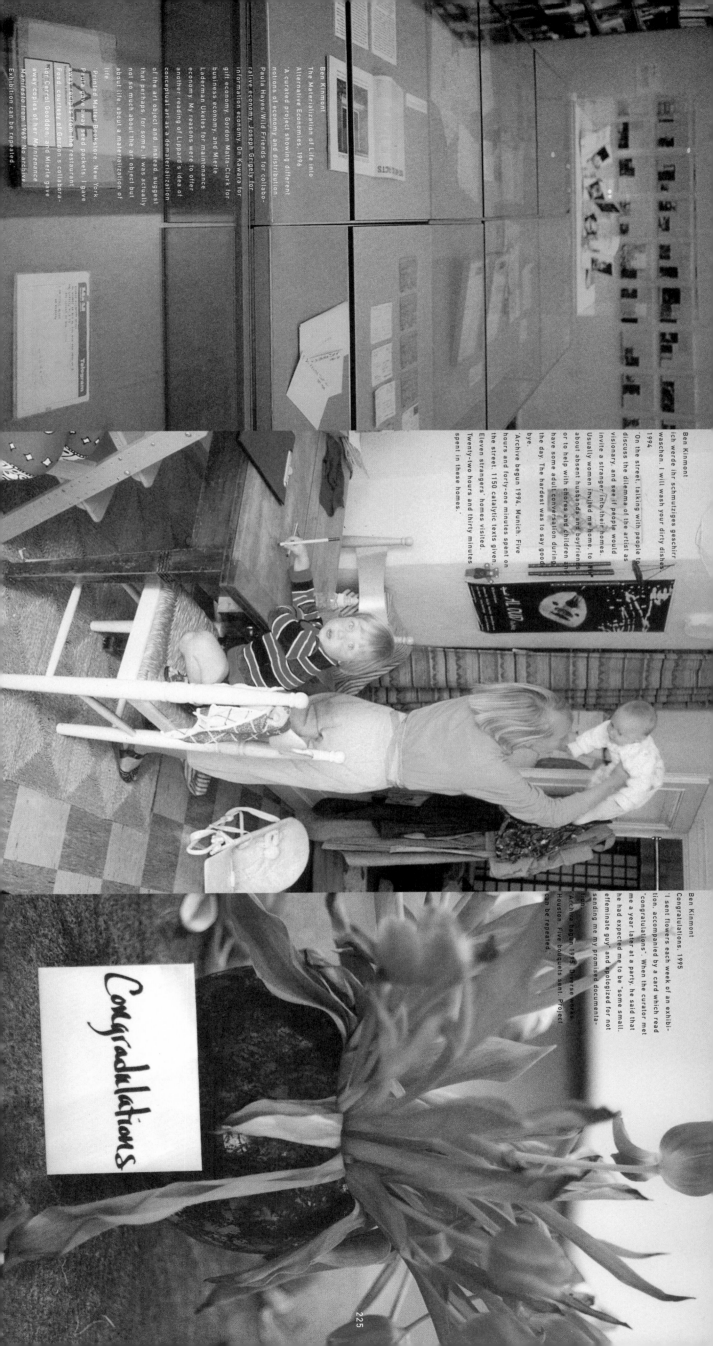

Ben Kinmont

The Materialization of Life into Alternative Economies, 1996

A curated project showing different notions of economy and distribution. Paula Hayes/Wild Friends for collaborative economy, Joseph Grigely for information economy, On Kawara for gift economy, Gordon Matta-Clark for business economy, and Merle Laderman Ukeles for maintenance economy. My reasons were to offer another reading of Lippard's idea of conceptual art as a dematerialization of the art object and instead suggest that perhaps, for some, it was actually not so much about the art object but about life, about a materialization of life.

Printed Master Bookstore, New York gave away recipes from the restaurant Food, courtesy of Gordon's collaborator, Carol Goodden, and Merle gave away copies of her *Maintenance Manifesto* from 1969. No archive. Exhibition can be repeated.

Ben Kinmont

... ich werde ihr schmutziges geschirr waschen. I will wash your dirty dishes, 1994

'On the street: talking with people to discuss the dilemma of the artist as visionary, and see if people would invite a stranger into their homes. Usually women invited me home, to talk about absent husbands and boyfriends or to help with chores and children and have some adult conversation during the day. The hardest was to say goodbye.'

'Archive begun 1994, Munich. Five hours and forty-one minutes spent on the street, 1150 catalytic texts given. Eleven strangers' homes visited. Twenty-two hours and thirty minutes spent in these homes.'

Ben Kinmont

Congratulations, 1995

'I sent flowers each week of an exhibition, accompanied by a card which read 'congratulations'. When the curator met me a year later at a party, he said that he had expected me to be 'some small, effeminate guy' and apologized for not sending me my promised documentation.

'Archive begun 1995. Diverse works, Houston. Five bouquets sent. Project can be repeated.'

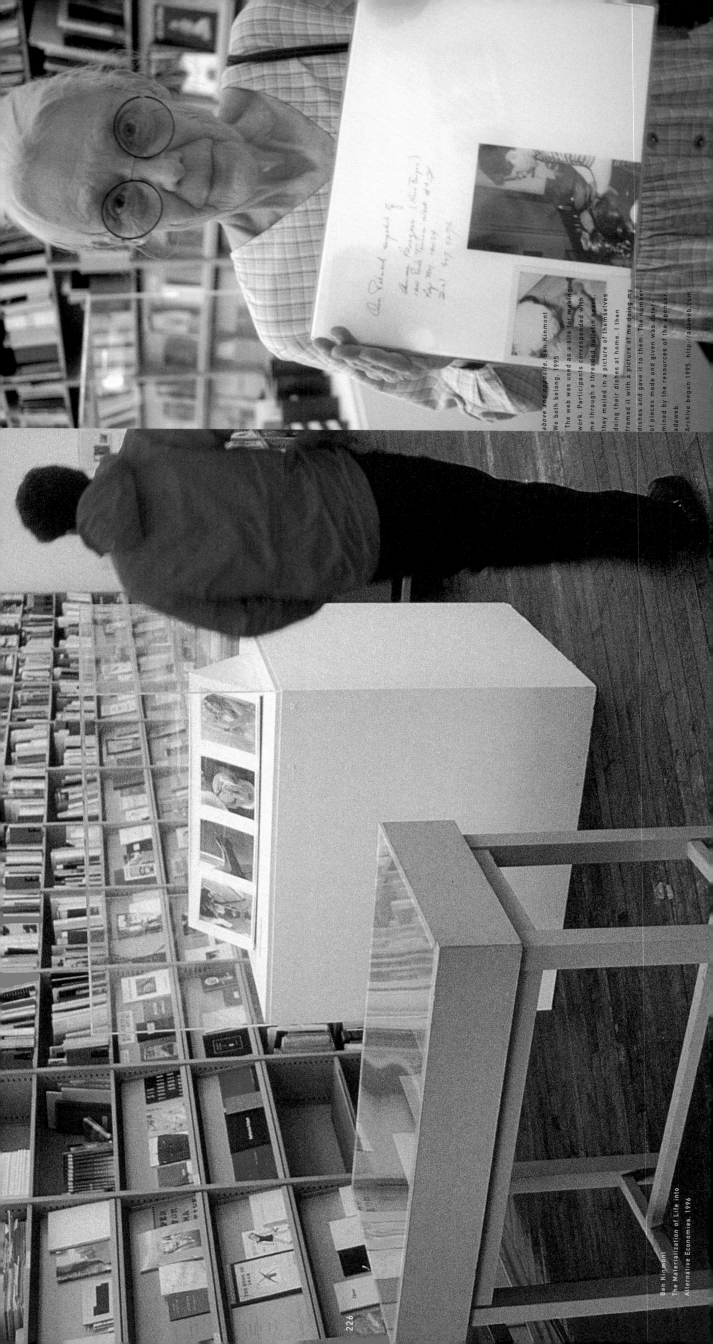

above and opposite, Ben Kinmont
We both belong, 1995

The web was used as a site for making
work. Participants corresponded with
me through a threaded bulletin board;
they mailed in a picture of themselves
doing their dishes at home. I then
framed it with a picture of me doing my
dishes and gave it to them. The number
of pieces made and given was deter-
mined by the resources of the sponsor,
adaweb.
Archive begun 1995. http://adaweb.com

Ben Kinmont
The Materialization of Life into
Alternative Economies, 1996

Born Vermont, 1963. Lives and works in New York. **selected so**

xhibitions: 1989 'Sculpture and Paintings', Sandra Gering Gallery, New York 1992 'Sculpture', Galerie Rolf Ri

ologne 1993 'Archives (I am for you, Ich bin fur Sie; I need you; For you for me for painting)', Sandra Gering Gallery, New

elected group exhibitions: 1988 'True Democracy', White Columns, New York 1990 'Programm

erie Rolf Ricke, Cologne 1991 'The Projected Audience', Four Walls, New York 1992 'The Art Mall: A Social Space', New Mus

Contemporary Art, New York 1994 'Are You Experienced?', Andrea Rosen Gallery, New York; 'Presque Rein', Galerie Jenr

y, Paris 1996 'In the Flow: Alternative Authoring Strategies', Franklin Furnace, New York; 'Joint Venture', Basilico Fine A

w York; 'We both belong: archive and distribution', Printed Matter, New York 1997 'adaweb: map the gap', Storefront for Art

hitecture, New York; 'I met a man who wasn't there ...', Basilico Fine Arts, New York **selected bibliogr**

ny: 1992 Gretchen Faust, 'The Projected Audience', *Arts Magazine*, New York, February; Gretchen Faust, 'Casual Ceremo

s Magazine*, New York, March; Gerard Goodrow, 'Ben Kinmont at Rolf Ricke', *ARTnews*, New York, November; Roberta Sm

sual Ceremony', *The New York Times*, 5 January 1994 Benjamin Weil, 'Ouverture: Ben Kinmont', *Flash Art*, Milan, Summ

git Sonna, 'Wie die Kunst so spult', *Sueddeutsche Zeitung*, Munich, 20 May 1995 Jon Ippolito, 'Out of the Darkness and Into

op', *Flash Art*, Milan, April 1996 Mary Pat Dunleavy, 'The View from the Street', *World Art*, New York, November; Bill Arn

itor's Choice', *Bomb*, New York, Summer 1997 Judith Hoffberg, 'Promised Relations; or, Thoughts on a Few Artists' Contra

brella*, Cambridge, Massachusetts, October

Netscape: <we both belong: the archive>

Back Forward Home Reload Images Open Print Find Stop

Location: http://adaweb.com/adaweb/influx/kinmont/bk6.html

we both belong archive

partipation in this project has come to a close.
this archive will enable you to browse through
another's correspondence, or consult the sketches and drawings
relating to the development of the project.

http://adaweb.com/cgi-bin/imagemap/adaweb/influx/kinmont/mapbw.map?286,113

suchan Kinoshita

Though Suchan Kinoshita's work is often almost intangible, it cannot be described as minimal. Rather, it can be located within a tradition of organic, performative and architectonic work by women artists including Marisa Merz, Eva Hesse, Carolee Schneemann and Andrea Zittel.

Her intention is to make her art and her own persona function as transmitters of new levels of perception, attempting to define an artistic syntax in which all existence can be fragmented into thousands of micro-feelings and recomposed into a new sculptural language. She achieves this by allowing her work to develop organically within the space, utilizing in particular the concavities in the existing architecture. Once she has carved her conceptual, physical and mental holes, the next step is to fill them with symbolic elements of time, sound and language.

In one performance, Lautsprecher (Loudspeaker), at the Istanbul Biennale, 1995, while two people whispered in her ears she communicated what she heard to the public. This mysterious inner conversation created a transcendent, new language formed by weaving the words of the whisperers with her own voice. In another performance, Highway Image I, 1991, she played a violin on the border of a busy motorway, an act that simultaneously drew attention to and obliterated her performance. Forming patterns of contradiction between space and sound, Kinoshita expands the limits within which a work of art can be experienced in transformative events demanding a high level of concentration from the audience. Avoiding any direct reference to oriental philosophy, she builds a near-religious state of suspension that confronts one's perception of reality.

Her use of dust, splinters, loose threads and other disposable materials activates them with a subliminal aura. While Joseph Beuys achieved this by imposing his own charismatic presence on the mundane, Kinoshita moves away from the self in order to create a situation whereby even the most traditional sculptural element is transformed into a tool for a new awareness. In a performance, Wall Piece, 1994, at her P.S. 1 studio in New York, she hid behind a wall with only her elbow sticking out from the white plaster. This radical action stretched the idea of performance to an extreme, using the body as a decorative, live and architectural element. In this respect her employment of the body is very different from that of artists such as Chris Burden, Ana Mendieta or Gina Pane. More relevant is a comparison with the early sculptural pieces of Charles Ray, where the body serves to define sculptural volume and scale in an abstract way.

Francesco Bonami

this page and opposite.
Suchan Kinoshita
Voorstelling (To visualize) (detail), 1997
Curtains, clothes, lights, furniture,
running rails
Approx. 300 x 400 x 300 cm
Installation, Van Abbemuseum,
Eindhoven, The Netherlands

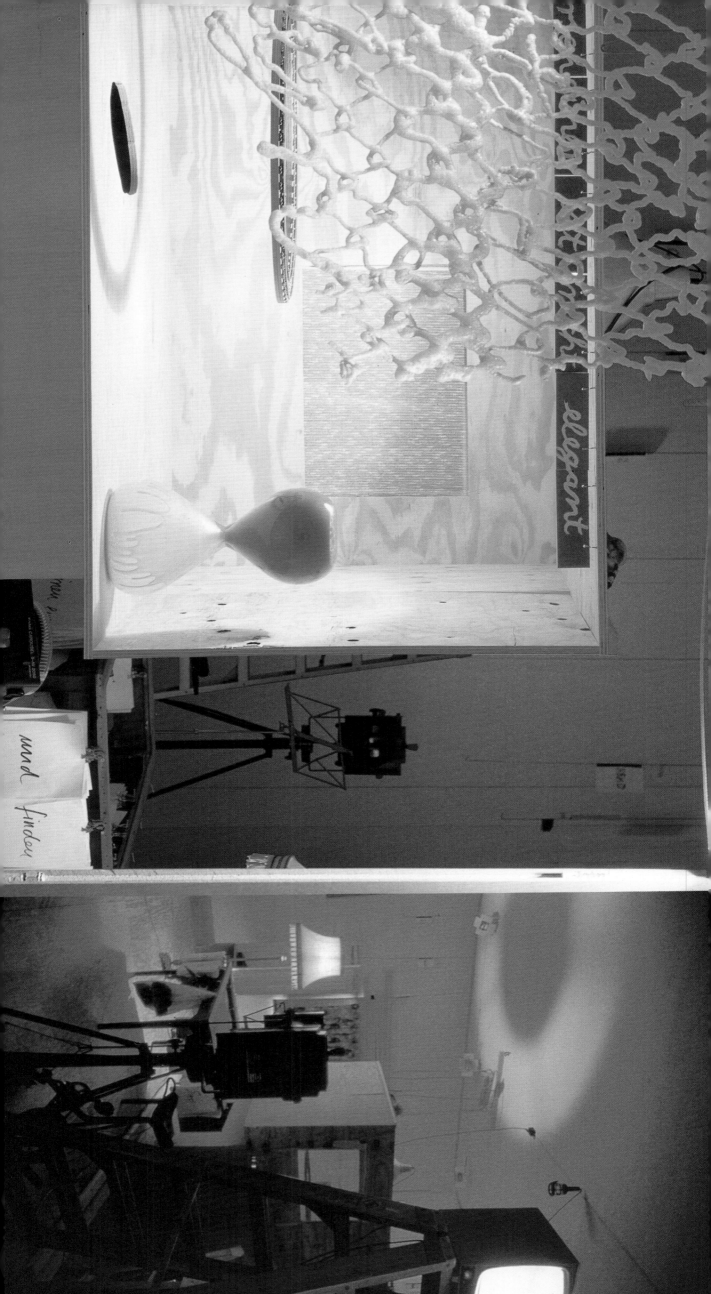

suchan kinoshita

Born Tokyo, 1965. Lives and works in Maastricht.

selected solo exhibitions: 1991 'Fabriek', De Fabrick, Eindhoven, The Netherlands 1996 'Stuff', White Cube, London 1997 'Voorstelling', Van Abbemuseum, Eindhoven, The Netherlands 1998 Chisenhale Gallery, London **selected group exhibitions:** 1992 'Tafel II', De Appel, Amsterdam 1994 'Wall-piece', P.S.1 Museum, New York; 'This is the show and the show is many things', Museum van Hedendaagse Kunst, Ghent 1995 'Travel Agent', Centraal Station, Maastricht; XLVI Venice Biennale; 'The Vision of Art in a Paradoxical World', 4th Istanbul Biennale 1996 Manifesta 1, Rotterdam; 'Doppelbindung, Linke Maschen', Kunstverein, Munich; 'Under Capricorn', Stedelijk Museum, Amsterdam; 'Inclusion/Exclusion', Steirischer Herbst, Graz 1997 'Suchan Kinoshita & Patrick Van Caeckenbergh', Zeno X Gallery, Antwerp; 'Truce: Echoes of Art in an Age of Endless Conclusions', Site Santa Fe, New Mexico; 'Trade Routes: History and Geography', 2nd Johannesburg Biennale **selected bibliography** 1992 Sjef Kusters, 'Eintagebuch kunstboek van Suchan Kinoshita', *De Limburger*, Maastricht, 15 August 1995 Jorinde Seÿdel, 'De eeuwigheid in het ogenblik. Over gefluister, telescopen en teennagels in het werk van Suchan Kinoshita', *Metropolis M*, No 4, Utrecht; Ineke Schwartz, 'Tijdgeest in luchtig lattenhok', *De Volkskrant*, Amsterdam, 16 April 1997 Etienne Wynants, 'Suchan Kinoshita', *De Witte Raaf*, Brussels, May/June; Dirk Pültau, 'Patrick Van Caeckenbergh Kinoshita', *NRC Handelsblad*, Rotterdam, 16 May; Wilma Sütö, 'Alleen ademhalen is al een hele krachttoer', *De Volkskrant*, Amsterdam, 9 March

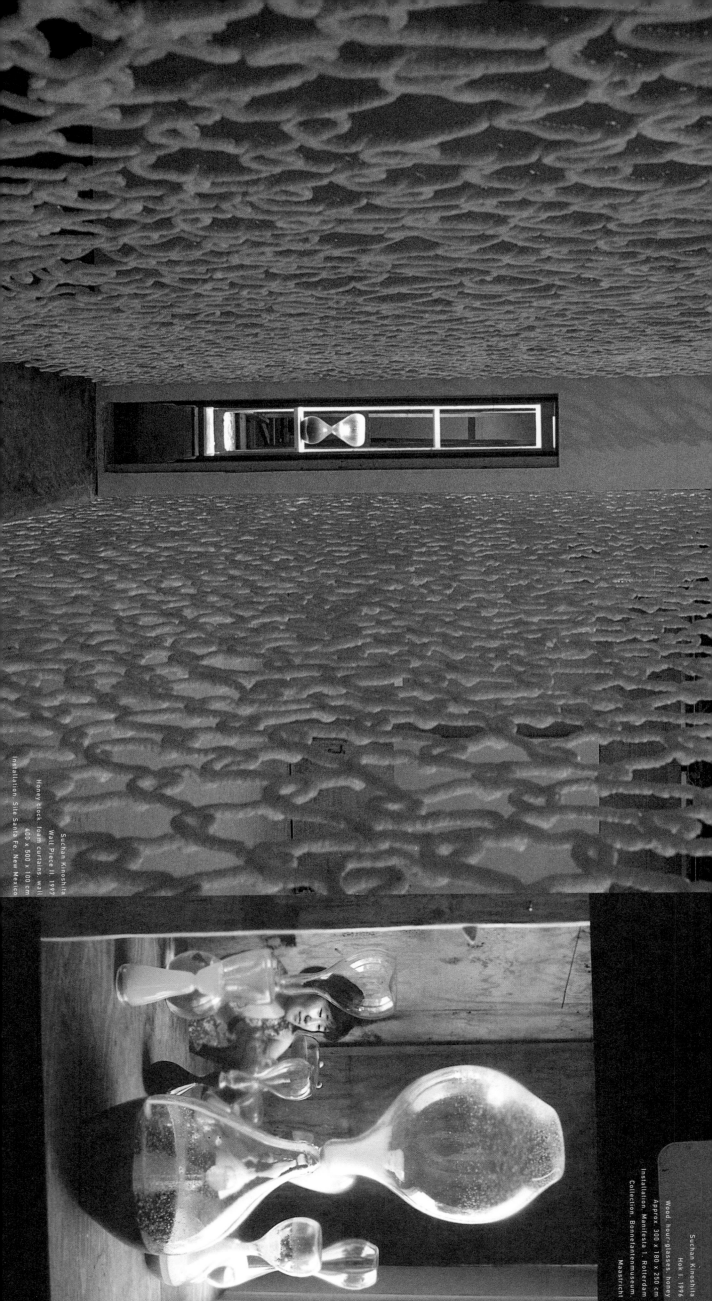

Suchan Kinoshita
Wall Piece II, 1997
Honey clock, foam curtains, wall
400 x 500 x 100 cm
Installation, Site Santa Fe, New Mexico

Suchan Kinoshita
Hok I, 1996
Wood, hour-glasses, honey
Approx. 300 x 180 x 250 cm
Installation, Manifesta 1, Rotterdam
Collection, Bonnefantenmuseum,
Maastricht

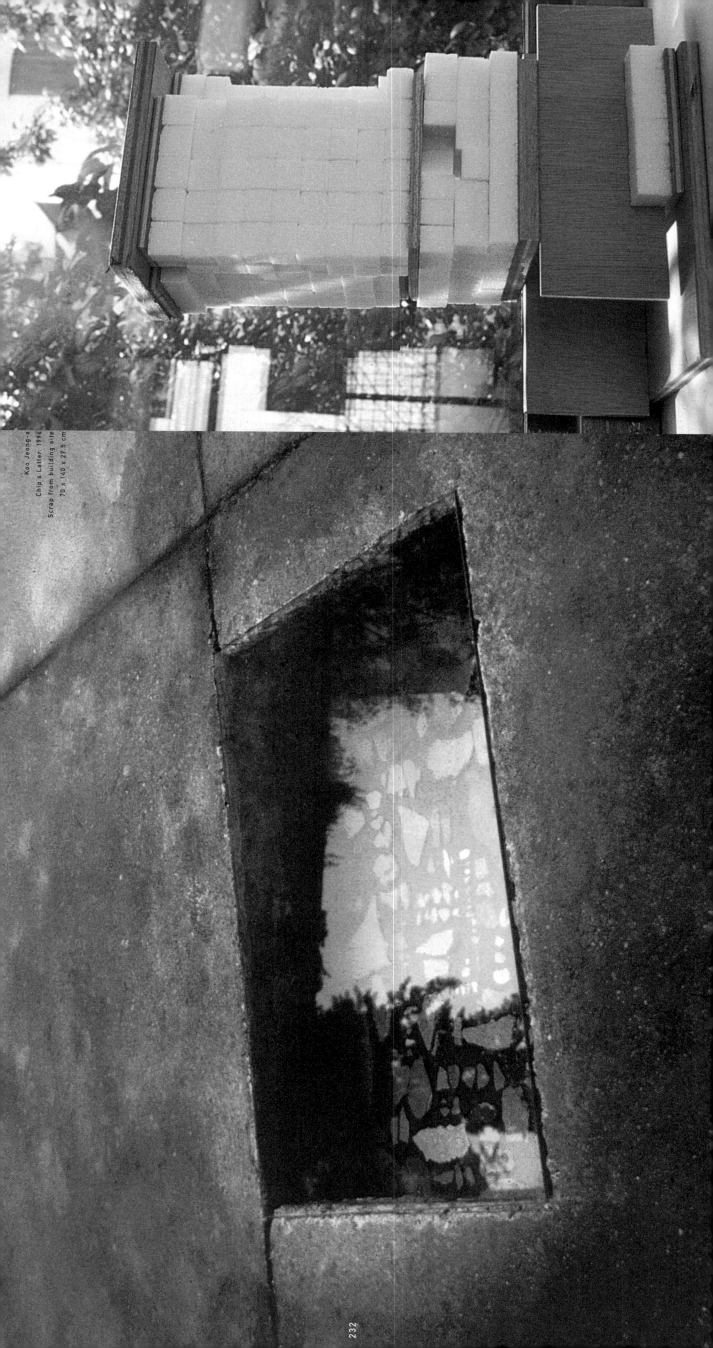

Koo Jeong-a
Chips Latter, 1996
Scrap from building site
70 x 140 x 27.5 cm

Koo Jeong-a
Floating House, 1996
Sugar, plywood
20 x 15 x 30 cm
Installation, Manifesta 1, Rotterdam

koo jeong-a

Swept away by globalization, our culture is increasingly demanding new creative processes that are 'original' yet connected with the structures of the Western aesthetic model of production and cultural intervention. In short, what we are asking from former 'third world' artists is that they start working as we would like them to work, that they should look at themselves through *our* eyes.

Korean artist Koo Jeong-a has responded to this Western approach to the new map of contemporary art by adopting a passive/aggressive method of working. Her strategy is to make interventions in the gallery space so imperceptible that they nearly disappear within the seams of defined structures, functioning almost like a *fata Morgana*. Images and gestures are made to hover at the border of perception in order to allow the viewer to become gradually adjusted to them. More akin in structure to poetry than to sculpture, her works manifest themselves as landscapes of the mind, where scale is altered by the use of memory or imagination. Her materials are chosen for their consistency, which matches the idea or the feeling that lies behind the work. The installation *Oslo*, 1998, for example, was a sort of landscape created from ground aspirin and lit by a dawn-like blue light.

Koo's interventions in the space are almost imperceptible: piles of debris, scraped from the room's surfaces or simply collected from the floor, arranged in a spiritual organization, a mandala of the insignificant. Rather than filling the space, they enhance its vastness, emphasizing its relevance against the irrelevance of objects and people. The slightest careless act on the part of the viewer could disrupt the entire work, and this need for 'care' is perhaps the most important sculptural element of Koo's project. Her work demands a level of vigilance that the viewer can rarely offer, or the space maintain. Yet her effort seems to succeed, creating a vacuum where it exists naturally. Her art has no story to tell; it simply points to the 'here and now' of a contemporary Heraclitean flow.

Francesco Bonami

Koo Jeong-a
My Love 130396, 1996
Colour photograph
30 x 30 cm

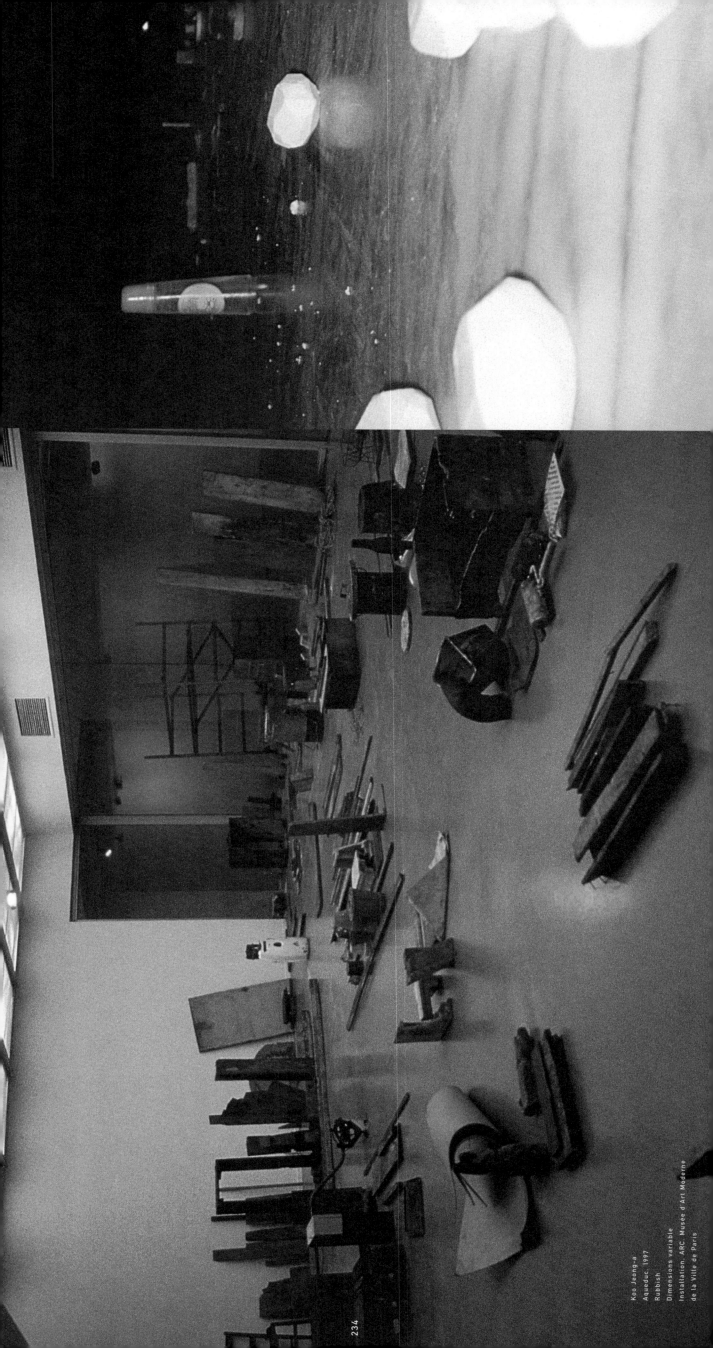

Koo Jeong-a
Aqueduc, 1997
Rubbish
Dimensions variable
Installation, ARC, Musée d'Art Moderne
de la Ville de Paris

koo jeong-a
Born Seoul, South Korea, 1967. Lives and works in Paris. **selected group exhibitions:** 1996 Manifesta 1, Rotterdam; 'Do it', Taidehalli, Helsinki; Forde, Geneve; Banhof, Messepalast, Vienna; 'L'art du Plastique', Musée des Beaux-Arts de Paris 1998 'Vertical time', Barbara Gladstone Gallery, New York **selected bibliography:** 1994 Hans Ulrich Obrist, 'Migrateurs', *art press*, Paris, July/August 1995 Michel Nuridsany, *Le Figaro*, Paris, 8 December 1996 Jean-François Taddei, 'Territories Furtifs', *Interlope*, Nantes, December/January 1997 Michel Nuridsany, *Le Figaro*, Paris, 10 June; Elisabeth Lebovici, *Libération*, Paris, 15 February; Elisabeth Lebovici, *Libération*, Paris, 15 December; Françoise-Aline Blain, *Tribeca 75*, Paris, June/August; Pascalin Cuvellier, 'The Letter from Paris', *Artforum*, New York, November

udomsak krisanamis

Udomsak Krisanamis makes unashamedly beautiful paintings that emerge effortlessly from the most prosaic of processes. Initially, he pastes strips of text – innumerable words and figures carefully extracted from daily newspapers and supermarket brochures – onto a canvas support. Then, using a magic marker pen, ink or acrylic paint, he carefully proceeds to obliterate everything from the painting's surface – save for the negative spaces contained within letters and numerals such as 'O', 'P', and 'zero'. The resulting sequence of ellipses – Fontana-esque 'orifices' that punctuate the painting's surface – combine to create a dense, all-over field. Contemplating this field – suc-cinctly described elsewhere as 'condensed gravity' – is an experience akin to the hallucinatory search for the buried image within a 3-D 'Magic Eye' picture.

Yet Krisanamis systematically reduces language to an arcane, indecipherable visual morse-code – all dots and no dashes. Krisanamis' visionary abstractions continue to invite narrative associations: for example a starry night sky, or an aerial view over a phosphorescent metropolis. Krisanamis' titles describe a nocturnal, bittersweet world of tentative trysts and broken hearts: Alice, Slender, Hesitant, I Love You, Midnight in My Perfect World, We Never Kiss, Tears on My Pillow and Cheat.

Oddly reminiscent of James Welling's photographic vistas of crumpled aluminium foil, the paintings entertain and encourage a promiscuous historical reference – a veritable index of the avant garde. A random sampling might include; Apollinaire's cal-ligrammes', or John Cage's cryptic scores and the radical ambience of the Black Mountain College in the late 1940s – notably Robert Rauschenberg's folksy monochromes. The paintings distil something of the homespun bohemian milieu of Wallace Berman's Los Angeles of the 1950s. They rekindle the beatnik serendipity of William Burroughs, and Bryon Gysin's fragmented texts. The paintings' laboured surfaces (recently with the addition of cooked noodles and graphite) suggest Manzoni's crafty Achromes', Sal Scarpitta's 'bandage' paintings of the late 1950s, Raymond Hains de-collage and Frank Stella's little seen, early metallic tape paintings. All this before we have even had a chance to consider Op Art's often derided illusionary dynamic and the more routine world of process-based abstraction. In Krisanamis' work it all remarkably gets a look in. Yet somehow his laid-back cross-overs from art history manage to side-step the burden of both their modernist and postmodernist legacies. Krisanamis col-lapses the former's certainty into the latter's doubt – creating for himself an idiosyncratic route through painting, and in doing so prescribes a palpable and necessary antidote to the end game of much recent strategic abstraction.

Matthew Higgs

this page. Udomsak Krisanamis
And one more, 1996
Ink and collage on canvas
274.5 x 183 cm

Udomsak Krisanamis
Cheat, 1996
Ink and collage on canvas
183 x 274.5 cm

Udomsak Krisanamis
Gazza, 1997
Noodle and graphite on canvas
183 x 122 cm

Udomsak Krisanamis
Skin Disease, 1993
Marker and collage on canvas
122 x 122 cm

udomsak krisanamis

Born Bangkok, 1966. Lives and works in New York. **selected solo exhibitions:** 1990 Goethe Institute, Bangkok 1996 Gavin Brown's enterprise, New York 1997 Henry Art Gallery, University of Washington, Seattle; Victoria Miro Gallery, London **selected group exhibitions:** 1993 'inconsequent', Natalie Rivera Gallery, New York 1996 'Drawings for the Mab Library', AC Project Room, New York 1997 'Longing and Belonging: From the Nearby to the Faraway', Site Santa Fe, New Mexico **selected bibliography:** 1995 David Pagel, '"New Testament" Puts Words to the Test', *The Los Angeles Times*, 10 August 1996 David Pagel, 'Isolated Concept', *The Los Angeles Times*, 1 February; Roberta Smith, 'Udomsak Krisanamis', *The New York Times*, 2 February; Peter Schjeldahl, 'Screenery', *The Village Voice*, New York, 13 February; Andrew Perchuk, 'Udomsak Krisanamis', *Artforum*, New York, April; Roberta Smith, 'Enter Youth, Quieter and Subtler', *The New York Times*, 17 May

Udomsak Krisanamis
Servants (Spit), 1994
Ink and collage on canvas
183 x 122 cm

elke krystufek

Hans Ulrich Obrist What part does drawing or painting play in your work?

Elke Krystufek Everything influences everything else.

Obrist Your self portraits are often in series.

Krystufek There can't be such a thing as an absolute picture any more.

Obrist Can you tell me about your first videos?

Krystufek The first videos started at home: they were entirely private. The first of all was a striptease video, made at home, for home – a home video made in the bedroom and conceived for the bedroom. Originally the camera was there in order to have a conversational partner in a very intimate sphere.

Obrist So it dealt with the question of witnessing?

Krystufek The witness has become a director. Witnesses are getting more and more powerful. What was originally only thought becomes documentation, which assumes the main role, and that's increasingly the case in the media ... the witness is the director.

Obrist So is the camera someone looking over your shoulder?

Krystufek Above all it can give you a dimension of yourself that you can never get otherwise. You can look at yourself, but it isn't someone else and how they see you. You can only tell yourself how you see yourself.

Obrist Are the videos like your painted self portraits – an investigation of the self?

Krystufek The first time you see yourself via a camera it's a complete shock because you aren't familiar with this viewpoint of yourself.

Obrist What was your second video?

Krystufek *Eating Vomiting,* it was just as intimate. It's about the fact that something normally hidden, which is the most intimate thing of all, the illness bulimia, which you even hide from your family and friends, is being made public. You can't take the total examination that you do with yourself and extend it to someone else, you can't examine another person as intensely.

Obrist The most private space goes public in your work ... The boundaries between public and private ...

Krystufek ... disappear.

Obrist Is the camera an autistic instrument?

Krystufek Yes and no. Because at the moment when you go out with your camera, you enter the public sphere and capture people other than yourself.

Obrist What about private space?

Krystufek Yes, you notice that when you go on investigating. You can go as far as you like with yourself. But you can't investigate someone else's private space. The extreme examination that you do with yourself can't extend to a second person.

Obrist We spoke once about Vienna Actionism, but your actions are more akin to Paul McCarthy.

Krystufek Because of Vienna, I'd say because of Vienna!

Obrist Is it ketchup or real blood?

Krystufek In my very first action in the Contemporary Institute in the Akademie I used blood instead of ketchup: everyone thought it was fake at first, and couldn't stand the fact that it wasn't ketchup but real blood. The action was stopped by the organizers and the audience.

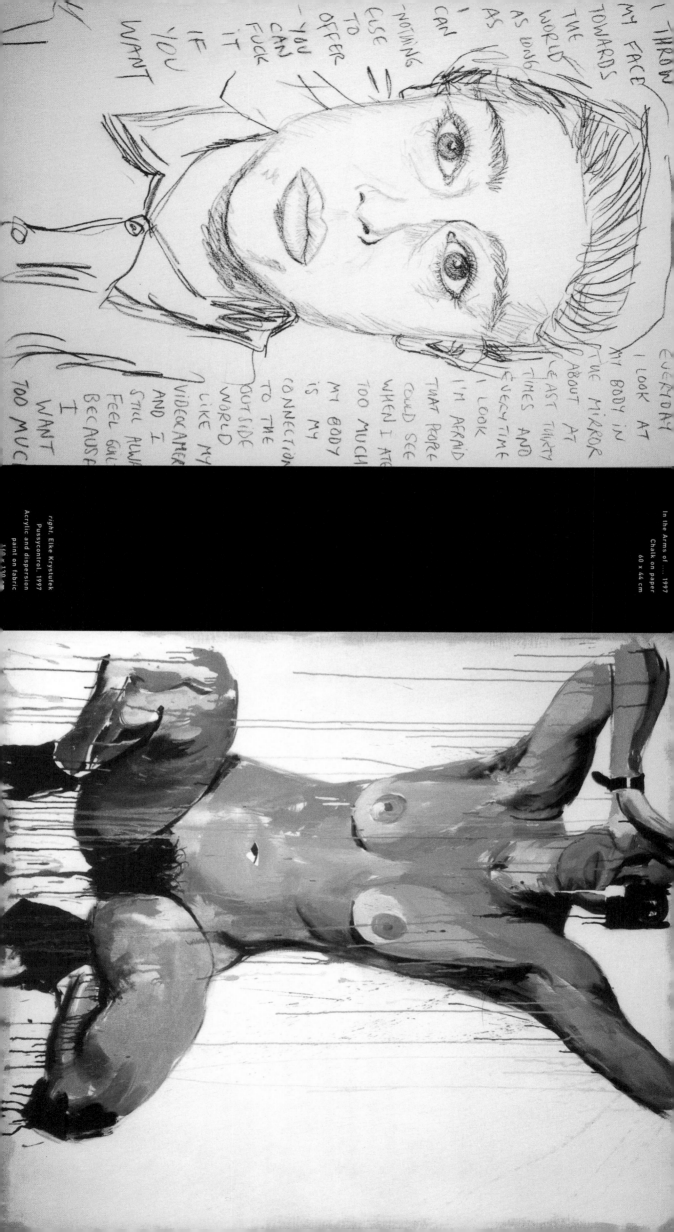

In the Arms of 1997
Chalk on paper
60 x 44 cm

right. Elke Krystufek
Pussycontrol, 1997
Acrylic and dispersion
paint on fabric
160 x 130 cm

I'm a sex-maniac so I want only

sex-maniacs around me -

things

I want people to feel what I feel - no other

elke krystufek
Born Vienna. 1970. Lives and works in Vienna. **selecte**

solo exhibitions: 1990 'Aktion'. Institute for Contemporary Art. Academy of Fine Arts. Vienna 1991 'Installatio

David Strasse 79/3/2'. Atelier Franz Graf. Vienna 1993 'Le Principe de Réalité'. Gallery Bruno Brunett. Berlin 1994 'Migrateurs

ARC. Musée d'Art Moderne de la Ville de Paris 1995 303 Gallery. New York 1997 Secession. Vienna 1998 303 Gallery. New Yor

Emily Tsingou and Company. London **selected group exhibitions:** 1989 'Sie betreten die Akademie

Academy of Fine Arts. Vienna 1990 'Nach der Natur'. Kunsthaus. Horn. Austria 1992 'Water Bar 2'. Jack Tilton Gallery. New Yor

'Informationsdienst'. Ausstellungsraum. Kunsthaus. Stuttgart 1993 Aperto. XLV Venice Biennale; 'Krieg'. Austrian Triennale fo

Photography. Graz; 'Elke Krystufek. Hanne Darboven. Sue Williams'. Gallery Metropol. Vienna 1994 'Jetztzeit'. Kunsthalle. Vienna

De Appel. Amsterdam 1995 'Country Code'. Bravin Post Lee Gallery. New York; 'Feminin/Masculin'. Centre Georges Pompido

Paris 1996 'White Cube/Black Box'. EA-Generai Foundation. Vienna; 'Sammlung Nummer 1'. Kunstverein. Salzburg 1997 ':Eng

:Engel'. Kunsthalle. Vienna; 'Little Explorer'. Bricks & Kicks. Vienna; W 139. Amsterdam **selected bibliogra**

phy: 1992 Joanna Hofleitner. 'Elke Krystufek and Franz Graf'. *Artforum*. New York. Summer; Kim Levin. 'Writings on the Wall

The Village Voice. New York. July; Francesco Bonami. 'Elke Krystufek'. *Flash Art*. Milan. November/December 1993 Danie

Salvioni. 'Aperto'. *Flash Art*. Milan. October 1994 Yvonne Volkart. 'Medusa and Co.'. *Flash Art*. Milan. May/June; Horst Christop

'Marilyn ist mein Vorbild'. *Profil*. Vienna. 12 September; Elizabeth Janus. 'Elke Krystufek. Private Functions'. *frieze*. Londo

December 1995 'The Cabinet of Recent Passions and Ecstasies'. *Blocnotes*. No 8. Paris 1996 Armelle Leturcq. 'Elke Krystufe

Une esthétique de la crudité'. *Blocnotes*. No 11. Paris 1997 Christian Kravagna. 'Elke Krystufek. Wiener Secession'. *Artforum*. Ne

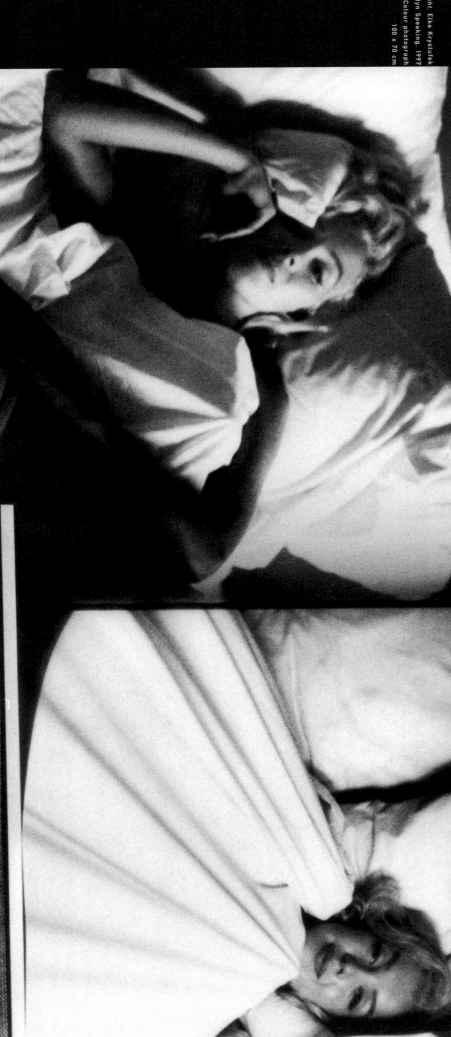

right. Elke Krystufek
Marilyn Speaking, 1997
Colour photograph
100 x 70 cm

opposite. Elke Krystufek
Marilyn Speaking, 1997
Colour photograph
100 x 70 cm

life: staying home and making a mess and communicating only on certain occasions with certain people. I'm saving my communication like itv was money. Maybe I don't have so much communicati+n.

I'm living the life you'd never dare to

243

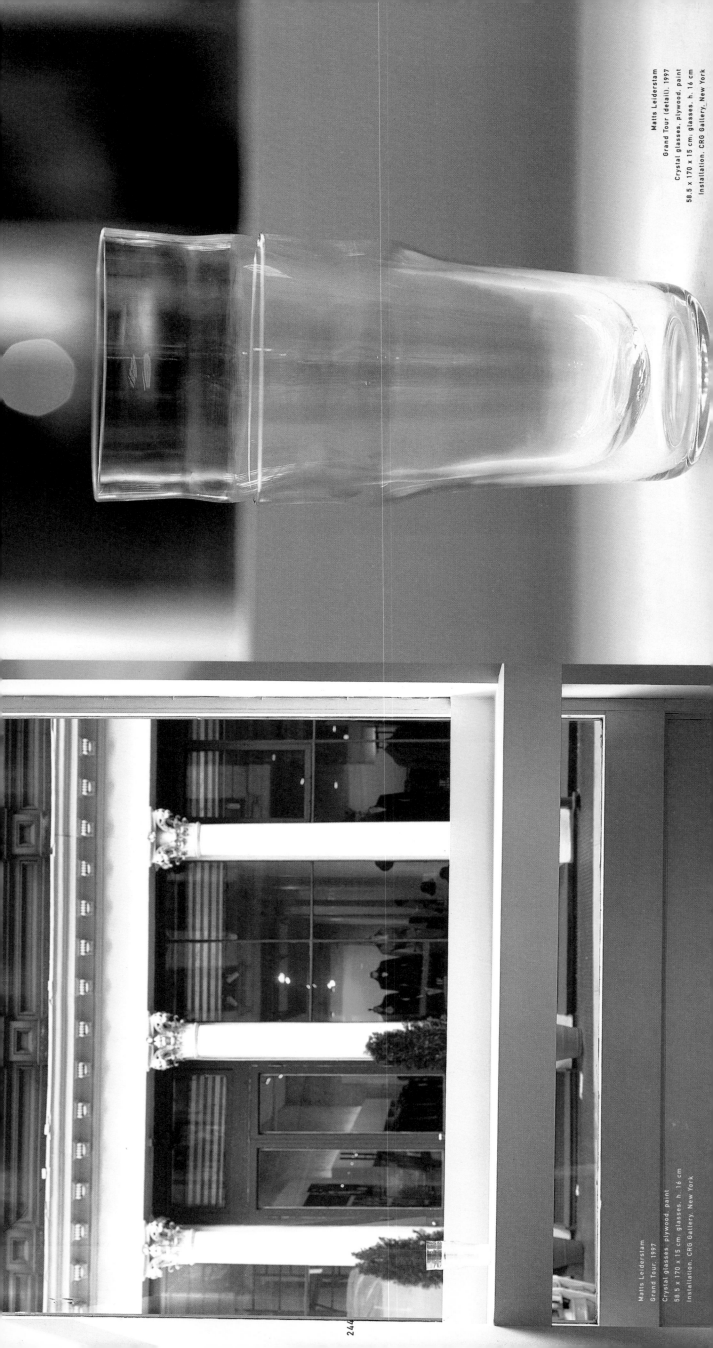

Matts Leiderstam
Grand Tour, 1997

Crystal glasses, plywood, paint
58.5 x 170 x 15 cm; glasses, h. 16 cm
Installation. CRG Gallery, New York

Matts Leiderstam
Grand Tour (detail), 1997
Crystal glasses, plywood, paint
58.5 x 170 x 15 cm; glasses, h. 16 cm
Installation. CRG Gallery, New York

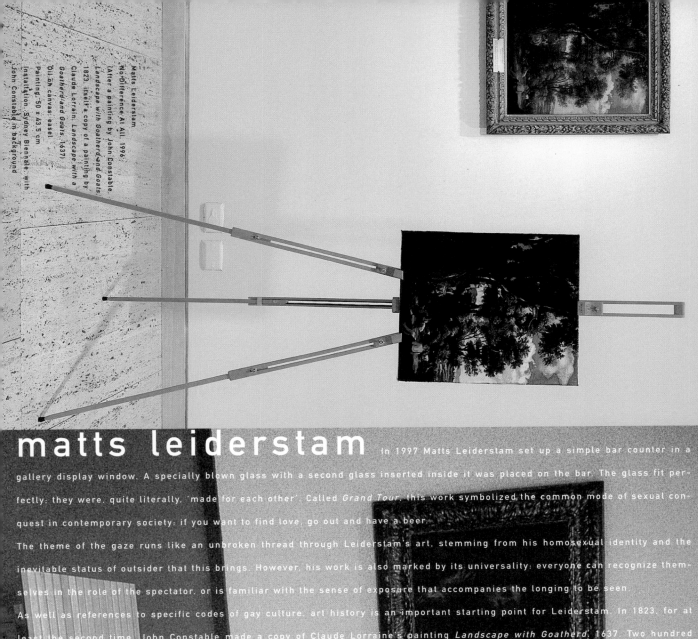

Matts Leiderstam
No Difference At All, 1996;
(after a painting by John Constable,
Landscape with Goatherd and Goats,
1823, itself a copy of a painting by
Claude Lorrain, Landscape with a
Goatherd and Goats, 1637)
Oil an canvas; easel
Painting; 50 x 43.5 cm
Installation; Sydney Biennale, with
John Constable in background

matts leiderstam

In 1997 Matts Leiderstam set up a simple bar counter in a gallery display window. A specially blown glass with a second glass inserted inside it was placed on the bar. The glass fit perfectly; they were, quite literally, 'made for each other'. Called *Grand Tour*, this work symbolized the common mode of sexual conquest in contemporary society: if you want to find love, go out and have a beer.

The theme of the gaze runs like an unbroken thread through Leiderstam's art, stemming from his homosexual identity and the inevitable status of outsider that this brings. However, his work is also marked by its universality: everyone can recognize themselves in the role of the spectator, or is familiar with the sense of exposure that accompanies the longing to be seen.

As well as references to specific codes of gay culture, art history is an important starting point for Leiderstam. In 1823, for at least the second time, John Constable made a copy of Claude Lorraine's painting *Landscape with Goatherd*, 1637. Two hundred years later, Matts Leiderstam made a further copy of Constable's version, entitled *No Difference At All*, 1996. Traditionally seen as a method of proficiency training and as a homage to the master, copying inevitably results in the imposition of an unconscious subjective viewpoint. However, both this truth and the fact that Leiderstam's painting was made from a photograph are belied by the title of the work. Furthermore, Leiderstam has turned the head of the goat-herd in the foreground so that he looks out of the painting, as if trying to catch the viewer's eye. This erotic invitation disrupts the chaste romanticization of the pastoral landscape, underscored by the implication of the title that in art, the park has always been tacitly understood as a place for amorous liaisons. Presenting the men that seek love in these places as the herdsmen of the pastoral landscape, *Returned, The Rambles*, 1997, was made as a homage and transient memorial to a vanished epoch in his own life, loaded with both erotic and art-historical connotations. Leiderstam made a copy of Nicholas Poussin's *Spring* (or the *Earthly Paradise*, 1660–64) and placed it on an easel in a park where he had spent many happy hours. The painting was left to to its fate, to be taken home by a passer-by, vandalized or destroyed.

Leiderstam's new installation, *The Shepherds*, 1998, made for the Liechtenstein Staatlische Kunstsammlung, takes a more conceptual approach. A bench, designed by the artist, was placed in front of three portraits from the museum's collection, depicting three men of various ages. The irregular, horizontal hang contrived to align the eyes of the subjects with those of the imaginary viewer on the bench; this accentuates their open and unguarded gaze. Just like the park, the museum can also be a cruising ground: a place for displaying and looking.

Åsa Nacking

Matts Leiderstam
The Shepherds, 1998
(paintings, l-r:
Franz Hals, *Flötespieleder Jüngling*, c.
1645; Bernardo Licinio, *Portrait eines
jungen Mannes*, c. 1525; Jan De Bray,
Portrait eines älteren Mannes, c.1670)
Pinewood bench
Bench; 45 x 200 x 60 cm
Collection, Staatliche Kunstsammlung
Vaduz, Liechtenstein

opposite, Matts Leiderstam
Room G Lower Floor (detail), 1997
Painting after Nicolas Poussin's paint-
ing *Landscape from the Roman
Campagna with a Man Scooping Water*,
c. 1637-38
Oil on Canvas
61 x 51 cm

Matts Leiderstam
Room G Lower Floor, 1996
Two paintings after Nicolas Poussin's
paintings, l. to r.: *Landscape from the
Roman Campagna*, c. 1639-40,
*Landscape from the Roman Campagna
with a Man Scooping Water*, c. 1637-38
Oil on canvas, pinewood bench
Paintings 61 x 51 cm each; bench, 45 x
200 x 80 cm
Installation, CRG Gallery, New York

Matts Leiderstam
Returned, The Rambles, 1997
Painting made after a painting by
Nicolas Poussin *Spring or the Earthly
Paradise*, 1660-64
Oil on canvas easel
Painting 55.5 x 40.5 cm
Event, The Rambles,
Central Park, New York

matts leiderstam

Born Göteborg, Sweden, 1956. Lives and works in Stockholm and Malmoe. **selected solo exhibitions:** 1993 Ahnlund Gallery, Umeå, Sweden 1994 Mölndals Kunsthalle, Göteborg, Sweden 1995 Art Museum, Malmoe 1997 CRG Gallery, New York 1998 Optica Center for Contemporary Art, Montreal **selected group exhibitions:** 1995 'Disneyland After Dark', Uppsala Art Museum; Bethanien, Berlin 1996 'Jurassic Technologies Revenant', 10th Sydney Biennale; 'Conceal/Reveal', Site Santa Fe, New Mexico; 'I am curious: These Days', Cubitt Gallery, London 1997 'Letter and Event', Apex Art, New York; 'Deposition', Venice Biennale 1998 'Studio Visit', Duende and Boymans Van Beuningen, Rotterdam; 'Transpositions', South African National Gallery, Cape Town; 'From the Corner of the Eye', Stedelijk Museum, Amsterdam **selected bibliography:** 1995 Milou Allerholm, 'Att förvrida seendet', *Expressen*, Stockholm, 19 April 1996 Bruce Ferguson, 'Matts Leiderstam: Cruising with Claud', *art/text*, Sydney, May 1997 Maria Lind, 'Excavating the Ideal Landscape', *Material*, Stockholm, Winter; Terry R. Myers, 'Believed to Be Seen', *Paletten*, Göteborg, January; Daniel Birnbaum, 'Where has all the Madness Gone?', *Parkett*, No 50/51, Zurich 1998 Luk Lambrecht, 'De Zweden', *De Morgan*, Brussels, 30 January; Henry Lehmann, 'Exhibit Offers Portraits that Avoid Our Eyes', *The Gazette*, Montreal, 9 May

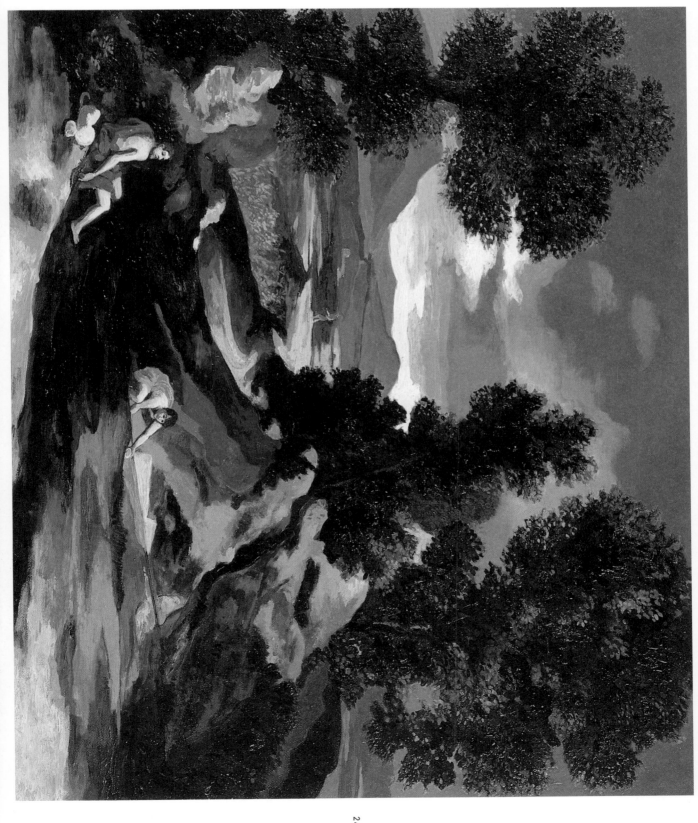

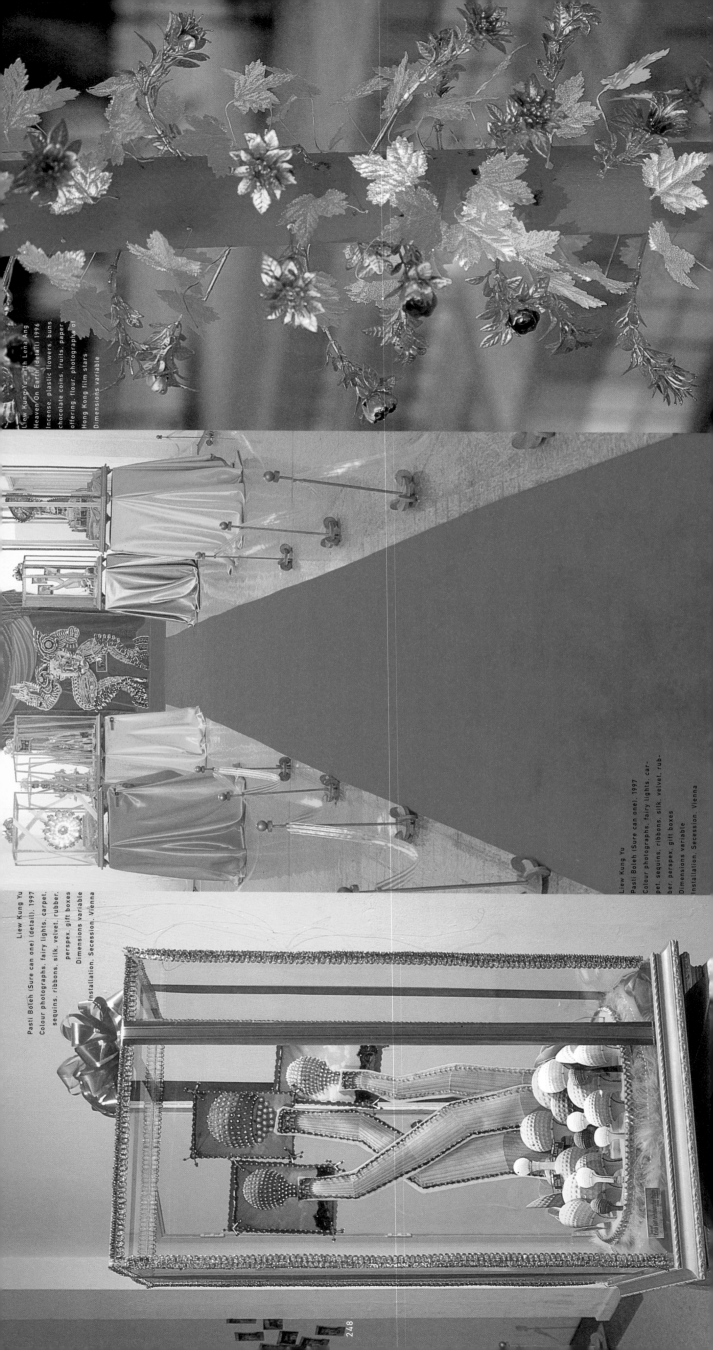

Liew Kung Yu with Lena Ang
Heaven On Earth (detail) 1996
Incense, plastic flowers, buns,
chocolate coins, fruits, paper
offering, flour, photographs of
Hong Kong film stars
Dimensions variable

Liew Kung Yu
Pasti Boleh (Sure can one) (detail), 1997
Colour photographs, fairy lights, carpet,
sequins, ribbons, silk, velvet, rubber,
perspex, gift boxes
Dimensions variable
Installation, Secession, Vienna

Liew Kung Yu
Pasti Boleh (Sure can one), 1997
Colour photographs, fairy lights, car-
pet, sequins, ribbons, silk, velvet, rub-
ber, perspex, gift boxes
Dimensions variable
Installation, Secession, Vienna

liew kung yu

In *Architectures of Excess, Cultural Life in the Information Age*, 1995, author Jim Collins suggests that 'semiotic excess' has become the norm in our everyday environment. Full of highly heterogeneous signs of different cultures, our world – especially the Western world – is entering a new phase of history, a kind of 'late-postmodern' age. It is an anachronistic world beyond any structure of linear time and space – once the defining factors of a modernist *Weltanschauung* (view of the world).

Such an anachronistic vision, however, has always been present in non-Western societies. Multi-racial, multi-lingual nations like Malaysia have experienced the transition from colonization, to de-colonization, to post-colonialism. Confrontation between this culturescape of co-existing traditions and Western influences has been a driving force in the accelerated modernization of these Southeast Asian countries. Kuala Lumpur, currently pursuing an ambitious project to develop into a veritable Global City with the construction of the tallest buildings in the world (Petronas Twin Towers), the Multimedia Super Corridor (MSC), the biggest theme park/hotel/shopping centre (Sunway Lagoon) as well as the largest mosque in the world, represents perfectly a new 'battle field' between global influences and local resistance.

Alongside Kuala Lumpur's spectacular skyscrapers in eclectic styles, the cityscape is typified by its countless billboards, on which images of local and global commodities overlap. This contradictory, hybrid mixture is pushing the inhabitants, whether they are of Malay, Indian or Chinese origin, into a kind of schizophrenia between the desire for modernization and the anxiety that their own cultures will eventually be rooted out. The excessively kitsch forms dominating the mass visual culture are a clear expression of this.

As a Kuala Lumpa-based artist of Chinese origin, Liew Kung Yu is a sensitive observer and powerful critic of this immense mutation, able to witness Malaysian society from a particular angle. In his photomontages he sarcastically appropriates this imagery of kitsch excess. His most ironic and provocative work is the photomontage installation *Trophies*, 1996, in which cut-outs of the main buildings in Kuala Lumpur are made into trophies to reward honourable contributors to the new urban culture. The exaggeratedly spectacular accumulation of kitsch forms provokes laughter, whilst the hands-on interactivity of the work – one can switch on the flashing bulbs and enjoy brilliant moments of glory – pushes the mockery to the extreme. This work is testimony to Liew's exceptional capacity to blend craft and 'high art' into a unique cocktail, a strategy that aims to transgress the established criteria of good taste.

Referring to Chinese traditional ideas and values, especially the spirituality embodied in ritual celebrations of the life cycle, Liew claims to establish a new union between mundane pleasure and spiritual transcendence as compensation for the schizophrenia generated by a rapidly changing world.

Hou Hanru

Found Chinese altar, TV monitors, red paint, red cloth, dried leaves
Dimensions variable

Liew Kung Yu
Who Am I, 1991

opposite, Liew Kung Yu
Bersatu Menuju Wawasan, 1994
Colour photograph
90 x 127 cm

left, Liew Kung Yu
Selamat Datang to Kuala Lumpur, 1998
Colour photograph, gold thread,
coloured paper, pins
22 x 30 cm

liew kung yu

Born Kedah, Malaysia, 1960. Lives and works in Kuala Lumpur. **solo exhibitions:** 1995 'Liew Kung Yu ke-Kopi tiam', six coffee shops and artist's studio, Penang, Malaysia **selected group exhibitions:** 1986 'Space', National Art Gallery, Malaysia 1987 The Young Contemporaries, National Art Gallery, Kuala Lumpur 1988 'Hong Kong International Sand Sculpture Competition' 1989 The Young Contemporaries, National Art Gallery, Kuala Lumpur 1991 'Alter Art', Theatre Works, Singapore 1992 'Collar Making Class', University Sains Malaysia, Penang, Malaysia 1993 1st Asia Pacific Triennial of Contemporary Art, Queensland Art Gallery, Brisbane 1994 Video Arts Festival, National Art Gallery, Kuala Lumpur 1995 'Mari Tangkap Gambar, Photography Exhibition', Creative Centre, National Art Gallery, Kuala Lumpur; 'Dilating Pupil', A&O Design House Gallery, Berlin 1996 'Dong Feng 2', The Japan Foundation Forum, Tokyo, ET, Komplex Budaya Negara, Kuala Lumpur; 'Heaven on Earth', Hong Kong Cultural Centre 1997 'Art in Southeast Asia 1997: Glimpses into the Future', Museum of Contemporary Art, Tokyo, City Museum of Contemporary Art, Hiroshima; 'Cities on the Move', Secession, Vienna 1998 'Asean Master Work', Mine Resort, Kuala Lumpur and National Art Gallery, Kuala Lumpur **selected bibliography:** 1993 A. B. A. Sharrif Zainol, 'Liew Kung Yu', *1st Asia-Pacific Triennial of Contemporary Art*, Queensland Art Gallery, Australia; Peter Hill, 'Liew Kung Yu: Into the New Asia-Pacific Art Age', *Asia Art News*, Hong Kong, November/December 1996 Joyce Tulkens, 'Liew Kung Yu: Shattered Ideas', *Photo Asia*, Vol 6 No 1, Singapore 1997 Ishida Tetsuro, 'Liew Kung Yu', *Glimpses into the Future: Art in Southeast Asia 1997*, Museum of Contemporary Art, Tokyo

Lin Tianmiao
The Temptation of Santa Teresa, 1995
Wooden boxes, moisture cream, rope
500 x 180 x 40 cm

Lin Tianmiao
The Proliferation of Thread Winding (detail), 1995
Bed, thread balls, needles, video
550 x 450 cm

lin tianmiao

One way or another, the castrating effects of authoritarian ideologies leave their mark, not only on the psychology of the individual but also on the work of artists. To understand just how effective a form of control the exclusion of certain creative tendencies from the official exhibition circuit can be, one need look no further than Lin Tianmiao, who, like many other Chinese artists of the same generation, was, until recently, only permitted to show her installations within the confines of her own home. Lin's work addresses the dual burden placed on women in her country both by a patriarchal society and by an existential philosophy that has lead to the somewhat oppressive assumption that true strength comes through humility, submission and discipline.

The installation The Proliferation of Thread Winding, 1995, gathers these reflections together in a beautiful yet disquieting configuration. Thousands of ping-pong balls, which hundreds of women have painstakingly covered in white thread, form an ample skirt around a bed. In the middle of the bed, twenty-thousand sewing needles have been arranged in an oval shape recalling a vulva. On the headboard and in the pillow, a TV monitor shows a pair of female hands at work, covering the ping-pong balls. In a corner of the room hangs a pair of men's trousers which are also covered in needles in an apparent reference to male body hair. The installation involves associations of aggression and receptiveness, of the bed as the site for intimate encounters of interchange as well as domination in the sexual and cultural spheres.

In The Temptation of Santa Teresa, 1995, smooth, pinkish face-cream flows over the rim of a series of coarse wooden boxes and falls to the floor, leaving a stain under each one. The rudimentary roughness of the hand-made boxes contrasts starkly with the fluidity of the cream, subtly exposing the dualities of hard and soft, the container and the contained. The dialectic between these two fundamental poles of life – Yin and Yang – is presented in Lin's works as a metaphor for the movements that define the rhythms of life, such as dispersion and gathering, proliferation and decrease, flow and retention, aggression and withdrawal.

In her most recent works such as Bound, Unbound, 1995-97, or There is No Fun of It, 1997, the thread returns as a primordial material. In a new twist, the artist insists on the need to deconstruct the patriarchal tradition and the multiple forms of oppression that continue to dominate the world.

Rosa Martínez

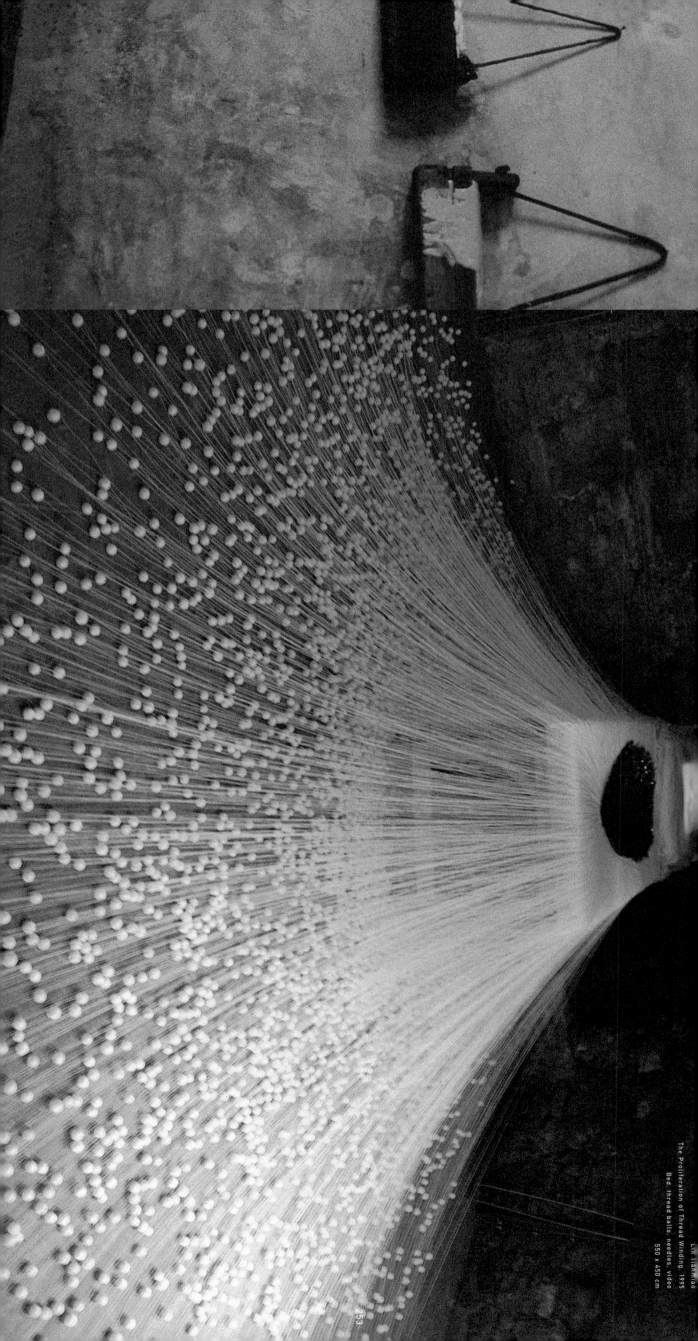

Lin Tianmiao
The Proliferation of Thread Winding, 1995
Bed, thread balls, needles, video
550 × 450 cm

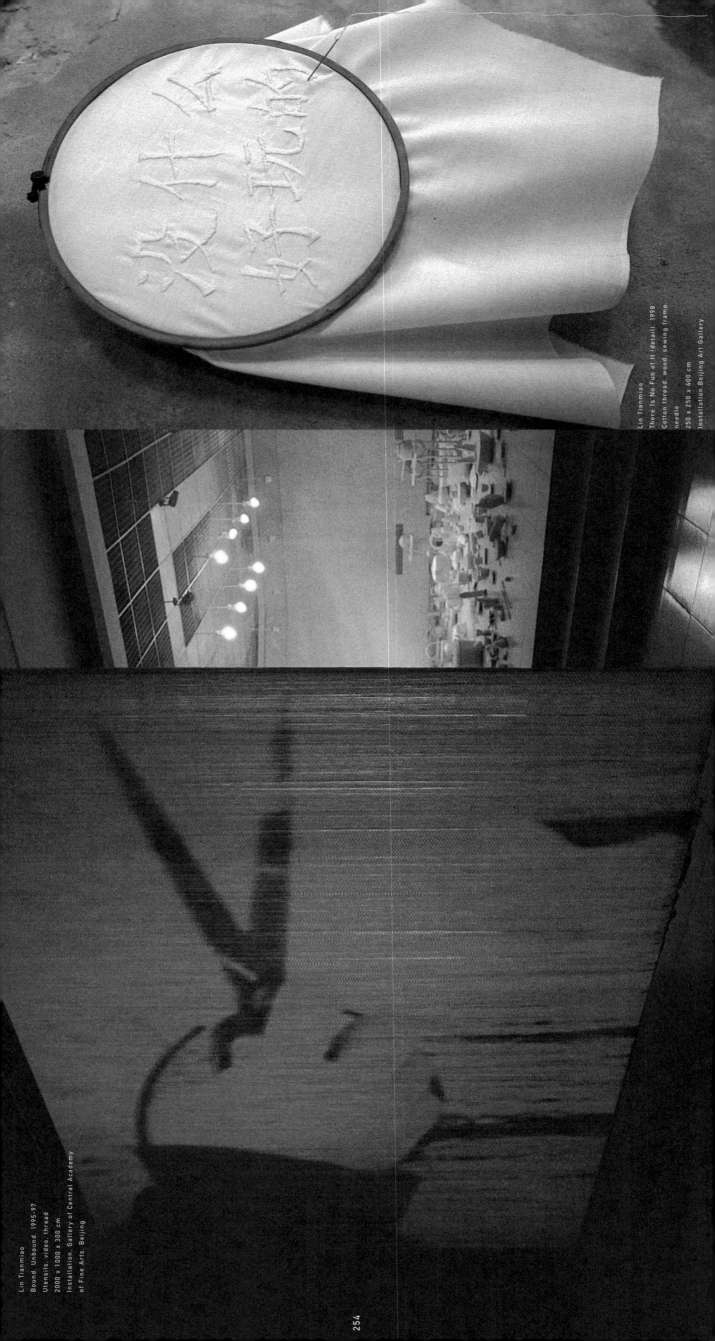

Lin Tianmiao
There Is No Fun of It (detail) 1998
Cotton thread, wood, sewing frame,
needle
250 x 250 x 400 cm
Installation, Beijing Art Gallery

Lin Tianmiao
Bound, Unbound 1995-97
Utensils, video, thread
2000 x 1000 x 300 cm
Installation, Gallery of Central Academy
of Fine Arts, Beijing

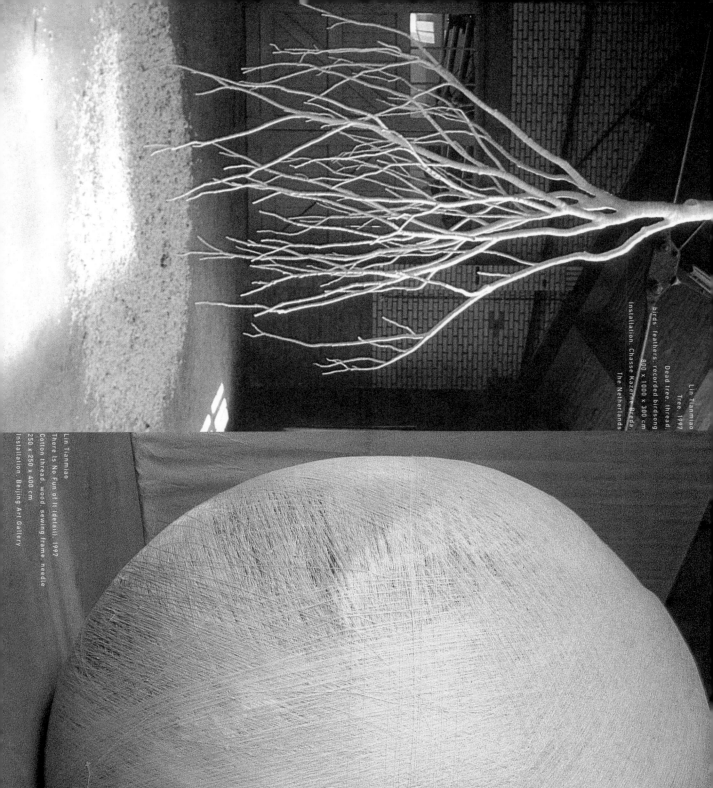

Lin Tianmiao
Tree, 1997
Dead tree, thread,
birds' feathers, recorded birdsong
800 x 1000 x 300 cm
Installation: Chasse Kazerne Breda,
The Netherlands

Lin Tianmiao
There Is No Fun of It (detail), 1997
Cotton thread, wood, sewing frame, needle
250 x 250 x 400 cm
Installation: Beijing Art Gallery

lin tianmiao
Born Shanxi Province, China, 1961. Lives and works in Beijing and New York.

selected solo exhibitions: 1995 'The Temptation of St. Teresa and the Proliferation of Thread Winding',
Open Studio, Beijing 1997 'Bound: Unbound', The Gallery, Central Academy of Fine Arts, Beijing **selected group
exhibitions:** 1984 Beijing Art Exhibition, China Art Gallery, Beijing 1985 International Youth Art Show, China Art
Gallery, Beijing 1988 City Gallery, Cortland, New York 1995 'Women's Approach to Art', Art Museum, Beijing; 'File No 1: Conceptual
Documents for Impossible Art', SoHo Biennale, New York 1997 'Crack in the Continent', Watari-um, Tokyo; 'On life, beauty, trans-
lations and other difficulties', 5th Istanbul Biennale; 'Against the Title', Bronx Museum, New York; 'Another Long March – Chinese
Conceptual Art 1997', Chasse Kazerne Breda, The Netherlands **selected bibliography:** 1995 'In Peking wird
eine menge rickiert', *art*, Hamburg, August 1997 Hou Hanru, *Another Long March*, Chasse Kazerne Breda, The Netherlands; Rosa
Martinez, 'Istanbul Biennial', *Flash Art*, Milan, November/December; Koichi Watari, *Gathering Wind*, Watari-um, Tokyo 1998
Francesca Dal Lago, 'Against The Tide', *Art Asia Pacific*, Sydney, January

lin yilin

Lin Yilin is a builder of brick walls. For him, these walls are traces of physical labour rather than sculptures – extensions of the human body and therefore part of real life. According to Lin, it is in the arduous labour of construction, rather than in abstract ideas, that art becomes meaningful.

The wall has been utilized as a cultural and political metaphor throughout China's history, from the Great Wall to the recent 'Fire Wall' – the imposition of official controls on the Internet. Due to the post-Cold War globalization of the capitalist economy, China is currently undergoing an unprecedentedly rapid process of modernization. This has engendered enormous conflict between the post-Communist system and the liberal market economy, between openness to the global culture and fear of losing local identity, between the fanatical pursuit of money and traditional values, between urban explosion and ecological consciousness. The new skyscrapers, with their brick walls, steel structures and glass facades, constantly moving, schizophrenic landscape. To institute a spectacular image of this new reality. Along with artists Chen Shaoxiong, Liang Juhui and Xu Tan – fellow members of the 'Big Tail Elephant' group in Guangzhou (Canton) – Lin has developed a strategy of active and critical intervention in order to disrupt this paradoxical world. In his controversial action/installation *The Result of 1000 Pieces*, realized in Guangzhou in 1994, Lin erected a wall of bricks and bank notes to evoke this moment of transition. In a further, even more subversive action, *Safely Manoeuvred through the Lin He Street*, 1995, he collected scores of bricks from a wall on a construction site on a busy street in Guangzhou, which he then transported brick by brick to another construction site on the opposite side of the street, where he rebuilt the wall. Causing a tremendous traffic jam in the city, the action halted for a moment the otherwise unstoppable growth

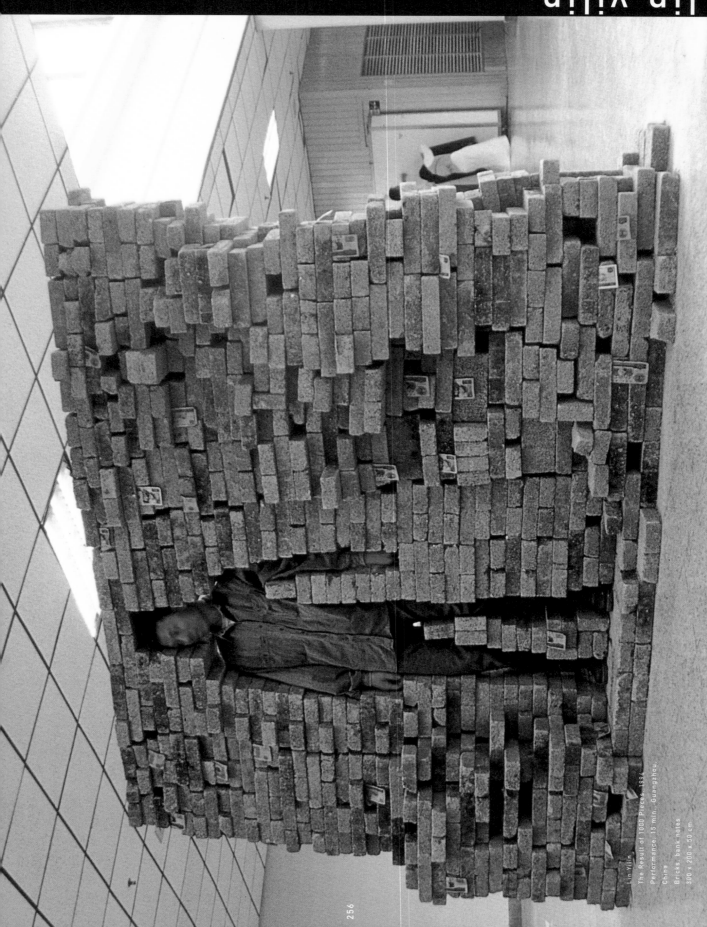

Lin Yilin
The Result of 1000 Pieces, 1994
Performance, 15 min., Guangzhou,
China
Bricks, bank notes
300 x 200 x 50 cm

The retrocession of Hong Kong is a potent symbol of the current global post-colonial transformation and extremely important to Lin, a resident of Hong Kong's neighbouring Guangzhou. His recent work attempts to reveal the collective, unspoken panic in the face of such a historic change. In the summer of 1996, he built a 'moving wall', which he carried through the streets of central Hong Kong. On it were written the names of Hong Kong's official institutions, political parties and corporations. The action interrupted the busy traffic and disturbed the long queue of people trying to obtain British Overseas Citizen's passports before the handover. Ironically, these have little real validity as travel documents – they serve more as a kind of psychological consolation for those seeking 'protection' after the transition. In November 1997, Lin realized another action in a swimming pool in Hong Kong. Calling the event *Shark Proof Web*, 1997, he was referring to the netting that protects Hong Kong people swimming in the ocean. His web, however, was made up of hundreds of copies of the Basic Law of the Hong Kong SAR (Special Administrative Region). When he had woven it, he lay on a life buoy and floated in the void.
Hou Hanru

Lin Yilin
A Sand Dune, 1996
Performance, 60 min., Guangzhou, China
Bricks, sand

Lin Yilin
Safely Maneouvred through the Lin He Street, 1995
Performance, 90 min., Guangzhou, China
Bricks

lin yilin

Born Guangzhou, China, 1964. Lives and works in Guangzhou, China.

selected solo exhibitions: 1995 'Supper'. West Coast Arts Centre, Guangzhou, China

selected group exhibitions: 1984 'First National Exhibition on Sports Themes'. China Art Gallery, Beijing. 1991 'Big Tail Elephant Group. Exhibition No. 1'. Workers' Palace, Guangzhou, China. 1992 'Big Tail Elephant Group. Exhibition No. 2'. Guangdong Broadcast/Television, No. 1', Guangzhou, China. 1993 'China Avant-Garde', Haus der Kulture der Welt, Berlin and tour. 1994 'Third Art Documentation Show of Contemporary Chinese Art'. Shanghai. 1996 'Outside the White Cube'. Hong Kong Arts Centre. 1997 'Another Long March – Chinese Conceptual Art 1997'. Chasse Kazern, Breda, The Netherlands. 'Trade Routes: History and Geography', 2nd Johannesburg Biennale. 'Cities on the Move'. Secession, Vienna. 1998 'Breach'. Hong Kong Polytechnic University.

selected bibliography: 1993 Juliane Noth. Wolfger Pöhlmann. China Avant-Garde. Museum of Modern Art, Oxford, England; Hervé Gauville. Canton, quatre éléphants et un sage'. Libération, Paris, 30 November 1996 Hou Hanru. 'Beyond the Cynical'. Art Asia Pacific, Vol. 3 No. 1. Sydney; Hou Hanru. 'Towards an Un-official Art'. Third Text, London. Spring. Karen Smith. 'China'. München, Munich. June 1997 Stephen Schulenburg. Verpachtetes Erbe'. Museum für Kunstandwerk, Frankfurt. July

Lin Yilin
Shark Proof Web, 1997
Performance, 30 min., Hong Kong
Copies of the Basic Law, water

258

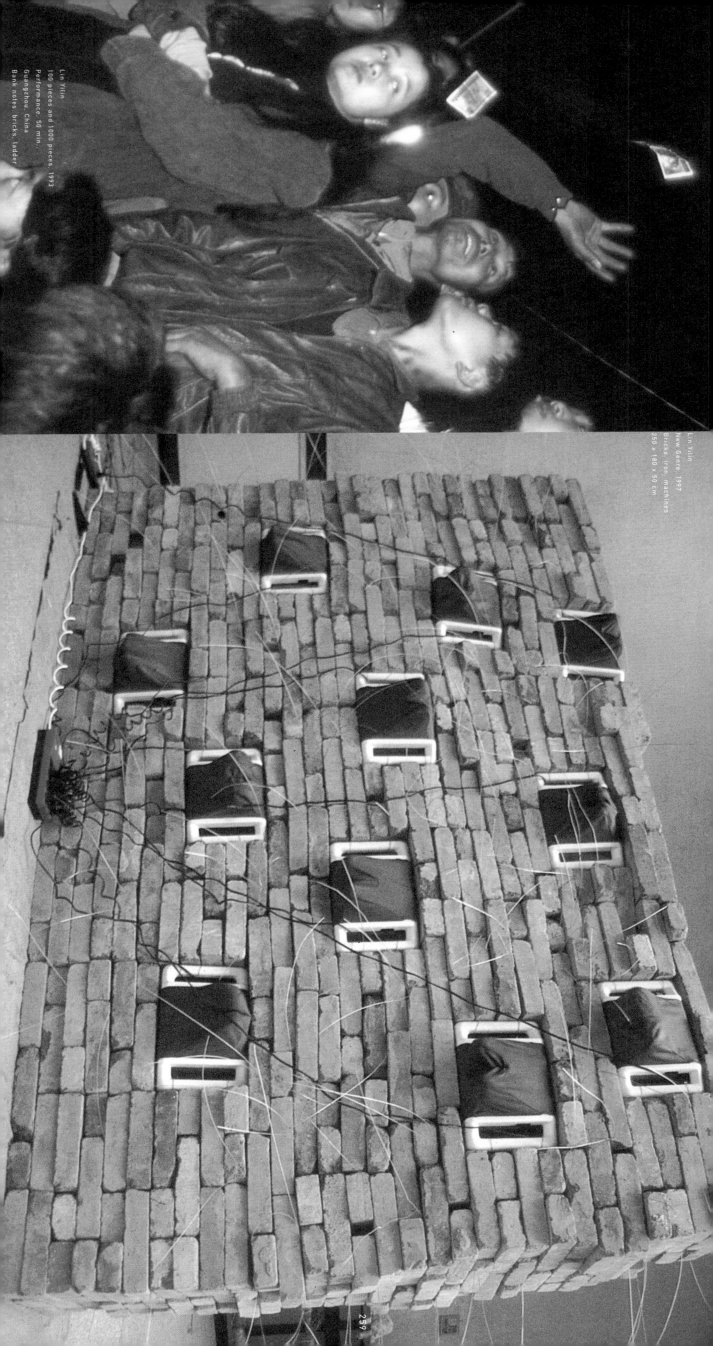

Lin Yilin
100 pieces and 1000 pieces, 1993
Performance, 50 min.
Guangzhou, China
Bank notes, bricks, ladder

Lin Yilin
New Genre, 1997
Bricks, iron, machines
250 x 180 x 50 cm

greg lynn

Greg Lynn
Generator for the Installation Design,
Gallery Encore ... Bruxelles, 1998
Computer image

Hans Ulrich Obrist In the art of the 1990s, there have been some strong shifts of emphasis. Time has become more important than space, for example, and artists practise multiple collaborations. Are there similar changes in architecture, and do you feel part of a new generation that emerged in the 1990s?

Greg Lynn The interesting experimental architects have tended to shift away from semiotics and linguistics, the primary concern in the 1980s, towards questions of geometry and diagrams, time, form and material production. You can see this in the work of Jessy Reiser, Ben van Berkel, Foreign Office Architects, for instance. The other major change is that architects are now working almost exclusively with computers. When you design with computers you get a new set of tools — one of which is animation — so you can start to look at time and motion. You also get a whole new set of geometries, which are made out of these curved surfaces. It has not yet been theorized, and one thing I'm trying to do is to theorize these tools. You see a kind of explosion of the typologies that the computer brings, and everybody is trying to figure out what can be done with these new surfaces.

Obrist How important are Rem Koolhaas' ideas for your generation?

Lynn Rem has been important to all of us — just in the way he approaches his office and design. He's not a person who wants to be known for a signature, but rather for a process, an approach.

The idea of what architecture is, is definitely shifting. Architectural graduates are doing a wider range of things than architects have done for a couple of hundred years. They're involved in multimedia, building construction, urban planning, development, finance ... There's an idea that architecture is in crisis: suddenly the professional organizations can't help architects get work anymore, and building is done by non-architects. There's some truth to this, but the other side of the crisis is that the definition of an architect's activity is expanding. My approach is that architecture doesn't begin with a problem that gets solved with a form, but is more about applying a spatial process. With all our building commissions we really start by supplying a kind of a schema or a strategy, and we don't have an idea what the building will look like. We don't have an aesthetic that we begin with; we start with a diagram or a process. The building ends up emerging out of some spatial strategy.

260

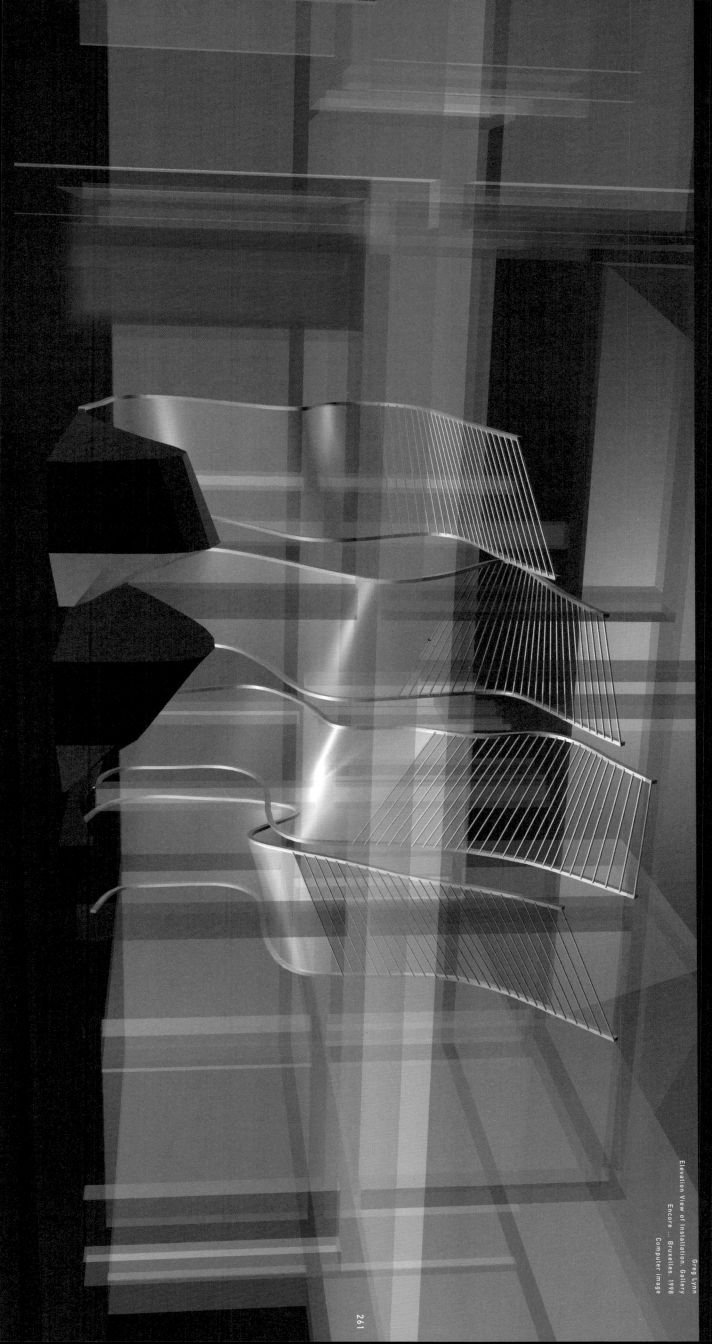

Greg Lynn
Elevation View of Installation, Gallery
Encore .. Bruxelles, 1998
Computer image

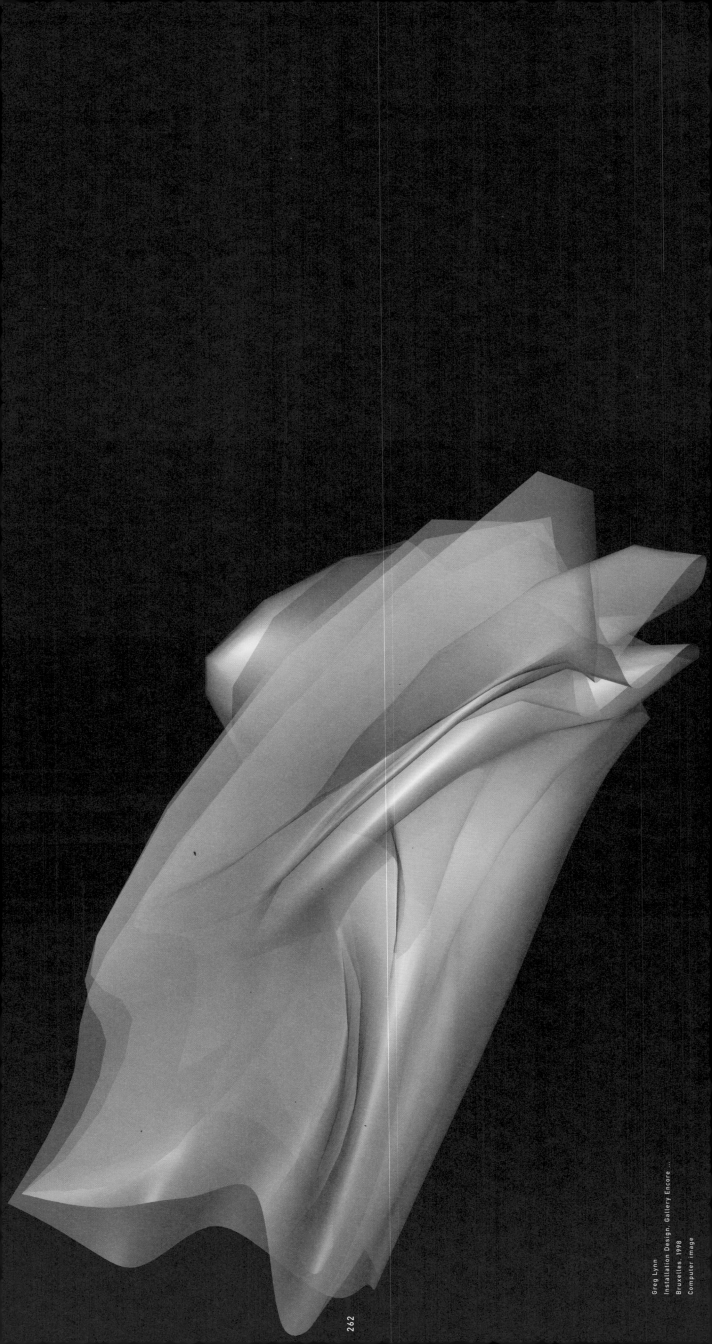

Greg Lynn
Installation Design, Gallery Encore ...
Bruxelles, 1998
Computer image

greg lynn

Born Vermilion, Ohio, 1964. Lives and works in New York and Los Angeles. **selected solo exhibitions:** 1995 Artists Space, New York. **selected group exhibitions:** 1992 'Stranded Sears Tower; Action-Interaction, Face-Interface, Section-Intersection', Gallery 400, Chicago 1994 'Cardiff Bay Opera House', Architectural Association, London; 'CAD Video Installation', Sabie Cultural Institute, Future City Art Museum, Kyoto 1996 Electra '96, Henie Onstad Kunstsenter, Hovikodden, Oslo, Norway 1997 Ecole des Beaux Arts, Paris 1998 Art Museum, Bregenz, Austria **selected bibliography:** 1996 Nicolais Ourossof, 'Review', *Artforum*, New York, January 1997 Aaron Betsky, *Architecture Magazine*, New York, June; Akiko Watanabe, *A+U*, Tokyo, August 1997 'Progressive Architecture Citation', *Architecture Magazine*, New York, January; Beatrice Colomina, *Assemblage*, No 30, Cambridge, Massachusetts 1998 Mark Wamble, *The Passing Eye*, Slow Space, Houston, Texas

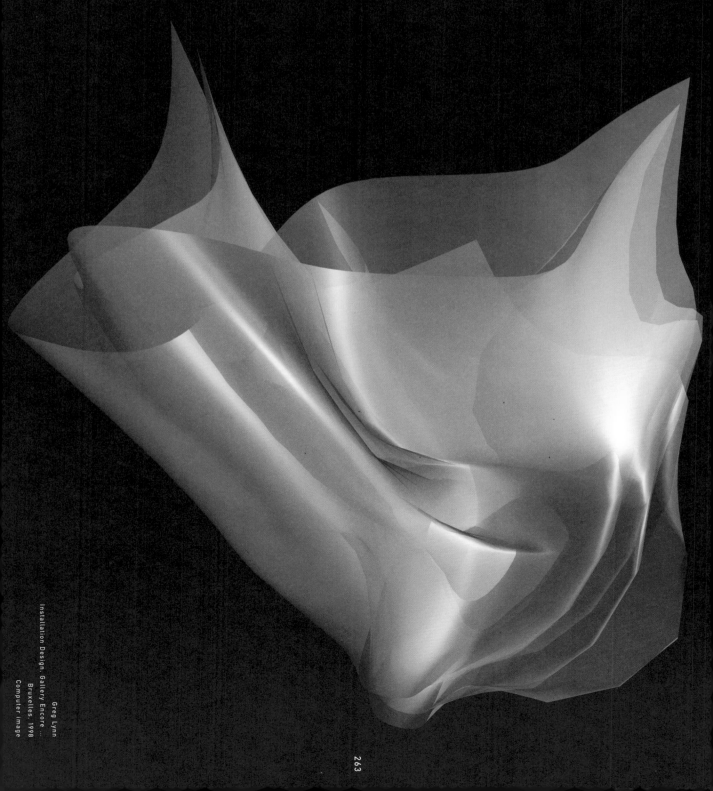

Installation Design, Gallery Encore...

Greg Lynn
Installation Design, Gallery Encore...
Bruxelles, 1998
Computer image

christina mackie

Intensifying. Avoiding permanent solutions, as Hakim Bey has written, is 'to be invisible in the cartography of control'. *Foo*, 1995, is a video made by Christina Mackie out of an accumulation of snapshots of her apartment/studio shown in sequence so as to create a visual path around the room, accompanied by an intense soundtrack. Alliances are more important than affiliations. Mackie does not yield to conventional ways of arranging things, trying instead to find different possibilities of classifying and accumulating. In *Foo*, the series of still photographs which, in the artist's words, 'fix the contents of a room at a particular moment', were scanned into a computer. Each image was assigned to a key on the keyboard, which was then played like a musical instrument – each key triggering both image and sound. The soundtrack is a spoken version of the tabla (an Indian percussion instrument, consisting of a pair of drums, one of which is made out of wood, and the other out of metal); in the written notation of the tabla, every stroke of the drum has a syllable, syllables make words and words, phrases. The images were played by hand through the keyboard, or in programmed sequences; they were also overlaid with colour passes. All the images that passed across the computer screen, along with those recording the computer's own processes, were recorded in real time onto videotape.

Throughout the 1990s, time has been particularly important in Mackie's work. Like *Foo*, 1994-95, *3/2 Wait*, 1995-96 (a two-channel video), is time-based. Both works reject the possibility of spatial orientation or, in the words of Georges Perec, 'make space a doubt'. The viewer can no longer orientate him/herself spatially. The critic Andrew Wilson has compared this oscillation between

Christina Mackie
Tabla Notation for sound track of *Foo*.
1994-95
Spoken by Chris Marshall

object and process, and the gradual loss of space found in Mackie's work to similar features in the art of London artist Cerith-Wyn Evans: 'If Mackie has projected a loss of space as an emotional as much as a durational problematic, Cerith-Wyn Evans shows how such loss allows narrative to be consistently re-made by occupying a truly fictional stage ... '

In other projects, Mackie's work breaks new boundaries: art meets cinema meets science meets music. An example is her outstanding *Suppression, Repression, Depression Compression*, 1995, for which six polystyrene cups were put under extreme pressure (equivalent to being submerged under eight kilometres of water) in the rock/ice physics laboratory at University College, London. In the resultant work, Mackie presents the cups in a row; through the traces they have left on the cups, the invisible forces are rendered visible. This idea is intensified by an accompanying Bruce Gilbert soundtrack — the subsonic sound vibrates through the viewer's body.

Hans Ulrich Obrist

Christina Mackie
Foo, 1994-95
Stills from 10 min. 3
sec. video, colour,
sound

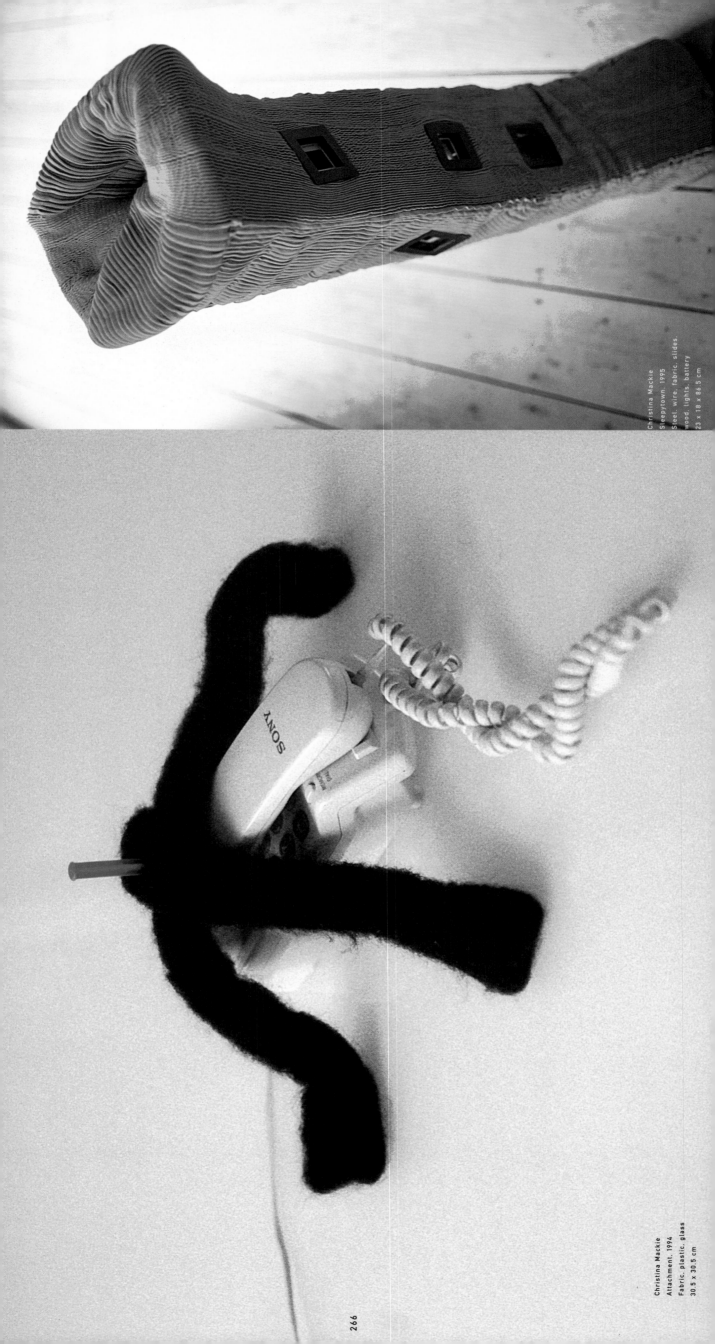

Christina Mackie
Sleepytown. 1995
Steel, wire, fabric, slides,
wood, lights, battery
23 x 18 x 86.5 cm

Christina Mackie
Attachment. 1994
Fabric, plastic, glass
30.5 x 30.5 cm

christina mackie

Born Oxford, England, 1956. Lives and works in London.

selected group exhibitions: 1994 'The Curator's Egg', Anthony Reynolds Gallery, London 1995 Gavin Brown's enterprise, New York 1996 'life/live', ARC, Musée d'art Moderne de la Ville de Paris; Centro Cultural de Belém, Lisbon; 'Against 30 Years of Video and Film', Anthony d'Offay Gallery, London 1998 'Show 50: Mark Hosking and Christina Mackie', City Racing, London; 'Office Party', The Gallery, Imperial College of Science, Technology and Medicine, London **selected bibliography:** 1996 David Barrett, 'Something Else', *frieze*, London, September/October; Andrew Wilson, 'Film and Video Work by Contemporary British Artists', *Art and Design: ART & FILM*, Profile No 49, Academy Group, London 1998 Martin Herbert, 'Mark Hosking, Christina Mackie: City Racing', *Time Out*, London, 6 May

Christina Mackie
Balloon, 1994
String, flour, balloon
Dimensions variable

Christina Mackie with Dr Phillip Meredith
Impression: Repression/Depression. Compression, 1995
Polystyrene cups
7 parts, clockwise from top left: 8 cm; 6.5 cm; 5.5 cm; 4.5 cm; 3.5 cm; 3 cm; 9 cm

fabián marcaccio

Environmental Paintant, 1997–98. While sharing something in common with the baroque pomp of Frank Stella's recent output, or the three-dimensional collage of Robert Rauschenberg's *Combine Paintings,* Fabián Marcaccio's *Environmental Paintant* calls most directly to mind the works of Giuseppe Pinot-Gallizio.

Towards the end of the 1950s, Pinot-Gallizio, a colourful member of the Situationist group, produced a series of groundbreaking works – if, indeed, we can legitimately call these seemingly interminable rolls of painted canvas 'works'. The artist called them 'industrial paintings', selling his wares by the metre in small shops, shopping centres or on the street. Pinot-Gallizio's strategy of artistic subversion was simple and to the point – the large format counterpoised mass production against the craftsmanly production that had hitherto characterized Fine Arts, equating pure scale with market value. Years later Andy Warhol would apply his own brand of cynical critique to the same purpose, although he would opt for methods of reproduction as a vehicle for his work. Pinot-Gallizio was not so much concerned with the issue of the copy, but rather preferred to push the notion of the original to the extreme. His entire output was composed of originals, though no limits were ever imposed on the quantity. Pinot-Gallizio and Warhol occupied the two extremes of a common logic and this, perhaps, is what makes it so curious that Fabián Marcaccio's *Environmental Paintant* should have recourse to elements of both positions in equal doses.

Environmental Paintant starts out as a relatively conventional painting hanging from the wall. However, its sheer length causes it to flop awkwardly on the floor, unfurling across the space before collapsing amidst a messy copper-tubing structure. Further complicating the work is a shelf attached to the wall-mounted section which in turn hosts a series of small transparent sculptures.

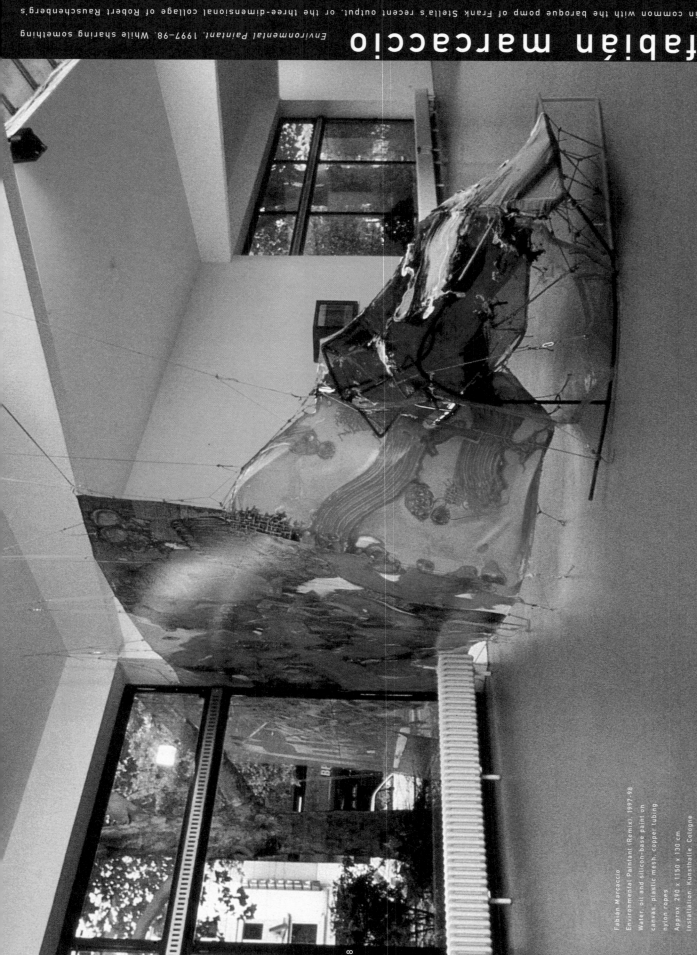

Fabián Marcaccio
Environmental Paintant (Remix), 1997-98
Water, oil and silicon-base paint on
canvas, plastic mesh, copper tubing
nylon ropes
Approx 290 x 1150 x 130 cm
Installation: Kunsthalle, Cologne

whimsical, incomplete concoctions of symbols and emblems. On closer inspection these objects bear traces of a hammer and sickle, the points of a star, fragments of a swastika and firearms in silhouette. The surface of the painting, meanwhile, is a whirl of brushstrokes and backgrounds, which stretch and transform into each other in saturated blood-reds and deep-greens. *Environmental Paintant* is at once tragic and grotesque. In a sense, Marcaccio's work is reminiscent of Beckett's theatre and it is perhaps no coincidence that the finished product is scenographic, resembling the almost trashy remains of an empty stage set. The most fitting term to describe this mutant hybrid might be 'disaster': an all-out collapse of painting and sculpture that stymies any hopes the viewer might have of grasping a full meaning. There is no hint of the emancipation that the modernist tradition afforded to the painterly gesture in this piece. And, perhaps, it is here that we can most strongly detect the kinship between Marcaccio's *Environmental Paintant* and Pinot-Gallizio's 'industrial painting' of forty years earlier. Both projects, with their respective acts of de-sublimation, plot out an aesthetic of inflation.

Carlos Basualdo

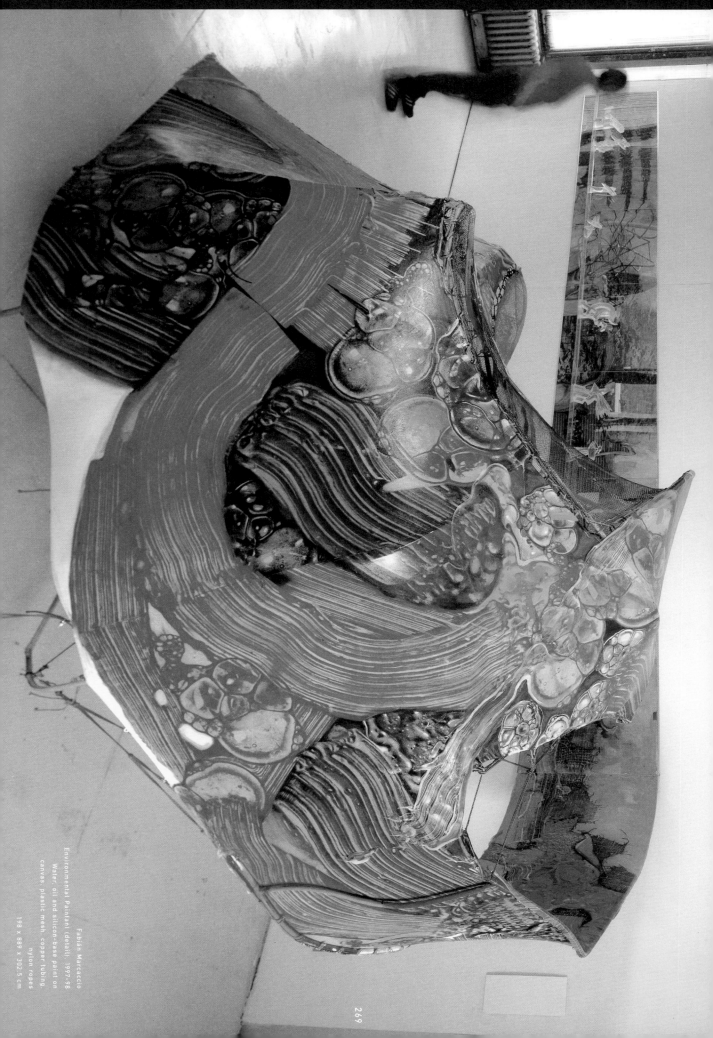

Fabián Marcaccio
Environmental Paintant (detail), 1997–98
Water, oil and silicon-base paint on
canvas, plastic mesh, copper tubing,
nylon ropes
198 x 888 x 302.5 cm

fabián marcaccio

Born Rosario de Santa Fé, Argentina, 1963. Lives and works in New York. **selected solo exhibitions:** 1992 John Post Lee Gallery, New York 1993 'Mutuac Betrayal', Barbara Farber Gallery, Amsterdam 1994 'On Unpaintables', Thaddaeus Ropac Gallery, Paris 1995 'Use of Evidence.', Contemporary Art Museum, Tampa, Florida 1996 'Conjectural Ammendments', Bravin Post Lee Gallery, Expoarte, Guadalajara, Mexico; Galeria Camargo Vilaca, São Paulo 1997 'Paintants', Baumgartener Gallery, Washington DC 1998 'With-ject-Spain', Galeria Diaz, Madrid, Galeria Joan Prats, Barcelona **selected group exhibitions:** 1992 'Slow Art', P.S.1 Museum, New York; 'Kinder Macht Neues!', Galerie Rolf Ricke, Cologne; 'Erwartung', Municipal Museum, Rosario, Argentina 1993 'New Museum Benefit', New Museum of Contemporary Art, New York; 'Irony & Ecstasy', Salama-Caro Gallery, London; 'Plotzlich Ist Eine Zeit Hereingebrochen, In Der Alles Moglich Sein Sollte', Kunstverein, Ludwigsburg, Germany 1994 'Conditional Painting', Galerie Nacht St Stephan, Vienna 1995 'The Corcoran Biennial Exhibition: Painting Outside Painting', The Corcoran Museum of Art, Washington DC; 'Unveiled Painting', Kunstraum, Vienna; 'The Adventure of Painting', Kunstverein, Dusseldorf; Kunstverein, Stuttgart; 'Pittura – Immedia', Neue Galerie/Landesmuseum Joanneum, Graz, Austria 1996 'Transformal', Secession, Vienna; 'Pratiques Abstraites', Galerie Thaddaeus Ropac, Paris; 'Without Frontiers', Museo Alejandro Otero, Caracas 1997 'New York Abstraction', Macdonald Stewart Art Center, Ontario; 'Ca-Ca Poo-Poo', Kunstverein, Cologne; 'Pintura', Galeria Juan Prats, Barcelona; 'Relations between Contemporary Architecture and Painting', Kunstlerhaus Palais Thum und Taxis, Bregenz, Austria; 'Vertical Painting', P.S.1 Museum, New York **selected bibliography:** 1993 Raphael Rubinstein, 'Fabián Marcaccio and Daniel Wiener', *Flash Art*, Milan, Summer; Roberta Smith, 'Group Show', *The New York Times*, 26 June 1994 Raphael Rubinstein, 'Private Eyes', *ARTnews*, New York, February; Raphael Rubinstein, 'Abstraction in a Changing Environment: An Interview with Fabián Marcaccio', *Art in America*, New York, October; David Moos, 'What you can do for Pop to What Pop can do for You', *art/text*, Sydney, January 1995 Raphael Rubinstein, 'On Target', *Art in America*, New York, May 1996 Jim Lamoree, 'Fabián Marcaccio at Barbara Farber Gallery', *Flash Art*, Milan, November/December 1997 Raphael Rubenstein, 'Abstraction out of Bounds', *Art in America*, New York, November; Carlos Basualdo, 'Tents of War', *Art Nexus*, Bogotá, Columbia, April/June

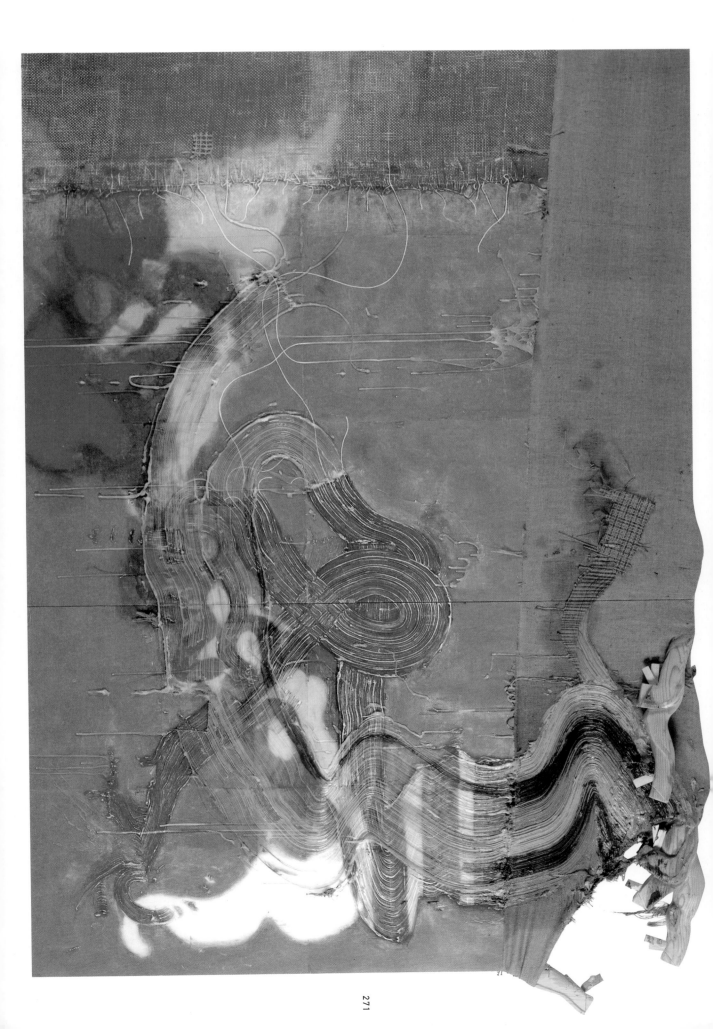

right. Fabián Marcaccio
Toxic Reason. 1991
Oil-base paint. silicon gel. collographic
fabric. wood. burlap
193 x 457 x 10 cm

opposite. Fabián Marcaccio
New Juvenile # 1. 1996
Water and oil-base paint on canvas.
copper tubing. nylon ropes
267 x 294.5 x 51 cm

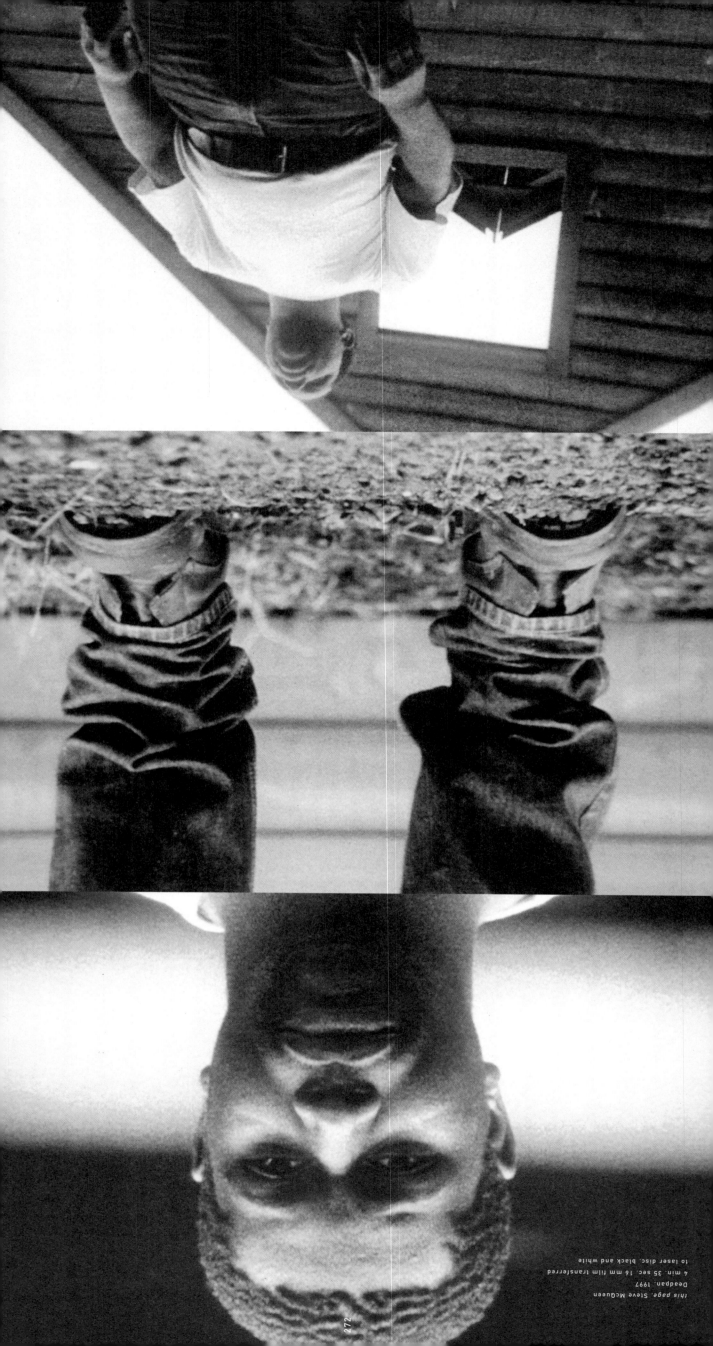

this page, Steve McQueen
Deadpan, 1997
4 min, 35 sec, 16 mm film transferred
to laser disc, black and white

steve mcqueen

Steve McQueen's large-scale, film-to-video installations are impos-
ingly physical: a man walks with a determined, purposeful stride (*Just Above My Head*, 1996); two wrestlers engage in a lumber-
ing, fleshy match (*Bear*, 1993); a woman balances upon a tightrope (*Five Easy Pieces*, 1995). The sense of vulnerability and physi-
cality depicted is enhanced by deep, sculptural shadows and the straightforward conciseness of his bold filmic imagery. McQueen's
work is manifestly cinematic, often adopting a lush black and white stock reminiscent of *film noir*, and made up of carefully con-
structed compositions and sequences of strong images. This is a far cry from the home-made, random feel of much of contempo-
rary arts' film and video. It is evident from the opening image of any of his films since the early 1990s that this is a skilled film-
maker, an artist who loves his chosen medium and who is responding to its very tradition and language. The deliberate absence of
a soundtrack adds to the compelling quality of the images, the works' 'airlessness' (to use the artist's own terminology) which
adds to our concentration on the pictures on screen. Though polished, his works are never 'slick': they maintain a quiet kind of
subtlety throughout.

Take for example *Deadpan*,1997, which the artist presented at The Museum of Modern Art in New York. On an obvious level,
Deadpan repeats a scene in *Steamboat Bill, Junior*, 1927, the Buster Keaton film in which the Hollywood comedian maintains a stoic
imperviousness as the facade of the building behind him falls forward, leaving him 'miraculously' unscathed thanks to a perfectly
positioned open window. Yet *Deadpan* is more than simply a literal homage to early filmmaking, and even more than a giant
metaphor for silent acceptance in the face of surrounding catastrophe. The work is a starkly beautiful, dramatically shot from
below, forming rich, changing compositions as the peak of the roof's gable, the square of the window frame, and the shingled plane
of the wall shift positions in relation to one another. This architecture, however, is — almost like a theatre-piece — quite literally a
'backdrop', the core of *Deadpan* is the self-portrait of McQueen himself, his performance of indifference, his unblinking faith in the
course of events. It becomes an image of trust, of innocent determination.

His earlier *Just Above My Head* is also a particular kind of self-portrait. Here we see only McQueen's head, bobbing just within the
bottom limits of the screen, as times vanishing altogether, as he walks steadfastly along some monodirectional path. To quote a
description of the work by critic Gilda Williams, 'Bearing an expression of grand, fearless determination, the fragmented face
occupies the screen with jerking irregularity. The artist is bodyless, voiceless, isolated and yet intact, struggling to remain "a part
of the picture".' Towards the end of *Just Above my Head*, a single tree is shadowed against the sky; McQueen continues on without
taking notice, as removed as he was in *Deadpan*, convinced of the film's integrity, independent of any distracting occurrences
around him.

Åsa Nacking

Steve McQueen
Five Easy Pieces 1995
7 min 34 sec, 16mm film transferred
to video, black and white colour

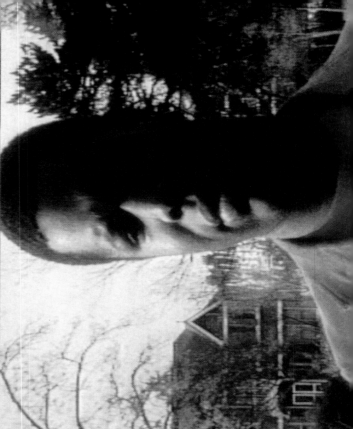

above and below, Steve McQueen
Catch, 1997
1 min. 54 sec. video transferred
to laser disc, colour

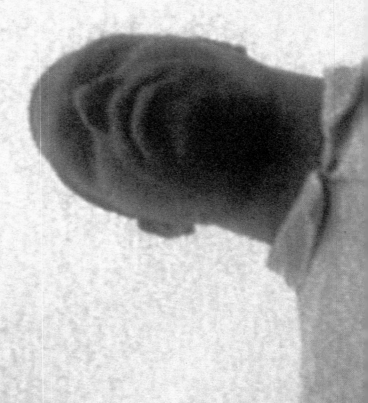

Steve McQueen
Just Above My Head, 1996
9 min. 16 mm film, black and white

steve mcqueen

Born London. 1969. Lives and works in Amsterdam. **selected solo exhibitions:** 1996 Museum of Contemporary Art, Chicago 1997 Stedelijk Van Abbemuseum, Eindhoven, The Netherlands; The Museum of Modern Art, New York 1998 Museum of Modern Art, San Francisco **selected group exhibitions:** 1991 'Acting Out: The Body in Video, Then and Now', Royal College of Art, London 1996 'Timing', De Appel, Amsterdam 1996 'life/live', ARC, Musée d'Art Moderne de la Ville de Paris, Centro Cultural de Belém, Lisbon 1997 Documenta X, Kassel, Germany; 'Trade Routes: History and Geography', 2nd Johannesburg Biennale 1998 Montreal Biennale **selected bibliography:** 1995 Christian Haye, 'Just an illusion', *frieze*, London, September; Sacha Craddock, 'Great British Hopes, Steve McQueen', *The Times*, London, 14 October 1996 Christian Hayes, 'Motion Pictures', *frieze*, London, May; Patricia Bickers, 'Let's Get Physical', *Art Monthly*, London, December 1997 Gilda Williams, 'Steve McQueen at Anthony Reynolds Gallery', *Art in America*, New York, April; Roberta Smith, 'Steve McQueen', *Time Out*, New York, 16 June; Jan Winkelmann, 'Steve McQueen', *art/text*, Sydney, August/October; David Frankel, 'Steve McQueen', *Artforum*, New York, November; Martha Schwendener, 'Steve McQueen', *Flash Art*, Milan, November/December 1998 Michael Archer, 'Steve McQueen', *Art Monthly*, London, February

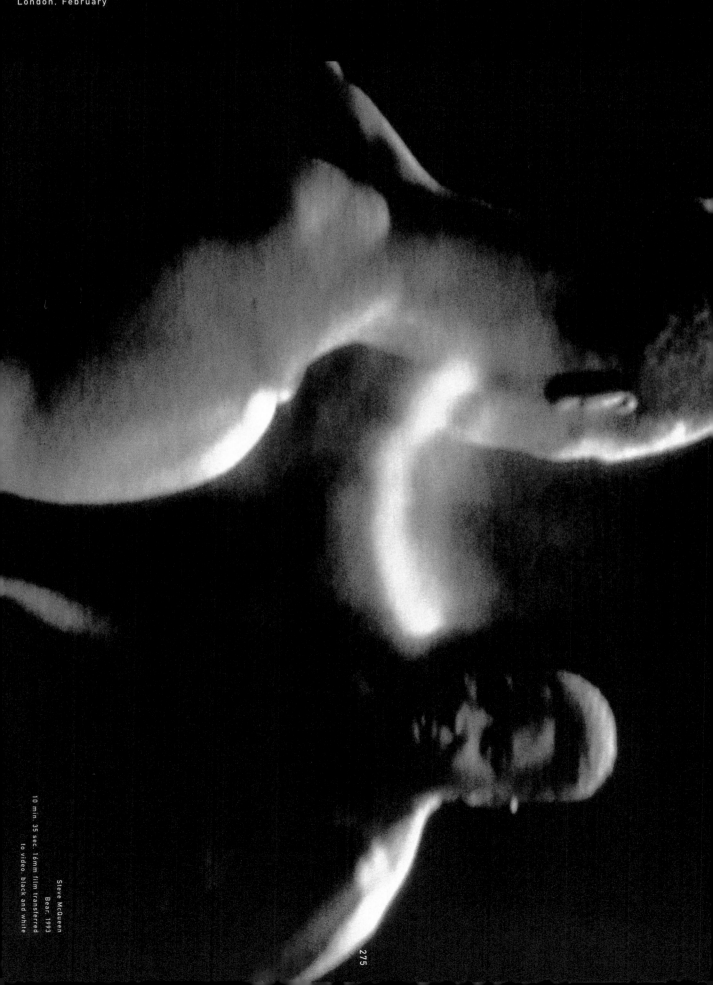

Steve McQueen
Bear, 1993
10 min. 35 sec. 16mm film transferred
to video, black and white

275

tracey moffatt

A grainy photograph shows a young man leaning against a wall, staring blankly into space. His listless stance is accentuated by the title and caption, both an integral part of the work: *Job Hunt*, 1976. After three weeks he still couldn't find a job. His mother said to him, 'maybe you're not good enough'. The picture is part of the series *Scarred for Life*, 1994, by Australian artist Tracey Moffatt, whose photographic works mix childhood experiences and memories to raise wider social and political issues.

Moffatt also works in film and video, referencing popular culture and film history. Her work is particularly indebted to the intentional crudeness, harsh lighting and anti-naturalistic approach of Pier Paolo Pasolini. She shares his preference for casting from the street rather than using professional actors. The scenarios in Moffatt's pictures always arise out of her own epic sense of reality: their artificiality is emphasized by the synthetic quality of her colours, in part influenced by post-war Australian landscape painting.

This aesthetic is evident in Moffatt's 35 mm film *Night Cries: A Rural Tragedy*, 1989, which contains critical reference to one of the first colonial ethnographic films, *Jedda*. Made in 1955 as a TV documentary, *Jedda* depicted the integration of Aborigines into a multi-racial society. Moffatt's story centres on the complex relationship between an old white woman and her adopted non-white daughter. It incorporates occasional sequences of the Aboriginal singer Jimmy Little performing the 1950s hit that made him famous, 'The Royal Telephone'. Little's success was an early example of the native population's acceptance into white society. The mother-daughter relationship in the film reflects a more overtly forced assimilation through its reference to an earlier official policy that removed Aboriginal children from their parents, placing them in white foster homes.

Similar issues are raised in *Up in the Sky*, 1997, a series of twenty-five photographs. Among the many narratives of the work is the story of a fair-skinned mother, living in squalor, who seems about to lose her child to a group of nuns. Images of the nuns taking charge of the child are interspersed with those of a group, headed by the mother, apparently plotting a rebellion. Interwoven with this narrative are a number of other, seemingly unconnected scenes; rather than insisting on a definite unfolding story, each picture becomes a point of departure for what the artist terms 'free-falling'.

The surfer as contemporary icon is the subject of Moffatt's video *Heaven*, from 1997. With the aid of a hand-held camera, her female gaze scrutinizes and objectifies the male athletes as they pose by their cars and don their wet suits. Her voyeurism becomes increasingly aggressive and intrusive, until, at the end of the film, her free hand grabs at the beach towel draped over the hips of one of the involuntary 'actors'. The sound-track alternates between the waves of the ocean and suggestive drumming, link-

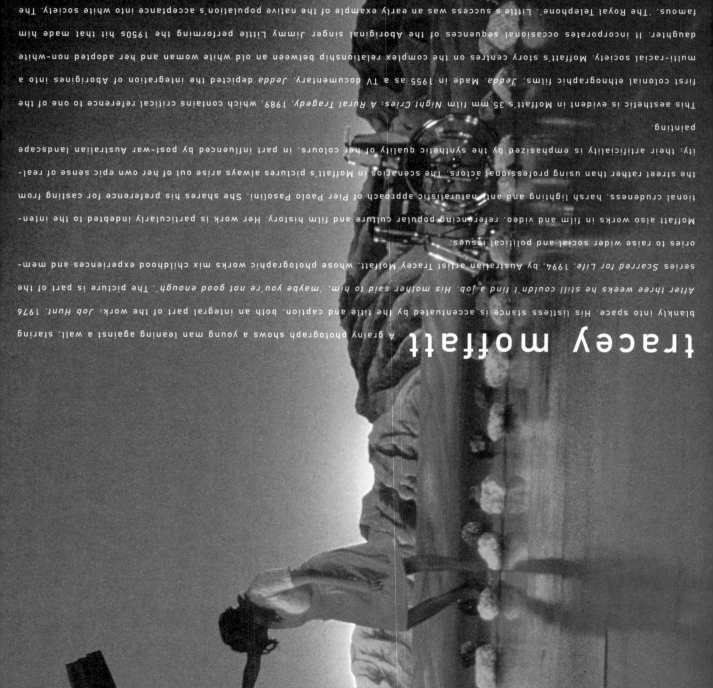

Tracey Moffatt
Night Cries: A Rural Tragedy, 1989
17 min, 35 mm film, colour, sound

right and far right, Tracey Moffatt
from the series Scarred for Life, 1994
Off-set print
80 x 60 cm each

Tracey Moffatt

Job Hunt, 1976
After three weeks he still couldn't find a job.
His mother said to him, 'maybe you're not good enough'.

Heart Attack, 1970 She glimpsed her father belting the
girl from down the street.
That day he died of a heart attack.

Tracey Moffatt

this page, Tracey Moffatt

from the series Up In the Sky, 1997

Off-set print

this page: Tracey Moffatt
Heaven
1997
20 min, video, colour, sound

tracey moffat

Born Brisbane, 1960. Lives and works in New York and Sydney.

selected solo exhibitions: 1989 'Something More', Australian Centre for Photography, Sydney and tour 1992 Centre for Contemporary Arts, Glasgow 1995 'Short Takes', Artspace, San Antonio, Texas 1997 DIA Center for the Arts, New York; Galerie Andreas Weiss, Berlin 1998 Victoria Miro Gallery, London; Kunsthalle, Vienna; Centre National de la Photographie, Paris **selected group exhibitions:** 1984 'Pictures for Cities', Artspace, Sydney 1987 'Art and Aboriginality', Aspex Gallery, Portsmouth 1990 'Satelite Cultures', New Museum of Contemporary Art, New York 1993 'The Boundary Rider', 9th Sydney Biennale 1994 'Antipodean Currents', The Kennedy Center, Washington DC; Guggenheim Museum SoHo, New York 1995 Kwangju Biennale, South Korea 1995 XXII São Paulo Biennial, Brazil; 'Campo 6, Il Villagio Spirale', Galleria Civica d'Arte Moderna e Contemporanea, Turin, Bonnefanten Museum, Maastricht; 'Jurassic Technologies Revenant', 10th Sydney Biennale 1997 'Truce: Echoes of Art in an Age of Endless Conclusions', Santa Fe, New Mexico; XLVII Venice Biennale 1998 'Echolot', Museum Fridericianum, Kassel, Germany **selected bibliography:** 1988 Amy Taubin, 'Firestarters', *The Village Voice*, New York, 3 May 1990 Paul Cox, 'Night Cries in Cannes', *Art Monthly*, London, August 1991 Marohla Dargis, 'Our Favourites', *The Village Voice*, New York, 8 January 1995 Ewen McDonald, 'Tracey Moffatt at Karyn Lovegrove and Mori', *Art in America*, New York, July 1997 Roberta Smith, 'Real Life Tableaux, Natural Yet Startling', *The New York Times*, 10 October; 1997 Charles Dee Mitchell, 'Report from Santa Fe, New Narratives', *Art in America*, New York, November 1998 Justin Spring, 'Tracey Moffatt Hunters & Collectors', *art/text*, Sydney, February

mariko mori

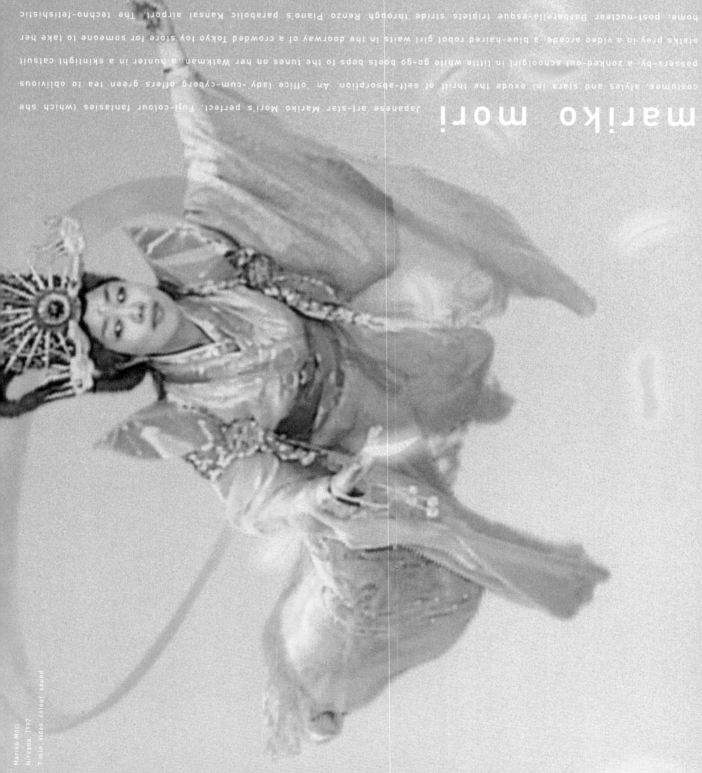

Mariko Mori
Nirvana, 1997
3 min. video colour sound

Japanese art-star Mariko Mori's perfect, Fuji-colour fantasies (which she costumes, styles in) exude the thrill of self-absorption. An office lady-cum-cyborg offers green tea to oblivious passers-by, a zonked-out schoolgirl in little white go-go boots bops to the tunes on her Walkman, a hunter in a skintight catsuit stalks prey in a video arcade, a blue-haired robot girl waits in the doorway of a crowded Tokyo toy store for someone to take her home; post-nuclear Barbarella-esque triplets stride through Renzo Piano's parabolic Kansai airport. The techno-fetishistic scenarios are not particularly riveting; media products playing upon the salary man's sexual obsessions routinely look like this. What's fascinating is the mix of incipient consumer critique and runaway feminine ego, presented here under the (computer-enhanced) banner of art.

Beginning with her break-out 'Made in Japan' show of 1995 (Shiseido Gallery, Tokyo and Deitch Projects, New York), Mori has been compared to Yasumasa Morimura (the Japanese artist who computer-manipulates his own portrait into Western masterpieces) on the one hand, and Cindy Sherman on the other. While the comparison to Morimura begs the question of a quintessentially Japanese obsession with ritualized imposture, from Kabuki to karaoke, the comparison to Sherman can be misleading. Where Sherman emphasizes a critical agenda, downplaying the pleasures of being her own life-sized Barbie, Mori revels in them. For her, dress-up is not a means to an end, but the end itself. The person Mori may be closest to, in fact, is Andy Warhol, whose pop ecstatics smelled like irony to those looking to justify his lust for all things plastic. Mori plays into that lust in *Empty Dream*, 1997, a spectacular six-panel cibachrome depicting one of Tokyo's ersatz, indoor beaches, with Mori in the guise of a big, blue mermaid sprawled on the sand, poised on a far-off rock, and splashing in the synthetic surf; a self-replicating, android princess. *Nirvana*, the 3-D video she showed at the 1997 Venice Biennale, features the artist clad in a luscious, pastel kimono, surrounded by miniature lavender sea-foam and lemon-coloured elves. While these creatures play music, crystal balls rotate, wisps of colour drift across the desert landscape and Mori appears and disappears. Here, then, is her empire, dovetailing spectacle into banality into revelation. Warhol incarnated a certain kind of transcendent virtuality. Mori incarnates another. She is the object of desire par excellence, inaccessible even to herself. Indeed, another person's narcissism is very attractive, especially to those who have renounced the greater part of their own. 'It is as if we envied them for maintaining a blissful state of mind', Freud wrote, 'an unassailable libidinal position which we ourselves have since abandoned.

Susan Kandel

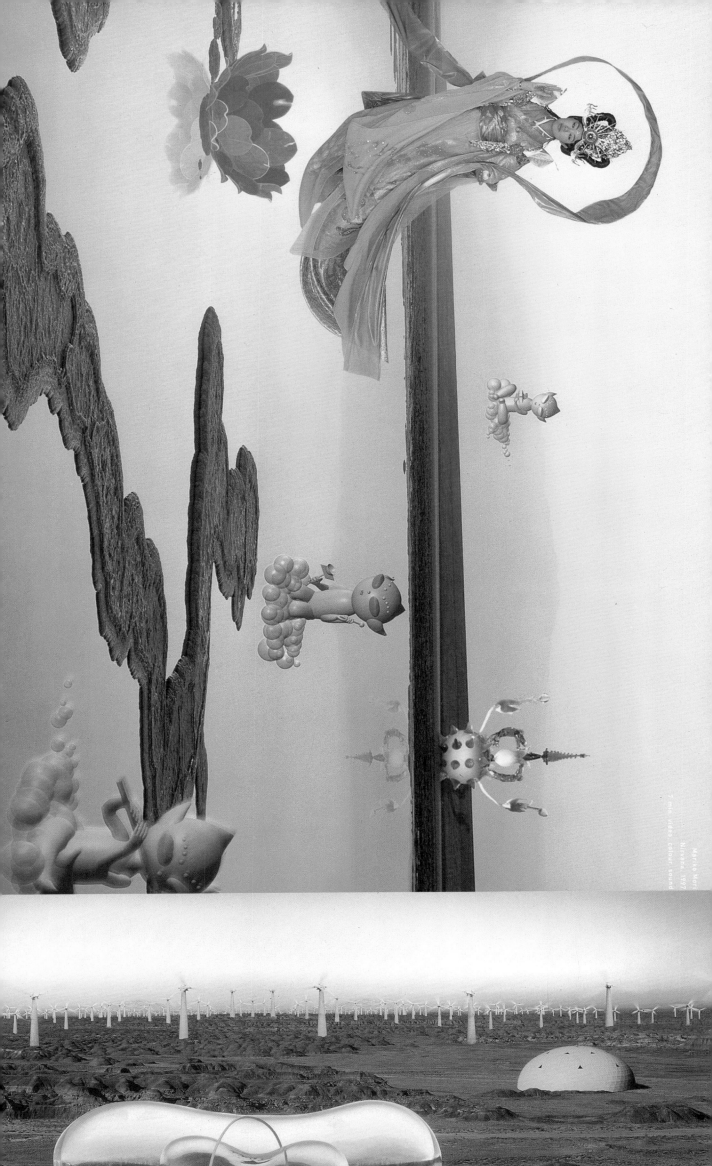

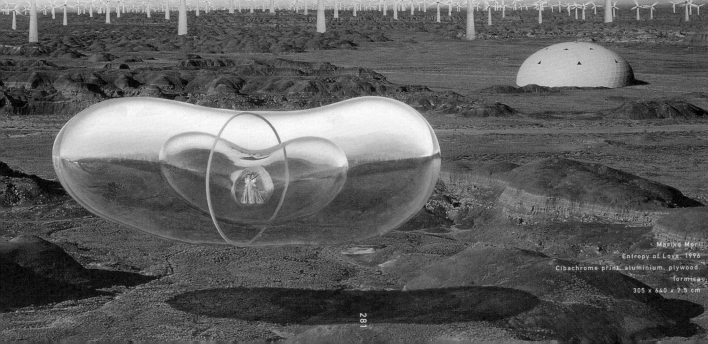

Mariko Mori
Entropy of Love, 1996
Cibachrome print, aluminium, plywood,
formica
305 x 640 x 7.5 cm

mariko mori

Born Tokyo, 1967. Lives and works in New York.

selected solo exhibitions: 1993 Art and Public, Geneva 1996 'Made in Japan', Shiseido Gallery, Tokyo. Deitch Projects, New York 1997 'Play with Me', Dallas Museum of Art, Texas 1998 Serpentine Gallery, London **selected group exhibi-tions:** 1993 'Fall from Fashion', Aldrich Museum of Contemporary Art, Ridgefield, Connecticut 1994 American Fine Arts Co., New York 1995 'Self Made', Kunstverein, Graz, Austria 1996 Museum of Contemporary Art, Chicago. 'By Night', Fondation Cartier pour l'Art Contemporain, Paris. 'Intermission', Basilico Fine Arts, New York 1997 'On life, beauty, translations and other difficul-ties', 5th Istanbul Biennale. 'Trade Routes: History and Geography', 2nd Johannesburg Biennale, Kwangju Biennale, South Korea. Lyon Biennale: XLVIII Venice Biennale 1998 De Appel, Amsterdam **selected bibliography:** 1995 David Coleman. 'Frock Tactics', Artforum, New York, October 1996 Richard Vine. 'Mariko Mori at Deitch Projects and Other Venues', Art in America, New York, September. Kathleen F. Magnan. 'The Cyber Chic of Mariko Mori', Art Asia Pacific, Vol 3 No 2, Sydney 1997 Barry Schwabsky. 'Costume Drama', World Art, No 14, New York: Cristoph Blase. 'L'Autre', Artforum, New York, October: James Roberts. 'Sweet Nothings', frieze, London, October: Marcia E. Vetrocq, 'A Space Odyssey', Art in America, New York, September: Michael Cohen. 'Mariko Mori: Plastic Dreams in the Reality Bubble', Flash Art, Milan May/June Steven Vincent. 'Portrait of the

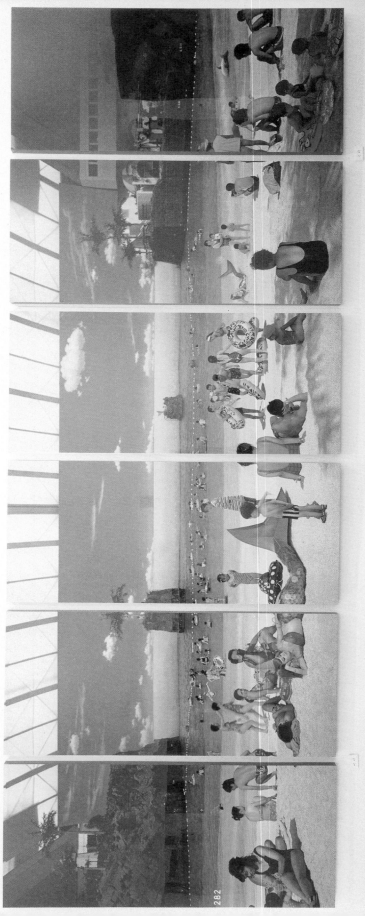

Mariko Mori
Empty Dream, 1995
Cibachrome print, aluminium, wood
6 parts, 274.5 x 1315 x 7.6 cm overall

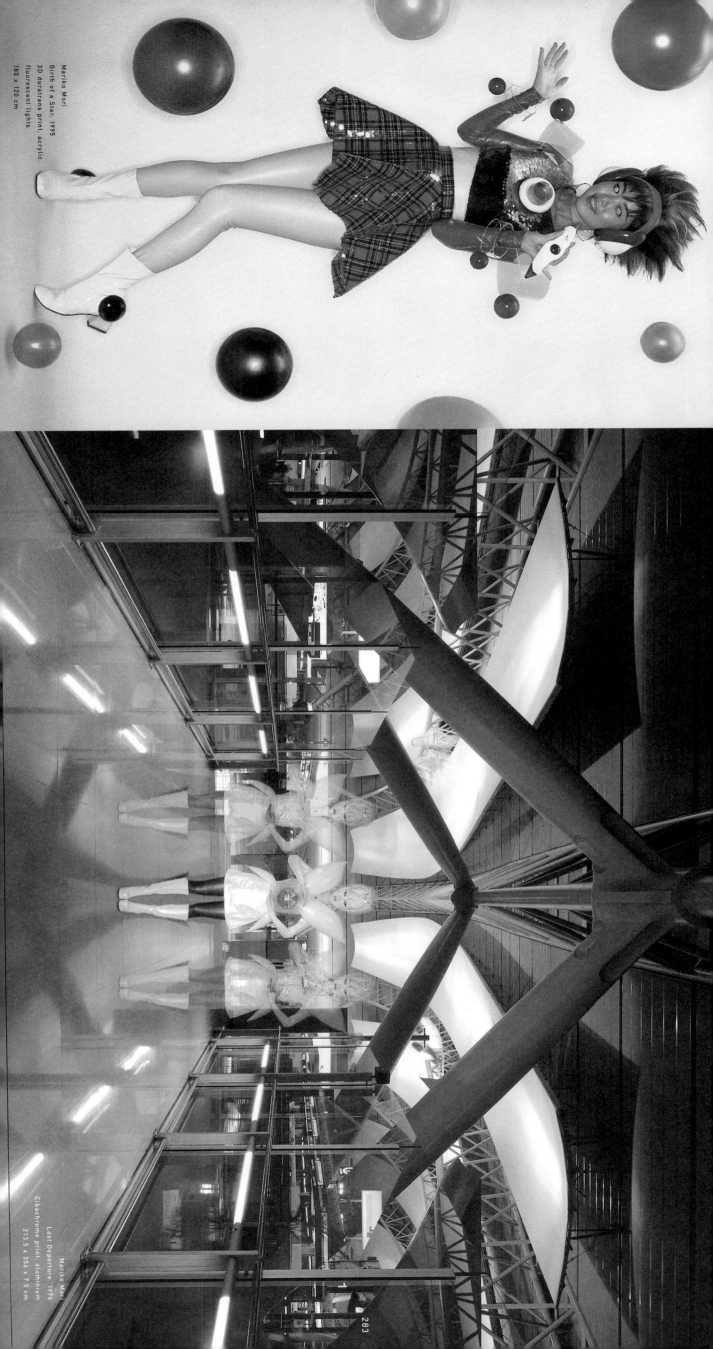

Mariko Mori
Birth of a Star, 1995
3D duratrans print, acrylic,
fluorescent lights
180 x 120 cm

Mariko Mori
Last Departure, 1996
Cibachrome print, aluminium
213.5 x 356 x 7.5 cm

283

above. N55
Table. 1997
Stainless acid-resistant steel.
birch plywood. bakelite
70 x 140 x 125 cm

right. N55
Hygiene System. 1997
Pump. hoses. Polyethylene plastic
bags. Polyethylene plastic containers
3 parts, 60 x 60 x 60 cm each

n55

N55 is a group of four artists of different Scandinavian nationalities who met in the early 1990s at the Academy of Fine Arts in Copenhagen. Today they live and work together in the centre of the city in a spacious apartment that also serves as an exhibition space. Their mode of living corresponds in practice to the aesthetic and ethical orientation advocated by their artistic work.

For almost four years now, N55 has been in the process of constructing a Living Unit. While the house itself is still at the model stage, some of the components have been realized: the ergonomically correct *Dynamic Chair* and matching table; a stackable *Hygiene System* that includes a toilet and a bath; a *Clean Air Machine* that is used for individual air conditioning; and the *Home Hydroponic Unit*, an easy-to-maintain greenhouse for indoor use in the form of shelf units, which provides toxin-free herbs and other greens all year round.

While the group itself comes up with the ideas and designs for these objects, it has turned to engineers, technicians and an architect for technical assistance. N55 has also collaborated with musicians and DJs involved in modern electronic music, and with the Niels Bohr-inspired Danish philosopher Peter Zinkernagel, who has worked with logical relations. This exchange has, for example, been given concrete form in the silent demonstration *It Is an Illusion That We Live in Time and Space*, 1995, and in an exhibition that recently took place in their home: 'It Is an Illusion That We Are Not in The Centre of The World', 1996.

N55's functional art objects and other activities embody a critical attitude that emerges on several levels. Its output is led by a political stance in which aesthetics is practised as an investigation of the possibility of existing with as small a concentration of power as possible. Working in a group fits well with this conviction, since it undermines the manifestation of the creative ego. But, above all, it is important that, through limitations of scale, N55 avoids the struggles for supremacy that are more or less implicit in larger concentrations of power.

The staging of this alternative system of living corresponds to the modernist conviction that everyday objects influence thought patterns and behaviour, and thus the way in which we treat each other and shape the world we live. The idealistic side of the project shares a common denominator with the visions of large-scale utopian environmental programmes of the 1960s. For N55, it is a question of inspired action at a time when living conditions are determined by, and may add to, economic and social limitations, with political consequences that often involve segregation and restricted individuality. N55 see art not as a product, but as a way of living – a dynamic process that should endlessly circumvent economic limitations and resist the separation of work and social life that underpins the inability to recognize the consequences of one's own actions.

Åsa Nacking

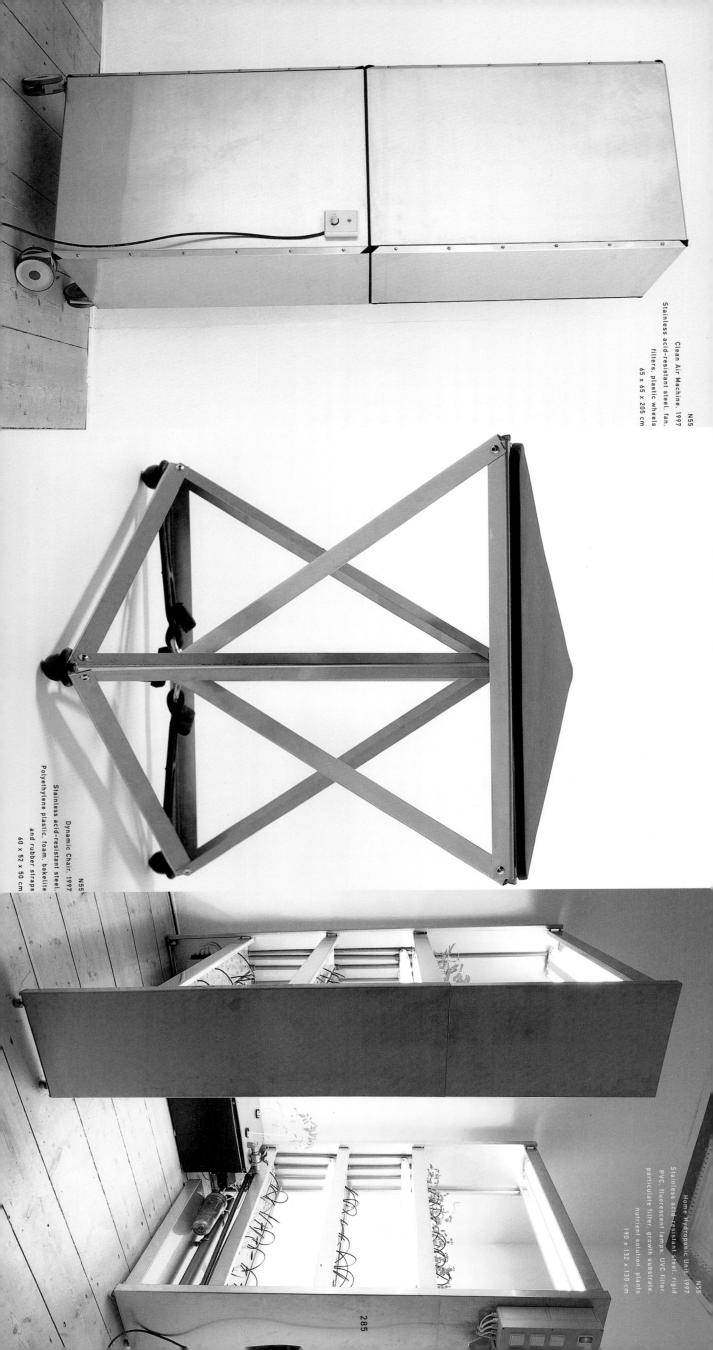

N55
Clean Air Machine, 1997
Stainless acid-resistant steel, fan,
filters, plastic wheels
65 x 65 x 205 cm

N55
Dynamic Chair, 1997
Stainless acid-resistant steel,
Polyethylene plastic, foam, bakelite
and rubber straps
60 x 52 x 50 cm

N55
Home Hydroponic Unit, 1997
Stainless acid-resistant steel, rigid
PVC, fluorescent lamps, UVC filter,
particulate filter, growth substrate,
nutrient solution, plants
190 x 132 x 130 cm

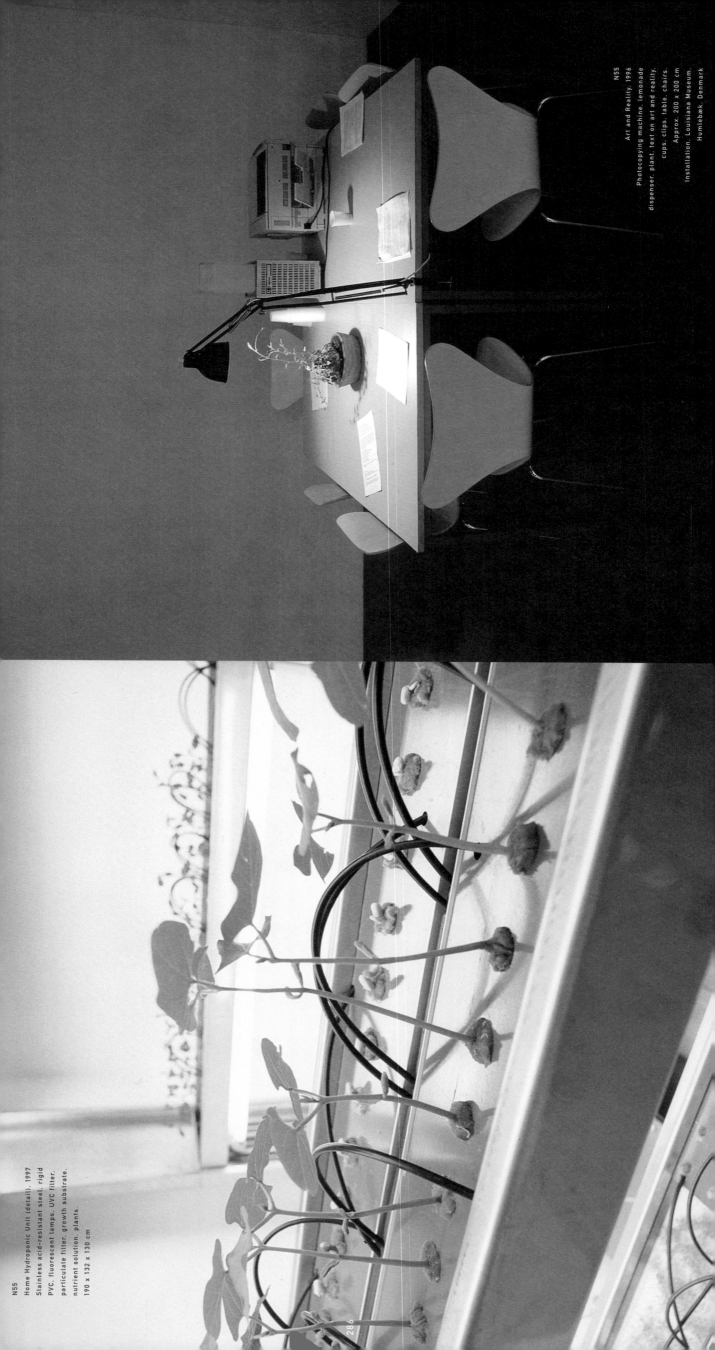

N55
Home Hydroponic Unit (detail), 1997
Stainless acid-resistant steel, rigid
PVC, fluorescent lamps, UVC filter,
particulate filter, growth substrate,
nutrient solution, plants.
190 x 132 x 130 cm

N55
Art and Reality, 1996
Photocopying machine, lemonade
dispenser, plant, text on art and reality,
cups, clips, table, chairs.
Approx. 200 x 200 cm
Installation, Louisiana Museum,
Humlebæk, Denmark

Jon Sørvin, born Copenhagen, Denmark, 1964; Rikke Luther, born Aalborg, Denmark, 1970; Cecilie Wendt, born Malmoe, Sweden, 1965; Ingvil Aarbakke, born Bergen, Norway, 1970. N55 live and work in Copenhagen.

website: http://www.pip.dknet.dk/~pip1064/ **selected solo exhibitions:** 1994 'Free Choice', Nørre Farimagsgade 55 (N55), Copenhagen 1995 'It Is an Illusion That We Live in Time and Space', Nørre Farimagsgade 55, Copenhagen 1996 'Jan Johansen and N55 - Replacement and Surplus', N55, Copenhagen; 'Anders Remmer, Søren Andreasen and N55 Will Find Themselves in This World's New World', N55, Copenhagen 1997 'Home Hydroponic Unit', N55, Copenhagen; 'Henriette Heise, Jacob Jacobsen and N55 Are Working Towards Greater Clarity', N55, Copenhagen; 'We Go On with the work', N55, Copenhagen **selected group exhibitions:** 1996 'NowHere, Work in Progress', Louisiana Museum, Humlebæk, Denmark 1997 'April Sessions 2', Institute of Contemporary Arts, London; 'Expoarte Guadalahara, Icebox', Guadalahara, Mexico 1998 'Come Closer', Liechtensteinische Staatliche Kunstsammlung, Vaduz, Liechtenstein; 'Pakkhus', Moss, Norway **selected bibliography:** Lars Bang Larsen, 'N55 Copenhagen', *frieze*, London, June/August **publications:** 1995 N55, 'Kunst og virkelighed', *Kunst og Kunstrelateret Materiale*, No. 14, Copenhagen 1996 *N55*, No 1, Copenhagen, September; *N55*, No 2, October; *N55*, No 3, November; *N55*, No 4, Copenhagen, December; N55, 'Det er en illusion at vi lever i tid og rum', *Kunst og Kunstrelateret Materiale*, No. 19 1997 *N55*, No 5, February; *N55*, No 6, April; *N55*, No 7, August; *N55*, No 8, September; *N55*, No 9, October; *N55*, No 10, October; *N55*, No 11, November 1998 *N55*, No 12, April

N55 with Anders Remmer
*It Is an Illusion That We Are Wet
in the Centre of the World*, 1996
Inflatable PVC-cushion with built-in
light and sound
400 × 400 × 180 cm

Nikos Navridis
On Difficulties (The Question of the Age
of the Void series), 1997
14 min. 35 sec. video projection, colour
185 x 295 cm each image
Installation, Yerebatan Cistern,
5th Istanbul Biennale

nikos navridis

Inhale, exhale. Fill, empty. Appear, disappear. Turn on, turn off. Our alternating respiratory movements plot the pace of our existence. They are an exercise which connects us, both physically and emotionally, to the world we inhabit. As we breathe, we absorb the very particles of the universe, transforming them within us, only to expel them in the form of breath, attesting to the rhythms and intensities of our every mood, our anxieties, our enthusiasm, our efforts and our abandonment.

Gaston Bachelard said that life is a pneumatic reality, that air and dreams associated with material lightness bring us closer to the metaphor of flight, enabling us to rise up into imaginary spheres. The perpetual ebb and flow of respiration speaks of the economy which regulates our interest in life, the poetics which illuminate our every emotional nuance, or the ethical stance that makes our struggles meaningful.

In a series he calls *The Question of the Age of the Void*, 1995–97, Nikos Navridis works with the limpid whiteness of silence and the sound of breathing which, like a rosy dawn charged with promise, has not yet been transformed into words. From the mouths and throats crowding his videos issue life-creating forces, capable of infusing beauty, of approaching others through translations, and of facing the difficulties inherent in all existential processes. This is starkly portrayed in four magnificent projections, created for the Istanbul Biennale in 1997, in which he reinterprets each of the ideas contained in the overall title of the Biennale, 'On life, beauty, translations and other difficulties'.

Navridis explores silence and emptiness, but he also places in a current context the urge and desire to communicate in its most pristine forms. Without uttering heart-rending cries or pompous words, he conveys the desire to live and an awareness of the complexities of life. From 1991 to 1994 he produced *Untitled*, which features a row of chairs arrayed in front of a wall teeming with delicate drawings. The chairs stand for the absence of the human figure, while the drawings are the marks of memory, signifying a presence which is no longer there. Another *Untitled*, dating from 1995, epitomizes his permanent preoccupation with space, with the body as a container and with the balloon as a fleeting projection of our endeavours. In this work, a face with a dark, gaping mouth, stretched open by hands, stands out from a photograph hanging on a wall. Under the photograph, a deflated balloon sits on a solitary chair. The desire to turn the human body into stretchable latex that could hold all the air in the world contrasts with the gloomy deflated balloon lying limply on the chair, which becomes a metaphor of death and loss. The works of Nikos Navridis breathe the intensity and delicateness of a breath of air capable of changing our perceptions and making our passage through life more bearable.

Rosa Martínez

Nikos Navridis
On Translations (The Question of the
Age of the Void series), 1997
14 min. 35 sec. video projection
185 x 295 cm
Installation, Yerebatan Cistern, 5th
Istanbul Biennale

nikos navridis

Born Athens, 1958. Lives and works in Athens.

selected solo exhibitions: 1995 Kalfayan Gallery, Thessaloniki, Greece 1997 Epikentro Gallery, Athens; Kouros Gallery, New York

selected group exhibitions: 1987 3rd Biennale for Young Artists from the Mediterranean Coast, Barcelona 1990 Aenaon, International Centre of Fine Arts, Athens 1996 XXIII São Paulo Biennial; 'Pro Patzia', House of Cyprus, Athens; Vilka Gallery, Thessaloniki, Greece 1997 On life, beauty, translations and other difficulties, 5th Istanbul Biennale

selected bibliography: 1995 Savvas Condaratos, 'The drawings and "drawing" of Nikos Navridis', Design and Art in Greece, No 26. Athens 1996 Katerina Koskina, Nikos Navridis, Kalfayan Gallery, Thessaloniki, Greece; Vasiliki Sariaki, 'Nikos Navridis: The Organic Structure of a Serving-Machine', The Art Magazine, Athens; Katerina Koskina, 'The Question of the Age of the Void', Nikos Navridis - Grecia - XXIII Bienal de São Paulo, Greek Ministry of Culture, Athens 1997 Catherine Millet, 'The São Paulo Biennale Has Changed', art press, No 220, Paris; Nikos Xidakis, 'An Adventure of Description of Volumes and Forms', Kathimerini, Athens, 15 January; Márcia Fortes, 'XXIII Bienal Internacional de São Paulo', frieze, London, January; Barry Schwabsky, 'Nikos Navridis', New York Review of Art, 1 March; Rosa Martinez, 'Instanbul Biennial: Curatorial Interpretations', Flash Art, Milan, November/December; Nikos Daskalothanassis, 'Is the Void Full?', Art Magazine Net, No 3, Athens

Nikos Navridis
Video projection II (from 'The Question of the Age of the Void' series), 1996
9min, 15sec, video projection
Installation, XXIII São Paulo Biennial

Nikos Navridis
Untitled (The Question of the Age of the Void series), 1995
Black and white photograph on paper, metal chair, balloon
Photograph, 100 x 135 cm
Installation, Kalfayan Gallery, Thessaloniki, Greece

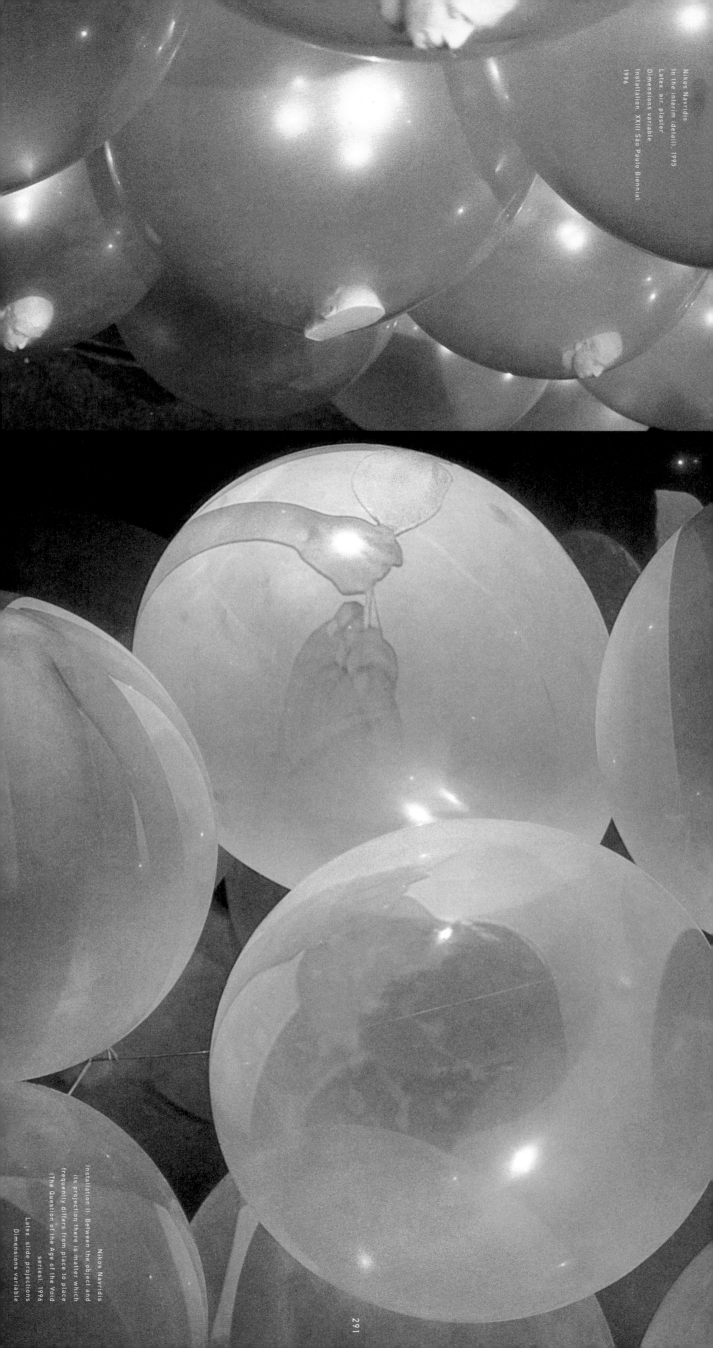

Nikos Navridis
In the interim (detail). 1995
Latex, air, plaster
Dimensions variable
Installation. XXIII São Paulo Biennial.
1996

Nikos Navridis
Installation II: Between the object and
its projection there is matter which
frequently differs from place to place
(The Question of the Age of the Void
series). 1996
Latex, slide projections
Dimensions variable

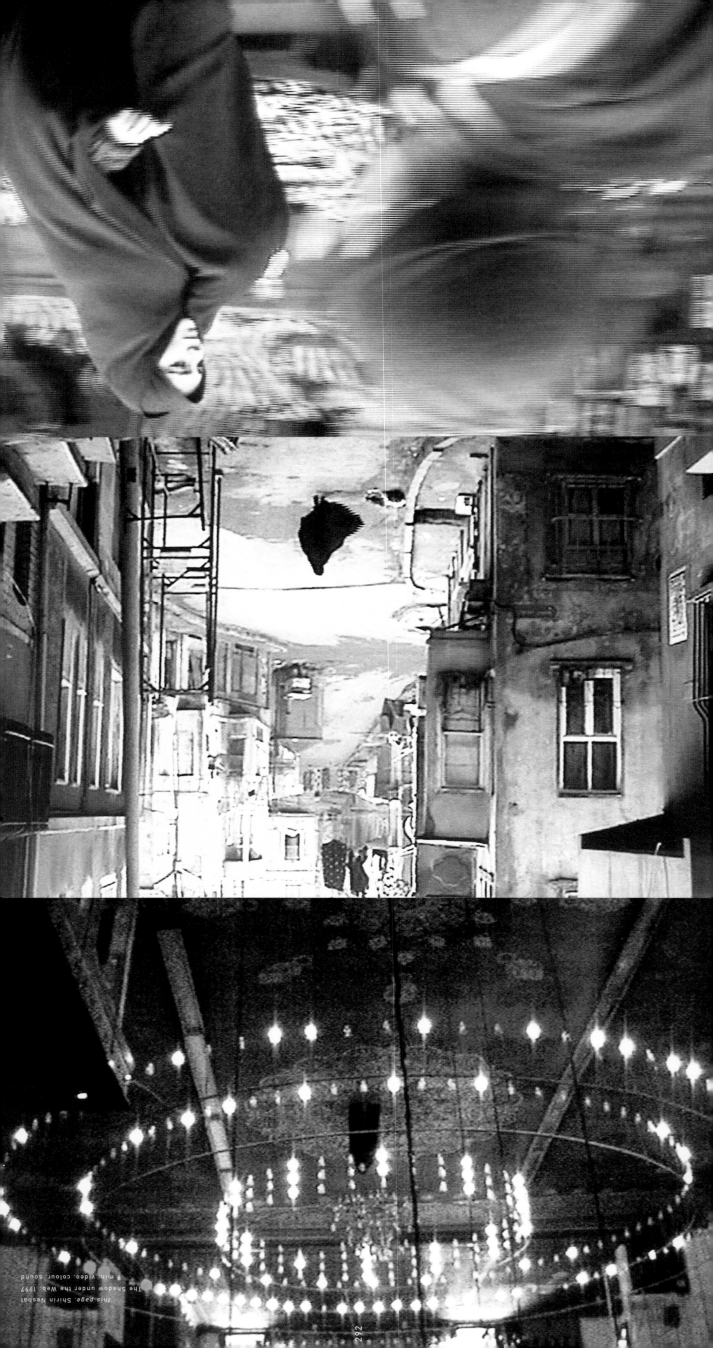

This page, Shirin Neshat
The Shadow under the Web, 1997
9 min. video, colour, sound

Shirin Neshat
Whispers, 1997
Black and white photograph, ink
114 x 188 cm

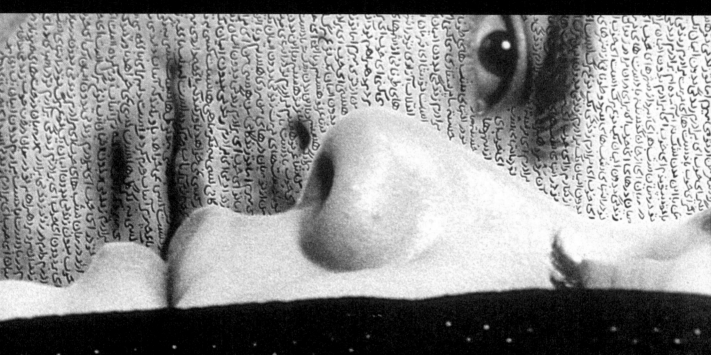

shirin neshat

One enters a long, dark, cavernous space. As one makes one's way deeper inside, a soft but intensely persistent voice is chanting a sonorous incantation that recalls the Muezzin's early morning call of prayer to the faithful. Now fully in the space, one sees a screen onto which is back-projected an image of a woman clad from head to ankle in a black *chuddar*; all that is visible are the hands, feet and face. It is a face both beautiful and stern, which immediately admonishes you to listen and pay attention, even if the words are in Farsi, the Persian language of Iran.

The face and voice belongs to Shirin Neshat. Her work, until recently restricted to photography and text, has taken on issues of the place of women in Islam and their faith and existential loneliness within that religion. Autobiographical and personal, Neshat's work is feminist, yet inverts all the clichés of feminism by deviating from its norms. In her non-denial of some of the controversial characteristics of her culture in dress and religion, she has much to teach contemporary popular feminism, which often assumes that what is good for American and European women must necessarily be good for all women. While she does not attempt a strict rebuttal of Western hegemonic practices, Neshat accommodates the versatile and often contradictory roles that women occupy in a society such as hers in Iran.

Repeatedly photographing herself, she carefully inscribes on these self-portraits devotional prayers and poems in Farsi, exploring, questioning and recasting different stereotypical roles of women as mother, nurturer, victim, and juxtaposing them with images of women as militant revolutionaries, terrorists and martyrs. Edward Saïd, whose landmark book, *Orientalism*, 1978, has contributed deeply to our changing views of the East, immediately comes to mind on first encountering Neshat's work. According to Saïd, we use the Orient as a phantasmic screen on which to replay and enjoy our notions of the mysteries of the East, but the East is unknowable precisely because it cannot be made irreducible through such fallacious intimacy.

In Neshat's work there is always a degree of ambiguity as to whether she is mocking, or wilfully exploiting, our ignorance of Islam; our intimacy with the figure of the East, our fantasy of a mysterious and palatable Orient. She presents us with what we may interpret as Islam's exoticism, only to deflate those assumptions by contradicting us. The power of her work then, is in its disarming simplicity, in its bare essentiality.

These images distabilize the idea that if something is beautiful, it must be easy to swallow. There is always an underlying tension in Neshat's work, a creepy discomfort. In *The Shadow under the Web*, 1997, the woman sings and twirls; rapturous and penitent either in meditation or exorcism. But in due course she will face you with her tautly drawn face, tremulous with anger or sorrow; you will stare into her intense eyes and into the blunt, menacing barrel of a pistol, which she cocks and fires at you.

Okwui Enwezor

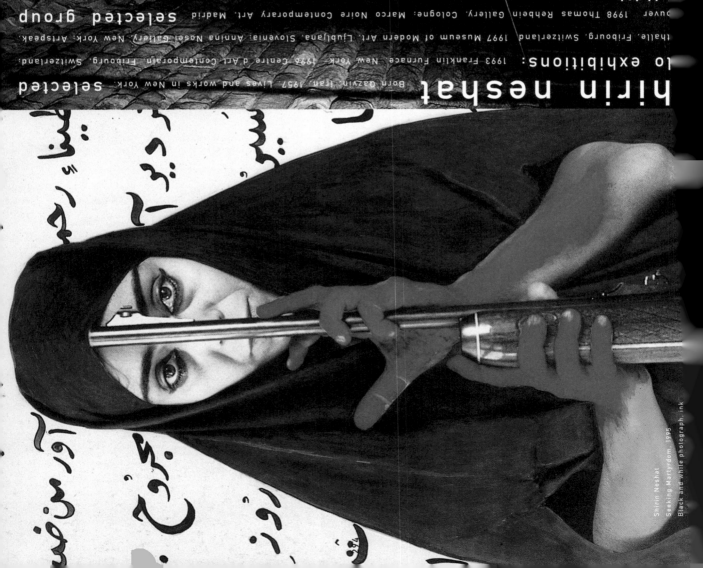

left. Shirin Neshat
Anchorage. 1996
4 min. video installation, colour, sound
101.5 x 152.5 cm
Installation. Anchorage. New York

shirin neshat

Born Qazvin, Iran, 1957. Lives and works in New York.

selected to exhibitions:
1993 Franklin Furnace. New York. 1996 Centre d'Art Contemporain. Fribourg. Switzerland.
thalle. Fribourg. Switzerland. 1997 Museum of Modern Art. Ljubljana. Slovenia. Annina Nosei Gallery. New York. Artspeak.
uver. 1998 Thomas Rehbein Gallery. Cologne. Marco Noire Contemporary Art. Madrid

selected group
1993 'Fever'. Exit Art. New York. 1994. Three New Photographers'. Haines Gallery. San Francisco. Beyond
orders. Art by Recent Immigrants'. The Bronx Museum of the Arts. New York. 1995 The Vision of Art in a Paradoxical World.
stanbul Biennale. XLVI Venice Biennale: 'It's How You Play the Game'. Exit Art. New York. 1996 'Jurassic Technologies
art. 10th Sydney Biennale: 'Radical Images'. Austrian Triennial on Photography'. Neue Galerie & Kunstlerhause. Graz.
a. Kunsthalle Szombathely. Hungary. 'Imaginary Beings'. Exit Art. New York. 1997 'On life, beauty translations and other dif-
es. 5th Istanbul Biennale. 'Trade Routes: History and Geography'. 2nd Johannesburg Biennale. 'Fotomanifestatie
erlicht'. Groningen. The Netherlands. 1998 'Echolot'. Museum Fridericianum. Kassel. Germany. Walker Art Center.
apolis. 'Vanessa Beecroft and Shirin Neshat'. Galleria d'Arte Moderna. Bologna

selected bibliography:
ate Bobby. 'Exploring the Secrets of the Veil: an interview with Shirin Neshat'. New Directions for Women. New York.
r 1994 Octavio Zaya. 'Shirin Neshat'. Flash Art. Milan. December. Octavio Zaya. 'Shirin Neshat and the Women of Allah'. An
ew. Purple Prose. No 7. Paris. 1995 Barry Schwabsky. Review. Artforum. New York. December. Octavio Zaya. 'Neshat:
contar el complejo mundo de la mujer musulmana'. Diario 16. Madrid 1996 Octavio Zaya. 'Women of Allah'. Creative Camera.
October/November. Roberta Smith. 'In Tomblike Vaults, the Future Flickers and Hums'. The New York Times. 9 August
na Bertucci. 'Shirin Neshat: An Interview'. Flash Art. Milan. November/December. 1998 Jonathan Goodman. 'Poetic Justice:
Neshat Defends the Faith'. World Art. No 16. New York

Shirin Neshat
Seeking Martyrdom. 1995
Black-and-white photograph. ink

Shirin Neshat
Careless, 1997
Black and white photograph, ink
101.5 x 152.5 cm

ernesto neto

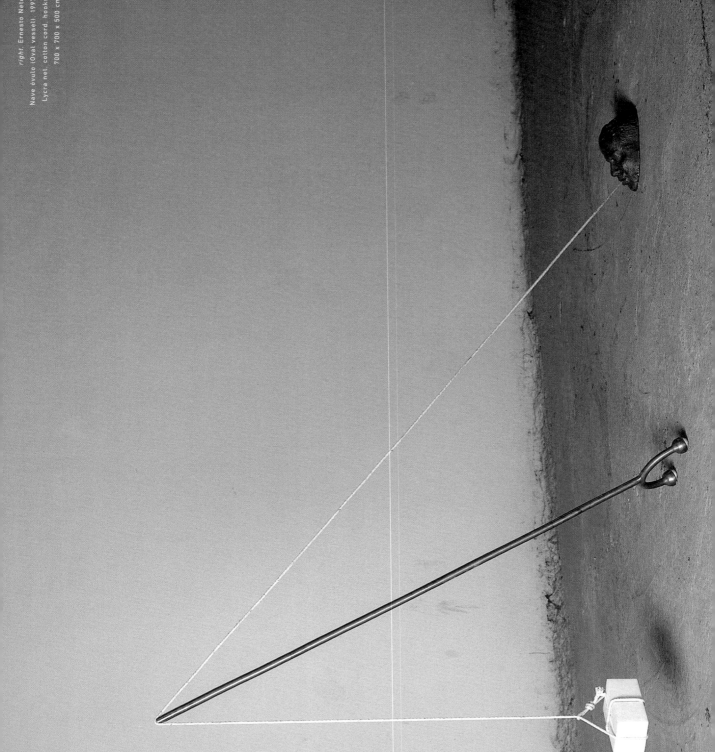

Ernesto Neto
ConCreta Sonho, 1994
Lead, nylon, steel, marble
230 x 166 x 25 cm

right: Ernesto Neto
Nave óvulo (Oval vessel), 1997
Lycra net, cotton cord, hooks
700 x 700 x 500 cm

Concreta Sonho, 1994. A literal translation of Concreta Sonho would be 'I dream of Crete', bringing to mind the homeland of the Minotaur and the thread of Ariadne, which is also the thread of dreams and their truth. Following this thread through the labyrinth is like trying to reach the omphalos, the very knot at the heart of the dream, which according to Freud defies analysis. Any search for meaning is thwarted as the analyst finds himself lost in the closed heart of an enigma. The ambiguous title of Ernesto Neto's work, however, also suggests different directions. Another way of reading it would be 'Concrete dream', an interpretation that endows the oneiric process with solidity and weight. Any concrete dream would necessarily be clear and shining, well-defined and precise – all adjectives that correspond closely to Neto's work. Concreta Sonho is a lead cast of the artist's face, lying on the ground as if partially submerged in the floor. A cord leading from the mouth is attached to the end of a steel rod, which is like an inverted crutch, and knotted around a small, suspended block of white marble. The materials are clear and differentiated, their articulation specific and defined, their relative weights and colours harmonious but distinct.

The work is so powerfully self-contained, its contrast with the surrounding space so clear, that the viewer gets the impression that the piece is the only real thing in the place that hosts it; the environment in comparison becomes imprecise and almost dream-like. The white cotton thread issues from the mouth like a solid emanation of breath. The tension of the thread draws attention to the steel crutch that leans over, as if drawn by the weight of the marble block. This leads us to think in terms of the story of Oedipus and the riddle of the Sphinx who walks with four feet in the morning, two in the afternoon and three at dawn. Oedipus guessed that

it was man in the three stages of his life, the third foot being a crutch. His answer to the riddle was loud and clear, and this very clarity would seal his fate, symbolized by the heavy marble. Oedipus' very identity is an abyss — the abyss into which the Sphinx threw herself when defeated by him. The work seems to be saying: 'we are all fatally the same, carrying the weight of our lack of identity'. The title, *ConCreta Sonho*, also contains an allusion to Constructivism in Brazil, or, more precisely, the work of those artists belonging to the Neo-concrete group (which includes Hélio Oiticica and Lygia Clark) who, in the late 1950s, broke away from the concretist line because of its excessive rationalism and mechanism. Seeking the expression of an original kind of subjectivity, the group did not consider emotion and reason to be opposing terms. They were capable of dreaming their way through labyrinths and conjuring up the very site of the omphalos, attempting to undo the heavy knot of dreams.

Carlos Basualdo

Ernesto Neto
Nave óvulo (Oval vessel), 1997
Lycra net, cotton cord, hooks
700 x 700 x 500 cm

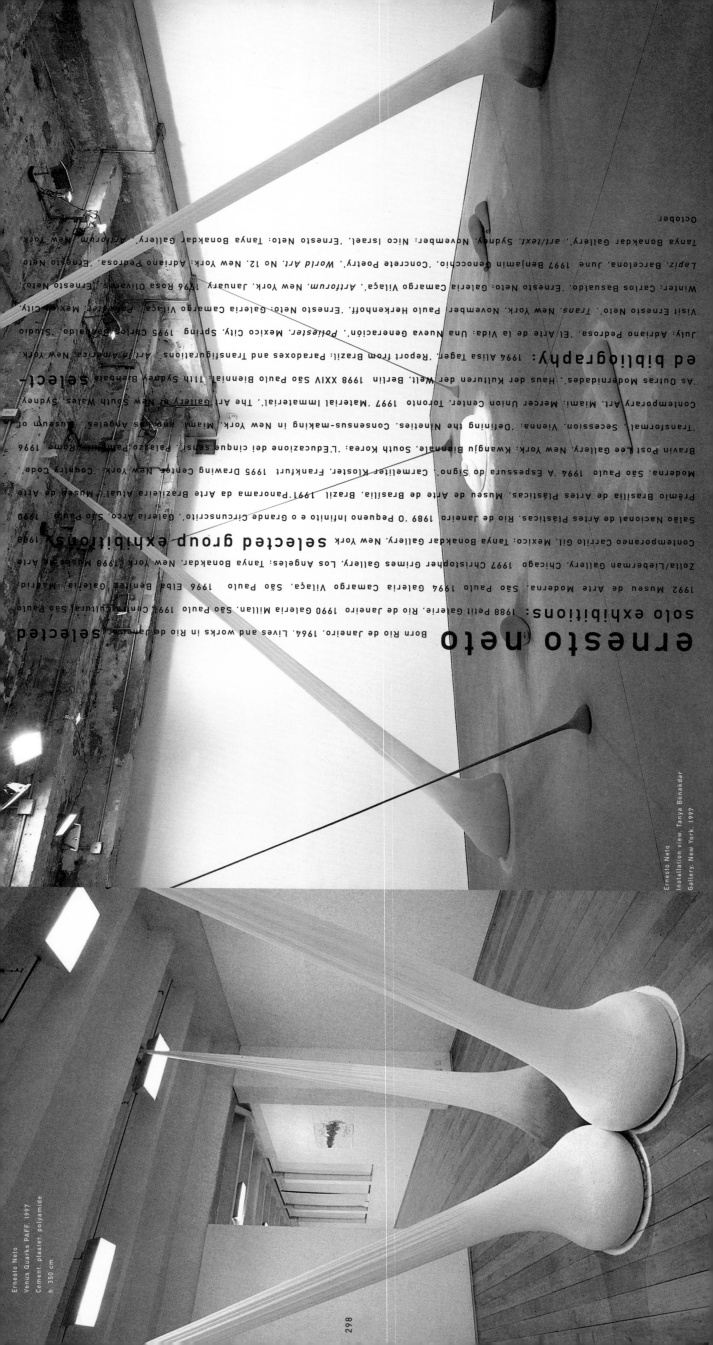

ernesto neto

Born Rio de Janeiro, 1964. Lives and works in Rio de Janeiro. **selected solo exhibitions:** 1988 Petit Galerie, Rio de Janeiro 1990 Galeria Millan, São Paulo 1991 Centro Cultural, São Paulo 1992 Museu de Arte Moderna, São Paulo 1994 Galeria Camargo Vilaça, São Paulo 1996 Elba Benítez Galeria, Madrid 1997 Christopher Grimes Gallery, Los Angeles; Tanya Bonakdar, New York 1998 Museo de Arte Contemporáneo Carrillo Gil, Mexico; Tanya Bonakdar Gallery, New York **selected group exhibitions:** 1988 Zolla/Lieberman Gallery, Chicago 1989 'O Pequeno Infinito e o Grande Circunscrito', Galeria Arco, São Paulo 1990 Salão Nacional de Artes Plásticas, Rio de Janeiro 1991 'Panorama da Arte Brasileira Atual', Museu de Arte Moderna, São Paulo 1994 'A Espessura do Signo', Carmeliter Kloster, Frankfurt 1995 Drawing Center, New York 'Country Code', Prêmio Brasília de Artes Plásticas, Museu de Arte de Brasília, Brazil Bravin Post Lee Gallery, New York; Kwangju Biennale, South Korea; 'L'Educazione dei cinque sensi', Palazzo Pamphili, Rome 1996 Transformal, Secession, Vienna; 'Defining the Nineties; Consensus-making in New York, Miami, and Los Angeles', Museum of Contemporary Art, Miami; Mercer Union Center, Toronto 1997 'Material Immaterial', The Art Gallery of New South Wales, Sydney 'As Outras Modernidades', Haus der Kulturen der Welt, Berlin 1998 XXIV São Paulo Biennial; 11th Sydney Biennale **selected bibliography:** 1994 Alisa Tager, 'Report from Brazil; Paradoxes and Transfigurations', Art in America, New York July Adriano Pedrosa, 'El Arte de la Vida; Una Nueva Generación', Poliester, Mexico City, Spring 1995 Carlos Basualdo, 'Studio Visit Ernesto Neto', Trans, New York, November Paulo Herkenhoff, 'Ernesto Neto: Galeria Camargo Vilaça', Poliester, Mexico City, Winter Carlos Basualdo, 'Ernesto Neto: Galeria Camargo Vilaça', Artforum, New York, January 1996 Rosa Olivares, [Ernesto Neto, Lapiz, Barcelona, June 1997 Benjamin Genocchio, 'Concrete Poetry', World Art, No. 12, New York; Adriano Pedrosa, 'Ernesto Neto. Tanya Bonakdar Gallery', art/text, Sydney, November; Nico Israel, 'Ernesto Neto: Tanya Bonakdar Gallery', Artforum, New York October

Ernesto Neto
Venus Quarks PAFF, 1997
Cement, plaster, polyamide
h. 350 cm

Ernesto Neto
Installation view, Tanya Bonakdar
Gallery, New York, 1997

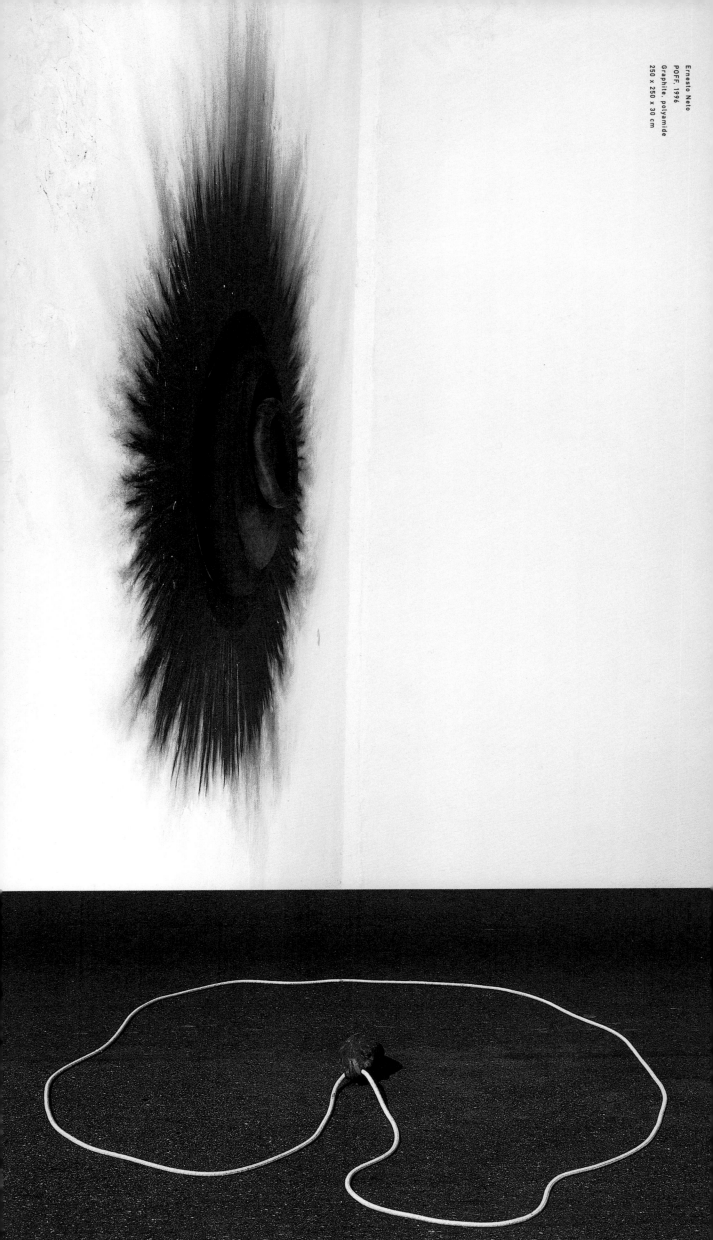

Ernesto Neto
POFF, 1996
Graphite, polyamide
250 x 250 x 30 cm

Ernesto Neto
Ringue (Ring), 1995
Lead, velvet
100 x 100 x 20 cm

Rivane Neuenschwander
Untitled, 1997
Garlic burned with incense
13 x 7 cm

rivane neuenschwander

The latest generations of Brazilian artists reveal the emergence of an aesthetic trend that might be termed 'organic Minimalism'. The artists in question, who come from different parts of the country, do not make up a homogeneous group. Neither have they adopted any established manifesto-like aesthetic or conceptual code.

While the works of Rivane Neuenschwander can be seen in this context, they are distinguished by their unusual intensity. This stems from her ability to communicate the immaterial, vulnerable processes of the life cycle. Capturing the entropy of organic materials as they proceed along the inevitable path towards decay, she momentarily freezes their decline at moments of transformation. In this sense, she creates a sort of silent resistance in the face of the destruction implicit in all life processes. In *Untitled*, 1997, for example, she gathered together ants from different countries, which were subsequently stuck to the wall with tape, plotting out a fictitious journey, a small trail in the voyage towards death.

She obtains the materials for her works — garlic, crumbs of bread, dried flowers, insects — through a slow and painstaking process of collecting. She then rearranges them into minimal essential configurations that arouse the pleasure of a sensation. Her sculptures are fragile and ethereal, free from the weighty symbolic charge present in so much contemporary art. She works with tenuous membranes to create a beauty that extends over concrete surfaces, charging them with strength and lightness and imbuing them with a delicate, though never tragic, sense of suffering. While the work is packed with the emotional qualities inherent in the materials and objects used, she allows them to breathe for themselves, enabling the viewer to complete them with their own interpretations.

As curator Lisette Lagnado has put it, Neuenschwander's desire for emptiness is more metaphysical than intimate and, despite its formal essentialism, which forges inevitable connections with the aesthetics of Minimalism, her awareness of the passing of time and her delicate attempt to capture it, place her firmly within the conceptual sphere of the Baroque.

Rosa Martínez

Rivane Neuenschwander
Untitled, 1997
Flowers, branches, leaves, glue
Dimensions variable
Installation, 5th Istanbul Biennale

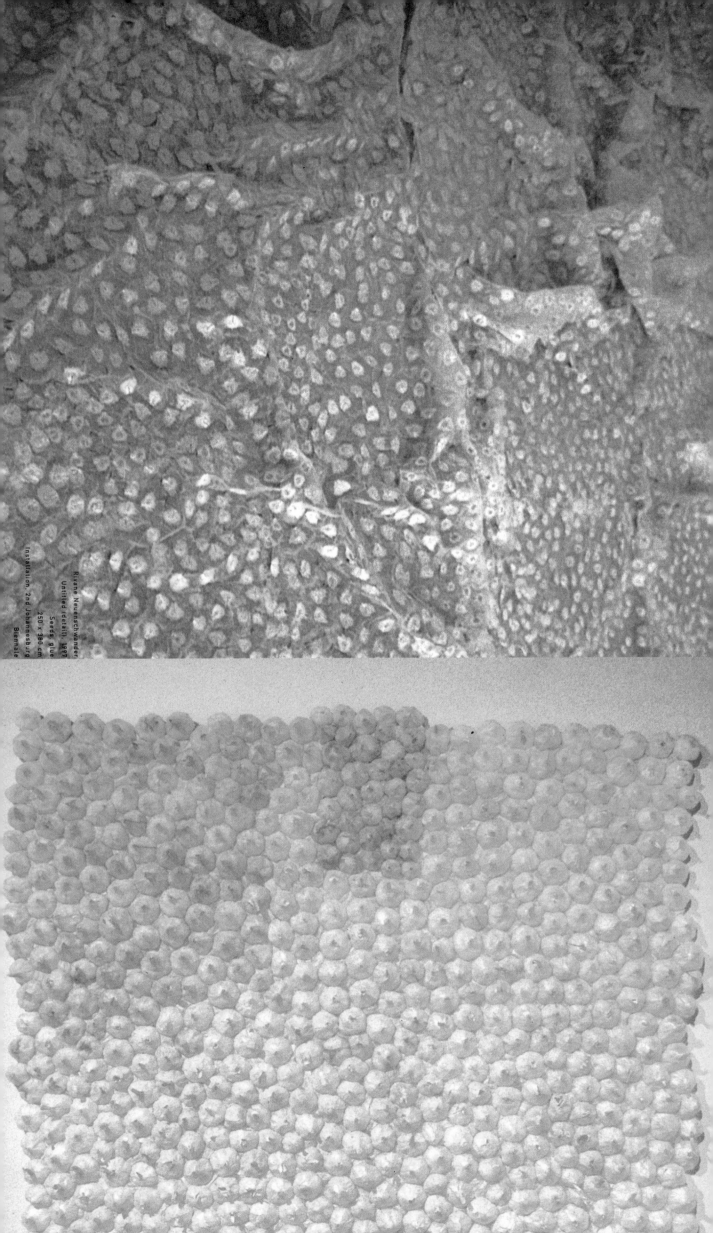

Rivane Neuenschwander
Untitled, 1997
Garlic, glue
Approx. 100 x 115 cm

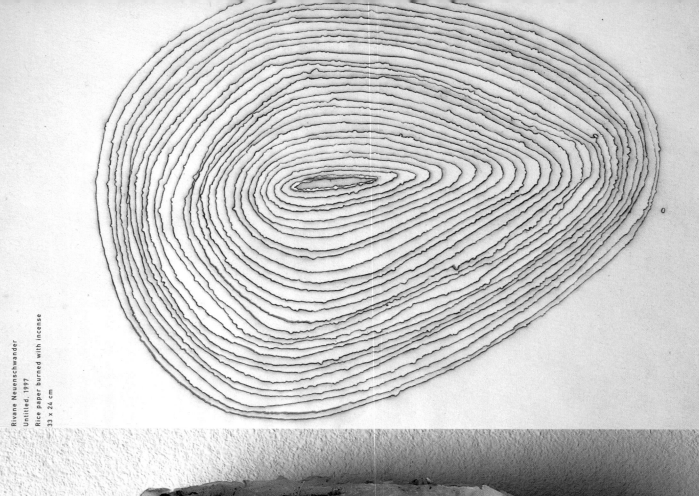

Rivane Neuenschwander
Untitled, 1997
Rice paper burned with incense
33 x 24 cm

Rivane Neuenschwander
Untitled, 1997
Root sheet burned with incense
7 x 11 x 2 cm

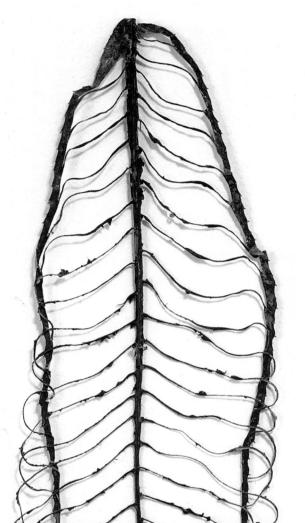

rivane neuenschwander

Born Belo Horizone, Brazil, 1967.

Lives and works in London and Brazil **selected solo exhibitions:** 1992 Itau Galeria, São Paulo 1996 Casa Triângulo, São Paulo 1997 Stephen Friedman Gallery, London **selected group exhibitions:** 1991 '15,000 kg', Palácio das Artes, Belo Horizonte, Brazil 1993 '13th Salão Nacional de Artes Plásticas da Funarte', Institute of Contemporary Art, Rio de Janeiro 1994 'A Imagem Não Virtual', Casa Triângulo, São Paulo 1995 'A Infância Perversa', Museu de Arte Moderna, Rio de Janeiro 1996 'Latino America '96', Museu Nacional de Belas Artes, Buenos Aires 1997 'Trade Routes: History and Geography', 2nd Johannesburg Biennale; On life, beauty, translations and other difficulties, 5th Istanbul Biennale **selected bibliography:** 1996 Celso Fioravante, 'Rivane Exibe o Seu Barroco Mínimo', *Folha de São Paulo*, 2 July; Celso Fioravante, 'Antartica Artes com a Folha Seleciona 62 Artistas', *Folha de São Paulo*, 1 August; Celso Fioravante, 'Antartica Escolhe os Seus Premiados', *Folha de São Paulo*, 2 October 1997 Nikos Papastergiadis, 'Material Immaterial', *art/text*, Sydney, August/October; Benjamin Genocchio, 'Concrete Poetry', *World Art*, No 12, New York; Sebastian Smee, 'Smells Like Art', *The Sydney Morning Herald*, 14 March; Alicia Murria, 'Arte y Lationoamerica', *Art Nexus*, Bogotá, Columbia, April/June; Sebastian Smee, 'Asking the Right Questions', *Art Monthly*, London, May; Celso Fioravante, 'Aristas Brasileiros vao a Australia', *Folha de São Paulo*, 23 January; Celso Fioravante, 'Brasileiros Conquistam o Mundo', *Folha de São Paulo*, 10 February

paul noble

Rejecting the lyrical, abstract paintings he had been encouraged to make whilst at art school in the mid 1980s – a decision prompted partly by his parents' general incomprehension when confronted with his work – Paul Noble elected to return to a more primary mode of communication: representation. The paintings and drawings that emerged were created not only through a desire finally to gain some parental respect – an art they could at least recognize if not quite understand – but perhaps, more poignantly, they were a way for Noble to come to terms with and rationalize the immediate world around him.

The early works indexed a diverse subject matter: favourite vegetarian recipes, murderous dolphins, fraternal masturbation, laborious copies of car-repair diagrams, literate dogs; portraits of book collectors and of the artist; scenarios of deviant coprophil-ia being played out in the non-fiction sections of public libraries and gangs of bored super-models confined to endless after-school detention sessions. Everything was executed with a fastidious, almost fanatical attention to detail.

Drawing on the legacies of both Surrealism and Viennese Aktionism – in particular Magritte's *période vache* of the late 1940s and Günter Brus' sadistic pictoral poems of the early 1970s – Noble's hybrids shared something of the former's absurdity with a great deal of the latter's depravity, itself cheerfully undermined by Noble's canny sense of humour, which served, in the words of the artist, as 'a valid popularizer'.

Recently Noble has begun to develop work in series. *Daley*, 1995–96, is a comic melodrama-cum-morality tale set amidst the dying embers of late Thatcherism, which holds up a mirror to the years Noble spent signing on (collecting public assistance). The work

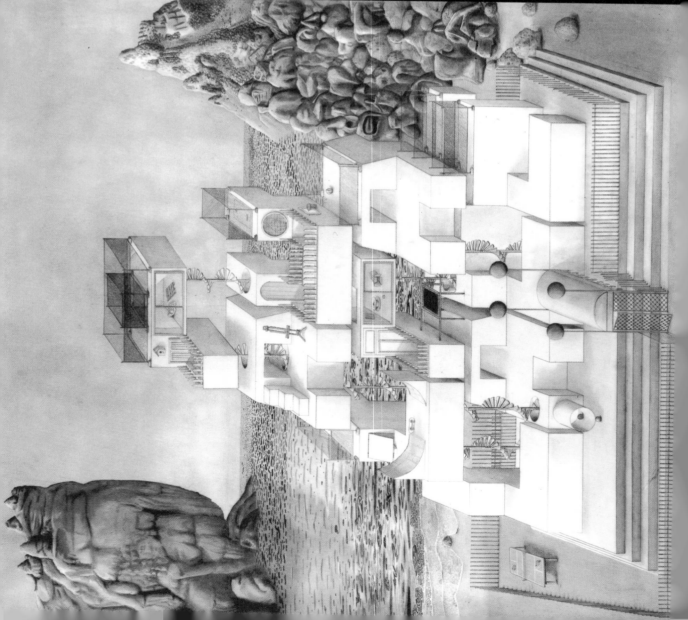

Paul Noble
Paul's Palace, 1996
Pencil on paper
Approx. 150 x 150 cm

...vestics with the parallel lives of five amoebic characters – Oblivious, Aimless, Formless, Ineffectual and Burnt Out – a thinly veiled composite for the artist himself, through a sequence of comic-strip style storyboards and a fully operational board game developed and subsequently marketed by the artist.

Nobson, 1996, is an ongoing series of over-sized panoramic pencil drawings that depict life – such as it is – in the fictitious fiefdom of Nobson Newtown. Chronicled in Noble's compelling guide book *Introduction To Nobson Newtown* (Salon Verlag, 1998, Nobson is 'an exercise in self-portraiture via town planning' constructed from building blocks hewn from the local quarry – each lovingly carved to form the letters of a typeface of Noble's own design. Seen from above – 'H-Block' fashion – Nobson's various architectures literally spell out their specific functions: the cemetery inevitably reads Nobsend. The social malaise that is Nobslum teeters under the permanent threat of a sewage-induced landslide. In sharp, almost majestic contrast to the routine squalor to be found elsewhere in Nobson Newtown is Noble's own 'architect designed' ivory tower, Paul's Palace. Kitted out with its own skateboard ramp, table-tennis table, basketball court, trampoline and open-air studio, Paul's Palace provides Noble the empire-builder with a secure vantage point from which to survey his ever-unfolding domain.

Matthew Higgs

Nobslum, 1996
Pencil on paper
Approx. 150 x 170 cm

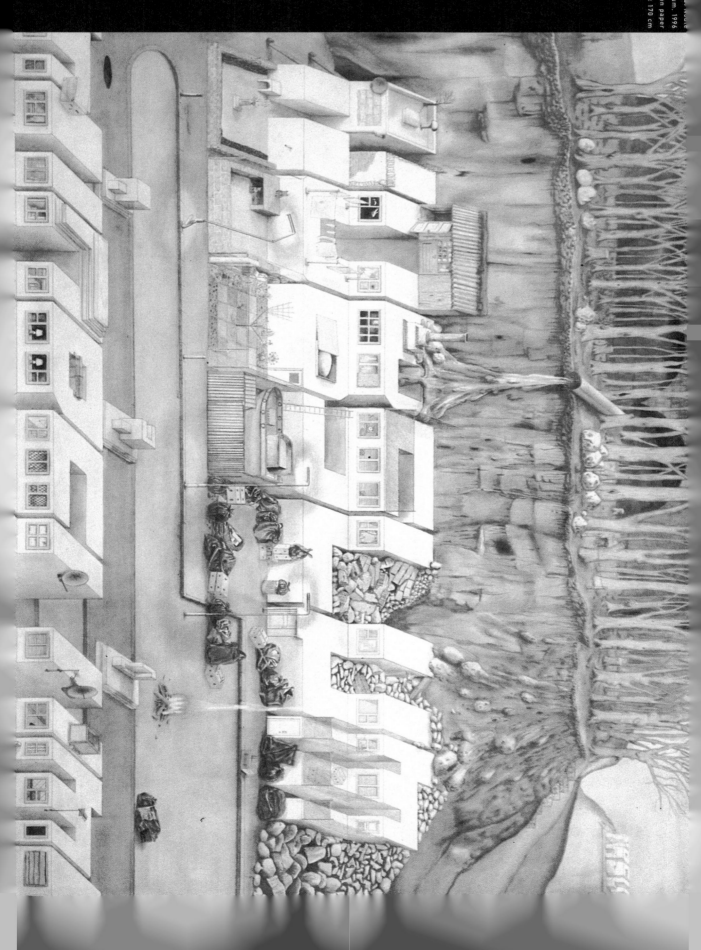

Paul Noble
Doley, 1996
Pencil on paper, oil on canvas, pastel
on paper, water-colour on paper
Dimensions variable
Installation, Interim Art, London

paul noble

Born Northumberland, England, 1963. Lives and works in London. **selected solo exhibitions:** 1990 City Racing, London 1995 'Ye Olde Worke', Cubitt, London 1996 'Doley', Interim Art/Maureen Paley, London 1998 'NOBSON', Chisenhale Gallery, London **selected group exhibitions:** 1987 'Ten Years On', Humberside College of Higher Education 1992 'Tattoo Collection', Jennifer Flay, Paris 1993 'Thomas Echnurr and Paul Noble', Kommunale Galerie, Frankfurt 1994 'Colin Lowe and Paul Noble', City Racing, London 1995 'Paul Noble, Giorgio Sadotti, Gillian Wearing, Sharon Lockhart, Jean-Baptitste Bruant', Interim Art/Maureen Paley, London 1996 'Paul McCarthy, Paul Noble, Allen Ruppensberg', Jay Gorney Modern Art, New York; 'Semikolon', Portikus, Frankfurt 1997 'Belladonna', Institute of Contemporary Arts, London; 'Peripheral Visionaries', De Fabriek, Eindhoven, The Netherlands 1998 'A to Z', The Approach, London

selected bibliography: 1994 Simon Grant, 'Antoni/Lowe/Noble/Coming up for Air/The Lisson Gallery', *Art Monthly*, London, May 1995 David Barrett, 'Jean-Baptitste Bruant/Sharon Lockhart/Paul Noble/Giorgio Sadotti/Gillian Wearing: Interim Art', *Art Monthly*, London, November; Brett Ballard, 'Funny Business', *Everything*, London, Spring 1996 Verena Kuni, 'Semikolon – Portikus', *Kunstbulletin*, Kriens, Switzerland, November; Dorothee Baer-Bogenschütz, 'Semikolon: Junge Kunst im Portikus', *Frankfurther Rundschau*, Frankfurt, 2 November; Carl Freedman, 'Some Drawings: From London', *frieze*, London, September/October 1997 Andrew Cross, 'Letter from America', *Art Monthly*, London, February; David Burrows, 'Popocultural', *Art Monthly*, London, December/January 1998 Matthew Collings, 'Choking on Art', *Modern Painters*, London, Spring

Paul Noble
The Doley Game (detail), 1995–96
Mixed media
Dimensions variable

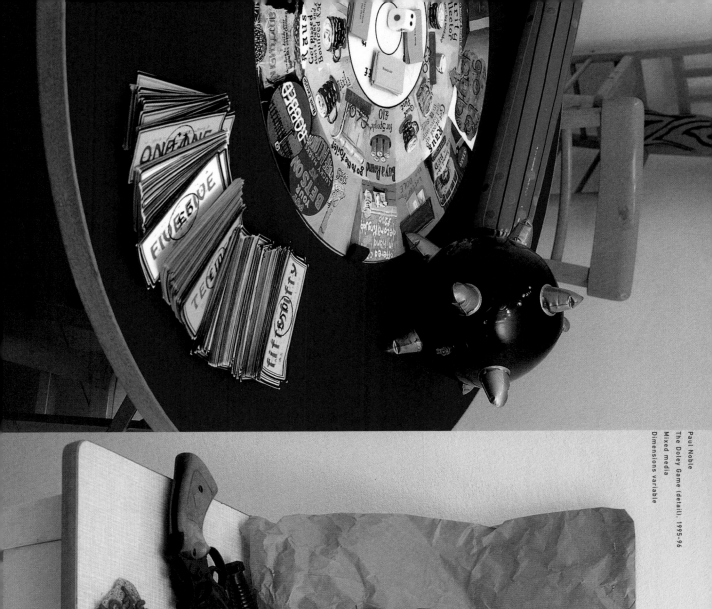

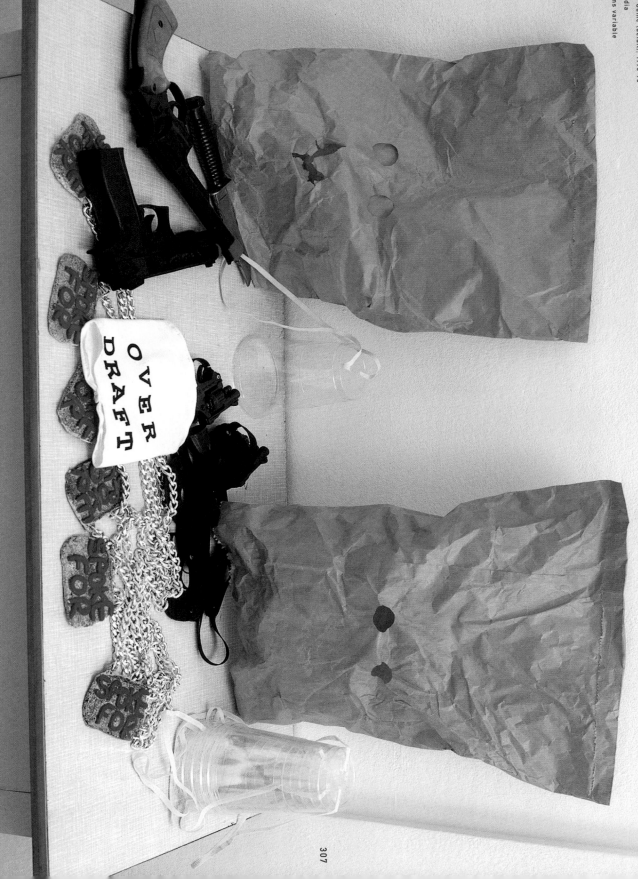

Paul Noble
The Doley Game (detail), 1995–96
Mixed media
Dimensions variable

chris ofili

Since 1997 Chris Ofili has been making small watercolours of black women wearing colourful clothes. Unlike the women who populate his large-scale paintings — archetypes consigned to play out misogynized roles: virgins, madonnas, beauty queens, vixens and whores — these unlikely fictitious subjects are treated with a reverential awe of a kind normally reserved for the portrayal of loved ones or treasured pets. Imagine, if you will, delicate hybrids of Seydou Keïta's studio portraits of the 1950s, Thomas Schütte's dreamy lovers and Andy Warhol's cats.

Less 'problematic' than their large-scale sisters, in so much as they depict a less overt, less contentious subject, these ambiguous, genuinely slight images challenge the spectacle of Ofili's more formally staged paintings. Ofili's aspiration is simply to construct an image that consists of 'something at the top' (an often elaborate Afro-hairstyle invariably crowned with a tiara), 'something in the middle' (a face, occasionally augmented by an all-seeing 'third eye') and 'something at the bottom' (the decorative swathes of psychedelic drapery). What could be construed as a lack of ambition is actually a conscious strategy on Ofili's part that allows him to say 'less'. Unlike the paintings — which both acknowledge and depend upon a dialogue with an audience who can engage with their complex historical referents — the drawings are not made with a 'public' in mind. They make a point of distancing themselves from the anecdotal 'testimony' that surrounds the paintings, 'evidence' that has increasingly begun to dominate their subsequent critical reception.' The drawings seem almost mute in comparison. Ofili feels no compulsion either to explain or justify them. They remain defiantly untitled. They delineate a reflective moment, emerging from the intimate relationship between

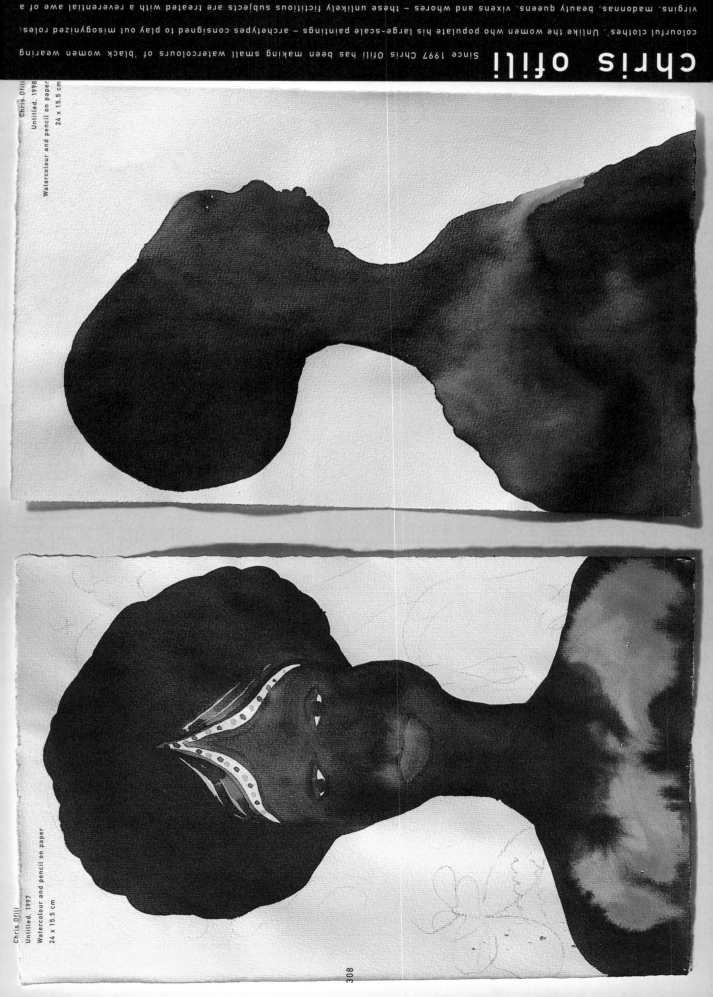

Chris Ofili
Untitled, 1998
Watercolour and pencil on paper
24 x 15.5 cm

Chris Ofili
Untitled, 1997
Watercolour and pencil on paper
24 x 15.5 cm

the artist and the tenuous drift of 'studio time'. Rarely shown, they tend to accumulate on the studio wall next to Ofili's work table.

A caucus of 'angels' keeping watch over the studio by night and day.

Matthew Higgs

1 A number of these anecdotes are now cited with such regularity that they have begun to achieve almost mythic status – a situation Ofili is keenly aware of. For example Ofili's first trip to Africa and his exposure to the Matopos cave paintings in Zimbabwe in 1992 is now widely taken as the departure point for all subsequent commentary. Certain notable quotes are repeated ad infinitum, memorably his first 'encounter' with a giraffe: 'The first time I saw a giraffe, everything turned upside down – not violently, but gently, because suddenly there was this animal bigger than the trees. To me, the only things bigger than trees were buildings. It was kind of upsetting.'

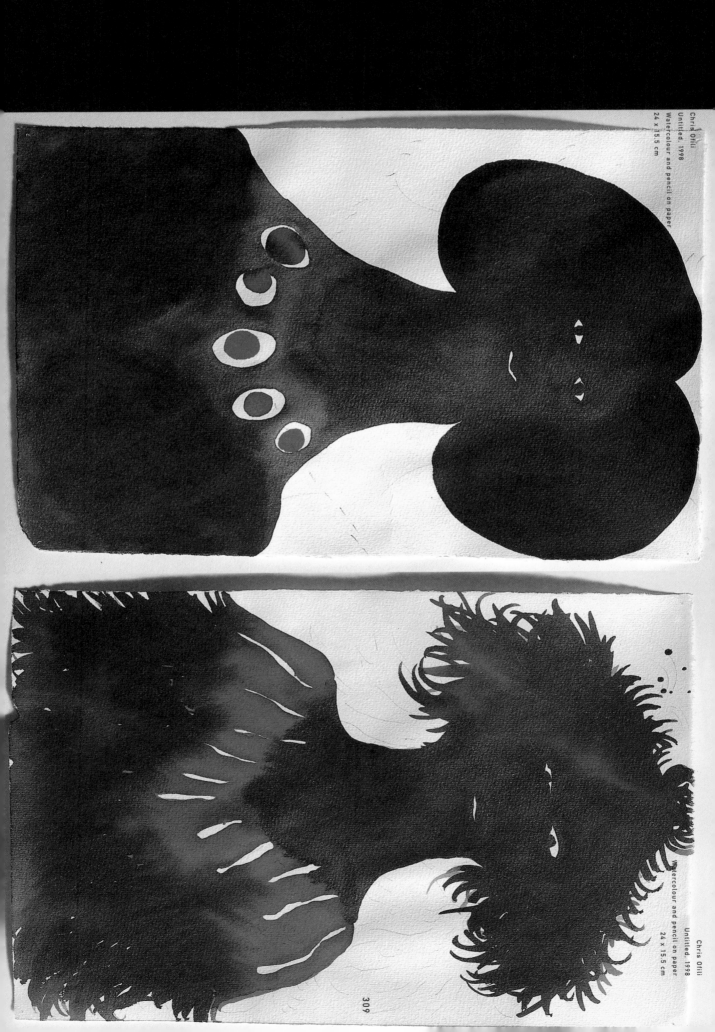

Chris Ofili
Untitled, 1998
Watercolour and pencil on paper
24 x 15.5 cm

Chris Ofili
Untitled, 1998
Watercolour and pencil on paper
24 x 15.5 cm

chris ofili

Born Manchester, England, 1968. Lives and works in London. selected solo exhibitions: 1991 'Paintings and Drawings', Kepler Gallery, London 1995 Gavin Brown's enterprise, New York 1996 Victoria Miro Gallery, London 1997 Contemporary Fine Art, Berlin 1998 Southampton City Art Gallery, England selected group exhibitions: 1989 Whitworth Young Contemporaries, Whitworth Art Gallery, Manchester 1993 'Shit Sale', Brick Lane, London; BT New Contemporaries, Cornerhouse Gallery, Manchester and tour 1995 'Brilliant! New Art from London', Walker Art Center, Minneapolis; Museum of Contemporary Art, Houston, Texas; 'Popocultural', Cabinet Gallery, London; Southampton City Art Gallery, England 1997 'Sensation: Young British Artists from the Saatchi Collection', Royal Academy of Arts, London selected bibliography: Stuart Morgan, 'The Elephant Man', *frieze* 1994 Adrian Searle, 'Going through the motions', in 'watch this face ... in the visual arts', *The Independent*, London, 27 December 1995 Roberta Smith, 'Chris Ofili at Gavin Brown's enter Herbert, "The rumour is ..."', *Dazed & Confused*, London, June; Louisa Buck, 'Fever Pitch: Letter from London', *Artforum*, New York, October; Louisa Buck, 'Works in Progress: Portraits of Five British Artists', *GQ*, London, December; Tim Hilton, 'The Best Painting in Britain', *The Independent on Sunday*, London, 17 November 1997 Louisa Buck, 'Openings: Chris Ofili', *Artforum*, New York, September; Sarah Kent et al., 'It's a Sensation! But is it art? Everything you need to know about the London art scene, but were afraid to ask', *Time Out*, 10-17 September

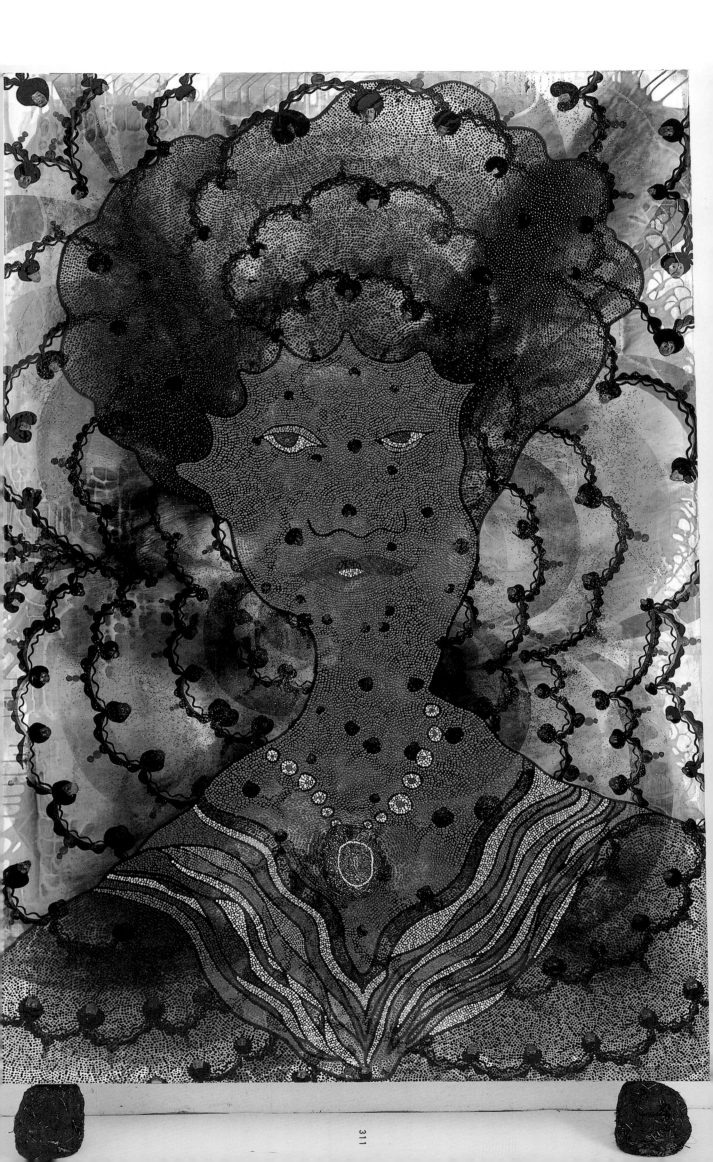

olu oguibe

If it were possible to envisage it, what would post-colonial art look like? According to current prescriptions, it would be the kind of art that seems always confined within its own boundaries; forever delineating its marginal space and status, very rarely effecting an open association with the world it engages. But of course, if such a notion as post-colonial art were permissible, it would necessarily have to be an art that exceeds its own sense of isolation and marginality; in other words, a non-victim aesthetic of encounters and experiences that sit tremulously on the edge between the global and local.

Olu Oguibe is one of those few artists whose practice has attempted to maintain a critical correspondence between the two spheres. He has produced work that is as varied as the media he has employed — most recently, video, slide projection, sound, CD-rom and photography. If he does not reject outright the collision between the global and local, post-colonial and metropolitan, contestatory or analytical, polemical or discursive, it is precisely because he sees the tension between these demarcations as an opportunity to engage with and to lay bare a complex and ironic situation.

Born in Nigeria, resident for a while in London and currently living in the United States, Oguibe has produced a body of work over the last decade that seems imbued with a perpetual sense of loss, alienation and abandonment. He has taken the unremitting traffic of violence in popular media as the subject of his most trenchant explorations and critiques, pointing out how such immersion inures us to this violence and inevitably destroys our ability to comprehend it within its historical context.

Most recently Oguibe has focused on the archive as a repository of both memory and its effacement. *The War Room*, 1997, a double slide projection accompanied by a soundtrack of Jimi Hendrix's 'Star Spangled Banner', presents an archive of twentieth-century violence. It is an archive that can never be complete, for new images of violence are ceaselessly being produced. In order to amass it, Oguibe meticulously researched and selected hundreds of the most frequently published photo-journalistic images spanning the last half-century. These range from Nazi rallies to photographs from Vietnam, Rwanda, Bosnia, Chile and Northern Ireland. Projected on a fragile curtain of rolls of tissue paper, the shaky, disembodied images are layered over each other in repetitive cycles standing for fragments of the decapitated, scarred and traumatized human body.

Hendrix' melancholic, weeping guitar version of the American national anthem reminds us that such powerful symbols of nationalism sometimes form the basis of the senseless employment of violence to achieve political agendas. With each vibrating panel of the projection surface, images rise and disappear like spectral figures, echoing their presence in our popular and historical consciousness as vivid memories of the twentieth century.

Okwui Enwezor

Olu Oguibe
Mementos, 1996
Plastic dolls, fabric, cardboard box,
adhesive tape
14 x 74 x 78 cm

olu oguibe

selected solo exhibitions: Born Aba, West Africa. 1964. Lives and works in New York and Tampa, Florida. 1988 "...unbind me". Didi Museum, Lagos. 1991 Olu Oguibe. Works and Words. Commonwealth Institute. London. 1992 A Gathering Fear. Drawings. Savannah Gallery, London. 1994 Roslyn Oxley 9 Gallery, Sydney. Songs for Catalina. Savannah Gallery, London.

selected group exhibitions: 1991 Original Prints from the 3rd Nsukka Workshop. Iwalewa Haus. Bayreuth, Germany. 1993 Mavambo N'dangani. Pitika Ntuli. Olu Oguibe. Open Air Sculpture Exhibition. Weaver's Field and Savannah Gallery London. Centre 181. London. 1994 Seen/Unseen. Bluecoat Gallery, Liverpool. '2. Friedberger Skulpturenpfad'. Friedberg, Germany. 1995 An Inside Story. African Art of Our Time. Setagaya Art Museum. Tokyo and tour. 1996 Seven Stories about Modern Art in Africa'. Kunsthalle, Sweden. Whitechapel Art Gallery, London. 'Hitch-Hiker'. Institute of Contemporary Arts. Johannesburg. 1997 Trade Routes. History and Geography. 2nd Johannesburg Biennale. 'Transforming the Crown. Asian and Caribbean Artists in Britain. 1966-1996'. Caribbean Cultural Center, New York and tour. 'The Poetics of Line. Seven Artists of the Nsukka Group'. National Museum of African Art. Washington DC

selected bibliography: 1990 Claudia Savelsberg. 'Suche nach der universellen Sprache'. Kurier. Bayreuth, Germany. 29 March 1991 Peter Townsend. 'Late Items'. Art Monthly. London. April. Henry Lydiate. James Odling-Smee. "F.'k". Art Monthly. May 1993 Anthony Ilona. 'Enchanting Child's Eyes Pathos'. Africa Events. London. October. David Lillington. 'Olu Oguibe'. Time Out. London. 11 August 1994 Andreas Schmidt. '"Schwarzkunstler" malt gerne den Rathausturm'. Friedberger Allgemeine. Friedberg, Germany. 28 April. Gernot Kirzl. 'Bilder, die festhalten.' Augsburger Allgemeine. Augsburg, Germany. 5 May. Julia Grunenberg. 'Ein Maler auf der Suche nach dem wahren Wesen der Dinge'. Friedberg Allgemeine. Friedberg, Germany. 10 May. Bronwyn Watson. 'Fighting injustice with art'. The Sydney Morning Herald. 3 August. 1995 Okwui Enwezor. 'Between Worlds. Postmodernism and African Artists in the Western Metropolis'. Atlantica. No. 12. Grand Canaries, Spain.

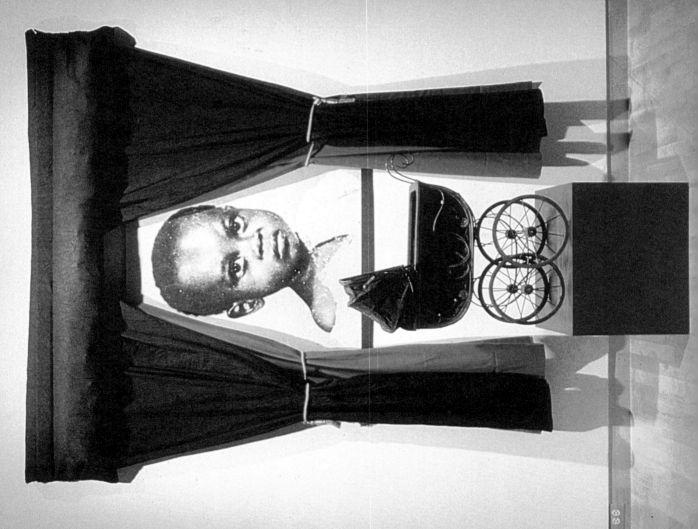

Olu Oguibe
Buggy. 1997
Fabric, antique buggy,
photographic print
274.5 x 152.5 x 122 cm

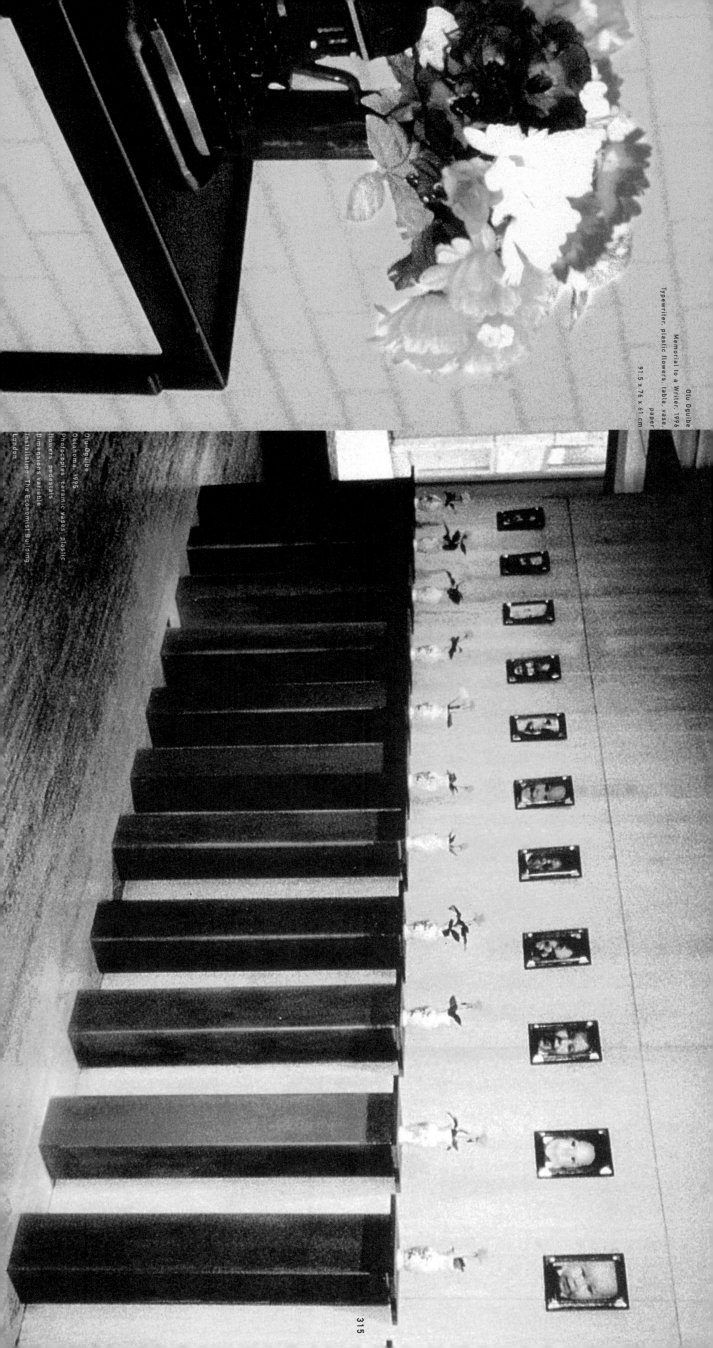

Olu Oguibe
Memorial to a Writer, 1996
Typewriter, plastic flowers, table, vase, paper
91.5 x 76 x 61 cm

Olu Oguibe
Oklahoma, 1995
Photocopies, ceramic vases, plastic flowers, pedestals
Dimensions variable
Installation, The Economist Building, London

Gabriel Orozco
La DS, 1993
Sutured car, metal, leather,
coated fabric
140 x 480 x 114 cm
Collection, Ministry of Culture, France

gabriel orozco

1 Thinking what to say about the work of Gabriel Orozco and how to say it, I have considered a variety of ways through which to convey the experience of work that presents itself to viewers under the contradictory terms of evanescence. I say 'contradictory' simply because as much as Orozco empties his work of any easily identifiable signs of facture, the prime strategy of his highly disciplined conceptual propositions is nonetheless the deconstruction of how we see things and images in the world. Hence, finding myself in a bind, I have opted to take a walk and perhaps thereby trace Orozco's footsteps. This is the way in which he brings his works alive – through the process of walking the city, purloining the most mundane aspects of the world and turning them into thinking pieces.

2 Stalking Orozco, I begin to learn what it must feel like to possess a mind that is so keenly aware of the minutiae of daily experience, a mind that recognizes substantiality in the solitary image of a weed growing between the cracks of the pavement, or greasy tyre tracks ensnarled in their own repetitious futility. I also learn that substantiality can be about what we always take for granted – even our own breath. His work *Recaptured Nature*, 1990, an oversized, inflated bicycle inner-tube, finds sculptural heft in the nothingness of breath. And he has strolled through the anonymous space of the global metropolis, rolling a ball of Plasticine through its streets (*Yielding Stone*, 1992). Walking the city, thinking of his work, one begins to develop the alarming habit of saying: 'Oh, that looks like an Orozco', or 'That could be an Orozco.'

3 As I think of all the things that make me respond so enthusiastically to an art that is about deflation, albeit one predicated on a muscular and trenchant analysis, it becomes clear that Orozco's works neither make direct reference to the world, nor transcribe an image of the world; rather, they seem to be consistently constructed as a set of correspondences between the referent and the image. So it seems that nothing could better exemplify the terms under which one may initiate a discussion of this work than to begin with the notion of 'the everyday'. Another way to think about his work is to relate it to fiction, for fiction – at its most compelling – builds on, in fact, *feeds* on its strange relationship to the real and the structural veracity of that phenomenon philosophers call 'truth'.

4 Lately, I've been thinking of Orozco as a kind of alchemist, a conjurer of dreams and shadow-plays that are cast upon the billowing, diaphanous fabric of everyday experience. It is his gift for making the insubstantial vibrate, leading us to that vertiginous zone between sleep and waking, the edge between consciousness and its disappearance, that makes his work such a wonderful companion for walking, breathing and thinking through the city.

Okwui Enwezor

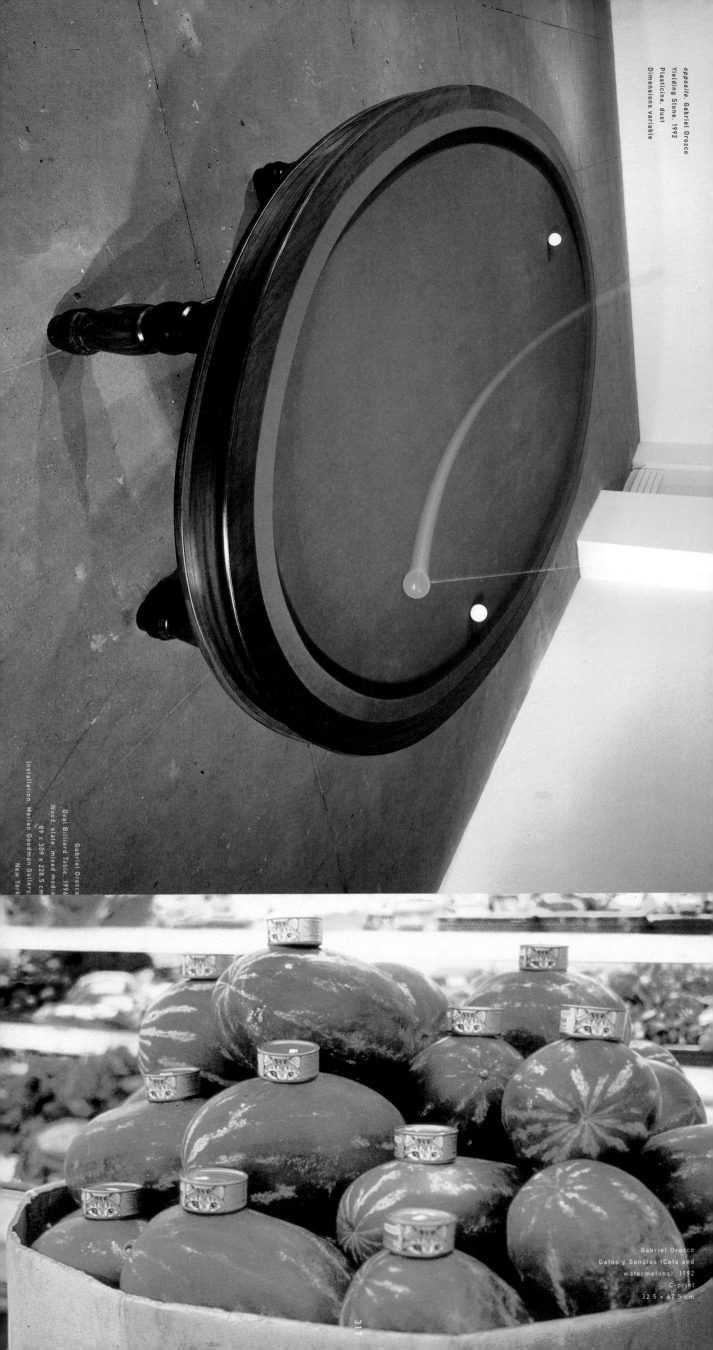

opposite, Gabriel Orozco
Yielding Stone, 1992
Plasticine, dust
Dimensions variable

Gabriel Orozco
Oval Billiard Table, 1996
Wood, slate, mixed media
89 x 309 x 228.5 cm
Installation, Marian Goodman Gallery,
New York

Gabriel Orozco
Gatos y Sandías (Cats and
watermelons), 1992
C-print
32.5 x 47.5 cm

gabriel orozco

Born Jalapa, Veracruz, Mexico, 1962. Lives and works in New York.

selected solo exhibitions: 1993 'Projects 41', The Museum of Modern Art, New York. 1994 Marian Goodman Gallery, New York. 1995 'Migrateurs', ARC, Musée d'Art Moderne de la Ville de Paris. 1996 Art Gallery of Ontario, Toronto; Institute of Contemporary Arts, London. 1997 'Gabriel Orozco: Recordings and Drawings', Stedelijk Museum, Amsterdam

selected group exhibitions: 1984 'Neográfica', Museo Universitario del Chopo, Mexico City. 1990 'Sculpture of the Americas into the Nineties', Museum of Modern Art of Latin America, Washington DC. 1993 XLV Venice Biennale. 1994 'The Epic and the Everyday: Contemporary Photographic Art', Hayward Gallery, London; 'Cocido y Crudo', Centro de Arte Reina Sofía, Madrid. 1996 Kwangju Biennale, South Korea; Galerie Chantal Crousel, Paris; 'Site of Being', Institute of Contemporary Art, Boston; 'Where is Abel, Thy Brother?', Zacheta National Gallery of Contemporary Art, Warsaw. 1997 Skulptur. Projekte Münster, Germany; Documenta X, Kassel; Gormann Biennial; Whitney Museum of American Art, New York. **selected hibiting-**

Gabriel Orozco
Elevador (Elevator), 1994
Altered elevator cabin
244 x 244 x 152.5 cm
Installation, Kunsthalle, Zurich, 1996

318

raphy: 1992 Jean Fisher, 'The "Bride" Stripped Bare, Even so ...', *Artforum*, New York, November 1993 Francesco Bonami, 'Gabriel Orozco', *Flash Art*, Milan, November; Francesco Bonami, 'Gabriel Orozco', *Flash Art*, Milan, Summer 1994 Jean-Pierre Criqui, 'Gabriel Orozco at Galerie Crousel-Robelin', *Artforum*, New York, March; Francesco Bonami, 'Gabriel Orozco', *Flash Art*, Milan, March/April; Claude Gintz, 'Orozco in Paris', *Parkett*, No 39, Zurich; Dan Cameron, 'Gabriel Orozco at Marian Goodman Gallery', *Artforum*, New York, November 1995 Miwon Kwon, 'The Fullness of Empty Containers', *frieze*, London, September/October 1996 Francesco Bonami, 'Back in Five Minutes', *Parkett*, No 48, Zurich; Catherine De Zegher, 'The Os of Orozco', *Parkett*, No 48, Zurich; Jean-Pierre Criqui, 'Like A Rolling Stone', *Artforum*, New York, April

Gabriel Orozco
Mesa con Arena
(Sand on table), 1992
Cibachrome
32 x 47.5 cm

this page: Jorge Pardo.
Pier. 1997.
Redwood, metal, cigarette vending
machine
Approx 1985 x 3925 x 325 cm.
Installation Skulptur. Projekte
Münster, Germany

320

jorge pardo

Pier. 1996–97. One of the underlying problems of the genre that touts itself as 'institutional critique' is the fact that, in many cases, the criticism is levelled at the very institution that has commissioned the project in the first place. This tinges the supposedly critical activity of the artist with the faint aroma of parody. Part of the problem in such cases stems from the functionality of the commissioned piece. The greater its degree of utility the more the artist becomes defined as the provider of a specialized service. This issue is given a particularly high profile among a large group of contemporary artists whose work explores situations inextricably linked with disciplines closely associated with functionality, such as design and architecture.

Jorge Pardo is part of this group. His *Pier*, conceived for the 1997 Skulptur. Projekte Münster, represents a particularly interesting proposition. On first impact, the work resembles functional sculpture, complete with direct references to modern architecture and furniture design. A wide pier made from light wood, it is situated on the Aase lake in Münster; at the end is a structure that can serve as a shelter, inside which is a cigarette machine. A pier is first and foremost a place where boats can moor, also providing a landing point for passengers. Pardo's 'pier', on the other hand, is completely useless. On the day I visited it, a group of youths sat on the steps of the shelter smoking and drinking beer. The wooden walls had been covered with the usual graffiti of erotic messages and telephone numbers. I even came across a heart, in ball-point pen, in which I could pick out the names of a couple of friends, both art critics. The view over the lake was calming and pleasant; there was nothing sublime, no trace of romanticism. It was calm, agreeable, relaxing.

The function of Pardo's *Pier* is to serve no function, to go against the grain of rationalist functionalism, the hallmark of an entire sector of modernity. Rather, it stimulates the eye and creates a moment of casual, disinterested contemplation. Serious meditation, for example, would be somewhat out of place on the *Pier*; one is more inclined to look absent-mindedly at the landscape in silence. In a sense, *Pier* should not even be called an artwork. It is less related to the notion of 'work' and to its instrumental connotations than to that of expense. It is a modest essay on aquatic *potlach*. Its critical function in the exhibition was not to have any function while stating the need to conceive of a dimension of excess as inseparably linked to artistic production.

Carlos Basualdo

Jorge Pardo
Le Corbusier Sofa, 1990
Welded copper pipes
66 x 162.5 x 76 cm

Jorge Pardo
Untitled, Lemon, Butterscotch and
Blood, 1995
Glass, light bulbs, cord
3 parts, 40.5 x 23 x 23 cm overall

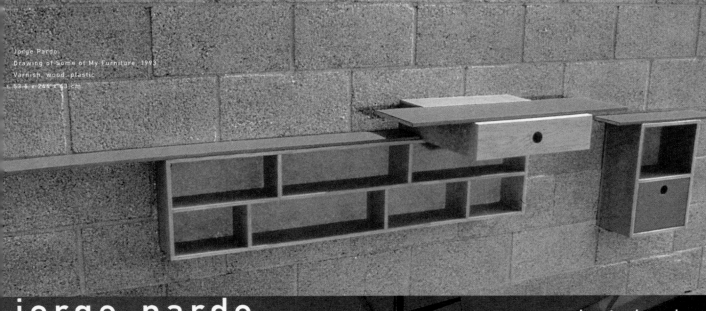

jorge pardo

Born Havana, 1963. Lives and works in Los Angeles. **selected solo exhibitions:** 1988 Bliss Gallery, Pasadena, California 1990 Petersburg Gallery, New York 1992 Terrain Gallery, San Francisco 1993 Person's Weekend Museum, Tokyo 1994 'One Component of the Work Is That the Show Will Have Many Titles, One of Them Being: MoCA Three Prints Per Second', Friedrich Petzel/Nina Borgmann, New York 1995 Borgmann Capitain Gallery, Cologne 1996 neugerriemschneider Gallery, Berlin 1997 Museum Boijmans Van Beuningen, Rotterdam; Museum of Contemporary Art, Chicago 1998 Museum of Contemporary Art, Los Angeles; Friedrich Petzel Gallery, New York **selected group exhibitions:** 1990 Luhring Augustine Hetzler, Santa Monica, California 1991 'Facing the Finish', Museum of Modern Art, San Francisco; Santa Barbara Contemporary Arts Forum, California 1992 'Gallery Artists Group Show', Thomas Solomon's Garage, Los Angeles; Mars Gallery, Tokyo 1993 'Backstage', Kunstverein, Hamburg; 'Displace', Michael Cohen Gallery, New York; 'California: North and South', Aspen Museum of Art, Colorado 1994 'Lost Paradise', Kunstraum, Vienna; 'Pure Beauty: Some Recent Work From Los Angeles', American Center, Paris, Museum of Contemporary Art, Los Angeles 1995 'Hawaii', Friedrich Petzel Gallery, New York; 'Alles was modern ist', Galerie Baerbel Graesslin, Frankfurt 1996 'Just Past: Contemporary and Permanent Collection 1975-1996', Museum of Contemporary Art, Los Angeles; 'Multiple Pleasure', Tanya Bonakdar Gallery, New York; 'Traffic', CAPC, Musée d'Art Contemporain, Bordeaux; 'wunderbar', Kunstverein, Hamburg 1997 'Assuming Positions', Institute of Contemporary Arts, London; 'Rooms with a View, Environments for Videos', Guggenheim Museum SoHo, New York; Skulptur, Projekte Münster, Germany **selected bibliography:** 1993 James Scarbourough, 'Jorge Pardo: Thomas Solomon's Garage', *Flash Art*, Milan, October 1994 Michael Cohen, 'Pachuco Style', *Flash Art*, Milan, May/June 1995 Christiane Schneider, 'Jorge Pardo', *frieze*, London, September/October 1996 Gregory Volk, 'Jorge Pardo at Friedrich Petzel', *Art in America*, New York, December; Miltos Manetas, 'Jorge Pardo', *Flash Art*, Milan, Summer 1997 Ulf Erdmann Ziegler, 'Open City: Report from Munster', *Art in America*, New York, September; Kate Bush, 'Design for Life', *frieze*, London, September/October; Benjamin H. B. Buchloh, 'Sculpture Projects in Munster', *Artforum*, New York, September; David Musgrave, 'Assuming Positions', *Art Monthly*, London, September; Bruce Hainley, 'Bastards of Modernity', *Artforum*, New York, March

marta maría pérez bravo

Marta María Pérez Bravo has been using black-and-white photography as the sole support for her work ever since the 1980s. From her early, small-format works to her larger-scale pieces of the 1990s, her output conveys all the energy of an artist who is willing to wager her most cherished and hallowed assets: her own body, the syncretism of her culture and her search for meaning and identity.

Pérez Bravo uses her body as an altar, a vessel, a gate, a temple or a bird-house, that is, as a vivid metaphor of her dreams and visions. For her, photography is a way of fixing symbolic scenarios, in which she constantly refers to the myths and rituals of Cuban witchcraft, known as *santería*. Although she uses votive offerings and other elements of popular lore, Pérez Bravo's approach is never folkloric. Rather, it is the fruit of meditation in which the significance of each object and each situation is intuitively re-invented. In order to give meaning to our personal vicissitudes and our relationship to the world. Indeed, Pérez Bravo's creations are no fiction or simulacrum; they are staged pieces which lend currency to interaction between the cultural, religious and personal spheres. While not entirely autobiographical, her work does occasionally feature personal experiences relived in the form of myths. In 1986, she became pregnant and gave birth to female twins, an experience she then associated with ancestral mythology and which endowed her life with magical meaning. Pérez Bravo does not delight in primitivist poetics for its ancestral content, but for the cherished truths it offers as a way of understanding and influencing the world, as an alternative to the logic derived strictly from rational thought processes.

Some of her images, notably *Para la Entrega (For the giving)*, 1994, in which she appears gathering the remains of her cropped hair in a white sheet, are charged with dramatism and symbolic density. This work is directly inspired by one of the initiatory rites of Cuban witchcraft, in which the initiate's hair is cut and jealously guarded until the end of their life, when their soul is delivered to Death. The series *Me pongo en sus manos (I place myself in his hands)*, 1996, comprising ten photographs, deals with the hope of the poor, stressing the optimism involved in trusting one's luck to achieve material success. This success does not consist solely of obtaining material wealth, but of successfully going through rites of passage and acquiring the inner strength required to continue making one's life bear fruit.

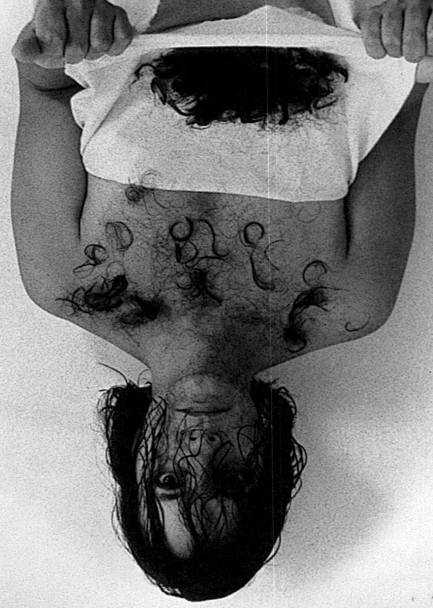

Marta María Pérez Bravo
Para la Entrega (For the giving), 1994
Black and white photograph
50 x 40 cm

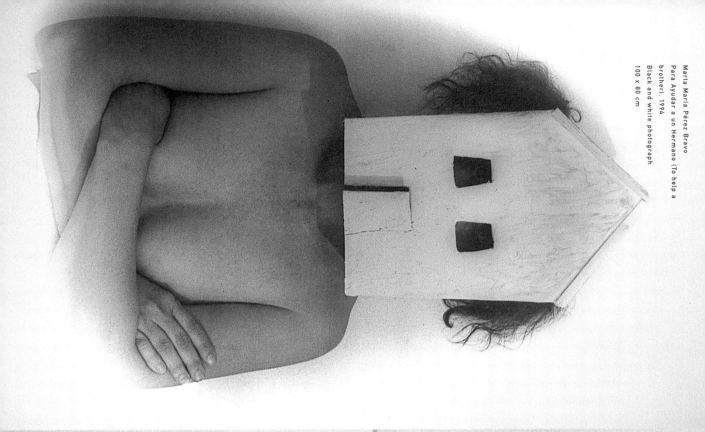

María María Pérez Bravo
Para Ayudar a un Hermano (To help a
brother), 1994
Black and white photograph
100 x 80 cm

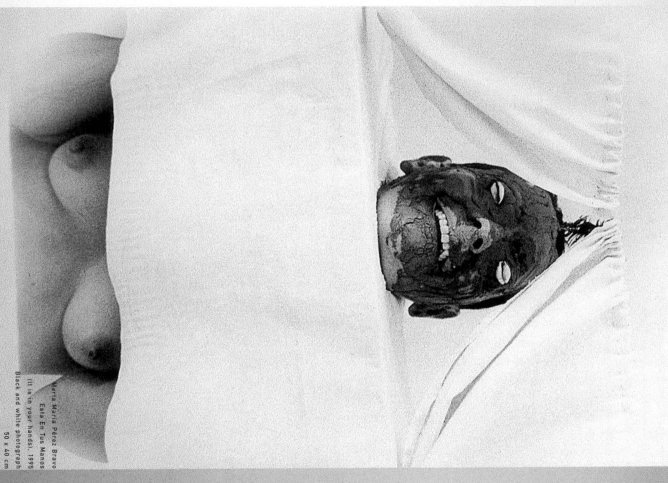

María María Pérez Bravo
Todo Lo Tengo, Todo Me Falta
(I've got everything,
I'm lacking everything), 1997
Black and white photograph
150 x 122 cm

María María Pérez Bravo
Esta En Tus Manos
(It is in your hands), 1995
Black and white photograph
50 x 40 cm

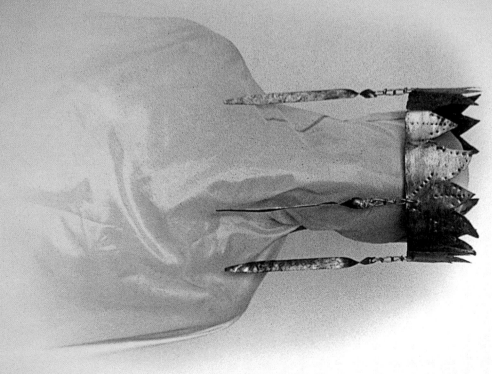

marta maría pérez bravo

Born Havana, 1959. Lives and works in Monterrey, Mexico.

selected solo exhibitions: 1982 'Drawings and Ceramics'. Casa de la Culture de Playa, Havana 1989 Museum of Art, Pori, Finland 1992 Galerie Le Lieu, Centre en Art Actuel, Quebec. 'Caminos'. Galerie Basta, Hamburg 1997 Throckmorton Fine Art Inc., New York

selected group exhibitions: 1979 'La Literatura en la Plastica'. Teatro Nacional, Havana 1981 'Four Young Creators'. National Museum and Palace of Fine Art, Havana 1984 1st Havana Biennial 1988 'Signs of Transition: '80s Art from Cuba'. Museum of Contemporary Hispanic Art, New York 1989 3rd Havana Biennial 1990 'Cuba OK'. Kunsthalle, Dusseldorf. São Paulo Biennial 1991 'The Nearest Edge of the World: Art and Cuba Now'. Bronx Museum, New York 1992 'Aktuelle Kubanische Kunst'. Kunstraum Farmsen, Hamburg 1993 First Internationale Graphic Biennale. Maastricht 1994 'Cartographies'. National Gallery, Ottawa and tour 1995 'Longing and Belonging: From the Faraway Nearby'. Site Santa Fe, New Mexico 1996 'NowHere'. Louisiana Museum, Humlebæk, Denmark 1997

selected bibliography: 1986 Lucy R. 'On life, beauty, translations and other difficulties'. 5th Istanbul Biennale

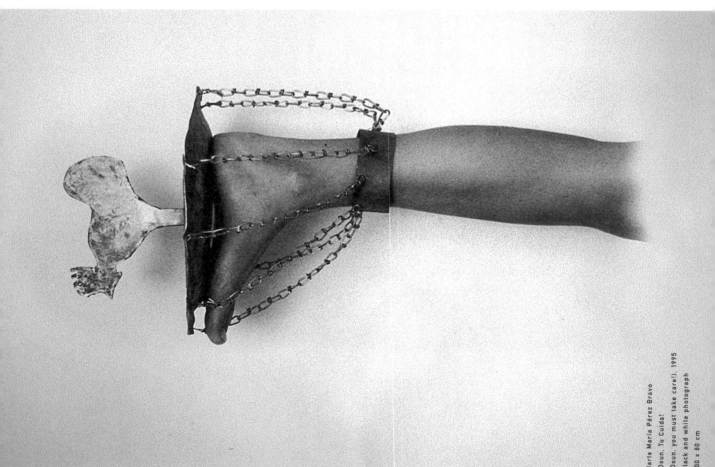

Marta María Pérez Bravo
¡Osun, Tu Cuida!
(Osun, you must take care!), 1995
Black and white photograph
100 x 80 cm

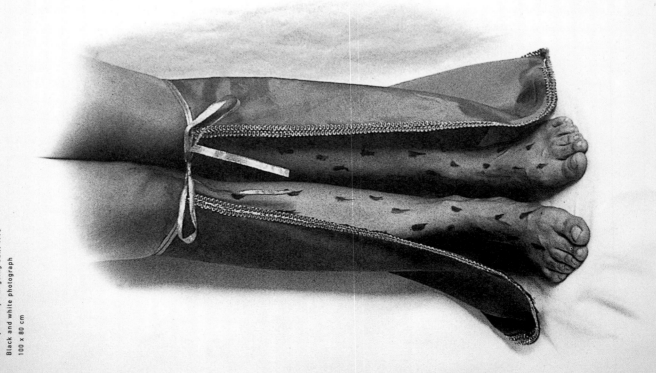

Marta María Pérez Bravo
Con Tu Ayuda Salgo
(With your help I'm going out), 1996
Black and white photograph
100 x 80 cm

Lippard, 'Made in USA: Art from Cuba', *Art in America*, New York, April 1992 Sebastian Lopez, 'Made in Havana', *Lapiz*, Madrid, May 1994 Karla Azen, 'Flash Mundo: International Latin America in Brief', *Flash Art*, Milan, October 1995 Natalia Bolivar Arostegui Arostegui, 'Las Formas de la Tierra', *Cambio 16*, Madrid, February; Garciela Kartofel, 'The Body as Object in Contemporary Photography', *Art Nexus*, Bogotá, Columbia, July/September; Gerardo Mosquera, 'Marta María Pérez Bravo: A Self-portrait of the Cosmos', Art Nexus, Bogotá, Columbia; Charles Hagan, 'Still/Life', *The New York Times*, 7 April 1997 Celia S. De Birbragher, 'Marta María Pérez Bravo', *Art Nexus*, Bogotá, Columbia, April/June; Rosa Martínez, 'Marta María Pérez Bravo', *Flash Art*, Milan, November/December; Yolanda Cañada, 'Historia de un Viaje: Artistas Cubanos en Europa', *Que y Donde*, Valencia, 26 May; Eva Teixidor Aranegui, 'Cubanos', *Posdata*, Valencia, 23 May 1998 John Angeline, 'Marta María Pérez Bravo', *Art Nexus*, Bogotá, Columbia, April/June

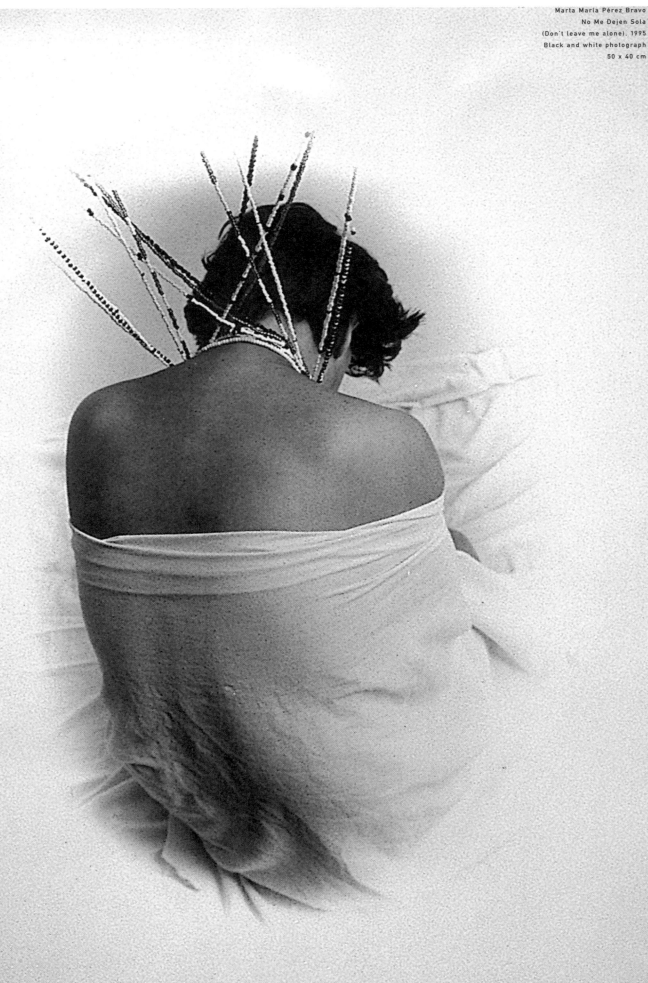

Marta María Pérez Bravo
'No Me Dejen Sola'
(Don't leave me alone), 1995
Black and white photograph
50 x 40 cm

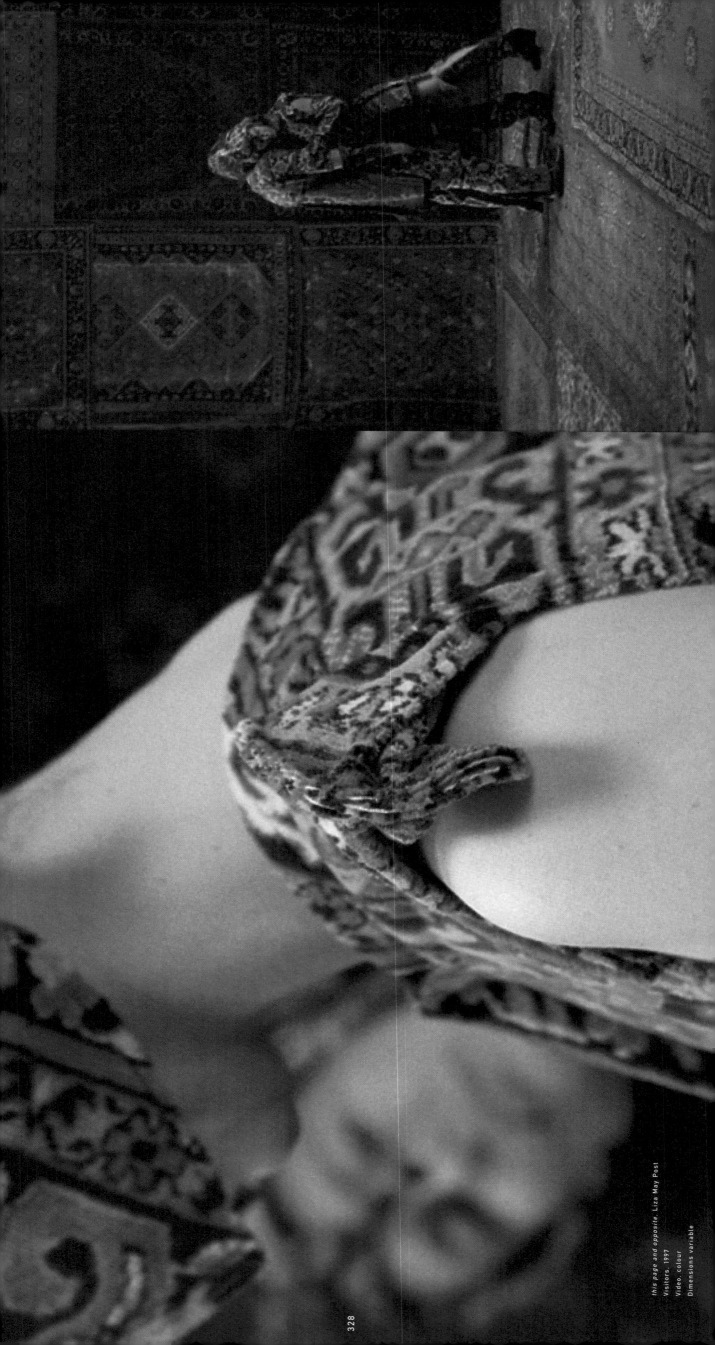

this page and opposite. Liza May Post
Visitors, 1997
Video, colour
Dimensions variable

liza may post

One of Liza May Post's most recent films, *Visitors*, 1997, is packed with the anxieties that invariably underpin this artist's work. Her photographs and videos speak of the inevitability of loneliness, the lack of communication, the impossibility of the desire to reach the other, the ephemeral and transitory nature of intimate relations. Also running through the narrative with delicate, poetic ambiguity are the connections between the self and the external environment. *Visitors* depicts a room in which not only the furniture, walls and floor, but also the protagonists have been covered in reddish tapestries, creating a strange fusion between background and figure. The artist explores the experience of the outsider as she tries to adjust to new situations. The impossibility of blending with one's surroundings and of completely adapting to what lies outside of one's own individuality is suggested by the glimpses of skin visible beneath the heavy costumes. A double, contrasting sentiment lies at the heart of this scenario: on the one hand, relief that such dissolving of the self cannot be completely achieved, on the other, the urge to continue to search for a foothold that will allow one to be totally integrated. Not insignificant is the fact that this film has been permanently installed in a hospital for mental patients in Holland.

The tension between the self and the exterior world is also present in *The Perfume Department*, 1996. In this video, Post lies rigidly motionless in the perfume department of a large department store as shoppers carry on their business around her, oblivious to her presence. It is an allusion to the need to create barriers around oneself, whether in a bid to protect oneself or in an attempt to find one's way.

In *Shadow*, 1996, the shadow is used as a metaphor for negative obsessions, referring to the potential to transform the darkness into something positive, and suggesting that we can learn from it rather than being haunted by it. The work also implies an awareness of the fact that help can be a form of control.

In Post's works, time is strangely suspended and the settings are rife with conflict. Faces are hidden, anonymous, allowing us to project ourselves onto the characters and the situations represented. In these staged re-enactments, Post brings about the gradual transformation of our emotional relationship with the world and our perception of reality.

Rosa Martínez

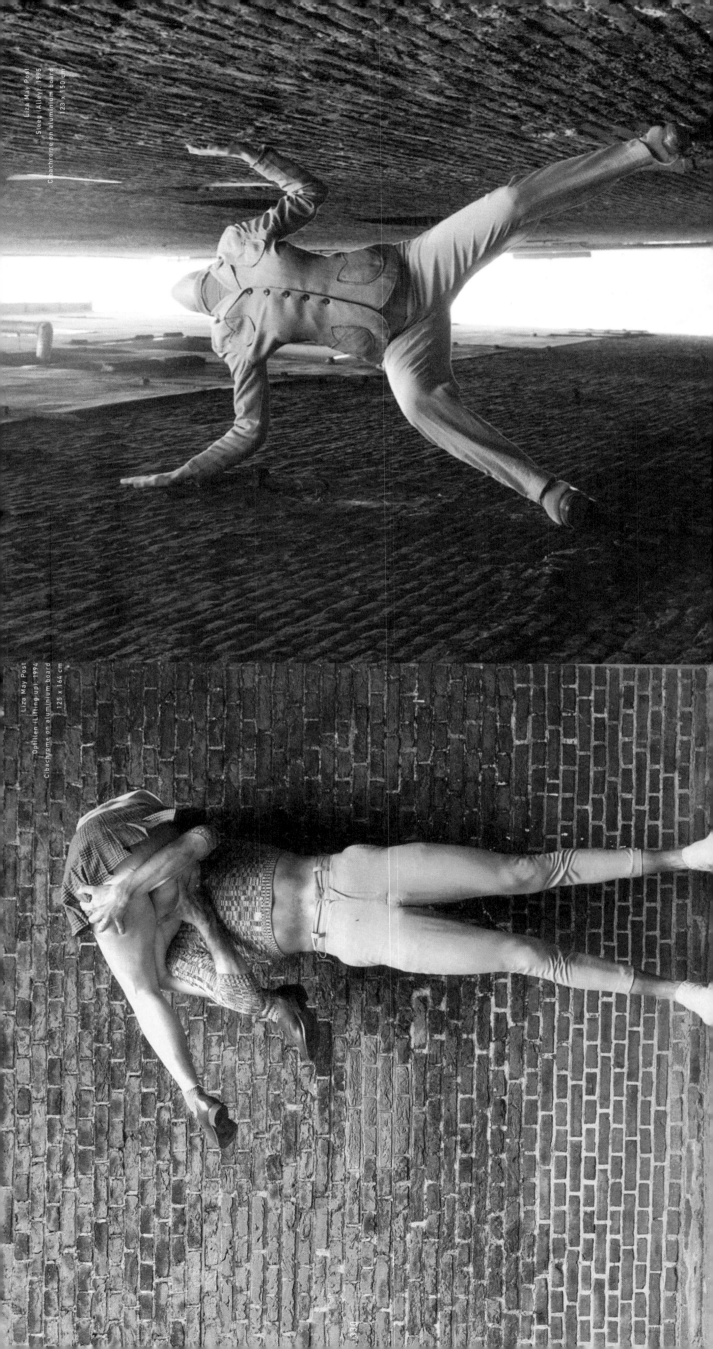

Liza May Post
The Perfume Department, 1996
Colour photograph on aluminium
140 x 140 cm

liza may post
Born Amsterdam, 1965. Lives and works in Amsterdam. **selected solo exhibitions:** 1996 Anthony d'Offay Gallery, London; 'Migrateurs', ARC, Musée d'Art Moderne de la Ville de Paris 1997 Espace Jules Vergne, Bretigny-sur-Orge, France **selected group exhibitions:** 1993 'Morgen Gemaakt', Arti et Amicitiae, Amsterdam, De Achterstraat, Hoorn 1994 'Seven jonge kunstenaars', Nouvelles Images Gallery, The Hague; 'Het Zevende Museum', The Hague 1995 'Une proposition de Bart Cassiman', Galerie Nelson, Paris; Fons Welters Gallery, Amsterdam; XLVI Venice Biennale; 'Call of the Wild', Transmission Gallery, Glasgow 1996 'Timing', De Appel, Amsterdam; 'Something Else', Exmouth Market, London; Manifesta 1, Rotterdam 1997 'Belladonna', Institute of Contemporary Arts, London; 'Ein stuck von Himmel', Kunsthalle Nürnberg Germany, Cornerhouse, Manchester; 'On life, beauty, translations and other difficulties', 5th Istanbul Biennale **selected bibliography:** 1995 Anna Tilroe, *NRC-Handelsblad*, Rotterdam, 16 June; Cornel Bierens, 'Onder anderen in Venetië', *Metropolis M*, No 3, Utrecht; Sjoukje van der Meulen, Max Bruinsma, 'Il fiore dell'arte', *Metropolis M*, No 4, Utrecht; 1996 Max Bruinsma, 'Amsterdam Poster Project', *Affiche*, Amsterdam, January; Elly Stegeman, 'Disappearer', *Metropolis M*, No 3, Utrecht; Janneke Wesseling, 'Steeds die gepoetste shoenen', *NRC-Handelsblad*, Rotterdam, 29 November 1997 Christoph Blase, 'Sehnsuchte verspielt', *Frankfurter Allgemeiner*, Frankfurt, 1 April; Collier Schorr, 'Still Ill', *frieze*, London, June/August

Liza May Post
Bound, 1996
Colour photograph mounted
on aluminium
148 x 150 cm

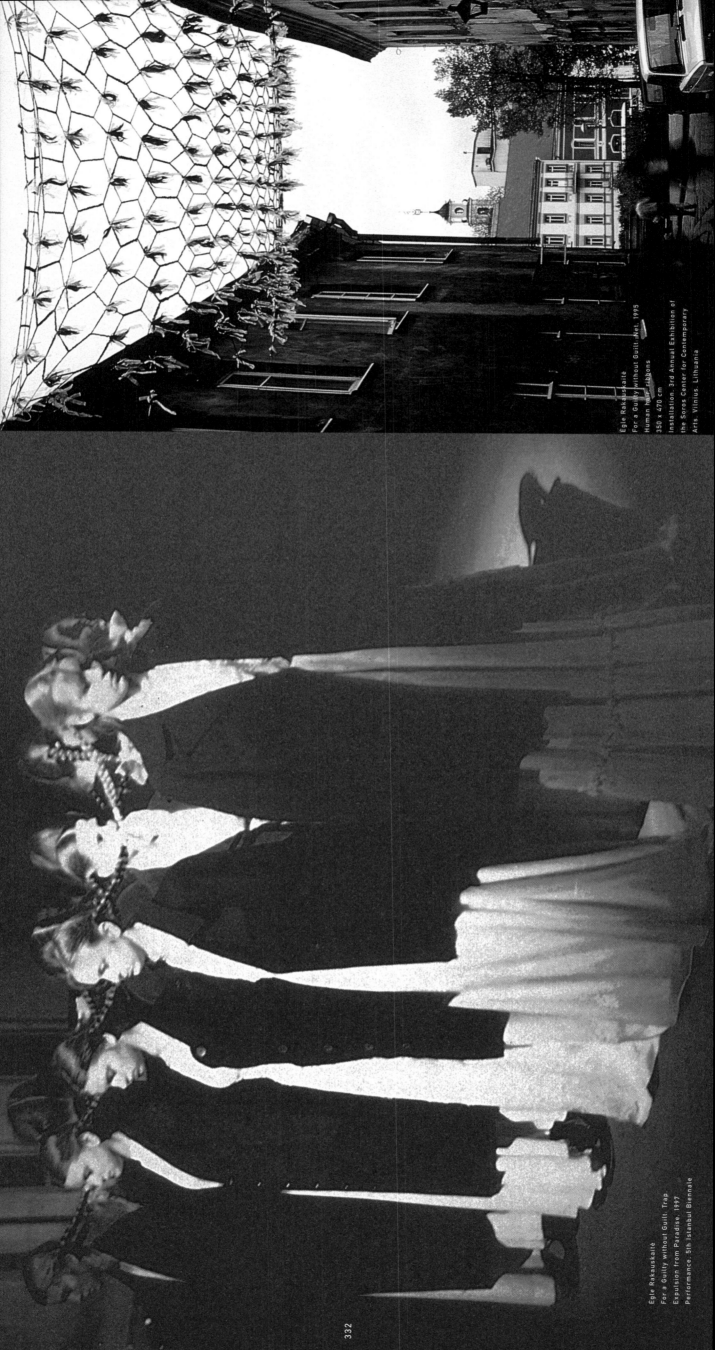

Eglė Rakauskaitė
For a Guilty without Guilt: Net. 1995
Human hair, ribbons
350 x 470 cm
Installation. 3rd Annual Exhibition of
the Soros Center for Contemporary
Arts. Vilnius. Lithuania

Eglė Rakauskaitė
For a Guilty without Guilt: Trap.
Expulsion from Paradise. 1997
Performance. 5th Istanbul Biennale

332

ėgle rakauskaitė

The art of Ėgle Rakauskaitė cannot be slotted into any particular category, though some of her most outstanding works have been sculptures and performances. Like many artists of her generation, Rakauskaitė uses a diverse range of materials. For her series of *Chocolate Crucifixes*, 1994, for example, chocolate was her chosen medium, while *Fur Coat for a Child*, 1996, was made from human hair. She has also made works involving women as living sculptures, and the female body often provides the prime referent in her work. *Hairy*, 1994, was her first work using human hair, which she knitted into a garment for a fashion model that covered the whole body except for those parts where natural hair grows, which were carefully shaved. The first piece in an ongoing series of dresses was *To Virginia*, created in 1994, using dried jasmine flowers. The artist has decided to keep on making other dresses until the flowers in her first dress have wilted and died. The process of disappearance and loss is an important concept in Rakauskaitė's work.

She started exhibiting publicly in 1995, participating in a site-specific project at the Soros Centre for Contemporary Art, Vilnius. The work she presented there, *For a Guilty without Guilt*, consisted of two parts: *Trap. Expulsion from Paradise* and *Net*. *Net* is a web of plaited human hair complete with white ribbons; this was stretched between two houses in a street of the former Jewish ghetto in Vilnius. In *Trap* ... , a group of adolescent girls, dressed in white wedding gowns under heavy black overcoats, were tied together by their hair. Each one was armed with a pair of scissors, which they used to cut the ribbons connecting their plaits.

The town of Vilnius still harbours painful memories of the persecution carried out in the Jewish ghetto, and *For a Guilty without Guilt* goes beyond the allusion of its first impact – the loss of virginity – to symbolize the suffering, loss and dreams of Eastern Europe. Above all, it refers to issues of guilt and truth. It calls to mind a mythical past, a paradise lost, and it is precisely this nostalgic emphasis that accentuates the suffering in the present.

Trap. Expulsion from Paradise, explores the connotations of the idea of 'virginity'. As Rakauskaitė explains, 'in Lithuanian, one of the oldest Indo-European languages, the word "virginity" comes from a word indicating the absence of guilt, while in the Catholic consciousness, even birth is associated with pain and natural "sin"'. When *Trap* ... was presented in 1997 in the Orthodox church of Saint Irene in Istanbul, the interpretation of the loss of virginity as something associated with guilt, punishment and expulsion from paradise took on a whole new dimension.

Rosa Martínez

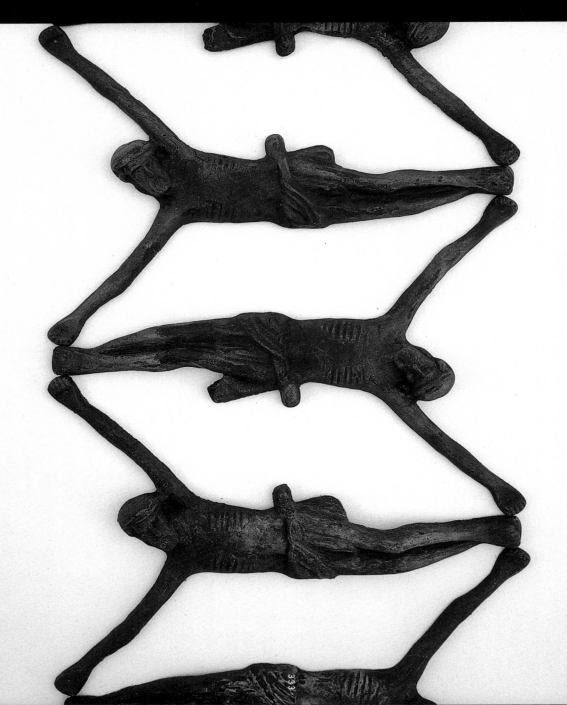

Ėgle Rakauskaitė
Chocolate Crucifixes, 1994
Chocolate
h. 42 cm each

333

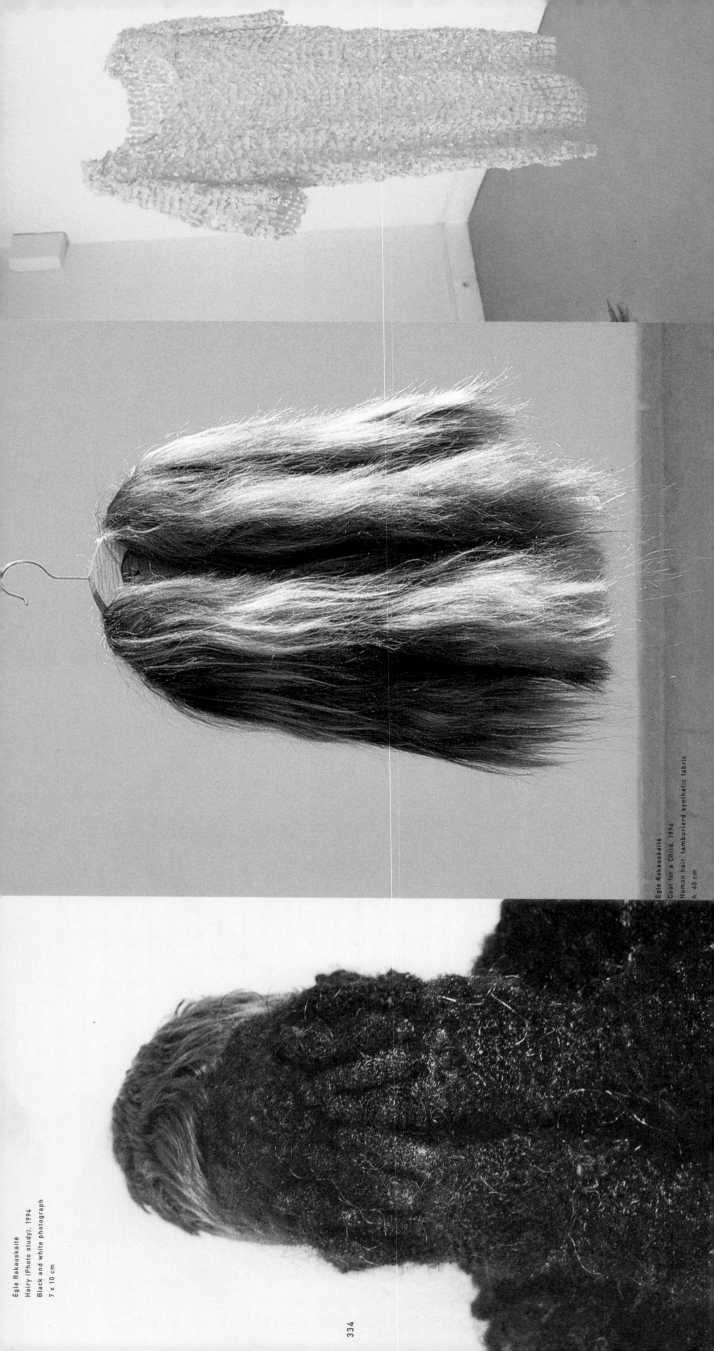

Ėgle Rakauskaitė
Hairy (Photo study), 1994
Black and white photograph
7 x 10 cm

Ėgle Rakauskaitė
Coat for a Child, 1996
Human hair, lamburierd synthetic fabric
h. 60 cm

334

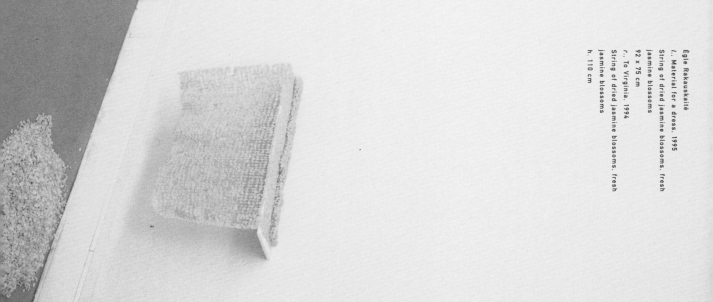

Ėgle Rakauskaitė
l., Material for a dress, 1995
String of dried jasmine blossoms, fresh
jasmine blossoms
92 x 75 cm
r., To Virginia, 1994
String of dried jasmine blossoms, fresh
jasmine blossoms
h. 110 cm

ėgle rakauskaitė

Born Vilnius, Lithuania, 1967. Lives and works in Vilnius, Lithuania. **selected group exhibitions:** 1994 Vilnius/Oslo, UKS, Oslo 1995 'Recent Documents, New Tendencies in Lithuanian Art', Balzekas Museum, Chicago; '1995: Art in Lithuania', Contemporary Art Centre, Vilnius, Lithuania 1997 'On life, beauty, translations and other difficulties', 5th Istanbul Biennale; 'Grosse Kunst Ausstellung Düsseldorf NRW', Kunstpalast, Dusseldorf **selected bibliography:** 1995 *Recent Documents, New Tendencies in Lithuanian Art,* Balzekas Museum, Chicago; *Joan of Arc: Eight Commentaries,* Centre for Contemporary Art, Vilnius, Lithuania; *Mundane Language,* Center for Contemporary Arts, Vilnius, Lithuania 1996 *Change of Rules: Tools/Frames/Parts,* Art Hall, Södertälje, Sweden; *Personal Time, Art of Estonia, Latvia and Lithuania 1945–1995,* Zacheta Gallery of Contemporary Art, Warsaw; *Nova Litva (New Lithuania),* State Academy of Fine Arts, Gdansk, Poland 1997 *5th International Istanbul Biennial,* The Istanbul Foundation for Culture and Arts, Istanbul; *Grosse Kunst Ausstellung Düsseldorf NRW 1997,* Kunstpalast, Dusseldorf, Germany; *Footnotes,* The Reykjavik Municipal Art Museum, Reykjavik, Iceland; *Dialoghi Lituani/Lithuanian Dialogues,* Stacione Marittima, Trieste, Italy

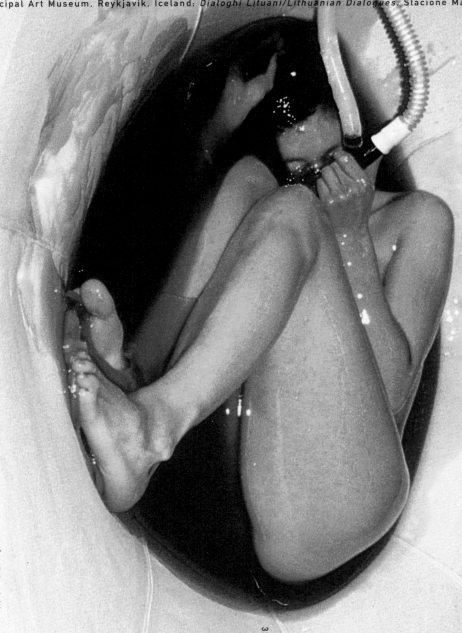

Ėgle Rakauskaitė
In Honey, 1996
Metal, honey, rubber, cotton bedsheet,
video monitor, 30 min, video recording
400 x 400 x 250 cm overall
Installation, Municipal Art Museum,
Reykjavik, Iceland, 1997

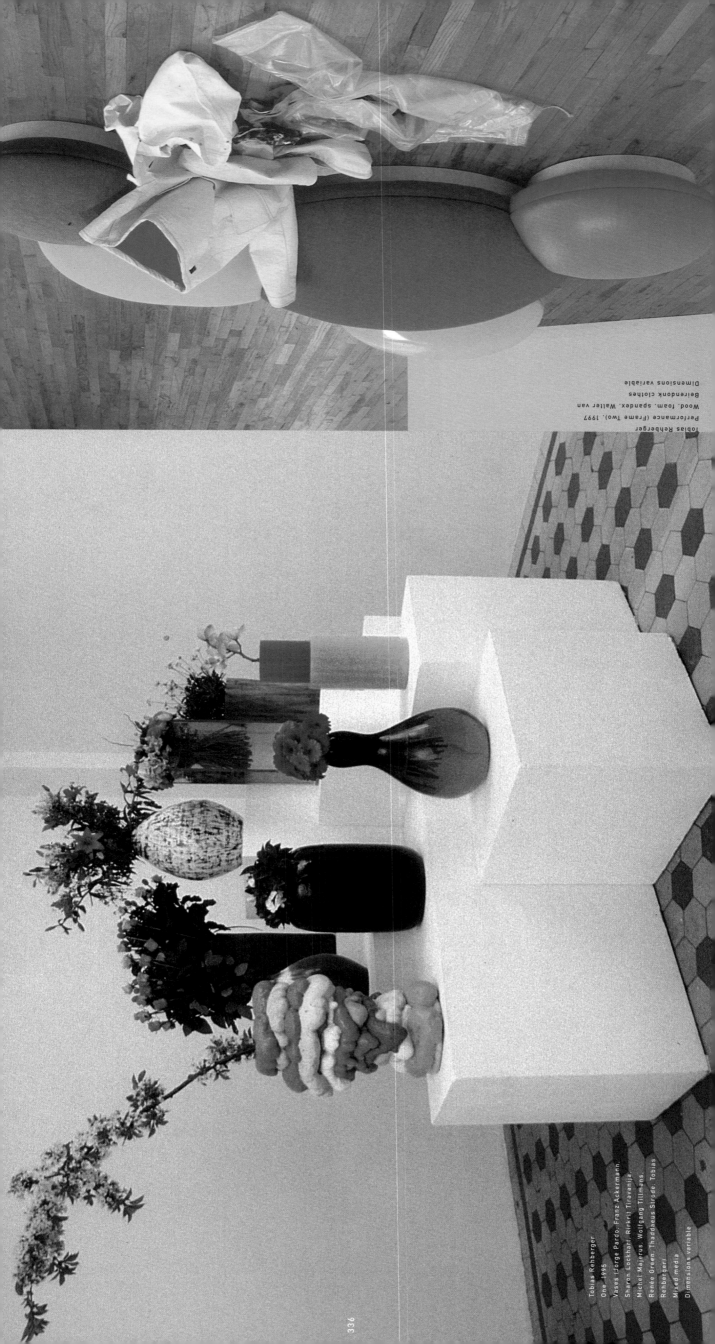

Tobias Rehberger
One, 1995
Vases (Jorge Pardo, Franz Ackermann,
Sharon Lockhart, Rirkrit Tiravanija,
Michel Majerus, Wolfgang Tillmans,
Renée Green, Thaddaeus Strode, Tobias
Rehberger)
Mixed media
Dimensions variable

Tobias Rehberger
Performance (Frame Two), 1997
Wood, foam, spandex, Walter van
Beirendonck clothes
Dimensions variable

tobias rehberger

The distinction between applied and fine art has recently become increasingly blurred, and is now being completely obfuscated by a generation of artists who have stepped into the realm of design and communication to create a new set of tools with which to handle the art fetish. Tobias Rehberger approaches art from the point of view of the objects that surround it.

His works are carefully designed conceptual footnotes, often self-quotations, which refer to the space that contains them. Working in an almost neo-classical way, he applies ideal dimensions to his models. A work that encapsulates this approach is *Campo*, a series of vases that he designed and fabricated for each of the artists who had been invited to the exhibition 'Campo 6: Il Villagio Spirale', Galleria d'Arte Moderna e Contemporanea, Turin, 1996. The idea for each vase came from Rehberger's interpretation of the work of the artist in question, and his knowledge of their personality. He then invited each of the artists to bring a bunch of flowers to the opening party, which he displayed in their respective vases. For 'Truce: Echoes of Art in an Age of Endless Conclusions', Site Santa Fe, New Mexico, 1997, Rehberger designed a series of different seats for the audience to sit on while viewing particular works during their visit to the exhibition.

But Rehberger's work is not always so public-friendly. Often, his intervention is more aggressive and the work disappears within the concept that generated it. In Manifesta 1, Amsterdam, 1996, for example, he worked with a fashion designer to create clothes that would be discreetly modelled during the exhibition. In this way he diluted the impact of his work: the crowd of visitors searched for it, unaware that it was all around them. At the Venice Biennale of 1997, he designed a set of underwear for the guards, who were instructed to reveal it at the visitor's request. Though the union protested, the work went ahead as planned.

In presenting subtle elements of our aesthetic habits, Rehberger attempts to strip the art space of its role as holy shrine. The garment projects underline the possibility of creating a subtext that focuses on re-negotiating contemporary art practice and its assumptions. Recently, Rehberger has made two works – *Missed Light*, 1997 and *Untitled, Performance 1, Performance 2, Performance 3*, 1997 – in two rooms of the Frederich Pretzel Gallery, New York, around the idea of video and performance. Each room was so empty of content, however, that the spaces were left floating in a kind of absence of action. In one room was a stage, upon which were some designer clothes, a sort of snail's trail, or mere signifier, of the concept of performance. In the other space a platform/bed was surrounded by three imageless, blue screens. The question Rehberger asks is: how can we develop a clearer, new language that will involve not only individual aesthetic elements, but will also activate the surrounding architecture, the viewer's experience and the artist's vision in a rhythmic harmony that will allow all of the participants to develop their own personal dimension?

Francesco Bonami

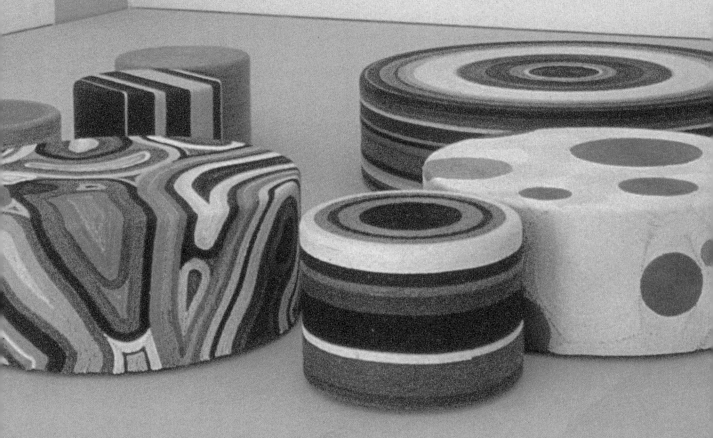

Tobias Rehberger
'Christian', Sitzgelegenheit, 1996
Wood, cardboard, jute
7 parts, ø 50 cm, ø 100 cm, Ø 170 cm

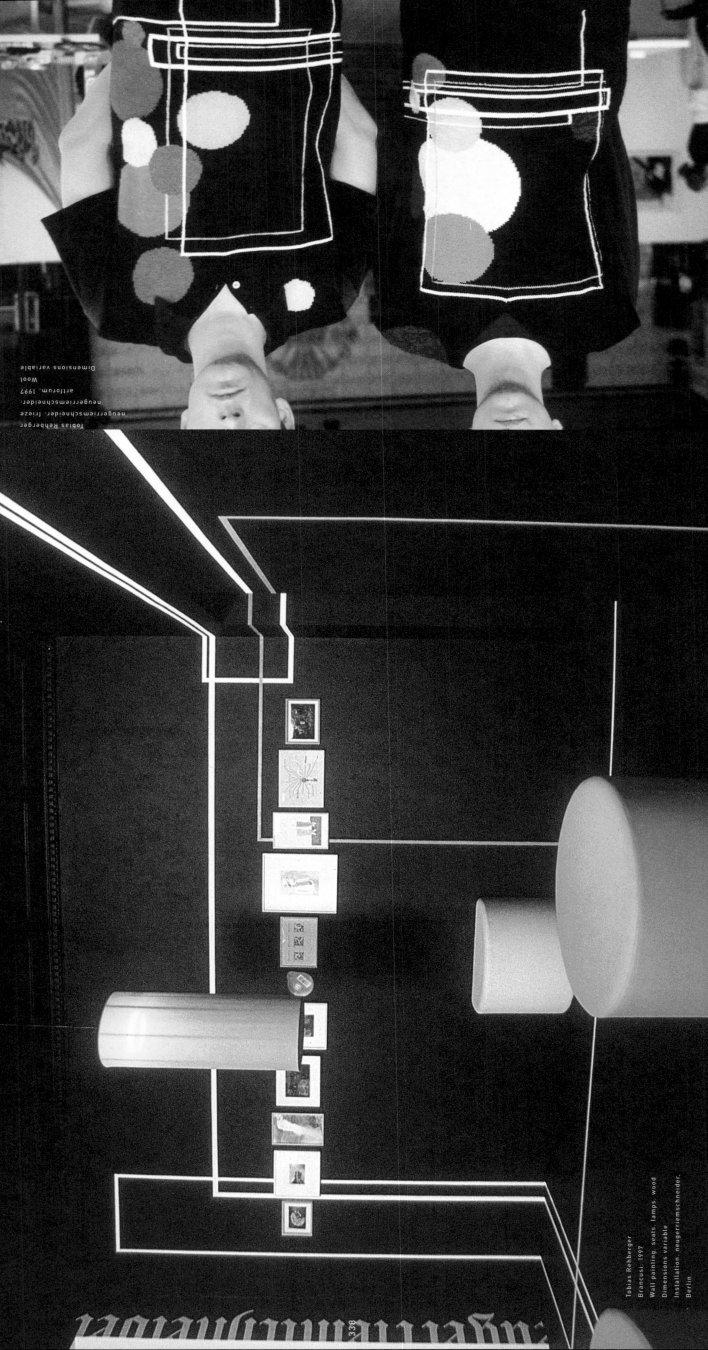

Tobias Rehberger
neugerriemschneider, frieze
artforum, 1997
Wool
Dimensions variable

Tobias Rehberger
Brancusi, 1997
Wall painting, seats, lamps, wood
Dimensions variable
Installation, neugerriemschneider,
Berlin

338

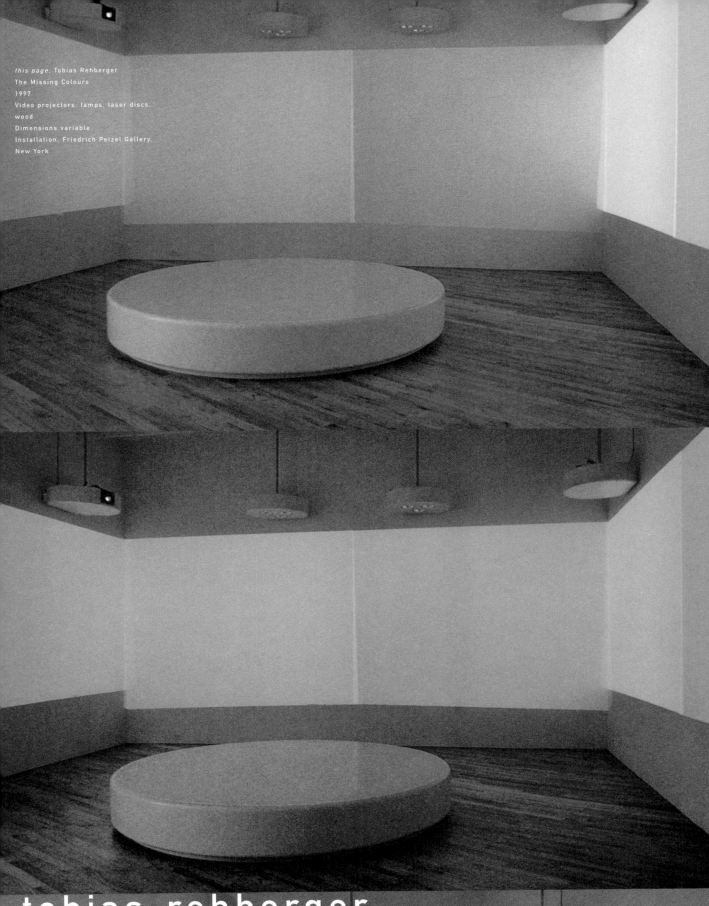

tobias rehberger
Born 1966 Esslingen, Neckar. Lives and works in Frankfurt.

selected solo exhibitions: 1992 '9 Skulpturen', Wohnung K König, Frankfurt 1994 'Rehberherst', Gallerie Bärbel Grässlin, Frankfurt 1995 'one', neugerriemschneider, Berlin; 'Cancelled Projects', Museum Fridericianum, Kassel, Germany 1996 'Suggestions from the Visitors of the Shows #74 and #75', Porticus, Frankfurt 1997 'Anastasia', Friedrich Petzel Gallery, New York **selected group exhibitions:** 'Virtuosen vor dem Berg', Galerie Grässlin/Erhardt, Frankfurt 1992 'Qui, quoi, où?', ARC, Musée d'Arte Moderne de la Ville de Paris 1994 'WM Karaoke', Portikus, Frankfurt 1995 'Filmcuts', neugerriemschneider, Berlin 1996 'Der Umbau Raum', Künstlerhaus Stuttgart; 'Something Changed', Helga Maria Klosterfelde, Hamburg; Manifesta 1, Rotterdam; 'Campo 6, Il Villagio Spirale', Galleria Civica d'Arte Contemporanea e Moderna, Turin, Bonnefantenmuseum, Maastricht 1997 'Rooms with a View: Environments for Video', Guggenheim Museum SoHo, New York; Skulptur. Projekte Münster, Germany; XLVII Venice Biennale; 'Assuming Positions', Institute of Contemporary Arts, London; 'Truce: Echoes of Art in an Age of Endless Conclusions', Site Santa Fe, New Mexico **selected bibliography:** 1995 Martin Pesch, 'Tobias Rehberger', *artist*, Bremen, April; Martin Pesch, 'Gegen die ganz grosse Pinselschwingerei', *Die Tagenszeitung*, Berlin, 2 April 1996 Martin Pesch, 'Tobias Rehberger', *frieze*, London, July/August; Eva Karcher, 'Die Vase ist ein Bild vom Freund', *art*, Hamburg, May 1997 Kaspar König, 'Tobias Rehberger', *Fama & Fortune Bulletin*, No 20, Vienna; Carl Freedman, 'Things in Proportion', *frieze*, London, March/April; Verena Kuni, 'Das Museum als Möbelhaus', *neue bildende kunst*, Berlin, February/March; Yilmaz Dziewior, 'Tobias Rehberger', *Artforum*, New York, January; Martin Pesch, 'Skulptur. Projekte Münster', *frieze*, London, September/October 1998 Joshua Decter, 'Tobias Ruhberger', *Artforum*, New York, February

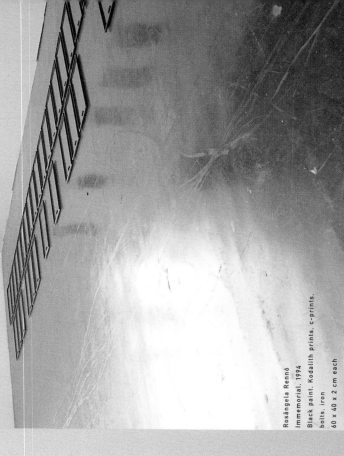

Rosângela Rennó
Immemorial, 1994
Black paint, Kodalith prints, c-prints,
bolts, iron
60 x 40 x 2 cm each

A forty-four-year-old kiss is the subject of a

complicated French lawsuit. A sexagenarian

couple is claiming rights to a 1950 photograph

taken by F.F. on a Paris street. The picture has

been seen all over the world. Now Y.X. and Y.X.

want to remove it from circulation and receive

royalties from its commercialization. The couple

feels that they were caught unaware by F.F.

during a moment of newlywed happiness and

want to retain the rights over that moment.

Rosângela Rennó
Cicatriz (Scar), 1996
Photographs laminated on RC-paper,
texts carved in drywalls
Dimensions variable
Installation, Museum of Contemporary
Art, Los Angeles
Collections, Museum of Contemporary
Art, Los Angeles; Giberto
Chateaubriand/Museu de Arte Moderna
de Rio de Janeiro; Museu de Art de
Brasilia; Lombard Freid Gallery,
New York

rosângela rennó

Although most of Rosângela Rennó's work is photographically based, she rarely, if ever, uses a camera to produce it. Instead, she spends a great deal of her time searching out official and unofficial archives, tracing the history of photography in her native Brazil. She tends to be most interested in the hidden narrative behind the deployment of photography in cases where the subject had little or no say over the outcome of the picture (police and prison archives, for example). In this way, Rennó's work addresses both the impossibility of collective memory as well as the ubiquitous nature of the innumerable devices that we have developed to contain it. Since her subjects have often found themselves at the wrong end of the police or penal system, it is not surprising to find a continuous undercurrent of violence in Rennó's work, especially in the contrast that she brings to light between the one who holds the camera and the one whose image is left behind. In some of her works of the mid 1990s, Rennó reinforced the anonymous aspect of the photographic subjects by not allowing her viewers to identify, recognize or otherwise examine the individuals depicted. Silhouettes, outlines, blurry and out-of-focus faces served to re-instate whatever privacy the photographic procedure had taken away. On the one hand, Rennó seems to have been deeply engaged by the visual qualities of these generally old and semi-anonymous photographs, where little, if any, effort went into making an image that could justifiably be preserved by posterity. At the same time, Rennó became interested in the appropriation of textual fragments, often taken from sensationalistic magazines, which were much more explicit about the de-humanizing motives behind their relentless pursuit of stars and royalty. Brought together, these contrasting sources serve as a double indictment of the social forces that produce them; at the same time they insist on a critical openness towards the materials themselves, as if to dispose of them too quickly would be akin to allowing those same social forces to proliferate.

In recent years, Rennó has chosen to emphasize photo-documentation of the incarcerated, most movingly in a series devoted to the tattoos identifying male prisoners as members of gangs. Her ability to draw out the most unexpected level of identification between her subjects and her viewers, who share little in common, has not diminished Rennó's deeper investigation into the ways in which a society undervalues its members. Seeing them blown up to several times their size, we cannot resist experiencing the flesh of the prisoner as a kind of painterly background onto which a paradoxical mark has been stamped. Fulfilling the violent parameters of the story, this mark both enables its bearer to become part of a group, and more or less guarantees that everything he experiences outside of that group serves to drive him deeper into its fatal embrace.

Dan Cameron

Rosângela Rennó
w/t (from Vulgo/Atlas series), 1997
Laminated digital Cibachrome print
120 x 110 cm
Collection: Museo Nacional Centro de
Arte Reina Sofía, Madrid

Rosângela Rennó
United States, 1997
Electrostatic print on paper,
auto-adhesive vinyl texts on glass,
16 parts, 300 x 3500 cm overall

rosângela rennó

Born Belo Horizonte, Brazil, 1962. Lives and works in Rio de Janeiro. **selected solo exhibitions:** 1989 'Anti-cinema — Veleidades Fotográficas', Sala Corpo de Exposições, Belo Horizonte, Brazil 1991 'A Identidale em Jogo', Centro Cultural, São Paulo 1994 'Humorais', Galeria de Arte do IBEU-Copacabana, Rio de Janeiro 1995 'In Oblivionem (no landScape)', De Appel, Amsterdam 1996 'Cicatriz', Museum of Contemporary Art, Los Angeles 1997 Galeria Luis Adelantado, Valencia, Spain 1998 Lombard Freid Gallery, New York; Australian Centre for Photography, Sydney **selected group exhibitions:** 1985 'Desenhos & Outras Intoxicações', Galeria do IAB, Belo Horizonte, Brazil 1988 'Luz, Cor & Experimentação', Galeria do InFOTO-FUNARTE, Rio de Janeiro 1990 'Iconógrafos, 14 Fotógrafos Hoje', Museu de Arte Moderna, São Paulo 1992 'Turning the Map — Images from the Americas', Camerawork Gallery, London 1993 'UltraModern: The Art of the Contemporary Brazil', National Museum of Women in the Arts, Washington DC; XLV Venice Biennale; 'Space of Time: Contemporary Art from the Americas', Americas Society, New York 1994 5th Havana Biennale; XXII São Paulo Biennial, Brazil; 'Cocido y Crudo', Museo Nacional Centro de Arte Reina Sofía, Madrid 1995 'Revendo Brasília — Brasília neu Gesenhen', Haus der Kulturen der Welt, Berlin 1996 'Novas Travessias: Recent Photographic Art from Brazil', The Photographers' Gallery, London; Christopher Grimes Gallery, Santa Monica, California; 'Public Works', VanAbbe Museum, Eindhoven, The Netherlands 1997 6th Havana Biennale; Kwangju Biennale, South Korea; 'Trade Routes: History and Geography', 2nd Johannesburg Biennale 1998 'Imagens Seqüestradas', Museu de Arte Moderna, Rio de Janeiro **selected bibliography:** 1991 Tadeu Chiarelli, 'The Object in Emerging Brazilian Art', *Review: Latin American Literature and Arts*, New York, January/June 1993 Kate Bush, 'Rosângela Rennó', *Flash Art*, Milan, November/December 1994 Bill Hinchberger, 'Photo Opportunities', *ARTnews*, New York, Summer 1996 Christopher Knight, 'The Writing on the Wall', *The Los Angeles Times*, 3 September; Arlindo Machado, 'The Vanishing Camera Obscura', *World Art*, No 4, New York; Gerardo Mosquera, 'Postmodernidad — Arte y Política en América Latina', *Art Nexus*, Bogotá, Columbia, October/December 1997 Tadeu Chiarelli, 'Photography in Brazil in the 1990s', *Lapiz*, Madrid, July/September; Charles Merewether, 'Archives of the fallen', *Grand Street*, New York, Fall; Catherine Millet, 'Museu de arte moderna — Rio de Janerio', *art press*, Paris, January; Adriano Pedrosa, 'Rosângela Rennó', *Artforum*, New York, January

Rosângela Rennó
Humorais (Humorais) (detail), 1993
Light-boxes, Kodalith print; coloured gelatin, Plexiglas, paint, iron, halogen lamp, electrical materials, PVC, incandescent lamp
97 x 72 x 42 cm each

Pipilotti Rist
Anna's Zimmer (Anna's room), 1995
4 min. 36 sec. video, colour

Pipilotti Rist
Anna's Zimmer (Anna's room), 1995
4 min. 36 sec. video, colour

Pipilotti Rist
Selfless in the Bath of Lava, 1994
1 min. 15 sec. video, colour, sound

Pipilotti Rist
Yoghurt on Your Skin. Velvet on TV. 1994
38 sec. video. colour. sound

pipilotti rist RIST-TIME

Neighbour Piece

'— read newspaper

– spring from chair and let the opened newspaper lie on the table

– run for your life around your best friend's house

– whistle and throw a stone up against her window

– wait till she opens the window

– shout up to her that our common idol has died

– cry together'

– Pipilotti Rist, *DO IT*. Independent Curators Incorporated. New York. 1996

Pipilotti Rist
The Room. 1994
Laser disc player. monitor. sofa.
armchair. lamp. picture. remote
control. *Pipi-channel*. ten videos
transferred to laser disc.

Video

'Video is like a compact handbag. it includes everything from literature

to paintings to music.'

Pop Culture

'Pop music is our collective unconsciousness. It formed me and is at the same time a subject of my artistic investigations. Pop

culture is an important part of my education. Music clips also exist which are neither formal nor conformist in respect to their

content. Some of them I admire deeply. They are real artworks. the difference between video art and such clips is based mainly

on the context of reception and the related expectations of the different audiences.'

Pipilotti Rist interviewed by Sadie Coles

Be Friendly

'What stops you from talking to someone who interests you? You even strike up conversation with people on the train or in the

lift! Open up to others! Ignore the fear of the moment in whoever is before you: you could tell them straight away the story of

your life (something you don't do or. if you'd like to imageine and invent. it's more exciting). Prepare your nice. fun way to greet

others. Be friendly and courteous. Apart from receiving human warmth in return. you'll realize life's too precious to be wasted

on coldness and rudeness. And it's also bad for your health.'

Pipilotti Rist. XLVII Venice Biennale. 1997

expo.01 and Service Enterprise

'The artistic direction of expo.01. the Swiss national exhibition of the year 2001 on which I am currently working with a team of

nine people. is organized as a service enterprise. As such we coordinate the exhibition projects laterally. thematically and for-

mally ... We have three main sources of inspiration: the "Join-In" campaign is composed of thousands of proposals from all sec-

tors of the Swiss population. the "kitchen" is the germ cell of the artistic direction – a kind of pantry for good suggestions. or a

laboratory for ideas. philosophies. images concepts and project sketches. Here we test ideas. develop models, and work out

solutions for problems. And finally or course there is the active search for creative potential.' Pipilotti Rist interviewed by the

author. 1997

Everything is in between

Rist would like to create 'unexpected partnerships between scientists and artists. writers and sports clubs. churches and ecolo-

gists. managers and kindergarten teachers ... ' Pipilotti Rist interviewed by the author. 1997

Pipilotti Rist describes the oscillation between collective and individual issues as follows:

'There seems to be a great need to talk about collective morality. maybe a kind of global ethos for a global society. In many pro-

jects the skeletons for direct democracy are offered. such as places where people might get together to talk. This hunger for

direct communication strikingly goes hand in hand with a trend towards total individualization.'

Hans Ulrich Obrist

345

this page: Pipilotti Rist
Sip My Ocean, 1995
3 min. 27 sec. video projection, colour

Pipilotti Rist

Born Schweizer Künstler, Switzerland, 1962. Lives and works in Zurich and Neuenburg

selected solo exhibitions: 1984 'Bank für Mond & Scheine'. Galeria Prottore/Stauraum, Neuenburg Vienna 1995 'I'm Not The Girl Who Misses Much – Ausgeschlafen, frisch gebadet und hochmotiviert'. Kunstverein, Hamburg. 'De kop van de kat is jarig en zijn pootjes vieren feest'. Galerie Akinci, Amsterdam 1996 'Slept in, had a bath, highly motivated.' Chisenhale Gallery, London. 'Shooting Divas'. Centre d'Art Contemporain, Geneva. Museum of Contemporary Art, Chicago 1997 'The Social Life of Roses, or Why I'm Never Sad'. Stedelijk Museum Het Domeijn, Sittard, The Netherlands

selected group exhibitions: 1994 Kunstverein, Munich. 'Oh Boy, It's a Girl! Feminismen in der Kunst'. Kunstraum, Vienna. 'Use Your Allusion: Recent Video Art'. Museum of Contemporary Art, Chicago 1995 'Wild Walls'. Stedelijk Museum, Amsterdam. 'FemininMasculin'. Centre Georges Pompidou, Paris 1996 'Nowhere'. Louisiana Museum, Humlebæk, Denmark. 'Mirades'. Museo d'Arte Contemporanea, Barcelona 1997 'Some Kind of Heaven/Ein Stück vom Himmel'. Kunsthalle, Nuremberg, Germany and tour. 'Rooms with a view'. 'Environments for Video'. Guggenheim Museum SoHo, New York. XLVII Venice Biennale. Lyon Biennale. Kwangju Biennale, South Korea. 'On life, beauty, translations and other difficulties'. 5th Istanbul Biennale.

selected bibliography: 1992 Anne Reich. 'Pipilotti Rist: Der Reiz des Unsauberen – Ein Interview'. Kunstbulletin, Kriens, Switzerland. December 1993 Claudia Jolles. 'Pipilotti Rist'. Artforum, New York. Harm Lux. 'Pipilotti Rist'. Flash Art, Milan. Summer 1996 Marius Babias. 'Pipilotti Rist'. frieze, London, March/April. Marius Babias. 'Risikofaktor Rist. Wenn Träume wie sterbende Fische zucken'. Parkett, No 48, Zurich. Paolo Colombo. 'Shooting Divas'. Parkett, No 48, Zurich. Elisabeth Janus. 'Pipilotti Rist'. Artforum, New York, Summer. Nancy Spector. 'The Mechanics of Fluids'. Parkett, No 48. Philip Ursprung, 'Pipilotti Rists Fliegendes Zimmer'. Parkett, No 48, Zurich. Gilda Williams. 'Pipilotti Rist at Chisenhale Gallery, London'. Art Monthly, London. June 1997 Annelise Zwez, 'Grossmut begatte mich, The Social Life of Roses', Artis, No 2, Stuttgart

Pipilotti Rist
Pipilotti's Mistake, 1998
11 min. 17 sec. video projection, colour,
sound

Pipilotti Rist
You Called Me Jacky, 1990
4 min. 7 sec. video, colour, sound

Pipilotti Rist
Pickelporno, 1992
12 min. 9 sec. video/film, colour, sound

matthew ritchie

'Seven earths. Seven characters. Forty-nine ways to die. There's only one way out ...' *The Hard Way*'. So goes the hard-boiled introduction to British-born, New York-based Matthew Ritchie's magnum opus, a treacherous universe revolving around seven 'watchers', each of whom corresponds to a colour, an element and one of the seven lobes of the brain: the fur-covered, pet-fucking Azazel; the lactose-intolerant revolutionary, Kasdejah; Shemjaza, the enthusiastic liar, mercurial, two-faced Tamail; the hooting and grinding traveller, Kokabel, an 'it'; the idealist, Penemue, who has the soul of a librarian; and Mulciber the builder, a pessimist certain everything will end badly.

In 50,000 BC, these beings – loosely based on giants mentioned in the beginning of Genesis, thrown out of heaven for having sex with the children of Adam and Eve – finally plunged to earth like giant comets, their body parts scattered across seven continents. Ritchie intends to track the whereabouts of this cursed pantheon during the course of seven adventures (the first of which he's already completed), to the black glaciers on the island of Svalbard in the Arctic Circle. *The Hard Way* tells the giants' story, via a constellation of charts, diagrams, a Web-based environment, drawings and paintings. These last are highly idiosyncratic agglomerations of satiny, flat shapes, which resemble patchworks, mosaics or crystalline structures. Some sprawl across the wall, like elaborate maps to this particular cosmos. Others slither down onto the floor, where they are transformed into cut-out bits of painted, linoleum-like plastic. Mining a pulp imaginary that extends from Dante to 'Dungeons and Dragons', not to mention the vast arcana of esoteric, religious and scientific systems (including but not limited to the cartographic, geographic, hermeneutic, iconographical, Biblical, linguistic, hieroglyphic, architectural, alchemical, mythological, mathematical, Gnostic, spatial, temporal, ludic

Matthew Ritchie
Day Three 1998
Enamel on sintra
244 x 279.5 x 213.5 cm

and mutogenetic). Ritchie weaves an information fantasy. Yet none of this is ironic, which is to say *The Hard Way* is not a metaphor for the encyclopaedic overload that characterizes the close of the cyber-century, but rather a story, every one of whose details offers up its own fascinations. Indeed, the best way to think of Ritchie's paintings may be in relation to the classical *ars memorativa*, described by Greek orators such as Cicero. Here was a technique for retaining vast stores of knowledge without recourse to written language. It involved devising a phantasmic structure such as a palace, each of whose rooms, doorways, even flickering candles becomes the starting point for a chain of recollections. Enamoured of such hermetic associations, Ritchie likewise incarnates a dream-like space in which cultural memory and personal obsession intersect.

Susan Kandel

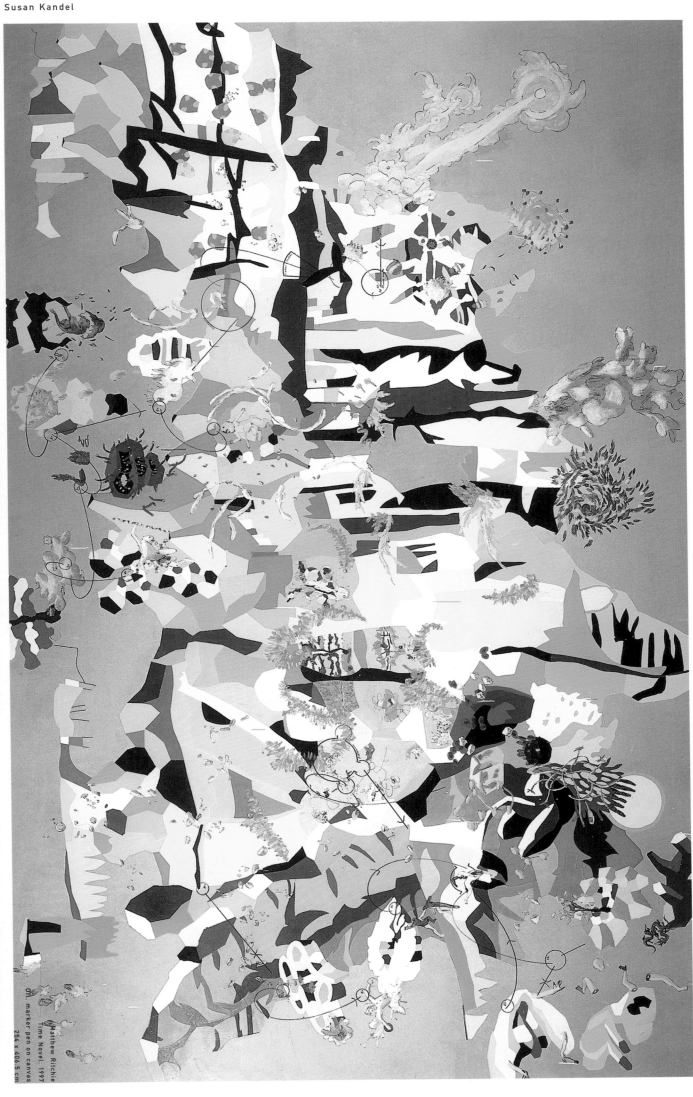

Matthew Ritchie, *Time Novel*, 1997. Oil, marker pen on canvas, 254 x 406.5 cm

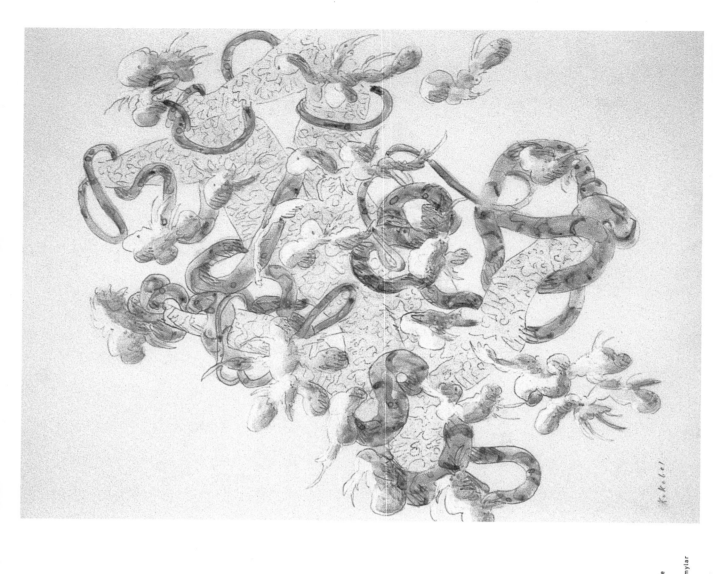

Matthew Ritchie
Kokabel, 1996
Ink, pencil on mylar
28 x 21.5 cm

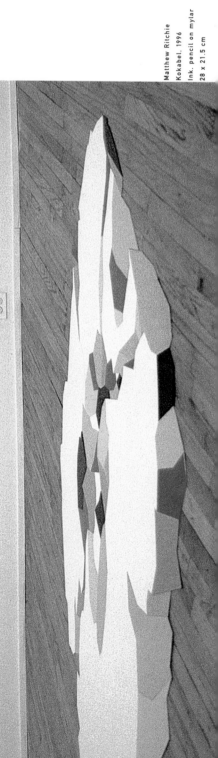

Matthew Ritchie

top.

Seven Earths, 1995

Oil, marker on canvas

152.5 x 213.5 cm

below.

Neziah, 1995

Sintra, paint

167.5 x 91.5 cm

matthew ritchie

Born London, 1964. Lives and works in New York. **selected solo exhibitions:** 1990 'Recent Paintings', Judy Nielsen Gallery, Chicago 1995 'Working Model', Basilico Fine Arts, New York 1996 'The Hard Way, Chapter III', Atle Gerhardsen, Oslo; 'The Hard Way, Chapter II', Basilico Fine Arts, New York; 'The Hard Way, Chapter I', Galerie Météo, Paris 1998 Galeria Camargo Vilaca, São Paolo; Basilico Fine Arts, New York **selected group exhibitions:** 1992 '9 X 2', Artists Space, New York 1993 'Back Room', Natalie Rivera, New York 1994 'modus operandi', Leonora Vega, New York 1995 'Verrückt', Schloss Agathenburg, Germany; 'Summer Fling', Basilico Fine Arts, New York; 'A Vital Matrix', domestic setting gallery, Los Angeles 1996 'New Work: Drawings Today', Museum of Modern Art, San Francisco; 'AbFab', Feature, New York; 'Between the Acts', Ice Box, Athens 1997 'Map the Gap', Storefront for Art & Architecture, New York; 'météo-show', Galerie Météo, Paris; Biennial, Whitney Museum of American Art, New York 1998 'Art Today', Museum of Art, Indianapolis, Indiana **selected bibliography:** 1995 Richard Kalina, 'Matthew Ritchie at Basilico Fine Arts', *Art in America*, New York, July; Roberta Smith, 'Matthew Ritchie at Basilico Fine Arts', *The New York Times*, 10 March; Kim Levin, 'Voice Listings, Recommended, Matthew Ritchie', *The Village Voice*, New York, 7 March 1996 Holland Cotter, 'Matthew Ritchie: The Hard Way', *The New York Times*, 15 November 1997 Brooks Adams, 'Turtle Derby', *Art in America*, New York, June; Reena Jana, 'New Work: Drawings Today', *Flash Art*, Milan, October; Peter Schjeldahl, 'Painting Rules', *The Village Voice*, New York, 30 September; Adrian Searle, 'Nowhere to Run', *frieze*, London, May; Sarah Bayliss, 'The Informers', *World Art*, No 13, New York

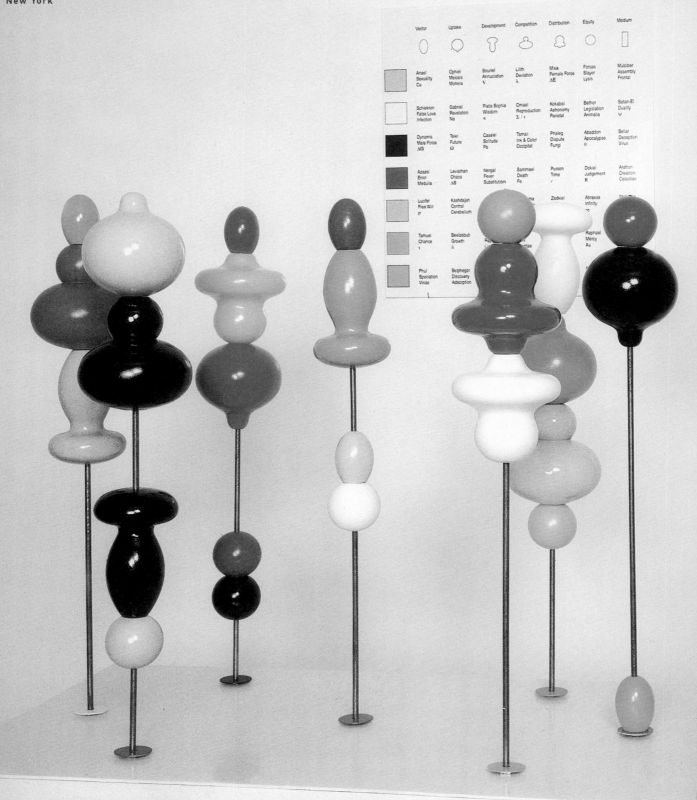

Matthew Ritchie
The God Game, 1995
Enamel, wood, steel
134.5 x 76 x 45.5 cm

liisa roberts

Betraying a Portrait ... 1995. The first thing the viewer noticed upon entering the gallery showing *Betraying a Portrait ...* was a scaffold-like metal structure at the centre of the space. There were also two 16 mm projectors, one facing the wall, the other directed towards a niche above the main door. A slide projector stood at the far end of the gallery, beneath a window. Although barely audible, occasional clicks and whirs were a reminder that something was happening. Depending on the time of day at which the exhibition was visited, the viewer gradually became aware that the projected image was that of the same wall that served as a screen. The overall effect – an empty room, or rather a room full of silent equipment (with the exception of the sporadic click of the slide projector) – was somewhat disconcerting. The title of the work, *Betraying a Portrait ...* left one wondering which portrait was actually being betrayed.

The invitation had announced the simultaneous projection of two films, which would take place daily at the precisely specified time of 4.59 pm. The imaginary space of the work opened up at the scheduled moment. The two projectors clicked into action in unison as if by magic. One projected, in colour, what seemed to be a circular travelling shot of a room not unlike the space hosting the exhibition, both during the day and at night. The other, in black and white, showed the head and shoulders of a young woman, her back to the viewer. Suddenly, she turned to face the camera, only to disappear again. The image was punctuated with the words, '... of honesty ... generosity ... and integrity'. Eight minutes later, the performance was over. Silence had been restored, save for the occasional click as slides changed. The time on the invitation corresponded exactly with nightfall on the first day of the exhibition.

The 'portrait of honesty, generosity and integrity' could be a reference to the young woman who had turned for an instant to reveal her face. Then again, it could be a portrait of the space, or of the moment that marked the end of the exhibition. Or possibly it was a portrait of the time that we inhabited almost without realizing it. The 'integrity' of the work gradually and inevitably disintegrated as the images became increasingly blurred with the increase in daylight hours. Its 'generosity' was short-lived, lasting only eight minutes each day, during which the meaning of the work was opened up, only to fold back into itself and into silence. An 'honest' portrait, necessarily, would be a true one. Yet the truth of time, like the truth of the woman's face as well as the truth of our own thoughts, were, ultimately, like the flame of a candle: in order to glow, they have to consume themselves until they dwindle into nothingness.

Carlos Basualdo

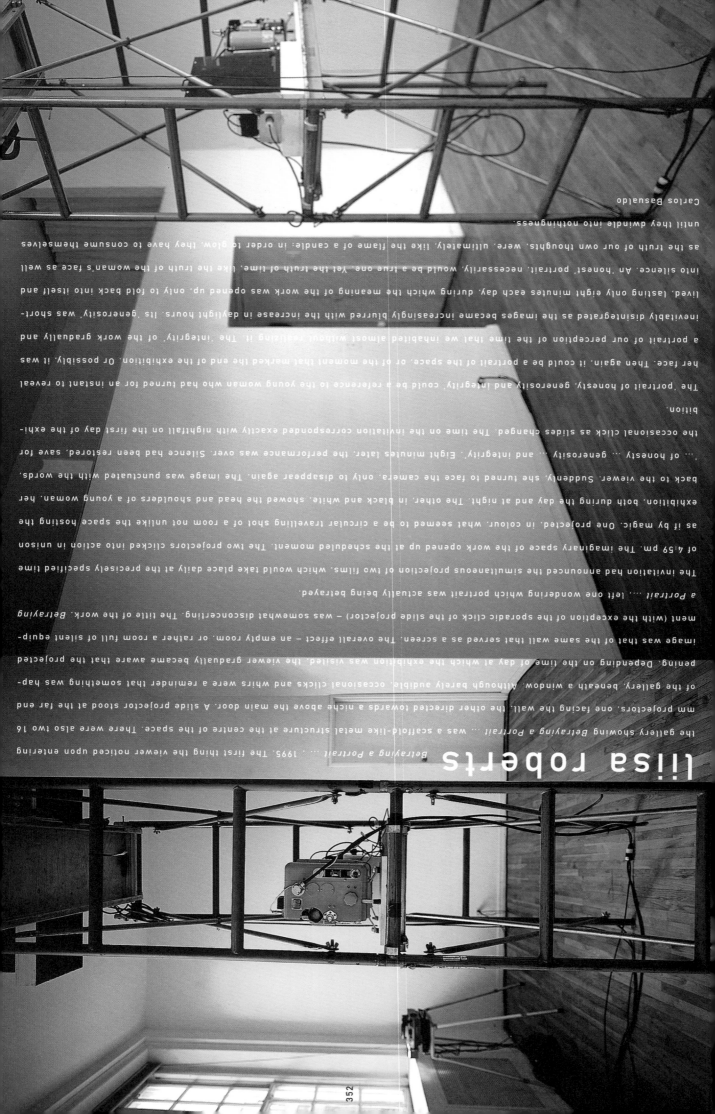

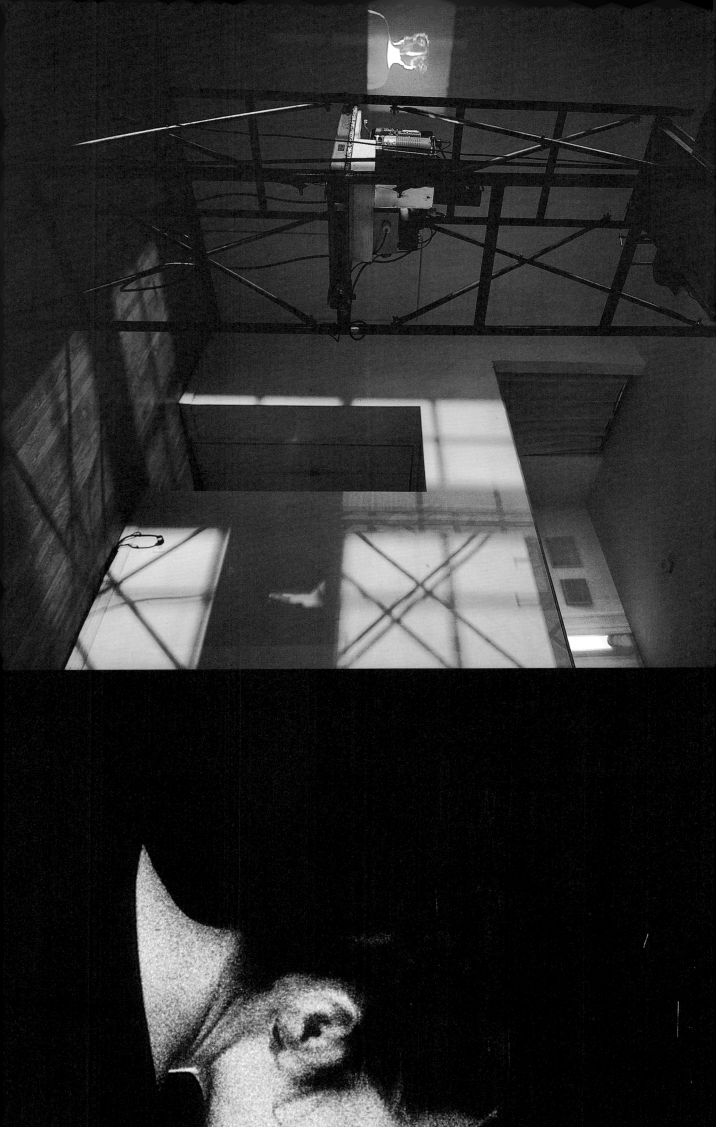

this page and opposite, Liisa Roberts
Betraying a Portrait..., 1995
black and white slide projection,
2 synchronized 8 min. 16 mm film pro-
jections, black and white and colour,
film projectors, film loopers,
programmed slide projector,
scaffolding and slide projector stand
Dimensions variable
Installation, Janice Guy, New York

Liisa Roberts
9 Minutes of Form. A Film by Liisa
Roberts, 1993
9 min. film, black and white

liisa roberts

Born Paris, 1969. Lives and works in New York

selected solo exhibitions: 1995 'Betraying a Portrait', Janice Guy Gallery, New York 1997 'Trap Door', Lehmann Maupin Gallery, New York 1998 Whitney Museum of American Art, New York **selected group exhibitions:** 1994 'Artists Select', Artists Space, New York 1995 'Lux Sonor', Helsinki Art Hall 1996 'Scream and Scream Again: Film in Art', The Museum of Modern Art, Oxford and tour 1997 'Heaven', P.S. 1 Museum, New York Documenta X, Kassel, Germany 1998 'Arkipelag', Nordic Museum, Stockholm 'Biennale de l'image Paris 98', Centre National de la Photographie, Paris 'Insertions'. **selected bibliography:** 1996 Richard Cork. 'Life and death in the glow of magic lanterns'. *The Times*, London, 6 August; Joshua Decter. 'Liisa Roberts at Janice Guy'. *Artforum*, New York, April 1997 Anne Doran. 'Heaven'. Public View, Private View. *Time Out*, New York, 6 November; Paul Myoda. 'Liisa Roberts at Lehmann Maupin'. *Art in America*, New York, November; Daniel Birnbaum. 'Documenta X: the Artforum Questionnaire'. *Artforum*, New York, September; George Baker. 'Narrative Urge at Lombard Freid Fine Arts'. *Artforum*, New York, September; Wolfgang Kemp. 'Aus unserer Franzosenzeit'. *Die Zeit*, Hamburg, 27 June; Michael Kimmelman. 'Few Paintings or Sculptures. But an Ambitious Concept'. *The New York Times*, 23 June; Martha Schwendener. 'Liisa Roberts at Lehmann Maupin'. *Art Papers*, Atlanta, Georgia, May/June 1998 Margaret Sundell. 'Openings: Liisa Roberts'. *Artforum*, New York, January

Liisa Roberts
A Film By Liisa Roberts, 1995
Three 17 min. 20 sec. film loops,
black and white
Installation, Bravin Post Lee, New York

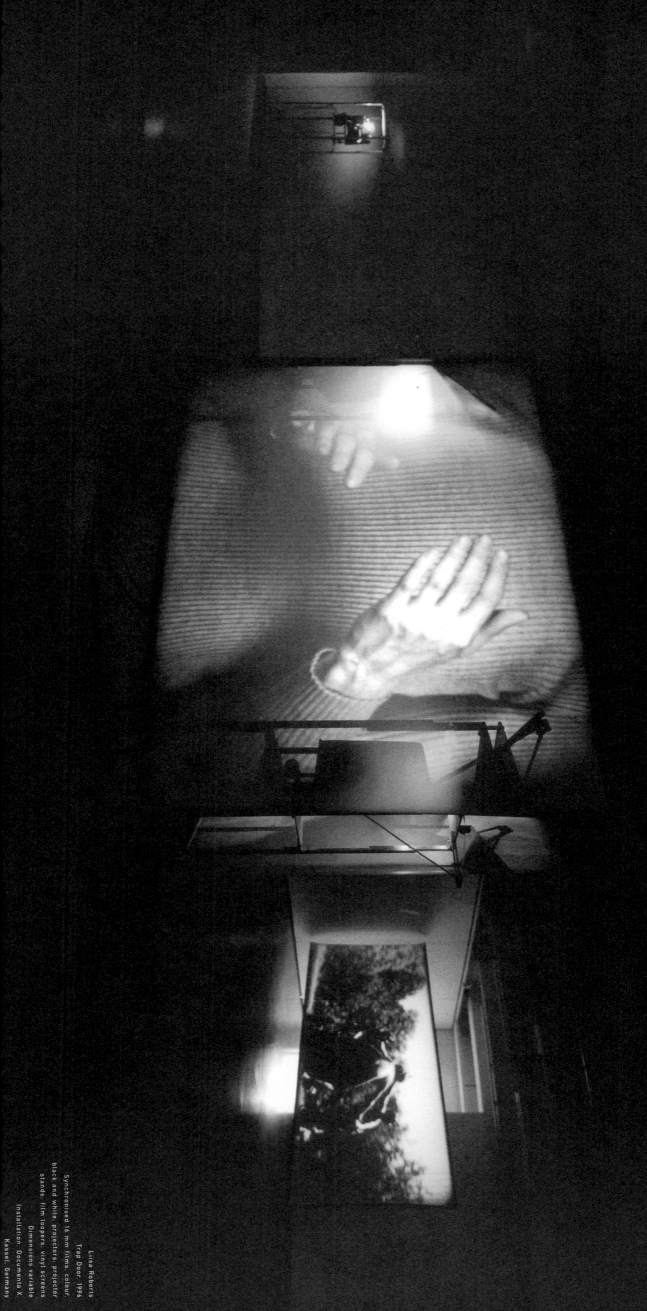

bülent şangar

For many young Turkish artists, everyday life and their social milieu provide rich source material for analyzing the complexities of their times. This work involves certain risks when taking a critical stance regarding political and cultural issues which are a sore point for the powers that be, but it does help in defining new goals that facilitate individual and collective change. Bülent Şangar analyzes the ways in which political, religious and family authority determines our conduct. He uses himself and people close to him as subjects and objects in his mises-en-scènes, which are set in his workshop, in the home or in significant public places. *Blue Jeans Advertisement*, 1994, in which the artist appears dressed in Levi jeans, in different military poses, is an ironic metaphor for the authoritarianism by which we are regimented. In *Sacrifice*, 1994-97, the artist and his father act out the moment when God tells Abraham to sacrifice his son Isaac. For both Christian and Islamic religions, this sacrifice is the paradigm of obeying authority and observance of the Law, but here, too, an element of doubt creeps in. In his most extensive series of images to date, Şangar's *Untitled*, 1997, depicts the various stages in a journey which takes place in a narrow window frame in his house. All the preparations, from sprinkling the traveller with water to bless his departure, to unfolding maps and scanning the horizon, are performed with the solemnity of a truly important journey. The fictitious nature of the various stages generates an *aller-retour* between interior and exterior which becomes a fascinating story of the imagination that can unfold in various directions. It also speaks of a desire to depart, and of the resignation associated with an imaginary attempt. *Feast of Sacrifice*, 1997-98, a set of clear snapshots taken on the outskirts of Istanbul, deals with the friction generated between wildcat urban development and the traditional rituals which migrant workers cling to for identity. These rituals become a valid 'pretext' for the slaughtering of lambs in filthy, desolate and wholly unsuitable places, such as alongside a motorway. *Untitled*, 1997, was, like many of his works, prompted by a piece of news that appeared in the press: a boy, having murdered his family, returns home to the scene of the crime and is horrified by what he has done. In this work, shock and distress in the face of violence have prompted a reflection on the personal, economic, ideological and social tensions that lead to crime. They also allude to the media's thirst for sensationalism. With his photomontages, snapshots and photographic series, Şangar has laid a bridge for moving between the personal and social spheres, between the symbolic and the commonplace. He calls into question the way in which our lives are conditioned by power, and shows how the choice between insubordination and obedience generates painful conflicts which are never halted, essential for disrupting ideological and existential confusion

Bülent Şangar
Sacrifice, 1994-97
Colour photographs
Dimensions variable

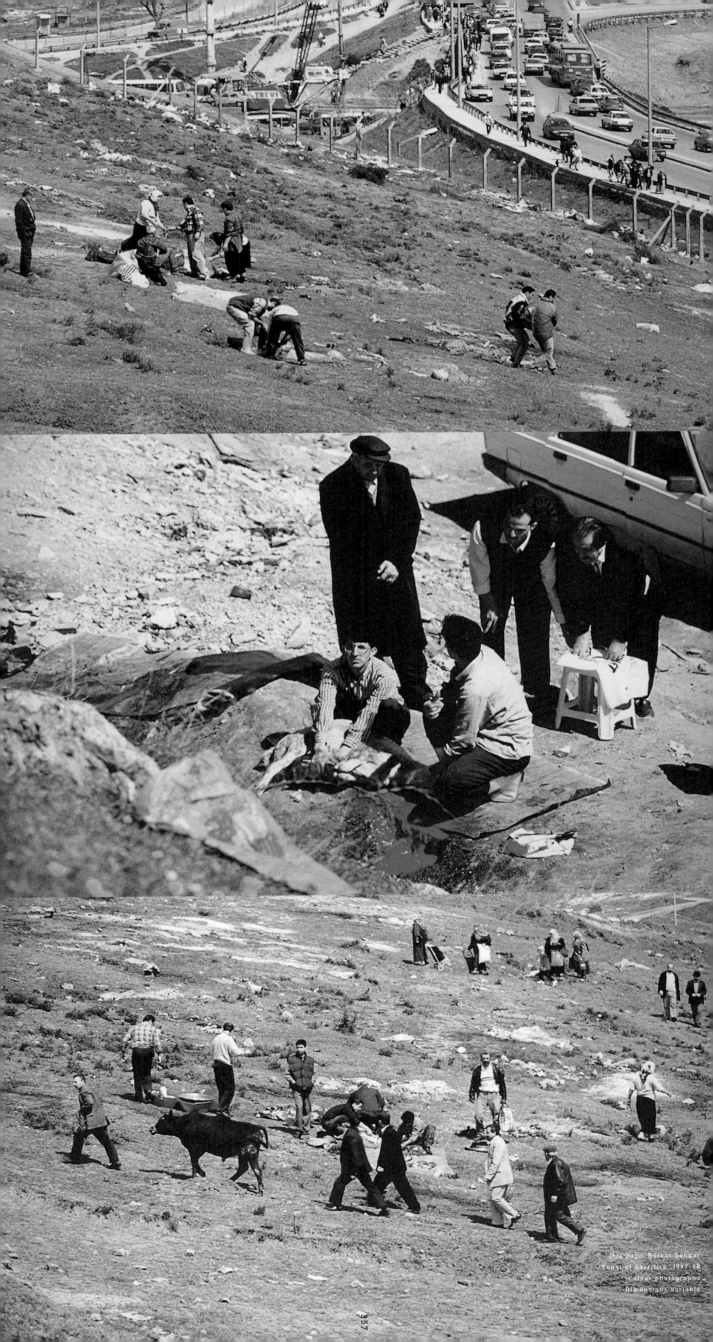

bülent şangar

select-ed solo exhibitions: 1992 **selected group exhibitions:** 1995 Urart Gallery, Istanbul Born Eskişehir, Turkey, 1965. Lives and works in Istanbul.

'XIII Today's Artists Exhibition', Hareket Köşkü, Istanbul 1993 'Memory Recollection II', Akaretler, Istanbul 1994 'X Yunus Emre Exhibitions', Hareket Köşkü, Istanbul 1995 'Gift Shop', Falez Hotel Art Gallery, Antalya, Turkey; 'Globalization, State and Poverty', Devlet Han, Istanbul; 'XI Yunus Emre Exhibitions', State Gallery, Istanbul 1996 'The Other', Habitat II, Antrepo, Istanbul 1997 'On life, beauty, translations and other difficulties', 5th Istanbul Biennale; 'Alter-Retour', 3rd Cetinjski Biennale, Montenegro; 'Va et Vient', Middle Eastern Technical University, Cultural Centre, Ankara, Turkey. 1998 'Esperanto 98', Jack Tilton Gallery, New York

selected bibliography: 1993 Ali Akay. 'Les Artistes archéologisent l'histoire: a-historicité'. Arredamento-Decoration Magazine, Istanbul, June 1995 Ayden Murtezaoglu. 'Les Gestes qui correspondent aux divers périodes de la vie'. Anons-Magazine D'Arte Plastiques, Istanbul, January Ali Akay. 'La Multiplication Des Corps Personels Dans Les Sphères Publiques', Arredamento-Decoration, Istanbul, January 1997 Necmi Sönmez. 'Les différentes voix sur les Artistes Turcs de la

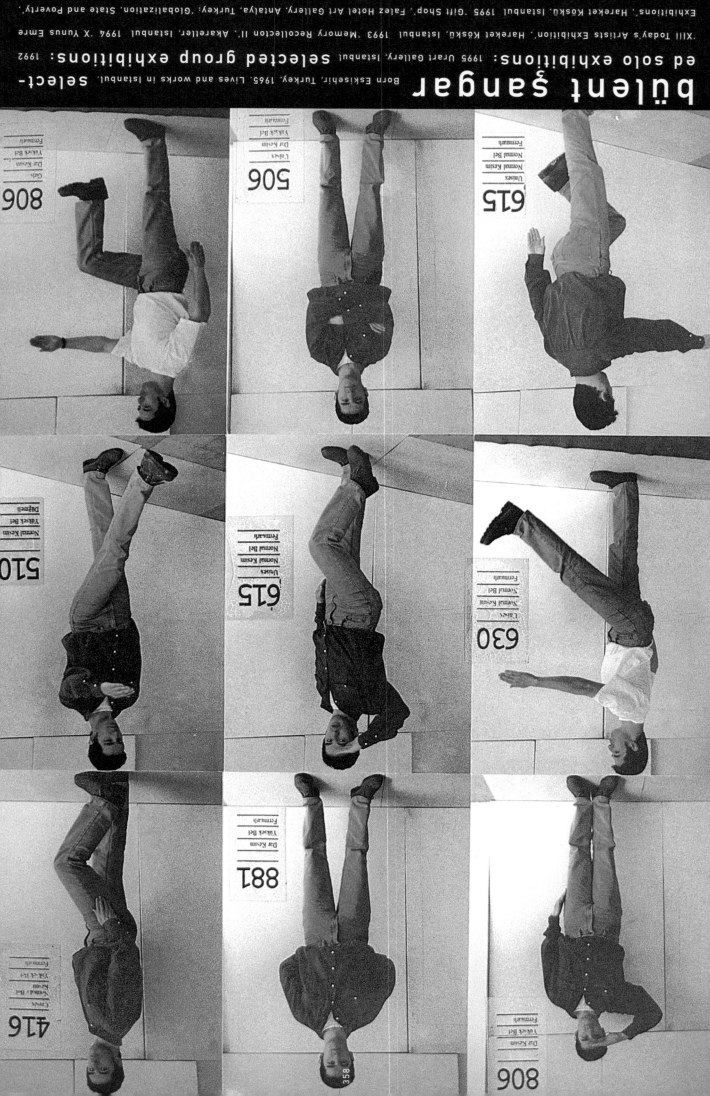

opposite. Bülent Şangar
Blue Jeans Advertisement (detail). 1994
Colour photographs
45.5 x 34.5 cm

this page. Bülent Şangar
Untitled (detail). 1997
Colour photographs
90 parts. 234 x 400 cm overall

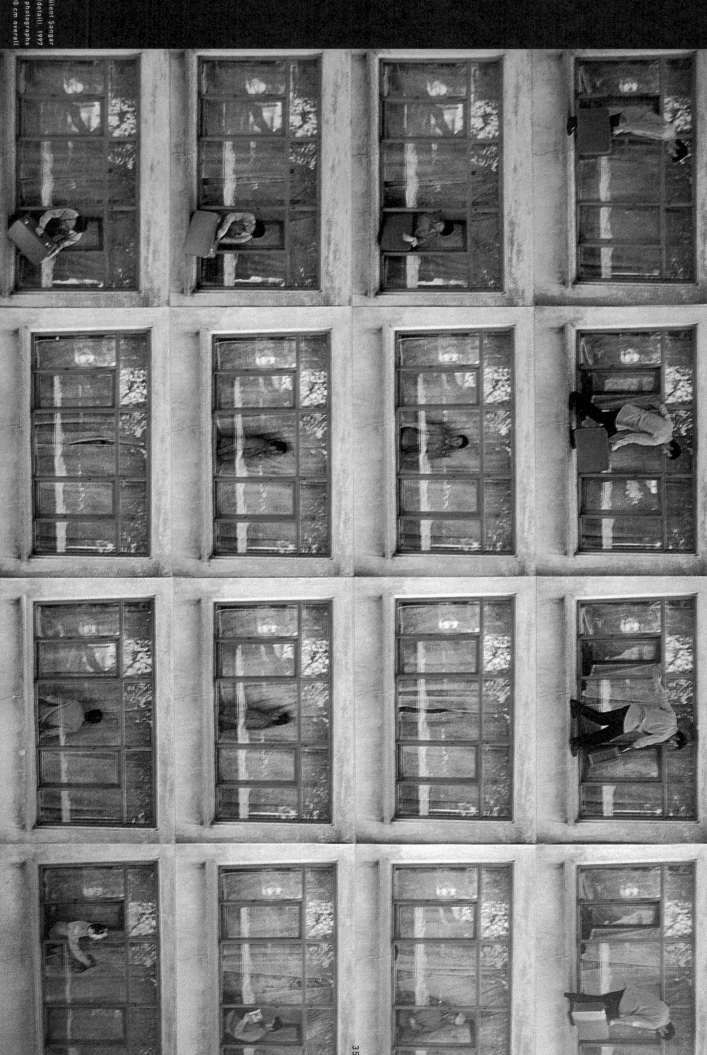

Yinka Shonibare's work marks a clearly nuanced, post-national approach within the increasingly important body of work being produced by diasporan artists and intellectuals in the tight confines of the global metropolis. A Nigerian/British artist, Shonibare arrives at this juncture without adopting the limp pose of the disenfranchised dissident, but rather through a carefully engaged critique, self-depreciating reflection and sheer elegance. Seductive and often colourful, Shonibare's work seeks out the ironies and allegories to be found in games of authenticity. It addresses the queulous theatricalization of difference, the myths of race and the complex language of distancing that is often loaded into the uncertain vessel of ethnic stereotype and colonial mimicry. It would, however, be a mistake to view Shonibare's work as an emblem of socio-cultural anthropology. Examined more closely, it cuts to the heart of the historicist fictions of Modern Art in relation to the art of Africa. This in turn becomes a question of how audiences position themselves in front of what has always been seen as fact or knowledge within representation. His work, intellectually rigorous and involving a great deal of research, also refers to the unique ability of visual art to absorb questions of representation that seem to belong to other disciplines such as anthropology, ethnography and sociology. Shonibare focuses on a critical investigation of how these areas influence notions of cultural transaction. His tableaux vivants, such as Victorian Philanthropist's Parlour, 1996–97, are made from what is popularly accepted as African fabric, which may also be understood as the colonial cloth of ethnic iconography and identification. By deceptively offering the fabric as 'African', with little mediation except by implicating other cultural norms into his installations through quotation and juxtaposition, Shonibare seems to be saying that if you accept uncritically the notion of its Africanness, then surely the joke is on you. But he is doing more than this. Employing the fabrics as readymades, Shonibare also unravels from within their fragile seams the imprecision of cultural authority, and hence the notion of authenticity. Throughout his career, spanning over a decade, he has worked assiduously to imprint a counter-discourse onto that increasingly alarming tendency called 'globalization'.

It is necessary to consider the intellectual dimension of Shonibare's art, especially the way in which he has raised many difficult questions regarding metropolitan post-colonial discourse, for example in Untitled, 1997. His work belongs to a genre of contemporary critical practice that dedicates itself to conducting acts of public speech. Such practices over the last couple of years implicate some of the uneven and discontinuous narratives of Modernism and Postmodernism within its critical position. And extending into these territories, Shonibare also questions contemporary art's desire to domesticate, as another academic formula, post-colonial issues within its own domain.

Okwui Enwezor

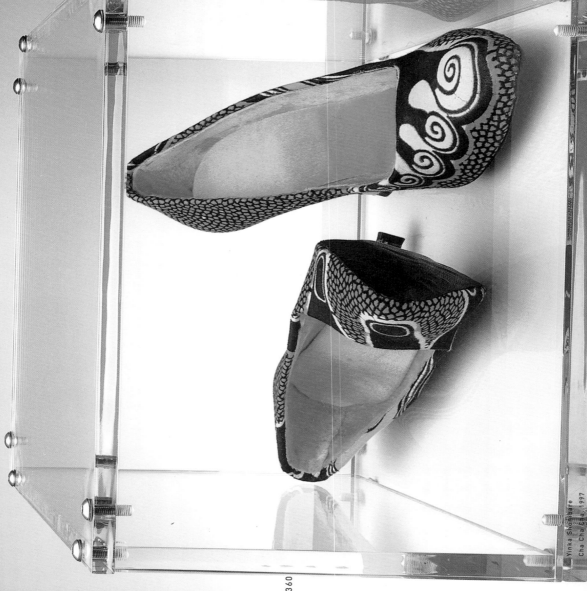

Yinka Shonibare
Cha Cha Cha, 1997
Wax-printed cotton textile, velvet, leather,
acrylic, metal, acrylic box
Acrylic box. 25.5 x 25.5 x 20 cm
Plinth. 44.5 x 44.5 x 111.5 cm

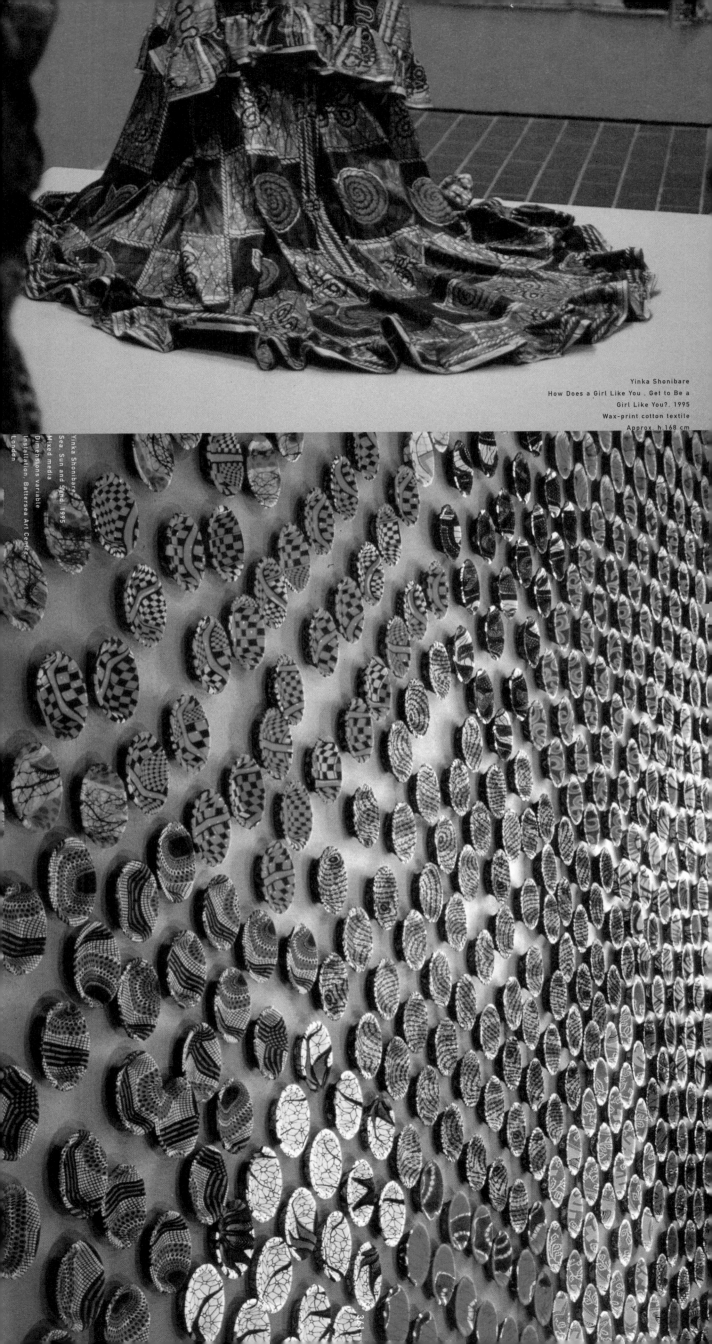

Yinka Shonibare
How Does a Girl Like You . Get to Be a
Girl Like You?, 1995
Wax-print cotton textile
Approx. h.168 cm

Yinka Shonibare
Sea, Sun and Sand, 1995
Mixed media
Dimensions variable
Installation, Battersea Art Center,
London

Sé Fié

Yinka Shonibare
Untitled, 1997
C-type print,
reproduction baroque frame
178 x 132 cm

yinka shonibare

Born London, 1962. Lives and works in London. **selected solo exhibitions:** 1997 Stephen Friedman Gallery, London; 'Present Tense', Art Gallery of Ontario, Toronto

selected group exhibitions: 1989 'Black Art New Directions', City Museum and Art Gallery, Stoke-on-Trent, England 1990 'Interrogating Identity', Grey Art Gallery, New York; Museum of Fine Arts, Boston; Walker Art Center, Minneapolis; Madison Art Center, Wisconsin; Memorial Art Museum, Ohio; Goldsmiths' College, London 1992 Barclays Young Artists Award, Serpentine Gallery, London 1994 'TENQ', Senegal, West Africa 1996 'Jurassic Technologies Revenant', 10th Sydney Biennale 1997 'Sensation', Royal Academy of Art, London; 'Trade Routes: History and Geography', 2nd Johannesburg Biennale

selected bibliography: 1992 Andrew Graham-Dixon, 'Generation Gaps', *The Independent*, London, 11 February; Sarah Kent, *Time Out*, London, February 1993 Elsbeth Court, *African Arts*, London, January 1994 Tania Guha, 'Yinka Shonibare', *Third Text*, London, Summer 1995 Kobena Mercer, 'Art That is Ethnic in Inverted Commas', *frieze*, London, November/December 1997 David Burrows, 'Ade Adekola, Yinka Shonibare, Mark Wallinger', *Art Monthly*, London, February; Sacha Craddock, 'Around the galleries', *The Times*, London, 14 January; Okwui Enwezor, 'Yinka Shonibare: The Joke Is on You', *Flash Art*, Milan, November/December; Sarah Kent, 'Yinka Shonibare', *Time Out*, London, 8 October

Yinka Shonibare
Five Under Garments and Much More,
1995
African fabric, rigilene, fishing line,
interlining
Approx. h.130 cm,
circumference 95 cm each

pablo siquier

9706, 1997. Such is the discreet violence evoked by Pablo Siquier's recent works, that they give the impression of being painted versions of a drawing: a mere interweaving of black lines on a white background. Inevitably, however, we can detect traces of painterliness in the subtle twists demanded by the composition. *9706* is so delicately unbalanced, so subtly composed in its apparent compositionlessness that one cannot help but be reminded of the symmetry and mirror-play of baroque painting. It is precisely this imperceptible relation with the past – like a watermark left by the history of art on the surface of Siquier's canvas – that reminds us we are witnessing a painting. Everything else seems to stem from a sullen yet fatal irony. What Siquier represents in his work is the basic element, the very underlying substratum of all pictorial representation. The interplay of shadow and light brings everything back to the level of obvious and schematic artifice.

The process is so simple it is brutal. Siquier comes across as a severe magician, emphatically revealing his one and only trick. Yet this is a self-imposed limitation which gives rise to the whole, inexhaustible constellation of meanings in his work.

9706 calls to mind an impressionistic landscape transformed into the binary language of the computer, or a wildly updated version of Mondrian's *Composition X*, 1915. At the same time, however, the piece could be the labyrinthine map of some suburban outreach or a jumbled page from some half-forgotten oriental text. The different densities of the black lines suggest diagrammatic levels of activity or heights. These are also clearly a recourse to painterliness, one of the few Siquier has conceded himself, the function of which is to produce an effect equivalent to that of degrees of grey in a traditional drawing.

In *9706*, the forms inserted into the loose field of lines that serve as the backdrop look like open windows on a computer screen. Meanwhile, the piece as a whole resembles a TV screen containing smaller ones, the whole compositional space curiously plunged into an abyss. It is not easy to understand with any degree of certainty what exactly is being represented by the painting. The formal and allusive uncertainty of the piece is pulled off with such an economy of resources that the result is paradoxical. The hypnotic attention it demands reinforces the sensation of visual impossibility, a feeling that strikes the viewer after contemplating the piece for any great amount of time. In the end, the painting keeps hold of the gaze and arrests its capacity to glean any meaning from what it is dwelling on. As we look at *9706*, we get the distinct sensation of being condemned to look forever, into the very limits of what is visible, without ever seeing anything.

Carlos Basualdo

opposite, Pablo Siquier

9001, 1992

Acrylic on canvas

150 x 150 cm

* Pablo Siquier

9212, 1992

Acrylic on canvas

175 x 120 cm

Pablo Siquier

9706, 1997

Acrylic on canvas

178 x 231 cm

pablo siquier
Born Buenos Aires, 1961. Lives and works Buenos Aires.

selected solo exhibitions: 1991 Galería Línea, Harrods en el Arte, Buenos Aires; Sala Amad's, Madrid 1993 Galería Jacobo Karpio, San José, Costa Rica 1995 Ruth Benzacar Gallery, Buenos Aires 1996 Ramis Barquet Gallery, Monterrey, California 199? Museo Nacional de Bellas Artes, Buenos Aires; Annina Nosei Gallery, New York **selected group exhibitions:** 1987 'Nueve pintores de la joven generacion', Ruth Benzacar Gallery, Buenos Aires 1991 'Los '80 en el MAM', Museo de Arte Moderno, Buenos Aires 1992 'Buenos Aires-Cordoba. Instalaciones 1992', Centro de Arte Contemporaneo, Cordoba 1993 'Space of Time', Americas Society, New York 1994 'Art Argentina', Barbara Farber Gallery, Amsterdam 1995 'Space of Time' Center for the Fine Arts, Miami 1996 'America Latina '96', Museo Nacional de Bellas Artes, Buenos Aires; 'The Rational Twist' Apex Art, New York 1998 'Amnesia', Christopher Grimes Gallery, Santa Monica, California **selected bibliography:** 1990 Merle Schippers, 'Letter from Buenos Aires', *The Journal of Art*, Los Angeles, February 1993 Bill Jones, 'Review' *Poliester*, Mexico City, Autumn; Carlos Basualdo, 'Arte Contemporáneo en Argentina', *Estilo*, No 18, Caracas 1995 Alisa Tager 'Argentine Artifice', *Art in America*, New York, September; Jorge López Anaya, 'Falsas representaciones', *La Nación*, Buenos Aires 4 November 1996 Lydia Dona, 'Mental Spasmology', *Trans*, No 2, New York; Jorge López Anaya, 'Arte Argentino de los '90', *Lapiz* Madrid, November; Pierre Restany, 'Emergenti', *Domus*, Milan, May 1997 Inés Katzenstein, 'Pablo Siquier', *Art Nexus*, Bogotá Columbia, October/December; Julio Sanchez, 'Pablo Siquier y Marcelo Pombo', *La Maga*, Buenos Aires, 5 March; Carlos Basualdo 'Pablo Siquier, Museo Nacional de bellas Artes', *Artforum*, New York March; Mónica Amor, 'Pablo Siquier, Museo Nacional de bellas Artes', *Art in America*, New York, March

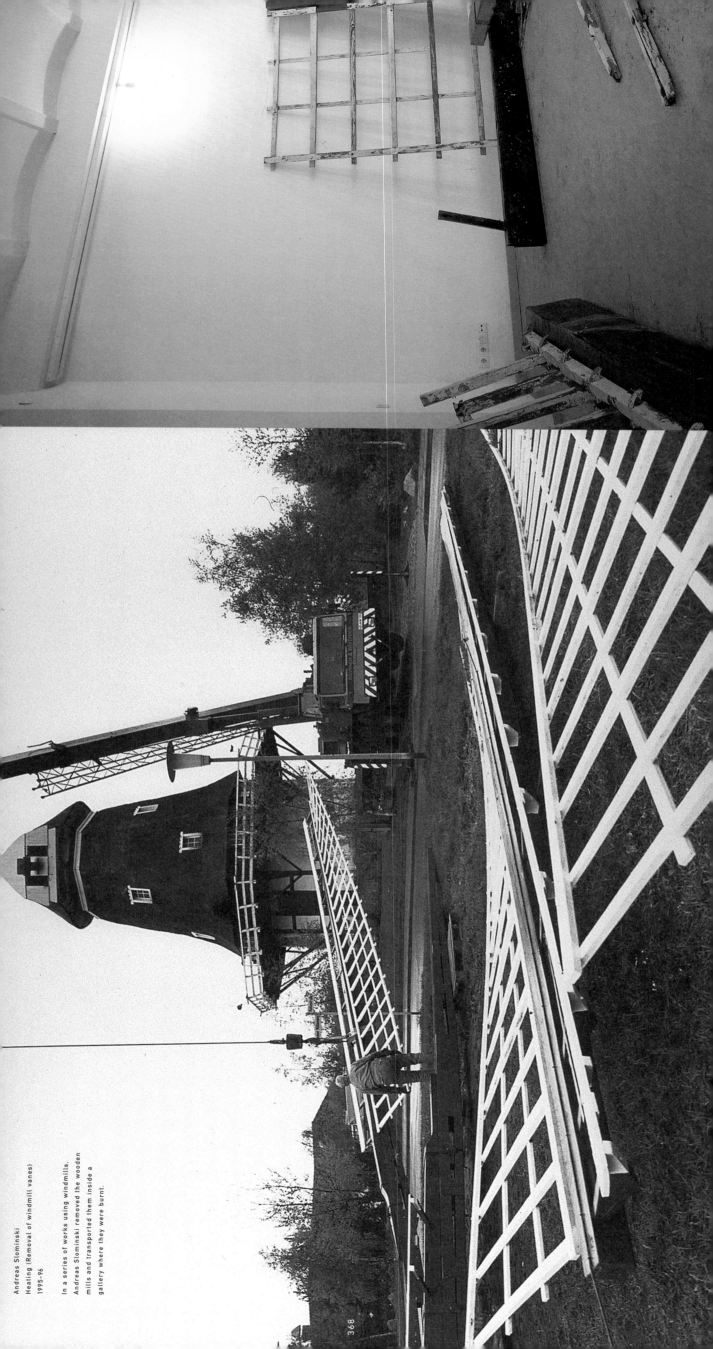

Andreas Slominski
Heating (Removal of windmill vanes)
1995-96

In a series of works using windmills,
Andreas Slominski removed the wooden
mills and transported them inside a
gallery where they were burnt.

368

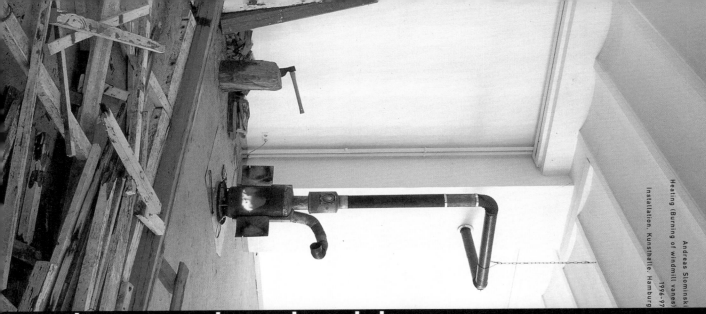

Andreas Slominski
Heating (Burning of windmill vanes)
1996–97
Installation, Kunsthalle, Hamburg

andreas slominski

The starting point for Andreas Slominski's work is often an encyclopaedic process of collecting. Surprisingly, despite his meticulous ordering of things and images into separate lists, family trees, catalogues etc., an overlapping linearity is set up. In a system that is both complex and simple, images and words point the way to new images and words. Exploration of each classification and category leads to the negotiation of many others. Slominski's subversive game of ordering evokes Robert Smithson's 1968 Manifesto 'Against Absolute Categories', in which the latter criticizes the self-referentiality of art and the division of aesthetics into categories such as painting, architecture, sculpture and film. In 'Art and Dialectics', 1971, Smithson further explores the importance of breaking down boundaries: 'Art as a distinct thing is not supposed to be affected by anything other than itself. Critical boundaries tend to isolate the art object into a metaphysical void, independent of external relationships.'

At the heart of Slominski's art is the trap. He has collected several hundred of these, designed to ensnare a wide variety of creatures, displaying them in taxonomical groups, all sprung for action. These real traps are also metaphors for trapped perceptions: they create a situation that is both dynamic and static. Though they could create a standstill at any moment, they also generate a potential for dynamic release. In this way, Slominski makes a distinction between the active use of working found objects and the static display of the frozen readymade. The potential for action, for the object to be tested, is also manifest in his exhibition of instructions-based art called 'Do It', 1994: 'set your bicycle saddle up until the tip is in the upright position, and squeeze lemons out on the tip of the saddle'. His more recent series of works, *Windmills*, 1996–97, also faced the viewer with an unmoving object that could potentially be set in motion, and showed a similarly participatory quality. For an exhibition at the Kunsthalle, Hamburg, 1997, for example, Slominski displayed a dilapidated set of windmill sails in the gallery, along with splinters of wood and lengths of beam. Twice a week he would ritually burn these fragments. For another show, he made a miniature series of working model windmills, activated by an electric fan. Like the traps, the windmills constitute a network of interrelationships between motion and stillness, matter and immaterality, potential energy and kinetic energy.

Hans Ulrich Obrist

Andreas Slominski
Windmill (Black Wings), 1996
Wood, electric fan, paint
89 x 83 x 37 cm

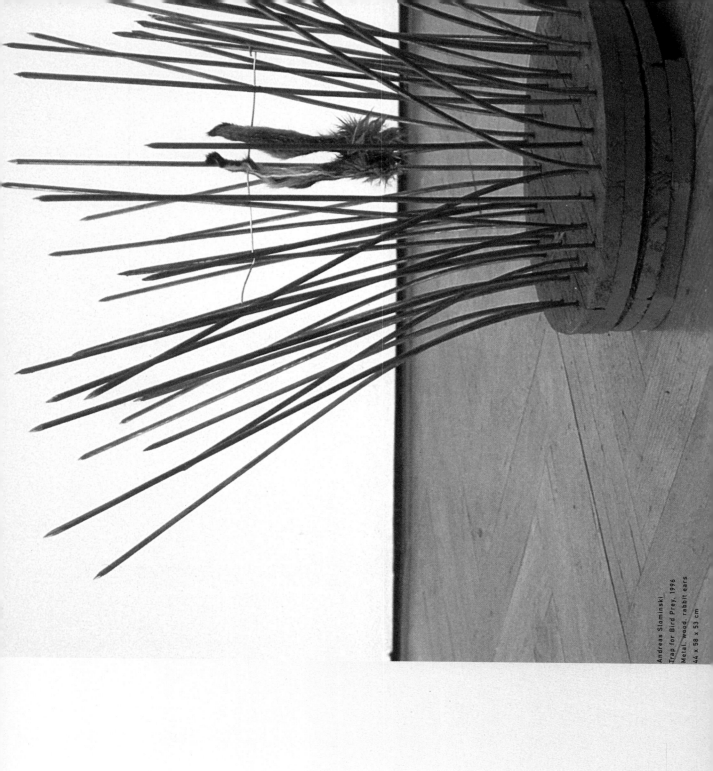

Andreas Slominski
Trap for Bird Prey, 1996
Metal, wood, rabbit ears
44 x 58 x 53 cm

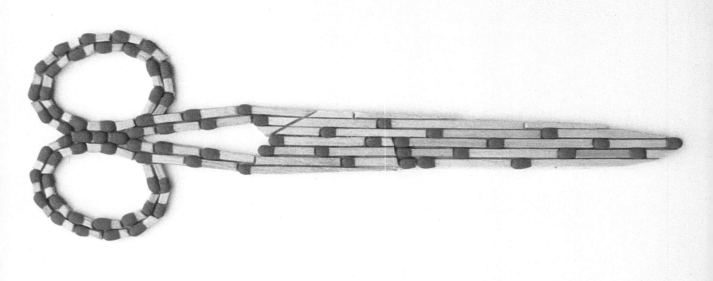

Andreas Slominski
Scissors, 1988
Matches
5.5 x 17 cm

andreas slominski

Born Meppen/Ems, Germany, 1959. Lives and works in Hamburg. **selected solo exhibitions:** 1987 Produzentengalerie, Hamburg 1993 Jablonka Galerie, Cologne 1995 Museum Weserburg, Bremen; Museum Haus Esters, Haus Lange, Krefeld, Germany 1997 'heizen', Kunsthalle, Galerie der Gegenwart, Hamburg; White Cube/Jay Jopling, London 1998 Wako Works of Art, Tokyo **selected group exhibitions:** 1988 'Neue Kunst in Hamburg', Kampnagelfabrik, Hamburg; Museum Haus Lange, Krefeld, Germany; 'Binationale', Kunsthalle/Kunstverein/Kunstsammlung, Dusseldorf, Museum of Fine Arts, Boston; 'Nobody's Fools', De Appel, Amsterdam 1991 'L'Exposition de l'Ecole du Magasin', Centre National d'Art Contemporain, Grenoble 1992 'Qui, quoi, où?', ARC, Musée d'Art Moderne de la Ville de Paris 1993 'Backstage', Kunstverein, Hamburg 1994 'Some Went Mad, Some Ran Away ...', Serpentine Gallery, London and tour 1996 'Views from Abroad: European Perspectives on American Art', Museum für Moderne Kunst, Frankfurt, Whitney Museum of American Art, New York 1998 'Artificial: Contemporary Figurations', Museu d'Art Contemporani, Barcelona **selected bibliography:** 1993 Marlon Leske 'Von Rasierkünstlern und Fallenstellern', *Die Welt*, Hamburg, 15 May; Isabelle Graw, 'Permierentage', *Text zur Kunst*, Cologne, July; José Lebrero Stals, 'Andreas Slominski: Jablonka', *Flash Art*, Milan, Summer 1995 Amine Haase, 'Glückliche Zufallstreffer', *Kölner Stadtanzeiger*, Cologne, No 70, March; Neomi Smolik, 'The Trap Slams Shut: Surprised by Andreas Slominski', *Parkett*, No 44, Zurich 1997 Carl Freedman, 'Winding Down', *frieze*, London, February; Hanno Rauterberg, 'Der Fallensteller', *art*, Hamburg, November

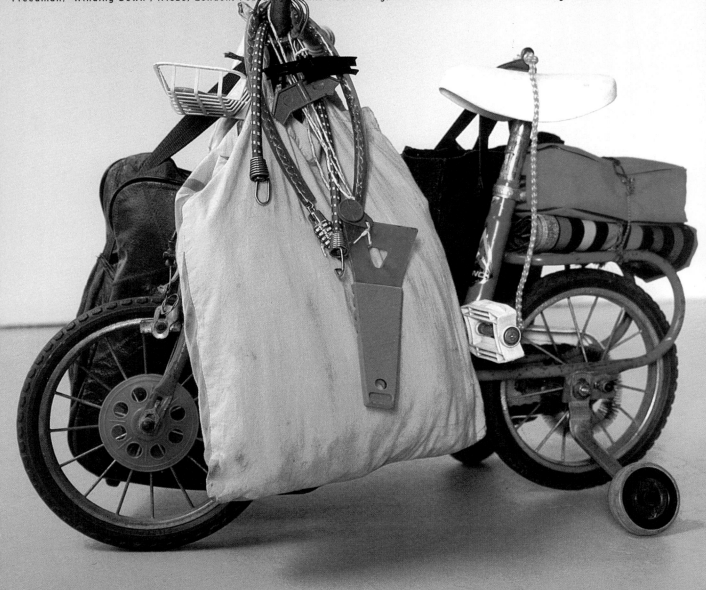

Peter Spaans
Photography of Nature, 1995-97
Colour photographs
30 x 30 cm

peter spaans

Peter Spaans' photographs are postcards dispatched from the frayed edges of the modern world – a world of commerce, decaying industrial buildings and machinery. In these works, the vanquished relics of modern aspiration declare themselves like haunting monuments to man's desire to imagine a future unencumbered by the past. Where history is retained, it appears in the form of erased presences, such as abandoned, empty lots or gentrified ghettos. These silent works turn the city into catacombs. But while there are recognizable, common elements in Spaans' work, it still cannot be summarized. Though it has a documentary quality, a casual artlessness belies the tough investigative stance that asks us to look again at the surroundings of the city we thought we knew. From the thousands of photographs Spaans has taken, it becomes apparent that major cities such as New York, Berlin and his native Amsterdam serve as character studies for his work. Like a *flâneur* he trawls abandoned landscapes in these exhausted industrial worlds, treating the built structures like examples of nature. Instead of cornfields, however, we find concrete pavements, the rusting bulks of bridges, fading advertising signs, barricaded storefronts

shiny, phallic skyscrapers that are almost a condensation of power and ruthless aspiration, aerial views of the city, impersonal
hotel rooms, paint peeling from the facade of buildings.

Or one may view these photographs as extended essays, in which the artist seeks to define his own personal relationship with a
world that defamiliarizes itself with every encounter. In this sense, rather than looking at each photograph as an individual,
autonomous work, it is best to see them as one great work in progress. Each single image is part of a discontinuous narrative pro-
viding different interpretations of the various aspects of the cities he visits. Spaans' work is a rumination on the question of indi-
vidual memory and identity within the complex processes of the modern city's transformation from a place of utopian desire to an
alienating and anonymous entity. It raises such questions as: what can possibly be the identity of a city in the global moment of
fast disappearing boundaries? Who are cities for? What is the meaning of place in defining a sense of community and identity? With
the increasing loss of faith in the utopian ideals of modernity and the virtualization of space through digital dystopia, time and
place are becoming not only irrelevant, but increasingly displaced and fragmented. In this context, Spaans' silent photographs
might seem quaint in their obsessive exactitude, which pinpoints the banality of our urban, built environments. But by fixing on
those structures that monumentalize modernity and its triumph of reason and industry, Spaans' work stands as a measure of the
way in which we encounter the spatial and temporal dynamics that define the global metropolis.

Okwui Enwezor

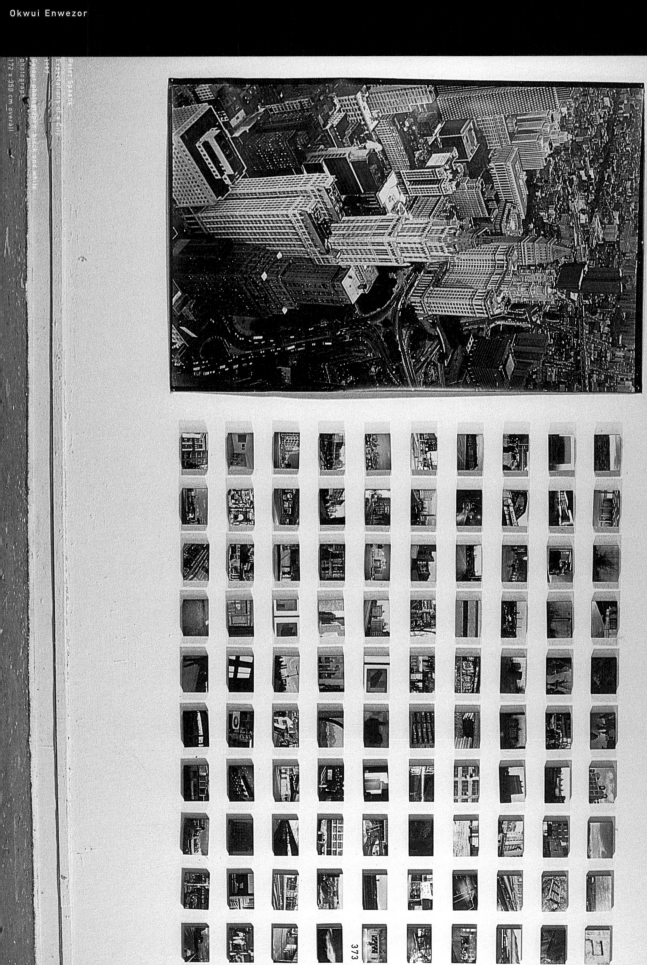

opposite, Peter Spaans
Photography of Nature (Cityworks)
1995-96
Colour photographs
30 x 40 cm

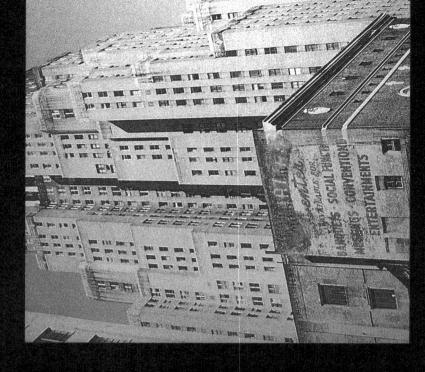

Peter Spaans
Entertainment.
1995
Black and white photograph, wood
122 x 122 cm

Peter Spaans
Trying to Catch Memory of
the Colour of 35 Photographs. 1996
Mordant and acrylic on wood
122 x 122 cm

Peter Spaans
Walking Around. 1996
Black and white photographs, colour
photographs, wood
122 x 122 cm overall

This group of Danish artists addresses broad social and political issues with the aim of taking art beyond the gallery. The group's approach is decidedly down-to-earth: they create products adapted to the commercial market. For instance, the desktop relaxation device *Endorphins*, 1996, which is activated when you place your palm on its vibrating surface, stimulates the body to release the morphine analogue endorphin – a fast and accessible form of stress relief that also helps to focus the mind. Or there's the portable sauna unit designed for nature-loving Scandinavians, which doubles as a powerful heater.

Having begun to manufacture actual products, Superflex established a company whose distinctive S-shaped trademark, by the loved and loathed Danish designer Per Anoldi, is a symbol of both scientific objectivity and comic-strip adventurousness. The group's most ambitious enterprise to date is an ongoing project for the introduction of biogas technology to Africa. In collaboration with Danish and African engineers, Superflex created a specially adapted biogas system designed to supply a family with energy for light and cooking. Bio-gas is ideal for African conditions; instead of conventional fuel, which is often scarce, families can use animal dung and human faeces to power the system. The result is not only ecologically correct, but also saves female labour, given that it is the women in the villages who are traditionally burdened with the heavy chore of collecting firewood.

Research for the biogas project began in 1996, when the artists travelled to Mozambique to meet local engineers and other key figures. The aesthetic 'look' of the biogas unit was intensely debated, the aim being to create a piece of equipment that would be attractive as a status symbol. In carrying out the first biogas project, Superflex teamed up with a Tanzanian organization, Surud (Foundation for Sustainable Rural Development), which had expressed an interest in alternative energy sources. The two partners went on to form Superrude (Super Rural Development) and this joint organization is now in charge of implementing and following up on the project. African initiative and genuine bilateral co-operation are especially important for guarding against the colonial connotations of conventional development-aid work. Mindful of history and the white man's imperial campaigns, the artists dress in neo-colonial safari uniforms, humorously confirming the old stereotype. They are determined to reflect upon the full implications of their own actions in an utterly foreign – and extremely loaded – cultural context.

While aesthetic considerations have remained essential, Superflex swiftly progressed from their initial abstract image of an African landscape filled with orange balloons – a new form of Land Art? – to a realistic art project that successfully assumes social responsibility. An important historical precedent can be seen in the actions of Joseph Beuys and Hans Haacke, who tried to address and influence social and political reality from within an isolated art context. Superflex combine this basic outlook with a rational philosophy that recognizes a commercial market economy – but one where the quest for profit need not always conflict with artistic enterprise.

Åsa Nacking

Superflex
Superflex Biogas in Africa, 1997
Photographs, monitor, projector, light
box, posters, aquarium, goldfish,
plastic, table, chairs
Dimensions variable
Installation, Louisiana Museum,
Humlebæk, Denmark

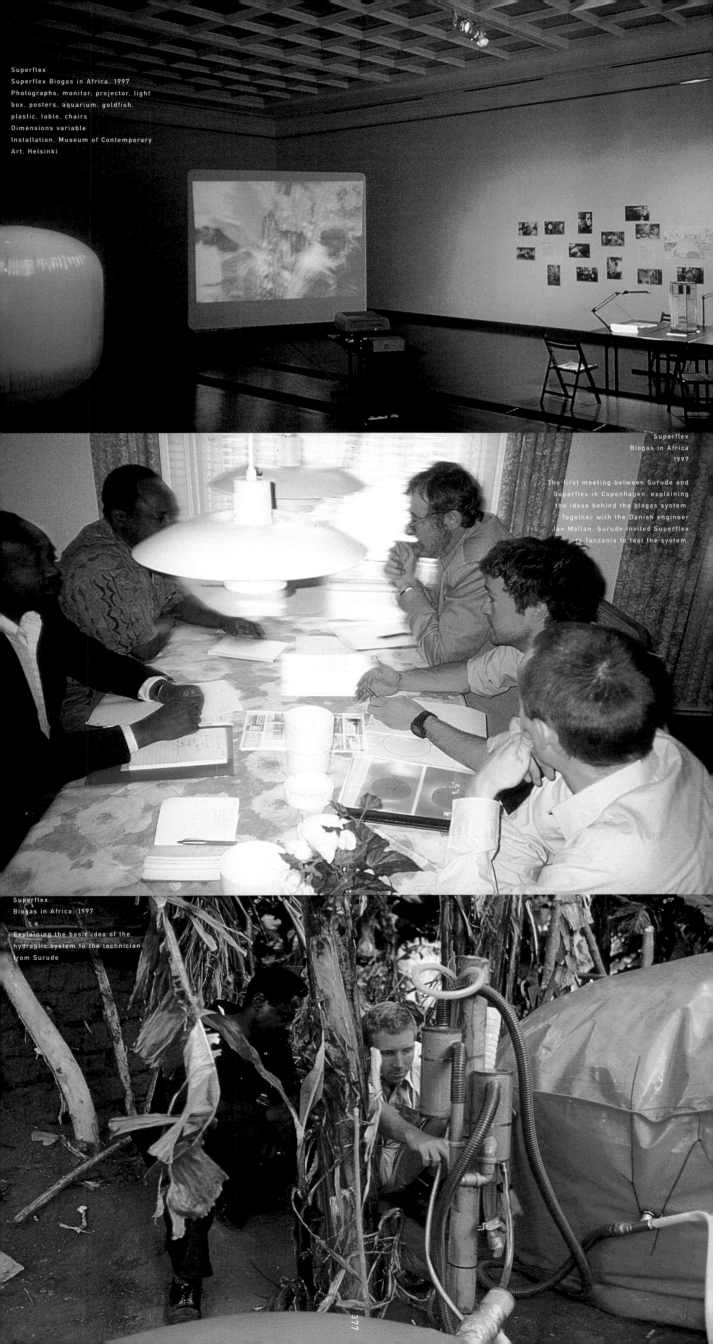

Superflex
Superflex Biogas in Africa, 1997
Photographs, monitor, projector, light
box, posters, aquarium, goldfish,
plastic, table, chairs
Dimensions variable
Installation, Museum of Contemporary
Art, Helsinki

Superflex
Biogas in Africa
1997

The first meeting between Surude and
Superflex in Copenhagen, explaining
the ideas behind the biogas system.
Together with the Danish engineer
Jan Mallan, Surude invited Superflex
to Tanzania to test the system.

Superflex
Biogas in Africa, 1997

Explaining the basic idea of the
hydraulic system to the technician
from Surude

Superflex
Orange Sauna
1996
Nylon with coating, aluminium, earth, wood
Sauna ø 200 cm, h 120 cm
Installation, Service Gallery, Stockholm

superflex

1968 Rasmus Nielsen, born Hjørring, Denmark. 1969 Superflex live and work in Copenhagen. Bjørnstjerne Christiansen, born Copenhagen. 1969. Jakob Fenger, born Roskilde, Denmark. **website:** http://www.super-flex.dk/ **selected solo exhibitions:** 1996 Orange Sauna. Service Gallery, Stockholm. 1997 'Superflex'. Biogas in Africa. Museum of Contemporary Art, Helsinki. **selected group exhibitions:** 1993 Opening Show. Gallery Nicolaj Wallner, Copenhagen. 1995 'Atomic'. Gallery Oberwelt, Stuttgart. '2.D'. Nikolai Church, Copenhagen 1996 Orange ist Human. Artgenda, Copenhagen. 'Proms III'. Brandts Klædefabrik, Odense 1997 XLVII Venice Biennale. 'New Art from Denmark and Scania'. Louisiana Museum. Humlebæk, Denmark. 1998 Copenhagen Video'. New Museum of Contemporary Art, New York. **selected bibliography:** 1994 Torben Weirup. 'Det er kunst'. Berlinske Tidende, Berlin, 13 June 1997 Lars Bang Larsen. 'The art for the end of the century'. Siksi, Helsinki. Spring. Lars Bang Larsen. 'Art's a Gas'. Springer, Vienna. June/September. Georg Schöllhammer. introduction to 'Art's a Gas'. Springer, Vienna. June/September. Superflex och Åsa Sonjasdotter. Samtale. Malmoe, Sweden. April. Lars Bang Larsen. 'Superflex – kunst og biogas'. Højskolebladet, No 32. Copenhagen. October. 1998 Octavio Zaya. 'Superflex'. Don't waste waste'. Flash Art, Milan. March/April

Superflex
Orange Sauna, 1996
Nylon with coating, aluminium
ø 200 cm, h 120 cm
Rosendal, Norway

The Orange Sauna is a portable sauna made for wildlife lovers in Scandinavia. Just find a nice place, make a fire, heat up some stones, arrange the sauna, bring the glowing stones into the sauna and pour water on the stones. The sauna will soon be filled with warm steam

Superflex
Endorphins, 1996
Acrylic, electric stimulator table, chairs
30 x 30 cm each stimulator

Endorphins are pain relievers produced by the human body in stressful situations; they are referred to as morphine analogues. To use: put your hand on the stimulator and press gently. The electrical stimulation will induce the release of endorphins in the body.

Sarah Sze
Untitled (Studio), 1996
Mixed media
Dimensions variable
Installation, the artist's studio, New York

sarah sze

At the end of the 1990s, how do people in the West, especially the younger generation, feel about, live in and react to their time — the age of ubiquitous computerization and standardization as well as of a globally omnipotent late Capitalism? Many can undoubtedly be classified as members of novelist Douglas Coupland's 'Generation X', who see no future in the future and spend their lives working in enclosed 'Microsofted' offices, consuming 'flat food' and boringly exciting video games. Fortunately, others, often by means of 'alternative' channels such as contemporary art, strive to resist this by re-thinking and re-imagining relationships between humans and the world, between the brain and the body, between the public and the private, between enjoyment and anxiety. One strategy is to develop critical discourses and images to transgress, politically and culturally, the dominant order. Others are working more unobtrusively to invent new ways of looking at the world, refreshing the rapport between the body and space in order to remind us that our existence is by no means frozen by strictly coded information. There is always potential for unexpected changes, incidents and, therefore, liberty. Idealism is still something to strive for.

New Yorker Sarah Sze strives for the ideal state of being, negotiating the seeming hopelessness of everyday life with riddles and myths. She collects quotidian objects, from soap bars to cotton sticks, matches to medical pills, candies to wrapping boxes, building them into extraordinary theatrical structures. The results are like miniature, ephemeral yet spectacular versions of *Cinecittà*. These works are inserted into indifferent corners of buildings, from houses to museums, and lit by lamps or spots to summon 'the unexpectedly profound out of the mundane'. They embody the artist's intention to rebuild real-life environments in which traces of

human activities can be rediscovered. But they are much more than simple reconstructions of the real. They are both rigorous and magnificent, attracting our gaze and encouraging us to discover a strange realm, surprising and refreshing, beyond our flat, mechanically organized world. Their vivid, brilliant juxtaposition of colours, lights, shadows, textures, sizes, order and disorder puts them into a swirling tension of beauty and chaos, idealism and anxiety, real and unreal. It is as if Sze were making visible by means of an Intel-Pentium chip an astonishing, previously hidden side of our life, somewhere between a global metropolis – New York, Hong Kong – and a science-fiction city – *Bladerunner* Los Angeles. This amazing world of 'anxious idealism', as the artist puts it, dramatically affects our awareness: we are deeply moved and even shocked by the pleasure and the fear of encountering an unfathomable, unknown but fascinating wonderland.

Hou Hanru

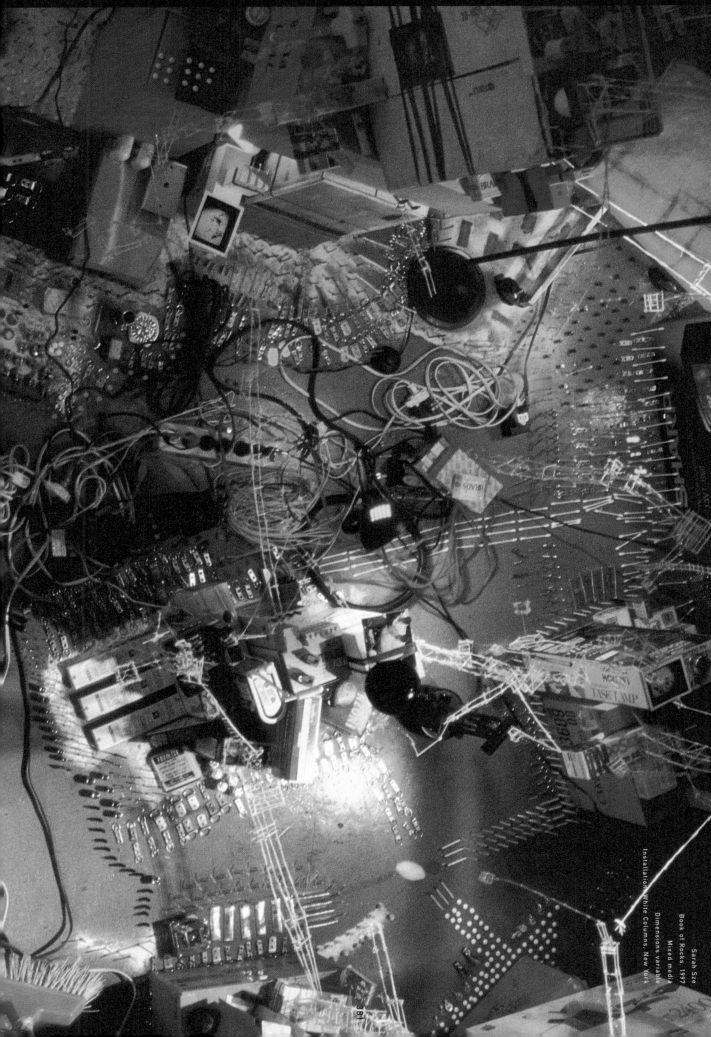

Sarah Sze
Book of Rocks, 1997
Mixed media
Dimensions variable
Installation White Columns, New York

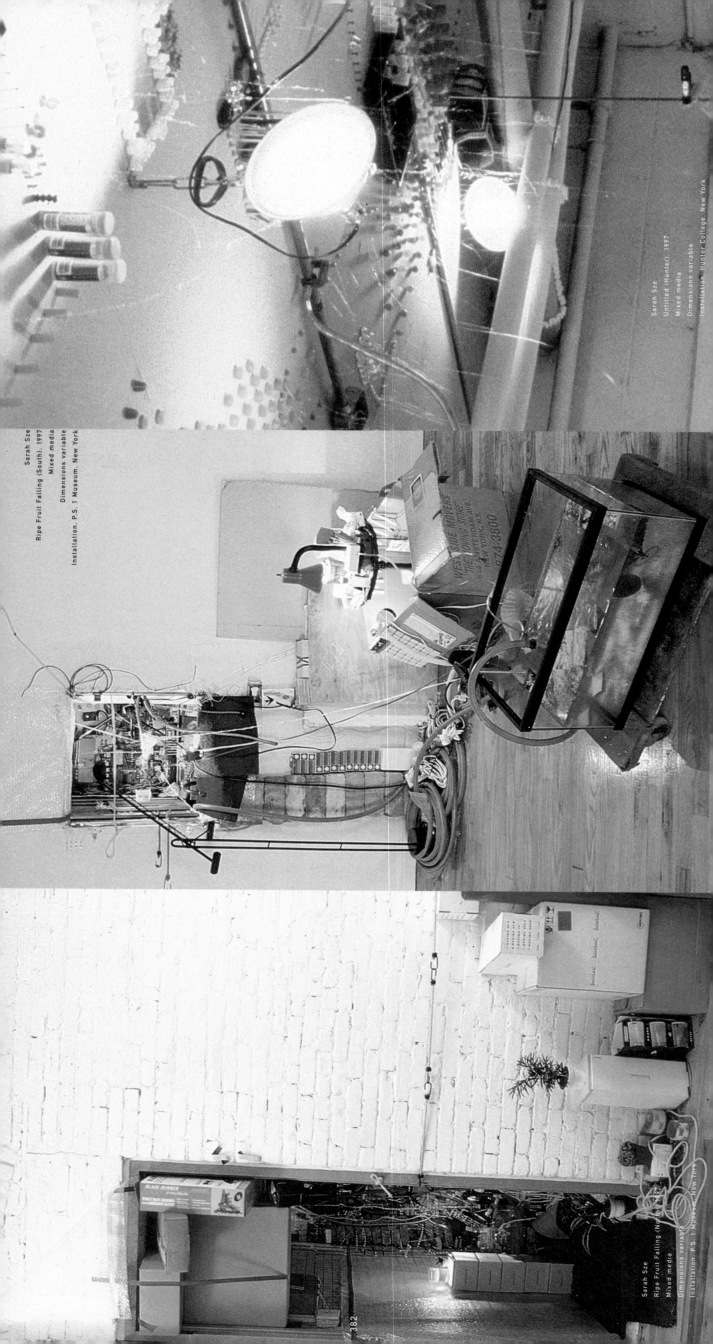

Sarah Sze
Untitled (Hunter), 1997
Mixed media
Dimensions variable
Installation, Hunter College, New York

Sarah Sze
Ripe Fruit Falling (South), 1997
Mixed media
Dimensions variable
Installation, P.S. 1 Museum, New York

Sarah Sze
Ripe Fruit Falling (North), 1997
Mixed media
Dimensions variable
Installation, P.S. 1 Museum, New York

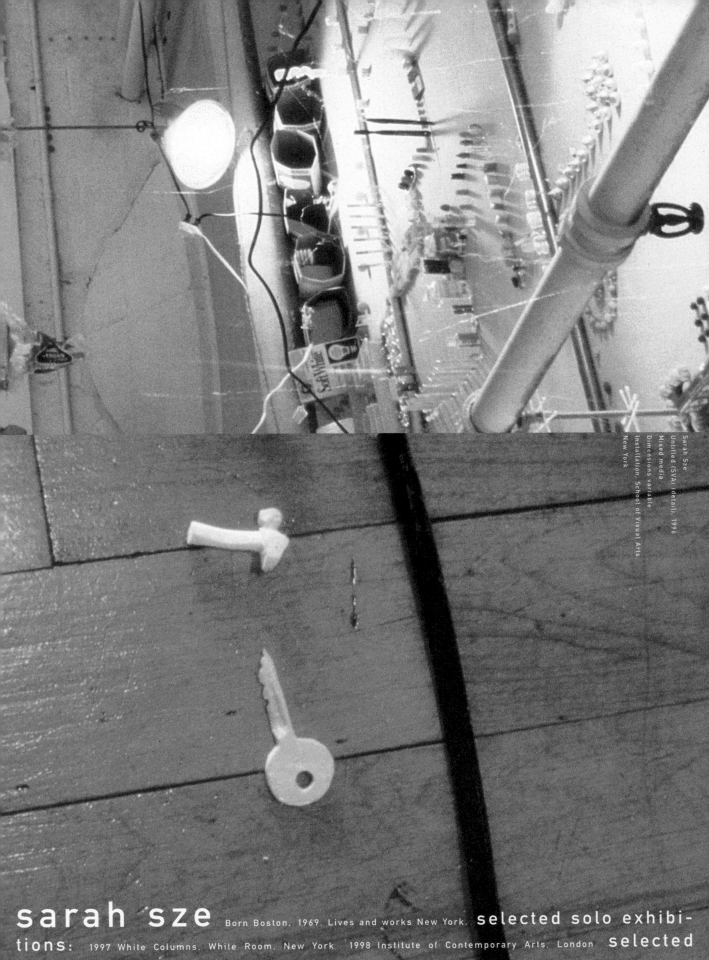

sarah sze Born Boston, 1969. Lives and works New York. selected solo exhibi-

tions: 1997 White Columns, White Room, New York 1998 Institute of Contemporary Arts, London selected

group exhibitions: 1996 SoHo Annual, New York 1997 'Migrateurs', ARC, Musée d'Art Modern de la Ville de

Paris; P.S. 1 Museum, New York; Casey Kaplan Gallery, New York 1998 Manifesta 2, Luxembourg selected bibliog-

raphy: 1996 Roberta Smith, 'Culture and Commerce Live Side by Side in SoHo', *The New York Times*, 13 September 1997

Roberta Smith, 'More Space and Gracious, Yet Still Funky at Heart', *The New York Times*, 31 October; Leslie Camhi, 'P.S. 1 Back in

Session', *The Village Voice*, New York, 4 November; Jeffrey Hogrefe, 'Late for School; P.S. 1 Re-opens', *The New York Observer*, 27

October; Holland Cotter, 'Art in Review; Drawings and Paintings, Wooster Gardens', *The New York Times*, 19 September; Jennifer

Dalton, 'Sarah Sze', *Review*, New York, 15 September; Holland Cotter, 'Art in Review; Killing Time', *The New York Times*, 12

September; David Frankel, 'The Name of the Place', *Artforum*, New York, May; Holland Cotter, 'Art in Review: The Name of the

Place, Casey Kaplan Gallery', *The New York Times*, 31 January 1998 Eleanor Heartney, 'The Return of the Red-Brick Alternative',

Art in America, New York, January 1998 Sarah Kent, 'Sarah Sze: ICA', *Time Out*, London, 22 April

Bhabha has identified the need to emphasize its performative aspect as opposed to its pedagogic definition, which tends to fix one to a somewhat abstract community of family, nation and culture. More importantly, perhaps, is the recognition that such a performative factor is leading to a general deconstruction of the very notion of cultural identity. At a time of expanding mass media and the late-capitalist world market, as well as constant border crossing and increasing cultural hybridization, one's existence becomes a process of transition between different geographic, economic, political and cultural spaces; spaces that are being opened up to cultural difference and restructuring. In other words, identity might perhaps be better understood as 'trans-identity'. Born in 1966 in Indonesia of a Chinese father and an Australian mother, growing up in Australia, living from 1988 in the Netherlands, and working internationally, Fiona Tan is a perfect embodiment of this trans-identification. Her art reflects a personal though increasingly common experience of permanent transition. Using time-based media such as film, video and motorized devices, her work involves the audience physically and psychologically in the revelation that such self-transformation is a destiny common to us all. Her sixty-minute documentary film *May You Live in Interesting Times*, 1997, is an ongoing project spanning the three years during which she visited family members who were spread all around the world due to anti-Chinese turmoil in Indonesia in the 1960s. Using a sophisticated, emotionally-triggered technique of editing, Tan presents an astonishing, overlapping panorama of global displacement and an in-depth scrutiny of the cultural memories, disruption and aspirations of China's post-colonial migrants. As the artist states: 'I aim with this project to investigate and hopefully deepen the current discussion of such hashed terms as: multiculturality, migration and transgression.'

If trans-identity is the sign of our times, it is a paradoxical or schizophrenic way of being. How to rise above such schizophrenia becomes a fundamental challenge, a necessary strategy of survival. Aware of this, Tan has developed a transcendent language with which to negotiate reality. Her two-channel video installation *Roll I & II*, 1997, is an example of this. In the endless, looped projection, the larger-than-life image of her body rolls and falls rapidly from the top of the wall to the bottom while a close-up of a lifeless hand is shown on a small monitor on the floor. The contrast between the two images holds the audience in a tremendous tension. One can sense a kind of suspension, a moment of rupture or emptiness. This is a perfect metaphor for the paradox of trans-identity itself: the negotiation between, and co-existence of, stillness and motion, identification and de-identification. In the artist's words, it is 'a piece both monumental and fleeting, like a memory constantly being forgotten.'

Hou Hanru

his page and opposite. Fiona Tan
May You Live in Interesting Times, 1997
0 min, video, colour, sound

Fiona Tan
Roll I & II, 1997
Video-loop installation, colour, sound

Fiona Tan
Roll I & II (detail), 1997
Video-loop installation, colour, sound

fiona tan

Born Pekan Baru, Indonesia, 1966. Lives and works in Amsterdam. **selected solo exhibitions:** 1992 'Wishing Well Wishing', W139, Amsterdam 1993 'Pépinière', Barcsay Terem, Budapest 1995 'Private Views', Die Weisse Galerie, Cologne; 'Doubt', Artspace Witzerhausen, Amsterdam 1996 Galerie O Zwei, Berlin **selected group exhibitions:** 1992 Het Lakenmeestershuis, Gent, Belgium; '1-hour art', Museum Fodor, Amsterdam 1994 'Art(s) d'Europe?', Galerie de L'Esplanade, Paris; Stedelijk Museum Bureau, Amsterdam 1995 'Arslab – I sensi del Virtuale', Palazo della Belle Arti, Turin 1996 'hARTware', Künstlerhaus, Dortmund, Germany 1997 'Trade Routes: History and Geography', 2nd Johannesburg Biennale; 'The Second – Time Based Art from The Netherlands', Stedelijk Museum, Amsterdam 1998 'Biennale de l'Image', Ecole National des Beaux-Arts, Paris **selected bibliography:** 1995 René Huigen, 'Human slices – Atlas of the Interior from Fiona Tan', *BVLD*, Amsterdam, November; Nadettee de Visser, 'Contemplating slices of a murderer', *Het Parool*, Amsterdam, 17 March; Robert Roos, 'Het lijk staat wuft te pronken', *Trouw*, Amsterdam, 7 August; René Huigen, 'Plakjes mens – Atlas of the Interior van Fiona Tan', *BVLD*, Amsterdam, November; Hans Beerekamp, 'De Brug', *NRC Handelsblad*, Rotterdam, 6 December 1996 Marina de Vries, 'De dans van wellustig levend plasma', *Het Parool*, Amsterdam, 13 December 1997 Dana Linssen, 'Interesting Times', *NRC Handelsblad*, Rotterdam, 25 July; Jos Bloemkolk, 'In search of the family Tan', *Het Parool*, Amsterdam, 25 July; Gerdin Linthorst, 'Impressive portrait of a Chinese familie', *Volkskrant*, Amsterdam, 26 July; Marijn van der Jagt, 'Square heads – television and ourselves', *Skrien*, Amsterdam, March; Rob Perrée, 'The Second starts in the Stedelijk', *Kunstbeeld*, Utrecht, March; Marijn van der Jagt, 'An eye that looks back', *De Groene Amsterdammer*, Amsterdam, 5 February; Marijke van Hal, 'Time based art', *Wave*, Amsterdam, January; Paoloa van de Velde, 'Nederlandse mediakunst volwassen geworden', *De Telegraaf*, Amsterdam, 14 February; 1998 Kees Schaepman, 'The best young artists, the choice of 11 museum directors', *Vrij Nederland*, Amsterdam, 7 March; Anna Tilroe, 'A lazy eye is sometimes enough, new Dutch art in De Appel', *NRC Handelsblad*, Rotterdam, 6 February; Paul Groot, 'NL', *Metropolis M*, Utrecht, April/May; Chris Dercon, 'Fiona Tan, The Choice of the Experts', *International Press Centre Nieuwspoort*, The Hague, March

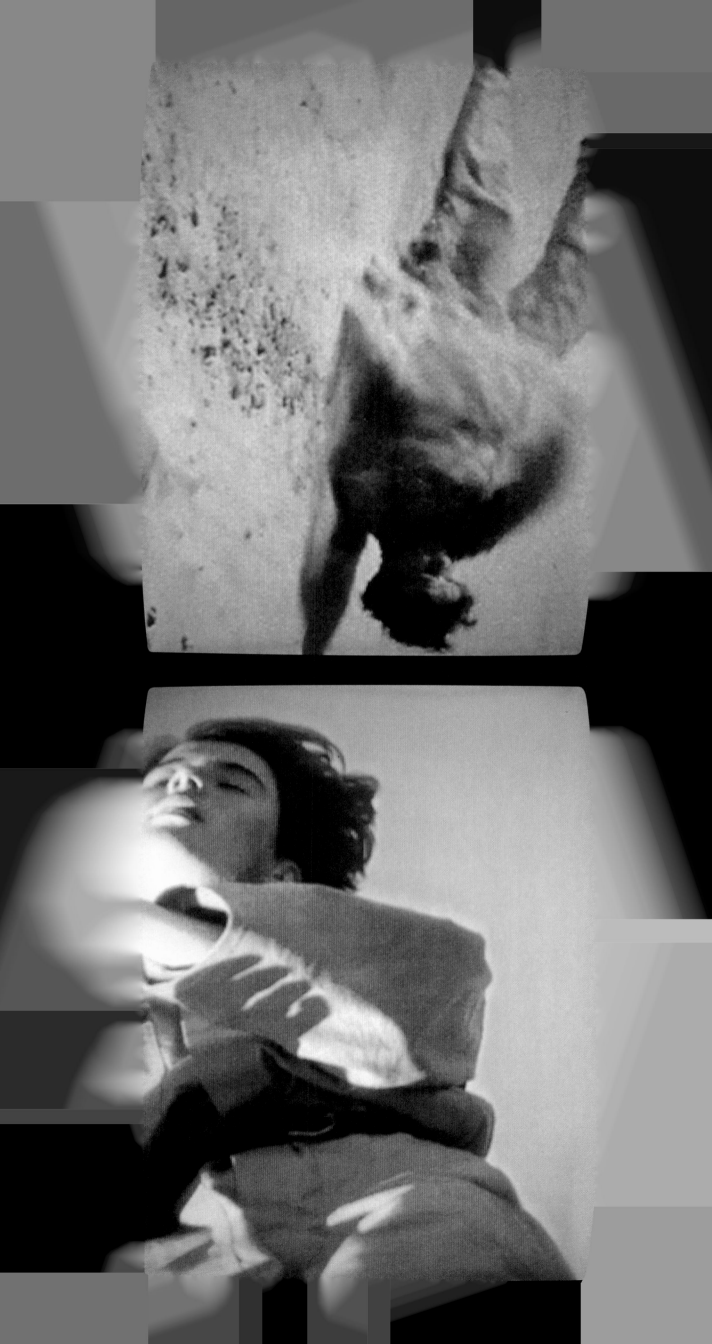

sam taylor-wood

Sam Taylor-Wood
Travesty of a Mockery, 1995
Two channel 10 min. video projection,
colour, sound

sam taylor-wood

Sam Taylor-Wood's works are underpinned by a filmic strategy, regardless of whether she is using film, video or photography. Allocating roles both to professional actors and friends, she often lifts an everyday situation out of context, investigating it in detail so that we can grasp its full import. *Method in Madness*, 1997, shows a method actor who, within a ten-minute period, works himself to the point of nervous breakdown, demonstrating the paradoxical freedom inherent in total loss of control.

Killing Time, 1994, in which refined culture and ordinary life coincide, could be read as a subtly political work. Over a period of an hour, four bored individuals lip-synch various roles in Strauss' *Electra*. Despite their indifference which contrasts sharply with the intense emotionality of the music, they remain seated until the concert is over, thus 'complying' with the expectations imposed by society. *Pent Up*, 1996, is also orchestrated like a modern opera and consists of five separate video narratives screened alongside each other on a wall. Each of the situations features an isolated person, preoccupied with their own mental trauma. These private worries are methodically communicated, but the way in which each monologue is formulated and the gestures choreographed creates an interaction between the different videos, giving the impression that every question, wish and grievance calls forth echoes from someone else's psyche.

The film-triptych *Atlantic*, 1997, shown at the XLVII Venice Biennale, investigates a female-male relationship. A quarrel between a woman and a man is staged in an expensive restaurant. Its splendid interior is lined with close-up photographs of the couple. The camera focuses on the woman's tearful face. Her words are drowned in the hubbub, but it is impossible to mistake their intent. The man's febrile, nervous hands fumble with a cigarette. The atmosphere is terribly painful and unerringly universal. The couple relationship implied in *Sustaining the Crises*, 1997, is no less complex. A film, set in an industrial area of London, shows a woman naked to the waist, walking determinedly towards the camera. Directly opposite, we see another film of a visibly disturbed man staring, breathing heavily, and we imagine that he can see what we can see. The viewer is left to speculate on the relationship between the two and the significance of their actions. *Somewhere*, 1997, was a collaboration between Taylor-Wood and the pop group the Pet Shop Boys for a concert in London. Projected onto two screens were black-and-white films showing the band and friends sitting on sofas at an elegant party. While the extras in the film seemed be listening to the live music, the musicians themselves appeared to move freely between stage and screen. After the interval, when the film suddenly became colour, it became clear that what had been perceived as a real-time performance had in fact been filmed beforehand, the precisely timed choreography allowing the band members to interact with the film. This time Taylor-Wood goes all the way, crossing the boundaries between reality and fiction that she constantly blurs in her work.

Åsa Nacking

Sam Taylor-Wood
Slut, 1993
C-print
50 x 41 cm

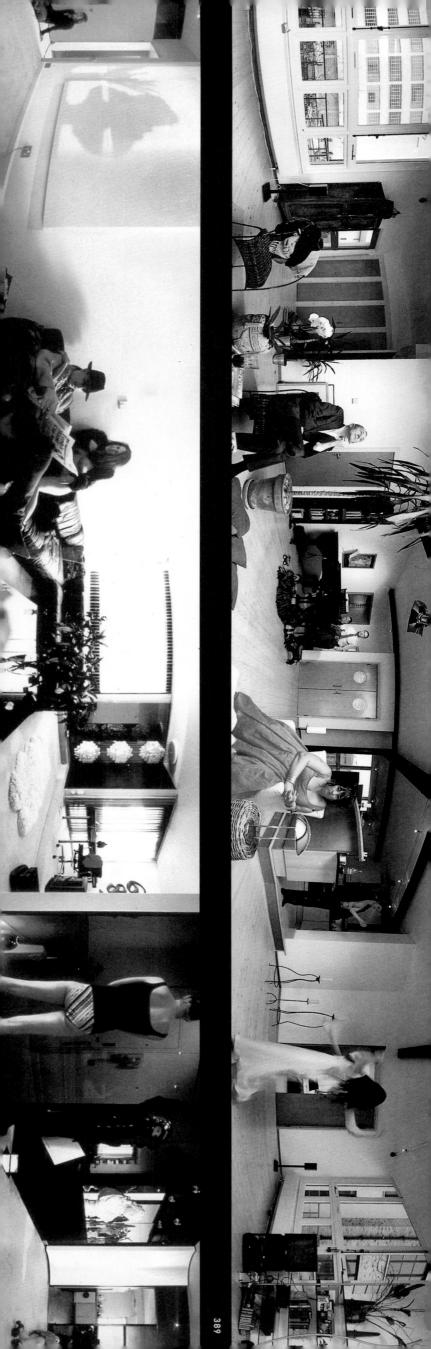

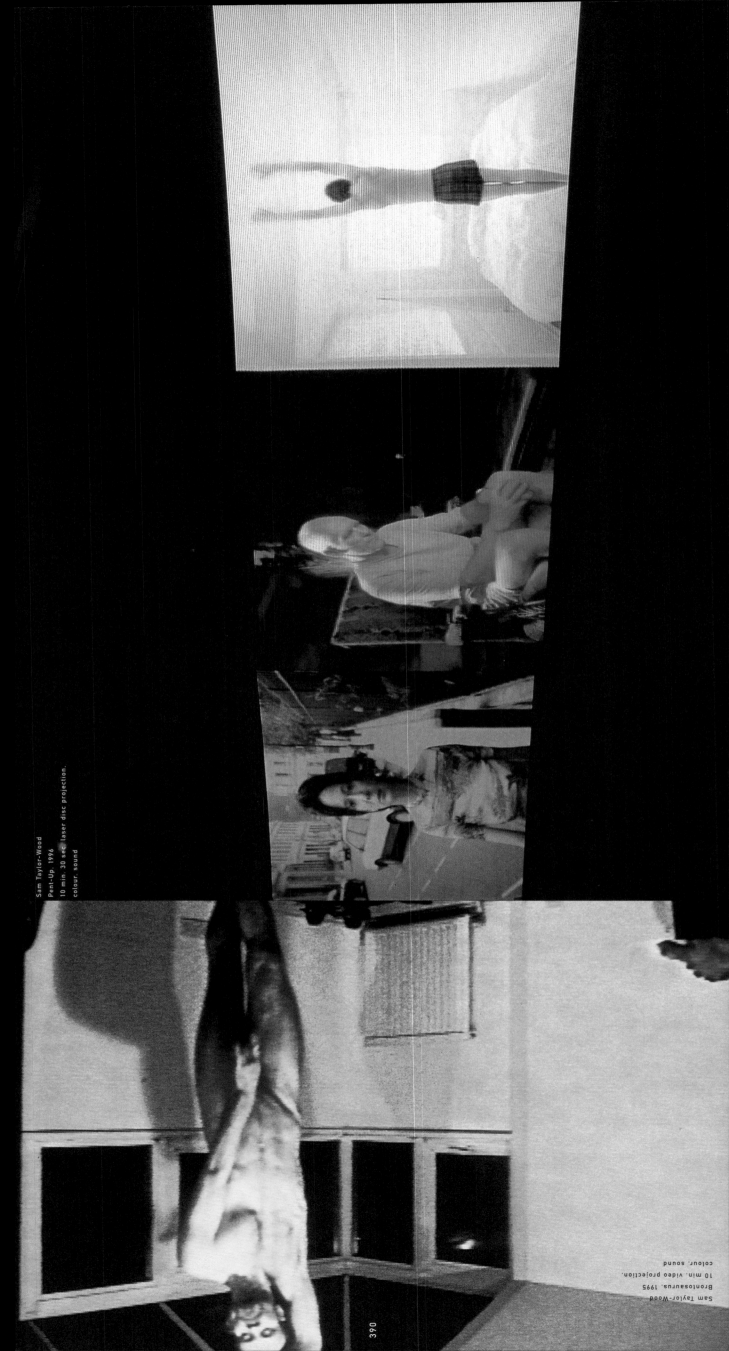

Sam Taylor-Wood
Pent-Up, 1996
10 min. 30 sec. laser disc projection,
colour, sound

Sam Taylor-Wood
Brontosaurus, 1995
10 min. video projection,
colour, sound

sam taylor-wood

Born London, 1967. Lives and works in London. **selected solo exhibitions:** 1994 'Killing Time', The Showroom, London 1995 'Sam Taylor-Wood', Galerie Andreas Brändström, Stockholm 1996 'Pent-Up', Chisenhale Gallery, London: Sunderland City Art Gallery 1997 Kunsthalle Zurich: Lousiana Museum, Humlebæk; 'Sam Taylor-Wood: Five Revolutionary Seconds', Sala Montcada de la Fundacio 'la Caixa', Barcelona

selected group exhibitions: 1996 'life/live', ARC, Musée d'Art Moderne de la Ville de Paris, Centro Cultural de Belém, Lisbon: Manifesta 1, Rotterdam; 'Prospect '96', Kunstverein, Frankfurt 1997 'Trade Routes: History and Geography', 2nd Johannesburg Biennale; 'On life, beauty, translations and other difficulties', 5th Istanbul Biennale; 'Sensation', Royal Academy of Arts, London; 'Truce: Echoes of Art in an Age of Endless Conclusions', Site Santa Fe, New Mexico: XLVII Venice Biennale; 'Strange Days', Gianferrari Arte Contemporanea, Milan 1998 'New British Video Programme', The Museum of Modern Art, New York **selected bibliography:** 1993 Michael Archer, 'Piss and Tell', *Art Monthly*, London, December/January 1996 Daniel Birnbaum, 'Sam Taylor-Wood', *Artforum*, New York, November; Gregor Muir, 'Sam Taylor-Wood', *frieze*, London, April; Ara de Monvel, 'Sam Taylor-Wood', *Flash Art*, Milan, May/June 1997 Susan Kandel, 'Art Reviews', *The Los Angeles Times*, 12 December; Francesco Bonami, 'Sam Taylor-Wood', *Flash Art*, Milan, March/April; Gilda Williams, 'Sam Taylor-Wood: Chisenhale Gallery', *art/text*, Sydney, February/April 1998 Terry R. Myers, 'Sam Taylor-Wood: Yesterday when I was mad', *art/text*, Sydney, February/April

Pascale Marthine Tayou
The Colourful Maze. 1997
Dried fish, fishing net, chalk, socks,
cardboard boxes, projectors, wire
hooks, wood
7000 x 7000 cm
Installation 2nd Johannesburg
Biennale

pascale marthine tayou

Walking into one of Pascale Marthine Tayou's installations is like experiencing a landscape after a hurricane, or a hotel room after a trashing by a post-adolescent rock band. Tayou sorts, arranges and deposits odd agglomerations of assorted detritus such as condoms, plastic bags, hundreds of socks and other articles of clothing, bricks, straws, decapitated dolls, scrawls and innumerable messages written on walls, as part of his visual tone poems, essays on obsolescence, waste and abjection. The effect of being inside these capsules of disparate thoughts, actions, experiences, materials and information, which totter at the edge of confusion in an aggressive confrontation with the viewer, is a kind of vertigo similar to that produced by the dizzying installations of Jason Rhoades, Bjarne Melggaard or Thomas Hirschhorn. And like these artists, Tayou creates a seeming chaos that often leaves one bewildered, pondering whether the parts add up to the whole, or if the whole is the sum of the parts. Such havoc does this young Cameroonian artist wreak on the exhibition space that it takes a while to realize that there is indeed a method to the madness. Tayou wants his installations to disorient, to re-route and tinker with the viewer's navigational compass in order to underline the fact that artists no longer merely wish to make aesthetic proposals. Artists like Tayou play multiple roles in their work – anthropologist, ethnographer, investigative reporter, curator, social historian, museum docent – in an unceasing analysis and complication of art's relationship to the world. Tayou's chief concern is how to bring alive dead things that other people have abandoned or cast out of their lives, how to make them resignify as items that carry a usable memory, providing a history, a trace of our distemperate time of AIDS and violence, to name two preoccupations in his work. On another level, Tayou could be seen as a stream-of-consciousness bard of the street who aspires to make of his work a social space for conversations, for discreet exchanges. For example, in his installation for the 2nd Johannesburg Biennale, *The Colourful Maze*, 1997, he built a labyrinth with a cheerful, bright yellow exterior and a more ponderous blackboard interior on which he drew and wrote in chalk hundreds of lines, words, notations, lyrics related to literature, art, philosophy, love and so on. These walls share a certain formal affinity with the chalkboard drawings of Cy Twombly, Joseph Beuys and Gary Simmons. But Tayou's installations are conceived as private spaces; spaces for thinking, for intimacy. In this sense, the wall becomes emblematic of that horizontal urban notice-board, the graffiti wall, which bears ciphers of modern consciousness (political manifestos, anarchic signs of rebellion, a love poem, a memorial site in a ghetto, or merely a simple statement announcing 'Kill Joy was Here'). All these, in one form or another, make art a terrain of social interaction. They become ways to mark and wound the body of the city, to make it acknowledge our suspiring voices, the fragment of our own singularity, our individual presence in the absurd, anonymity of the modern metropolis.

Okwui Enwezor

Pascale Marthine Tayou
The Colourful Maze 1997
Dried fish, fishing net, chalk, socks,
cardboard boxes, projectors, wire
hooks, wood
7000 x 7000 cm
Installation, 2nd Johannesburg
Biennale

pascale marthine tayou

Born Yaounde, Cameroon. 1966. Lives and works in Yaounde and Douala, Cameroon.

selected group exhibitions: 1994 'Atelier la Rencontre', Goethe Institut, Yaounde, Cameroon. 1995 Kwangju Biennale, South Korea. 1997 'Trade Routes: History and Geography', 2nd Johannesburg Biennale. 6th Havana Biennial. 'Truce: Echoes of Art in an Age of Endless Conclusions', Site Santa Fe, New Mexico. Kwanju Biennale, South Korea.

selected bibliography: 1995 Franklin Sirmans. 'Pascal Marthine Tayou'. 'NKA: Journal of Contemporary African Art', New York, Summer/Fall. Kawaguchi Yukiya. 'Biennale Dakar, Senegal'. May 1997 Sue Spaid. 'Art in America', New York, May. Francesco Bonami. Olu Oguibe, et al. 'Trade Routes: History and Geography'. 2nd Johannesburg Biennale. Greater Johannesburg Metropolitain Council, South Africa. and Prince Claus Fund for Culture and Development, The Netherlands. 1997

Pascale Marthine Tayou.
Deballage. 1997.
Clothes, dried fish, wire, hooks, salt,
pepper, socks, magazines, casava,
plants, tree actors.
5000 x 5000 cm.
Installation/performance, Goethe
Institut Yaounde, Cameroon.

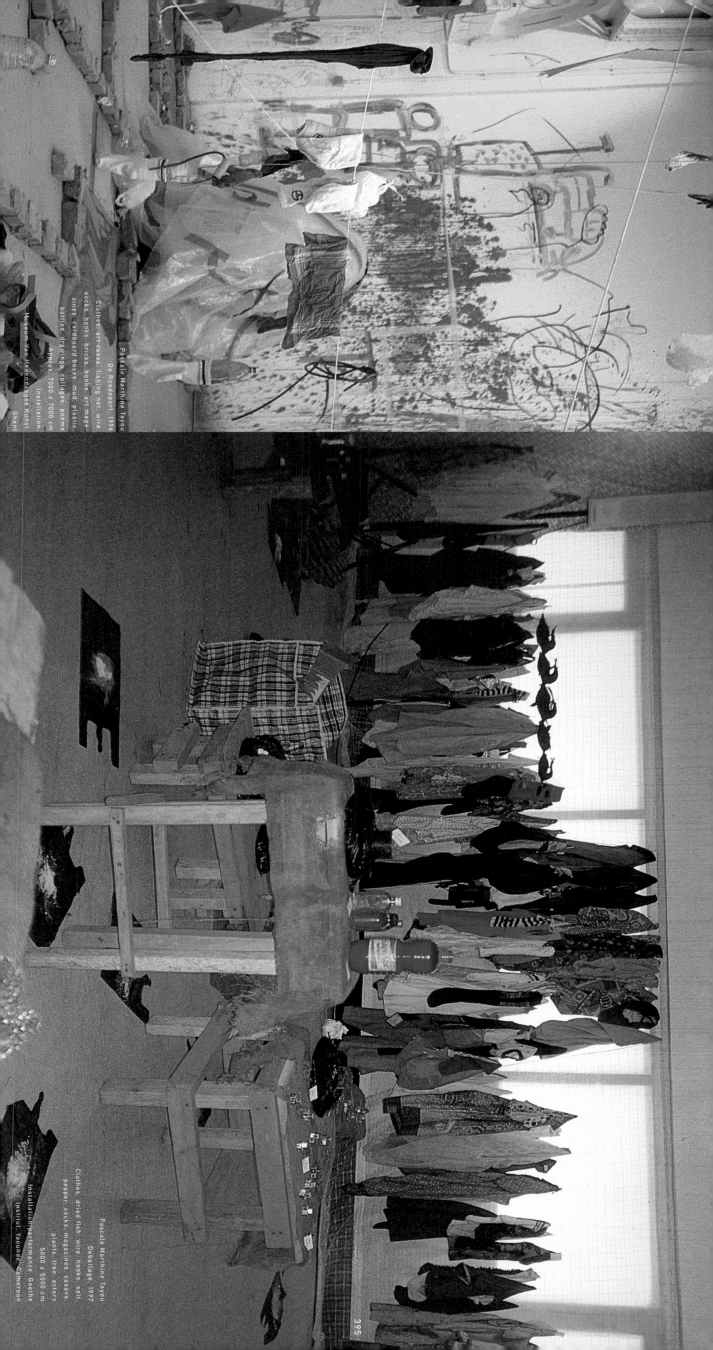

Pascale Marthine Tayou
De Roodeport, 1996
Clothes, art cases, fishing net, wire,
socks, hooks, bricks, books, art maga-
zines, cardboard boxes, mud, plastic,
bottles, drawings, collages, poems
Approx. 7000 x 7000 cm
Installation
Museum Van Hedendaagse Kunst,
Ghent

Pascale Marthine Tayou
Deballage, 1997
Clothes, dried fish, wire, hooks, salt,
pepper, socks, magazines, casava,
plants, tree, actors
5000 x 5000 cm
Installation/performance, Goethe
Institut, Yaoundé, Cameroon

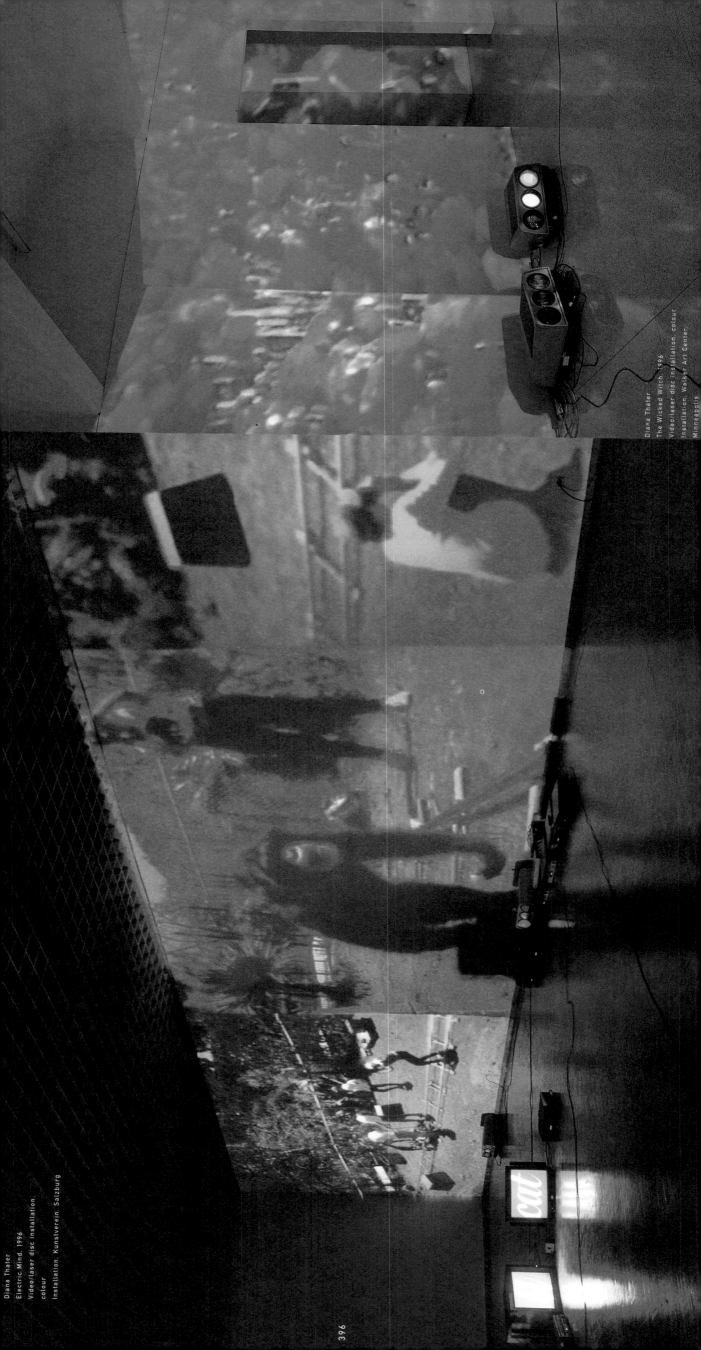

Diana Thater
Electric Mind, 1996
Video/laser disc installation,
colour
Installation, Kunstverein, Salzburg

Diana Thater
The Wicked Witch, 1996
Video/laser disc installation, colour
Installation, Walker Art Center,
Minneapolis

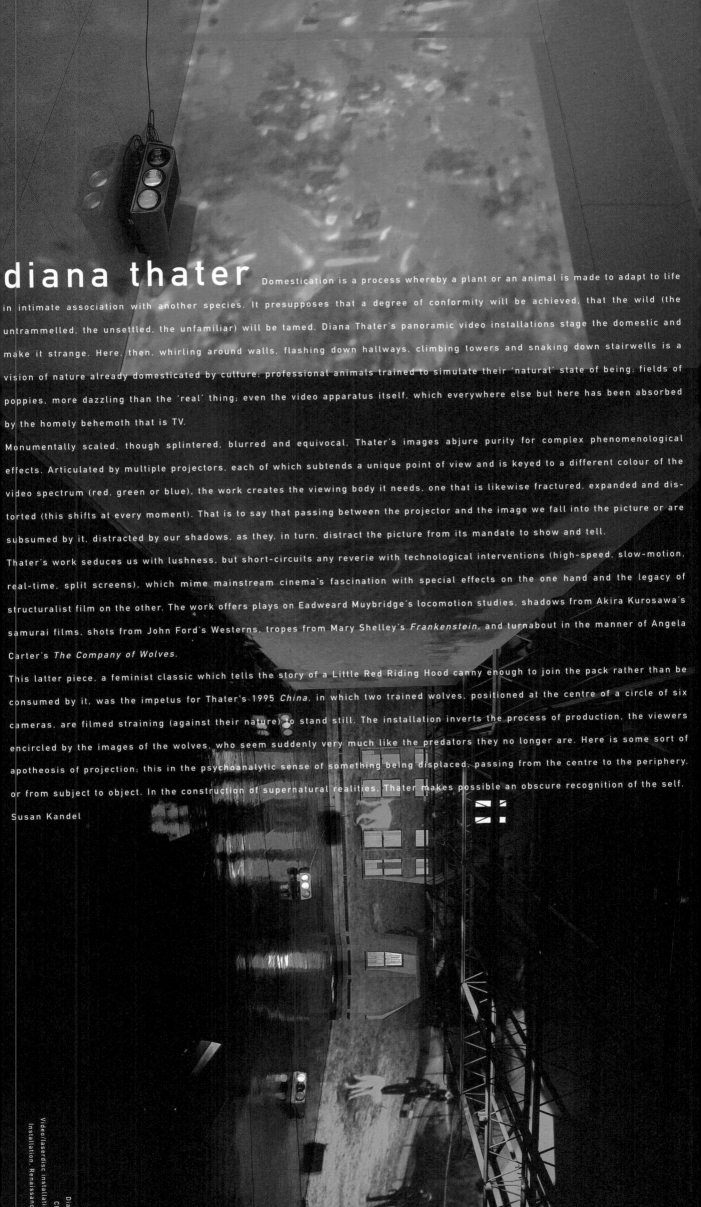

diana thater

Domestication is a process whereby a plant or an animal is made to adapt to life in intimate association with another species. It presupposes that a degree of conformity will be achieved, that the wild (the untrammelled, the unsettled, the unfamiliar) will be tamed. Diana Thater's panoramic video installations stage the domestic and make it strange. Here, then, whirling around walls, flashing down hallways, climbing towers and snaking down stairwells is a vision of nature already domesticated by culture: professional animals trained to simulate their 'natural' state of being; fields of poppies, more dazzling than the 'real' thing; even the video apparatus itself, which everywhere else but here has been absorbed by the homely behemoth that is TV.

Monumentally scaled, though splintered, blurred and equivocal, Thater's images abjure purity for complex phenomenological effects. Articulated by multiple projectors, each of which subtends a unique point of view and is keyed to a different colour of the video spectrum (red, green or blue), the work creates the viewing body it needs, one that is likewise fractured, expanded and distorted (this shifts at every moment). That is to say that passing between the projector and the image we fall into the picture or are subsumed by it, distracted by our shadows, as they, in turn, distract the picture from its mandate to show and tell.

Thater's work seduces us with lushness, but short-circuits any reverie with technological interventions (high-speed, slow-motion, real-time, split screens), which mime mainstream cinema's fascination with special effects on the one hand and the legacy of structuralist film on the other. The work offers plays on Eadweard Muybridge's locomotion studies, shadows from Akira Kurosawa's samurai films, shots from John Ford's Westerns, tropes from Mary Shelley's *Frankenstein*, and turnabout in the manner of Angela Carter's *The Company of Wolves*.

This latter piece, a feminist classic which tells the story of a Little Red Riding Hood canny enough to join the pack rather than be consumed by it, was the impetus for Thater's 1995 *China*, in which two trained wolves, positioned at the centre of a circle of six cameras, are filmed straining (against their nature) to stand still. The installation inverts the process of production, the viewers encircled by the images of the wolves, who seem suddenly very much like the predators they no longer are. Here is some sort of apotheosis of projection: this in the psychoanalytic sense of something being displaced, passing from the centre to the periphery, or from subject to object. In the construction of supernatural realities, Thater makes possible an obscure recognition of the self.

Susan Kandel

Diana Thater
China, 1995
Video/laserdisc installation, colour
Installation, Renaissance Society,
Chicago

diana thater

Born San Francisco, California, 1962. Lives and works in Los Angeles.

selected solo exhibitions: 1991 'Dogs and Other Philosophers', Dorothy Goldeen Gallery, Santa Monica, California 1992 'Up the Lintel', Shoshana Wayne Gallery, Santa Monica, California 1993 'Late and Soon', David Zwirner, New York 1994 'Diana Thater', Witte de With, Centre for Contemporary Art, Rotterdam 1995 'Crayons & Molly Numbers 1 through 10', Galerie Schipper & Krome, Cologne 1996 'Electric Mind', Kunstverein, Salzburg 1997 'Diana Thater: Orchids in the Land of Technology', Walker Art Center, Minneapolis 1998 'Diana Thater', The Museum of Modern Art, New York

selected group exhibitions: 1990 'Heart in Mouth', Fahey/Klein Gallery, Los Angeles 1993 'Sugar and Spice', Museum of Art, Long Beach, California. 'The Time', Anderson O'Day Gallery, London 1994 'Pure Beauty', The American Center, Paris. Museum of Contemporary Art, Los Angeles 1995 Lyon Biennale. Kwangju Biennale, South Korea. Biennial, Whitney Museum of American Art, New York 1996 'Jurassic Technologies Revenant', 10th Sydney Biennale 1997 'Trade Routes: History and Geography', 2nd Johannesburg Biennale. Biennial, Whitney Museum of American Art, New York. Skulptur. Projekte Münster, Germany

selected bibliography: 1991 Colin Gardner, 'Diana Thater', Artforum, New York, May 1992 Adam Ross, 'Diana Thater', Art issues, Los Angeles, Winter 1993 Roberta Smith, 'Diana Thater', The New York Times, 24 December 1994 David Pagel, 'Into the Light', frieze, London, June 1995 Laurie Palmer, 'Review', Artforum, New York, Summer 1996 Jan Avgikos, 'Sense Surround: Diana Thater', Artforum, New York, May. Roberta Smith, 'Diana Thater', The New York Times, 23 February 1997 Hans-Christian Dany, 'Diana Thater', frieze, London, June/July. Thryza Nichols Goodeve, 'Signs of the Times', Artforum, New York, May. Mary Anne Staniszewski, 'Diana Thater: Orchids in the Land of Technology', Artforum, New York, May

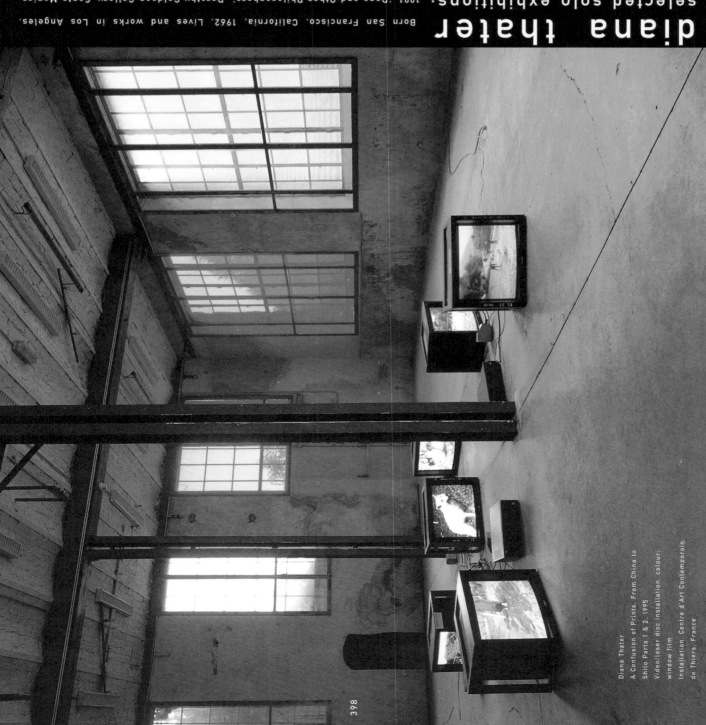

Diana Thater
A Confusion of Prints, From China to
Shito Paris I & 2, 1995
Video/laser disc installation, colour,
window film
Installation, Centre d'Art Contemporain
de Thiers, France

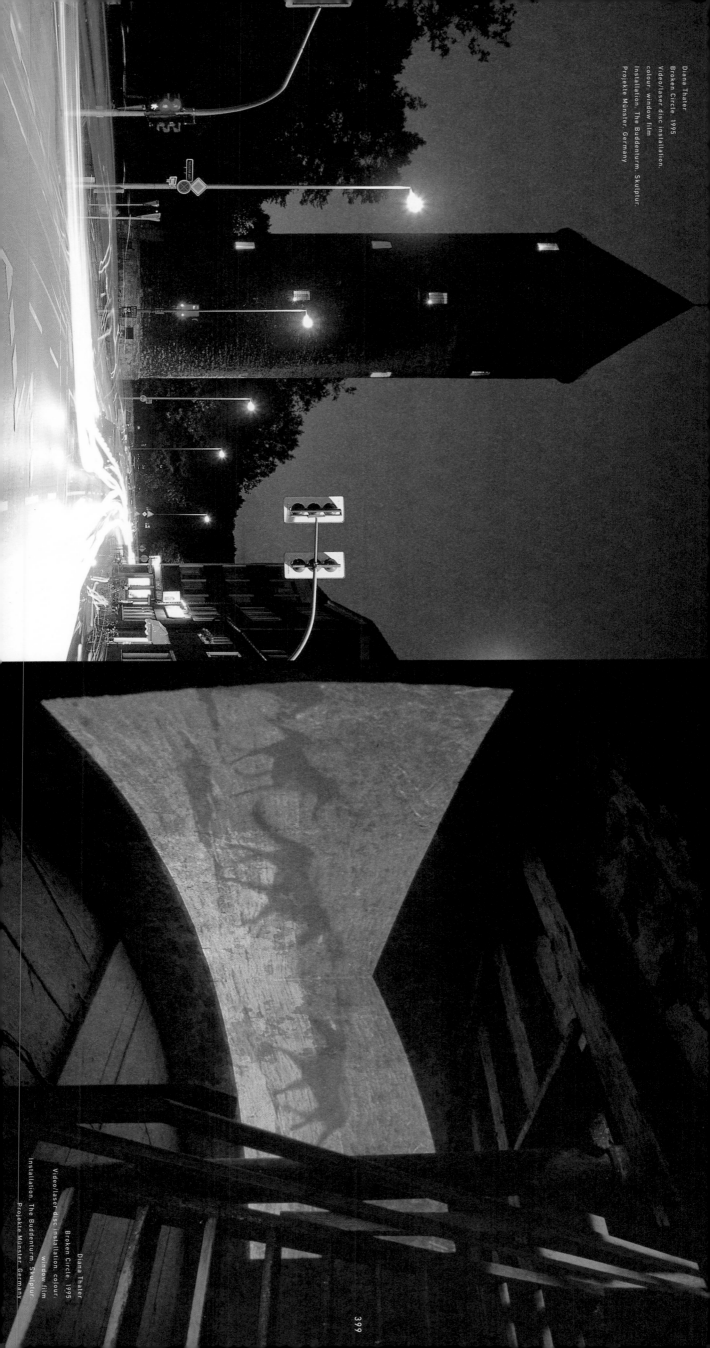

Diana Thater
Broken Circle, 1995
Video/laser disc installation,
colour, window film
Installation, The Buddenturm, Skulptur.
Projekte Münster, Germany

Diana Thater
Broken Circle, 1995
Video/laser disc installation, colour,
window film
Installation, The Buddenturm, Skulptur.
Projekte Münster, Germany

399

rirkrit tiravanija

Rirkrit Tiravanija can perhaps be said to be more responsible than any other artist of his generation for putting an artistic attitude into practice that has effectively transformed the rules of contemporary art. From turning the gallery space into a storage room with an annex kitchen in which he and the gallery staff cooked meals for audiences (for example, at the 303 Gallery, New York, 1992, or XLV Venice Biennale, 1993), to his latest project for the Philadelphia Museum (*On the Road*, 1998) which will consist of a trip across the United States with a group of students from Thailand, the artist has effected what Joseph Beuys only suggested in formal, more egocentric terms — the democratization of art. Like characters in a scene from a Jacques Tati film, all the participants in Tiravanija's work take on equal hierarchical status in the action and are equally relevant to the final success of the event.

Tiravanija uses those elements that art institutions fragment into departments — education, press, fund-raising, etc. — as sculptural materials, not towards a political action, but in a process that leads to a sense of conviviality, an exchange of experience that questions the very essence of the official art world and disrupts the museum as a sacred place for culture. He achieves this goal by shifting the function of the space — the gallery as storage, the museum as playground, restaurant, theatre. His artistic project cannot be defined by individual works but must be perceived as a whole, an open test both for the viewer and for himself. If art has to be institutionalized in order to make an impact on the audience, how can Tiravanija's research and transformations, which reject this notion, create their own impact in the fluidity of the present world? This question stands in the way of Tiravanija's works and challenges his own existence as an established artist, shifting his position into a semi-philosophical realm. By his own strategy, the charismatic role of the artist and the system that nurtures it are shattered, reduced to mere functions of the participating viewer. In *Playtime*, 1997, a work made for The Museum of Modern Art in New York, he rebuilt Philip Johnson's *Glass House*, scaled down to child-size and set in Johnson's museum garden. In this way he created a moment of ephemeral relevance in relation to a historical point of reference, stressing the meaning and the appreciation of contemporary art and culture. Mining both popular and personal references, Tiravanija, an artist of Thai origin who has lived in America for most of his life, creates his own language, which relates to architecture, objects, sound and images, in such a way that Western and Eastern influences converge into a vanishing point very different from the binary structure of present culture. Perpetually shifting the terms of his work, Tiravanija has even re-invented himself as a kind of Bergmanesque street actor in the puppet show with local school children made in Munster during Skulptur. Projekte, 1997, (*Untitled; The Zoo Society*). Tiravanija's project is to create and direct the present in an almost hypnotic flow that takes us as viewers and social share-holders into a realm of metaphysical implications.

Francesco Bonami

Rirkrit Tiravanija
Untitled (... Cure), 1993
Mixed media, people
305 x 305 x 305 cm
Installation, Künstlerhaus Bethanien,
Berlin

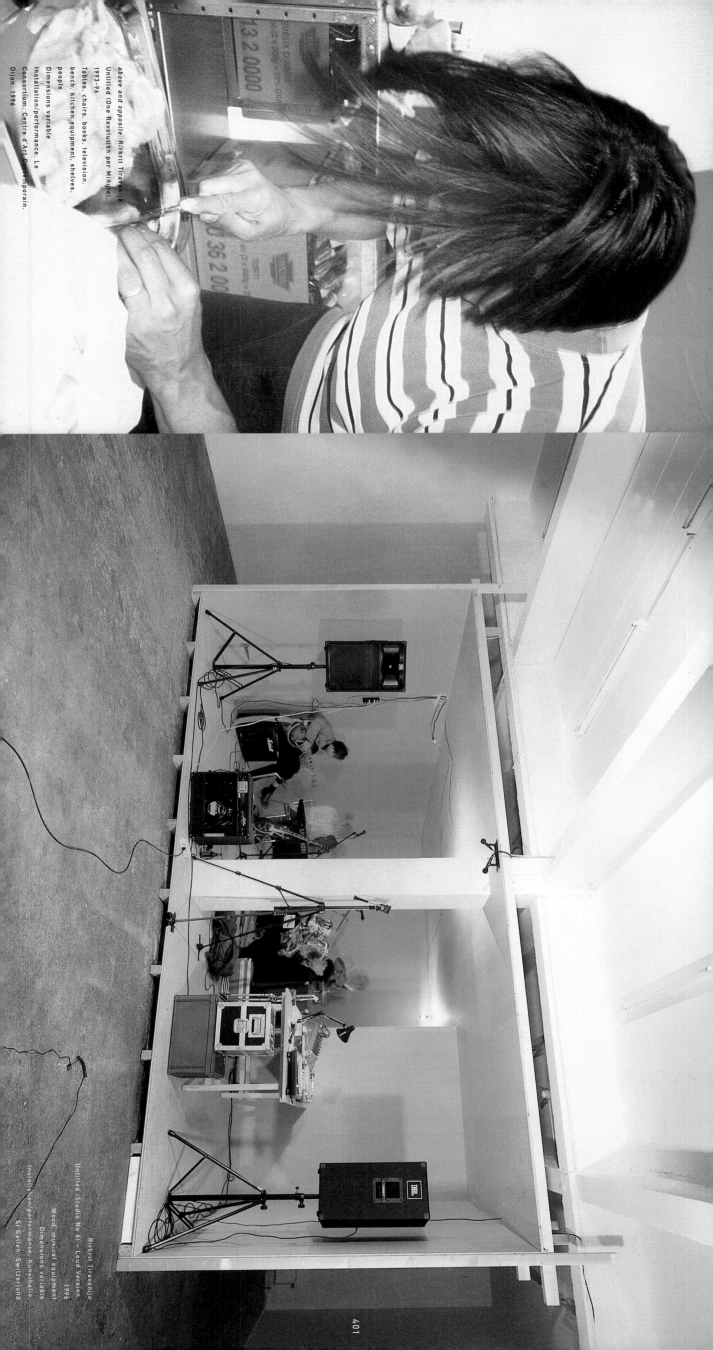

above and opposite, Rirkrit Tiravanija
Untitled (One Revolution per Minute),
1993-96
Tables, chairs, books, television,
bench, kitchen equipment, shelves,
people
Dimensions variable
Installation/performance, Le
Consortium, Centre d'Art Contemporain,
Dijon, 1996

Rirkrit Tiravanija
Untitled (Studio No 6) – Loud Version,
1996
Wood, musical equipment
Dimensions variable
Installation/performance, Kunsthalle
St Gallen, Switzerland

401

Rirkrit Tiravanija
Untitled (Café Deutschland), 1993
Table, chairs, stove, cardboard
boxes, books, people
Dimensions variable
Installation, Galerie Max Hetzler,
Cologne

rirkrit tiravanija

Born Buenos Aires 1961 Lives and works in New York.

selected solo exhibitions: 1990 Pad Thai, Project Room, Paula Allen Gallery, New York 1994 Andy Warhol/Rirkrit Tiravanija, Gavin Brown's enterprise, New York. Untitled, 1994, (Meet Tim & Burkhard), neugerriemschneider, Berlin 1995 Untitled, 1994 (From Baragas ... To Reina Sofia), Kunsthalle, Basel 1996 Tomorrow's Another Day, Kunstverein Cologne. Untitled, 1996 (One Revolution per Minute), Le Consortium, Centre d'Art Contemporain, Dijon

group exhibitions: 1989 Caught in a Revolving Door, The Alumni Association of the School of the Art Institute of Chicago 1991 The Big Nothing or Le Presque Rien, New Museum of Contemporary Art, New York. Wealth of Nations, Centre for Contemporary Arts, Ujazdowski Castle, Warsaw 1992 One Leading to Another, 303 Gallery, New York 1993 Migrateurs, ARC, Musée d'Art Moderne de la Ville de Paris; Real Time, Institute of Contemporary Arts, London. XLV Venice Biennale, Galerie Max Hetzler, Cologne 1994 Cocido y Crudo, Museo Nacional Centro de Arte Reina Sofia, Madrid. Don't Look Now, Threadwaxing Space, New York. L'Hiver de l'Amour, ARC, Musée d'Art de la Ville de Paris. P.S. 1 Museum, New York 1995 Lyon Biennale, Carnegie International, Carnegie Museum of Art, Pittsburgh. Kwangju Biennale, South Korea; Whitney Biennial, Whitney Museum of American Art, New York; Volatile Colonies, 1st Johannesburg Biennale 1996 Thinking Print, The Museum of Modern Art, New York; Manifesta 1, Rotterdam. Traffic, CAPC, Musée d'Art Contemporain, Bordeaux 1997 Skulptur Projekte Münster, Germany; Campo 6, Il Villaggio Spirale, Galleria Civica d'Arte Moderna de Contemporanea, Turin. Bonnefantenmuseum, Maastricht

selected bibliography: 1991 Roberta Smith, 'The Gallery is the Message', The New York Times, 4 October 1992 Lois Nesbitt, 'Rirkrit Tiravanija', Artforum, New York, December 1993 Ludo Weitzer, 'The Accidental Tourist', Flash Art, Milan, October. Benjamin Weil, 'Ouverture', Flash Art, Milan, January/February 1994 Dan Cameron, 'Food for Thought', Frieze, London, June/July/August 1995 Liam Gillick, 'Forget about the Ball and Get on with the Game', Parkett, No 44, Zurich; Richard Flood & Rochelle Steiner, 'En Route', Parkett, No 44, Zurich 1996 Rirkrit Tiravanija Talks with Peter Fischli and David Weiss', Artforum, New York, October. Bruce Hainley, 'Where Are We Going? And What Are We Doing? Rirkrit Tiravanija's Art of Living', Artforum, New York, February. Jerry Saltz, 'A Short History of Rirkrit Tiravanija', Art in America, New York, February

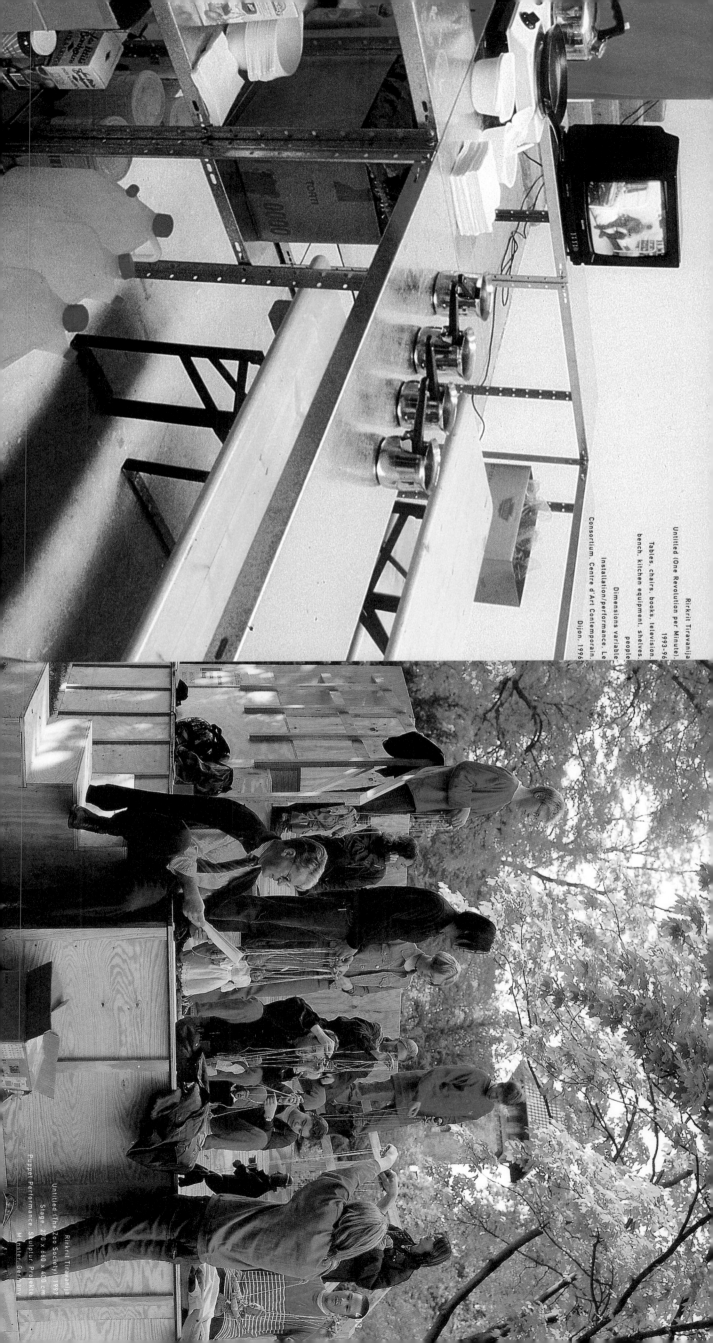

Rirkrit Tiravanija.
Untitled (One Revolution per Minute).
1993–96.
Tables, chairs, books, television,
bench, kitchen equipment, shelves,
people.
Dimensions variable.
Installation/performance. Le
Consortium, Centre d'Art Contemporain,
Dijon. 1996.

Rirkrit Tiravanija.
Untitled (The Zoo Society). 1997.
Stage. 270 x 660 x 400 cm
Puppet Performance Sculptur Projekte
Münster, Germany.

Sophie Tottie
Monitor. Monitor. Monitor. Monitor
(from Pictures for the Chief
Electrician). 1995
Oil on canvas. photograph on Plexiglas
4 parts. 216 x 113 cm each

sophie tottie

Pictures for the Chief Electrician, 1995. In 1995 Sophie Tottie presented *Pictures for the Chief Electrician* in a New York gallery. The installation included two videos – *The Terrorist* and *Still Life Antipole* – a series of paintings, photographs and a wall painting. The exhibition title appeared to serve as a way to assign a single meaning or at least a single 'family' of meanings to the collection of works that comprised the show. In this sense, the key work in the exhibition was, perhaps, *The Terrorist*, a four-minute video. It tells the story of a revolutionary terrorist whose position in time and place is obscure. The narrative is punctuated by a series of static images of the protagonist in different phases of his life. In the final sequences, when the twists and turns in the story have already made the intersections between the documentary and fictional aspects of the tale evident, the fixed image is replaced with one last animated take featuring the central character. This final image is a paradigm for the impossibility of pinning the work down to a specific genre, either documentary or fiction, and places the video in the blurred boundaries between an anonymous story and the tragic tales of individual subjectivity.

The title of the installation, 'Pictures for the Chief Electrician', offered the viewer a path towards understanding the individual works within it. But the complexity of *The Terrorist* prevented the observer from seeing the installation as a seamless unit. Perhaps the impossibility of assigning a single meaning lay in the installation title's allusion to the work of the electrician as one appointed to 'illuminate' (bring light), counterpoised with the terrorist figure as a dispenser of the darkness of terror. The studied ambiguity of the *The Terrorist*'s narrative inevitably affected the surrounding works. Consequently, it emphasized the constant exploration of the boundaries between genres and the equivocal nature of the situations described. Within this perspective, the rest of the pieces in the installation served only to highlight the affected meticulousness of the act of painting, the process of calculation that is always implied by a photograph, and the repeated re-arrangement called for by video. Trial, calculation, repetition: this is precisely how the terrorist himself operates as he proceeds through the brief, fragmentary stories that draw the dividing line between the fiction of art and political fact, the passion of the subject and the ecstasy of statistics. Tottie has carefully subjected her work to a systematic process of decomposition: decomposition of all the qualities of a painting or a photograph, whether abstract or figurative; decomposition of the very genres themselves, which she meticulously mixes. The imaginary unity of the subject was altered, as was the linearity of the narrative, which called simultaneously upon documentary tradition and the theatrical-ization of the situations narrated. What *The Terrorist* and *Still Life Antipole* ultimately offer is not so much a story as an ensem-ble of tics.

Carlos Basualdo

Sophie Tottie
The Terrorist
1993-95
4 min. video. colour. sound

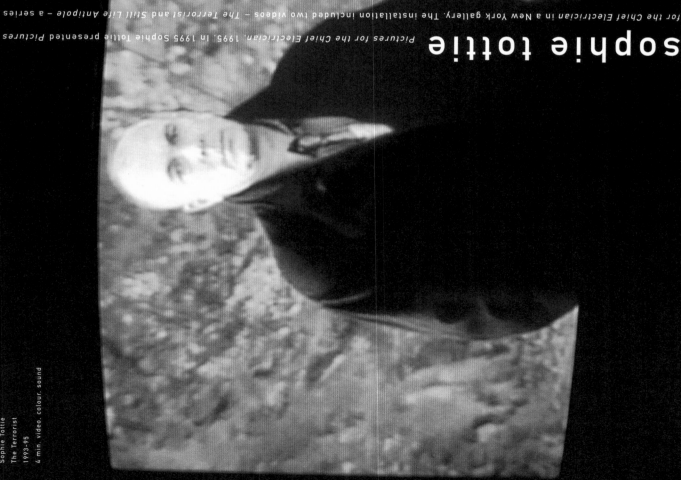

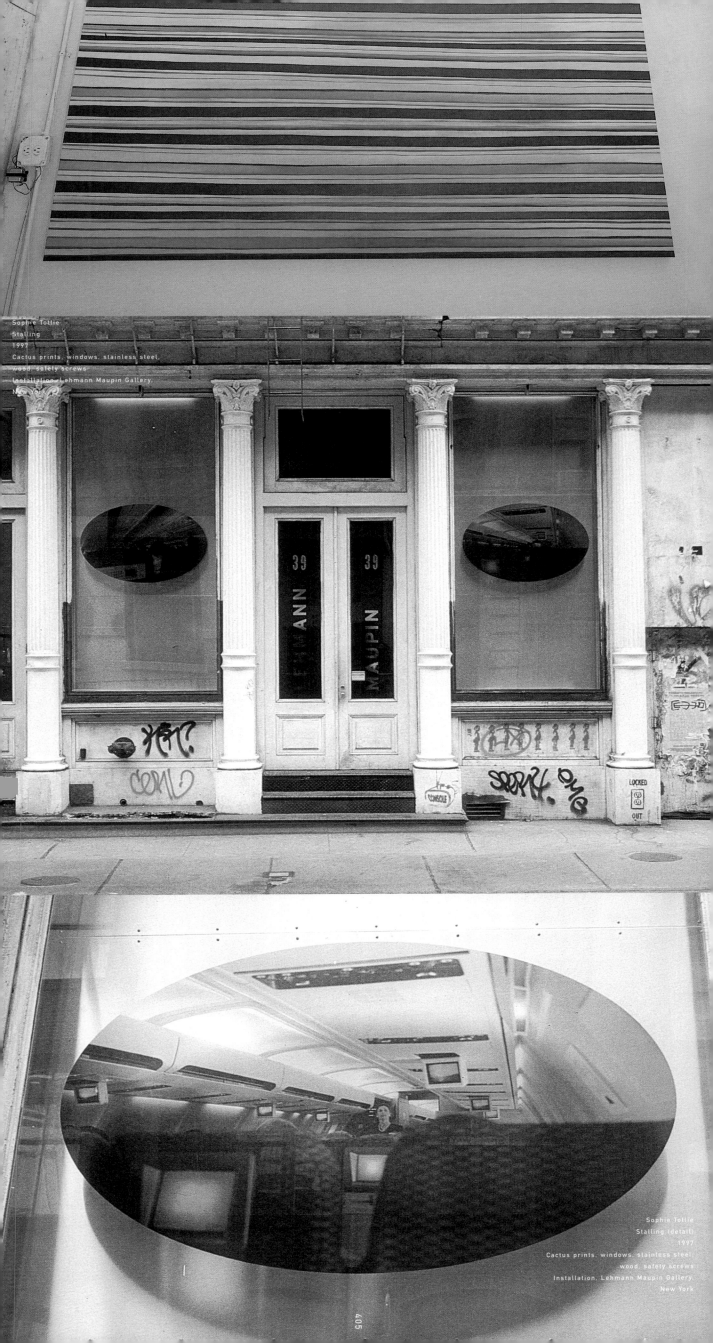

Sophie Tottie
Stalling
1997
Cactus prints, windows, stainless steel,
wood, safety screws
Installation, Lehmann Maupin Gallery,
New York

Sophie Tottie
Stalling (detail)
1997
Cactus prints, windows, stainless steel,
wood, safety screws
Installation, Lehmann Maupin Gallery,
New York

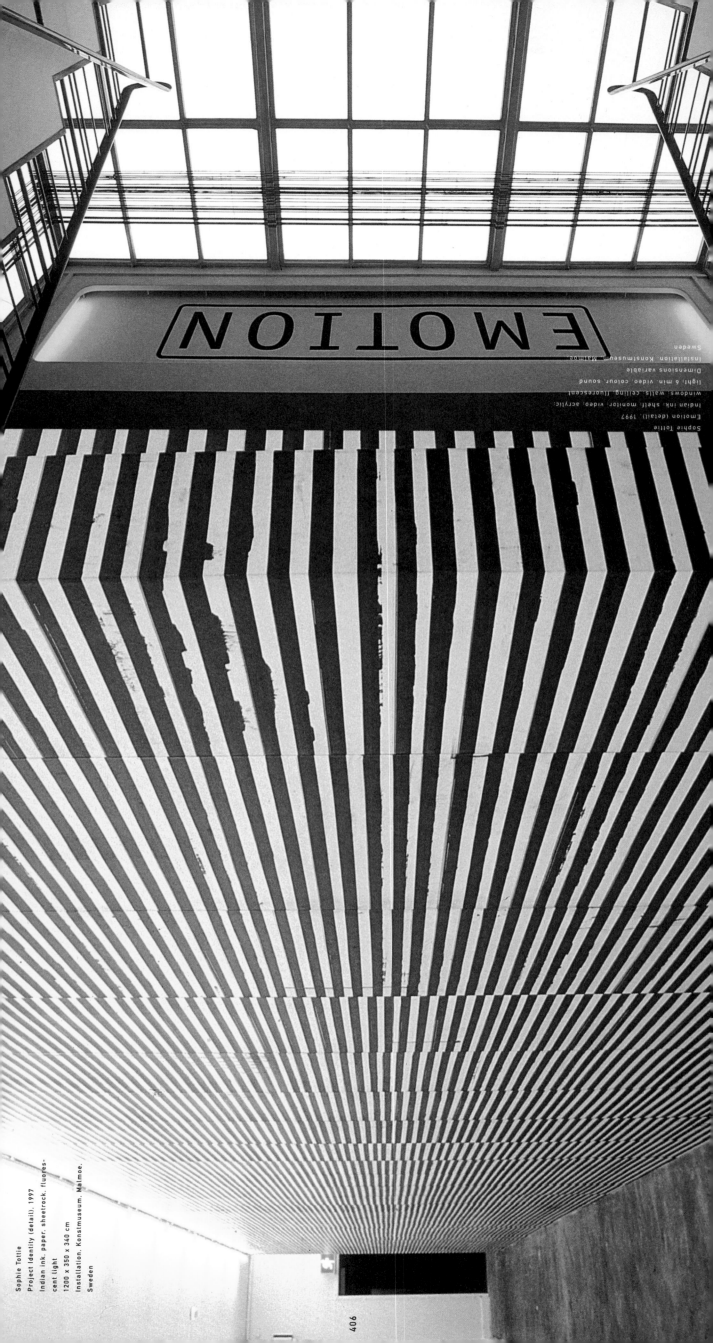

Sophie Tottie
Project Identity (detail), 1997
Indian ink, paper, sheetrock, fluores-
cent light
1200 x 350 x 340 cm
Installation, Konstmuseum, Malmoe,
Sweden

Sophie Tottie
Emotion (detail), 1997
Indian ink, shelf, monitor, video, acrylic,
windows, walls, ceiling, fluorescent
light, 6 min video, colour, sound
Dimensions variable
Installation, Konstmuseum, Malmoe,
Sweden

sophie tottie

Born Stockholm, 1964. Lives and works in Stockholm. **selected solo exhibitions:** 1994 Gallery Andréhn-Schiptjenko and Enkehuset, Stockholm 1995 'Pictures for the Chief Electrician', Patrick Callery, New York 1996 Museum of Contemporary Art, Chicago 1997 'Protect Identity', Konstmuseum, Malmoe, Sweden 1998 '"Welcome to Earth" Arkipelag', The Museum of National Antiquities, Stockholm **selected group exhibitions:** 1990 'Le territoire de l'art', The Russian Museum, Leningrad 1991 'STILLSTAND Switches', Shedhalle, Zurich; 'Moika 22, Apartment 9', Saint Petersburg 1992 'Granowskaya 5, Apartment 52', Moscow, Russia 1996 'På Tiden', Moderna Museet, Stockholm; 'The Architecture of Dreams', Museo Regional, Guadalajara, Mexico; 'Se Hur det känns', Rooseum, Malmoe, Sweden 1997 XLVII Venice Biennale; 'The Crystal Stopper', Lehmann Maupin Gallery, New York 1998 'Nuit Blanche', ARC, Musée d'Art Moderne de la Ville de Paris; 'Come Closer', Staatliche Kunstsammlung, Vaduz, Liechenstein **selected bibliography:** 1992 Maria Lind, 'Om "Sophie Totties Bilder"', *Hjärnstorm*, No 45/46, Stockholm 1996 Carlos Basualdo, 'The Structure of Paleness', *See What It Feels Like*, Malmoe, Sweden 1997 Jessica Morgan, 'Sophie Tottie', *Deposition*, Venice; Carolina Ponce de Leon, 'Studio Visit', *Trans*, No 3, New York 1998 Samuel Herzog, 'Entdeckungsreise in Europas Norden, "Visions du Nord", im Pariser Musée d'Art Moderne', *Neue Züricher Zeitung*, Zurich, 13 March

this page: Sophie Tottie Emotion (detail), 1997 Indian ink, shelf, monitor, video, acrylic, windows, walls, ceiling, fluorescent light; 6 min. Video, colour, sound Dimensions variable Installation, Konstmuseum, Malmoe, Sweden

piotr uklanski

Piotr Uklanski's early works – small gestures that engaged directly with everyday realities – deliberately renounced a determined physical presence: a few holes burnt through a net curtain with a lighted cigarette, or a sequence of black lines traced across a gallery floor – the marks made by the heavy rubber-soles of the artist's boots. Uklanski's 'social' works – ephemeral 'installations', made in cafés – were discrete, almost poetic interventions into existing structures: informal constructions created from Polish tea glasses and spoons and haphazard accumulations of plastic drink stirrers and sachets of sugar displaced into half-filled polystyrene cups of coffee. For an exhibition in London in 1995, he produced thousands of leaflets 'advertising' carefully staged arrangements of disposable coffee cups. The leaflets were then wantonly scattered around the streets of Kings Cross train station, to be found later, crumpled, torn and dishevelled in the gutter, awaiting their inevitable removal by the street-cleaners. A nearby Italian restaurant became host to an illuminated light box in *Il Capuccino*, 1995. Its 'message' was an orderly line of the same disposable coffee cups each supporting, with Brancusi-like precision, neat rows of coloured drinking straws.

Hot Snow, 1996, made during the stifling heat of a New York summer, was an artificial snow machine that allowed for an unseasonal shower to fall onto the rooftop of the Clocktower Gallery. An open doorway leading from the gallery space framed this gentle 'miracle'. Only by stepping outside into the sunshine could you witness the makeshift device that Uklanski had constructed to set in motion this wilfully romantic illusion. The recent series of illuminated dancefloors – melancholic collisions between Carl Andre and Saturday Night Fever installed in galleries in New York, London and Glasgow – induced a collective sense of nostalgia

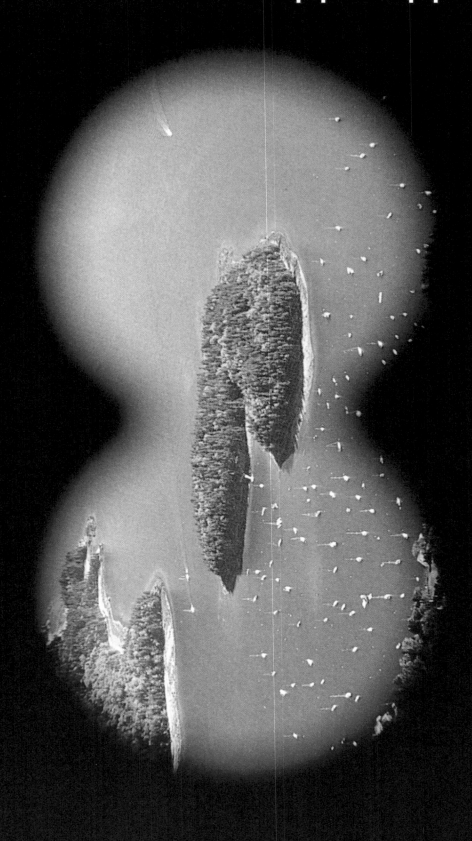

Piotr Uklanski
Untitled (Island), 1997
C-print, plexiglas
40.5 x 30.5 x 5 cm

t never stooped to kitsch. Rekindling faded memories of simpler, less uncertain times, they became *memento mori* for an unbelievable youth.

klanski's ongoing series of what might be termed 'generic' photographs continue this romanticized theme. The images of fanta islands, soap bubbles, crashing waves, starry skies and moonlit waters are created using outmoded photographic technique d are indebted to the utopian imagery widely promoted in photographic manuals of the 1970s (including one from Kodak, pruri tly and memorably called *Joy of Photography*, which provided Uklanski with the title for a recent exhibition in Frankfurt) klanski takes great pleasure in the photographs' apparent denial of progress — they promote a self-consciously idealized worl nsullied by the impact of digital technologies, a world ultimately witnessed through the perpetual and forgiving haze of 'so cus'.

tthew Higgs

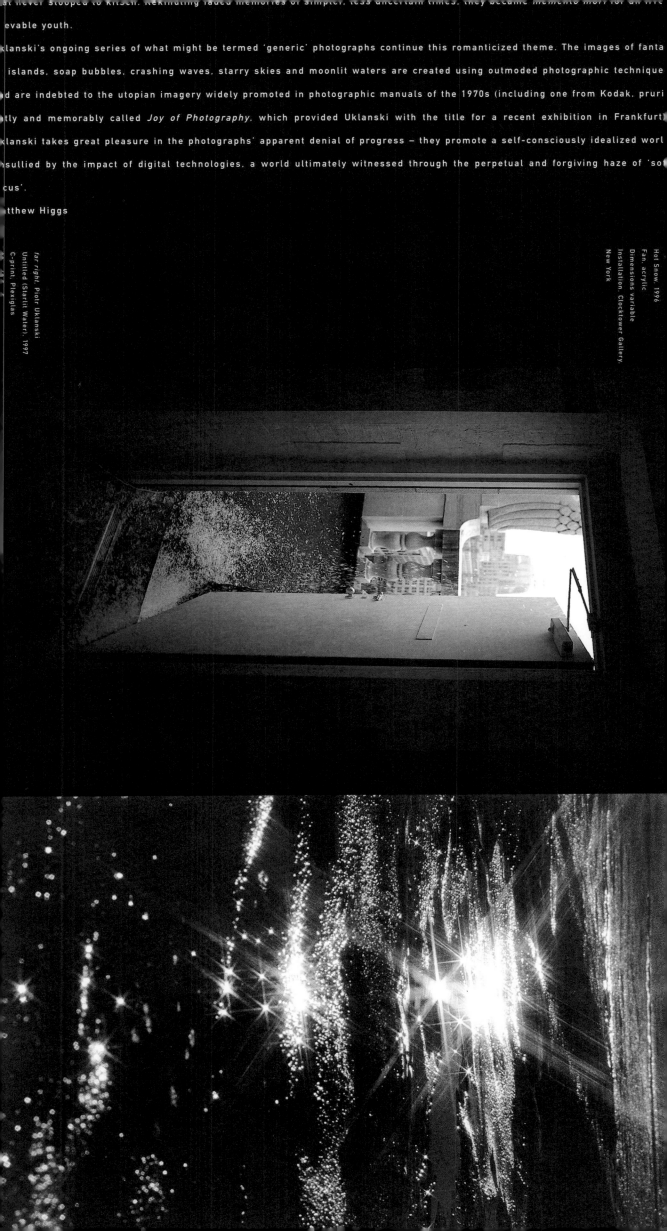

Hot Snow, 1996
Fan, acrylic
Dimensions variable
Installation, Clocktower Gallery,
New York

far right. Piotr Uklanski
Untitled (Starlit Water), 1997
C-print, Plexiglas

...AK. 1996
Collage
Reproduced in *Goeteborgs-Posten.*
Sweden, 3 January 1996

Piotr Uklanski
Il Capucino
1995
Light box
Dimensions variable
Installation, café, Kings Cross, London

This work was hosted by an Italian café in the Kings Cross area of London. An illuminated light box displayed an orderly line of disposable coffee cups each supporting a row of coloured drinking straws. Uklanski also made hundreds of leaflets featuring similarly carefully staged arrangements of the same coffee cups.

Piotr Uklanski
Untitled (Fortune Teller Session), 1995
C-print
50 × 60 cm

mika vainio

'I have been so influenced by Panasonic. It was the most impressive music I heard last year. They make up dance music with a digital tone and signal sound – for example using the sounds of a refrigerator and answering machine with techno beat ...'

Eye Yamataka in an interview with the author

Together with Ilpo Väisänen, Mika Vainio is co-founder of Panasonic, one of the cult electronic music groups of the 1990s. The name Panasonic means 'the whole sound' or 'the universe'. Their first albums appeared on the small, artist-run Finnish label Sähkö/Tommi Groenlund, which has played a crucial role in the Helsinki music scene.

Repetition is crucial in Vainio's music. Small changes are indiscernible at first, but after a certain period lead to new rhythmic structures', Vainio explains. In an article entitled 'Silence', Mika Hannula describes how Vainio's music uses found and self-built instruments: 'What he does and creates in the field of experimental electronic music is so utterly connected to our present daily lives that it is simply astonishing. One rather funny reason for this is that the used instruments are horribly dated. In the age of

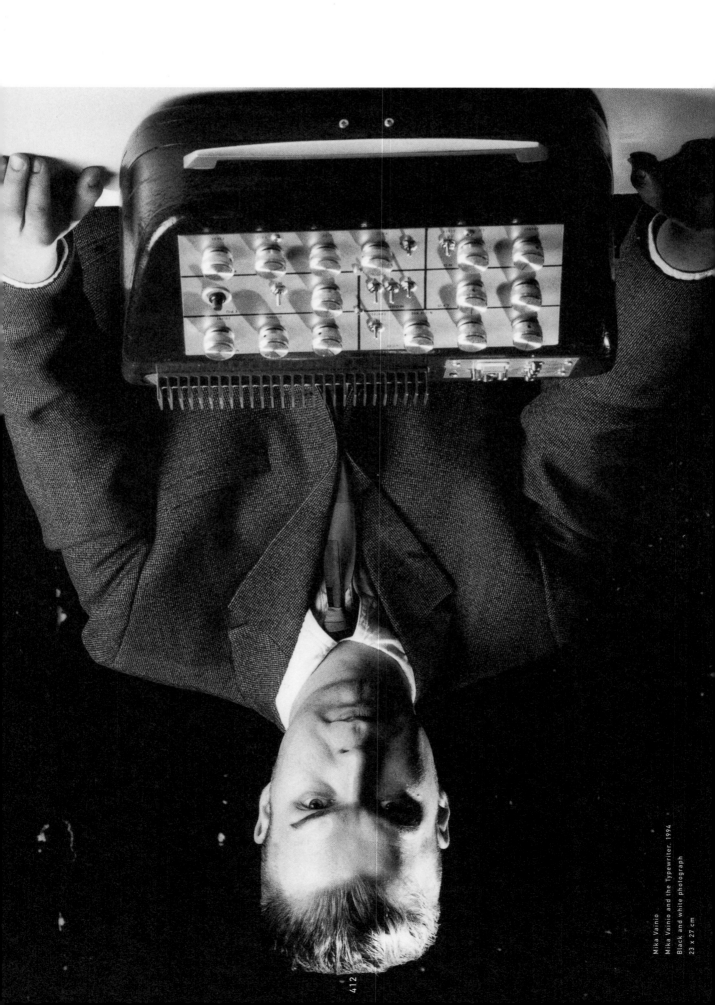

Mika Vainio
Mika Vainio and the Typewriter, 1994
Black and white photograph
23 x 27 cm

highly developed computer programmes for music writing, he is still pushing those keys of the old analogue synthesizers and other instruments. Another important element is the self-made equipment, which turns the basic features of those standardized sound boxes into something raw and unique. Thus the vital link is that these sounds are so common and so apparent that it is hard to notice them.'

Vainio's music cannot be categorized as part of a school. The closest comparison is with Gagaku, the seventh-century Japanese noise music that was played in temples, shrines and legal courts, and with Japanese noise musicians of the present like Merzbow, alias Masami Akita. But compared to Merzbow, Panasonic is much more static and at the same time more hypnotic.

Parallel to his group activities, Vainio makes solo recordings and solo concerts as well as sound installations. For the exhibition programme 'Migrateurs' at ARC, Musée d'Art Moderne de la Ville de Paris, Vainio developed a sound installation that was situated next to a work by Raoul Dufy. The electric circuit of three old radios was modified, producing a constantly changing sound display. A fourth radio emitted a programme specially composed by the artist. Vainio's small room became a concert space between virtualization and actualization within the museum.

Hans Ulrich Obrist

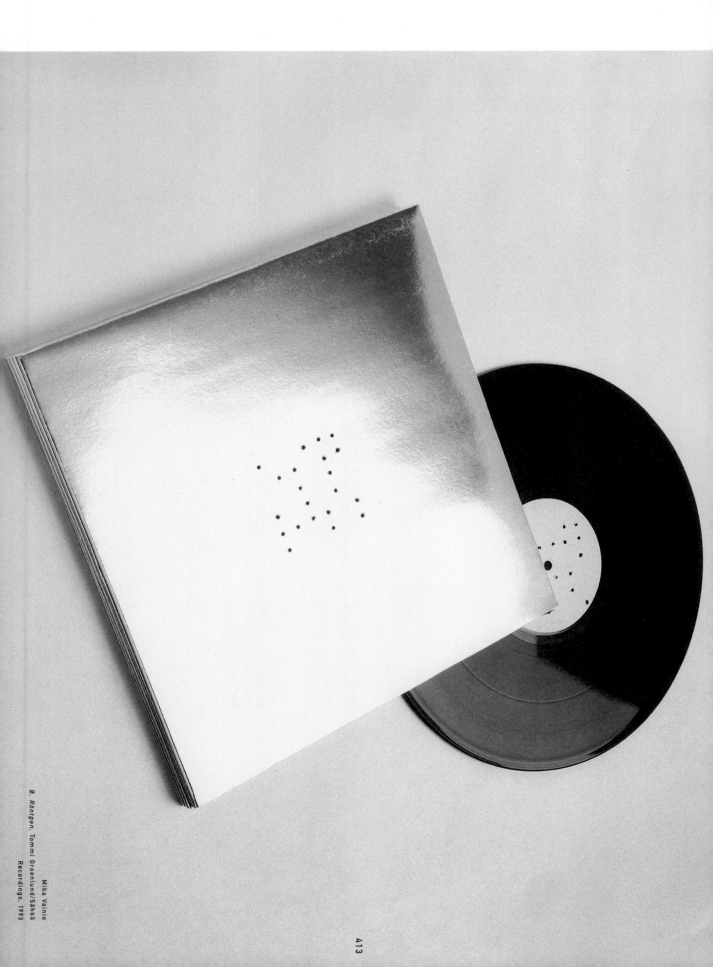

Mika Vainio
0. Röntgen, Tommi Groenlund/Sähkö
Recordings, 1993

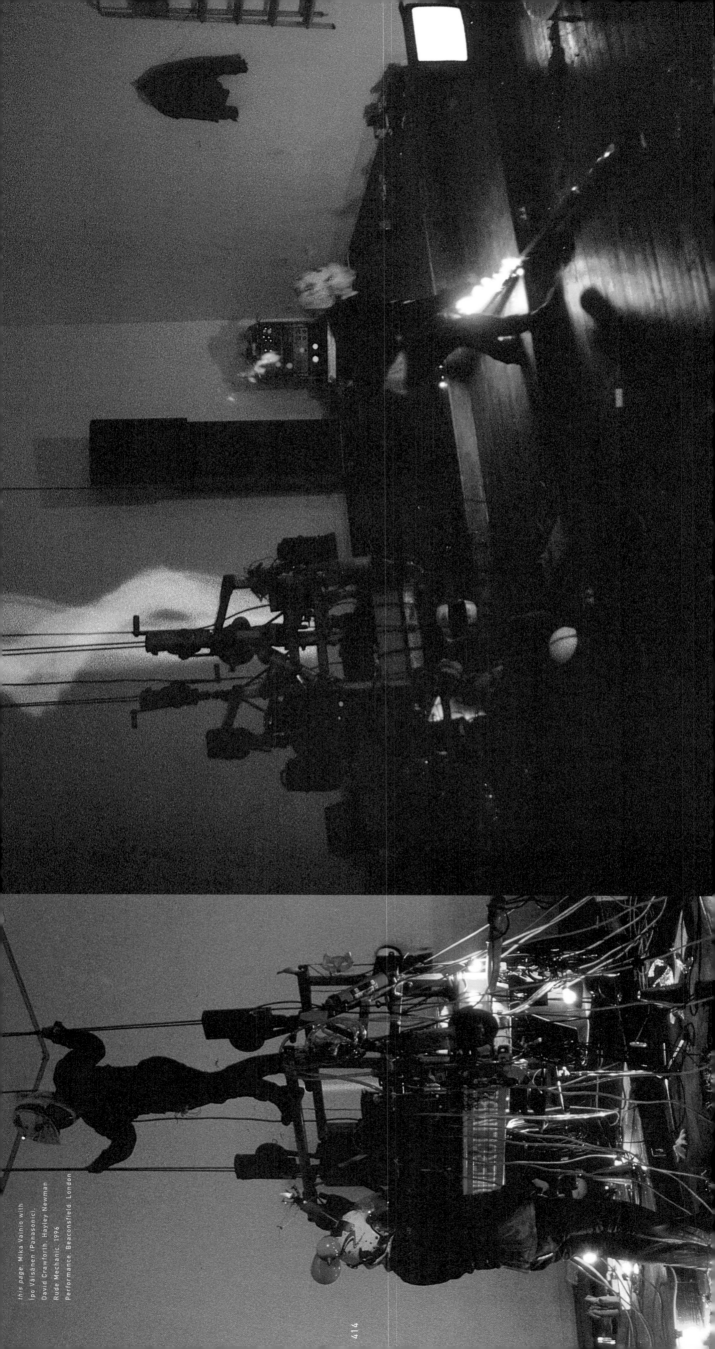

This page: Mika Vainio with
Ilpo Väisänen (Panasonic),
David Crawforth, Hayley Newman
Rude Mechanic, 1996
Performance, Beaconsfield, London

mika vainio

Born Helsinki, Finland, 1963. Lives and works in Turku, Finland and London.

selected solo exhibitions: 1996 'Onko', Boymans van Beuningen Museum, Rotterdam 1997 'Migrateurs', ARC, Musée d'Art Moderne de la Ville de Paris **selected group exhibitions:** 1996 'Rude Mechanics', Beaconsfield Gallery, London; 'Mikro/Mikro', Industrie Museum, Chemniz, Germany 1998 'Nuit Blanche', ARC, Musée d'Art Moderne de la Ville de Paris **selected discography:** 1993 Ø, *Röntgen*, Sähko Recordings, Finland; Ø, *Kvantti*, Sähko Recordings, Finland 1994 Ø, *Metri*, Sähko Recordings, Finland; Panasonic (Mika Vainio with Ípo Väisänen), *Muuntaja*, Sähko Recordings, Finland 1995 Ø, *Atomit*, Pi Records, Scotland; Phílus, *pH*, Sähko Recordings, Finland; Tekonovel, *Reuma*, Tension, United States of America; Panasonic (Mika Vainio with Ípo Väisänen), *Vakio*, Blast First, England 1996 Ø, *Olento*, Sähko Recordings, Finland; Tekonivel, *Keimola*, Cheap, Austria; Panasonic (Mika Vainio with Ípo Väisänen), *Osasto*, Blast First, England; 1997 Ø with Casten Nicolai, *Mikro/Makro*, Noton, Germany; Ø, *Tulkinta*, Sähko Recordings, Finland; Phílus, *Kolmio*, Sähko Recordings, Finland; Phílus, *Tetra*, Sähko Recordings, Finland; Tekonivel, *Sirkus*, Sähko Recordings/Puu, Finland; Mika Vainio, *Onko*, Touch, England; Panasonic (Mika Vainio with Ípo Väisänen), *Kulma*, Blast First, England **selected bibliography:** 1996 Rob Young, 'Rude Mechanic: Pyrotechnic performance', *The Wire*, London, December 1997 Pauline van Maurick Broekman, 'Hub-Capped Diamond Studded Halo', *Mute*, London, Winter

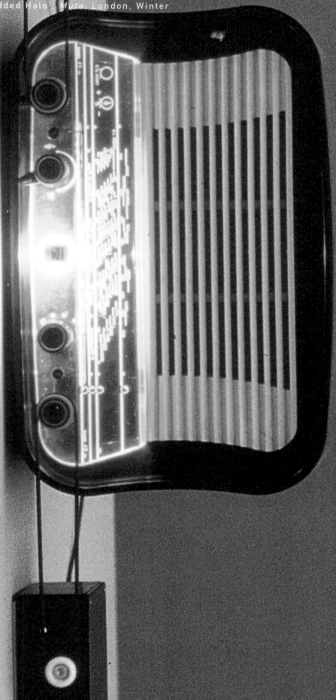

Migrateurs (4 x Radio), 1997
Modified radios, audio recording
Dimensions variable
Installation: ARC, Musée d'Art Moderne de la Ville de Paris

Mika Vainio

eulàlia valldosera

Eulàlia Valldosera explores the body as the scene of emotional battles, a landscape marked by frustration and desire, a container of phantoms and a never-ending web of energies. In the installation *El melic dell món (The world's navel)*, 1990, cigarette butts on a canvas placed on the ground plot out the shape of a woman's body. In her performance *Sweeping*, 1991, the artist smudged this silhouette with a broom (which served the dual function of paintbrush), a gesture of recoil from her addiction to cigarettes, as well as an embodiment of the desire for cleanness and the urge to explore new horizons beyond painting.

In 1992, Valldosera presented a performance entitled *Vendajes (Bandages)*, which heralded what would become one of the fundamental themes of her work, illness. Here, the artist pushed a film projector on a hospital bed around a room, integrating the shadow of her body with the filmed image on the wall. This created a dialogue between fiction and reality, memory and its reinterpretation, the actual body and its anaemic shadow. The same coming to terms with the ravages of illness is also present in the installation *Estante para un lavabo de hospital (Shelf for a Hospital Bathroom)*, 1992, in which a light plots out a dramatic trajectory across the everyday objects on display, eventually coming to rest on a urinal on the floor.

Valldosera has frequently addressed the body as if it were a house inhabited by light and shadow, and everyday objects as depositories of pain. In the photographs of the *Burn Series*, 1990, the artist's body is projected onto the interior walls of a house, assimilated into corners, inserted into walls and at rest on a mattress on the floor. It is in her spatial installations, however, that Valldosera makes her most cogent evocation of the emotional and psychic phantoms lurking in the walls of the domestic space. In *El amor es más dulce que el vino: Tres estadios en una relación (Love's sweeter than wine: three stages in a relationship)*, 1993-94, she explores the tensions inherent in intimate relationships, by casting the shadows of one series of displayed objects onto another in a three-room space.

The emotional labyrinth associated with such relationships is also the focus of *The Fall: Out of the Frying Pan into the Fire*, 1996, her most complex and harrowing installation, which brings together all the essential themes of her artistic and existential quest. Two beams of light survey a darkened room in which a complex interplay of projections, mirrored reflections and arranged objects are suddenly interrupted by a scream, implying that some mysterious drama is being played out. A spatial journey through a series of corridors creates an anxious narrative, and ultimately, affords a glimpse of a way out.

In *El comedor: la figura de la madre (The dining-room: figure of the mother)*, 1994-95, and *Envasos: el culte a la madre. Número 1: Maher semilla (Vessels: the figure of the mother, Number 1, Woman Seed)*, 1996, the shadows of everyday household cleaning paraphernalia create menacing phantasms, which are converted into archetypal representations of the mother figure. Leaving the artifice exposed and revealing, almost pornographically, the reality behind her images, Valldosera shows how dark the recesses of the unconscious really are. The work also suggests the therapeutic possibilities in the reinterpretation of the painful connections between the everyday, the latent and the archetypal through art.

Rosa Martínez

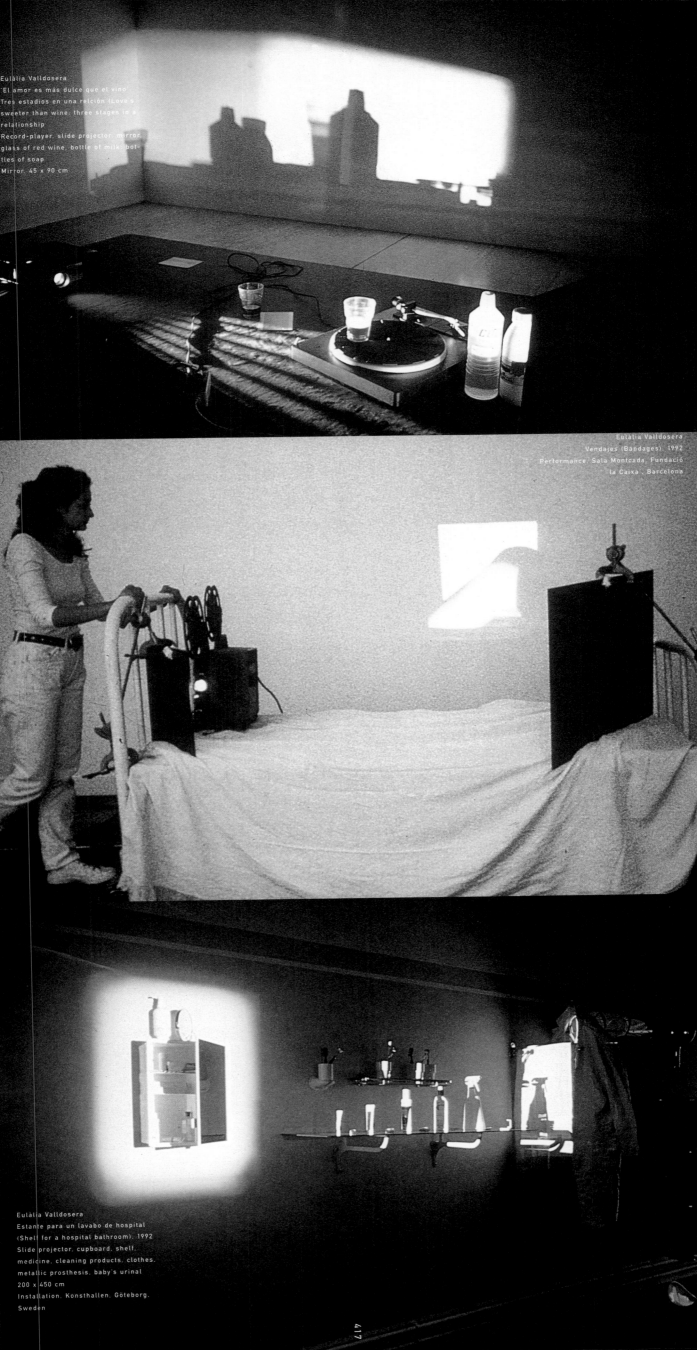

Eulàlia Valldosera
'El amor es más dulce que el vino'
Tres estadios en una relción (Love's
sweeter than wine: three stages in a
relationship)
Record-player, slide projector, mirror,
glass of red wine, bottle of milk, bot-
tles of soap
Mirror, 45 x 90 cm

Eulàlia Valldosera
Vendajes (Bandages), 1992
Performance, Sala Montcada, Fundació
'la Caixa', Barcelona

Eulàlia Valldosera
Estante para un lavabo de hospital
(Shelf for a hospital bathroom), 1992
Slide projector, cupboard, shelf,
medicine, cleaning products, clothes,
metallic prosthesis, baby's urinal
200 x 450 cm
Installation, Konsthallen, Göteborg,
Sweden

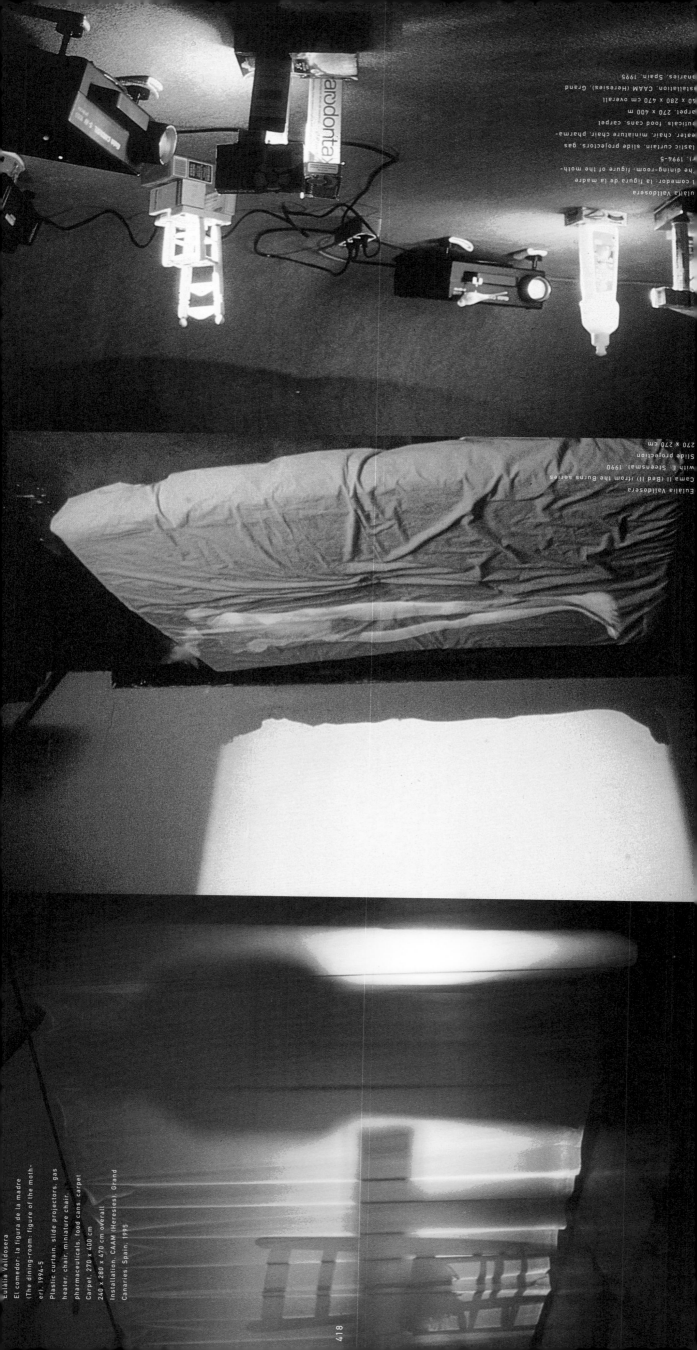

Eulàlia Valldosera
El comedor: la figura de la madre
(The dining-room: figure of the mother), 1994–5
Plastic curtain, slide projectors, gas
heater, chair, miniature chair,
pharmaceuticals, food cans, carpet
Carpet: 270 x 400 cm
240 x 280 x 470 cm overall
Installation, CAAM (Heresies), Grand
Canaries, Spain, 1995

Eulàlia Valldosera
El comedor: la figura de la madre
(The dining-room: figure of the mother), 1994–5
Plastic curtain, slide projectors, gas
heater, chair, miniature chair, pharma-
ceuticals, food cans, carpet
Carpet: 270 x 400 cm
240 x 280 x 470 cm overall
Installation, CAAM (Heresies), Grand
Canaries, Spain, 1995

Eulàlia Valldosera
Cama II (Bed II) (from the Burns series
with E. Steensma), 1990
Slide projection
270 x 270 cm

418

eulàlia valldosera

Born Barcelona, 1963. Lives and works in Barcelona.

selected solo exhibitions: 1991 'El ombligo del mundo', Galeria Antoni Estrany, Barcelona 1992 'Vendajes', Sala Montcada, Fundació 'la caixa', Barcelona; 'Burns, Bundages', Galerie van Rijsbergen, Rotterdam 1995 'Apparenze', Galeria Gentili, Florence 1997 'La caiguda', Metrònom, Barcelona **selected group exhibitions:** 1991 '13. Terapias incidentes, escapes', Galeria Antonio de Barnola, Barcelona 1992 'Interferenzen IV, performance-intermedia', Ludwig Museum of Modern Art, Vienna 1993 'Di volta in volta', Castello di Rivara, Turin 1994 'Mudanzas', Whitechapel Art Gallery, London 1996 'Jurassic Technologies Revenant', 10th Sydney Biennale; Manifesta 1, Rotterdam; Kwangju Biennale, South Korea 1997 'Trade Routes: History and Geography', 2nd Johannesburg Biennale; 'On life, beauty, translations and other difficulties', 5th Istanbul Biennale; Skulptur. Projekte Münster, Germany **selected bibliography:** 1994 Saretto Cincinelli, 'Biffures, Liliana Moro, Eulàlia Valldosera', *El Guía*, No 2, Barcelona; Glòria Picazo, 'Estrategias de la representación: el Sujeto, el Objeto', *Photovision*, July/December 1995 Glòria Picazo, 'Inszenierungstrategien I: Das Subjekt, Das Object, Fotografie als mittel der Selbsdarstellung in der Spanischen Kunst', *Kunstforum*, Cologne, Summer; Victoria Combalia, 'Eulàlia Valldosera: Corps indigne et transcendant', *art press*, Paris, April; Jonathan Allen, 'El yo múltiple. Visiones multimedia de la representación', *Atlántica*, No 11, Grand Canaries, Spain; Jean-Jacques Lebel, 'Ritos/Rutinas/Creencias', *Creación*, Madrid, May 1997 Rosa Martínez, 'Eulàlia Valldosera', *Flash Art*, Milan, October

Eulàlia Valldosera
Envasos: el culte a la madre, Numero 1.
Maher semilla (Vessels: the cult of the
mother, Number 1, Woman Seed)
1997
Slide projectors, bottles
Dimensions variable
Installation, Yerbitan Cistern, 5th
Istanbul Biennale

419

kara walker

In little less than four years Kara Walker's highly original and idiosyncratic work has won her both high praise and scorn. To those who champion her work, she brings a refreshing and honest investigation into such perennially prickly notions as race, memory, history, revisionism, sexual freedom and perversion with a sly but nonetheless in-your-face post-feminist attitude of delicious irony. For her detractors — often older, African-American critics — her work is not only an affront to the history of discrimination, negative portrayals, and denigration through all kinds of injurious stereotypes of African-Americans, it also signals a simple-minded and uncritical appeal to popular transgression. Such transgression, they argue, takes little account of the unfinished business of racism in the United States. The post-slavery and Civil Rights era in the United States brought African-American consciousness of its history of racial violence to a point where anything vaguely critical of the positivistic ideology of blackness from inside the community was seen as the enemy within. Hence, in order to liberate the race from its sense of socio-cultural inferiority and political anxiety, positive stories of its emergence must be privileged, and less than flattering portrayals of the community must either be suppressed or censored outright.

By flouting the demands of this community, Walker's art can truly be viewed as the return of the repressed. It is precisely the kind of debate that her highly skilled art anticipates. Her intention is to debunk any definitive reading of history. Like artist Ellen Gallagher before her, Walker's takes on issues of reductionist and essentialist notions of blackness and turns them into works of public discourse in which she attacks the positivistic images of blackness by bringing in questions of cruelty, depravity, liberal and kinky sexuality as central markers to how we redefine subjectivity and history. In this respect she can be seen as heir to the brilliant legacies of such notable authors as Toni Morrison and Alice Walker.

Walker's murals of black, cut-out silhouettes and delicate watercolour studies are built on producing new narratives and interpretations of the identity of Africa-Americans by subverting and questioning their enduring constructs. She does so through a rogues gallery of pickaninnies, slave masters and their mistresses, incestuous women, perverts, lynchings, rapes and other iconography of a violent racial past. If one were then to take Walker's work and measure it against the so-called morbidity and misogyny of gangster rap and the raunchy, deliberately 'crude' sexual posturing of female African-American singers such as Da Brat, Foxy Brown and Little Kim, then her work would really be child's play. One important aspect of Walker's work is the emergence of a new generation of African-American artists who no longer see themselves as shackled to the demands of a generation whose signal anxiety is based more on fear of self-examination than on the preservation of racial memory.

Okwui Enwezor

left, Kara Walker
The End of Uncle Tom (Grand allegorical tableau) (detail), 1995
Cut paper
Dimensions variable

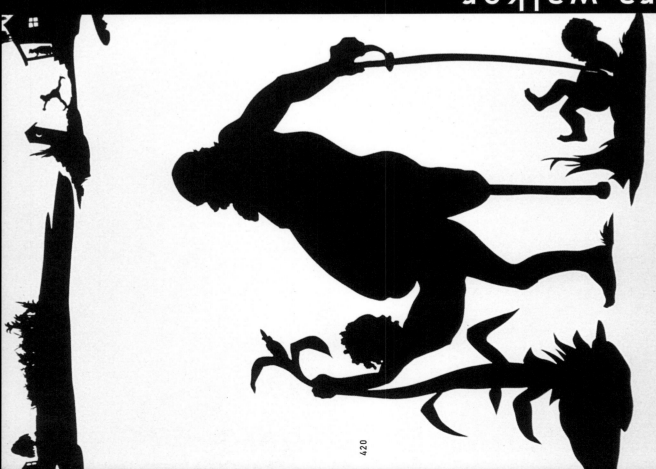

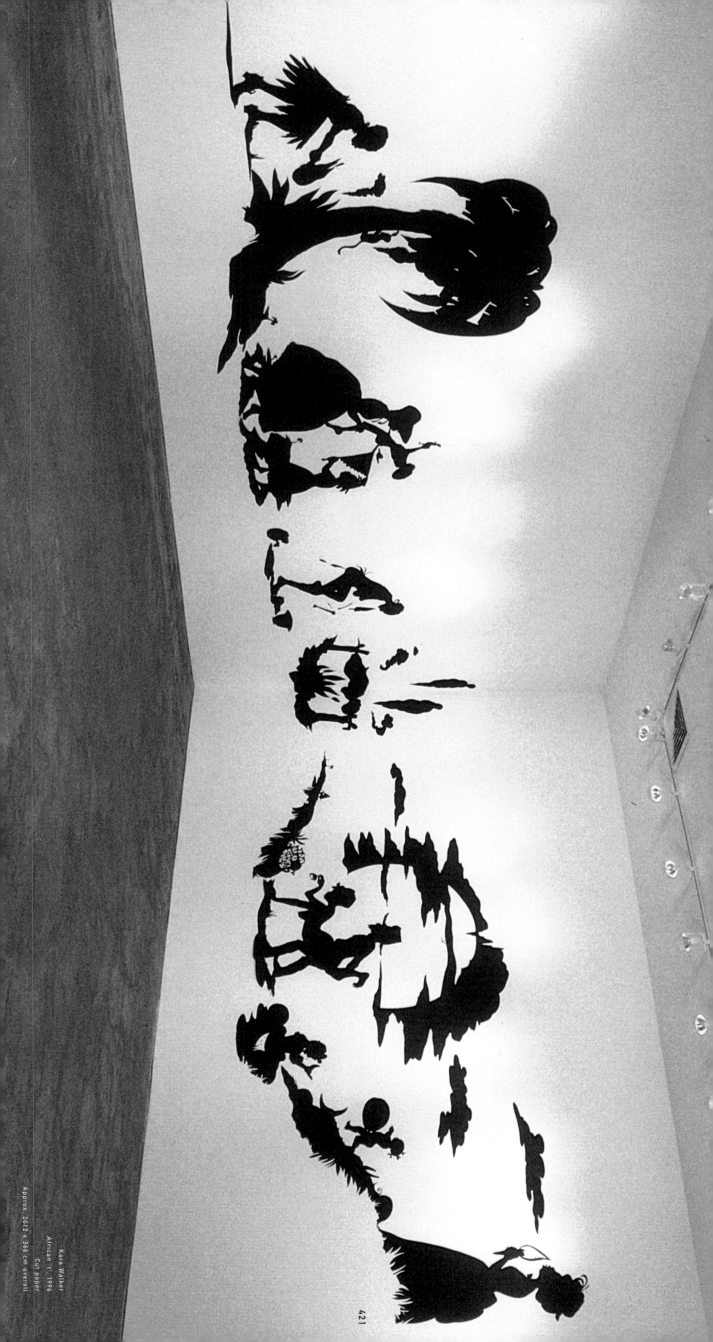

Kara Walker
African' t, 1996
Cut paper
Approx. 2012 x 366 cm overall

left, Kara Walker
B'rer, 1996
Watercolour and gouache on paper
161.5 x 131 cm

kara walker
Born Stockton, California, 1969. Lives and works in Rhode Island. **select-ed solo exhibitions:** 1995 'The High and Soft Laughter of the Nigger Wenches At Night', Wooster Gardens, New York 1996 'From the Bowels to the Bosom', Wooster Gardens, New York 1997 'Upon My Many Masters – An Outline', Museum of Modern Art, San Francisco; The Renaissance Society, Chicago 1998 The Forum, St Louis, Missouri **selected group exhibitions:** 1991 'Rated RX: Pathological Conditions', New Visions Gallery, Atlanta, Georgia 1993 'Into the Light', Nexus Contemporary Arts Center, Atlanta, Georgia 1994 'Selections 1994', The Drawing Center, New York 1995 'La Belle et La Bete', ARC, Musée d'Art Moderne de la Ville de Paris 1996 'New Histories', Institute of Contemporary Art, Boston 1997 Biennial, Whitney Museum of American Art, New York 1998 'Postcards from Black America', De Beyerd, Breda and The Frans Hals Museum, Harlem, Netherlands; 'Arturo Herrera and Kara Walker', Stephen Friedman Gallery, London **selected bibliography:** 1995 Roberta Smith, 'Kara Walker', *The New York Times*, 5 May 1996 Alexander Alberro, 'Kara Walker', *Index*, Stockholm, January; Anne Doran 'Kara Walker, "From The Bowel To The Bosom"', *Grand Street*, No 58, New York; Thelma Golden, 'Oral Mores: A Postbellum Shadow Play', *Artforum*, New York, September; Christian Haye, 'Strange Fruit', *frieze*, London, September/October; Kim Levin, 'Art Short List – Kara Walker', *The Village Voice*, New York, 13 March 1997 Alan G. Artner, 'Reaching Back, Kara Walker's Vision is Rooted in the Past', *The Chicago Tribune*, 19 January; Grace Glueck, 'An Unconventional Publisher with an Appetite for the Comic and Quirky', *The New York Times*, 28 March; Lynn Gumpert, 'On the Edge: Kara Walker, Anything But Black and White', *ARTnews*, New York, January; Peter Schjeldahl, 'Museumification 1997, The Whitney Biennial as Pleasure Machine', *The Village Voice*, New York, 1 April; Miles Unger, 'New Histories, the Institute of Contemporary Art, Boston', *Flash Art*, Milan, January/February

Kara Walker
The Gift, 1997
Gouache on paper
236 x 1600 cm

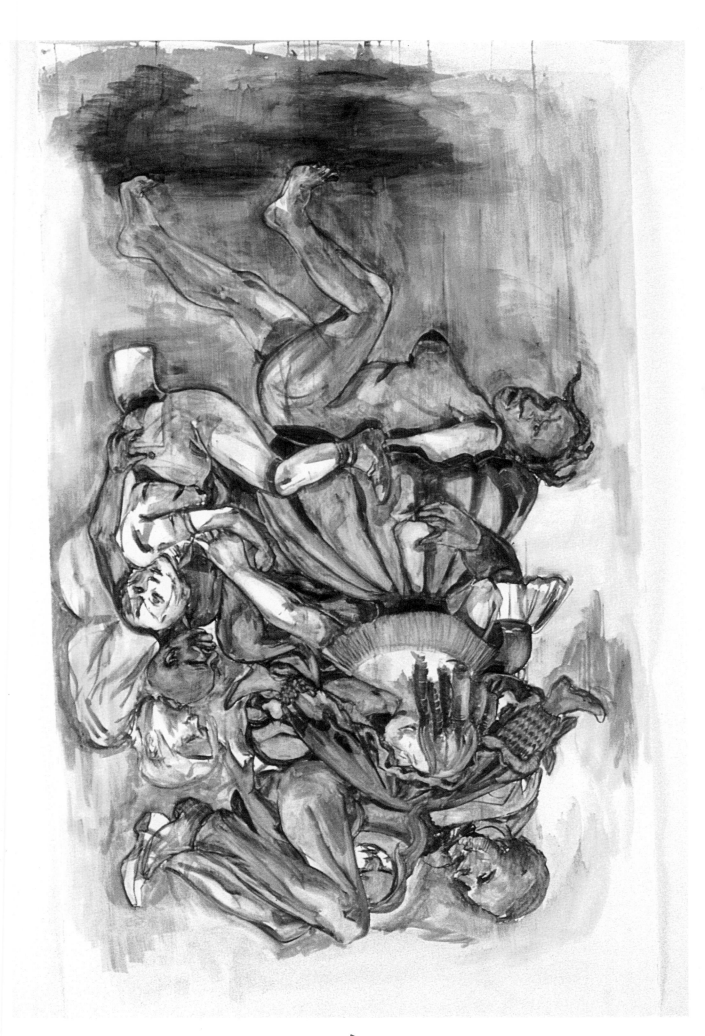

Wang Du
Réliques (Relics) (detail), 1994
Plaster, acrylic, newspaper, resin
Dimensions variable

wang du

The question of how to side-step aesthetic judgement, or more precisely, taste, has concerned artists ever since Marcel Duchamp invented the readymade in order to achieve a kind of 'visual indifference'. Using a similar strategy, Wang Du takes images from magazines and newspapers and reconfigures them into three-dimensional, painted sculptures. Choosing banal, often salacious stories, such as that of Mrs Bobbit, who mutilated her husband's genitals, or a couple who won a car after continuously kissing for two days in a kissing contest, Wang not only makes us laugh at the triviality of these reports but causes us to question why the mass media are interested in them. Those of us who expect to read about important, monumental issues in newspapers and wish them to be presented 'tastefully' may even find the articles offensive.

Wang claims 'indifference' towards the aesthetic effects of the images that he 'happens' to choose for his *objets travaillés*. He endeavours to reproduce as faithfully as possible all the details of the original: even the framing and the perspectival quirks of the photographs are strictly respected. This gives rise to certain abnormalities and distortions in the finished sculpture: a disembodied hand, apparently belonging to an invisible person, holds the arm of one subject; another seems to have an impossibly large head in comparison to his companion.

Wang's work is funny, refreshing, ironic and provocative. It disturbs and interrupts our perception of people and objects and, most importantly, exposes the way in which we construct knowledge and cultural values. Additionally, it reveals how these are manipulated by the strategies and mechanisms of an omnipotent media system. In his recent works such as *Travaux du Corps* (*Work of the body*), 1997, and *La Famille* (*The family*), 1997, Wang brings the same provocative irony to bear on the media's exploitation of people's desire to achieve the perfect body through plastic surgery and other technological processes. Reproducing in these large-scale sculptures advertising images promising 'ideal beauty', or inventing imaginative new humans, he powerfully illustrates the way in which we can be said to be entering an epoch of 'artificial evolution'.

Hou Hanru

Wang Du
Réliques (Relics) (detail), 1994
Plaster, acrylic, newspaper, resin
Dimensions variable

Femmes mariées de 5 à 7

Danielle G..., dite Dany, un bien joli « maquereau ».

NICE

nier ou classés dans un dossier. Mais cette lettre-là est différente. D'abord, elle est signée : un nom et une adresse sont portés au haut d'un feuillet couvert d'une écriture régulière. Ensuite, elle contient un certain nombre de précisions qui convainquent rapidement les policiers qu'il s'agit d'une affaire sérieuse.

Les hommes de la brigade des mœurs de Nice, sous les ordres du commissaire Roland, passent donc à l'action. Ils organisent une discrète surveillance autour d'Angèle. C'est une ravissante jeune fille aux longs cheveux blonds, aux grands yeux bleus en amande, qui ne tarde pas à les conduire, à son insu, au pied d'un immeuble modeste de la rue Verdi, dans le quartier de la gare de Nice, et plus précisément au premier étage de cette bâtisse, où une plaque discrète indique qu'est installée la une agence

DES RENDEZ-VOUS DANS LES PALACES DE LA CÔTE

La brigade des mœurs, à une époque, avait été sur le point de mettre un frein à de telles activités. Mais Danielle G..., ayant eu vent de l'enquête, s'était arrangée pour changer de « métier ».

Fin octobre 93, la brigade des

cine niçoise de la rue Verdi. Une agence matrimoniale en principe, mais qui, par voie de petites annonces, recrute des « hôtesses d'accompagnement ». C'est-à-dire, tous les policiers le savent, de jolies filles peu farouches qu'on met en contact avec des hommes aux revenus confortables, pour la soirée ou pour la nuit. Au passage, l'intermédiaire qui a organisé la rencontre touche, bien sûr, sa « commission » et le tour est joué.

« hôtesses » et choisissent celle avec qui ils désirent passer une heure, une nuit ou même un week-end. Sous chaque photo, quelques lignes anodines (genre annonces matrimoniales) sont censées présenter la jeune femme : « Aime la lecture, le cinéma, les voyages et la natation. Désirerait rencontrer un homme entre 40 et 60 ans »... Sont précisées aussi quelques unes de leurs « spécialités »...

L'amateur ayant fait son choix, il ne reste plus à Dany qu'à prévenir l'élue et à organiser le rendez-vous qui a lieu dans un bar huppé ou dans le hall d'un palace. Soir après soir, les policiers de la brigade des mœurs suivent. Ainsi Jessica, Angèle et d'autres filles dans leurs folles nuits. Les clients roulent en Porsche ou en Alfa Romeo et, après un dîner dans l'un des grands restaurants de la région, une heure ou deux passées au casino du Ruhl ou dans une discothèque à la mode

la porte de l'agence. Dans son bureau aux murs clairs, Dany est seule, au téléphone avec un client... Lorsqu'elle entend la sonnette, Dany s'excuse auprès de son interlocuteur pour aller ouvrir.
— Police, annonce un des deux hommes en montrant sa carte.
Très élégante dans son tailleur beige, Dany pâlit mais ne se démonte pas.
— Entrez, messieurs, dit-elle.
Puis elle retourne dans son bureau, saisit le téléphone et dit à son correspondant, avant de raccrocher.
— Désolée, mais pour ce soir, ce ne sera pas possible.

ELLES FAISAIENT ÇA POUR L'ARGENT OU POUR LE PLAISIR...

Ni pour ce soir, ni pour bien long temps, et elle le sait. Conduite dans les locaux de la Sûreté urbaine, gar

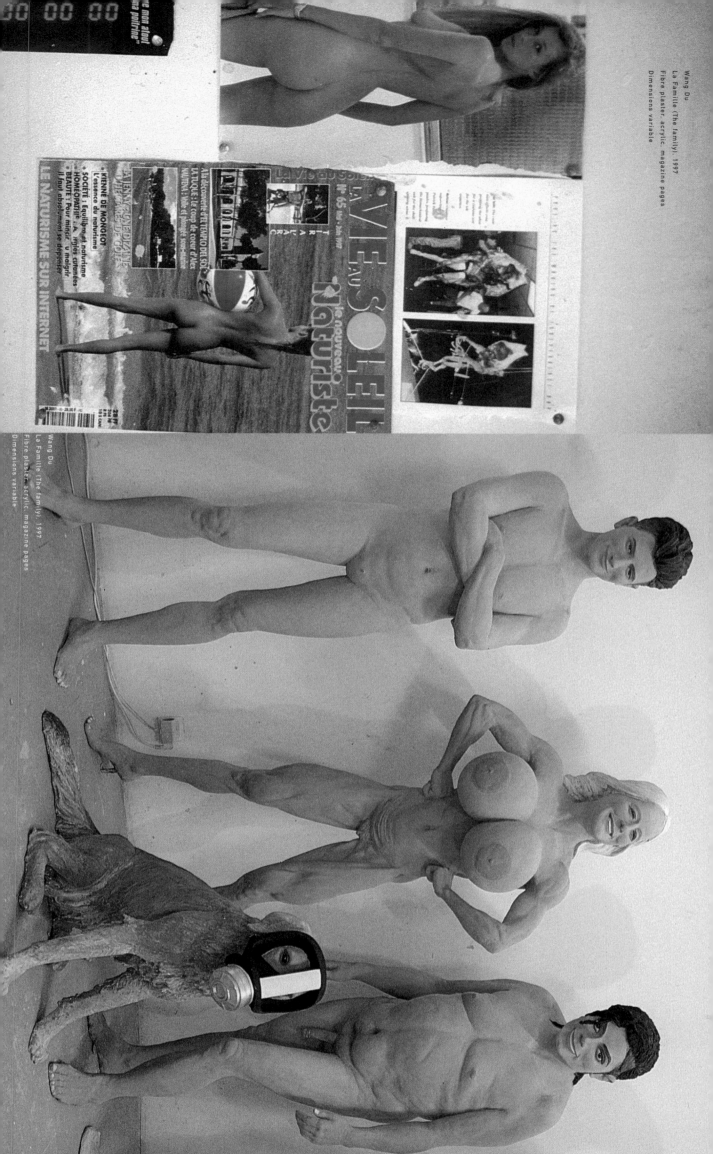

Wang Du
La Famille (The family), 1997
Fibre plaster, acrylic, magazine pages
Dimensions variable

this page, Wang Du
Les Travaux du Corps: l'Homme du
Sein. (Works of the body: the man of
the breast), 1997
Fibreglass, plaster, acrylic, magazine
pages
Dimensions variable

wang du
born Wuhan, Hubei Province, China, 1956. Lives and works in Paris. **selected solo exhibitions:** 1994 'Relique', Galerie Anne de Villepoix, Paris 1997 Foundation, Amsterdam **selected group exhibitions:** 1976 Wuhan Museum, Hubei Province, China 1989 China Avant Garde, National Museum of Art, Peking, China 1991 Galerie Jacob, Paris 1996 Kulturschmiede, Frankfurt 1997 'Uncertain Pleasure–Chinese Artists in the 1990s', Art Beatus Gallery, Vancouver; 'Soap', Museum Voor Volkenkunde , Rotterdam; 'Cities on the Move', Secession, Vienna 1998 'Trans(ORIENT)ations', Lisbon **selected bibliography:** 1987 Zhang Qiang, *New Wave of Art*, Jiangsu Art Publishing House, Nanjing, China 1991 Lu Peng, Yi Dan, *A History of Modern Art in China*, Hunan Art Publishing House, China 1994 Hou Hanru, 'Wang Du', *Purple Prose*, No 9, Paris 1997 Hou Hanru (ed.), *Uncertain Pleasure: Chinese Artists in the 1990s*, Art Beatus, Vancouver; *Cities on the Move*, Secession, Vienna, CAPC, Musée d'Art Contemporain, Bordeaux 1998 Henry Tsang, 'Uncertain Pleasure', *Art Asia Pacific*, Sydney, February

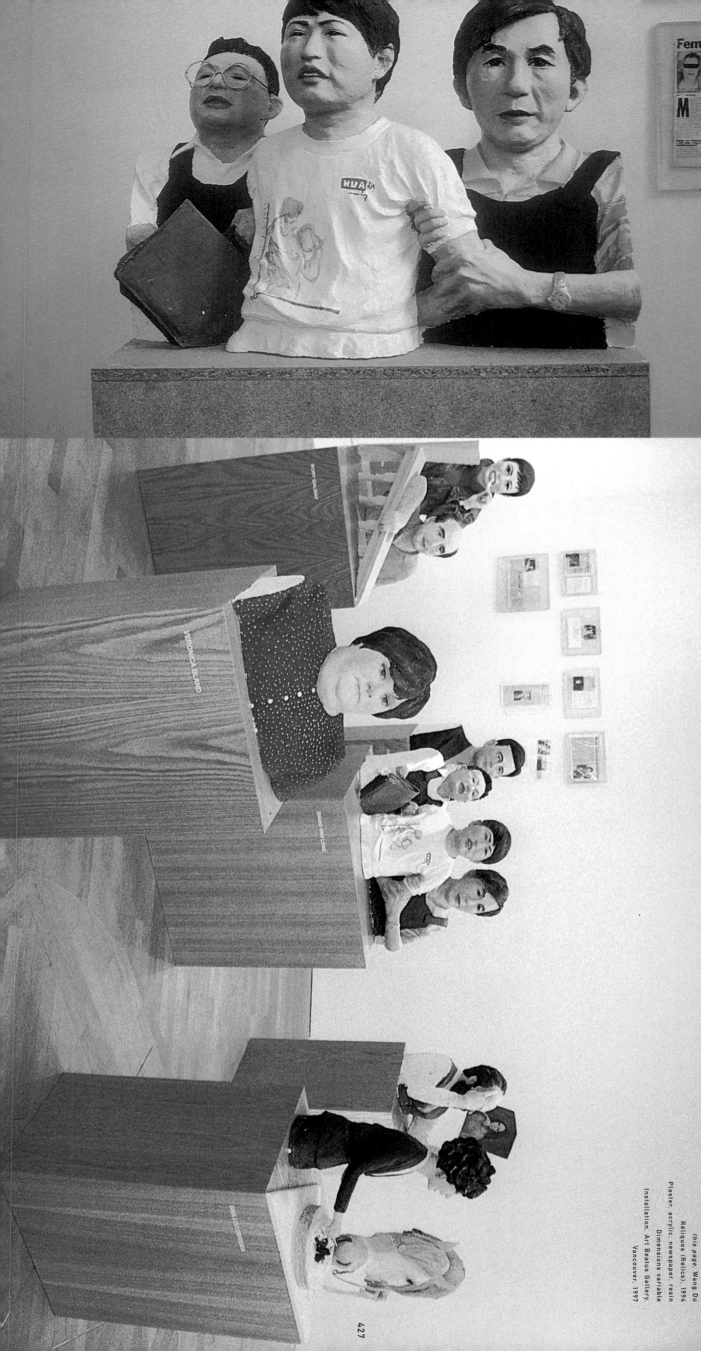

this page, Wang Du
Réliques (Relics), 1994
Plaster, acrylic, newspaper, resin
Dimensions variable
Installation, Art Beatus Gallery,
Vancouver, 1997

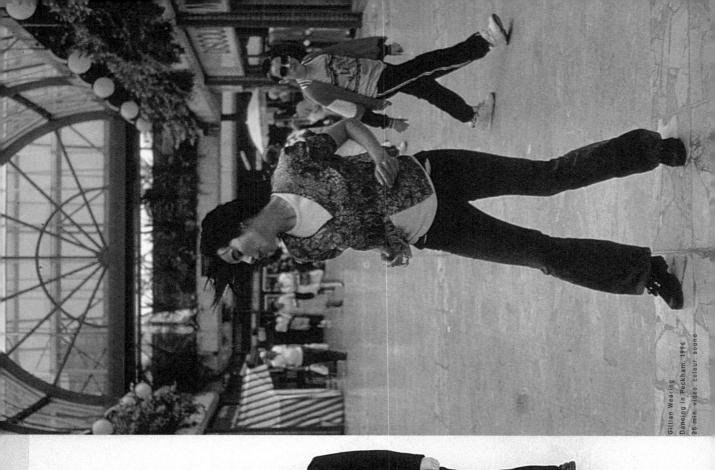

Gillian Wearing
Dancing in Peckham, 1994
25 min. video, colour, sound

Gillian Wearing

Sixty-Minute Silence, 1996

60 min. video projection, colour, sound

that many people initially considered a joke. From a five-year vantage point, however, *Signs that say what you want them to say not Signs that say what someone else wants you to say*, 1992–93, seems almost prescient in its use of media strategies to unearth subject matter that is both startlingly personal and more than bit unsettling. With its series of single format placards upon which willing strangers have written the message of their choice, *Signs ...* enables the subject and the reader to share a conspiratorial moment of being set up by the artist for what appears to be an aesthetic venture. The work reveals passions and vulnerabilities that are so direct they make the artist seem like an intruder.

Confession and therapy seem to be at the heart of Wearing's project. In the well-known video *Dancing in Peckham*, 1994, She spends twenty-five minutes dancing in a shopping mall, while ambient noises surround her. She has a secret, however: the music she's listening to is playing only in her memory, so that both the mall public and the viewer are brought together by being left out of the artist's silent inner world. In a concurrent work, *Confess All on Video*, 1994, the artist advertized for participants to don masks and share secrets that they would be very unlikely to reveal were their faces recognizable. In both works, a forced or arti-ficial situation is created in which some new piece of knowledge is brought to light only under conditions that alter the way in which the truth is received.

During the past two years, 1997 Turner Prize-winner Wearing has produced the most important and ambitious works of her career, including *Sixty-Minute Silence*, 1996, and *10–16*, 1997. In the first work, the artist instructed her subjects to stand still for sixty minutes for a video portrait. As the hour progresses, the gradual breakdown of self-control, manifested by twitches, shifts of weight and the occasional nostril tweak, becomes alternately funny and excruciating for the viewer. *10–16* provokes discomfort for quite different reasons: the confessions of a series of maladjusted children and adolescents are heard coming from the mouths of grown adults, who are in fact actors trained to lip-synch the voices of their younger 'subjects'. As the age of the subject increas-es, a quite noticeable shift takes place, from the giddy optimism of the youngest to the self-conscious embarrassment of the old-est. As we gaze at the sometimes pained or bloated faces of the adult interlocutors, we realize that we have just experienced a few small but decisive steps on the long road of life, where the problems that beset us as children continue to shape our destinies today.

Dan Cameron

Gillian Wearing
10–16, 1997
15 min. video projection, colour, sound

gillian wearing

Born Birmingham, England, 1963. Lives and works in London.

selected solo exhibitions: 1993 City Racing, London 1996 Interim Art, London; 'Wish you were here', De Appel, Amsterdam; Le Consortium, Dijon 1997 Jay Gorney Modern Art, New York; Kunstlerhaus, Zurich, Chisenhale Gallery, London 1998 Centre d'Art Contemporain, Geneva **selected group exhibitions:** 1991 'Empty Gestures', Diorama Art Centre, London 1992 'British Art Group Show', Le Musée des Beaux-Arts, Le Havre, France 1993 'Vox Pop', Laure Genillard Gallery, London; 'Okay Behaviour', 303 Gallery, New York; BT Young Contemporaries, Cornerhouse, Manchester and tour 1994 'Le Shuttle', Künstlerhaus, Berlin 1995 'Brilliant! New Art from London', Walker Art Center, Minneapolis; XLVI Venice Biennale; 'X/Y', Centre Georges Pompidou, Paris 1996 'I.D.', Van Abbe Museum, Eindhoven, The Netherlands; 'life/live', ARC, Musée d'Art Moderne de la Ville de Paris, Centro Cultural de Bélem, Portugal 1997 'Strange Days', Gianferrari Arte Contemporanea, Milan; 'Pictura Britannica: Art from Britain', Museum of Contemporary Art, Sydney and tour; 'Projects', Irish Museum of Modern Art, Dublin; 'Sensation', Royal Academy of Art, London; 'The Turner Prize', Tate Gallery, London **selected bibliography:**

1994 Adrian Searle, 'Gillian Wearing', *frieze*, London, September/October; Jon Savage, 'Vital Signs', *Artforum*, London, March 1995 Roberta Smith, 'Some British Moderns Seeking to Shock', *The New York Times*, December; Gregor Muir, 'Sign Language', *Dazed and Confused*, No 25, London 1997 Richard Dorment, 'Out of the Mouths of Babes', *The Daily Telegraph*, London, 21 May; David A. Greene, 'Kids', *The Village Voice*, New York, 21 October; John Ronson, 'Ordinarily So, John Ronson on documentary film-making and Gillian Wearing', *frieze*, London, September/October; Melissa E. Feldman, 'Gillian Wearing at Interim Art', *Art in America*, New York, July; Iwona Blazwick, 'City nature', *Art Monthly*, London, June; Gilda Williams, 'New Work', *Art Monthly*, London, February/May 1998 Nico Israel, 'Gillian Wearing', *Artforum*, New York, January; Nancy Princenthal, 'Gillian Wearing', *Art in America*, New York, January; Gilda Williams, 'Wah-Wah: The Sound of Crying or the Sound of an Electric Guitar', *Parkett*, No 52, Zurich; forthcoming, Russell Fergusen, Donna de Salvo, John Slyce, *Gillian Wearing*, Phaidon Press, London

left, Gillian Wearing
from Confess all on video ..., 1994
30 min, video, colour, sound

opposite, Gillian Wearing
from Signs that say what you want them
to say and not Signs that say what
someone else wants you to say, 1992-93
C-print, aluminium
30.5 x 40.5 cm

elin wikström

Elin Wikström's projects address social concerns by placing the viewer at the very centre of the work. She makes us aware of the connections between the institution, the artwork and the public – an approach that has been called 'relational aesthetics', but which Wikström often refers to as 'constructed situations'. These works share certain formal affinities with Performance Art, although Conceptualism is the most pertinent art-historical reference point. Made for Skulptur. Projekte Münster, 1997, *Returnity* was the result of a collaboration between Wikström and the Swedish artist Anna Brag. They created a temporary cycling club comprising eleven customized bicycles and a club house located beside a park. Each bicycle was equipped with a pair of extra cog-wheels that caused it to move backwards when pedalled. In order to facilitate smooth reverse travel, rear-view mirrors and training wheels were also fitted. Some 2,200 people experimented with 'returnity' cycling', and a group of fifty or so true enthusiasts returned every week to experience an alternative stance that challenged routine conceptions of knowledge, movement, progress and relativity. In an age when our perceptions of reality are increasingly oriented towards the virtual and the non-bodily, *Returnity* offered a new perspective based on direct physical experience.

There is no single agenda behind Wikström's various projects – although each one is site-specific and springs from a concrete situation – but it is nevertheless clear that she works in a general humanist vein, presenting alternative models of reality, often feminist in outlook. In an earlier project, *Rebecka is Waiting for Anna, Anna is Waiting for Cecilia, Cecilia is Waiting for Marie ...*

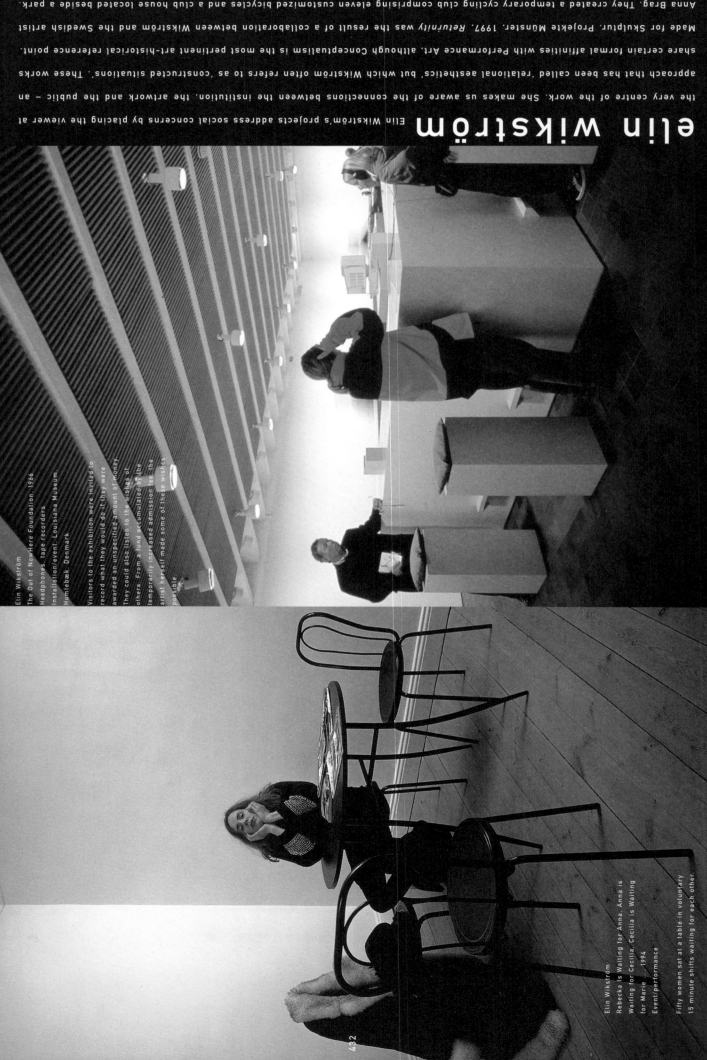

Elin Wikström
The Out of Nowhere Foundation, 1986
Headphones, tape recorders
Installation/event, Louisiana Museum,
Humlebæk, Denmark

Visitors to the exhibition were invited to record what they would do if they were awarded an unspecified amount of money. They could also listen to the wishes of others. From a fund accumulated by the temporarily increased admission fee, the artist herself made some of these wishes possible.

Elin Wikström
Rebecka is Waiting for Anna, Anna is Waiting for Cecilia, Cecilia is Waiting for Marie, 1994
Event/performance

Fifty women sat at a table in voluntary 15 minute shifts waiting for each other

Sustaining loyalty that exists between women is evoked by this work, and conventional images of women 'waiting for the right man'

 or 'being left on the shelf' dissolve when we know that these women are in fact waiting for their female friends.

Occasionally, Wikström's projects take the form of 'living sculpture', with either the artist or hired performers as models. In most

works, however, active audience participation is fundamental. In *The Out of NowHere Foundation*, 1996 – a kind of wishing well –

visitors stepped up to a counter where they were asked what they would do if they suddenly received a considerable sum of money.

Having dictated their replies into a microphone, they could then listen to tapes of others' wishes – ranging from the opportunistic

to the fantastic, from the egotistical to the politically correct. To fund the project, the standard admission fee was increased by one

crown per person and the resulting 110,000 Dkr (approximately £10,000) was used to realize some of the visitors' wishes, for

example a single mother's desire for a washing machine, a child's wish for a new Barbie doll. The good will shown by the organ-

izers and the self-searching and reflection engaged in by the participants were characteristic of Elin Wikström's work as a whole.

Åsa Nacking

this page, Elin Wikström
Oh hell!, 1997
Performance
Los Angeles Contemporary Exhibitions
Part of this work consisted of a woman slant-parking of four cars between the mandatory space and the parking lot out-side. The temperature was very heavy and required the assistance of a helpful visitor or passer-by.

This page: Elin Wikström
*Åsa Who Has Given It to Bill Is Risking
Not to Get It Back and Pat Who Has Got
It from Pip Is Risking Not Being Able to
Give It Back.* 1995
Performance/event

Visitors to this exhibition were asked to
pay an entrance fee of two crowns. On
entering the gallery they were then
offered (and usually refused) two
crowns.

elin wikström

**select-
ed solo exhibitions:**

Born Västerås, Sweden, 1965. Lives and works in Göteborg

**select-
ed solo exhibitions:** 1994 'Mice and Men'. Hemma Hos, Göteborg 1995 'Goods and Services', Rum, Malmoe and
tour 1996 'One in a Million: Maybe She, Maybe You, Maybe He, Maybe She ...'. Museum of Modern Art, Göteborg 1998 'A Portrait of
Mr Weimar'. Andreas Brandström Gallery, Stockholm **selected group exhibitions:** 1993 'ICA'.
Malmborgs Supermarket, Caroli City, Malmoe 1995 'Shift. De Appel, Amsterdam 1996 'Nowhere'. Louisiana Museum, Humlebæk,
Denmark: 'I Am Curious: Come and See Us'. Independent Art Space, London 1997 'Letter and Event'. Apex Art, New York; xLVII
Venice Biennale. Skulptur. Projekte Münster, Germany **selected bibliography:** 1993 Åsa Nacking. 'Elin
Wikström Leaves Room for Waiting'. *Siksi*, No 3, Helsinki 1995 'Elin Wikström in Conversation with Åsa Nacking'. *Shift.* De Appel,
Amsterdam 1996 Laura Cottingham. *Nowhere.* Louisiana Museum, Humlebæk, Denmark; Maria Lind. 'At What Price?'. *See What it
Feels Like!*, Rooseum, Malmoe. Sara Arrhenius. 'See How it Feels'. *Flash Art*, Milan. June 1997 Rhonda Lieberman. *Jim Shaw. Toy
Store.* Los Angeles Contemporary Exhibitions. Maria Lind. *Letter and Event.* Apex Art, New York; Susan Kandel. 'A Swedish
Mentality Toys with U.S. Pop Sensibility'. *The Los Angeles Times*, 18 April

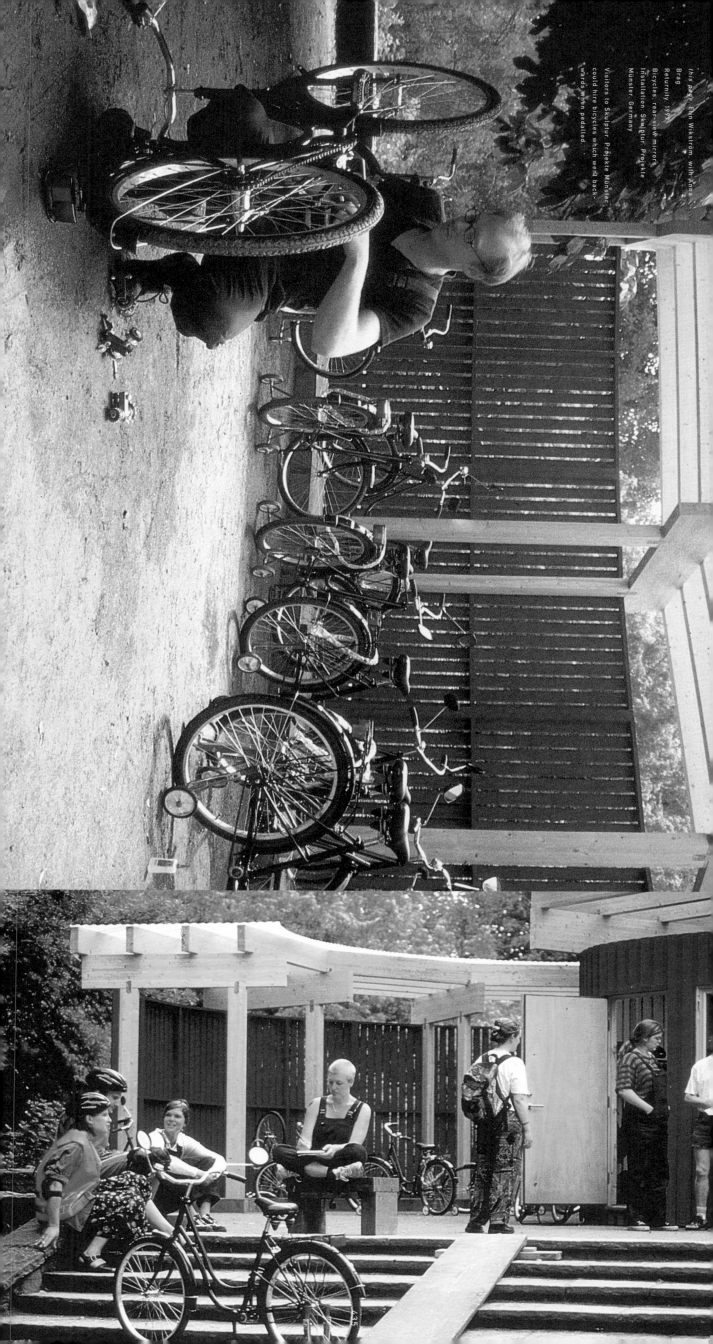

this page: Elin Wikström, with Anna
Brag
Returnity, 1997
Bicycles: rear-view mirrors
Installation, Skulptur. Projekte
Münster, Germany

Visitors to Skulptur. Projekte Münster
could hire bicycles which went back-
wards when pedalled.

lisa yuskavage

Yuskavage's paintings represent the worst cultural nightmares of most liberals. Although her work is technically accomplished and beautifully executed, her choice of subject matter suggests a continuing traumatic reaction to the discovery (whether real or apocryphal) of her father's *Penthouse* magazine collection when she was still at an impressionable age. For better or worse, Yuskavage's introduction to the world of exploited female bodies continues to dominate her visual description of the world. From her first exhibitions in the early 1990s, Yuskavage has deployed an unusually hard-hitting response to misogynistic cultural norms. Rather than supplant this mode of representation with a more uplifting one, or attempt to correct it outright, Yuskavage prefers to exploit it on her own terms, transforming anatomical exaggeration and display into disturbing questions about the troubled intersection of beauty and sexuality in contemporary art. In Yuskavage's canvases, the anatomically challenged female is shown in an eternal dream-state, hovering over the artificial horizons like humourless sentinels. In *Motherfucking Foodeating Still-Life*, 1997, a hefty blonde turns towards us from the misty background, her inscrutable expression reinforced by a lack of corporal substance from her thighs downward. The circular forms scattered about a receding plane seem to be issuing from her vagina, as an ominous redhead glides into the shadows on stage right. The diptych *Goodevening Hamass*, 1997, opts for a more conventional desert setting. On one side is the title figure, her *derrière* transforming into a massive topographic element that appears to recede into red dust and billows of smoke; on the other is a stereotypically perfect arrangement of flowers in a vase, towards which the giant figure seems to be making her vengeful way.

The role played by feminism in Yuskavage's work is worth touching upon, if only because it seems eagerly to revive the mostly rhetorical dispute between those who feel that personal liberation demands that the imagination be entirely unfettered, and those who worry about the possible negative impact of imagery that quotes the demeaning status quo without an explicit challenge. In Yuskavage's view, the far greater danger lies in the perpetuation of largely mythic viewpoints about age, shape and sexual sub-missiveness in the construction of ideal feminine beauty. Her figures may not be beautiful in the conventional sense, but they make a strong case for the much greater monstrosity that occurs when women, who look more like Yuskavage's models than those in fashion magazines, wind up feeling devalued when they see the latter's impossible standards reflected back at them. Yuskavage's women may be ponderous and even horrific, but they also signal a continuing problematic raised when standards for depicting women are still being re-written by the subject-authors.

Dan Cameron

opposite. Lisa Yuskavage
Surrender. 1998
Oil on linen
91.5 x 91.5 cm

this page. Lisa Yuskavage
Goodevening Hamass. 1997
Oil on linen
106.5 x 228.5 cm

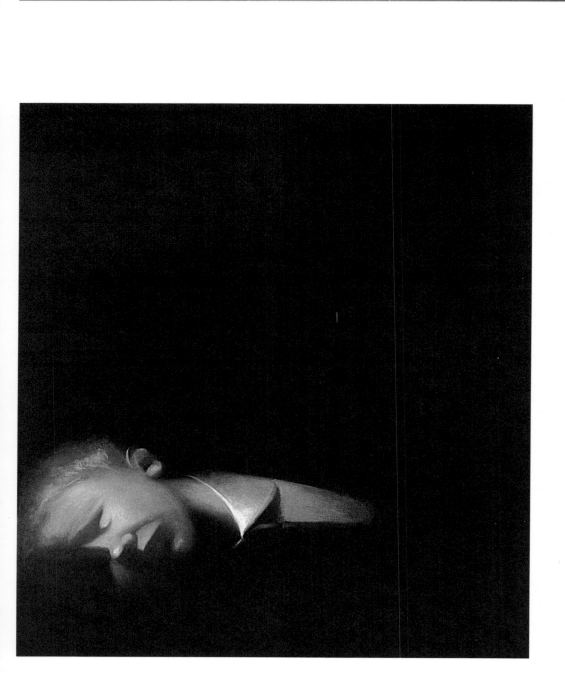

above. Lisa Yuskavage
The Feminist's Husband. 1996
Oil on linen
106.5 x 119.5 cm

right. Lisa Yuskavage
Interior: Big Blonde with Beaded
Jacket. 1997
Oil on linen
213.5 x 183 cm

lisa yuskavage

Born Philadelphia, Pennsylvania, 1962. Lives and works in New York.

selected solo exhibitions:

1990 Pamela Auchincloss Gallery, New York 1993 Studio Guenzani, Milan 1994 Luhring Augustine Gallery, New York 1996 Christopher Grimes Gallery, Santa Monica, California 1998 Marianne Boesky Gallery, New York

selected group exhibitions:

1986 'New Talent', Alpha Gallery, Boston 1988 'Twenty Artists Choose Twenty Artists', Provincetown Art Museum, Massachussetts 1993 'The Return of the Cadavre Exquis', The Drawing Center, New York 1995 'Pittura Immedia: Painting in the '90s', Kunstlerhaus and Neue Galerie, Graz, Austria 1996 'The Tailor's Dummy', Christopher Grimes Gallery, Santa Monica, California; 'Early Learning', Entwistle Gallery, London 1997 'My Little Pretty', Museum of Contemporary Art, Chicago 1998 'Young Americans', Saatchi Gallery, London

selected bibliography:

1993 Barry Schwabsky, 'Lisa Yuskavage at Elizabeth Koury', *Artforum*, New York, April 1994 Jerry Saltz, 'A Year in the Life of Painting', *Art in America*, New York, October; Barry Schwabsky, 'Confessions of a Male Gaze', *The New Art Examiner*, New York, April 1996 Hannah Feldman, 'The Lolita Complex', *World Art*, No 2, New York; Rosetta Brooks, 'Some Girls Do', *art/text*, No 54, Sydney 1997 Barry Schwabsky, 'Picturehood is Powerful', *Art in America*, New York, December; Peter Schjeldahl, 'Painting Rules', *The Village Voice*, New York, 30 September; Matthew Ritchie, 'Lisa Yuskavage at Boesky & Callery', *Flash Art*, Milan, March/April; Sydney Pokorny, 'Lisa Yuskavage at Boesky & Callery', *Artforum*, New York, February

Lisa Yuskavage
Motherfucking Foodeating
Still-Life, 1997
Oil on linen
213.5 x 183 cm

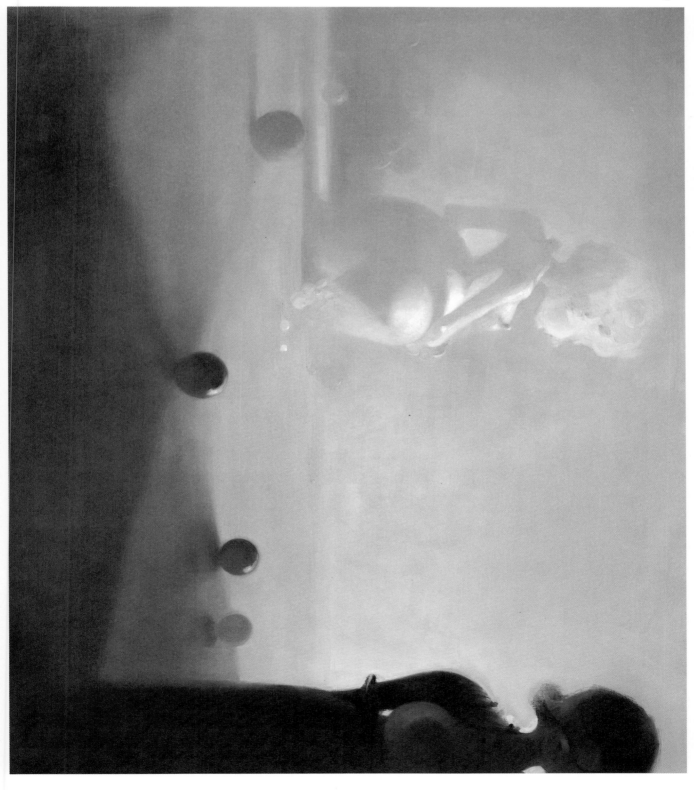

zhang peili

Most people think a virus is something accidental, so it is usually called 'abnormal'. In my eyes, all kinds of viruses are a part of the normal phenomenon of life, or it is simply another phenomenon of life. When observing carefully, we will discover there exists a strong metaphysical power behind it.

— Zhang Peili

In *Report on the Epidemic Status of Hepatitis*, 1988, Zhang Peili, a victim of the illness, not only presents a description of the epidemic proportions reached by this disease in China, but also questions the mechanisms of observing and understanding health and illness. By looking at the virus as 'another phenomenon of life' he challenges the relationship between man and the natural world. However, for Zhang the relationship between man and world reveals an ontological paradox: the world is unfathomable, and all human efforts to understand it begin from a position of isolation and result in a profound sense of pointlessness. As a metaphor for this situation Zhang employs semi-transparent medical rubber gloves. These may project us from infections, but they also prevent us from making contact with the metaphysical power inherent in the virus. Protection in this equation equals isolation and ignorance. The ambition to discover metaphysical power ends in the revelation of one's ineffectuality.

To Zhang, this reflects the state of mind of a generation of Chinese who grew up in the transition from an enclosed and stagnant Cultural Revolution to cultural liberation, social reform and the current globalization. However, he sees these changes as ultimately idle and absurd. Preferring to take a distanced, neutral position in order to create a space that allows him more freedom to ponder upon the relationship between man and the world, he proposes alternatives to established concepts. In works such as *30 x 30*, 1988, he pushes this neutrality to its extreme by mechanically and repetitiously breaking a mirror into pieces and gluing the fragments back together over a period of several hours. *Artistic Project No 2*, 1988, is a conceptual project, which violently demands that participants obey its rigorous but ridiculous rules. Such aggressive, even ruthless actions, underline Zhang's sense of the unbearable pointlessness and absurdity of the world.

In his more recent works, Zhang reinforces this tension by contrasting the electronic spectacle of video installation with a concentrated gaze that scrutinizes a single object, gesture or body. In *Amusement Park*, 1992, he transformed a toy into an infernal machine of noise and violence, while in *Wei* (Document on Hygiene No 3), 1990, he incessantly washed a chicken over a period of hours, exposing the absurdity of the human obsession with cleanliness. *Uncertain Pleasure*, 1996, a multi-channel video installation, deliberately provokes our discomfort by inviting us to watch intensely close-up images of someone constantly scratching, an experience that causes us to itch as well. The 'uncertain pleasure' of the title is perhaps a reference to the unconscious enjoyment

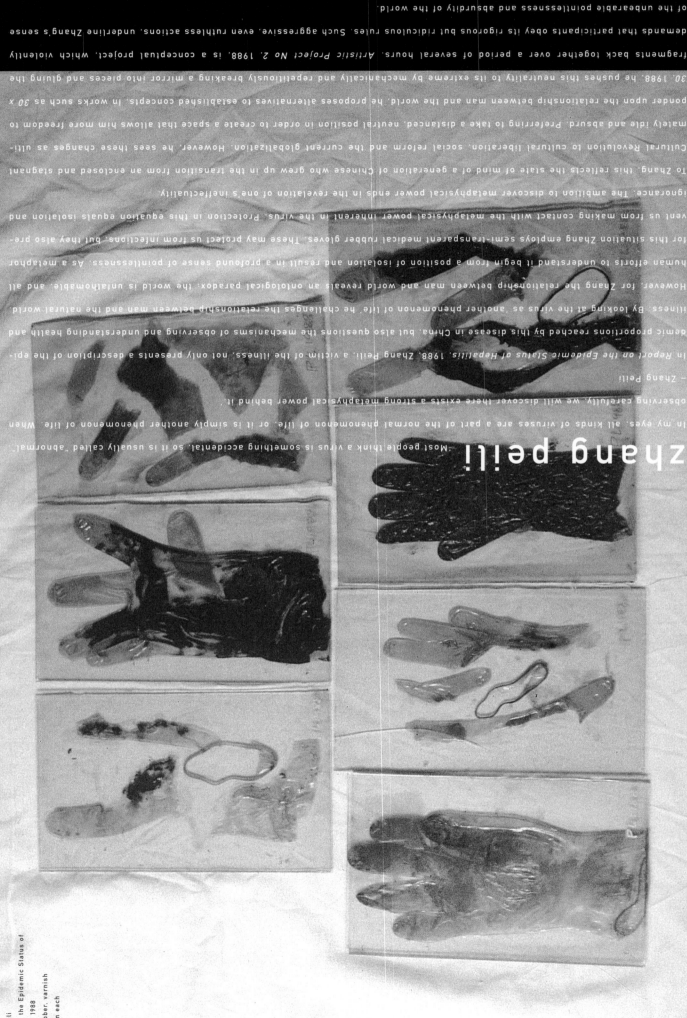

Zhang Peili
Report on the Epidemic Status of
Hepatitis, 1988
Glass, rubber, varnish
30 x 30 cm each

Zhang Peili
Wei (Document on Hygiene No 3), 1990
60 min. video, colour

Zhang Peili
Uncertain Pleasure
30 min. video installation, colour

zhang peili
Born Hangzhou, China, 1957. Lives and works in Hangzhou, China. **selected solo exhibitions:** 1993 Galerie Crousel-Robelin, Paris 1997 Galerie Krinzinger, Vienna; The Art Gallery of Chulalongkom University, Bangkok **selected group exhibitions:** 1993 'China Avant Garde', Kunsthal, Berlin 1994 'Gaze – L'Impossible Transparence', Parc Floral, Carré des Arts, Paris 1995 'Pier Show 3', Red Hook, New York 1996 'Image and Phenomena', The Gallery of Zhejiang Academy of Fine Arts, Hangzhou, China 1997 'New China' Jack Tilton Gallery, New York; Lyon Biennale; 'Cities on the Move', Secession, Vienna **selected bibliography:** 1989 Fei Dawei, 'Chine/Avant Garde', *art press*, Paris, November 1991 Michel Nuridsany, 'Zhang Peili: La China, si proche', *Le Figaro*, Paris, 19 January; Philippe Piguet, 'Zhang Peili', *Le Monde*, Paris, 15 February; Ami Barak, 'Zhang Peili-Galerie du Rond Point', *art press*, Paris, March; Li Xianting, 'Arte Cinese Contemporanea, dalla fine della Rivoluzione Culturale al Post-89', *Flash Art Italia*, Milan, May; Guy Brett, 'Zhang Peili at Crousel-Robelin Bama', *Art in America*, New York, November 1995 Joan Lebold Cohen 'A Studio Visit With Zhang Peili', *Art Asia Pacific*, Sydney, Autumn

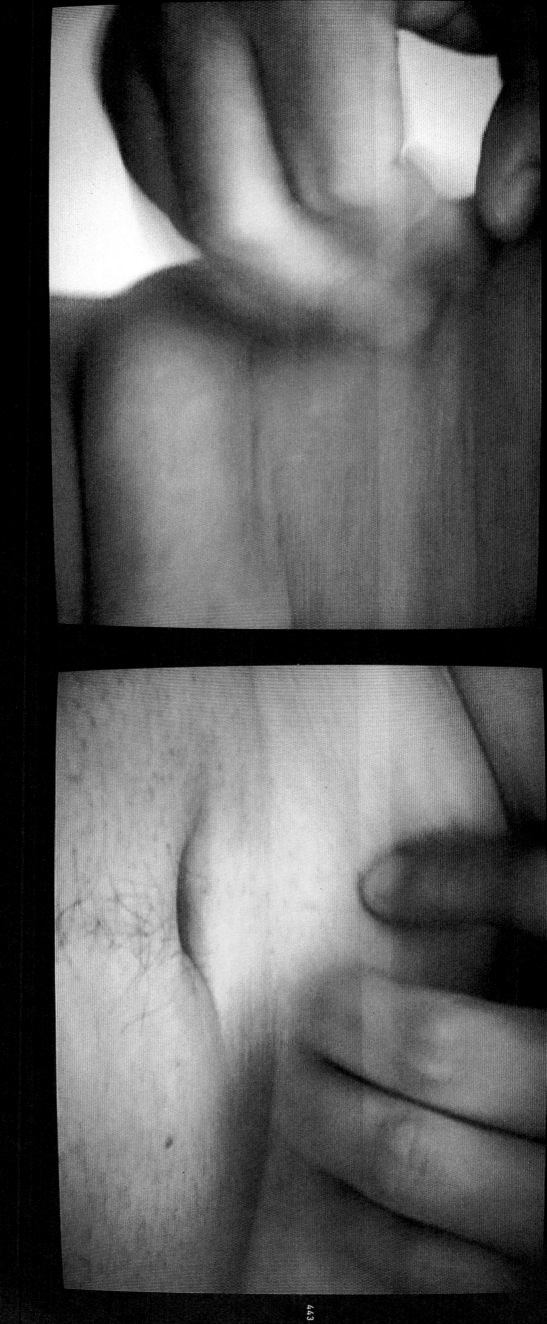

Zhang Peili
Uncertain Pleasure
30 min. video, colour

New Listing, Zhou Tiehai, Rises On Debut Before Reaching Fair Value

Shanghai

WHEN first listed July 12 on the Shanghai Stock Exchange, Zhou Tiehai appeared undervalued, rising only slightly in the first few hours of trade.

But Class B* shares in the issue appreciated steadily over the next two weeks, as foreign buyers learned more about the enterprise's fundamentals. One European buyer even was rumoured to be accumulating large blocks of the stock in a bid to obtain a majority stake, traders said.

The gradual appreciation accelerated into an all-out buying spree beginning on July 26, when the unnamed European buyer discovered previously undisclosed assets in Zhou Tiehai. The stock closed out the month just below a psychological high. Traders then said they doubted the stock would rise much further.

"If the Zhou climbs much higher it will find itself very vulnerable to market fluctuations and exposed to the whims of profit-takers," said a market analyst with a Shanghai-based securities firm.

Yet an injection of new funds on Aug. 6 caused the stock to soar on strong buying again rumoured to originate from Europe. The initial surge was followed by three to four days of consolidation in the value of the stock. Traders said it was a technical correction, ending on Aug. 10.

The Zhou fell slowly over the next few sessions, as the European buyer, realising its in-

vestment had become overvalued, took som profits.

By Aug. 13, the Zhou had fallen to more su tainable level, before its shares were su pended from trading ahead of a sharehol ers meeting.

When trading resumed Aug. 26, the Zhou too a slight knock, consolidating on Aug. 27 to level just below its pre-suspension price.

According to market participants, the stock now valued fairly in the eyes of the big house and seems likely to remain stable in the fore seeable future.

Its fundamentals remain sound, and bullis traders expect renewed interest by oversea buyers to bring the Zhou Tiehai higher in the long term. Indeed, some traders said they have seen indications in recent sessions that foreig houses are accumulating the Zhou again.

*Shanghai has two stock markets. Class B shares are denominated in US dollars and tradable only by overseas investors; Class A shares, denominated in yuan, are available only to domestic Chinese buyers.

PRICE CHART

Zhou Tiehai
Stock Market Project. 1997
Printed page from magazine
Dimensions variable

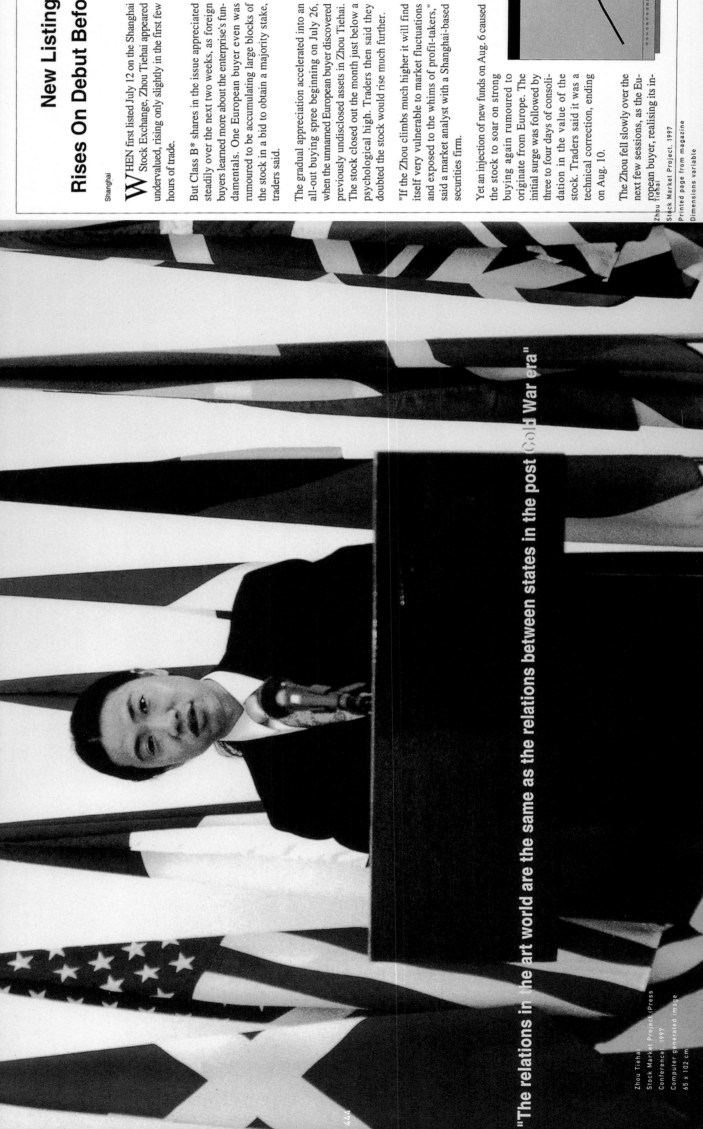

"The relations in the art world are the same as the relations between states in the post Cold War era"

Zhou Tiehai
Stock Market Project (Press Conference). 1997
Computer generated image
65 x 102 cm

zhou tiehai

A singular figure in the Chinese art scene, Zhou Tiehai works at the margins of the avant garde. This position allows him to maintain a distance in order to observe an art world increasingly involved in the global market. Having spent his life in Shanghai, China's biggest city and a new strategic point in the 'grid of Global Cities' (to use a term coined by Saskia Sassen, an Urban Planning professor at Columbia University), Zhou is no stranger to the radical social, economic, political and cultural changes there. In his latest advertisement-like work, *Stock Market Project*, 1997, printed in books, newspapers and on billboards both in China and abroad, he poses as a government spokesman in front of the flags of the super powers, to announce that 'the relations in the art world are the same as the relations between states in the post-Cold War era'. This act of self-mockery exposes a collective desire for fame and wealth in the art world, a cynical greed that pushes it towards a general integration with the mechanisms of multinational capitalism. The image is often introduced by a page stating 'If you want to know how the West sees Shanghai, read *Time, der Spiegel, The Asian Wall Street Journal*, etc. If you want to know the view of a Shanghai artist, see page ... ' Another page often follows it resembling a stock market report with the headline: 'New Listing, Zhou Teihai Rises on Debut before Reaching Value'.

Zhou's casual attitude to institutional recognition gives him the freedom to express his ideas through a range of media without being anxious about their marketing possibilities. He practices art beyond the established categories and hierarchies of materials and techniques in inventive works that parody the media from which they are made. These have included painting, computer-generated images, conceptual statements, films, the Internet, performance and soundtracks. His extraordinary gouache works on immense sheets of wrapping paper can be compared with 'bad painting' or graffiti art, whilst his computer-generated magazine covers, upon which he appears as a media star, and his film *Will*, 1996 – a thirteen-minute sequence of black frames – can be considered as conceptual work. Whether exotic images or ironic statements, all these diverse works have in common a poignant sarcasm directed at power plays in international artistic, cultural and commercial worlds, especially manipulation by the omnipotent Western mass media and the ambivalent reaction of the modern Chinese society.

Hou Hanru

Zhou Tiehai
Cover (*Art in America*), 1995
Computer-generated image
27.5 x 23 cm

Zhou Tiehai
Cover
(*The New York Times Magazine*), 1995
Computer-generated image
24.5 x 29 cm

Zhou Tiehai
Cover (*Flash Art*), 1995
Computer-generated image
27 x 20.5 cm

Zhou Tiehai
Cover (*Newsweek*), 1995
Computer-generated image
27 x 20.5 cm

zhou tiehai Born Shanghai, China, 1966. Lives and works in Shanghai. **selected solo exhibitions:** 1998 'Shower', Un/Limited Space, German Consulate, Shanghai; 'Zhou Tiehai', Kunsthal, Rotterdam 1996 'Too Materialistic, Too Spiritualized', CIFA Gallery, Beijing **selected group exhibitions:** 1986 'M', Hongkou District Cultural Centre, Shanghai 1994 'APE', Hua Shan Art School, Shanghai 1996 'Cities on the Move', Secession, Vienna 1997 'Promenade in Asia', Shiseido Gallery, Tokyo; 'In the Name of Art', Liu Hai Su Museum, Shanghai; 'Another Long March: Chinese Conceptual Art 1997', Fundament Foundation, Chasse Kazerne, Breda, The Netherlands 1998 'Critical Paintings of the Late Nineties', Westfälischer Kunstverein, Munster, Germany; 'Asia City', Photographers' Gallery, London **selected bibliography:** 1996 Hou Hanru, 'Ambivalent Witnesses: Art's Evolution in China', *Flash Art*, Milan, November 1997 Maggie Farley, 'China's Young Generation', *The Los Angeles Times*, 23 March; Chris Droiessen, Heidi van Mierlo, *Another Long March: Chinese Conceptual Art 1997*, Breda, The Netherlands; Iro Toshiyuki, Higuchi Masaki, *Promenade in Asia*, Shiseido Gallery, Tokyo 1998 Karen Smith, 'Another Long March', *Art Asia Pacific*, No 17, Sydney; Layne Christensen, 'Art After Mao', *North Shore News*, Vancouver, 6 March; Karen Love, 'From Communist China to North Vancouver', *Arts Alive*, Vancouver, March/April

Zhou Tiehai
We Cannot Afford It, 1995
Gouache on paper
111 x 238 cm

index